History of
Japanese Art

Second Edition

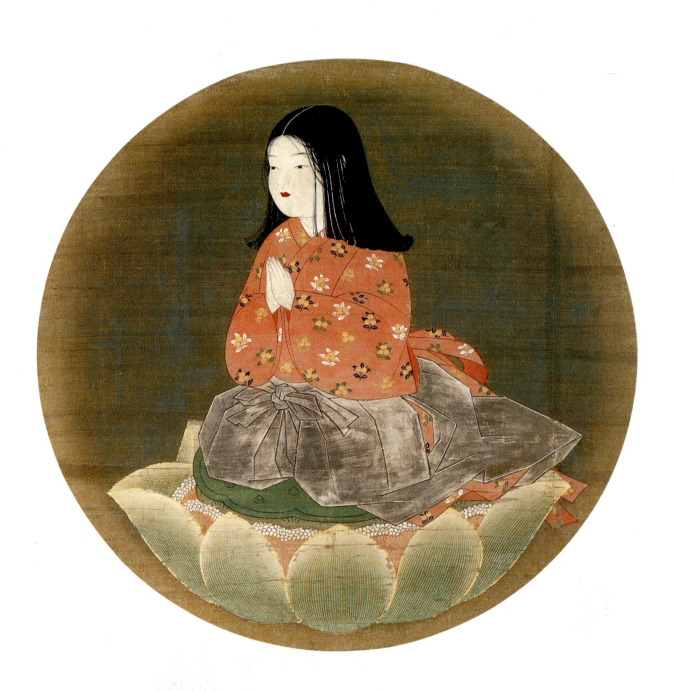

History of Japanese Art

Second Edition

Penelope Mason

Revised by
Donald Dinwiddie

PEARSON

Prentice
Hall

Upper Saddle River, N.J. 07458

Library of Congress Cataloging-in-Publication Data

Mason, Penelope E., (date)
 History of Japanese art / Penelope Mason ; Donald Dinwiddie, revising author.--2nd
ed.
 p. cm.
 Includes bibliographical references and index.
 ISBN 0-13-117601-3 (paper) -- ISBN 0-13-117602-1 (case)
 1. Art, Japanese. I. Dinwiddie, Donald, (date). II. Title

N7350.M26 2004
709.52--dc22

 2004044653

Editorial Director: Charlyce Jones Owen
Editor-in-Chief: Sarah Touborg
Editorial Assistant: Sasha Anderson
Manufacturing Buyer: Sherry Lewis
Executive Marketing Manager: Sheryl Adams

Credits and acknowledgments borrowed from other sources and reproduced, with
permission, in this textbook appear on page 414.

Copyright © 2005, 1993 by Pearson Education, Inc., Upper Saddle River, New
Jersey, 07458. Pearson Prentice Hall. All rights reserved. Printed in China. This pub-
lication is protected by Copyright and permission should be obtained from the publisher
prior to any prohibited reproduction, storage in a retrieval system, or transmission in any
form or by any means, electronic, mechanical, photocopying, recording, or likewise. For
information regarding permission(s), write to: Rights and Permissions Department.

Pearson Prentice Hall™ is a trademark of Pearson Education, Inc.
Pearson® is a registered trademark of Pearson plc.
Prentice Hall® is a registered trademark of Pearson Education, Inc.

Pearson Education LTD. Pearson Education, Canada, Ltd
Pearson Education Australia PTY, Limited Pearson Educación de Mexico, S.A. de C.V.
Pearson Education Singapore, Pte. Ltd Pearson Education–Japan
Pearson Education North Asia Ltd Pearson Education Malaysia, Pte. Ltd

This book was designed and produced by
Laurence King Publishing Ltd, London
www.laurenceking.co.uk

Every effort has been made to contact the copyright holders, but should there be any
errors or omissions, Laurence King Publishing Ltd would be pleased to insert the appro-
priate acknowledgment in any subsequent printing of this publication.

Editor: Anne Townley
Picture Researchers: Julia Ruxton, Emma Brown, DNP Archives.Com Co. Ltd.
Designer: Peter Ling
Map Illustrator: Advanced Illustration Limited

Front Jacket: Detail of *Pine Trees in the Snow*, right screen of a pair of six-panel *byōbu*, by
Maruyama Ōkyo. 4th quarter of the 18th century. Ink, slight color and gold on paper;
each screen: 60⅞ x 142⅛ in. (155.5 x 362 cm). Mitsui Bunko, Tokyo

Frontispiece: Chigo Daishi (Kōbō Daishi as a child). Kamakura period, 14th century.
Hanging scroll, ink, color and gold on silk; 34⅛ x 19¼ in. (86.7 x 48.9 cm). The Art
Institute of Chicago. Gift of the Joseph and Helen Regenstein Foundation. (1959.552)

1 0 9 8 7 6 5 4 3 2
ISBN 0-13-117601-3

Printed in China

Contents

Preface

One of Japan's defining features is that for much of its history it has successfully maintained itself as a world apart. This has provided Japanese culture with a kind of hothouse environment where the influx of outside influences could be regulated in a way that few of its neighbors could ever hope to achieve. Yet, where this control might have produced an art and culture both stale and monotonous, the particular dynamism of the Japanese character has instead fostered a flowering of what seems a limitless variety of rare and beautiful blooms. Because of this profusion, Japanese art and culture has enjoyed an immense popularity in the West since the country opened its doors to the outside world in the mid-nineteenth century. Japanese art has had a not inconsiderable impact on Western art forms of the last century and a half, and Japanese artists and architects today stand at the forefront of developments on the world stage.

Perhaps because it is so easy to become engrossed in just one aspect of Japan's cultural heritage, there have been surprisingly few publications to attempt a synthesis of the entirety of Japan's long and distinguished art history. When in 1993 Penelope Mason wrote the first edition of *History of Japanese Art*, it was the first such volume in thirty years to chart a detailed overview of the subject. The present, revised edition builds on Mason's massive achievement, extending the book's coverage of Japanese art beyond 1945 and introducing new discoveries in both archaeology and scholarship. The new edition also brings into the discussion other art forms left largely or entirely uncovered in the book's original remit. Among these are calligraphy, ceramics, lacquerware, metalware, and textiles. Finally, there has been an attempt to tie together more closely the development of these different art forms within a well-articulated historical and social context, so that the student might better grasp the distinct, but complex evolution of Japanese aesthetics.

The first step towards such an understanding, however, rests in the knowledge of a few basic principles of the culture. As this book is intended for the beginning student, the following explanations should provide the necessary grounding.

Japanese Language

Although the fundamental structure of Japan's spoken languages was probably set some time within the pre- or proto-historic periods, it was not until the seventh century CE that the Japanese people actually began formulating their own written language. Before this time, they used the Chinese language for all affairs of letters. The great flexibility of the Chinese system of ideographs—or characters—is that they represent ideas or concepts and can

therefore be recognized by the speakers of any number of languages, each of whom can pronounce the word for any particular idea or concept according to his or her own linguistic custom. At first, therefore, the Japanese written language was a simple appropriation of Chinese characters, known as *kanji*, and these still form its basis. *Kanji* can be read in two different ways. There is the *on* reading of a character, which is an approximation of its standard Chinese pronunciation at the time the character entered the Japanese vocabulary—not unusually around the seventh century. There is also the *kun* reading, in which the character is pronounced according to its equivalent in Japan's spoken language. For example, for the *kanji* for "temple", the *on* (or Chinese) reading is "*ji*," while the *kun* (or Japanese) reading is "*tera*" or "*dera*." As the language developed, the Japanese came to play with these *on* and *kun* readings, using them to give different nuances to a name or term. In the case of the word "temple," the first Japanese Buddhist temples were often given names ending with "*dera*," but when these Japanese-style names went out of fashion, they were replaced by more Chinese-sounding names ending with "*ji*."

However, Japanese is a language with many more polysyllabic words than the form of Chinese for which the Chinese characters were initially devised. Therefore, at the end of the eighth century, two syllabaries or *kana*—*hiragana* and *katakana*—were developed to represent the syllable sounds of the Japanese language. While *kanji* could represent a concept, the *kana* could, in effect, spell it. *Kanji* and each of the *kana*—particularly *hiragana*—can be used on their own, but most commonly all three are used together. The traditional way of writing Japanese is to write the *kanji* and *kana* sentences vertically in tiers, to be read from top to bottom, and from right to left. The custom of reading leftward is basic not only to writing but also to the viewing of paintings, and particularly those in the hand-scroll format.

For this book, however, all Japanese terminology is given in a romanization adapted from the Hepburn system. Certain Japanese terms that now appear in Webster's New Collegiate Dictionary—such as geisha, haiku, raku, netsuke and sake—are given in their unitalicized and anglicized form. All other Japanese terms, with the obvious exception of names, are placed in italics. Pronouncing Japanese is relatively easy because the vowels have constant sounds.

"a" as in f<u>a</u>ther: ka sa ta na ha ma ya ra wa
"i" as in w<u>ee</u>k: ki shi chi ni hi mi ri wi
"u" as in wh<u>o</u>: ku su tsu nu fu mu yu ru
"e" as in b<u>e</u>d: ke se te ne he me re we
"o" as in <u>oh</u>: ko so to no ho mo yo ro wo
The vowels "o" and "u" are often lengthened when speaking, and

this is indicated in the romanization with a macron, essentially a hyphen or bar over the letter: "Ō," "ō," "Ū," "ū." To aid the Japanese speaker, these have been used throughout the book, except in the case of anglicized terms as given above. Finally, conforming to current usage, most compounds formed of a root and a suffix are closed: hence Hōryūji and not Hōryū-ji. Exceptions are made where the absence of a hyphen could be dangerously confusing, particularly to indicate where one syllable ends and another begins: hence Susano-o and not Susanoo.

Names

As in much of the rest of Asia, Japanese personal names are preceded by the family or surname and followed by the individual's given name. Usually comprised of three or four syllables, the surname is often a reference to a geographical location. For example, Yamamoto means "at the base of the mountain," Kitagawa, "the north river," and Fujiwara "a field of wisteria." Given names are more complicated. Sons are sometimes named according to the sequence in which they were born. For example, Ichirō means the first born; Jirō, the second; Saburō, the third, and so on. Women's names often end in "ko," written with the symbol for child. However, the symbols for given names can be pronounced in a variety of on and kun readings, and it is difficult to know exactly how the individual reads his or her own name. Furthermore, in the course of a lifetime individuals may change their names or the reading of their names a number of times.

Aside from these standard family names, the Japanese have traditionally also had recourse to a host of titles, professional—or studio—named nicknames. These could be used in place of, or together with, an individual's family name depending on social circumstance. For example, courtiers serving in the imperial palace often had a palace name different from their original given name, and they usually changed their name again when they retired from service. The woman known as Akiko became Shōshi when she married Emperor Ichijō and then Jōtōmonin when she left the palace, became a nun, and took up residence in the Jōtōmonin Palace. When someone became a monk or a nun, it was standard to assume an ordination name, usually employing two kanji to form a Chinese-style epithet—for example: Kūkai (Empty Sea). An emperor on his accession would be given a reign name, and sometimes even acquire a new one upon his death. Recent examples are the emperor Hirohito (r. 1926–1989), whose reign name was Shōwa, and his son Akihito (r. 1989–present) who is known as Heisei. The syllable "go" before an emperor's name indicates that he is the second to be so designated. For example, the emperor Daigo reigned from 897 to 930 and was the namesake of Go Daigo, who was on the imperial throne from 1318 to 1339.

Artists often adopt studio names with which they sign their work and may change them as they feel the style of their work has changed. One artist changed his when the seal he used to sign his work cracked. The woodblock print artist whom we know as Hokusai (1760–1849) took as one of his last studio names "Old Man Mad With Painting." Traditionally when an artist or artisan

achieves a reputation, they not only establish a family and studio of disciples, but also will select one of their pupils (preferably from their own offspring) to be their spiritual descendant, and that person will be asked to take on the master's name. Thus Saburō, the third son, may be asked to take the studio name of the father and become Danjurō II. If no child within the family can be trained to succeed the father, a promising pupil may be adopted and asked to take the name of the teacher.

Dates and Periods

Over time the Japanese have used several different ways of calculating time, most of which have been adopted from their neighbor China. The oldest known calendar, dating back to 604 CE, is a sexagenary system of reckoning the years in groups of sixty and it is based upon the waxing and waning of the moon. Each year is distinguished by the conjunction of two sets of symbols, one from the cycle of ten units known as stems, jikan, the other from a cycle of twelve units known as branches, junishi. The ten-stem cycle is based on the yin/yang, positive/negative aspects of the five elements: wood, fire, earth, gold, and water. The twelve branches are a sequence of animals: rat, ox, tiger, rabbit, dragon, snake, horse, sheep, monkey, rooster, dog, and the boar. It takes sixty years before a particular pair of symbols is repeated, thus determining the standard length of a cycle. There were traditionally twelve months in the Japanese year, but, being based on lunar rather than solar phases, the measurements of years and months predating 1873 do not quite match those of the Western solar calendar. In that year, Japan abandoned the sexagenary system and adopted the standard calendar used internationally today. Traditionally the hours of the day were also reckoned in the twelve junishi, units applied to the years, and therefore one such unit is equivalent to two Western hours. For official purposes today, the Japanese use the Western system of reckoning age, but traditionally, regardless of when during the year a child is born, that child becomes one year old on the first day of the first month of the new year.

When the 604 calendar was adopted it was used by Japan's first historians to determine the reign dates of previous emperors both divine and human, such periods being the basic historical division of time. In 645, the Japanese imperial court adopted the Chinese imperial system of reign eras, or nengō, whereby a ruler's reign was composed of a number of eras, the beginnings and endings of which were determined by astrological and other conditions, such as an auspicious or inauspicious event. These reign eras were the principal means of reference within pre-modern Japanese texts to historical periods. However, as there are over two hundred of them, modern scholars have preferred to group Japan's history into more easily manageable units. In the pre- and proto-historic periods, the units have been determined through the results of modern archaeology, and bear the name either of a prominent site or artefact. In the historical periods, divisions are made according to significant political change, and usually bear the name of the region or place associated with the seat of power. Alternatively they can bear the name of the clan which held the

decisive balance of power during the period. Within this system of periods, there is an overlap between the proto-historical and the historical. The archaeologically defined Kofun period extends through the first two historical periods of the Asuka and Hakuō. For the last 150 years, scholars have returned to the *nengō*. But Emperor Meiji (r. 1868–1911) determined to have only one era and therefore one name for his reign, and his successors have followed suit. The names of these periods are the emperors' reign titles.

The principal periods as used in this volume are:

Prehistoric	Jōmon period (*c.* 11,000–400 B.C.E.)
Protohistoric	Yayoi period (*c.* 400 B.C.E.–C.E. 300)
	Kofun period (300–710)
Historic	Asuka period (552–645)
(Classical)	Hakuhō period (645–710)
	Nara period (710–794)
	Heian period (794–1185)
	Early Heian (794–951)
	Middle Heian or Fujiwara (951–1086)
	Late Heian or Insei (1086–1185)
(Medieval)	Kamakura period (1185–1333)
	Nambokuchō period (1336–1392)
	Muromachi or Ashikaga period (1392–1573)
(Early Modern)	Momoyama period (1573–1615)
	Edo or Tokugawa period (1615–1868)
(Modern)	Meiji period (1868–1911)
	Taishō period (1911–1926)
	Shōwa period (1926–1989)
	Heisei period (1989–present)

Religion

Buddhism and Shinto are the two poles around which the spiritual lives of the Japanese for the most part revolve, and as institutions they were largely established by the end of the seventh century C.E. Shinto is an accretion of local divinities and ancestors gathered around the central cult of the imperial house and its divine ancestors. Most significant of these is the sun goddess Amaterasu whose emblem of the sun remains to this day Japan's symbol, as exemplified by the national flag. Buddhism was officially introduced from Korea in the latter half of the sixth century, and a century later had also established itself as an important creed of the state, remaining closely associated with all of Japan's rulers up to the mid-nineteenth century. The problem of there being two separate national creeds was resolved by the eighth century with the formulation of a fusion of Shinto and Buddhism, so that the deities of the one came to be seen as having an equivalent manifestation in the other. Thus Amaterasu was simply one

kind of emanation of the great universal Buddha, and the latter a manifestation of Amaterasu. This happy circumstance continued until 1868, when the leaders of the newly restored imperial government decided that, in order to strengthen the imperial cult, it was necessary to dissolve the partnership, although it certainly lives on in popular religion. Buddhism itself developed into a number of schools, almost all of which have their source in either China or Korea, and has been one of the greatest patrons of the arts in Japanese history, particularly between the seventh and sixteenth centuries.

Mention should also be made of another Chinese import, Confucianism, which was probably again first established in Japanese circles around the sixth century. A wide-ranging system of thought embracing subjects as diverse as protocol and truth to be found in pure logic, Confucianism was the basis of the educational principles established at the imperial court in the seventh century, and remained so until the advent of Westernization in 1868. As a motivating force in political philosophy, it is always, therefore, in evidence in Japanese history, although during the Edo period it enjoyed its greatest influence.

Class Structure

According to Confucian principles, Japanese society is led by the person of the emperor, and around him (or her) are ranged the aristocracy (or *kuge*). The latter were originally made up of the great clans who leagued themselves with the future imperial Yamato house during the creation of the state in the Kofun period. The Classical epoch of the Asuka to Heian periods was the heyday of imperial and aristocratic culture, and they led the way in the arts as both artist and patron. By the end of the Heian period, there had arisen—largely out of aristocratic and imperial houses—a military class known as the samurai. Ranking just below the court aristocracy, from 1185 to 1868 they took effective control of the country, relegating the emperor, and the surviving aristocratic houses, to a largely symbolic and cultural role. The samurai themselves, however, have also played an important cultural role, not least in their espousal of Zen Buddhism and the arts that developed from it.

Fourth in rank were the agricultural peasantry, who—although accorded a relatively exalted place in society—were throughout much of Japan's history basically tillers of the land for a landlord, whether the emperor, aristocrat, samurai, Buddhist temple, or Shinto shrine. Fifth in rank were townsmen (or *chōnin*), the artisans and merchants. Although lowest on the ladder, their urban setting often gave them a greater freedom than that enjoyed by their social betters. By the Edo period, they would, in fact, outstrip both the emperor and samurai in personal wealth, and become the great art patrons of the time. Outside society there also existed several subclasses of outcasts who performed the jobs considered unclean in both Buddhism and Shinto. These could comprise members of the five classes who had fallen off the social ladder, but were more often made up of the archipelago's ethnic minorities, and of Chinese and Korean slaves plundered from the continent during pirating raids or military endeavor. The

way to escape all social classification was to be ordained as a Buddhist monk or nun, or enter the Shinto priesthood. Many of Japanese culture's greatest figures chose this route to escape either the responsibilities or the limitations of their class, gaining the freedom to pursue unfettered their artistic passion. After 1868, all of these classes were officially abolished.

One of the great pleasures of studying Japanese art and culture derives from the fact that not all the questions have been answered. An archaeological dig will yield new data on the past or a museum may discover a cache of paintings long overlooked which document a particular artistic project. Similarly, a scholar may present a systematic study of an artist whose corpus of work had never before been properly analysed as a whole. It is hoped that *History of Japanese Art* will encourage readers to learn about Japan and to appreciate its art, and perhaps even to stimulate further study.

Author's Acknowledgments

A work as extensive as a history of Japanese art from 10,500 B.C.E. to 1945 could not have reached fruition without the help of a great many people. Most important in this regard has been the commitment and support of the publishing house of Harry N. Abrams, Incorporated, and the funding of the Japan Art Foundation. The Foundation has funded this project twice: through a grant to me in 1978–79 to begin work on the text and through an award to the publisher in 1992–93 to help support its publication. I am most grateful.

The project was originally developed by Margaret Kaplan, and no author could have had a more encouraging and helpful editor in the early stages of writing. Under Paul Gottlieb's presidency, the project was continued, and Julia Moore became my editor. Again, I could not have asked for a finer colleague. Caroline D. Warner as editor was also extremely helpful.

From the outset of this project, Abrams has assumed responsibility for gathering the photographs, and as there are 456 illustrations, this was no small job. Two women, Barbara Lyons in New York and Yoshiko Nihei in Tokyo, were responsible for this task. I would like to thank Yoshiko-san particularly for the time she put into picture research and for her help while I was in Tokyo in the spring of 1992.

The manuscript has been read by a number of scholars and teachers of Japanese art, some of whom I know and some who remain anonymous. Of the former I would like to thank John M. Rosenfield, Yoshiaki Shimizu, Stephen Addiss, J. Edward Kidder, and especially Christine Guth for their useful criticisms and helpful suggestions. Finally, I would like to thank Maribeth Graybill, whose fifty-page critique helped me significantly in making the final revisions to the text. I very much appreciate her efforts, which went beyond the call of duty.

PENELOPE MASON, 1993

Revising Author's Acknowledgments

The revision of a book of this scope was work not taken on lightly. My immense respect and thanks go first to Penelope Mason herself. Compiling the research for such a tome, much less writing it, is certainly a lifetime's achievement. In planning the actual revision I was greatly assisted from the beginning by the well-considered and perceptive reviews of the book given by those who have been using it as a teaching aid since its publication in 1993: Lara C. W. Blanchard, Hobart and William Smith Colleges; Cecilia Levin, Wellesley College; Tracy Miller, Vanderbilt University; Clifton Olds, Bowdoin College; Quitman E. Phillips, University of Wisconsin, Madison; and Tanya Steel, Harvard Extension School. Their comments helped to point out areas where scholarship had moved on in the past decade as well as areas—principally in the decorative and applied arts and in the post-1945 era—that would improve the book significantly by their inclusion. Time has not allowed for extensive new research or long consultation, but many scholars have indirectly contributed through their own work and publications to the book's new material. Not least of these are Stephen Addiss, Audrey Yoshiko Seo, Christine Guth, Alexandra Munroe, James Ulak, Dale Carolyn Gluckman, Robert T. Singer, Martin Lorber, Patricia J. Graham, Matthew Welch, Elizabeth Lillehoj, Stephen Little, Julia Hutt, Mimi Yiengpruksawan, Haino Akio, Simon Kaner, John T. Carpenter, Seizō Hayashiya, Joe Earle, Miyeko Murase, Mark Holborn, Lawrence Smith, Timon Screech, Mary Elizabeth Berry, Louis Frédéric, Koji Mizoguchi, Paul Berry and Clifton Olds. In terms of the text, my final thanks goes to James Harper for carefully reviewing and commenting on all the new material.

There are now 468 illustrations, including 67 new color and 52 new black and white, filling out the book with calligraphy, lacquer, metalwares, ceramics, textiles, and developments in Japanese art since 1945. Thanks for sourcing and organizing this go to Julia Ruxton, and the brilliant design uniting the text with the color images so sorrowfully segregated in the earlier edition is the work of Peter Ling. Editing this book could have been no easy task, and my thanks to Mary Davies for bearing those troubles. My thanks also to Kara Hattersley Smith for setting up the whole project, and to Anne Townley and Lee Greenfield for their patience and support in seeing it through to publication.

DONALD DINWIDDIE, 2003

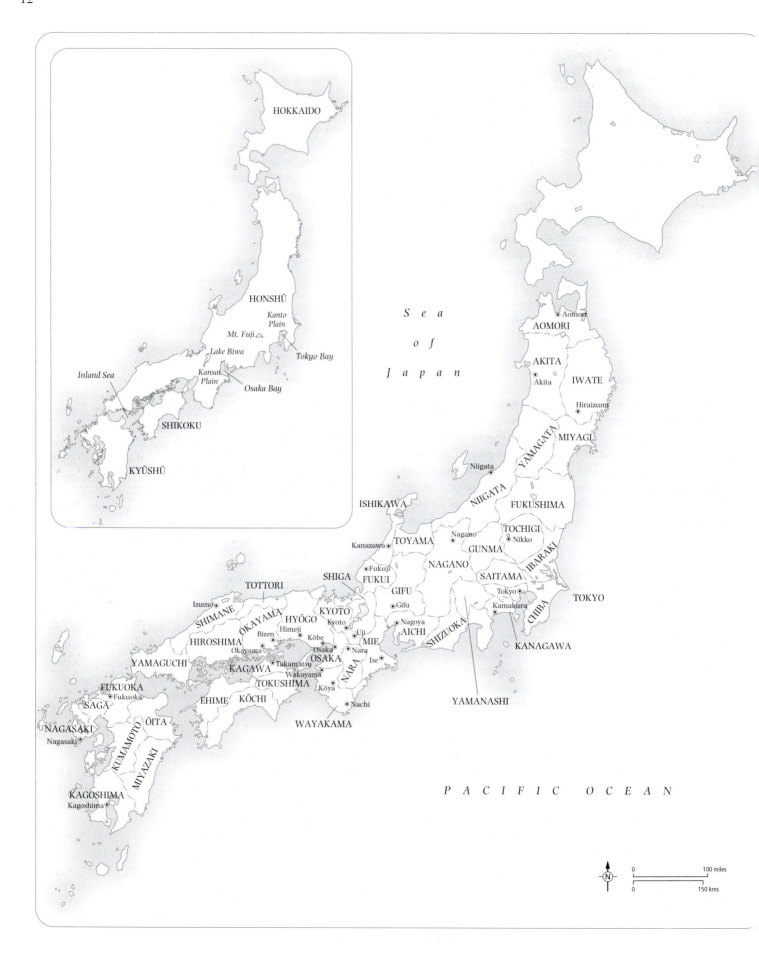

HOKKAIDO

HONSHŪ

Kanto Plain

Mt. Fuji △

Lake Biwa

Tokyo Bay

Kansai Plain

Osaka Bay

Inland Sea

SHIKOKU

KYŪSHŪ

S e a

o f

J a p a n

Aomori

AOMORI

AKITA

Akita

IWATE

Hiraizumi

YAMAGATA

MIYAGI

Niigata

NIIGATA

FUKUSHIMA

ISHIKAWA

TOCHIGI

Nikko

Kanazawa

TOYAMA

Nagano

GUNMA

IBARAKI

Fukui

SHIGA

FUKUI

GIFU

NAGANO

SAITAMA

Tokyo

TOTTORI

Gifu

Kamakura

TOKYO

CHIBA

SHIMANE

Izumo

OKAYAMA

KYOTO

Kyoto

Nagoya

AICHI

SHIZUOKA

KANAGAWA

HYŌGO

Himeji

Uji

HIROSHIMA

Bizen

Kōbe

MIE

Okayama

Osaka

Nara

YAMAGUCHI

OSAKA

Ise

KAGAWA

Takamatsu

NARA

Wakayama

FUKUOKA

TOKUSHIMA

Fukuoka

EHIME

KŌCHI

Kōya

YAMANASHI

SAGA

ŌITA

Nachi

NAGASAKI

WAYAKAMA

Nagasaki

KUMAMOTO

MIYAZAKI

KAGOSHIMA

Kagoshima

P A C I F I C O C E A N

N

0 100 miles

0 150 kms

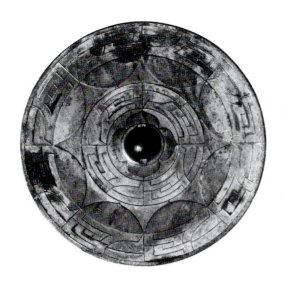

The Birth of Japan

THE NEOLITHIC JŌMON AND THE PROTOHISTORIC YAYOI AND KOFUN PERIODS

According to Japan's primary creation myth, the Heavenly Progenitor ordained that the twin gods Izanami and Izanagi should go forth and procreate to fill the empty space below the heavenly domain. Yet the pair know not how to begin this great work until they sighted a wagtail. The backward and forward movements of the bird's tail feathers suggested the essential technique, and from the joyful union that resulted the eight islands of the Japanese archipelago were born. For the Ainu, living in Japan's northernmost island of Hokkaido and considered by many to be remnants of the islands' indigenous population, it is the humble wagtail itself that takes the central role, sent by the Great Spirit down into the marshy quagmire created out of the chaos below heaven. The wagtail piled, pressed, and patted mounds of sand until they came to form the eight islands of the Japanese archipelago. And from that point on earthly life began.

Out of Myth and into the Archaeological Record

Curiously, however, neither creation myth reflects the fact that when humans first came to the Japanese islands, they were not islands at all. Until twelve thousand years ago, at the end of the last Ice Age, the eight islands that now make up the Japanese archipelago were in fact connected to the Asian mainland, enclosing the Sea of Japan as a lake. The large northernmost island of Hokkaidō adjoined the coast of Siberia, and the other main islands, Honshū, Kyūshū, and Shikoku, were an extension of the Korean peninsula. Together with the landmasses of the future islands of Ryukyu and Okinawa to the south, they provided multiple paths of entry for peoples migrating eastward across the Eurasian continent. The preferred route seems to have been through the Korean

peninsula into Kyūshū, and current estimations place the first human presence within Japanese territory at the very least around a hundred thousand years ago, around the beginning of the last Ice Age. The stone tools, such as flint and obsidian knives and axes, typical of most paleolithic cultures make their first appearance in Japanese territory approximately thirty-two thousand years ago, much as they did elsewhere. However, a discovery in recent years at Odai Yamamoto in Aomori prefecture, northern Honshū, has demonstrated that at least one paleolithic community in what was to become Japan made pottery vessels some sixteen thousand years ago, making it the world's earliest ceramic-producing culture.

Even before the discovery of these shards, archaeological efforts were beginning to unearth ceramic material at Ice Age paleolithic sites in China and Siberia. However, in Japan it had been assumed that the production of pottery vessels was a phenomenon associated with the end of the Ice Age and the beginning of the neolithic period. This was based on the discovery in 1960 of shards at the Senpukuji and Fukui caves on the island of Kyūshū, dating to around 10,700 B.C.E. Significantly, all of these finds have firmly established East Asia, and Japan in particular, as important centres for the production of the first pottery, laying to rest long-held theories that ceramic production first made its appearance around 9000 B.C.E. with the shift from hunter-gatherer to agricultural societies in the ancient Middle East. It is now clear that, at least in East Asia, ceramic wares were first made by hunter-gatherer communities of the paleolithic period. And in the subsequent post-glacial period, with the rising of the sea level and Japan's isolation from the Asian mainland, it is the hunter-gatherer culture that flourished on the newly-formed archipelago which produced one of the most dynamic ceramic traditions of the ancient world.

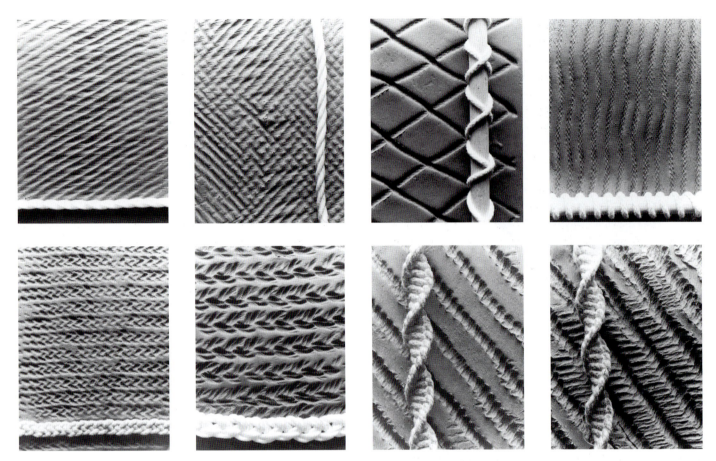

1 Cord-marking patterns. Courtesy Mark Lindquist Studio.

The end of the Ice Age coincides with that of most of the paleolithic cultures across the Eurasian continent. The so-called neolithic cultures that came into being as the climate grew warmer are characterized by more refined, polished stone tools, and increasing evidence of social organization within communities. While from China to the Middle East, this is indeed normally accompanied by a departure from hunting and gathering ways and the beginning of animal husbandry and agriculture, in Japan this same material and social progress is achieved within a foraging context. And the most remarkable accomplishment that has come down to us of this neolithic hunter–gatherer culture is, in fact, its ceramic wares. In 1877, the American scholar Edward S. Morse (1838–1925), while excavating some shell mounds, discovered numerous ceramic shards decorated with marks that seemed to have been produced by impressing rope or cord into the wet clay. He referred to these shards as "cord-marked" wares, and the Japanese translation of that term—Jōmon—soon came to be applied to the entire culture. Thousands of Jōmon sites have since been found throughout the archipelago. Extending over a period of almost ten thousand years, each site has been rich in the trademark cord-marked ceramics, and the development of this ceramic tradition over the millennia has helped to illuminate the nature of Jōmon civilization. The ceramics themselves have since been categorized into seventy styles with more than 400 "local" variations (Fig. 1).

The Jōmon Period (c. 11,000–400 B.C.E.)

The origins of the Jōmon people remain shrouded in mystery. Not only is it uncertain whether they were descendants of the Ice Age paleolithic population, but how they relate to the post-Jōmon period Japanese population is also highly problematic. Furthermore, Jōmon development as a culture over ten thousand years is so unwieldy that it is usually divided into six distinct phases:

> Incipient Jōmon (c. 11,000–8000 B.C.E.)
> Initial Jōmon (c. 8000–5000 B.C.E.)
> Early Jōmon (c. 5000–2500 B.C.E.)
> Middle Jōmon (c. 2500–1500 B.C.E.)
> Late Jōmon (c. 1500–1000 B.C.E.)
> Final Jōmon (c. 1000–400 B.C.E.)

What is known about the Jōmon is that they began as a hunter-gatherer society and remained one. Yet the second great mystery of the Jōmon people is how—as a hunter–gatherer society—did they manage by the Middle Jōmon phase to support themselves in relatively large and settled communities, even to the extent of forming a network of communities that traded with each other. There is still a great deal of research being done on whether the Jōmon people's highly organized methods of foraging might not constitute a kind of

agriculture—what is termed swidden cultivation—and whether their methods of fishing and hunting might not have encompassed some elements of animal husbandry. It is clear that they subsisted not only on the hunting of game and collecting of the fruits of the field and forest, but also relied on the sea, even to the extent of fashioning special harpoons for deep-sea fishing. Furthermore, from the Middle Jōmon onward certain of the roots they ate—such as yam, taro, and lily bulbs—seem to be products of cultivation, while in Final Jōmon sites, evidence of different grains has been found, and in particular rice, pointing towards the beginning of their cultivation. During the Incipient and Initial Jōmon—more than half of the long history of the Jōmon period—the overall population did remain small and thinly distributed in foraging groups across all the main Japanese islands, but especially in central and northern Honshū. However, by the end of the Initial Jōmon in the fifth millennium B.C.E., these groups had begun associating in settlements. Often these Jōmon settlement sites seemed to be inhabited only on a seasonal, cyclical basis, but by the Early Jōmon phase more permanently occupied settlements are to be found as well.

The third great mystery of the Jōmon people is that while the shift into settled communities across the greater part of the Asian continent also ultimately brought about the Bronze Age from the fifth millennium B.C.E. onward, and subsequently the Iron Age in the first millennium B.C.E., the Jōmon remained resolutely a Stone Age society. It was not until their replacement by the Yayoi culture, around the fourth century B.C.E., that metalworking and formal agricultural practices came to Japan. With the arrival of the Yayoi, Jōmon culture seems to disappear almost overnight across most of the archipelago. Yet it can be argued that the alternation between a simple elegance and a rough exuberance that characterizes Jōmon material culture, and especially their hallmark ceramics, forms an aesthetic template that will be repeatedly used in every subsequent Japanese artistic period.

INCIPIENT (C. 11,000–8000 B.C.E.) AND INITIAL JŌMON (C. 8000–5000 B.C.E.) PHASES

Kato Shinpei has estimated that the Jōmon population during the six thousand years of the Incipient and Initial phases remained at around only twenty thousand, organized in small groupings ranging over a wide area, not unlike hunter–gatherer communities in desert or arctic areas of the present day. In sites dating to the later Incipient phase, evidence of settlements can be found, but always of an ephemeral nature, with at best evidence of recurring, seasonal occupation.

No complete pottery vessels have been preserved from the Incipient phase, but on the basis of shards it is generally assumed that the vessels were small and had rounded bases. This suggests a portability in keeping with a nomadic lifestyle since such designs would be suited to the uneven surfaces of a forest or cave campsite and for use as cooking utensils in the middle of a fire. From the paleolithic shards from Odai

Yamamoto onward, it is obvious that the majority of these vessels were meant for boiling food while placed on an open fire or more formal hearth. Like all Jōmon pots, these first Incipient wares were earthenware made of coiled clay and then fired in open fires. The surfaces of Incipient pottery shards commonly have coarse raised lines or ridges not unlike those seen on corrugated cardboard and may result from a simple smoothing of the clay coils from which the vessels were formed. Later in this phase, there is an evolution from these perhaps accidental designs to patterns made by impressing string or fingernails.

By the end of the Initial Jōmon phase, a fairly consistent type of ceramic had developed for boiling food. Many of these typically deep bowls remained relatively small (and therefore portable), measuring about 8–19 inches (20–50 cm) in height, but larger vessels measuring around 30 inches (75 cm) in height are also not uncommon. These larger bowls are significantly less portable than their smaller counterparts, and their appearance is one signifier of the increasing trend towards settlement. One of the most aesthetically pleasing of the smaller cooking pots comes from an undocumented excavation, but is generally believed to date to around the end of the Initial phase, or c. 5000 B.C.E. (Fig. 2). The gentle undulations of its rim are echoed by the pattern of the cord markings. These rim undulations will be seen to become more accentuated in the succeeding phases, as will the character of the cord-marked designs.

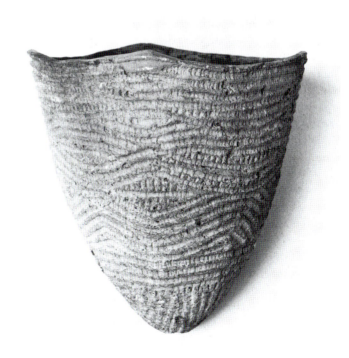

2 Conical, round-bottomed vessel, from a site in Hokkaidō. Initial Jōmon phase (c. 8000–5000 B.C.E.), c. 5000 B.C.E. Earthenware; height 6 ½ in. (16.6 cm). Hakodate Municipal Museum.

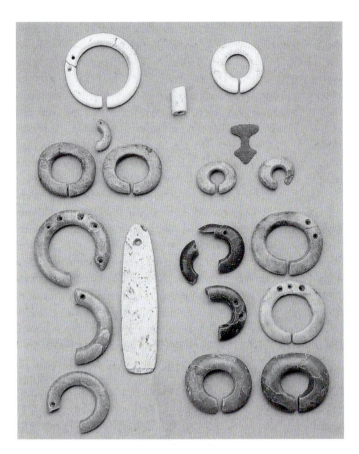

3 Earrings, from Kuwano, Fukui prefecture. Initial Jōmon phase
(c. 8000–5000 B.C.E.), c. 6,500–5000 B.C.E.. Steatite; diameter, top left, 2 in.
(5 cm). Courtesy of Kanazu Town Board of Education.

Other artifacts of the Incipient and Initial Jōmon phases include small, portable figurines (*dogu*). Of a very rudimentary character, these figurines of stone and clay will in later phases take on much more definite and even flamboyant shapes, and have better defined functions within a ritualistic tradition. However, their presence, no matter how primitive and unformed, in these Incipient and Initial phases points to the fact that ritualistic traditions were being established at this time. Even more advanced are the stone earrings and pendants found among the grave goods of a large cemetery at Kuwano in Fukui prefecture, western central Honshū, dating to the mid to the late Initial phase, c. 6,500 to 5000 B.C.E. (Fig. 3). Their well-shaped and polished circular forms indicate a significant departure from the paleolithic chipped flint knives and axes. They not only demonstrate an already well-developed culture of personal adornment, which would become ever richer as the Jōmon period progressed, but also one with formalized funerary rituals. It is possible as well that possession of these beautifully crafted pieces represent the individual's position within a social hierarchy.

EARLY JŌMON (C. 5000–2500 B.C.E.) PHASE

It is not until the Early Jōmon phase, however, that a clear picture emerges of how Jōmon communities were organized. The population during the Early phase began to rise steadily, and particularly on the northeastern coast of Honshū. Numerous village sites have revealed a great quantity of ceramic cooking pots, ceramic and stone figures, wicker baskets, stone tools, stone and bone earrings and pendants, as well as sewing implements of bone. In addition, the first objects in Japan's long and esteemed lacquer tradition were produced, including lacquered pottery, wooden and basketry vessels, and personal ornaments such as combs and thread. Finds of similar age have been made in China, but their presence in Jōmon communities indicates an independent origin for what in future centuries would become one of the most distinctive of Japanese crafts.

Early Jōmon pit houses, so-called because their floors were dug approximately 20 inches (50 cm) below ground level, were usually square in plan, measuring about 13 x 13 feet (4 x 4 m). They were covered by a roof thatched with reeds or bark, supported by posts and beams around the center and by leaning posts around the periphery of the pit (Fig. 4). The organization of these houses into permanent communities now begins to take on a distinctive character. Kobayashi Tatsuo has outlined several types of community organization that were established at least by the Early Jōmon. The first and most important type is the "core" or permanent settlement. It is often built on a terraced hillside and consists of pit houses, storage pits, and burials grouped around a central village green or plaza. A second type of village settlement is smaller in scope, and usually located on the top of a ridge with a very narrow plaza; in some such cases there may be no more than one or two houses. A third type of settlement has no houses but evidence of repeated campsites; these are thought to be the sites of hunting or seasonal foraging grounds. A fourth type of site becomes increasingly common late in the succeeding Middle Jōmon, and includes cemeteries separate from the living settlements, rubbish dumps, quarries for clay and stone, stone-tool manufacture areas, animal pit-traps, and the first stone circles.

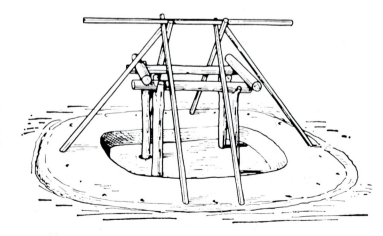

4 Reconstruction of early Jōmon pit house.
(Ōta Hirotarō in *Illustrated History of Japan*, published by Shōkuka-sha.)

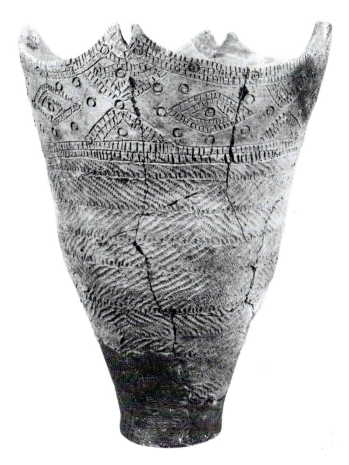

these designs and the even more distinctive ones of the Middle Jōmon phase relate to Jōmon systems of belief—ideas often connected to fertility and regeneration. However, while most of these pottery vessels retain a practical everyday use, the clay and stone figures, which in the Early Jōmon also begin to take on more distinctive shapes, have only a ritual role.

Early Jōmon figurines are exemplified by the stone carving found in Akita prefecture, northern Honshū (Fig. 6). The upper part of the sculpture has a head, long hair, and arms folded at shoulder height, while the lower half of the figure is distinctly abbreviated into a shape reminiscent of an inverted phallus. Such phallic figures become more prevalent in the Middle Jōmon, and stone phalluses can be found incorporated into the stone-lined hearths or near them in many of the homes that have been excavated. In some cases these stone objects also incorporate female genitalia. Unsurprisingly, these objects have been interpreted as unashamed symbols of regeneration, just as they have in other cultures. It should be mentioned that such phallic imagery did not die with the Jōmon period, but is an important symbol of regeneration and life force even within present-day Shinto and folk belief.

5 Conical, flat-bottomed vessel with scalloped lip. Early Jōmon phase, (c. 5000–2500 B.C.E.), 3000–2500 B.C.E. Earthenware; height 13 ¾ in. (35 cm). Nanzan University, Aichi prefecture.

Another interesting feature of Early Jōmon phase architecture has been the discovery of a series of enormous structures in some of the core settlements. Most famous is the one measuring around 56 x 26 feet (17 x 8 m) at Fudodo in Toyama prefecture. Dating to around 2800 B.C.E., this building and others like it may also have had raised floors. Watanabe Makoto has proposed they were communal gathering and working areas, meant especially for protection during the winter and inclement weather.

In contrast to Incipient and Initial Jōmon vessels, pots of this phase seem to be intended as more than merely functional cooking vessels. They usually have flat bottoms so that they can be placed on smoothed surfaces, and their decoration, created with a variety of materials, including twisted plant fibers and bamboo stalks, becomes increasingly varied and important. An example from the latter half of the Early Jōmon phase shows an attempt at creating an unusually complicated pattern (Fig. 5). The scalloped rim of the vessel evident in the Initial Jōmon has now become much more accentuated. In the zone immediately below the rim, a bamboo stick has been used to incise diamond shapes and impressed circles, while the body of the pot is decorated with cord markings in a herringbone pattern. It has been proposed by several scholars that pottery production was the province of the Jōmon women, and that

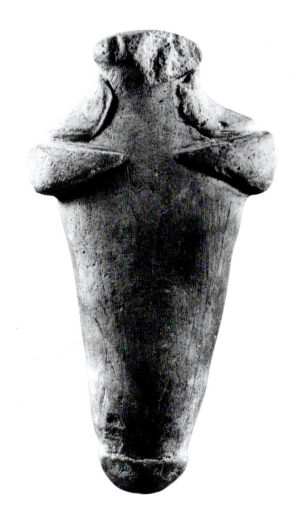

6 Figurine, from Akita prefecture. Early Jōmon phase (c. 5000–2500 B.C.E.), c. 3000–2500 B.C.E. Earthenware; height 5 ⅞ in. (14.8 cm). Keio Gijuku University, Tokyo.

MIDDLE JŌMON (C. 2500–1500 B.C.E.) PHASE

Probably as a result of the post-Ice Age warming trend of higher temperatures, which peaked toward the middle of the third millennium B.C.E., the Jōmon population shifted from the humid coastal sites of the east and west coasts to highland regions of north/central Honshū, in particular the mountains of Chūbu and the northern part of the Kantō Plain. For the Middle Jōmon peoples, the nomadic lifestyle of their forebears becomes largely a thing of the past. Their villages become larger, and their storage and processing of gathered crops and hunted game more refined and specialized. It is at this period that we find the first evidence of the simple cultivation of such roots as yam, taro, and lily bulbs. Supporting at its height something like a quarter of a million people, the Middle Jōmon population has one of the highest densities a non-agricultural society has ever known. The large number of ceramic vessels and other goods found at Middle Jōmon sites suggests that these people had a stable economy and sufficient leisure to engage in crafts and to truly explore their aesthetic sensibility. The individual pit house also became larger, evolving into a circular form some 16–18 feet (5–6 m) in diameter. These larger dimensions permitted as many as five people—possibly the average number in a household—to gather around the central hearth. Some communities added a stone platform or altar on the northwest side of the house, on which were placed stone phalluses, ceramic fertility images, or broken pots.

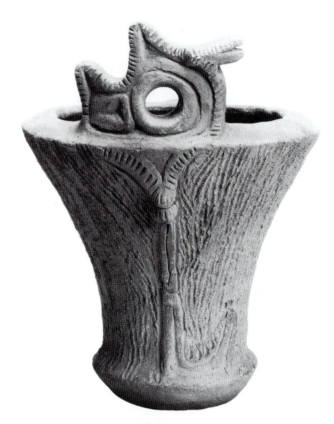

8 Vessel with snake-form handle, from Togariishi, Nagano prefecture. Middle Jōmon phase (c. 2500–1500 B.C.E.). Clay; height 6 ½ in. (16.6 cm). Togariishi Archaeological Museum, Nagano.

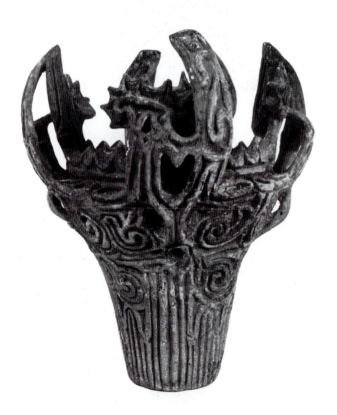

7 "Flame ware" (*kaen-doki*) vessel, from Niigata prefecture. Middle Jōmon phase (c. 2500–1500 B.C.E.), c. 2500–2400 B.C.E. Earthenware; height 12 ⅛ in. (30.8 cm). Kokubunji, Kokununji City, Tokyo.

Visually, the most dramatic difference between the Middle Jōmon and the earlier phases can be found in ceramic production, and in particular in the exuberantly decorated "flame wares" (*kaen doki*). A broad range of shapes make their appearance in Middle Jōmon pottery, formed according to their function, both practical and ceremonial: the more traditional deep pots for storage and cooking, lamps or incense burners, and goblets and shallow bowls, as well as pedestaled wares. The familiar cord markings of the preceding period appear much less frequently, replaced by a new technique: the application of cordons of clay to the surface to build up strong three-dimensional designs. Most famous of all Jōmon wares are the so-called "flame wares" found at sites along the Shinano River and its tributaries in Niigata prefecture. Typical of the flamboyant shapes of these wares is a pot with a flaring cylindrical body (Fig. 7). The scalloped edge that began so subtly in the Initial Jōmon has now flared into a wildly flame-shaped cockscomb (*keitō*). Although the vessel is only about 12 inches (30 cm) tall, its openwork, sculptural form and almost three-dimensional decoration of parallel grooves and swirls arrest the gaze in a way that prehistoric Japanese artifacts seldom do. But, however emphatic their expression, the meaning of the flame-style decoration is as elusive as the cord markings of earlier vessels. Furthermore, as a style of vessel it did not spread to other areas of the Middle Jōmon world and was relatively short-lived even in the place of its creation.

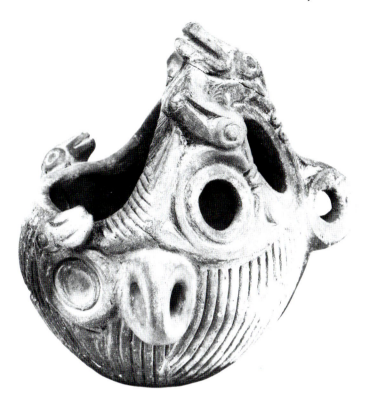

9 Vessel of "incense burner" type, from Suwa City, Nagano prefecture. Middle Jōmon phase (c. 2500–1500 B.C.E.). Earthenware; height 7 ⅞ in. (20.1 cm). Educational Commission of Sunwa City, Nagano Prefecture.

Before the end of the Middle Jōmon the Shinano River settlements had adopted a less flamboyant and more utilitarian form of storage and cooking vessel, closer in form to Early Jōmon types, but often having four lug handles.

Another and longer-lived development in Middle Jōmon ceramic decoration involves the use of modeled images on the rims of large cylindrical vessels. A snake motif based on the *mamushi*, Japan's only poisonous viper, appears first as a rim design in the mountainous regions of Nagano prefecture and later in Yamanashi prefecture and, less frequently, in the area of present-day Tokyo. A vessel from Togariishi in Nagano displays a snake's head and body curving upward from the rim to surround a circular handle (Fig. 8). A similar motif is the rodentlike head that appears along the rim of vessels, usually overlooking the contents. In both types of pot, the decoration of the body consists of simple cord markings. A particularly charming example of modeled decoration of this phase is a small lamp or incense burner from Nagano prefecture (Fig. 9). It is essentially a sphere with enough of its surface cut away to permit a hand to reach in to fill it with oil or, possibly, incense. The lower part of the bowl has been decorated with simple vertical cuts in the clay; the upper section is a free-flowing design based on a circle surrounding a hole. Spinning off from the largest circles are the heads of a snake or a long-beaked bird, a motif repeated along the lower rim of the largest hole to the left. Theories abound as to what these animals might be intended to convey to the viewer: were they meant to be

guardians over the vessel's contents (why else place a poisonous viper on the handle of a jar?), or, as with the seemingly more whimsical imagery of the lamp/censer, were they meant to amuse? As will be demonstrated often in succeeding periods, the playful has often a role to play and is not necessarily excluded even when the most sober topics are being addressed.

The production and variety of ceramic figurines increases considerably during this period, and the detailing of facial features becomes specific enough to suggest both animal and human images or hybrids of the two. The torso and head of a curiously feline figurine has been preserved from a site in Yamanashi prefecture (Fig. 10). The face has an inverted U-shaped outline with holes cut through the clay for slanting eyes and a three-lobed mouth. Incised lines on the cheeks may represent tattoos. Along the shoulders and the upper parts of the arms, a stippled design of circles suggests a spotted pattern on fur. The left arm bends in a curve, pressing a three-fingered hand against the breast. The gesture of placing the left hand on the chest, with the right hand presumably on the hip or abdomen, has been interpreted as indicating a pregnant woman. If this is a female figure, the absence of breasts is puzzling. For the moment it remains an interesting but also a baffling object.

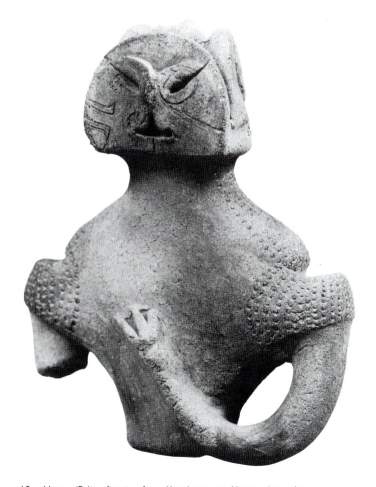

10 Human/Feline figurine, from Kurokoma site, Yamanashi prefecture. Middle Jōmon phase (c. 2500–1500 B.C.E.). Earthenware; height 10 in. (25.2 cm). Tokyo National Museum.

LATE (C. 1500–1000 B.C.E.) AND FINAL JŌMON
(C. 1000–400 B.C.E.) PHASES

The middle centuries of the second millennium B.C.E. that straddle the shift between the Middle and Late Jōmon are marked by a catastrophic collapse in population. From a peak of around two hundred and fifty thousand, archaeologists of the period estimate that roughly half that number of people existed in the Late phase, while by the Final phase the population numbered perhaps only around seventy thousand. Theories on the collapse all remain highly speculative, with the mini-Ice Age that occurred at this period often being the focus of blame, as are the age-old curses of disease and famine. Certainly it is true that many of the more upland settlements of the Middle Jōmon are abandoned, and the population centres shift to either the east or west coast of north/central Honshū, with the vast majority grouping on the east coast, or just above present-day Tokyo. If the food sources of the land gave out, then the spirits of the sea did not abandon the peoples of the Late and Final Jōmon phases. Fish was their primary food source, and they developed new and more efficient types of fishing equipment to help them meet their needs, including the toggle harpoon.

Coinciding with the decrease in population is the multiplying of figurines in the Late and Final phases, giving further support to theories ascribing a propitiatory role to these images in Jōmon ritual. One aspect of these images—like their ancestors from earlier phases—is that they are usually either overtly female with prominent breasts, or they have an ambiguous gender. Because Jōmon culture was not shy about representing male genitalia, it has been posited that these less certain images are probably meant to represent females as well. One theory suggests that female figurines represent an Earth Mother to the Jōmon peoples, the being who in later, post-Jōmon periods would be known as Jiboshin. As many of these Late and Final figurines have been damaged, it follows that they might also have acted as votive offerings—the missing or damaged body part representing a corporeal equivalent that the supplicant wished healed. Two types of figurines are characteristic: fleshy, female statuettes wearing what look like snow goggles, and seated figures with their knees drawn up to their chests and arms entwined in specific positions.

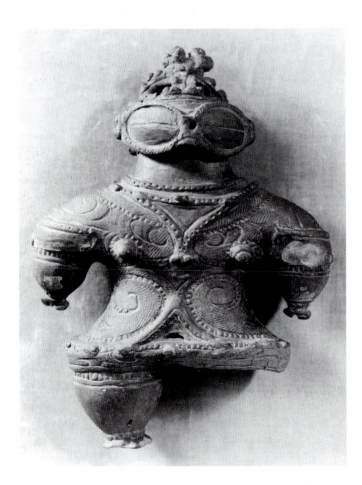

11 "Heavily-modeled" female figurine, from Aomori prefecture. Final Jōmon phase (c. 1000–400 B.C.E.). Earthenware; height 15 in. (38.1 cm). Private collection, Japan.

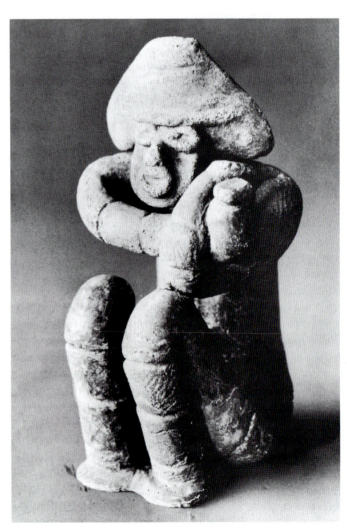

12 "Crouching" female figurine, from Fukushima prefecture. Final Jōmon phase (c. 1000–400 B.C.E.). Earthenware; height 8 ½ in. (21.5 cm). Fukushima Municipal Board of Education.

The heavily-modeled or bulky female figurines are hollow, and often wear a well-defined robe decorated with a large and bold swirling pattern (Fig. 11). The bodies are distorted, as are the faces, which have a tiny down-turned mouth and a single hole for a nose between enormous round eyes bisected by a horizontal line. It has been suggested that the body may have been made hollow to permit the soul to take up residence within, but there is little agreement among scholars about the reason for the eye treatment. Some specialists see the eyes as reflectors of death; others see them as more benign windows onto the soul. As with so much other Jōmon material, their significance remains a puzzle to be solved at some future date.

The crouching, seated figures usually have hands pressed together, as if in an act of propitiation. In contrast, the best known of these images has arms bent so that the right extends across the body, while the left draws the right arm close to the chest (Fig. 12). Discovered in Fukushima prefecture, the charming image has a U-shaped face, bulging circles for its eyes and mouth, a raised triangle for a nose, and appears to wear a large triangular headpiece. Another engaging, but more unusual image is a female figurine from Gunma prefecture (Fig. 13). Unlike typical Jōmon sculptures, this piece presents a complete and freestanding image. Furthermore, it has what appears to be a tiny handle at the back of the head. Seen from the front, its curving body, narrow at the waist and wide at the hips, projects an impression of volume, articulated by shallowly cut horizontal lines interrupted at the shoulder and hip joints and at the breastbone by spiral markings. Its most interesting feature is its heart-shaped head on a plane slightly tipped up from the main vertical of the body, with round eyes and a broad thick nose.

Stone circles with an almost certainly ritual purpose also appear in these last two phases. In the previous Early and Middle Jōmon phases there had been evidence of altars in the home and in the village as a whole, but these circles represent a new development within the ritual life of Jōmon culture. Significantly, they are located at sites close to, but separate from, the living quarters of the villages. The most elaborate of them are two circles on a vast scale found at Ōyu in Akita prefecture: one is 151 feet (46 m) in diameter and the other is 138 feet (42 m) across; they are spaced 295 feet (90 m) apart. Each has a single vertical stone in the center, surrounded by long, narrow stones laid on the ground and radiating out from the central pillar in two concentric circles. This configuration is enclosed by a third ring of stones set at right angles to the radials. The majority, however, are simple circles of stone some 39–49 feet (12–15 m) in diameter, some even smaller (Fig. 14). In addition to having hosted communal ceremonies, these sites also contain burials.

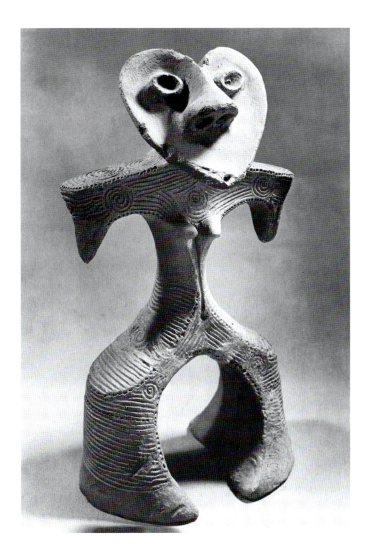

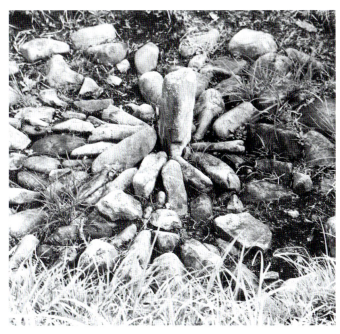

13 Female figurine, from Gunma prefecture. Final Jōmon phase (c. 1000–400 B.C.E.). Earthenware; height 12 ½ in. (31 cm). Private Collection, Gunma prefecture.

14 Stone circle in Towadamachi, Kazuno City, Akita prefecture. Late Jōmon phase (c. 1500–1000 B.C.E.).

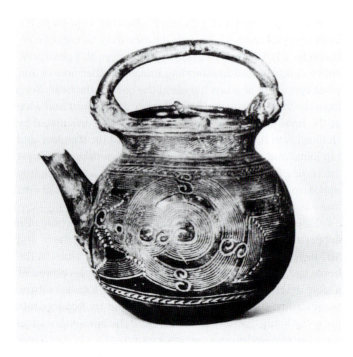

15 Ewer with bridge handle and "erased cord" designs, from Ibaraki prefecture. Late Jōmon phase (c. 1500–1000 B.C.E.). Earthenware; height 8 ¾ in. (22.3 cm). Tatsuuma Archaeological Museum, Nishinomiya City, Hyōgo prefecture.

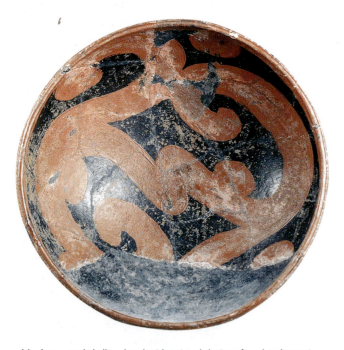

16 Lacquered shallow bowl with painted designs, found at Aomori, Kamegaoka site. Final Jōmon phase (c. 1000–400 B.C.E.). Earthenware; diameter 8 in. (20.5 cm). Aomori Prefectural Museum, Aomori.

The explosion of diversity that characterized Middle Jōmon pottery is countered in the last two phases by a reduction to a much more standardized output. However, the number and size of kiln sites suggests that the scale of pottery production seems, if anything, to have increased, with centralized manufacture becoming the norm. Among the standardized cooking pots with only slightly flared walls and others with spouts, resembling teapots, there are also some vessels of very refined execution which can only be described as serving dishes, including a kind of shallow bowl. These Late and Final Jōmon wares are distinctively black with highly polished surfaces, and they are commonly decorated with a technique referred to as "erased-cord marking". With this method, designated zones of decoration were incised on the surface of a vessel, cord markings were applied and the area surrounding the zones smoothed out. A particularly refined example of this technique is a Late Jōmon "teapot" from Ibaraki prefecture (Fig. 15). On the swelling sides of the body, in a wide zone marked off by a pattern resembling a double-stranded cord, bands of incised lines form a circle, within which is a shape resembling a figure eight. S-shapes are cut into the incised bands at irregular intervals, and the whole is framed by a curved and angular zigzag design.

In the Final Jōmon, the Tōhoku region of northern Honshū became the center both of the population and of pottery production. Kamegaoka, a site in Aomori prefecture, gives its name to the wares of this phase. Kamegaoka ceramics were frequently burnished, painted with red iron oxide and lacquered with a clear resin over pigment, presumably to reduce their porosity as well as to decorate them. An excellent example of this is the shallow bowl (Fig. 16) found at Aomori, which is also an example of the new kind of serving dish. The bold iron oxide swirls on a black ground elegantly echo the carefully modeled body of the bowl. There has been a certain amount of speculation that such fine serving/presentation wares in the Late and Final Jōmon might be one of the indications that the much reduced population of this period was beginning to stratify into a strict hierarchy, these bowls being important signifiers of a person or family group's status within this hierarchy. Certainly there seems to be some differentiation in burial practices during this period, with a small, but significant minority of graves being better equipped than those of their neighbors. However, such speculation has often led to the projection of earlier Jōmon phases, which do not have such clear indications of social differentiation, as a kind of Arcadian republic, a lost golden age of human equality succeeded by ages that brought civilization but also despotic tyranny. Tempting and comforting though this image might be, it should be remembered that twentieth-century anthropological studies of societies existing at a paleolithic or neolithic level have seldom if ever stumbled across such a utopia.

The Yayoi Period (c. 400 B.C.E.–300 C.E.)

While the Jōmon population was shifting ever further north, according to archaeological evidence the southern extremes of Honshū and Kyūshū became ever more sparsely populated. Never the principal areas of settlement during the Jōmon period, they suddenly from around 400 B.C.E. became the focus for a new kind of agricultural-based culture—the Yayoi.

Ironically enough Yayoi is in fact the name of a district of Tokyo where the first archaeological finds relating to this period were found. Yet it would not be until the period was somewhat advanced that Yayoi-type settlements would actually extend up into this ancient heartland of the Jōmon. Yayoi culture is distinguished from the Jōmon by several elements: the manufacture of bronze and iron objects, the cultivation of rice and, in association with it, the establishment of comparatively large (when compared with Jōmon) settled communities. It remains a matter of considerable debate and ongoing research exactly how Japan stepped so late, but so suddenly, from a hunter-gatherer lithic culture to one that worked metal and focused almost entirely on the cultivation of rice.

One long-standing theory has been that the people of the Yayoi are a colonial invasion from Korea and/or China, displacing the indigenous Jōmon. The case for this arises from the fact that the earliest yet known Yayoi sites have been located in Kyūshū—not far from the southern tip of the Korean peninsula—and that these sites display a complete and fully evolved practice of rice cultivation as also employed on the continent where it had taken many thousands of years to evolve. Although charred rice grains have been discovered at the few Final Jōmon sites to be found in Kyūshū, their presence a few hundred years prior to the Yayoi is unlikely ever to be convincingly argued as evidence for an indigenous evolution of rice culture. Furthermore, although much of the Yayoi metalwork appears rough, crude and even deliberately archaic in comparison to contemporary developments on the Asian mainland, it nevertheless does not resemble the products of a nascent metalworking culture.

Apart from the archaeological evidence, supporters of the colonization theory look also at the case of the Ainu, who live on Japan's northernmost island of Hokkaido. The Ainu believe themselves, and are traditionally believed by the Japanese, to be descended from people who once inhabited all the islands of the archipelago, but were pushed ever northward across the islands by the Japanese, only retreating entirely to the island of Hokkaido in early historic times in the second half of the first millennium C.E. Until the late nineteenth century, the Ainu lived in a well-developed hunter-gatherer society. These people, the colonial theorists would argue, are the remnants of the Jōmon culture, while the Japanese are descendants of the Yayoi colonizers.

A more recent line of thought, however, is that the Yayoi is not so much a colonial invasion, as a revolution—and a technological and social one at that. This argument runs that the presence of a fully formed ricegrowing and metalworking culture need not indicate displacement, but instead a kind of industrial and agricultural revolution. Certainly these changes were imported from the continent, but they could as easily have been brought back and used to transform the existing Jōmon society, just as after 1868 Japan—long cut off from the world—became fully exposed to the fruits of the Western Industrial Revolution, and within the space of a century utterly transformed itself.

One of this theory's supporting arguments is that there is very little evidence of violent death amongst the buried of the early Yayoi period, or of an inordinant amount of dead, or burnt or otherwise violently destroyed settlements, as one would expect to find with a colonization and displacement of the aboriginal community. Oddly enough, such evidence does surface in the middle Yayoi period—around the beginning of the first millennium C.E.—but in a context where the adversaries must almost certainly have been other Yayoi peoples. Furthermore, while there are many details of the material culture that are exactly mirrored on the continent, there is nothing in Korea or China from which the whole of Yayoi society could be derived, whereas there are likely inheritances to be found in Yayoi culture from the Jōmon, most tangibly in the ceramic and lithic production.

It is also important not to overlook the testimony of Japan's first written history, the *Kojiki* (*Record of Ancient Matters*). Compiled in 712, it gathered together all of the myths surrounding the gods of Japan, how the islands were created, and how they came to be ruled by the Japanese imperial house (the Yamato), and related the reigns of the emperors of that house up to the Empress Gemmei (r. 708–14) who commissioned the work in the early eighth century. It was supplemented by the *Nihon shoki* (*Chronicle of Japan*, alternatively titled *Nihongi*) in 720, which revised the earlier text and added mythological and historical information gathered by imperial officials from the different prefectures and written up in reports known as *fudoki*. Of course, both texts were intended to glorify the imperial house and to justify its right to rule the whole of Japan. Therefore, the first ruler, Ninigi, is the grandson of the sun goddess Amaterasu, who sent her descendent with a retinue of eight million deities down to the earth (i.e., Japan) to rule it. Ninigi found Japan already ruled by a race of earth deities (he and his grandmother being of the race of heavenly deities). Therefore, Ninigi formed alliances with, fought with, intermarried with, and ultimately subdued the legions of earth deities. Ninigi's great grandson, Jimmu, is the first human emperor, and tradition holds that he reigned from 660 to 585 B.C.E. Furthermore, Ninigi descended to and subdued the island of Kyūshū, and it was only in the reign of Jimmu that the imperial house departed for southern Honshū where they ultimately made the Yamato Plain their home.

The traditional dates for Jimmu and presumably that of his great grandfather Ninigi place them squarely within what archaeology so far believes to be the non-agricultural and lithic society of the Final Jōmon phase. These dates established in the eighth century C.E. are—like a great deal in the text and of the period—influenced and shaped by Chinese historical precedents, in whose relatively ancient written historical culture dates in the mid first millennium B.C.E. would be considered venerable, but hardly the mists of time. Nevertheless, allowing for a bit of chronological hyperbole on the part of the compilers of the *Kojiki* as well as for the pitfalls they must have encountered in applying the Chinese sixty-year calendar cycle to dates for Japan's protohistorical period, the arrival of Ninigi

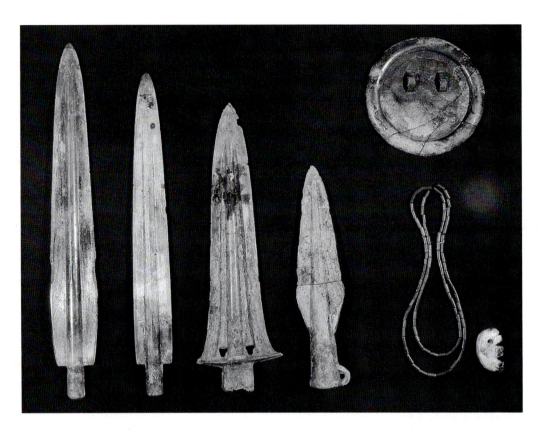

17 Swords, halberd, spear, mirror, tubular beads and *magatama* jewel, from Yoshitake Takagi, Fukuoka prefecture. Yayoi period, 2nd century B.C.E. Bronze and steatite; length (swords only) 13 ⅛ in. and 11 ⅞ in. (33.4 cm and 30.2 cm). Fukuoka City Museum, Fukuoka, Agency for Cultural Affairs.

in Kyūshū and the departure of Jimmu for Honshū and the Yamato Plain only differ by a couple of hundred years from the appearance of the first Yayoi sites in Kyūshū and their spread north from the island.

THE THREE SACRED TREASURES

Curiously enough, another aspect of Japanese traditional lore appears to be borne out by a grave in northern Kyūshū dating to the second century B.C.E. (Fig. 17). In the grave were a quantity of objects, including a bronze mirror very probably of Korean manufacture and cast with sophisticated geometric designs on its back, two bronze daggers, a bronze spearhead, a bronze halberd, and an E-shaped stone bead known in later epochs as a **magatama**, although it is more often in a C-shaped form. Within a scientific archaeological context, these are goods that belong to a high-status member of the community, the bronze blades are Korean in form and (in a period when iron would have been used for actual weapons) ceremonial in nature. Whether that ceremonial purpose was limited to burial, or if it was also applied in life remains open to speculation. In the opinion of Koji Mizoguchi, the mirror and *magatama* were certainly indicators of the deceased's status while living. He points out that the lens of the mirror is not flat, but is instead curved inward so that it will concentrate the light and is therefore designed to reflect and communicate with the spirit world. Based on the combination of the blades, mirror, and *magatama*, Mizoguchi describes the deceased as a shamanistic leader.

For the *Kojiki* and Shinto religion, this grouping of objects is nothing other than the *Sanshu no jingi* (Three Sacred Treasures), regalia given by the imperial grandmother, the sun goddess Amaterasu, to her grandson Ninigi to bring down to earth. The association of the mirror with Amaterasu remains an all-important symbol. According to mythology, it relates to the occasion when Amaterasu, angered by the irresponsible and destructive antics of her brother Susano-o no Mikoto, shut herself into a cave, thereby extinguishing all light from the world. When the contrite Susano-o and the other gods managed to persuade her to rejoin them, the mirror was placed in the cave to be a proxy for the goddess. When Amaterasu hands the mirror to Ninigi, she charges him:

> My child, when thou lookest upon this mirror, let it be as if thou wert looking on me. Let it be with thee on thy couch and in the hall, and let it be to thee a holy mirror.
>
> W.G. Aston, trans., *Nihongi*, London, 1896, 83.

Thus the mirror carries several associations: the magic power to reflect an image even in the dark, the symbol of the sun goddess, and the extension of her power to others. By the time of the writing of the *Kojiki* and *Nihongi*, these others meant only one entity, the imperial house. To this day, this grouping of sword, mirror, and *magatama* remain the imperial regalia, although the original mirror is held to be in the custody of the Ise Shrine. Yet within Yayoi culture, perhaps people other than the ancestors of the Yamato emperors also held the mirror as an extension of divine and/or continental authority.

The nature of the transition from the neolithic Jōmon to the Iron Age Yayoi may never be completely understood. Still, the combination of archaeological and written testimony can give some idea. It does seem that well before the advent of the first Yayoi site Jōmon settlement in the Kyūshū, Shikoku, and southern Honshū islands had declined to a point where vast areas of these territories were unlikely to have been occupied on a permanent basis. If there had been an incursion of technologically advanced colonists to this southern region, would they necessarily have encountered any significant amount of armed resistance to their occupation? By the same token, it is evident from Final Jōmon sites in Kyūshū that rice was not unknown to these communities, and that, increasingly dependent on the sea, they might have more opportunity of commerce and trade with the kingdoms of the Korean peninsula. Perhaps, at least in part, the Yayoi transition to metalworking and agriculture took place within formerly lithic communities, while the wholesale adoption of the external accoutrements and social organization of their Korean (and possibly also Chinese) neighbors—particularly by the community's elite—may have been seen as an important factor in the agricultural and technological revolution. Certainly such a passionate adoption of foreign technologies and customs and the setting aside of native custom occurs to varying degrees throughout Japanese history.

Another popular theory of recent years is that perhaps some Korean elites abandoned their homeland due to overly aggressive neighbors and set themselves up instead in southern Kyūshū either through force or through intermarriage—bringing some of their people with them, but not entirely displacing the native population which (perhaps eagerly) was assimilating to this technologically advanced and ecologically more stable society. That amongst the new Japanese of the seventh and eighth centuries there still persisted, even in the central Yamato Plain, *emishi* (barbarian; i.e., uncivilized and unassimilated) elements within the greater population (usually in the unenviable position of slaves), suggests that what perhaps did begin as a lifestyle choice in the fourth century B.C.E. had a thousand years later become an ethnic division between what was regarded as the Japanese and an uncivilized other.

By the second century B.C.E., however, the transition to Yayoi-type settlements across Kyūshū, Shikoku, and all but the Tohoku region of northern Honshū appears to have been effected. These settlements do not seem to have been connected under a central authority, but each operated as an independent polity. As evinced by the grave goods in these communities, they had not only taken on agricultural and metalworking technologies from—most likely—Korea, but they had also adapted (or brought with them) a continental social organization with a shamanic/warrior aristocracy atop an agricultural peasant base.

The discovery in 1989 of the Yoshinogari site on the island of Kyūshū adds to our picture of life in the early Yayoi period. It is one of the largest settlements found to date, consisting of some three hundred pit dwellings—one significantly larger than the rest, presumably the residence of the local leader—and all enclosed within two moats. Inside the inner moat were four watchtowers estimated to be about 36 feet (11 m) tall and outside the outer moat were twenty raised storehouses. More than two thousand burial sites were found to the northwest of the village. Occupation of the site began in the second century B.C.E. at the beginning of the middle Yayoi period and peaked around the first century C.E. Yoshinogari demonstrates that by the middle Yayoi period relatively large agricultural communities had formed in Kyūshū. Moats are not an infrequent feature of early to middle Yayoi settlements, and in the past have generally been interpreted as defensive structures. However, Koji Mizoguchi has pointed out that these moats existed during a period when the archaeological evidence points to a fairly peaceful coexistence between the different communities, whereas later in the period, when there is considerable evidence of armed conflict, such moats are not found or have silted up. Furthermore, if the moats were defensive, why were the rice granaries placed outside them? He posits the theory that, instead of being defensive structures, the moats are in fact elements of a primitive system of irrigation for the rice paddies.

Certainly, by the middle of the Yayoi period when the moats fall out of use, cultivation techniques had advanced to a more recognizable irrigation system that allowed for relatively easy regulation of the flow of water into the rice paddies. These techniques, together with the development of new farming tools, resulted in a rapid increase in the number of villages in Kyūshū, and subsequently the spread of Yayoi settlements into southwestern Honshū, and later throughout this larger island. In addition a new type of building had been designed to store the harvests as demonstrated by the Yoshinogari site. In the Jōmon, their gathered crops of nuts and roots were kept in storage pits, but in the Yayoi—perhaps influenced by continental prototypes—a new granary was developed to store rice. A rectangular building made of wood planks, it was covered with a thatched roof, and the whole raised off the ground on stilts, and reached by a set of steep steps or ladder (Fig. 18). The obvious advantage of this type of

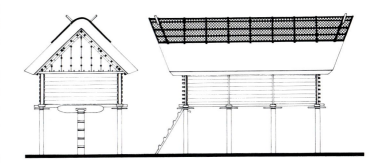

18 Elevations of a Yayoi raised storehouse. Yayoi period (c. 400 B.C.E.–300 C.E.). (Pierre and Liliane Giroux, after Ōta Hirotarō, from *The Art of Ancient Japan*, Editions Citadelles, Paris.)

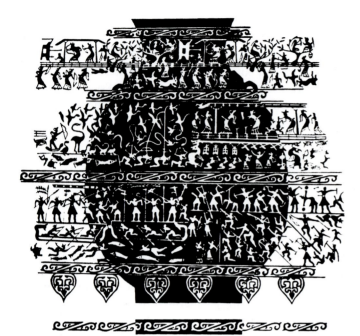

19 Schematic reconstruction of scenes on Chinese bronze vessel. c. 480–222 B.C.E. Courtesy Zhang Suicheng, *China Today*, Beijing.

often deliberately buried in hoards. In type, they seem to be related most closely to the Chinese *zhong*, a kind of bell without a clapper common to Chinese cultures of the first millennium B.C.E. *Zhong* of decreasing size and tone would be suspended from a framework along with stone chimes and struck as part of ritual music. One such assemblage is depicted on the side of a Chinese bronze vessel dating to between 480 and 222 B.C.E. (Fig. 19). Framed above and below by scenes of warfare, the *zhong* and chime assemblage can be seen above figures poised to strike them. A pair of fantastic bird or dragon figures frame the supporting bar. Whether in Japan the *zhong*/*dōtaku* were ever meant for musical use or simply for ceremonial presence is the topic of continuing research.

Yayoi *dōtaku* are 4–51 inches (10–130 cm) in height and consist of an oval body, a semicircular handle, and a flange that extends from the base of the bell to its apex. Most have geometric designs arranged in bands or blocks over the body, though occasionally a few figural images appear. The most

structure is that it prevented the rice from rotting by providing a layer of air between it and the moist ground. More interestingly it would be adapted in the succeeding centuries as a kind of sacred architecture.

Metal objects—bronze weapons and mirrors, and iron tools—were first imported from Korea and China early in the Yayoi period, and soon afterward there is evidence that these objects were beginning to be locally made. By the end of the Yayoi period, Japanese craftsmen had advanced enough to reproduce the complicated designs cast on Korean and Chinese mirrors. Curiously, however, these bronze objects, the mirrors and weapons, and also a kind of bell (**dōtaku**), were reproduced in styles that had often long gone out of fashion on the mainland—usually by at least a couple of hundred years. As demonstrated by the *Sanshu no jingi* (Three Sacred Treasures) of the second-century B.C.E. grave burial in Kyūshū, the bronze mirror and blades were markers of status and ceremonial. The archaic nature of these objects' design, therefore, would appear to hark back to some continental heritage which justified their possessor's status within the community—just as the original Three Sacred Treasures were given as imperial regalia to Ninigi by the sun goddess Amaterasu as indication that he ruled on the earth by the will of herself and of heaven.

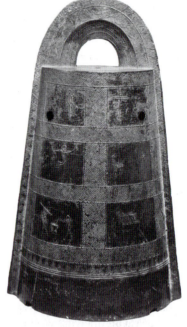

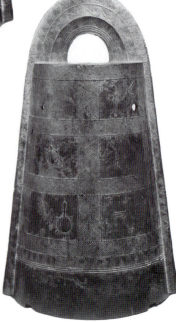

20 *Dōtaku* with designs of animals, plants and daily life, from Kagawa prefecture. Late Yayoi period, c. 100 B.C.E.–300 C.E. Bronze; each: height 16 ⅞ in. (42.8 cm). Tokyo National Museum.

DŌTAKU

While bronze blades and mirrors are a feature of burials in Kyūshū, in southern Honshū, primarily the Kyoto–Osaka area, and on Shikoku there can also be found the bronze bell, or *dōtaku*. More than four hundred of them have been discovered,

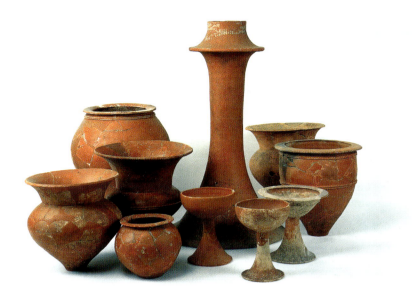

21 Pedestal and other vessels, found at Kurita. Middle Yayoi Period, c. 100 B.C.E.–100 C.E. Painted earthenware; height 20 ⅞ in. (53 cm). Prefectural Amagi Museum, Fukuoka.

interesting bells, both visually and from the point of view of history, are those showing figures interacting. A bell from Kagawa prefecture in Shikoku has reliefs of people engaged in various activities, as well as animals, birds, and insects (Fig. 20). Reading from right to left, in the upper tier of blocks are depicted a praying mantis, dragonflies, and a salamander. In the middle tier there are two cranes and a turtle, a man shooting at a deer, and a figure in midair, identified by J. Edward Kidder as a shaman performing a ritual involving leaping. The bottom tier of illustrations is perhaps the more interesting. A man aims a bow and arrow at a wild boar held at bay by five small animals, perhaps dogs trained to hunt. Next, a turtle and a salamander are shown together, and finally there are two village scenes showing a granary and two people pounding rice.

The sticklike treatment of the human figures is too diagramatic for gender distinction, but, as Kidder has pointed out, the heads of the leaping shaman, the hunter, and one of the pounders are suggested by outlines, while the head of the other pounder is solid, possibly representing a woman. Although the pictures are simply and even crudely executed, perhaps this—as with the mirrors and blades of Kyūshū—is a deliberate archaism.

CERAMICS

Although the appearance of metal objects is the most dazzling development within Yayoi material culture, the objects most commonly found at Yayoi sites are—as with the Jōmon—ceramics. Like their neolithic predecessors, they are unglazed earthenware ceramics used both as ritual objects and for everyday living, and virtually in continuation of developments in the Final Jōmon phase, their shapes are standardized, being limited primarily to tall, narrow-necked vessels, pitchers, wide-mouthed cooking pots, and storage jars and bowls, some with pedestals (Fig. 21). As in the Jōmon period, they are built of stacked coils of clay, although their final shaping and embellishing has sometimes been done on a recent innovation, the rotating wheel. They continued to be fired in open fires, but also were sometimes placed in pit kilns. Although many Yayoi vessels are simply painted red, some are decorated with incised geometric designs such as zigzags, pricked lines, and patterns made with a comb. Others have raised appliqué designs that run the gamut from a simple row of button-like shapes around the neck of a vessel to shapes symbolizing a human face.

A clay vessel from the western plain of Honshū, in the region of ancient Yamato and present-day Kyoto, Osaka, and Nara, is a particularly fine example of the drag and press technique of decoration (Fig. 22). To make this pattern, the comb was pressed into the clay vertically and then dragged

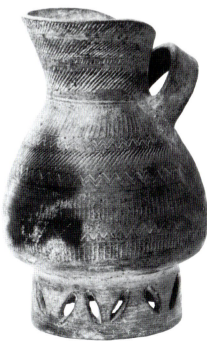

22 Pitcher, from the Kansai region, Nara prefecture. Middle Yayoi period, c. 100 B.C.E.– 100 C.E. Clay; height 8 ⅝ in. (21.9 cm). Nara Prefectural Kashihara Archaeological Institute Museum, Kashihara.

across the surface. The vessel sits on a rather tall base, into which leaf-shaped holes have been cut. The belly swells outward above the base and the form narrows again at the neck. The surface of the vessel has been divided into registers, four on the neck and seven on the body, and these have been decorated with a variety of motifs: zigzag lines, diagonal pricking of the surface, and a design the Japanese call the "bamboo blind," a combination of wide horizontal and thin, raised vertical lines. A handle is attached horizontally below the lowest point of the curving lip. The shape of the pitcher is sturdy but refined, contrasting the smooth surface of the cylindrical base with the natural swelling and narrowing of the body, which is embellished with shallowly impressed comb markings.

Although they are relatively rare, there is a group of Yayoi pottery vessels that present interesting problems of interpretation. While varying greatly in shape, the individual pieces share a common characteristic: the depiction of a human face on the neck or body of the jar. One such vessel is seen in Figure 23, and was found in a cemetery in Ibaraki prefecture with forty-one separate burials. It is unusually tall, measuring about 28 inches (70 cm), has a flat base, and swells to its widest point midway between the base and the rim. On one side, beginning at the neck and extending to the rim, is the representation of a human face, suggested by a thin ridge of clay that curves below the mouth at the jawline, two ear-like projections, and raised ridges to indicate the nose, lips, and eyelids. The areas around the eyes and mouth are scored with diagonal lines cut into the clay.

Kidder has suggested that large vessels with short necks like that in Figure 23 may have been used for storing grain, with the face intended as a protecting presence. In a funerary context, these grain containers would be either an offering to the spirit world or food for the deceased. Other theories revolve around Yayoi burial preparations, in particular the practice of a secondary burial. With all except a minority of very high-status burials (such as the one in Kyūshū with the Three Sacred Treasures), after a body had been buried for a certain period of time, it would be exhumed, the bones washed and possibly painted with red ocher, and reburied in a large earthenware jar. A vessel with a long narrow neck and a face just below the rim may have contained water and been used in the bone-washing ceremony, while a large, wide-necked storage jar would have received the bones. As these pieces with human faces are usually found singly in a cemetery among many plain jars, the protecting presence symbolized by the face may have been intended to protect the spirits of all the deceased buried around it.

Although there has so far been no evidence of written documents found at Yayoi sites, the period is still considered to be a protohistorical one because of the mention of Japan in contemporaneous Chinese records, and in particular those of the *Hanshu*. This history of China's first great imperial dynasty, the Han (206 B.C.E.–220 C.E.), records mention of an embassy arriving in 57 C.E. from a ruler of Na (JAP. Wa) who craved recognition by the Emperor Guangwu (r. 25–58) as the supreme ruler of Na. This the emperor conferred in the form of a golden seal. In fact, Na/Wa has been correlated with not the entire archipelago, but merely with Kyūshū, which is described in the Chinese annals as a congregation of tiny kingdoms. Almost two hundred years later in the *Weizhi*—the annals of the state of Wei (220–52), one of the successor states of the Han empire located on the southeastern coast of present-day China—there is mention of an embassy of 238 from a certain Himiko, a female ruler of Yamatai (an alternative reading of Yamato), which is once again located in Kyūshū. Himiko is also referred to in the Chinese text as the sovereign of Na, conjoining the name of the future imperial house with that of the ancient name given by China and Korea for Japan. The *Weizhi* also records the sudden death of Himiko and that a vast tomb mound was erected to her, accompanied by the sacrifice of many hundreds of people—something which no archaeological finds of any Japanese period can even begin to confirm. In the Japanese *Kojiki* and *Nihon shoki*, there is also a female ruler at this period, the empress Jingu (r. 201–70). Although embassies to Wei are not specifically mentioned, Jingu is most famous for having invaded and subdued the kingdoms of

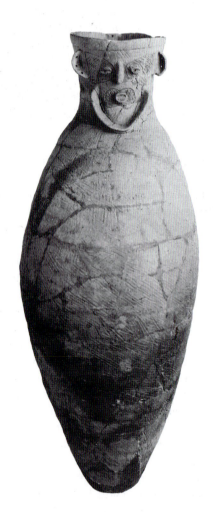

23 Vessel with human face, from Ibaraki prefecture. Middle Yayoi period, c. 100 B.C.E.–100 C.E. Earthenware; height 27 ⅝ in. (70.2 cm). Tokyo National Museum.

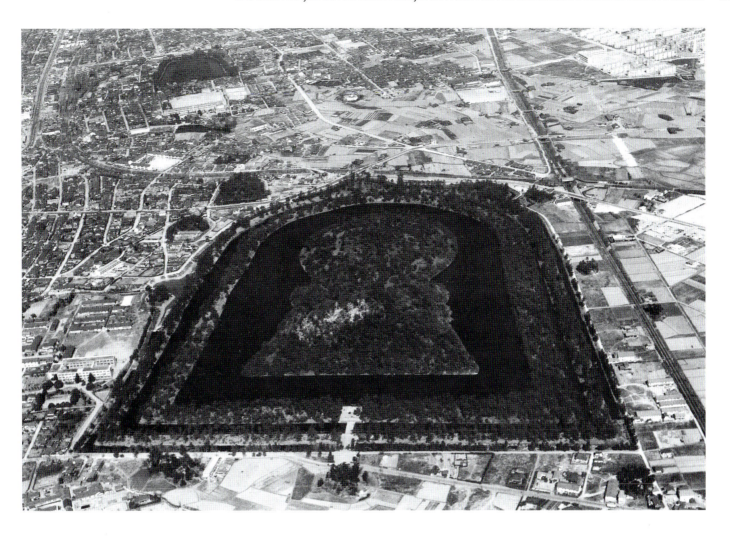

24 Tomb of Emperor Nintoku in Sakai, Osaka prefecture.
Late 4th to early 5th century C.E.

southern Korea—events unmentioned in either Korean or
Chinese histories.

In the opinion of the fourteenth-century historian
Kitabatake Chikafusa, Jingu should be considered identical
with the Himiko of the *Weizhi*, although she outlasted the
Chinese state of Wei and is reputed to have died at the venerable
age of 100. Obviously, when compared to the archaeological
record, both histories are made unreliable by their outrageous
claims—mass human sacrifice in the first case and conquer-
ing Korea in the second. There is also a disparity of locale, as
the *Weizhi* places Himiko of Yamatai within a Kyūshū context,
whereas by this time, according to the *Kojiki*, the house of
Yamato had long been firmly ensconced on the Yamato Plain
of southern Honshū. However, both texts do confirm Japan's
interaction with the outer world, and importantly feature sig-
nificant positions for women within the Yayoi elite, to the
extent that they could take on the supreme role of Mizoguchi's
shamanic/warrior ruler. In early historical times, this situa-
tion would continue, but in the eighth century it would
famously come to an end in the name of national security.

The Kofun Period (300–710 C.E.)

According to the *Kojiki*, Jingu's grandson was the emperor
Nintoku (r. 395–427), and one of the earliest monuments of
the succeeding Kofun period has traditionally been ascribed to
this emperor. An enormous key-shaped mound known as a
kofun it is in fact the largest of all such tomb mounds that
would be created in this period (Fig. 24). Located at Sakai,
near Osaka, the central keyhole shape is 90 ft (27 m) at its
apex and almost one third of a mile (half a kilometer) long and
is surrounded by three moats; the entire monument, including
its moats, covers 458 acres (185 ha). Nintoku's alleged tomb,
however, is not the first *kofun*, as these massive monuments
make their appearance on the Yamato Plain—in the present
Kansai region—around the beginning of the fourth century,
and gradually spread throughout Japan. Their appearance in
other parts of Japan parallels the efforts beginning in the
fourth and fifth centuries to centralize authority in the main
islands of Kyūshū, Shikoku, and Honshū within a Yamato
state. Therefore, the spread of the *kofun* style of tomb has been
interpreted as mirroring that extension of Yamato power. The
rulers of the Yamato dynasty themselves would have been
interred in the Kansai region, the seat of their power, but those
buried outside the imperial precinct would have been high-

ranking members of the great clans who helped to establish the Yamato state and who ruled in the provinces as the emperor's representatives.

Although tomb mounds for great leaders have a strong precedent in China in the two millennia before the Kofun period, and in Korea for at least a thousand years before, the most direct ancestor of the Japanese *kofun* is likely to be found in the relatively small, but numerous mound burials that first started appearing in the early Yayoi period. By the middle Yayoi period, around the beginning of the first millennium C.E., a new type of monumental mound for the burial of a single important personage had appeared. Placed inside a wooden chamber at the heart of the mound, the body was accompanied by the blades and mirrors that symbolized its status. This replaced the simpler coffin burial for the elite, and the new mounds were sited separately from the cemeteries, often on the crest of a hill and making a significant impression from a considerable distance. Essentially these Yayoi mounds were round and could be up to 151 feet (46 m) in diameter. They often had two other mound projections, rectangular in shape, which served the practical purposes of leading to the mound's summit—up to 17 feet (5 m) in height—and acting as platforms for funerary rituals. The Yayoi mounds were also surrounded by stone markers that delimited this sacred space from the countryside around.

However, although these Yayoi mounds are the ancestors of the keyhole-shaped *kofun*, there are substantial differences between them and it is these that form the distinction between the Yayoi and Kofun periods. First is the question of sheer size: even the smallest of the *kofun* measures in length more than 328 feet (100 m), while the largest of the Yayoi mounds is less than 164 feet (50 m) long. Second, the bronze blades, as well as the ritual burying of *dōtaku* that feature in Yayoi grave mounds, utterly disappear in the *kofun*. Third, the rectangular projections either side of the Yayoi mound become a single triangular mound fronting the massive circular **tumulus** to create the characteristic keyhole shape of the *kofun*. All these differences point to a substantial shift in ritual practice as well as to the increased importance with which the community regarded such honored dead.

The main *kofun* tumulus also contains a pit-shaft grave, in which the burial chamber, an earth-floored room with stone walls, was usually located near the top of the mound. Once the wooden coffin and the appropriate grave goods were in place, the chamber would be sealed with a rock cap and earth would then be then mounded over it. The objects placed within the tomb continue to be weapons—but made of iron and now not of archaic form—in addition to the bronze mirror and the C-shaped *magatama* and ornaments of jasper, as well as gold crowns and jewelry, and exotic items such as glass bowls. Furthermore, clay sculptures modeled on a cylindrical form and called **haniwa** were distributed over the surface of the mound. These appear to have evolved out of the jars and cylindrical stands that were placed on similar mounds during the late Yayoi period.

As mentioned, the most impressive *kofun* are located in the Kansai region and were built for members of the imperial Yamato family. However, the joining of the main clans under a more or less nominal allegiance to the Yamato rulers is not considered to have been effected until the end of the fourth century, perhaps in the time of the semi-legendary Emperor Nintoku, whose reign is famous for the long period of peace and productivity it brought. Yet there are quite a few *kofun* of more than 656 feet (200 m) in length that predate the one attributed to Nintoku, and would have required for their construction a concentration of labor it is likely that the Japanese islands had never before seen. In the opinion of Koji Mizoguchi, the Yamato would not have had either the military, political, or economic clout to have either forced or hired labor to construct these tombs. With an eye to the powerful belief that the emperors are of unilineal descent from Amaterasu and the heavenly gods, Mizoguchi suggests that perhaps the labor to construct the imperial *kofun* was offered on a voluntary basis, much as the Christian faithful of medieval Europe would offer themselves for the construction of a cathedral.

Certainly the aura of sanctity that surrounds the imperial house is immensely strong, even in today's Japan. Although the Kofun period is the most recent of these prehistoric and protohistoric periods, archaeologists still know surprisingly little about it compared to the Jōmon and Yayoi periods. The primary reason for this is that a significant number of the most important *kofun* are still today the property of the emperor, and under the administration of the Imperial Household Agency. Access to these sites is largely prohibited, and the possibility of digging or disinterring unthinkable. For example, the tomb identified with Emperor Nintoku is attributed to him by imperial tradition, but this claim has not been substantiated by modern scientific archaeology. However, not all *kofun* are considered imperial, and therefore can be investigated; and on special occasions even the great imperial *kofun* can become subject to limited inspection, such as when material within sites is exposed through the damage caused by events such as natural disaster.

HANIWA

Haniwa (*hani* means "clay" and *wa* "circle") appeared first on the early *kofun* of the Kansai region; it is conjectured that the *kofun* of Nintoku was once covered by over twenty thousand. Typically, a house-shaped *haniwa* was placed directly over the deceased, with others distributed in concentric patterns at midslope, at the base of the mound, and at the entrance to the burial chamber. During the sixth century, however, *haniwa* disappeared as a feature from imperial *kofun* of the Kansai region, and the manufacture of these objects appears to have shifted eastward to the Kantō, the plain surrounding present-day Tokyo. The pattern of *haniwa* placement on tomb mounds is demonstrated in Figure 25 by the diagram of their distribution on one of these eastern *kofun*, the Futatsuyama tumulus in Gunma prefecture. The largest *haniwa* house appeared at

25 Diagram of *haniwa* placement, Futatsuyama Tomb, Gunma prefecture.

the center of the circular mound over the deceased, and on the top of the triangular section was a neat line of four additional houses. Simple cylinders outlined the entire keyhole shape; inside this border figural images were placed around the curve and also along the straight edge of the mound.

It is thought *haniwa* evolved out of hourglass-shaped jar stands used in conjunction with mound burials in the Yayoi period, perhaps to support vessels containing offerings. *Haniwa* were made of unglazed ceramic fashioned out of slabs or coils of clay and fired at low temperatures by the same craftsmen who made the everyday ware, or *haji*; the materials and techniques were the same for both. The *haniwa* ranged in shape from the simplest cylinders to detailed renderings of architecture and military equipment, and included shields decorated with incised patterns, quivers, helmets, ceremonial parasols, and, occasionally, human figures.

An episode from the *Nihon shoki* (or *Nihongi*) of a gentleman riding past the *kofun* of Emperor Ōjin (Nintoku's father) by moonlight suggests how lifelike these *haniwa* could appear.

> [he] fell in with a horseman mounted on a red courser, which dashed along like the flight of a dragon, with splendid high-springing action, darting off like a wild goose....In his heart he wished to possess him [the red horse], so he whipped up the piebald horse which he rode and brought him alongside. But the red horse shot ahead, spurning the earth, and galloping on, speedily vanished in the distance.
>
> W.G. Aston, trans., *Nihongi*, London, 1896, 357–8.

However, the rider of the other horse intuited the man's desire and exchanged horses with him. Happy, the gentleman returned home, placed his new horse in the stable, and went to bed. The next morning he found the red courser to be made of

clay and upon going back and searching around the tomb he found his own piebald horse, for which he exchanged the *haniwa* horse.

The function for which the *haniwa* were intended is still being debated. However, even by the eighth century it is obvious that the Japanese themselves were struggling for an explanation of their use: in another passage from the *Nihon shoki*, an emperor, perhaps Suinin (r. 29–70), requested that a substitute be found for the live burial of attendants after the death of a member of the imperial family, and, in response, the clayworkers' guild produced images of people and horses.

There are isolated mentions in the *fudoki* reports from the provinces of child sacrifices occurring in the past at the foundation of structures such as bridges (and these are described as barbaric practices by the recorders). However, unlike in ancient China (which the writers of the *Nihon shoki* clearly admired), there has so far been no evidence to support the idea of mass human sacrifice near any tomb of the Japanese elite. The story of Emperor Suinin was written at a time when the Japanese elite were almost fanatically trying to model themselves on Chinese imperial custom. Indeed in tombs of the Chinese elite, and particularly in the Chinese imperial tombs, there was a long tradition of placing ceramic figures within the tomb chamber. These are meant to represent the attendants and possessions of the deceased, and had evolved from a practice of human sacrifice at the time of burial that was discontinued no later than the early first millennium C.E. The most curious facet of this episode from the *Nihon shoki* is the extent to which the Japanese imperial court of the eighth century would attribute to themselves even the most unsavory aspects of Chinese imperial history. Amongst continental tomb ceramics, however, *haniwa* have close cousins in the cylindrically-based and simply modeled tomb sculptures that can be found placed in pairs in fifth/sixth-century tombs of the Kaya Hill States (part of present-day Korea).

It has also been suggested that the *haniwa* were intended to keep the earth of the artificial mounds in place, but the placing of the clay cylinders, at least as known today, would not have prevented erosion. The most workable theory is that they served two functions: to separate the world of the dead from that of the living, and to protect the deceased and provide their spirits with a familiar resting place.

The early *haniwa*, those produced in the Kansai region, are very limited in type, as though the clayworkers were required to adhere to a precise ritual standard that allowed little room for creative variety and evolution. Nevertheless, the pieces are well, often superbly, made, and some are striking in appearance. The sunshade, or *kinugasa*, from Anderayama *kofun* (in a suburb of modern Kyoto) is an object of great formal strength (Fig. 26). The basic shape is that of a round umbrella set on a cylindrical base, probably deriving from the sunshade held over people of importance at outdoor rituals. The drama of the piece is considerably heightened by the four featherlike shapes that rise up from a ring at the top, and by the four flanged pieces that extend down from the ring to the

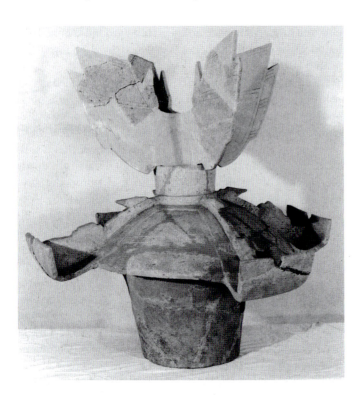

26 Sun-shade-shaped *haniwa*, from Anderayama *Kofun*, Uji prefecture.
Kofun period (300–710). Clay; height 36 ⅝ in. (93 cm).
Archeological Museum, Kyoto University.

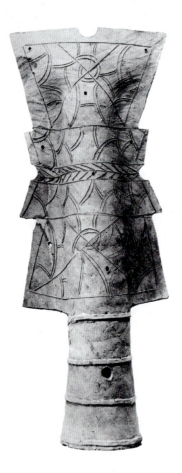

27 Shield-shaped *haniwa*, from Nara prefecture. Kofun period (300–710).
Clay; height 58 ⅝ in. (149 cm). Tokyo National Museum.

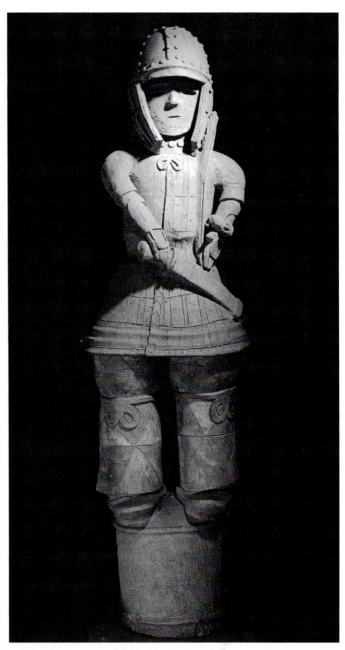

28 *Haniwa* figure of a warrior, from a site in Gunma prefecture.
Kofun period (300–710). Clay; height 49 ¼ in. (125 cm).
Aikawa Archaeological Museum, Isezaki.

edge of the umbrella and then curl back again. Carved on the surface of the piece is a design known as the *chokkomon*, a geometric pattern of curves and intersecting lines. Another shape frequently found in the Kansai is the shield (Fig. 27). Modeled from what might have been a leather object, it is set on top of the cylinder typical of *haniwa* sculpture. The surface of this piece, too, is decorated with the *chokkomon* design.

The variety of later *haniwa* shapes from the eastern Kantō region around Tokyo is much richer. Figural *haniwa*—men, women, singers, dancers, soldiers, and animals—are found throughout the region in such numbers and different types

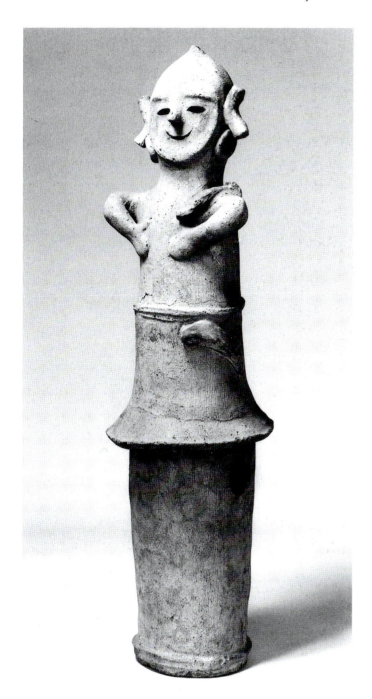

30 *Haniwa* figure of a monkey, from a site in Ibaraki prefecture. Kofun period (300–710). Clay; height of entire figure 10 ¾ in. (27.3 cm). Private collection, Tokyo.

29 *Haniwa* figure of a farmer, from a site in Gunma prefecture. Kofun period (300–710). Clay; height 36 ⅜ in. (92.5 cm). Tokyo National Museum.

that Miki Fumio has called them genre sculpture. The frequency with which armor-clad figures appear suggests that warfare was not uncommon in this hinterland of the Yamato state. The warrior in Figure 28 wears full-body armor over wide-legged trousers, gauntlets, and a helmet. In contrast, the farmer, with a hoe over his shoulder and a wide grin on his face, is the epitome of a happy-go-lucky peasant (Fig. 29). The sculpture of a monkey is a true masterpiece (Fig. 30). From one angle she appears to turn her head as if to communicate with an offspring perched on her back. From another she seems alert and watchful, as if danger were at hand.

31 Female head from a *haniwa* figure, from the Tomb of Emperor Nintoku. Kofun period (300–710). Clay; height 7 ⅞ in. (20 cm). Imperial Household Agency.

32 *Haniwa* figure of a house, from Miyazaki prefecture. Kofun period (300–710). Clay; height 21 ½ in. (54.5 cm). Tokyo National Museum.

33 Mirror with design of four buildings, from Takarazuka Tomb, Nara prefecture. Early Kofun period, c. 300–450. Bronze; diameter 9 in. (23 cm). Imperial Household Agency.

Two sculptures of particular interest, not only because of their craftsmanship but also for the information they provide about Kofun culture, are a female head from the tomb of Emperor Nintoku and a large house found in northern Kyūshū (Figs 31 and 32). The female head, from an otherwise closed and unexcavated site, offers a rare glimpse into the fine quality of those imperial objects still hidden from view. The house *haniwa* from Kyūshū provides important information about residential architecture for the affluent. Its basic shape is that of a pit dwelling. Additions on the long sides permit access to the interior by way of ramps. The structures on the short sides represent secondary, shorter extensions set into the main building. The sculpture seems to present a stage in the evolution of the house from pit dwelling to a single-story structure with walls.

MIRRORS

Mirrors continue to be important elements within the grave goods of high-status individuals throughout Kofun-period culture. It is also likely that the association with Amaterasu that can merely be imputed in the Yayoi period becomes apparent in this dawn of imperial government. Indeed, given the dissemination of Kofun-period mirrors throughout the country in the course of *kofun* burials, scholars believe that the mirrors were bestowed on local leaders as evidence that they were representatives or part of the Yamato state.

Of the many hundreds known, two mirrors must be singled out for special attention: a mirror with a design of four buildings and one from a group of mirrors, all from the same tomb, ornamented with the *chokkomon* design. Both are pieces that could have been made only in Japan. The first mirror (Fig. 33), from the Takarazuka Tomb in Nara prefecture, illustrates four separate pieces of architecture. Most probably the buildings should be identified as three residences—a three-bay

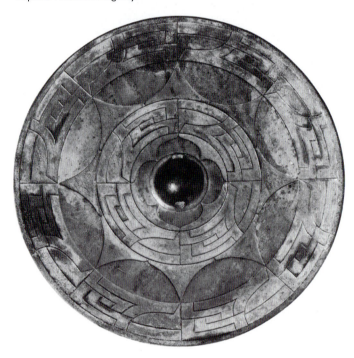

34 Mirror with two *chokkomon* bands, from Ōtsuka Tomb, Kyūshū prefecture. Early Kofun period, c. 300–450. Bronze; diameter 11 in. (28 cm). Imperial Household Agency.

house raised off the ground on piles, a house with walled sides and gabled roof, and a pit house—and one raised granary. The question of whether the design was intended as a depiction of existing buildings or had a less literal meaning has not yet been resolved, but the mirror certainly provides an interesting view of the diversity of architecture that can be found in use in the Kofun period.

The mirror with the *chokkomon* design comes from the Ōtsuka Tomb on Kyūshū, along with two others bearing the same motif (Fig. 34). The name *chokkomon* means "pattern of straight lines and arcs" and was coined by archaeologists to describe this motif. The bands with the *chokkomon* design are divided into segments, almost like wedges of pie; eight are in an outer band and four in an inner one. These units of arcs and lines in the two bands are similar except for their size, two in the outer band equalling one in the inner band. The design in this context is particularly pleasing, with its emphasis on fine raised lines disposed delicately between flat zones.

OTHER GRAVE GOODS

Amongst the other materials found in *kofun* are some that also featured in elite burials of the Yayoi period, but others show the continuing evolution of the culture and its still close ties with the Korean and Chinese domains. China during most of the Kofun period was experiencing one of its periods of disunity, during which a succession of dynasties carved up portions of the empire. These rival states nevertheless were powerful neighbors and China's cultural influence remained important for the Japanese. Korea at this time was comprised of four states: Paekche, Koguryŏ, Silla, and the confederacy of the Kaya Hill States. It is often hypothesized that the Japanese elite and the Yamato clan are in fact descendants of Kaya princes forced to flee their homeland. Certainly by 562 the last of the Kaya states had been swallowed up by Silla. Kaya grave goods of this period have close parallels with those of the Japanese elite, as has been demonstrated in relation to the *haniwa* (see pages 30–34). Paekche grave goods also bear many similarities, and it is known that the Yamato court had close diplomatic and cultural ties with Paekche before it too was swallowed by Silla in 660. In addition, the Yamato permitted several waves of immigration from Paekche to their domain from the fourth to seventh centuries. By the end of the Kofun period, China was once again united under a strong and

36 Earrings, from Niizawasenzuka No. 126 Tumulus, Kashihara-shi, Nara. Kofun Period, 5th century. Gold; overall length 8 ½ in. (21.5 cm). Tokyo National Museum, Important Cultural Property.

dynamic dynasty—the Tang (618–907)—and Korea under Unified Silla (668–918), which was additionally a client state of Tang China. All of these nations seemed to have influenced the grave goods that the Japanese elite of the Kofun period carried with them into the next life.

Of the artifacts of personal status and adornment that survive from the Yayoi into the Kofun period, the C-shaped bead or *magatama* is a quietly important part of the accoutrements of high Japanese rank (Fig. 35). One of the *Sanshu no jingi* of the imperial regalia, it can be found in this C-shape and in the E-shape seen in the Yayoi burial of Figure 17. The C-shape, however, is at once more ancient and international than the second variety. *Magatama* of this type have been found not only in Jōmon period burials, but also hang from Korean gold crowns, necklaces, and earrings in the royal Paekche tombs contemporaneous with the Kofun period. Also stylistically close to the grave goods of Paekche, Kaya, and Silla are a pair of gold earrings excavated from a fifth-century tomb in the Nara region and a gilt bronze cap from a fifth/sixth-century mound located in Kyūshū (Figs 36 and 37). The discovery of a glass bowl with gold spots in a Nara area

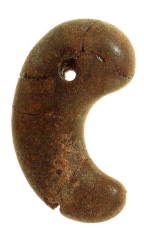

35 Curved Bead. Kofun period, 4th century. Length 1 ¼ in. (3.3 cm). Kyoto National Museum.

37 (above) Crown, from Funayama Tumulus, Kikusui-machi, Kumamoto. Kofun Period, 5th–6th century. Bronze with gilding; height 6 ½ in. (16.5 cm), lower length 5 ¾ in. (14.6 cm). Tokyo National Museum, National Treasure.

tomb of the fifth century (Fig. 38) also is similar to finds in Korean tombs of the period. Obviously a vessel held to be immensely precious, and possibly used by the deceased in life, it is likely to be the product not of a Japanese craftsman, but instead an expensive import from China, or possibly even further to the west from the region of ancient Persia.

ORNAMENTED TOMBS

The late Kofun period coincides with the sixth century and overlaps with the beginning of two historical periods, the Asuka (552–645) and Hakuhō (645–710). Nevertheless the erection of vast tumuli and their furnishing with lavish grave goods continued until the early eighth century, when the imperial house and aristocracy turned instead to more modest structures in keeping with Buddhist funeral practices. The tombs of this final century will therefore be treated in this chapter as being the closing part of a long tradition, while the other aspects of seventh-century material culture properly belong to Chapter 2, and the discussion of the early historical centuries in the Nara area prior to the permanent removal of the imperial court to Heian (modern Kyoto).

Toward the end of the fifth or the beginning of the sixth century, the pit-shaft burial common to the *kofun* gave way instead to a Korean-style corridor tomb, such as that used in the royal tombs at Paekche. This design consists of a horizontal hallway leading from the slope of a mound to a stone-lined burial chamber. The chief advantage of the corridor tomb as opposed to the pit-shaft grave was that it was easier to reenter and could be used for multiple burials. By the sixth and seventh centuries, among the aristocracy family tombs became popular, along with the practice of decorating the stone walls of the main chamber with either painted or incised designs.

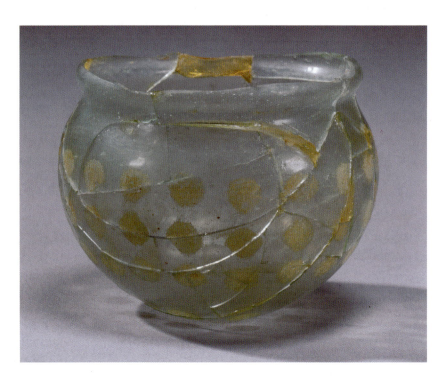

38 (right) Clear bowl with gold spots, from Niizawasenzuka No.126 Tumulus, Kashihara-shi, Nara. Kofun Period, 5th century. Glass; diameter 3 in. (7.8 cm), height 2 ½ in. (6.7 cm). Tokyo National Museum, Important Cultural Property.

39 Painted wall with *chokkomon* design, Idera Tomb, Kumamoto prefecture. Late Kofun period, 7th century.

In the late Kofun period more tombs were built than in any of the preceding eras. They were smaller in size, and sometimes ornamented. They were not only constructed for the emperor and local leaders, but for all levels of the growing court aristocracy and officialdom. The most interesting of the ornamented tombs are in Fukuoka and Kumamoto prefectures in northern Kyūshū. The Idera Tomb, named for the village in Kumamoto where it is located, is remarkable for the complexity of its construction. The corbel vaulting of the hallway and burial chamber are the finest known in Kyūshū, and the *chokkomon* pattern chiseled on stone slabs at the base of the wall in the burial chamber is the most advanced example of the design known today (Fig. 39). Japanese scholars have classified these patterns of arcs and lines into two basic types: the A-type, in which a spiral is superimposed over crossing diagonals, resulting in four units that are further divided by curving lines; and the B-type, in which the spiral is no longer evident, but a strong sense of circular motion is still conveyed. Various suggestions have been made about the origin of the *chokkomon* design, including the idea that it is an abstraction of Chinese Han dynasty cosmic symbolism. The *chokkomon* motifs on the stone slabs are painted red, blue, and white, further emphasizing their abstract quality. Because of the advanced building techniques used at Idera, the tomb is usually dated to the seventh century.

The Takehara Tomb in Fukuoka is remarkable for the figural painting still preserved on the rear wall of the burial chamber (Fig. 40). The tomb is much smaller and not nearly as complicated in construction as the one at Idera, but the striking red and black painting makes this example prominent among known ornamented tombs. The composition is framed by two large, standing ceremonial fans, and the remaining pictorial elements are distributed in three loosely defined registers. At the top, a red-spotted black quadruped with wiry hairs extending from its body, particularly from the tail, gallops full tilt to the left. Directly in front of it is a small boat. Below and to the right is a vertical row of triangular shapes, perhaps an abstraction of a mountain pattern, and to the left is a groom tending to a horse placed above a boat. At the bottom, a stylized pattern of cresting waves forms a base line for the boat and the groom. The spotted quadruped is undoubtedly a spirit while the horse and groom below are of this world. Possibly the upper animal is the spirit of the horse. The groom may be a shaman. The presence of landscape elements suggests movement through space and may refer to the journey of the soul after death. Whatever its exact meaning, the painting, on a crudely smoothed stone at the back of the chambers, is a strong reminder of the mythic and spiritual dimensions of Kofun culture.

Two tombs in particular shed light on the cultural and political climate of the late Kofun period. Dating to the late sixth century, the Fujinoki Tomb in Ikaruga was excavated in 1985; it is one of the longest corridor tombs so far found, and held a large quantity of fine grave goods. The sarcophagus contained the remains of two people, a small figure presumed to be a woman, and a larger one, probably male, approximately seventeen to twenty-five years of age, who was placed in the coffin after the woman, in what was clearly a secondary burial for him. Some of his bones were painted with vermilion, and the remains were surrounded by a great assortment of opulent objects, including openwork gold crowns, gilt bronze shoes, a belt, and silver daggers. More than eight different candidates have been proposed for his identity. Kidder has suggested that he was Emperor Sushun, assassinated in 592—after his death, Sushun would have been given a temporary burial, and, when his wife died, placed beside her in her tomb.

40 Painted wall, Takehara Tomb, Fukuoka prefecture. Late Kofun period, 6th/7th century.

41 Rear saddle bow, from Fujinoki Tomb, Ikaruga, Nara prefecture. Late Kofun period, late 6th century. Gilt bronze; height 16 ⅞ in., width 22 ½ in. (height 43 cm, width 57 cm). Nara Prefectural Kashihara Archaeological Institute, Kashihara.

Two of the most beautiful objects found in the tomb are sheets of openwork gilt bronze fashioned to ornament the wooden front and back bows of a saddle (Fig. 41). Once again, they are stylistically close to similar saddle panels discovered in Korean tombs. Both are decorated with hexagonal shapes enclosing animal and floral motifs: Chinese symbols such as the dragon, the phoenix, the lion, and the elephant; the *makara* (a crocodile-like animal found in Indian Buddhist art); and the Central Asiatic motif of the palmette.

The Takamatsu Tomb near Asuka, south of Nara, once identified with Emperor Monmu (r. 697–707), was permitted to be excavated in 1972 after the imperial Household Agency dropped it from the list of Imperial tombs. It had been looted in the distant past and as a result the surface of the south-entry wall has been badly damaged. Nevertheless, what was found upon opening was a set of wall paintings that provides yet another strong link with Korea.

The motifs depicted consist of three types of images: four groups of four human figures; three of the four animals symbolic of the four directions—originally derived from Chinese Daoist mythology and geomancy, but adopted by Korea and subsequently Japan; and representations of the sun, the moon, and the constellations. Of the directional animals, the blue dragon of the east and the white tiger of the west appear between two groups of human figures on the east and west

walls respectively. The dark warrior symbolic of the north is in fact a tortoise entwined with a snake and appears on the north wall (Fig. 42). The red phoenix which should have been on the south wall was damaged by the looters. Above the dragon on the east wall is a golden circle for the sun on a pattern of thin red cloud lines of irregular length and on the opposite wall above the tiger is a silver circle for the moon. The constellations are represented on the ceiling by seventy-two circles, once covered with gold leaf but now too damaged to be appreciated. Of most interest are the groups of human figures: the men on the south side of the tomb, the bright, warm, positive side, and the women on the north, the dark, cold, negative side—according to Chinese theories of yin and yang. Among the figures the most important is the deceased, positioned at the head of the group of men on the east side facing south. The other male and female figures are his attendants.

The tomb is extremely small, too low for the artist to have been able to stand while working. Nevertheless, the stone walls have been prepared in the continental fashion, with fine layers of plaster applied in order to build up a proper surface to bind the pigments. The best preserved section of painting shows the women on the northern end of the west wall (Fig. 43). They are court ladies, all about the same height, but placed at different levels along the wall to suggest depth and interrelated by their positions rather than their actions. The

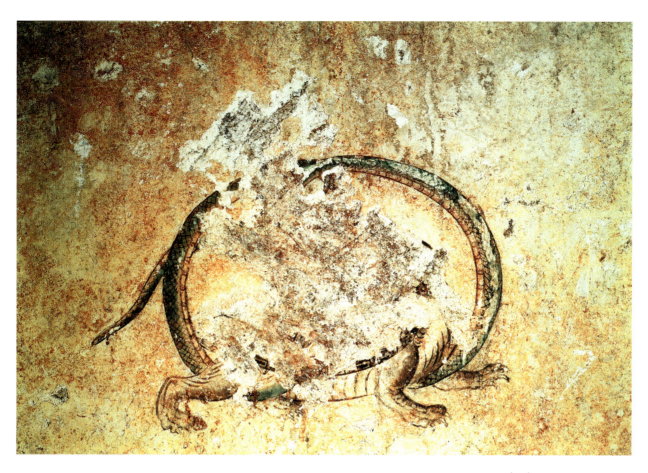

42 *Dark Warrior of the North*, painting on north wall, Takamatsu Tomb, Nara prefecture. Late Kofun period, late 7th/8th century. Color on plastered panel.

women wear long jackets over what appear to be pleated skirts, a style of garment that is Korean in flavor. The faces and costumes are delineated by distinct, slightly calligraphic outlines, brush lines that vary slightly in width, depending on the pressure applied to the implement. The colors used are bright yellow, orange, red, and light green as well as some darker blues and greens.

From the skeletal remains of the deceased, experts have judged him to be a man in his forties, and from the evidence of a Chinese mirror ornamented with a lion and grape-leaf design dateable to 698, the tomb must have been closed near the end of the seventh century. The most likely candidate for the deceased is generally thought to be Prince Takechi (654–96), the son of Emperor Tenmu and a woman other than the empress Jitō, his principal consort. At any rate, the tomb was clearly made at the end of the seventh century for someone of importance, a person who could plan for himself and arrange for a resting place in consonance with Chinese Daoist principles for burial, a space decorated in the best continental styles and techniques available in Japan at the time.

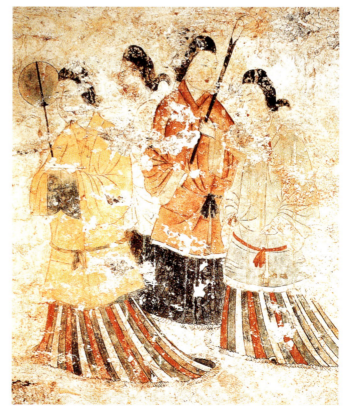

43 (right) Female attendants, painting on west wall, Takamatsu Tomb, Nara prefecture. Late Kofun period, late 7th/8th century. Color on plastered panel.

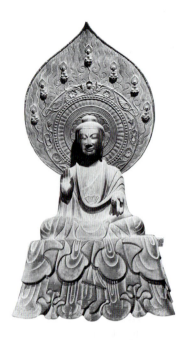

CHAPTER 2
Imperial Models

THE IMPACT OF CHINA AND BUDDHISM ON JAPAN

*The Asuka period (552–645) is distinguished by two major events, the beginning of the great passion for all things Chinese by the imperial court, and the formal introduction of **Buddhism** from the Korean kingdom of Paekche. The period begins with the year 552—twelve years into the reign of the Emperor Kimmei (r. 540–71)—to mark the arrival of the Paekche diplomatic mission and their Buddhist gifts. The name Asuka itself refers to a valley of the Yamato heartland to the south of present-day Nara where the imperial court often resided between the reign of the Emperor Inkyō (r. 412–53) and that of Gemmyo (r. 708–15). The imperial court and government was of a semi-nomadic nature during this period. Shinto ritual stipulated that the death of an emperor made the palace unclean, and therefore with each accession a new palace on a new site had to be built. Furthermore, the emperors could also move their residence about in an effort to consolidate the allegiance of the different aristocratic clans under their authority. Wherever the emperor chose to make his palace—and therefore government—a temporary capital would spring into being.*

Centralization of Power

As the Asuka period opened, the imperial house in Yamato was technically the focus of all government, with each of the ancient clans of the warrior aristocracy, who had helped to establish the Yamato state in the early centuries C.E., holding hereditary positions within the court. Furthermore, the country was united in its belief in the imperial house's descent from the sun goddess Amaterasu, the supreme deity, in a belief system that came to be characterized as Shinto (Way of the Gods). Nevertheless, the provinces beyond Yamato were under the hereditary authority of these aristocratic clans, who ruled them more or less autonomously, keeping the gathered

revenues largely for themselves. So, while the clans became rich, the imperial house, although holding the most privileged position in the country, was relatively powerless and poor.

It was to remedy this situation that the imperial government from the Asuka period in the sixth century through the end of the Nara period in the late eighth century took an overwhelming interest in both Chinese culture and, by connection, Buddhism. The Chinese imperial system of government did not have provinces administered as if they were feudal baronies. Instead, its structure was based on a well-organized bureaucracy of officials with the emperor at its center. Governors and other officials were appointed from this bureaucracy to administer the provinces, appointments which could be made and recalled according to the direction of the central imperial bureaucracy. In addition, revenues gathered in the provinces would pour back into the imperial coffers. In the Japanese adaptation of this new system, if the old aristocratic clans wished to continue to wield their power and privileges, they would be obliged to reside in close proximity to the imperial seat of power—waiting upon the emperor at court, instead of staying in their provincial strongholds. Only in this way could they hope to participate actively in the government of ministries staffed by officials. The imperial house would become, therefore, not simply the spiritual and figurative focus of the state. It would take on a more active and central role in its governance, and be the agency by which members of the aristocracy could hope to gain lucrative and influential government positions.

It took almost a century to bring about the first major stage in this massive restructuring, and two of the key reformers were Soga no Umako (d. 626) and Umayado no Ōji—more commonly known as Shōtoku, a prince of the imperial house (574–622). The Soga clan were relatively parvenu amongst

the aristocracy, said to have been descended from a noble of Korean Paekche of the fifth century. Ambitious as they were, the Soga had quickly gained high influence with the imperial family, Umako's sister even becoming one of Emperor Kimmei's consorts. However, they had no hereditary court position, such as the ancient warrior aristocracy held. Therefore, they, and other aristocrats like them, stood to gain a great deal by the abolishment of the old government structure in favor of a new one dominated by an appointed bureaucracy. In 587, Shōtoku and Soga, together with the imperial bodyguard, engaged in open battle against those opposed to the new introductions. They won, and in the succeeding decades set about slowly implementing the shift to the Chinese system of government. Their work was only complete after their deaths with the proclamation of the Taika Reforms in 645, which laid out the formal restructuring of both imperial and provincial government according to the Chinese template.

The new system of government was a rigidly ordered and symmetrically apportioned division of responsibilities. The entire bureaucracy was divided into two departments: the Department of Worship, which oversaw Shinto affairs, and the Department of State, which was concerned with all aspects of secular government. The latter was further divided into eight ministries, four under the control of the Sadaijin (Minister of the Left) and four under the Udaijin (Minister of the Right). The country itself was organized in provinces, each with a governor. The provinces were subdivided into districts, each with its own administrator, and further subdivided into townships—each consisting of fifty households and governed by a headman responsible to the district administrator. The officials to serve this bureaucracy were to be drawn from the aristocratic clans and trained at a university known as the Daigakuryō, which taught a curriculum of the Chinese Confucian classics in the Chinese language. Before the establishment of the first capital, this university was sited near the palace and government buildings—wherever those happened to be. Since the establishment of Fujiwara as the first "permanent" capital, it has always been located within the precincts of the capital.

The Hakuhō period (645–710) begins with the proclamation of the Taika Reforms in 645. It rapidly became apparent that old ritual and political concerns would have to be set aside, and that a permanent home for this imperial bureaucracy would need to be established. And it was decided that a capital city along the lines of the Chinese Chang'an would be most suitable. The first attempt was made in 694 with the founding of Fujiwara-kyo in the Asuka Valley (see Fig. 44). However, Fujiwara was abandoned after only sixteen years, and a new permanent capital was established at Heijō-kyo, about 12 miles (20 km) to the north in 710. The period (710–94) that this inaugurated is known by Heijō's present name, Nara. Heijō was laid out on a similar Chinese imperial plan, and for eighty-four years thrived as Japan's first great metropolis, embracing one of the most culturally fertile periods in the nation's history. However, in 794 the capital was once again reestablished—this time at the city of Heian-kyo (present-day Kyoto). To the northwest of the Nara basin, Heian was founded and built along the same Chinese imperial plan as Fujiwara and Heijō, but unlike them it served as the imperial capital for more than a thousand years until the emperor's removal to Tokyo in 1868.

Beginnings of a Metropolitan Court Culture

It would not be until after the removal of the capital to Heian in 794 and the beginning of the Heian period (794–1185) that the transformation of the way Japan was governed would be fully achieved. By this time, power had been transferred completely to the emperor and his appointed ministers, and the formerly semi-independent aristocracy had been transformed into a metropolitan elite concerned utterly with the person of the emperor and the intrigues, rituals, and pastimes of the imperial court.

An important feature of the transformation of the imperial court during the more than two centuries that this political changeover took was the head-long passion with which the court threw itself into adopting the cultural trappings of Chinese civilization. In 618, the Tang dynasty established itself in China and began an almost three-hundred-year reign in which Chinese culture is often considered to have achieved its greatest flowering. The Chinese capital of Chang'an was the hub of Asia, as Rome had once been of the Mediterranean. The many cultures that gathered in the Chinese capital produced a material culture that was certainly unrivalled elsewhere in the late first millennium C.E., and its magnificent achievements in all fields, from literature, painting, and sculpture to the decorative arts, have arguably never been repeated on such a scale in the country's history. It was certainly not only Japan that held Tang China up as its shining aspiration; neighboring Korea was equally under its influence. The artistic styles that came out of Tang China—often characterized by Indian and Central Asian influences of the Silk Roads, such as a new three-dimensionality and realism through modeled forms in the visual arts—became known as the Tang International Style.

By the advent of the Tang, Buddhism had been long established in China, and by the fifth century the Korean kingdoms of Koguryō and Paekche had officially adopted it, Silla ultimately also following suit. In the Tang, as in several preceding Chinese dynasties, Buddhism played an important role in the affairs of the nation. The Buddhist community was spread throughout the Chinese empire in a closely knit network of **temples** and monasteries that, not unimportantly, acknowledged the Tang emperor as being the supreme authority on earth. The Buddhist foundations across Tang China were wealthy and influential, and as such they were important patrons of the arts. Much of what we know of the Tang International Style is in fact in the form of surviving Buddhist sculpture and painting.

Neither the Paekche embassies of 552 nor of 584 were successful in introducing Buddhism to the Japanese imperial court. However, they did attract the interest of both Soga no Umako and Prince Shōtoku, who championed the Buddhist cause . When they managed to gain control of the government in 587, Buddhism gained its crucial foothold. A century later, Buddhism was well established within Yamato itself, with Emperor Tenmu (r. 673–86) and his successor, Empress Jitō (r. 686–97) openly advocating Buddhism as an instrument of the state. The power and wealth of the court were accordingly mobilized for the construction of large and elaborate Buddhist temples in the next century. In addition, all official residences were required by imperial edict to have a Buddhist altar with an image and appropriate **sutras**, and Buddhist institutions were to be established in each of the provinces. Already, however, these great "national" temples had been preceded by privately founded temples, in particular those established by Soga no Umako and Prince Shōtoku, and it is their patronage which ignited Japan's long and great tradition of Buddhist art. Although these first Buddhist images of the Asuka, Hakuhō, and Nara periods closely imitate the styles of the continent, they nevertheless feature the seeds of a Japanese idiom that in the succeeding Heian period would begin to flower, and would continue to do so through to the sixteenth century.

The Creation of an Imperial City

Although the concept of a permanent capital was set forth in the Taika reforms of 645, it was not, as mentioned above, until the reign of Emperor Tenmu (r. 673–86) that a site was selected and laid out with a formal design. This was the city of Fujiwara-kyo, in the Asuka Valley, which was actually built by Tenmu's successor, Empress Jitō, and occupied in 694. The site of the city was on land belonging to the Nakatomi clan, who had been hereditary heads of Shinto affairs, and who had fought against the Shōtoku/Soga alliance in 587 and their desire to promote the Chinese reforms and allow the propagation of Buddhism. Though they lost that battle, the Nakatomi proved to be a clan of great resilience and adaptability. By 645 and the proclamation of the Taika Reforms, they had turned the political tables on the Soga clan, eliminating its principal members and taking their place at the emperor's side. The Nakatomi clan held the Fujiwara region of the Asuka Valley in fief, and had been granted the name as their official surname by the end of the century. The Nakatomi/Fujiwara retained their traditional, hereditary role as the heads of Shinto affairs, or of the new Department of Religious Affairs, and as the hereditary priests of the imperial shrines. However, they also began a long and distinguished career providing many of the ministers who directed the Department of State, so that by the middle of the Heian period (794–1185) they would effectively control all government and the emperor, with whose family they had by this time become very intimately connected through many generations of intermarriage. This state of affairs would not change until the complete reorientation of political power away from the imperial court and into the hands of provincial warlords in the late twelfth century.

The site of the city of Fujiwara, chosen within their fief, is near the village of Kashihara, and from the 1930s excavations began there to uncover this first capital city, becoming a permanent, ongoing project in 1969. What has so far been uncovered is a city site measuring one mile by one mile (2 x 2 km), and organized on a grid plan of nine large avenues cross cut by thirteen smaller ones (Fig. 44). However, excavations have now revealed that the extent of the city was perhaps even larger than this. This grid neatly divided the city into large blocks, which were further subdivided by a pair of crossed lanes into four units known as *cho*. Each *cho* formed the basic residential unit, and the city's buildings covered areas ranging from a portion of a single *cho* to the 64 *cho* covered by the imperial palace. The palace grounds at the heart of the city measured about half a mile (1 km) on each of its four sides, and was accessed by the principal avenue, which was over 98 feet (30 m) in width and ran from the southern city's entrance. The other eight avenues flanking it varied from 33 to 79 feet (10–24 m) in width, and were roughly spaced about 870 feet (265 m) apart. The Asukagawa River ran diagonally across the city, and the foothills of one of the neighboring Yamato mountains intruded into the city's western flank, which by disrupting the grid plan must have softened the otherwise rigid aesthetic of the urban design.

The palace precinct was surrounded by an earthen wall some 17 feet (5 m) in height and capped with a tiled roof, and similar earthworks surrounded the city. It is doubtful that either were intended primarily to be defensive, but were instead more of a ceremonial division of space—the city from the country, and the emperor and government from the commonalty. The imperial precinct's principal southern gate opened onto a great courtyard, at the opposite end of which was the Great Audience Hall (Daigokuden). The government offices of the Ministries of the Right and Left were ranged on either side of the courtyard, while to the north of the Great Audience Hall appeared the imperial residence. The Great Audience Hall was some 148 feet (45 m) in width and almost 66 feet (20 m) deep, it sat upon an earthen foundation with stone bases for each of the building's wooden pillars, and was—as were the government buildings—roofed with tiles. The imperial residence was made up of numerous buildings that were on a more intimate scale, which appear to have been roofed with the more homely materials of planks or cedar-bark shingling.

In addition to the imperial palace, Fujiwara encompassed several Buddhist temples that had been founded long before the city itself was thought of, including Asukadera, which was the very first great Buddhist foundation and had been completed in 588, followed by the Kawaradera in 667, Daikandaiji in 673, and Yakushiji in 680. Built on a large scale to impress, they each covered several *cho*. So too did many of the mansions of the great courtiers.

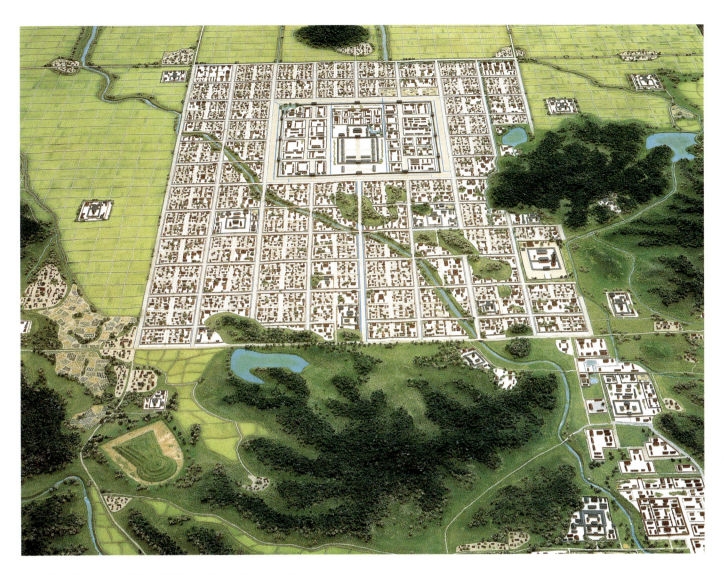

44 Plan of Fujiwarakyo (694–710). Nara Cultural Properties Research Institute.

As has already been mentioned, the model for Fujiwara was Chang'an, which was more than four times the size of the first Japanese capital. However, it has been estimated that Fujiwara supported a population of no more than thirty thousand, while Chang'an at its height had a population of over a million people. Given the ratio in size, it would appear that Fujiwara provided the luxury of considerably more space for each of its citizens than was the case in the crowded Chinese capital. But it is usually a burgeoning population that is cited as being the principal reason that the government persuaded the Emperor Mommu (r. 697–708) to remove the capital from Fujiwara in 710 and reestablish it on a completely new site about 13 miles (20 km) to the north. The result was the city of Heijō-kyo, which—built on a plan almost identical to that of Fujiwara—measured some 3 miles (4 km) from east to west and almost 4 miles (6 km) from north to south. It reputedly supported at its height a population of some sixty to seventy thousand people (Fig. 45).

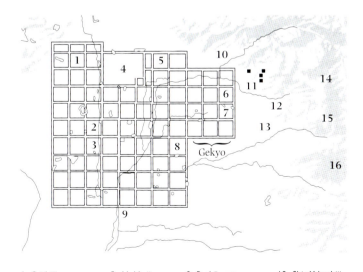

1 Saidaiji	5 Hokkeji	9 Rashōmon	13 Shin Yakushiji
2 Tōshōdaiji	6 Kōfukuji	10 Shōmu's Grave	14 Mt. Mikasa
3 Yakushiji	7 Gangōji	11 Tōdaiji	15 Mt. Kasuga
4 Heijō Palace	8 Daianji	12 Kasuga Shrine	16 Mt. Takamado

45 Map of Heijō-kyo (Nara).

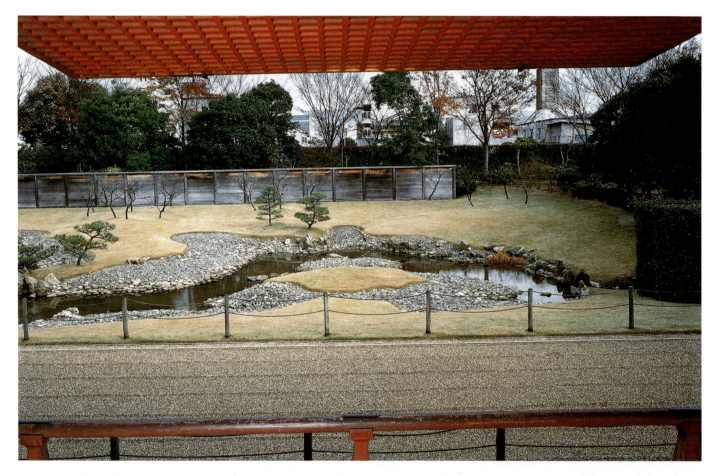

46 View of Nibo no Miya, a restored garden of an aristocratic palace of Heijō-kyo. Nara Cultural Properties Research Institute, Nara Municipal Board of Education.

The new city also sat within a plain, and was flanked by mountains on three sides, although these were ranged to the north instead of to the south and west, as they were at Fujiwara. The city grid was laid out with ten lateral avenues and nine longitudinal ones. However, the parallel avenues were twice the distance from each other as their equivalents in Fujiwara, and the large blocks that they delineated could be broken down into sixteen *cho* by bisecting lanes. The large central avenue leading to the new imperial palace, the Suzaku Oji, was over 229 feet (70 m) in width, while the subsidiary avenues were 69–118 feet (21–36 m) in width. The Heijō palace enclosure was only about ten percent larger than its Fujiwara predecessor, but instead of being in the heart of the city it rested at the centre of the northern perimeter, as did the imperial palace at Chang'an. The buildings within the palace precinct remained roughly the same as those at Fujiwara, but excavations have shown that they seem to have been repositioned several times within the enclosure during the seventy-odd years that the palace was in use.

The great upheaval engendered by removing the population of Fujiwara to Heijō can only be guessed at. In the end, however, it was achieved, and the Shinto shrines and Buddhist temples of Fujiwara were reestablished in the new capital. Indeed, a suburb known as the Gekyō, or Outer Capital, was created in the foothills of the eastern mountain, especially to accommodate the rebuilt Asukadera (renamed at this point with the more Chinese style of name, Gangōji) as well as a private Buddhist foundation of the Fujiwara clan, the Kōfukuji. The old shrines and temples of Fujiwara were relegated to a subsidiary role by their departed occupants, and many were destroyed in 711 by the great conflagration that swept through the abandoned city.

Heijō would not long escape a similar fate. From the reign of Emperor Konin (r. 770–82) it was felt that a new capital was needed and a site was found some 25 miles (40 km) to the northwest. One of the reasons often cited for the government's desire to move was to put some distance between the imperial seat and the principal Buddhist temples that had come to dominate the city. With the exception of these Buddhist foundations and some Shinto shrines, Heijō was as quickly abandoned as Fujiwara, and its former palaces, mansions, markets, and neighborhoods turned over to farmland. This farmland, however, has largely preserved the grid layout of the lost city's neighborhoods, greatly facilitating archaeological study of this second capital. The great Buddhist compounds established in the Nara period for the most part endure to this day, and to serve them the city of Nara was slowly formed to the east of the site of Heijō. It is with this city that the ancient capital has

come to be identified in the popular imagination. Both Fujiwara and Heijō are important not only as the first planned cities of Japan, but because they provided models for smaller cities which were to be built in each of the provinces as administrative centers. The basic grid plan established by these cities was also adopted for the new capital of Heian, and would be the Japanese urban template used for many centuries to come.

Sadly, the excavated sites of neither the Fujiwara nor Heijō palaces can give a complete idea of what these compounds might have looked like. Comparing them with images of the palace subsequently established at Heian (see Figs 126

47 *Male–Female Fountain Sculpture*, excavated at Asuka mura, Ishigami. Asuka period, 7th century. Stone; height 67 in. (170 cm). Asuka Historical Museum.

and 127), and with some of the Nara-period Buddhist temples (see Figs 66, 69, 75, 80, 82, and 83), gives a very rough and perhaps not entirely reliable idea. However, from their layouts, both the public buildings and private mansions seem to have been heavily influenced by palace-type architecture to be found on the continent. Basically wooden structures of a post-and-beam construction, roofed with either tiling or a kind of wood or bark shingle. The buildings would have formed enclosures around courtyards, but it is obvious that they would also have framed ornamental gardens, sometimes of great size (Fig. 46). The excavated and recreated garden of Nibo no Miya once sat in the compound of an aristocratic mansion of ancient Heijō and was the focus of poetry-writing parties and other such pastimes of the imperial aristocracy. There are many descriptions of similar gardens in Nara- and Heian-period literature, featuring an artificial pond representing the sea or a stream representing a river, bordered by rocks and plants molded and cultivated to reproduce in miniature a natural landscape. Ultimately this type of garden has a continental inspiration, but by the Nara period it is evident that gardens had long been an important feature of both aristocratic mansions and imperial palaces.

In fact, at the last imperial palace before the removal to Fujiwara, there have also been found remains of a palace garden, although regretfully not in such a state that they could be recreated, as at Nibo no miya. The palace of Kiyomihara no miya within the city limits of present-day Asuka served as the last of the principal imperial residences not to be encased in a Chinese-style capital city. It was from here that the city of Fujiwara was planned and its construction overseen. At one corner of the site has been found the remains of a vast garden, and, most interestingly, pieces of stone sculpture that once ornamented it. One of the more unusual of these is a stone carving of an entwined man and woman which served as a fountain, water spouting from the two mouths (Fig. 47). When compared to the Buddhist sculptures of the same period (see Figs 84 to 89) and earlier, this is an ungraceful and crude piece. However, there is a sense as well that this roughness is deliberate, and the image's comic quality is certainly eloquently communicated. Another cone-shaped stone sculpture of Mount Sumeru, which in the Buddhist conception rests at the centre of the universe, points to a Chinese influence in not only the fashion for garden sculpture, but also in its subject matter. It is not clear, however, to what extent these sculptures represent a Chinese sculptural idiom and to what extent an emerging Japanese sculptural style.

The Introduction of Writing

The Japanese elite had long before the Asuka period (552–645) been exposed to written language. There have been rare finds at Yayoi-period (400 B.C.E.–300C.E.) burials of Korean or Chinese mirrors bearing inscriptions in Chinese characters, and even more unusual finds of Kofun-period

(300–710 C.E.), Japanese-made objects bearing inscriptions in Chinese. However, with the reorientation of the imperial court towards a Chinese model, writing and the art of its production —or calligraphy—has a sudden and spectacular flowering. By the Nara (710–94) and Heian (794–1185) periods, knowledge of writing, and even more importantly, accomplishment at calligraphy, would be the most important factors within aristocratic and court circles in determining a person's character and breeding. Furthermore, as in the rest of East Asia, it would be from calligraphic style and technique that painting as a fine art would evolve.

The Chinese system of ideographic writing took its present shape early in the first millennium B.C.E., and was adopted largely throughout the Korean peninsula by the end of the second century B.C.E. In Japan, with its close cultural links from the Yayoi period onward with continental culture, it seems unlikely that the ready-made Chinese system of writing would not have been utilized early on within Na and the early Yamato state—if for no other reason than for the ruler's household records and accounts. Certainly by the mid-Kofun period, imperial administration must have been sufficiently complex to require some form of written record. Nevertheless, the first such records are from the Nara period. However, the large numbers of thin wooden strips inscribed in ink with characters created by clear and confident hands that have been found at the Heijō palace site certainly did not appear overnight. In addition, it is known that, by the time of Prince Shōtoku in the late sixth/early seventh century, the more forward-looking members of the court eagerly sought out texts of the Chinese Confucian classics and dynastic histories such as the *Hanshu* and *Weizhi*, as well as texts on Daoist philosophy, geomancy, and poetry. In addition, Buddhism, based as it is on the word of the Buddha embodied by the sutras, requires a level of literacy amongst its clergy and practitioners. The Japanese were certainly not importing Indian **Sanskrit** texts; all of their Buddhist transmissions—whether from Korea or China—were of texts written with Chinese characters.

The beauty of the Chinese writing system is that it is ideographic. That is to say, because a specific character represents an idea or an object rather than a word for an object, many different and mutually unintelligible languages can share it, applying to the ideographic character for a particular object or concept their own spoken word for that object/concept. Thus, one of the first ways Chinese characters were used was for their basic ideographic value, each character being equated with the appropriate Japanese word. However, by the Asuka period it had become clear that a way must be found to adapt the Chinese writing system to the particular inflections of Japanese grammar and the Japanese tendency towards polysyllabic words. Thus a system called ***manyōgana*** emerged in the seventh and eighth centuries. Certain Chinese characters were chosen for their phonetic pronunciation within the Chinese language and used as a primitive phonetic syllabary with which words and phrases in the Japanese language could—as it were—be spelled out.

The name *manyōgana* is derived from the first-known Japanese literary work, the compilation of poems known as the *Manyōshū* (*Collection of Ten Thousand Leaves*). Although it was not actually compiled until after 759, the vast majority of the poems in this anthology of over four thousand date from the second quarter of the seventh century to the mid-eighth century, the heyday of the *manyōgana* experiment. Written for the most part by imperial courtiers, they range in sentiment from verses composed to commemorate official events to more personal lyrics; from short, thirty-one syllable love poems to longer pieces lamenting the absence of a loved one, the pains of old age and of poverty. An excellent example of their sophistication is the following from a series of poems characterized as "personal exchanges":

> Like the hidden stream
> trickling beneath the trees
> down the mountainside
> so does my love increase
> —more than yours, my lord.

Ian Hideo Levy, *Ten Thousand Leaves*, Princeton, 1981, vol. 2, 92.

The poem is by one Princess Kagami at the court of Emperor Tenji (r. 662–72), and is a response to a poem sent by the emperor himself to the princess. She uses the imagery of nature to convey her passion and also wryly express her feeling that it is not quite returned. *Manyōgana*, however, was also used to compose the first great histories of Japan, the *Kojiki* and *Nihon shoki* (or *Nihongi*), which were both commissioned by the imperial court and written in the early decades after the removal of the capital to Heijō.

Actual survivals of calligraphy from this early epoch are rare, but there are a certain number dating from the eighth century, many of them attributed to imperial hands. While poetry formed one of the main pastimes and accomplishments of the imperial courtier, and the primary stage on which mastery of calligraphy (not to mention poetics) could be displayed, there were many other occasions on which it might also be shown to its advantage. One instance is a fragment of an imperial decree by the Emperor Shōmu (r. 724–49) to be circulated amongst twelve temples of the Kansai region (Fig. 48), and dated 749, the year of his abdication in favor of his daughter Kōken. Shōmu is perhaps the most famous of all the emperors of the eighth century. He was a vigorous ruler, and a great supporter of Chinese learning and Buddhism, launching the Nara period's greatest project—the national Buddhist temple of Tōdaiji and its monumental Buddha image. Unfortunately, the first part of the message is missing, so it is uncertain which of the twelve temples this particular version of the decree was meant for. The decree accompanied offerings of linen, cotton, and grants of land to each of the temples, and requested them to pray for peace and happiness throughout the land, as well as the further promulgation of Buddhism. As with Chinese and Korean texts, the decree itself is meant to be read from right to left.

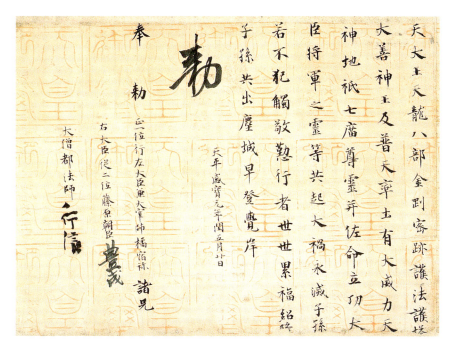

48 (above) *Message by Emperor Shōmu* (r. 724–49). Nara period, dated 749. Hand scroll, ink on paper; 11 ½ x 37 ¾ in. (29.2 cm x 95.8 cm). Heiden-ji temple, Shizuoka.

49 (right) Fragment of the Izumo Edition of *Daihoshakkyo (Dabaojijing) Sutra*, attributed to Empress Komyo, consort of Emperor Shōmu (r. 724–49). Ink on paper; 10 ⅝ x 5 ¾ in. (27 cm x 14.6 cm). Kyoto National Museum.

The only part of the message written by the emperor is the large character for *choku* (imperial decree) at the end of the fragment. To the left below this character are the signatures of various government ministers. This single character is written with a particular flourish, demonstrating a strong, virile, and educated hand. At this early period, the standard form of calligraphy is the very readable, measured strokes with which government officials wrote decrees such as this one. Yet, even in such a government document, one can note a variation in the width of the strokes which lifts the characters off the paper. With the appearance of having been executed with elegant ease, this calligraphy—though only by a government clerk—is still the product of a mature and well-practiced hand, and would have been perceived as such by whomever saw this decree. The repeated pattern of imperial seals in red behind the text and signatures decoratively proclaim the decree as being imperial.

Another calligraphic occupation of the Nara-period elite was the copying of Buddhist sutras. Throughout the Buddhist world to copy a sutra, or to have one copied, was to help spread the word of the Buddha; thereby one accrued a great deal of merit and proceeded some little bit towards Enlightenment, or at the very least rebirth into a Buddhist paradise. While in China many examples of this practice are executed with a calligraphy of less than mediocre quality, in eighth-century Japan, where the imperial court formed the core of the Buddhist community, such exercises often resulted in works of great calligraphic beauty. One survival from this period has been attributed to Shōmu's consort, Kōmyo (Fig. 49). A fragment of a much longer scroll, the sutra is part of a collection of forty-nine sutras known collectively as the *Daihōshakkyō* (CH. *Dabaojijing, Sutra Treasury of the Buddhist Law*). Of particular note is the beautifully colored paper which the empress has chosen with its border of chrysanthemums at top. Also interesting is the nature of her calligraphy. An even more formal rendition of the clerical script than in the imperial decree, it has thicker, less various lines. The particular grace of the curves, however, suggest an accomplished, feminine hand.

Silk Roads to Japan

The period of the Japanese court's great fascination with Tang China coincided with the golden age of the Silk Roads connecting East Asia with India, Western Asia, and ultimately the Mediterranean. Although there is no evidence that any Japanese ever traveled beyond the Silk Roads' eastern terminus of Dunhuang, the exotic and luxury goods that were traded along it and which helped to create the dynamic and cosmopolitan Tang International Style were as avidly sought after by the Japanese court and aristocracy as by their Tang Chinese and Korean counterparts.

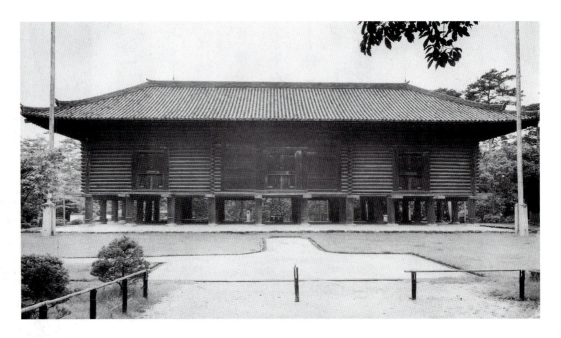

50 Shōsōin, Tōdaiji. 756.

It was in the early centuries C.E. that traffic along these trade routes across the wastes of the Taklamakan Desert began to increase. The history of the Silk Roads at this period was dominated by the Parthian (235 B.C.E.–224 C.E.) and Sassanian (224–c. 645) empires of Persia to the west of the Taklamakan, the empires and kingdoms of the Indian subcontinent to the south, and the Chinese states and kingdoms from the Han empire (206 B.C.E.–220 C.E.) at the beginning of the millennium to the establishment of the Tang empire in 618. Peppered along the northern and southern extremities of the Taklamakan were oasis city-states and kingdoms that grew rich from the great quantity of trade passing through them and whose wealth was often coveted by their more powerful neighbors, particularly those to the east. Both the Han and Tang empires extended their borders almost to the western extremity of the Taklamakan for periods of time.

Each of the economies linked by the Silk Roads was famous for a wide variety of goods. China was most famous for raw silk, while Sassanian Persia was famous for weaving that silk into fantastic brocades, as well as for its metalwork—in particular gold and silver vessels for the table. The kingdoms of the western Taklamakan were a famous source of jade, and India's most famous export along the Silk Roads was, in fact, Buddhism. By the seventh century, all of these elements had come together in the Tang capital of Chang'an to create an elite lifestyle with an aesthetic definitely favoring a sophisticated multi-culturalness.

Part of the Japanese elite's fascination for all things Chinese at this time also embraced this same lifestyle and aesthetic. As mentioned, there is no evidence that Japanese diplomats, traders, or Buddhist pilgrims went further west than China's great capital of Chang'an or the eastern Silk Roads entrepot and Buddhist center of Dunhuang. However, it is evident from both the literature of the period, and from actual surviving objects, that the Japanese elite fully engaged with this international culture, whether or not they were completely aware of its nature or simply considered it to be an aspect of the Chinese culture to which they subscribed.

Most of the surviving Silk Roads artifacts have, in fact, been preserved in temple treasuries. As was the practice in many other countries, the Japanese aristocracy and imperial court would donate precious objects which they had used in their daily life to a favored Buddhist foundation, where they would be converted to a sacred use. Although Japan's Buddhist temples were not immune to the passage of time or the civil wars of the twelfth to sixteenth century, they have weathered them better than the mansions of the aristocracy or even the palace of the emperor. Within the treasures of Nara's great Buddhist foundations, therefore, live on something of Heijō's aristocratic and imperial households, which are now no more than plots of farmland on the suburbs of modern Nara. However, the relative stability of the imperial household and the court aristocracy over the past fifteen hundred years has meant that sometimes these objects have also managed to survive as treasured heirlooms within the collections of the Imperial Household or of certain aristocratic families who survived the civil wars and other vicissitudes of fortune relatively unscathed.

Decorative Arts (sixth to eighth centuries)

The greatest such trove was given to the temple of Tōdaiji on the death of Emperor Shōmu in 756. In Shōmu's memory, his consort Kōmyō donated to his great foundation and "national" temple hundreds of his personal objects, and to house these objects a building was constructed within the temple's precinct known as the Shōsōin. Some idea of the importance of the Shōsōin and its links with the imperial family can be gleaned from the fact that these objects are today overseen no

longer by the temple, but by the Imperial Household Agency. They not only have shed a great deal of light on the material culture of the Nara period, but, as many of them are products of the Silk Road trade and the workshops of Chang'an, they have also been some of the most important material for the study of Tang-period painting and decorative arts, in addition to those of the other cultures of the Silk Roads, and especially those of Persia.

The style of the Shōsōin building is of considerable interest, harking back as it does to architecture of the Yayoi period (Fig. 50). Constructed in the granary—or *azekura*—style, its walls are composed of lengths of triangularly-shaped wood placed one above the other in such a way that at the corners of the building the logs of one side interlock with those of the adjacent wall, obviating the need for the standard post-and-beam construction. The triangular shape results in a smooth wall surface on the inside of the building, and a corrugated one outside. In order to reduce moisture damage to the contents of the storehouse, the body of the structure is raised off the ground by round logs more than 7 feet (2 m) in height, which are set on stone bases. The *azekura* style of building is frequently seen in temple complexes as a sutra repository, but such structures are rarely as large as the Shōsōin, which consists of three separate units joined together. The exact year in which the Shōsōin was completed is not known, but it was functioning as a storage facility by 761. In 1953, two new concrete storage facilities were built to house the collection, but eighty years before that it had become a tradition each autumn—after the typhoon season had passed—to remove the objects from the building and air them in the dry autumn atmosphere. A certain kind of homage is still paid every autumn to this rite, when a special exhibition of the collection is held in the Nara National Museum.

A particularly valuable group of paintings preserved in the Shōsōin is a set of six panels from a **folding screen**, each depicting a beautiful woman standing under a tree (Fig. 51). The screen can be dated between 752 and its donation to the Shōsōin in 756, because a scrap of paper bearing the date of 752 was pasted to the backing of one of the panels. Although the painting and subject are both Chinese in style, it is attributed to a Japanese rather than a Chinese artist. The screen is remarkable for the fact that the faces and other exposed areas of the women's bodies were painted in strong pigments, but the hair and the garments were sketched in black ink, or *sumi*. Originally, pheasant feathers were pasted to the screens to cover the undetailed areas, imparting to the surface a rich coloration and a tactile quality. However, the importance of the screen is that it documents the knowledge the Japanese had of Chinese figure-painting in the eighth century. The theme, young ladies of the imperial Tang court in China, is a popular one in Chinese imagery of the period, and would have been familiar to the Japanese court fascinated with all things Chinese.

Another work of great interest is a **biwa** (CH. *pipa*), a lute, possibly of Chinese manufacture, although this type of instrument did not originate there but further west in Central Asia

51 *Lady under a Tree*, detail of screen panel, in the Shōsōin, Tōdaiji. c. 752–56. Ink and color on paper; height 49 ½ in. (125.7 cm).

52 *Entertainers Riding an Elephant*, on a plectrum-guard of a *biwa*. 8th century. Painted leather; 16 ⅜ x 6 ⅞ in. (41.7 x 17.5 cm). Shōsoin, Tōdaiji.

53 Lobed dish with chased design of a dragon pond, mandarin ducks, and fish. Chinese, 8th century, preserved in Japan. Gilt silver; diameter 5 ½ in. (14 cm), height 2 in. (5.2 cm). Hakutsuru Fine Art Museum, Hyōgo.

(Fig. 52). Its leather plectrum-guard is decorated with a theme common to painting of the Tang period—musicians and dancers mounted on an elephant and set in a mountainous landscape. Two of the entertainers are Central Asian in appearance, distinguished by their hats and the bony, angular face of the drummer. The other two figures have the dress and coiffure of Chinese children. Such groupings are also found in sculptural form among the ceramic figures of Chinese tombs of the Tang dynasty, although they are more usually mounted on a camel. Central Asian musicians and dancers were in great vogue in the Tang court, and, although the fashion for them died out with the end of the dynasty, their instruments became part of Chinese, Korean, and Japanese culture.

Equally interesting, however, is the treatment of the background. To the left, tall mountains with deep crevices rise sharply from the gorge through which the elephant and its cargo are passing, and in the distance, to the right, hills cut occasionally by flat plateaux can be seen. This topography, frequently represented in surviving Chinese painting in the Tang style, formed the point of departure for Japanese artists depicting landscape scenes. However, in China, Tang-period landscapes usually have a much harder and even jagged aspect, as opposed to the softness of the rock outlines and vegetal shapes in this painting, which is much more similar to the *yamato-e* (Japanese-style painting) which would develop from the ninth century onwards.

It was the fashion of the Tang Chinese elite, and therefore also the Japanese imperial court and aristocracy, to have dining services of gold or silver-gilt vessels. The origin of these wares is to be found in Persia, which had long been famous for its metalworking crafts. Where China had for millennia been foremost in bronze casting, Persia had similarly developed to a fine art the hammering and chasing of precious metals into light and elegant vases, plates, bowls, and ewers. The Tang Chinese greatly admired these wares, and they began producing them in China itself with more Chinese motifs. In this enterprise, they were possibly greatly facilitated by the fall of the Sassanian Persian Empire in c. 645 to the Islamic *jihad* and the flood of refugees that entered Chang'an in the succeeding years, which presumably included not only princes of the royal house, but also metalworking craftsmen.

One such eighth-century gilt-silver bowl (Fig. 53) would once possibly have graced the table of a Heijō aristocrat before being donated to a temple for use on the altar or in rituals. The lobed arabesque design is typical of Sassanian shapes, but the chased decoration of ducks and fish betrays a distinctly Chinese taste. Although such bowls never seem to have become a feature of the Japanese metalworking tradition, the aesthetic of a richly-decorated surface, as well as its component parts of an arabesque vegetal design and motifs such as the duck and fish, did resonate with a local aesthetic and can be found throughout the long traditions of all of Japan's decorative arts.

One immediate example of its impact is a contemporaneous example of a sword scabbard that was among a group of objects placed within the foundation of the *kondō* ("golden" or "image" hall) of Tōdaiji as a placatory offering to the local earth deities (Fig. 54). The leather body of the scabbard is inlaid with a gold design depicting a scrolling vine against which fly two ducks. Lifted from the repertoire of motifs also

54 Detail of sword scabbard with design of birds and flowering designs (part of a group of earth-placating articles buried in the foundation of the *kōndo*). Nara period, 8th century. Leather with inlaid gold. Tōdaiji temple, Nara.

used by the Chinese craftsmen of the gilt-silver bowl, they have nevertheless already been altered in their outline to something that seems much more Japanese.

Since at least the Han dynasty, lacquerware had been one of China's great export commodities. Lacquer objects were created by starting with, usually, a wooden core, and coating it with numerous layers of the sap of an Asiatic sumac bush. This sap can be colored, and decoration created out of other materials —such as flakes of gold, precious stones, and mother-of-pearl—can also be placed between the lacquer coats and effectively sealed and made smooth. As mentioned in Chapter 1, lacquer was far from unknown to Japanese craftsmen from the Jōmon period (c. 11,000–400 B.C.E.) onward, but during the Asuka to Nara periods the local production was greatly influenced by its Tang Chinese counterpart. A Chinese lacquer box decorated on its four sides with boys cavorting with lions could almost have been created for the Japanese market of the period (Fig. 55). Certainly the inlaying of the design with mother-of-pearl would become a significant feature of Japanese lacquer decoration, particularly with the lacquer production of the southerly Ryukyu islands.

The theme of Chinese boys and lions was a favorite theme from the Tang period onward in China. The lion motif originates from Sassanian art while the theme of Chinese boys—symbolic of eternal youth in the Daoist tradition—remains a popular image to this day in China. Both also enter into the Japanese artistic tradition, but are always considered Chinese in context.

Although the Japanese elite were passionate in their adoption of Chinese culture, there were some aspects that they never adopted. One such was the organization of rooms, whether private or public. Unlike China, and ultimately Korea, where interior life, and particularly among the elite, moved off the floor and onto tables, chairs, and other raised furniture, the Japanese way of living in indoor spaces until very recently remained on the floor. In this environment, boxes such as that shown here would have been an essential item of furniture, both for storage—often of documents—and as an impromptu table surface.

The floor surfaces themselves would have been primarily of wood, although in public buildings and Buddhist temples they would have imitated the continental fashion for stone flooring, as they did in roofing with ceramic tiles. On these floors would be placed different kinds of matting, including a kind of felt carpet from Korea, of which the Shōsōin also has some examples. What proved of more enduring popularity, however, was a kind of thick, woven reed mat known as the tatami. These came in rectangular form in a variety of sizes, and also in a circular format. They were used both as seating

55 Box with design of boys and lions. Chinese, 8th century, originally preserved in Horyu-ji. Lacquer with inlaid mother of pearl; 7 ⅛ x 9 ¼ x 9 ¼ in. (18.1 x 23.5 x 23.5 cm). Museum of Imperial Collections, Sannomaru Shōzōkan, Tokyo.

56 Panel with medallions of hunting lions. Chinese, 7th century; 1st mentioned in Kamakura period (1182–1279) records as having belonged to Prince Shōtoku (574–622). Brocaded silk; 98 ½ x 53 in. (250 x 134.5 cm). Horyu-ji, Nara.

57 Detail of wrapping cloth with design of conversing sages and grape vines, considered to have been the cover for a rectangular box. Nara period, 8th century. Leather with dyed designs; height 30 ⅛ in. (76.7 cm). Tōdaiji temple, Nara.

blocks and as beds. As the latter, they would be piled with padded winter robes which served both as mattress and bed linen. Although due to the influence of Chinese custom there were some low chairs and daises, these were used primarily for ceremonial, especially within Buddhist contexts. Generally, however, the Japanese elite would seat themselves on felt rugs or tatami, with more distinguished personages, such as the emperor, being seated on two or three tatami that were piled one atop the other.

The greatest commodity of the Silk Roads was, of course, silk. Although the concept of sericulture had by this period

leaked out of China and spread to points west, the Chinese were still the largest and finest producer of the raw material. However, by the seventh century they had come to appreciate what the Persians could do with it. Preserved at the Hōryūji in Nara is a stunning silk-brocaded panel made up of medallions featuring archers on winged horses hunting lions (Fig. 56). Dating to the seventh century, the panel's subject is pure Persian with precedents reaching back to the Achaemenid dynasty of the first great Persian Empire in the mid-first millennium B.C.E. This particular piece of fabric was almost certainly made in Persia and transported across the Silk Roads

to China. From there it made its way to Japan, where, if twelfth-century records at Hōryūji are to be believed, it was the personal property of Prince Shōtoku.

A soft leather wrapping-cloth preserved in the Tōdaiji displays another motif that became incredibly popular during the seventh and eighth centuries, the scrolling grape vine (Fig. 57). There is little evidence for the successful development of this fruit in East Asia, and almost certainly this is, once again, a motif brought from points much further west along the Silk Roads. Another curious feature of this cloth is an identical scene depicted at either end of the cloth, showing two Chinese ascetic-types divided from each other by a tree and each seated on a rocky outcrop. Interestingly one of the figures appears to be playing a form of the *qin* (JAP. **koto**), a Chinese instrument, the playing of which became one of the accomplishments of a person of quality and education in Japan.

Shinto

Although the first occurrence of the term Shinto appears only in the *Nihon shoki* (or *Nihongi*) of 720, it is clear that the belief systems that it refers to date back much further. Since at least the formation of the Yamato state in the early centuries of the first millennium C.E., there had been the cult of deities from which the house of Yamato was descended, as well as of those with whom these ancestral gods associated. It seems equally clear that, in addition to Izanagi, Izanami, Amaterasu, Susano-o, and Ninigi (not to mention his retinue of five million deities), there were numerous other deities associated with other clans. Furthermore, there were spirits of a more local variety, associated with a part of the landscape or with a particular village. These are of perhaps an even more ancient lineage, conceivably handed down from the Jōmon period. As has been demonstrated in Chapter 1, there is ample archaeological evidence for "religious" belief in all three pre- and protohistoric periods. How all of these came together to form Shinto is still a matter of much study. However, it is clear that before the introduction of Buddhism they had all been brought together in some fashion, centered around the imperial cult with the sun goddess Amaterasu at their head.

By the eighth century and its first mention in the *Nihon shoki*, Shinto had also been considerably influenced by Chinese Confucianism and Daoism. Confucianism (and other Chinese logical and legalistic schools of philosophy grouped together under its umbrella) formed the core of the philosophy of government throughout East Asia, and particularly of the Japanese reforms of the seventh and eighth centuries. Its impact on Shinto, however, can largely be found in the parallels between Confucianism's reverence for one's ancestors and concepts behind the imperial ancestral cult and those of the great clans. Daoism, however, had a much deeper impact. The Dao (Chinese for "The Way") refers to the philosophy of the great sage Laozi (sixth century B.C.E.), which looks for a balance between the yin (negative) and yang (positive) within all

things. By the second century C.E., a great variety of smaller movements had come together to establish the single dominant strain which is today known as Daoism, and its temples and priests gathered into their pantheon all the animistic and local traditions that continued (and continue) to flourish in China. The Tang dynasty considered themselves to be descendants of Laozi, and saw themselves and their court as an earthly mirror of that of the celestial Jade Emperor who headed the Daoist pantheon.

There were many parallels, therefore, between the Yamato cult of the seventh to eighth centuries and Daoism, especially as it was espoused by the Tang dynasty. Inevitably, the organization of the Chinese Daoist community and of its temples, like all other things Chinese, had some impact on the organization of what came to be known as Shinto. Shinto is, in fact, a Chinese-style reading of the Chinese characters for "Way of the Gods" (CH. Xiandao), *kami no michi* being the Japanese reading of those same characters.

It is still a matter of much debate whether the Shinto of the *Nihon shoki* is at all the same as that which emerged at the end of the Heian period in the twelfth century. The Shinto of the Nara and early Heian periods was perhaps much more overtly Chinese than that which existed by the twelfth century, by which time there had been a reaction against the overwhelming influence of China on court and culture. However, in general, Shinto is organized around the heavenly gods led by Amaterasu and the earthly gods led by her brother Susano-o. The Japanese term for the gods is "**kami**," and they are unseen and often awe-inspiring. While the great imperial ancestors can be at times depicted in human form (as in the dances relating the imperial origins), most of the time they are not. The sun goddess, Amaterasu, for example, is almost always depicted in the form of the mirror that the gods placed in her cave in order to coax her back into the world. The vast majority of *kami* are believed to inhabit such natural phenomena as rocks, trees, waterfalls, and mountains. Indeed, if a tree is particularly ancient, it will be considered to be inhabited by a *kami*, and a backwards-wound rope (*shimenawa*) will be placed around it to demarcate its sanctity.

With the defeat of the anti-Buddhist forces in 587, Buddhism came increasingly to dominate the spiritual concerns of the court and aristocracy, and the eighth century, when the capital was at Nara, was its time of greatest influence. However, the ritual of the court and of each clan remained resolutely focused on Shinto observances, probably not a little preserved by the enduring and growing power at court of the clan with hereditary rights as Shinto priests—the Nakatomi and their principal branch, the Fujiwara. Efforts were made to demonstrate the harmonious relationship between Shinto and Buddhism. One such exercise in rapprochement occurred in 743, when Emperor Shōmu pledged the building of Tōdaiji, which was intended to rival anything, even in China. An imperial messenger was sent to the principal Shinto shrine at Ise to ask the will of Amaterasu. Her response was that she and **Birushana** Buddha were aspects of

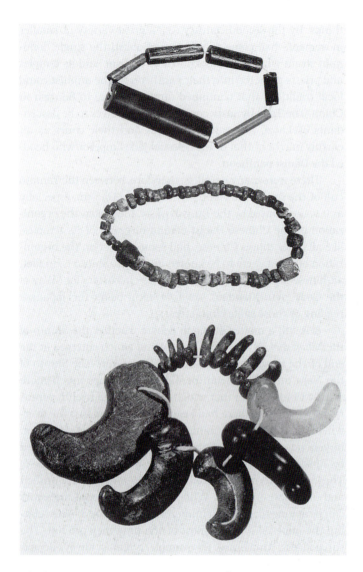

58 Objects excavated from ritual sites at the Ōmiyame Shrine, Kyoto. Asuka/Nara periods, 6th–7th centuries. Jade. Ōmiyame Shrine, Kyoto.

gives access. *Torii* are two posts surmounted by two lintels with a slightly concave curve (see, for example, the *torii* at the entrance to the Kasuga Shrine in Fig. 198). The actual ritual of worship consists of three elements: prayers, obeisance, and offerings. The supplicant climbs the steps to the upper level of a shrine and pulls a cord that rings a gong to alert the god. Prayers are then offered, followed by a deep bow of perhaps a minute in length, and finally offerings are made. Today these consist of food and drink and sometimes a piece of paper cut in a widening zigzag design and attached to a stick of new wood or a twig from the sacred *sakaki* tree, intended to symbolize the cloth that was once included in the gifts to a deity. In the past, however, these offerings have taken many forms, including personal objects and those for ritual use. Excavations of ritual sites, such as those at the Ōmiyame Shrine in present-day Kyoto, have demonstrated that in the sixth and seventh centuries offerings still took the form of the stone beads and *magatama* that have been found either as grave goods or ritual offerings at excavation sites dating from the Jōmon period onward (Fig. 58).

Perhaps the most sacred of all offerings given to a shrine is the mirror at Ise. As mentioned earlier, the mirror became the symbol of Amaterasu when the other gods used it and the original *magatama* to coax her out of her cave. The mirror also

the same reality. This was only one among the many interactions between Buddhism and Shinto in the Nara and Heian periods that facilitated harmony between the two religions. Finally, in the Kamakura period (1185–1333), the relationship was formalized in the system of Ryōbu Shinto. Therefore, by the time that Buddhism became a truly popular religion in Japan, it had been well established by the government what one owed to Shinto *kami* in terms of observances, and what one owed to Buddha. This is certainly a balance that was never successfully achieved in China, either within the elite or on a popular level.

SHINTO ARCHITECTURE

The elements essential to worship of a *kami* are first of all the **iwakura**, the natural site at which he or she has taken up residence. The *iwakura* is usually represented by a wooden shrine within an enclosure, to which a special type of gate, or **torii**,

I	bridge *torii*
2	arched bridge
3	Isuzu River
4	first *torii*
5	roofed area for hand washing
6	river site for hand washing
7	enclosure gate
8	west site for main shrine
9	east site for main shrine

59 Plan of the Naikū shrine at Ise.

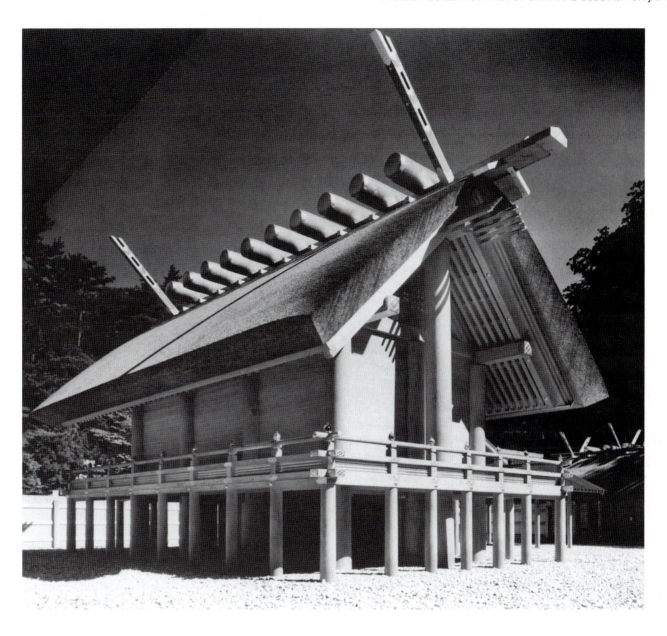

60 *Honden* (main hall), Ise, Mie prefecture.

was the most important part of her gift to her grandson Ninigi when she sent him down to earth to establish it as his domain in her name. According to tradition, the mirror was handed down among Ninigi's descendants until the reign of the tenth emperor, Suinin, whose reign dates have been set within the first century C.E. He had it enshrined at Ise, to the east of the Kansai region, where it rests to this day and Ise remains the principal shrine of the imperial court and of Shinto.

The precinct of the shrines at Ise, encompassing unpainted wooden buildings and thickly wooded hills traversed by pebble-covered pathways, is the classic example of a Shinto worship complex (Fig. 59). The enclave consists of an outer shrine, or *gekū*, dedicated to the provider of grain, and an inner shrine, or *naikū*, dedicated to Amaterasu. To reach the *naikū*, one must pass beneath the distinctive *torii* gateway. The pathway to the shrine runs parallel to a river, and immediately to the right, in front of the *torii*, is a long, narrow stone basin filled with water for rinsing the mouth and hands. Alternatively, one can continue further into the precinct and perform the same purification ritual in the clear waters of the river. (Originally, worshippers waded through the shallow river to reach the shrine.) Next, one climbs a gentle slope through a forest of cedar trees to the foot of a flight of stone-bordered steps that leads up to a solid wooden gate in a wooden fence. This outermost wooden fence of the enclosure at the top consists of boards so closely fitted together that it is impossible to see inside to the actual buildings, which are, in any case, enclosed within three additional fences and accessible only through gates in the center of the short sides and only for the shrine priests and specially designated members of the imperial family. The **honden**, or main hall of the shrine (Fig. 60), is in the center of the innermost enclosure, and behind it are two treasure houses called the east and the west halls. The

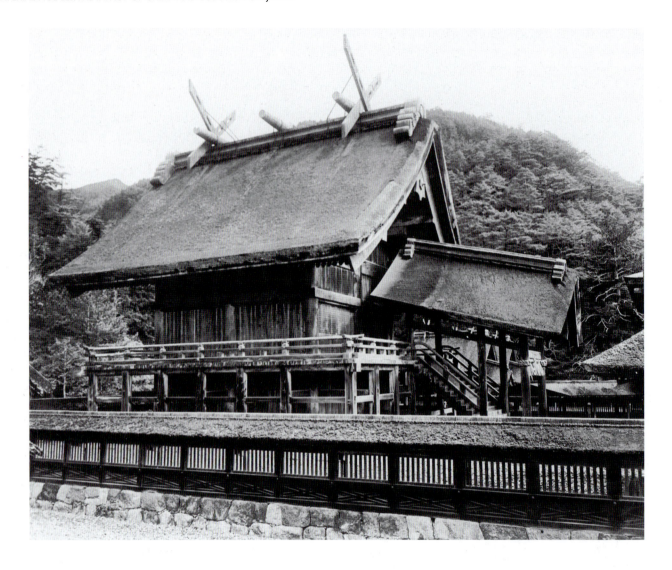

61 *Honden* (main hall), Izumo, Shimane prefecture. Rebuilt 1744.

mirror is placed in the *honden* at Ise, and the *honden* of other Shinto shrines also contain such offerings. The treasure houses flanking the *honden* are for the mass of offerings that have accumulated at Ise over more than a millennium and a half.

The format of the Ise shrine is the standard followed by other later Shinto shrines, but a special feature of Ise is that to one side of the *honden* enclosure is an open, pebble-covered plot of the same size, where the previous *honden* stood. Since the reign of Empress Jitō (686–97), it has been customary to rebuild the *honden* every twenty years in a ritual act of renewal. The last reconstruction at Ise in 1993 was the sixty-first, the tradition having been suspended during several periods of strife, particularly during the tumultuous thirteenth to seventeenth centuries. In addition to the main enclosure, there are many smaller shrine buildings within the precinct. Although the *honden* itself is of a construction that harks back to Yayoi-type granaries, many of the other buildings are of much later structural styles—at present reflecting the architecture of the

Edo period (1615–1868), such as a ceremonial rice granary, stable, support buildings for the priesthood and the administration of the shrine, and a hall for the performance of the sacred dances known as the *kagura*. The *kagura* were first danced outside Amaterasu's cave by the goddess Uzume no Mikoto as one of the attempts to coax the sun goddess out of her hiding place.

The building styles of the *honden* at Ise and at Izumo, Shinto's second most important shrine, both derive from the Yayoi-period raised granary, and it is thought that this type of structure, elevated as it is above all the other buildings, would first have been appropriated by the headman or shaman during the early Yayoi, and in later centuries became the obvious dwelling place for the ancient gods. The style of the *honden* at Ise is known as **shinmei zukuri**, and because of the complex's connection with the imperial family, no other shrine may be built following the same pattern. Set up above the ground on round piles, the *honden* is three bays wide by two bays deep, with the entrance on one of the long sides. Surrounding the upper level is a veranda, and the whole is capped by a gabled roof. Freestanding pillars at the short ends of the building add further support for the roof, and along the ridgepole are ten

katsuogi, logs intended to weigh down the roofing material, originally thatch, today the bark of the cypress tree. Extending up from a point near the ends of the roof are two thin-sawn boards with gold-leaf ornamentation. These are *chigi*, originally extensions of the outermost rafters at each end of the gable, and a common feature of shrine architecture. A similar motif at the Izumo shrine appears as two Xs sitting on the ridgepole. Ise displays a Japanese taste for the look of aging wood. The buildings are beautiful when new, and also as they darken with time, until after twenty years the grey, weathered wood is replaced to renew the *iwakura*. Many later shrines, following the example of Buddhist temples, were painted red.

The shrine at Izumo, on the west coast in Shimane prefecture, may possibly predate Ise. The Izumo *taisha*, (grand shrine), is dedicated to Ōkuninushi no Mikoto, reputedly a fifth- or sixth-generation descendant of Amaterasu's brother Susano-o no Mikoto, who gave aid to Ninigi upon his descent from heaven. When Susano-o was banished from heaven for outraging his sister, he descended to Izumo, where he slew an eight-tailed dragon that had eaten eight of the nine daughters of an old couple who lived there. In one of the dragon's tails

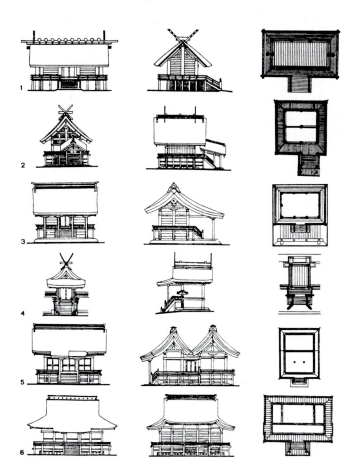

62 Shinto shrine types. Façades, side views and ground plans, left to right: 1. *shinmei* (shrine at Ise); 2. *taisha* (shrine at Izumo); 3. *nagare* (Shrine of Kamo in Kyoto); 4. Kasuga (Kasuga Shrine in Nara); 5. Hachiman (Usa Hachima Shrine, Oita prefecture); 6. Hie (Hie Shrine at Shiga). (From *Oriental Architecture*, Electa Editrice, Milan, drawings by Studio of Enzo di Grazia, after Ōta Hirotarō.)

Susano-o found a magnificent sword, known as Kusanagi (Grass Cutter), which he gave to Amaterasu, who in turn ultimately gave it to Ninigi as one of the *Sanshu no jingi* of his imperial regalia. Ōkuninushi no Mikoto is credited with the introduction of medicine, fishing, and sericulture.

The main hall at Izumo (Fig. 61) is said to be modeled on the palaces of the early Yamato rulers. Its size, which is considerably greater than the *honden* at Ise, is sometimes attributed to its palace prototype and sometimes explained by the idea that at some point Izumo was given the responsibility for governing religious affairs, while Ise oversaw secular matters. Raised on round piles set directly into the earth, the Izumo *honden* comprises two square bays with eight pillars framing the enclosing walls and a central pillar. The whole unit is surrounded by a veranda and capped by a curved, gabled roof. The staircase leading to the veranda is off center and the entry door pierces the gable end of the structure in the right-hand bay. This configuration of elements is known as **taisha zukuri**, and is thought to be the oldest of the known architectural shrine styles. The Izumo *taisha* has not had the same history of rebuilding as that of Ise, and the present buildings at the shrine date, by and large, from 1744, although the Izumo *honden*, like Ise, has always retained its ancient style.

In addition to the *taisha* and *shinmei zukuri* configurations of Shinto *honden*, three more official Shinto types (and a few subsidiary ones) were developed in the succeeding Heian period, bringing Shinto architecture much more in line with developments in both Buddhist architecture and that of the aristocratic palaces (Fig. 62).

Buddhism

Buddhism evolved out of the teachings of one Shakyamuni, who lived in northern India in the fifth century B.C.E. Born a prince, he subsequently abandoned his privileges in order to search for the true nature of being. He came to understand this after many years of meditation and privation under a bodhi tree, and after his Enlightenment he set out to teach what he had discovered to others. The teachings of the Buddha (Enlightened One; JAP. *butsu*) are characterized as the **Dharma** (Law; JAP. Hō), and the teaching of them the Buddha characterized as the "turning of the wheel of the Law." As his first sermon took place in a deer park, these creatures have ever since symbolized throughout the Buddhist world the first sermon and the commencement of the turning of the wheel of the Law.

Shakyamuni's teachings were based on the age-old Indian concept of interdependent origination—or karma (JAP. *go*). That is, each moment arises out of a multitude of causes and conditions and in turn conditions the next moment. Thus the soul is repeatedly reincarnated and the nature of those reincarnations is created by karma. If one's karma is bad, then the soul will have a lowly reincarnation, perhaps even subhuman. If one's karma is good, then one will have an improvement in

the next incarnation, perhaps even being elevated into the ranks of the gods. It was the Buddha's particular understanding, however, that this whole karmic cycle of birth, death, and rebirth, and the entire universe that it supposedly supported (that is, the universe we exist in), was in fact a great and self-perpetuating illusion. It is the goal of the Buddhist practitioner to break through these illusions and the endless cycle of reincarnation and realize the true nature of things thus achieving true bliss—or **nirvana**, which is often equated with emptiness.

However, it was realized that it could in fact take many lifetimes for the individual to achieve the understanding that would allow him or her to pass into nirvana. The Buddha himself formulated the Four Noble Truths: 1. life is suffering, 2. the reason for suffering is desire, 3. liberation from suffering comes from the cessation of desire, and 4. there is a path that one can follow to free oneself from desire. This path was the Eightfold Path, which consisted of right understanding, purpose, speech, conduct, livelihood, effort, awareness, and concentration. The individual who follows this path closely will ultimately achieve Enlightenment and release into nirvana.

In northern India, followers of Buddhism formed themselves into a community during the Buddha's lifetime, which further evolved and expanded after his death. Those who chose, like the Buddha's disciples, to live separate from the world and not as householders became an important component of this community. From these monks and nuns, who were the core of the community, came the teachers who proselytized the message of Buddhism. However, the majority of the community always existed as laymen and women. By the beginning of the first millennium C.E., Buddhism was actively spreading beyond the confines of India into Central Asia and subsequently was to arrive in China by no later than the second century C.E. By the fifth century it had infiltrated to the Korean kingdoms, and by the sixth century it had finally arrived in Japan.

In each case, Buddhism made a terrific impact, especially with the elites of these nations, and quickly the newly established Buddhist communities founded rich and powerful—and not infrequently royally and imperially sponsored—temples, monasteries, and convents. It has been theorized that one of the concepts of Buddhism that attracted Indian and Central and East Asian rulers and their elites to Buddhism was not simply the persuasive elegance of its belief system, but also a particular aspect of it—the concept of the *chakravartin*, or universal ruler. Probably derived from an ancient Indian concept of kingship, within Buddhism the *chakravartin* came to represent a secular version of the Buddha. Therefore, a ruler could be recognized by a Buddhist community as a *chakravartin*, and for all the Buddhist faithful that ruler would thenceforth be recognized as having a kind of divine right to rule. In return, the ruler would protect and foster Buddhism within his domain.

Many different varieties of Buddhist which will be introduced in the succeeding pages. However, some notion of

hierarchy is a useful starting point. Most importantly, there is the Buddha, meaning the so-called Historical Buddha Shakyamuni (JAP. **Shaka**). Just below the Buddha are the **bodhisattvas** (JAP. *bosatsu*), who are great beings that have achieved Enlightenment but have resolved not to enter nirvana until every last being has achieved that same state. To these must be added a whole host of other manifestations of the Buddha and bodhisattvas, in addition to the gods and creatures of ancient Indian cosmology. The gods in particular, usually drawn from the Vedic pantheon of ancient India, quite often are converted to Buddhism and become its protectors.

As it developed in India from around 410 B.C.E. to c. 500 C.E., Buddhism divided into three principal traditions out of which all the schools of Buddhism in Japan have evolved. The earliest of these has come to be termed by the later strains as the **Hinayana** ("Lesser Vehicle"; JAP. Shōjō). It developed the basic concepts of the Buddhist community, both monastic and lay, and also gathered together all the sutras and writings into the first the Buddhist canon—the "Three Baskets" or Sanzō (SKT. Tripitika). By the end of the first century B.C.E., however, growing dissatisfaction with what was perceived as the selfish pursuit of only one's own enlightenment led to a new Buddhist philosophy, which has come to be characterized as the **Mahayana** (Greater Vehicle; JAP. Daijō). This new tradition focused on the liberation of all living beings. During the early centuries C.E., Mahayana philosophy was formulated by the Indian scholar Nagarjuna and his followers, and it was Buddhist schools associated with it that were largely transmitted across Central Asia into China and Korea in the first half of the first millennium C.E., although there were also some important Hinayana schools. The third great Buddhist tradition is the Mantrayana, more commonly known as **Tantric** Buddhism (JAP. Kongōjō). The tantric philosophies began developing out of the Mahayana in India by at least the mid first millennium C.E. **Tantra**, in fact, refers to a literary genre distinct from the sutras. While the latter are the collected words of Shaka Buddha's earthly manifestation, the tantra are the words of the celestial Buddhas transmitted through visions to great earthly masters. These tantric schools reached China soon after their formulation in India, and from there spread to the rest of East Asia.

BUDDHISM'S INTRODUCTION TO JAPAN

Paekche's embassy to the Yamato court of 552 brought with it Buddhist scriptures or sutras, an image of the Shaka Buddha, and various ritual implements. Unfortunately the same year a terrible epidemic broke out throughout the archipelago, and its cause was interpreted to be the wrath of the native deities at the incursion of this foreign doctrine, and Buddhism was officially proscribed by Emperor Kimmei (r. 540–71). The small temple that had been erected for Buddhist worship was burned down, and its image was broken into pieces and thrown into the Naniwa Canal in what is now present-day Osaka.

In 584, in the reign of Kimmei's successor Bidatsu (r. 572–86), emissaries from Paekche again brought Buddhist gifts, this time an image of Shaka and also one of the Future Buddha, **Miroku** (SKT. Maitreya). Within Buddhist cosmology as it had developed by the sixth century, Shaka was only the latest of innumerable Buddhas who over countless millions of years had manifested on the earth in order to spread the Dharma. As we are still in the age of Shaka, Miroku exists in the Tosotsu (SKT. Tushita) heaven as a bodhisattva until the age of his Buddhahood, when he will descend to the earth. He is therefore either represented as a meditating and youthful bodhisattva awaiting his Buddhahood, or as a **Buddha** already, newly enthroned. Miroku was the focus of a saviour cult that was popular across Asia, particularly in the fifth and sixth centuries. Indeed, nowhere perhaps more than in Korea, where the image of the youthful, meditating Miroku becomes one of the most recognizable of Buddhist icons.

When these new Paekche images arrived, Soga no Umako asked for the images and sent a man by the name of Shiba Tatto, a Chinese immigrant who worked for the horse-trappings guild, to scour the country for Buddhist practitioners. A former monk was found, and three young women, including Tatto's daughter, became nuns. However, when Umako tried to persuade the emperor to accept Buddhism as a national religion, the leader of the Mononobe clan destroyed Umako's new-built temple, burnt the Buddha images, and had the nuns stripped and publicly flogged. The *Nihon shoki* records that a pestilence once again broke out, causing its victims to feel as if they were being consumed by fire, as the Buddha images had been. The emperor therewith relented the proscription and allowed Umako to practice unmolested, but not to proselytize.

Three years later in 587, during the reign of Emperor Yōmei (r. 586–88), the Soga clan, Prince Shōtoku, and the Ōtomo (hereditary imperial bodyguards) made their bid for power against the anti-Buddhist Nakatomi and the Mononobe, who oversaw the national armory. Although the Soga/Shōtoku faction ultimately won this civil war, Emperor Yōmei did not long survive it, and in 588 Umako's nephew Sushun ascended the imperial throne (Umako's sister had been a consort of Emperor Kimmei). As mentioned in the previous chapter in connection with his suspected burial in the Fujinoki Tomb, in 592 Sushun was assassinated—because he objected to this uncle's interference in government affairs. Sushun's sister Suiko then ascended the throne, Umako was appointed her chief minister, and Prince Shōtoku acted as both her regent and heir apparent.

In Suiko's reign (593–629), Buddhism took full root amongst the elite of Japan, quickly growing to a position of prominence that remained unchallenged for the next thousand years. Shōtoku, who died in 622, was a leading figure in promoting the adoption of Buddhism. As regent he took a leading role in the sinification of the court, but he also did a great deal to integrate Buddhism into his governmental reforms. Soga no Umako and Shōtoku are perhaps the most important Buddhist patrons of the Asuka period (552–645). Umako's support in particular became as lavish as it was conspicuous. He founded the Asukadera (known today as Gangōji or Angoin), the first full-fledged Buddhist complex to be built in Japan. Shōtoku founded the Shitennōji (in the environs of present-day Osaka) and the Wakakusadera, later renamed Hōryūji, in the area that would become the capital city of Heijō (later Nara).

By the reigns of Tenmu (r. 673–86) and Empress Jitō (r. 686–97), the idea of Buddhism as the nation's protector was being publicly pronounced, and this empowerment of the Buddhist community accelerated with the move from Fujiwara to Heijō, where centers for the six schools of Buddhism that flourished in Japan were established. The first of these was the **Sanron** (Three Treatises), introduced to Japan c. 625 and based on the Mahayana philosophy developed by Nagarjuna and his disciple Aryadeva in the early centuries C.E. The second was the **Jōjitsu**, introduced from Paekche, as was the Sanron with which it soon merged. The third was the **Hossō** (SKT. Yogacara; CH. Faxiang), introduced about 650 by the monk Dosho, who had studied in China, and which espoused a Mahayana philosophy that argued the ultimate existence of the mind (i.e., that the mind is not part of the illusion of the rest of existence). The fourth school, **Kusha**, appeared about the same time as Hossō and took as its basis the Mahayana philosophy of the Indian Vasubandhu (fourth century), which focused on the analysis of phenomena through the Buddha's vision, including the ordering of the universe. The fifth school, **Kegon**, was based on the *Kegonkyō*, or *Garland sutra* (SKT. *Avatamsakasutra*; CH. *Huayanji*), which focuses on Shaka as a manifestation of the supreme, universal Birushana (SKT. Vairocana) Buddha (see below). The Kegon school became particularly prominent, developing elaborate rituals that appealed to the monarchy. And the sixth school was the **Ritsu** (SKT. Vinaya; CH. Lüzong).

The Vinaya also forms one part of the Buddhist canon—the Three Baskets or Sanzō—and includes the texts that lay down the rules one must follow in life, whether as a monk, nun, or householder, in order to work towards Enlightenment. The Vinaya school as it developed in China and Japan focused on early, Hinayana Buddhist philosophy and particularly that which translated the Buddha's teachings into codes by which one should live one's life. Ironically as it claimed to hold to an earlier form of Buddhism, it was in fact the last of the six to be introduced from China, by the Chinese monk Jianzhen (JAP. Ganjin) in 754.

During the reign of Shōmu (r. 724–49), Buddhism and its works became the focus of not only the court, but the entire government and aristocracy. In 741, and again in 743, he decreed the establishment of a monastery and a nunnery in each province. However, for Shōmu, the *Kegon sutra* was the authoritative Buddhist text, and likewise the Kegon the authoritative Buddhist school. In 743, he ordered the construction of a national temple to house the Kegon school, the Tōdaiji, and the creation of a colossal Birushana Buddha to

serve as its principal image. Unlike Shaka and Miroku, Birushana is not an earthly manifestation of Buddhahood. In fact he is its quintessential essence, and all other Buddhas, bodhisattvas, and deities are merely emanations and aspects of him. Normally, he is configured at the center of a group of five Buddhas, the other four being his emanations to the four directions. On a secular level Birushana served as an apt metaphor for the relationship between the emperor and his provincial governors and officials.

The production of this Buddha image and the temple to house it—Tōdaiji—became the major focus for the court, the clergy, and the nation in the mid-Nara period. The apogee of the Tōdaiji project came in 752, in the eye-opening ceremony. Prior to this rite, in a very public ceremony Emperor Shōmu presented himself before the Birushana image and humbly declared himself to be a servant of the Three Treasures of Buddhism: the Buddha, the Law, and the Community. Never again, until the end of the World War II, would a Japanese emperor, no matter how devout a Buddhist practitioner, come so close to setting aside the importance of his own divine descent. The precedent for Shōmu's policy of constructing a series of provincial Buddhist institutions, each linked to a central, mother temple in the capital, can be found in the policy of the pro-Buddhist interregnum of Empress Wu (r. 684–705) in China, who more than any other Tang ruler used Buddhism as a tool for controlling a country that considered it not only abnormal for a woman to hold the imperial throne, but that she had usurped it from her son. It is not at all surprising that Shōmu, with the Yamato house's enduring problem during these early centuries of maintaining their imperial authority, would look to the effectiveness of this example from China's recent past.

During the reign of Shōmu's successor and daughter, the Buddhist clergy gained such an influence at court that it was ultimately decided by the aristocracy that something would have to be done about it. Kōken, in fact, served as empress twice; during her first reign, from 749 to 758, she was known as Kōken, and during her second, from 764 to 770, she took the name of Shōtoku. She had as one of her closest advisers the monk Dōkyō of the Hossō school, and he attempted to persuade the empress to appoint him as her heir apparent. The leaders of the most powerful clans managed to block his ambitions, and, following the death of the empress in 770, forced Dōkyō into exile. Thereafter it became policy that no woman should hold the throne, a precedent that has been followed with only two exceptions down to the present day: Meishō (r. 1630–43) and Gosakuramachi (r. 1762–70). Further inspired by these events, the government began to consider rebuilding the capital elsewhere, away from Nara and the power centers of the six Buddhist schools.

ARCHITECTURE

Following the civil war of 587, both Soga no Umako and Prince Shōtoku undertook the building of the first great Buddhist foundations. As mentioned, Umako built the Asukadera in the Asuka Valley, and Shōtoku built the Shitennōji in the region of present-day Osaka and the Wakakusadera on the outskirts of present-day Nara. Completed about 593, the Shitennōji has burnt to the ground many times in the course of the centuries, the most recent destruction taking place in World War II. In its latest incarnation, the temple was rebuilt in reinforced concrete on the original foundations and with an attempt to simulate the post-and-lintel construction of the old wooden structure.

Asukadera, begun about 588 and completed by 596, survived the decimation of the Soga clan in 645 and became one of the principal edifices of the first permanent capital, Fujiwara-kyo. When the capital moved to Nara, the Asukadera establishment moved there as well, into a new temple, Gangōji. The original edifice at Fujiwara became a subsidiary temple of the Nara establishment, and managed to survive the fire which seems to have destroyed much of Fujiwara in 711. However, it too was largely destroyed by fire in the Kamakura period (1185–1333) and was never rebuilt. Extensive excavations carried out in the 1950s uncovered the original foundations, roof tiles, and many interesting details of the temple.

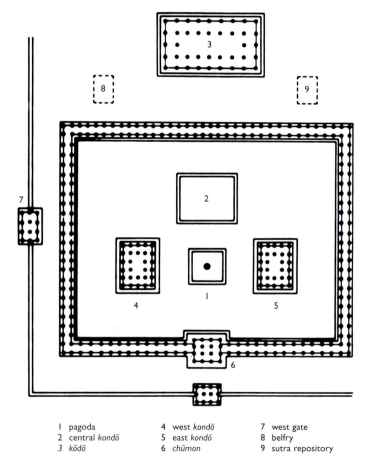

1 pagoda	4 west *kondō*	7 west gate
2 central *kondō*	5 east *kondō*	8 belfry
3 *kōdō*	6 *chūmon*	9 sutra repository

63 Plan of Asukadera, Asuka.

Shōtoku's second foundation, Wakakusadera, was completed in the first decade of the seventh century, but was destroyed by fire in 670. Its rebuilding was started immediately, but only completed by 711, by which time it had become part of the new capital of Heijō, and it was renamed Hōryūji. Much of the temple's history as the Wakakusadera can be pieced together from primary sources such as the *Nihon shoki*, inscriptions on extant sculptures of the period, and later temple records, and from such secondary sources as recent excavations at the site. What we can gather from the literary evidence is that shortly after Prince Shōtoku took up residence in his palace at Ikaruga (in the Nara area) in the early 600s, Wakakusadera was erected adjacent to it. The temple rebuilt in 711 survives virtually intact to this day, providing an assemblage of some of the oldest wooden sculptures in the world.

In speaking of Japanese Buddhist architecture, the word "temple" can, and usually does, refer to an entire site and its complex of buildings. The suffixes –*tera* or –*dera* and –*ji* refer to a temple where there are images for veneration and where ritual ceremonies are performed by the monks or nuns living there. The suffix –*dera* is the Japanese reading of the Chinese character for temple, *si*, while –*ji* is the Chinese-style pronunciation of the same character. Toward the end of the seventh century, it was decreed that all Japanese Buddhist temples should have names with this Chinese-style of reading, so when Wakakusadera, Temple of Young Grass, was rebuilt, it was renamed Hōryūji, Temple of the Exalted Law. Often a temple complex will be divided into smaller units, precincts, which are designated by the suffix in italics.

The most important buildings in early Japanese temples were the entrance gate (**chūmon**; literally central gate), which was set within a roofed cloister encircling the principal worship structures, the **pagoda**, and the *kondō* or golden hall (which also came in some temples to be called the **hondō** or main hall, which contained the temple's principal altar and images. Necessary support buildings, such as the refectory, kitchen, and living quarters of the monks, were built outside the precinct walls.

The information gleaned from the excavations of Shitennōji (Temple of the Four Guardian Kings), Wakakusadera, and its replacement Hōryūji, as well as of Asukadera, suggests that Buddhist architecture in the Asuka and Hakuhō periods drew on a number of different Korean models. Asukadera was built on the model of Koguryō temples—Chōnganni in particular, which consisted of three large *kondō* arranged around three sides of a square pagoda, the entire cluster surrounded by a roofed corridor, or cloister, penetrated by a single entrance gate (Fig. 63). Outside the main worship compound were separate support structures: a sutra repository (*kyōzō*), a belfry (*shōrō*) and a lecture hall (*kōdō*). Judging by the tiles originally nailed to the exposed ends of the *kondō* roof rafters, they were massive round supports, capping a building of impressive dimensions. By contrast, Shitennōji (Figs 64 and 65) and Wakakusadera (Figs 66

1 pagoda
2 *kondō*
3 *kōdō*
4 *chūmon*
5 roofed corridor

64 Plan of Shitennōji, Osaka.

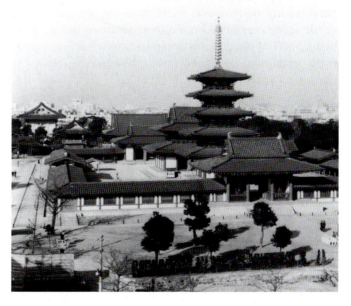

65 Shitennōji, Osaka.

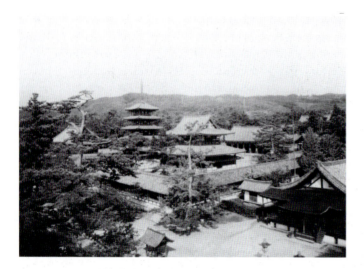

66 General view of Wakakusadera/Hōryūji complex, Ikaruga, Nara prefecture. 7th century.

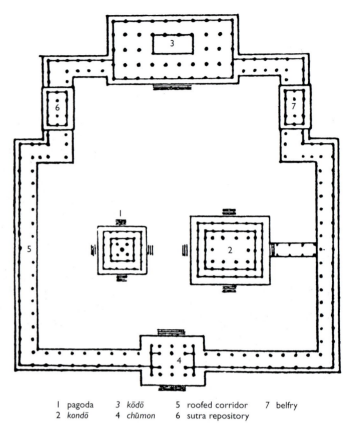

| 1 pagoda | 3 kōdō | 5 roofed corridor | 7 belfry |
| 2 kondō | 4 chūmon | 6 sutra repository | |

67. Plan of compound of Wakakusadera/Hōryūji as it exists today.

and 67)—also based on Korean prototypes, in this case of Paekche—employed an axial layout with a pagoda and a single *kondō* distributed along the median line of a rectangle enclosed by a roofed cloister pierced by a single entrance gate. As was the case with Asukadera, outside the main worship compound were support buildings: a sutra repository, a belfry, a refectory, and quarters for the monks.

According to the *Nihon shoki*, by 624 Japan could boast of forty-six Buddhist temples, while by 694 they had multiplied to a staggering 545. In addition it is clear from Hakuhō temple buildings, and their artifacts, that new styles and techniques of architecture, painting, and sculpture were constantly being imported from the continent and then mastered by Japanese craftsmen.

When Fujiwara was laid out as the capital, the four major temples of Asukadera, Kawaradera (built 662–7), Daikandaiji (673), and Yakushiji (680) were already in existence and were incorporated into the plan of the city. Of these four, only Yakushiji (now relocated to the Nara region) has survived in anything like its original form. After the removal of the capital to Heijō in 710, Gangōji was built on completely different lines to that of the original Asukadera, but Yakushiji was rebuilt following exactly the scale of the original temple at Fujiwara. The only other temple surviving from the pre-eighth century in anything like its original form is Wakakusadera/Hōryūji. Because of its age, its state of preservation, and its association with Prince Shōtoku, Hōryūji has been accorded greater importance by art historians than it was by the court in the late seventh century. By those standards it was a provincial temple. Had it not been the private temple of Prince Shōtoku, undoubtedly it would not have been reconstructed when it burnt down in 670. Hōryūji and Yakushiji, together with their paintings and sculptures, exemplify the two poles of Hakuhō-period art: the conservative Hōryūji moving slowly away from the norm of Asuka-period art and the innovative Yakushiji, embracing the full flowering of the styles of the Chinese early Tang period, recreated in the Japanese idiom.

Hōryūji

When the original Wakakusadera burnt down, it was decided to give the subsequently rebuilt temple a more Chinese-style name, Hōryūji. The site is located 7 miles (11 km) south of present-day Nara (see figs 66 and 67), and the main entrance to the temple grounds is, in fact, the Great South Gate, the Nandaimon, at the foot of a gentle incline. The approach to the main compound is a broad, pebble-strewn avenue that

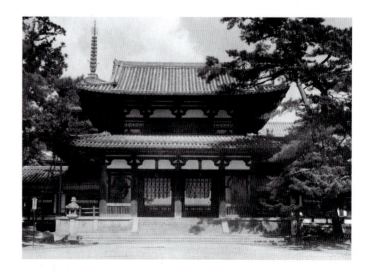

68 *Chūmon* (central gate), Hōryūji. 7th century.

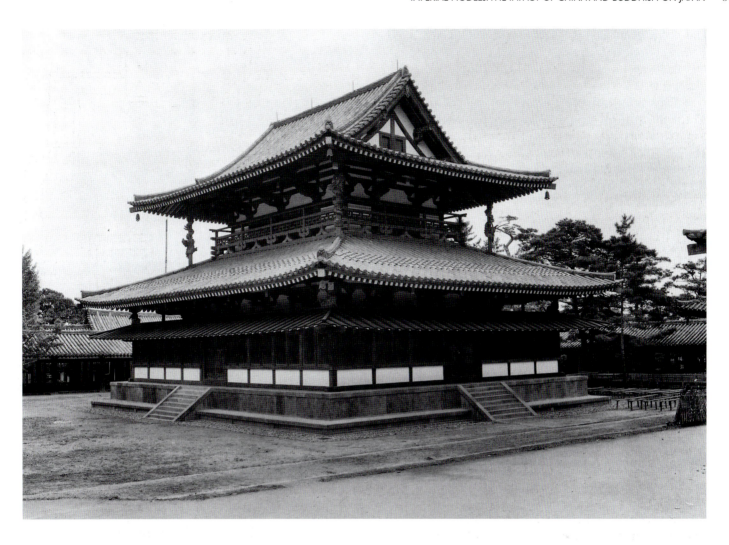

69 *Kondō* (golden hall), Hōryūji. 7th century.

passes beside roofed walls enclosing the lesser cloisters of the temple. The entrance to the main compound, the *chūmon* (central gate), is set within the roofed plaster perimeter cloister wall, and is a two-storied structure four bays wide (Fig. 68). In the outermost bays of the gate are fierce Niō, deities belonging to a group known as *kongōjin*, who are sworn to guard Buddhism and its adherents. The east guardian is Ungyō, defender of the night. He is a black-skinned figure with clenched teeth. The west guardian is Agyō, guardian of the daylight hours, and a creature with red skin and open mouth. Once inside the broad open courtyard, the visitor encounters the two main structures of the compound, the broad, squat *kondō* and the tall, exuberant, five–storied pagoda.

In the Hōryūji compound, as with other Japanese Buddhist temples, the *kondō* and the pagoda serve different functions. The *kondō* is a building dedicated to active worship (Figs 69 and 70). One enters it, stepping over a high, thick threshold, to find oneself before an array of huge statues on a raised altar platform (see Fig. 93) that fills a large proportion of the space. The room is dark, in contrast to the brightness of the open spaces of the compound, but there is sufficient light to illumine the gilded and painted images of Buddhas, bodhisattvas, and guardian deities. The practitioner performs the

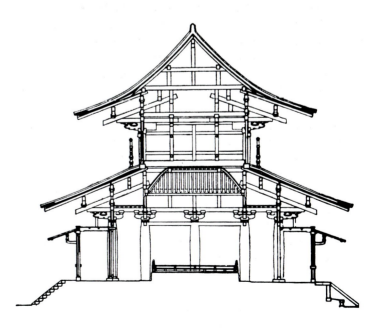

70 Elevation of *kondō* (golden hall), Hōryūji, showing double-roof system of rafters.

rite of circumambulation clockwise around the altar platform, pausing before the statues.

The *kondō* in a sense fulfills one of the purposes of the *chaitya* hall of ancient India, which consisted of a high central hall flanked by two lower aisles—not unlike the plan of Christian churches that would develop in western Europe some centuries later. At the end of the central "nave" would be placed a **stupa**, an ancient funerary mound-like structure representative of the Buddha, whose remains were placed in such an object after his final passing into nirvana. In the *chaitya*, monks could assemble in the open central space, but they could also individually perform the rite of circumambulation around the stupa. Built almost a thousand years later than the Indian *chaitya*, the early Japanese *kondō* were based on the post-and-lintel construction employed in Chinese and Korean temples, and buildings in general, and made of wood and not stone. They did not provide a central nave for assembly, but the placement of the altar in the center of the hall, with an open area around it, facilitated the rite of circumambulation.

The pagoda adjacent to the *kondō* is a structure developed to fulfill the function of the Indian stupa (Fig. 71), the pagoda being adapted in China from the form of a watchtower. Embodied in the Buddhist stupa are two basic ideas: the structure as a memorial to an important person (e.g., the Buddha) and the structure as a diagram of the universe. As a diagram of the universe, it makes manifest the invisible path of the Buddhist practitioner's aspiration, which rises along a vertical axis, the heart pillar of the structure, to unite with the absolute (Figs. 72 and 73). Similarly, the bright light of truth can penetrate downward along this vertical axis to illumine our dark illusion. The pillar, a single piece of wood that extends from below ground to the peak of the highest roof, is set on a foundation stone in which there is a cavity for various Buddhist treasures, such as sutra rolls, or offering treasures, such as the sword scabbard in Figure 54.

The pagoda's most obvious use as a memorial is its function as a reliquary, holding sacred remains from the past (perhaps of the Buddha himself, or of some other eminent Buddhist personage). The relics are contained within the

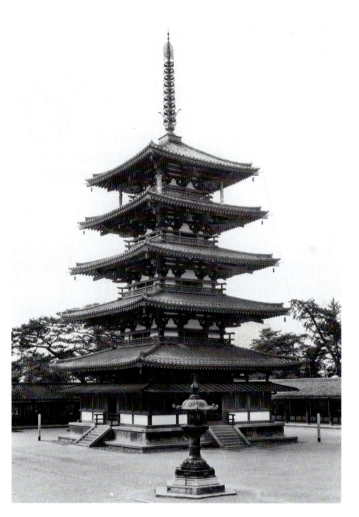

72 Five storied pagoda, Hōryūji. 7th century.

71 Diagram of stupa.

stupa hemisphere, which in India is capped by a *harmika*, or little palace, intended as a residence of divinity. This is matched on the pagoda by a copper structure called a *sōrin*, extending skyward from the top of the pillar and the uppermost roof, and consisting of an inverted bowl shape (*fuku bachi*) on a saucer-like "dew basin" (*roban*), and above it a shaft that projects upward. The origin of the pagoda's *sōrin* is the configuration of the *harmika* surmounted by a shaft bearing three or more umbrellas, the ancient symbol of both royalty and divinity. Attached to its shaft are nine rings (*kurin*) topped by an open-work "water flame" design (*suien*), a form known as the dragon wheel (*ryūsha*), and at the very top the sacred jewel of Buddhist wisdom, the *hōshu* (SKT. *chintamani*).

The organization of the Hōryūji compound is an example of beautifully balanced asymmetry. Unlike the plan of the Shitennōji, the *chūmon* has been set slightly off center into one of the long cloister walls. At first it was thought that some accident of the temple's history must account for the similar asymmetric placement of the *kondō* and pagoda in the

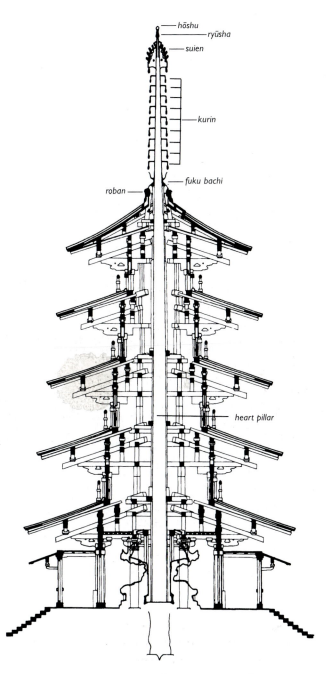

hōshu
ryūsha
suien

kurin

fuku bachi

roban

heart pillar

73 Elevation, five-storied pagoda, Hōryūji. (Drawing by Pierre and Liliane Giroux, after Ōta Hirotarō, from *The Art of Ancient Japan*, Editions Citadelles, Paris.)

courtyard, but, as new excavations have shown, in the latter half of the seventh century there was a good deal of experimentation with temple layouts when the rebuilding of Shōtoku's private temple was undertaken in the late seventh and early eighth centuries. Although the *kondō* occupies more ground space than the pagoda, the soaring height of the latter balances the relatively low proportions of the former. The orientation of the *kondō* and pagoda along a line just north of the longitudinal median line of the compound meant that the distance from the front cloister to the façade of the *kondō* was greater than the distance from the rear wall of the hall to the

back of the compound, thus permitting a better vista of the buildings when passing through the *chūmon*. Today, however, this adjustment of perspective has been lost due to a later extension of the cloister to accommodate a belfry, sutra repository, and *kōdō* (lecture hall).

The oldest structures at Hōryūji are the *kondō*, perhaps completed by 680, the pagoda, the *chūmon*, and part of the cloister. The proportions of the pagoda and the *kondō* are particularly satisfying because of the diminution from one story to the next. The fifth story of the pagoda is approximately half the width of the first story, giving the structure a feeling of lightness and stability not found in later buildings. The roofs are made with square rafters. The pillars of the pagoda's lower story are massive, round wooden columns, decreasing in diameter toward the top, a device called entasis also found in Classical Greek architecture to counteract the impression of concavity at the top of tall, round pillars. The brackets supporting the eaves are of a stylized cloud-shape—accentuating the concept of an ascent into the heavens—and have a strong three-dimensional presence.

The miniature *kondō* of the Hōryūji's portable Tamamushi Shrine is, in fact, the earliest extant evidence of Japanese Buddhist architecture (see Fig. 90). The shrine can be dated only on the basis of stylistic comparisons, but it is probably a work of the later part of the Asuka period, or the second quarter of the seventh century. It clearly precedes the *kondō* of the Hōryūji, which dates after 670. The miniature building has bracket arms extending outward and upward to support the wide overhanging eaves. The tiled roof is of the hipped-gable type—in other words, a gable surmounting a truncated hipped roof—and the most common form in Japanese Buddhist architecture. A simple hipped roof can be seen on the *kondō* of the Tōshōdaiji (see Fig. 83). The unusual features of the Tamamushi Shrine roof are the way in which the tiles are applied to the surface, the fact that the understructure of the roof employs a single rafter system, and the use of *shibi*, fishtail-like ornaments at the ends of the ridgepole. The roofing tiles are applied in such a way that the junction of the gable and hipped roof is clearly indicated by the round tiles at the end of the upper rafters. This style of tile application is believed to have been used at Asukadera, but, by the time Wakakusadera/Hōryūji's *kondō* was rebuilt, the line of the gable curved gently into the hipped section without any break. *Shibi* are said to represent sea-dwelling mammals like the dolphin. They are found on the roofs of temples and castles in the Edo period (1615–1868) but are rare in the seventh and eighth centuries, appearing only on the Tamamushi Shrine and the *kondō* of Tōshōdaiji. Another unusual detail of the Tamamushi building is the stylized cloud shape of the bracket arms under the eaves. This type of bracket appears on temples of the Asuka and Hakuhō periods, but is not found afterward.

Yakushiji

The history of Yakushiji begins with Fujiwara's founder, Emperor Tenmu, who in 680 pledged to build the temple when

his consort Jitō was afflicted with an eye disease and it was feared that she might go blind. Yakushi, known also as the Medicine Buddha (SKT. Bhaishajyaguru), had long been a popular deity, Wakakusadera reputedly being built by Shōtoku in order to house an image of this Buddha. According to Buddhist thought, Yakushi Buddha is like a doctor, the disciple like the sick person, and the Dharma like the remedy for his illness. However, in the popular imagination, this Buddha could also be applied to for the resolution of more mundane afflictions. For some reason, the actual building of the temple was deferred until after Tenmu's death in 686, but it appears to have been completed by 697, three years after the occupation of the new city, in which it stood in a prominent location. Of the twenty-four temples integrated into the design of Fujiwara, Yakushiji was one of the most important, and by 718 work had commenced on its reconstruction in the environs of the new capital of Heijō. It was completed by 730, and current opinion based on excavations of the old site at Fujiwara tends to the belief that the temple closely followed the plan and style of the earlier structure. Clearly Yakushiji, being of fairly recent foundation and an imperially sponsored temple, had a unique significance, both historical and religious for the eighth-century court. It already had a Chinese-style name, unlike the older Asukadera, which in its new incarnation of Gangōji was given a completely new layout.

The main compound of Yakushiji has a *hondō* (another term for the *kondō*, meaning "main hall") and two pagodas, in addition to a lecture hall incorporated into the cloister wall (Fig. 74). Of these buildings, only the east pagoda remains from the early eighth-century construction, but recently the *hondō* and west pagoda have been reconstructed in their

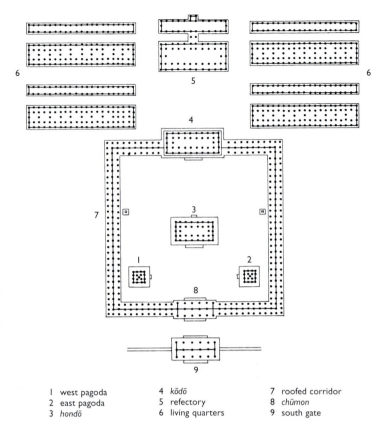

1	west pagoda	4	*kōdō*	7	roofed corridor
2	east pagoda	5	refectory	8	*chūmon*
3	*hondō*	6	living quarters	9	south gate

74 (above) Plan of Yakushiji temple. (From *Sekaikōkogaku Taikei*.)

75 (below) View of *hondō* (main hall), Yakushiji, Nara. Rebuilt 1980s after original of *c*. 730.

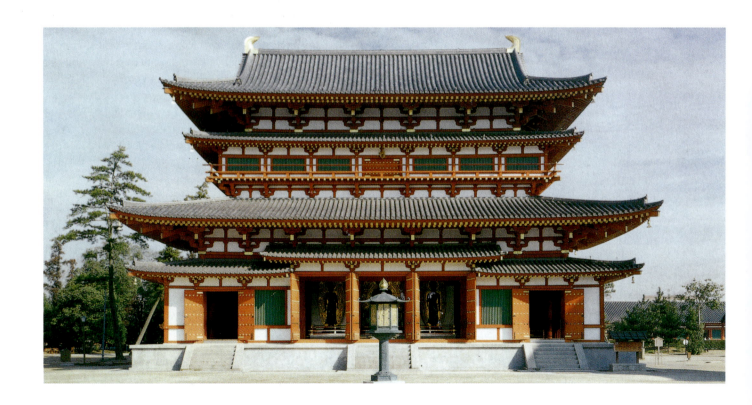

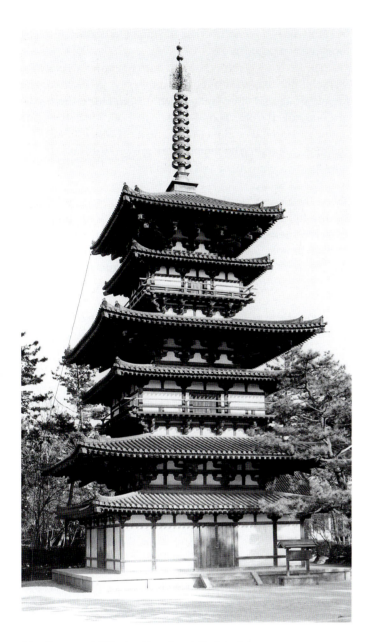

76 East pagoda, Yakushiji, Nara. First half of the 8th century.

three-storied structure with a *mokoshi* added at each level (Fig. 76). The result is a building at once more stable and more buoyant than the Hōryūji pagoda. Enhancing this impression are the system of three-stepped brackets and the latticed ceilings beneath the rafters, which allow more light to penetrate under the eaves. Today the Yakushiji pagoda stands as a unique example of this style.

Kōfukuji

Of the many temples erected in Nara between 710 and the beginning of construction of Tōdaiji in 747, the Kōfukuji affords the best glimpse of Buddhist art and architecture in the first half of the eighth century. Kōfukuji, which stands near the rebuilt Asukadera/Gangōji in the Gekyō suburb of now vanished Heijō, was built as a private temple of the Fujiwara clan under the direction of Fujiwara no Fuhito (659–720), and was clearly the largest and most impressive temple in Nara in the pre-Tōdaiji years. The site chosen for the temple complex was a sixteen-block area on a plateau at the foot of Mount Mikasa overlooking Heijō to the west. Further up the slope of the mountain, the Fujiwara also established their own private Shinto shrine, the Kasuga, which in the centuries to come would continue to grow and flourish under this powerful family's patronage (see Fig. 198). The Yakushiji and Gangōji occupied only nine city blocks each, while temples of the second rank such as Tōshōdaiji, the main post-Tōdaiji project, occupied only four blocks, and minor temples were allotted only one.

Clearly Fujiwara no Fuhito was one of the most influential men of the day. It was on his father that the surname of Fujiwara had been conferred by the emperor, and it was also Fuhito who was a key figure in the drawing up of the code of laws known as the Taihō Ritsuryō, which were promulgated in 701, and modeled closely on those of the Tang. It was revised in 718, and thereafter remained in use until 1858. Fuhito was also successful in marrying several daughters into the imperial family. Thus he had the freedom to build his clan temple and shrine in as magnificent a manner as he wished, without censure from the emperor.

As originally conceived, the temple consisted of three image halls, or *kondō*, in addition to such support buildings as a lecture hall, a sutra repository, a belfry, a refectory, and quarters for the monks. The focal point of the main cloister is the central *kondō*. The one pagoda at Kōfukuji is located to the east, in a separate enclave with the eastern *kondō*. The western *kondō* is also located outside the main enclosure. Thus on entering the *chūmon* into the cloister, one would, in fact, encounter only the single central *kondō*. In 721, the year after the death of Fuhito, a new type of building, the so-called round hall, actually an octagon, was built to the north of the western *kondō* to honor him. A similar hall, also dating to the early eighth century, the Yumedono, or Hall of Dreams, was built at Hōryūji to honor Prince Shōtoku and today houses the Yumedono Kannon (see Fig. 89), one of the most famous sculptures dating from this period. This octagonal type of

original style, restoring the compound to something close to its original appearance. The plan of the Yakushiji was a remarkable departure from earlier temple complexes, such as either the Asukadera or Wakakusadera. The emphasis was placed on the *hondō*, which is a towering, two-storied structure immediately visible as one enters the temple precinct (Fig. 75). The two smaller pagodas are of diminished importance in the ritual life of the Yakushiji, and they are placed near the perimeter wall of the cloister on either side of a path leading to the *hondō*, in front of which there is ample room for a large assembly to gather for viewing the image of Yakushi Buddha and his attendant bodhisattvas inside (see Figs 102 and 103).

The most striking stylistic innovation in the building of the Yakushiji is the use of the double-roof system (**mokoshi**) for each story of the *hondō* and pagodas. The east pagoda is a

1 pagoda
2 *chūmon*
3 Daibutsuden
4 north middle gate
5 *kōdō*
6 monks quarters
7 refectory

8 Shōsōin
9 Tegaimon, formerly
 Saihojimon; only extant
 original gate
10 *kaidanin*
11 Nigatsudō (Second
 Month Hall)

12 Hokkedō
 (Sangatsudō) (Third
 Month Hall)
13 Great South Gate
14 original enclosing wall
15 roofed corridor

77 (above) Plan of Tōdaiji complex. (From *Early Buddhist Japan* by J. E. Kidder, Thames & Hudson.)

78 (below) View of Daibutsuden, Tōdaiji.

building seems to have usurped the function of the pagoda as a reliquary repository.

The Kōfukuji complex was intended not only as a place for worship, but also as a monastic university. In addition, the temple staffed a Mercy Hall, which offered aid to the needy, orphans, and the elderly, and a Medicine Hall, which served as a kind of hospital or clinic. The garden, in which flowers for the many altars in the temple were grown, was open to the laity for their enjoyment and recreation.

Tōdaiji: The Nation's Temple

Up the hill from Kōfukuji stands the magnificent project of Emperor Shōmu, the temple complex of Tōdaiji. The building of this temple and the casting of its colossal Birushana Buddha were the most important projects undertaken by the court, the clergy, and the Japanese people in the eighth century. At the time that Emperor Shōmu ordered the temple's construction, he was living at a place called Shigaraki in Ōmi province (present-day Shiga prefecture) and work on the buildings was begun there. However, in 745 he moved back to Nara, and land surrounding the hermitage of the famous Kegon master Rōben was then selected for the new temple. The area allotted for Tōdaiji was equivalent to sixty-four city blocks (Fig. 77).

Two pagodas were included in the original plan, enormous seven-storied structures 330 feet (101 m) tall, each contained within a separate cloister. To the north of these was the main compound, which consisted of the *hondō*, more commonly known as the Daibutsuden (Great Buddha Hall) as it

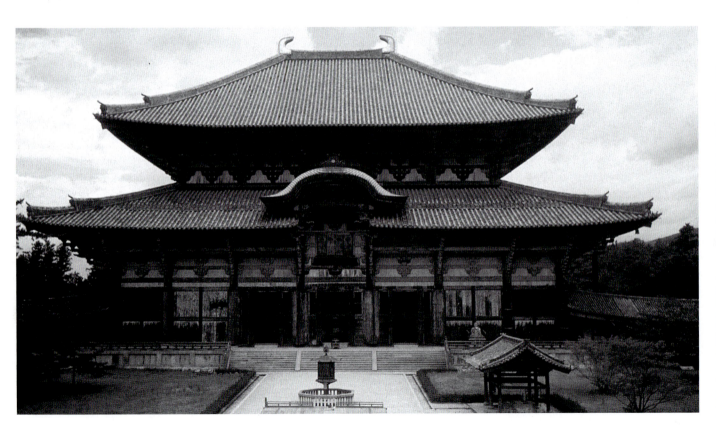

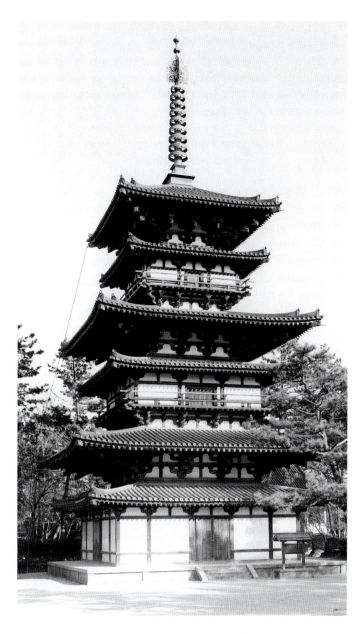

76 East pagoda, Yakushiji, Nara. First half of the 8th century.

three-storied structure with a *mokoshi* added at each level (Fig. 76). The result is a building at once more stable and more buoyant than the Hōryūji pagoda. Enhancing this impression are the system of three-stepped brackets and the latticed ceilings beneath the rafters, which allow more light to penetrate under the eaves. Today the Yakushiji pagoda stands as a unique example of this style.

Kōfukuji

Of the many temples erected in Nara between 710 and the beginning of construction of Tōdaiji in 747, the Kōfukuji affords the best glimpse of Buddhist art and architecture in the first half of the eighth century. Kōfukuji, which stands near the rebuilt Asukadera/Gangōji in the Gekyō suburb of now vanished Heijō, was built as a private temple of the Fujiwara clan under the direction of Fujiwara no Fuhito (659–720), and was clearly the largest and most impressive temple in Nara in the pre-Tōdaiji years. The site chosen for the temple complex was a sixteen-block area on a plateau at the foot of Mount Mikasa overlooking Heijō to the west. Further up the slope of the mountain, the Fujiwara also established their own private Shinto shrine, the Kasuga, which in the centuries to come would continue to grow and flourish under this powerful family's patronage (see Fig. 198). The Yakushiji and Gangō ji occupied only nine city blocks each, while temples of the second rank such as Tōshōdaiji, the main post-Tōdaiji project, occupied only four blocks, and minor temples were allotted only one.

Clearly Fujiwara no Fuhito was one of the most influential men of the day. It was on his father that the surname of Fujiwara had been conferred by the emperor, and it was also Fuhito who was a key figure in the drawing up of the code of laws known as the Taihō Ritsuryō, which were promulgated in 701, and modeled closely on those of the Tang. It was revised in 718, and thereafter remained in use until 1858. Fuhito was also successful in marrying several daughters into the imperial family. Thus he had the freedom to build his clan temple and shrine in as magnificent a manner as he wished, without censure from the emperor.

As originally conceived, the temple consisted of three image halls, or *kondō*, in addition to such support buildings as a lecture hall, a sutra repository, a belfry, a refectory, and quarters for the monks. The focal point of the main cloister is the central *kondō*. The one pagoda at Kōfukuji is located to the east, in a separate enclave with the eastern *kondō*. The western *kondō* is also located outside the main enclosure. Thus on entering the *chūmon* into the cloister, one would, in fact, encounter only the single central *kondō*. In 721, the year after the death of Fuhito, a new type of building, the so-called round hall, actually an octagon, was built to the north of the western *kondō* to honor him. A similar hall, also dating to the early eighth century, the Yumedono, or Hall of Dreams, was built at Hōryūji to honor Prince Shōtoku and today houses the Yumedono Kannon (see Fig. 89), one of the most famous sculptures dating from this period. This octagonal type of

original style, restoring the compound to something close to its original appearance. The plan of the Yakushiji was a remarkable departure from earlier temple complexes, such as either the Asukadera or Wakakusadera. The emphasis was placed on the *hondō*, which is a towering, two-storied structure immediately visible as one enters the temple precinct (Fig. 75). The two smaller pagodas are of diminished importance in the ritual life of the Yakushiji, and they are placed near the perimeter wall of the cloister on either side of a path leading to the *hondō*, in front of which there is ample room for a large assembly to gather for viewing the image of Yakushi Buddha and his attendant bodhisattvas inside (see Figs 102 and 103).

The most striking stylistic innovation in the building of the Yakushiji is the use of the double-roof system (*mokoshi*) for each story of the *hondō* and pagodas. The east pagoda is a

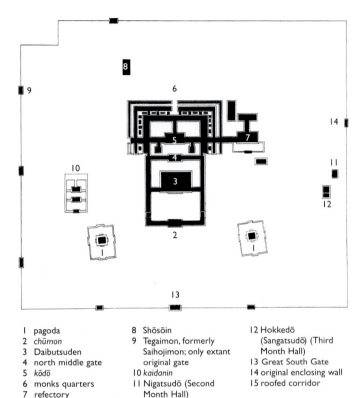

1	pagoda	8	Shōsōin	12	Hokkedō
2	*chūmon*	9	Tegaimon, formerly		(Sangatsudō) (Third
3	Daibutsuden		Saihojimon; only extant		Month Hall)
4	north middle gate		original gate	13	Great South Gate
5	*kōdō*	10	*kaidanin*	14	original enclosing wall
6	monks quarters	11	Nigatsudō (Second	15	roofed corridor
7	refectory		Month Hall)		

77 (above) Plan of Tōdaiji complex. (From *Early Buddhist Japan* by J. E. Kidder, Thames & Hudson.)

78 (below) View of Daibutsuden, Tōdaiji.

building seems to have usurped the function of the pagoda as a reliquary repository.

The Kōfukuji complex was intended not only as a place for worship, but also as a monastic university. In addition, the temple staffed a Mercy Hall, which offered aid to the needy, orphans, and the elderly, and a Medicine Hall, which served as a kind of hospital or clinic. The garden, in which flowers for the many altars in the temple were grown, was open to the laity for their enjoyment and recreation.

Tōdaiji: The Nation's Temple

Up the hill from Kōfukuji stands the magnificent project of Emperor Shōmu, the temple complex of Tōdaiji. The building of this temple and the casting of its colossal Birushana Buddha were the most important projects undertaken by the court, the clergy, and the Japanese people in the eighth century. At the time that Emperor Shōmu ordered the temple's construction, he was living at a place called Shigaraki in Ōmi province (present-day Shiga prefecture) and work on the buildings was begun there. However, in 745 he moved back to Nara, and land surrounding the hermitage of the famous Kegon master Rōben was then selected for the new temple. The area allotted for Tōdaiji was equivalent to sixty-four city blocks (Fig. 77).

Two pagodas were included in the original plan, enormous seven-storied structures 330 feet (101 m) tall, each contained within a separate cloister. To the north of these was the main compound, which consisted of the *hondō*, more commonly known as the Daibutsuden (Great Buddha Hall) as it

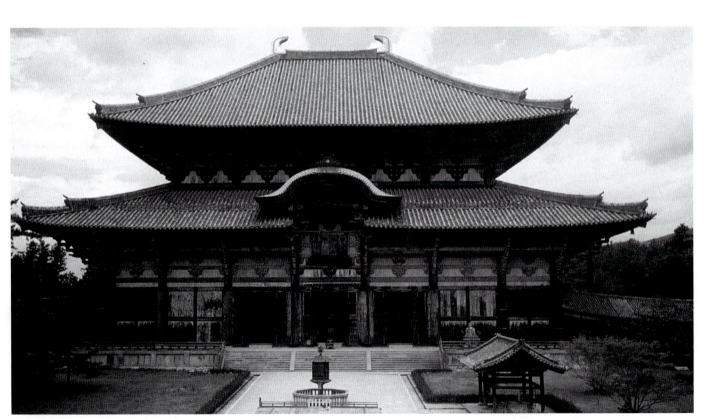

houses the colossal image of Birushana Buddha (Fig. 78), and two cloisters enclosing, respectively, front and back courtyards on either side of the Daibutsuden. Directly behind the Daibutsuden in the rear courtyard was the lecture hall (*kōdō*), surrounded on three sides by quarters for the monks. The refectory was a separate building with its own enclosed courtyard. The imperial clan's storehouse, the Shōsōin (see Fig. 50), is located far to the northwest of the Daibutsuden, while the Hokkedō, or Hall of the Lotus Sutra, the oldest extant building in the Tōdaiji complex, is a short climb up the hill to the east.

The Daibutsuden is a huge building by any standards, eleven bays long by seven bays deep, forming a rectangle some 285 x 170 feet (87 x 52 m) and measuring 154 feet (47 m) at the ridgepole—far larger than the audience hall of the imperial palace. Some idea of the scale and the magnificence of the Daibutsuden and its colossal Buddha can be gained from a twelfth-century *emaki*, or narrative scroll, the *Shigisan engi emaki* (Fig. 79). The last section of the story, told in words and pictures, deals with an elderly nun journeying to Nara to pray to the Great Birushana image for a revelation of her younger brother's whereabouts. We see her to the right at the doorsill, looking up reverently as she prays to the Buddha. Then she sleeps through the night near the base of the statue, and the next day makes her farewells, having been told in a dream where to look for her brother. The story and the illustration testify to the importance of Tōdaiji and the authority of the Birushana image, which survived the removal of the capital to Heian. The Daibutsuden was burnt to the ground in 1180 in

80 Hokkedō (also known as Sangatsudō), Tōdaiji, Nara. 1st half of the 8th century.

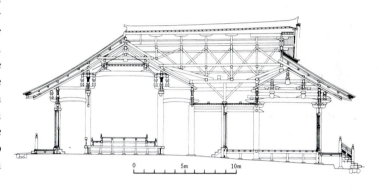

81 Cross section of Hokkedō, Tōdaiji. Nara period (710–794) section on the left and Kamakura period (1185–1333) addition on the right.

the **Genpei Civil War**, but was immediately rebuilt and a new colossal image of Birushana cast.

Earlier, in 733, Shōmu had constructed a temple on the future site of Tōdaiji for the Kegon master Rōben (689–773), who became one of his most trusted religious advisers and later was appointed the first abbot of Tōdaiji. This first temple was known as the Konshōji, and scholars generally agree that it was later included in the Tōdaiji complex and is known today as the Hokkedō or Sangatsudō (Third Month Hall) (Fig. 80). In the thirteenth century, the building was remodeled, and a *raidō*, or worship hall, was added in front of the main sanctuary, and the roofs of the two structures joined (Fig. 81).

Tōshōdaiji

In 754, the Chinese monk Jianzhen (688–763), known in Japanese as Ganjin, arrived in Nara with the express purpose

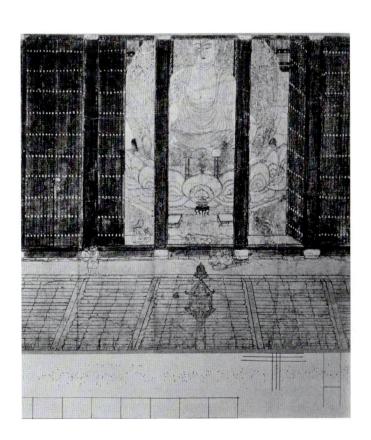

79 Daibutsuden at Tōdaiji, detail from *Shigisan engi emaki*, scroll 3. Late 12th century. Ink and color on paper; height 12 ½ in. (31.8 cm). Chōgosonshiji, Nara.

of establishing the Ritsu school, which adhered strictly to the codes by which monk, nun, and householder must live their lives in order to follow the Eightfold Path to Enlightenment. Most importantly Ganjin also brought the correct, complete ritual of ordination for the Buddhist clergy. Buddhist law required a properly ordained cleric to perform the ritual, but, despite the fact that monks from the continent had visited Japan, some staying for many years, there seems to have been no one who, before Ganjin, could conduct the ceremony properly. Therefore, in 755, an ordination platform was built at Tōdaiji and some four hundred people, including the imperial consort Komyō, were properly ordained. Whatever the reason, Ganjin preferred not to take up residence at Tōdaiji, but instead retired to a separate temple of his own. And in 759 the first steps towards the building of Tōshōdaiji were taken.

Tōshōdaiji is the best-surviving example of the construction style typical of the second half of the Nara period, and particularly the style of buildings in which those of Tōdaiji would have originally been built. As a private temple built with donations from aristocratic families of the capital, primarily the Fujiwara, it occupied a four-block site in the western part of the capital, very near Yakushiji. There are no clear records concerning the dates at which specific buildings were completed. The logical choice for the first building would have been the *kondō*, but it is quite possible that instead it was the *kōdō*, or lecture hall, because the principal reason for building the temple was in order to provide Ganjin and the newly established Ritsu school with a base for their teachings (Fig. 82). This building was first constructed as the East Morning Hall in the Imperial Palace, but was subsequently dismantled and donated to Tōshōdaiji, possibly before Ganjin's death in 763. However, it is certain that the rest of the complex was not finished until the ninth century, when the capital had already removed to Heian-kyo. The main area, of course, consisted of the *kondō* and *chūmon*, linked by a roofed cloister that enclosed

a rectangular courtyard between the two structures, in the manner of both Kōfukuji and Tōdaiji.

The *kondō* of Tōshōdaiji is seven bays wide and four bays deep (Fig. 83). The long, low silhouette of the building projects a sense of horizontality and stability, which is further emphasized by such architectural details as the bracketing system and the hipped roof. The three-stepped brackets represent the final development of the Asuka–Nara period. They are much more compact than earlier systems. The roof is a simple hipped shape with no crowning gable. The height of the ridgepole was raised 8 feet (2.5 m) in the Edo period, making the pitch of the roof much steeper. The original, lower eighth century roof would have better complemented the horizontality of the building, whereas the later roof gives it a heavier appearance. Unusually for the period, *shibi* were attached toward the ends of the ridgepole, in the manner of the building represented by the Tamamushi Shrine.

TORI BUSSHI AND ASUKA-PERIOD SCULPTURE (552–645)

The one artist of the Asuka period whose name, genealogy, and work have been preserved to the present day is the sculptor Tori Busshi (Tori, the maker of Buddhist images). His ancestry can be traced back to his grandfather, Shiba Tatto, the Chinese craftsman who helped Soga no Umako establish his first Buddhist temple. As a member of the saddlemakers' guild, Tatto had mastered a wide range of skills, including many of those needed for making sculpture: metal casting, wood carving, and lacquer work. Tasuna, his son and the father of Tori, also belonged to the saddlemakers' guild, and at the time of Emperor Yomei's last illness in 588 offered to become a Buddhist monk and to carve a Buddha image out of

82 *Kōdō* (lecture hall), Tōshōdaiji, Nara. Mid–8th century.

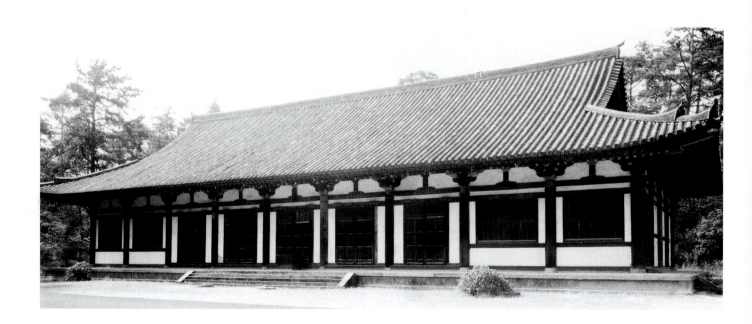

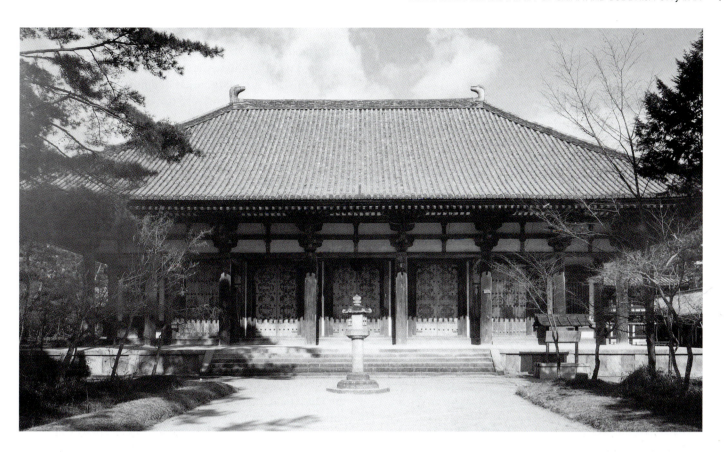

83 *Kondō* (golden hall), Tōshōdaiji. 759.

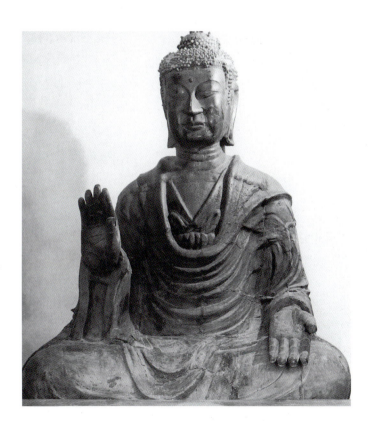

84 *Asukadera Buddha*, attributed to Tori Busshi, in the Asukadera, Asuka. 606. Gilt bronze; height 108 in. (276 cm).

wood. The son, Tori Busshi, appears to have become the principal sculptor working for Soga no Umako and Prince Shōtoku in the early seventh century and is credited with executing the Shaka image for Asukadera in 606, the Yakushi Buddha image for Wakakusadera (later Horyūji) in 607, and also, surviving at Hōryuji, the magnificent Shaka Triad by Tori, the Buddha flanked by two bodhisattvas, dated by an inscription on the back of the halo to 623.

In the single remaining *kondō* of the original Asukadera temple is a seated, gilt-bronze statue of Shaka about 10 feet (3 m) high (Fig. 84). Although the image has been much restored over the centuries, it retains many general characteristics comparable to those of the principal survival of Tori Busshi's work, the Shaka Triad at Hōryūji (see Fig. 86). The Asukadera Shaka sits erect, legs crossed, the drapery falling in sharply defined, regular folds. The right hand is raised, palm outward, in the *semui-in* (SKT. *abhayamudra*) hand gesture that symbolizes the Buddha's power to grant tranquillity and freedom from fear. The left hand is lowered, the palm turned outward in a gesture of wish-granting, by extension offering the promise that the Buddha's teachings are the true path to release from suffering.

The gestures of individual Buddha images carry particular meanings and often derive from hand movements made at a particular moment in the life of the Historical Buddha. The *semui-in* gesture of the Asukadera image's right hand is the "fear-not" gesture traditionally said to have been made when Shaka found himself in danger of being trampled by an elephant made drunk by his evil cousin. The Buddha raised his

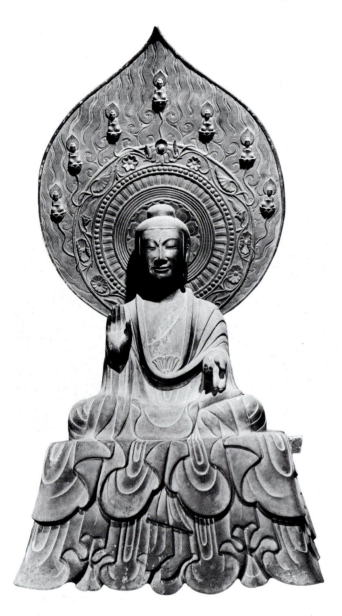

85 *Yakushi*, in the *kondō*, Hōryūji, Ikaruga, Nara prefecture. 1st half of the 7th century. Gilt bronze; height 24 ¾ in. (63 cm).

and the *nikkei* (SKT. *ushnisha*), the cranial protuberance above the normal curve of the head—are signs of the Buddha's increased wisdom and understanding. In all there are thirty-two such signs associated with Buddhist imagery, but these three are most commonly seen. The upper part of the Shaka's face has a strongly geometric quality, the smooth curving plane of the forehead descending to form the bridge of the nose, and the nostrils are indicated by what seem almost to be cuts in the metal. The eyes and eyebrows also form strongly curvilinear accents, flowing horizontally across the face.

The distinctive style of this image and of Tori's other works—particularly the linear and geometric quality of the facial features and body pose, and the fascination with the drapery of the robe—is originally derived from the Buddhist sculpture of the Wei dynasties of northern China of the late fourth to sixth centuries. By the time Tori would have cast this Buddha, the Wei styles had long gone out of fashion in China, replaced by a greater attention to curves and volumes, and, therefore, from a modern perspective by a greater realism. It is perhaps because Japan's early Buddhist art works came from Paekche, which adhered more to this "antique" style, that these first Japanese images also hark back to it, instead of to the more fluid realism to be found in China in the early seventh century. Certainly, however, it is a tribute to Tori Busshi's genius and ability that he took what could be a very stiff style

hand and the animal became quiet. The gesture of offering, or vow-fulfilling, the *seganin* (SKT. *varadamudra*), is a more general hand movement and seems to have no specific point of origin in the biography of Shaka.

The head of the Asukadera Buddha is the least restored and therefore most telling part of the image. The face is long and cylindrical, capped with hair depicted as a mass of snail-shell curls. This type of curl is one of the *shōgō* (SKT. *lakshana*) of the Historical Buddha, that is the physical symbols that distinguish him as a perfected being. The point of origin for the curls is said to be the result of Shaka shaving his head upon leaving his father's palace and entering an ascetic life. What grew back were the tightly packed curls depicted in his imagery, and in that of other Buddhas. Two other *shōgō* that are readily visible in the Asukadera Buddha—the *byakugō* (SKT. *urna*), a small tuft of hair or raised circle just above the nose,

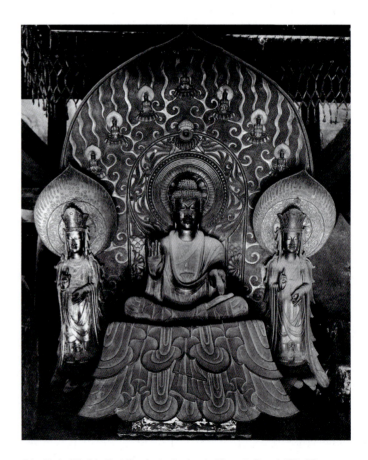

86 *Shaka Triad*, by Tori Busshi, in the *kondō*, Hōryūji. Dated 623. Gilt bronze; height 46 in. (116.8 cm).

and instead used it to imbue his subject with a great tranquillity that even has an element of softness.

Tori Busshi's Yakushi of 607 was created as the principal image for Prince Shōtoku's newly established Wakakusadera. It is represented today by a seated image enshrined in the *kondō* of Wakakusadera's successor, the Hōryūji (Fig. 85). On the reverse of the halo is an inscription that gives many of the circumstances surrounding the production of the original image, attributing it to Tori Busshi. Superficially, the sculpture has many Wei-style characteristics in common with the Asukadera Buddha and the later Shaka Triad. However, scholars generally agree that the inscription and the halo itself postdate 607. Is the sculpture the original work of 607, with the halo and wooden pedestal being later replacements, or is the entire work a Hakuhō period (645–710) copy, made after the original Wakakusadera had been destroyed? Today most historians support the latter theory, and this sculpture indeed has many features considered to be Hakuhō period in style.

In the Shaka Triad of 623, we see the full flowering of Tori Busshi's art. The Shaka sits serenely atop a rectangular platform (Fig. 86). His eyes seem to gaze straight forward, his hands promise the believer tranquillity and an infallible path to salvation. In contrast to the severe and immobile quality of the body, the long skirts flow down the front of the platform like a waterfall. Further animation is suggested by the flickering flame patterns in the outer border of his halo, amongst which sit small seated images of the Seven Buddhas of the Past—the seven earthly manifestations of Buddhahood who immediately preceded Shaka. Just above Shaka's head is a raised circle, which represents the flaming jewel of Buddhist wisdom, enshrined on an inverted lotus blossom. Emanating from it is a lotus vine that in gently undulating curves sprouts leaves that encircle the Buddha's head. The delicate linear patterns of the flames and lotus leaves form a strong contrast to the calm, but vivid features of the Buddha.

An inscription on the reverse of the halo explains that the triad was commissioned by Empress Suiko (r. 593–629) and other court members because of the death of two important court ladies in 621 and the illness of Prince Shōtoku and his consort the following year. The statue was intended as a votive offering to promote Shōtoku's recovery or his rebirth into paradise. In 622 both Shōtoku and his consort died, and in 623 the statue was completed and dedicated to their spiritual well-being. It is not known where at Wakakusadera the triad was originally placed, since the Yakushi of 607 was already the main icon of the *kondō*. Various theories have been put forward, but, since it is beyond question that the statue is a work of the early seventh century, the inscription is generally accepted as valid, and the assumption is made that the piece was housed outside the main worship complex of the temple in a place untouched by the fire of 670.

The Shaka Triad reflects the mature Wei style in China during the first quarter of the sixth century, of which numerous examples can be found in the rock-cut temples of Longmen, near the Wei capital of Luoyang (Fig. 87), and in

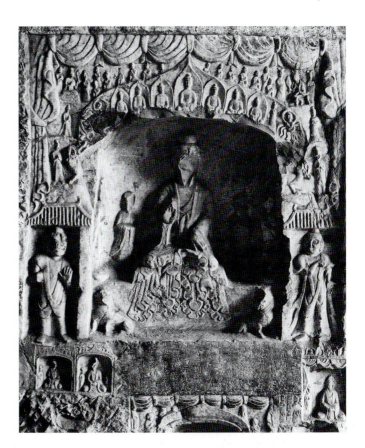

87 *Seated Buddha*, in cave 13, Longmen, China. 527. Stone.

cast-bronze figures. With Wei imagery, and with Tori's interpretation of it, the strong plasticity of the images transmitted along the Silk Road from India to China has been tamed by an East Asian love of linear patterning. The bodies of the Buddha and the bodhisattvas are barely revealed beneath their garments. Instead, attention is focused on the exuberantly articulated drapery of their skirts and the scarves that splay out on either side, creating serrated outlines that contradict the apparent volume of the figures. A clear demonstration of this is provided by a side view of one of the bodhisattvas from the Tori Triad (Fig. 88). These bronze sculptures are not complete figures in the round, but instead half images, terminated at the tips of their flaring scarves. The triad was intended to be viewed only from the front, like the relief carvings of the Chinese cave temples.

A statue not directly attributable to Tori Busshi, but clearly within the limits of his style, is the Kannon image in the octagonal Yumedono (Hall of Dreams) of Hōryūji's eastern precinct (Fig. 89). Of all the bodhisattvas, Kannon (SKT. Avalokiteshvara; CH. Guanyin) is the most enduringly popular throughout the history of Buddhism in East Asia. The Bodhisattva of Compassion, he represents the compassionate aspect of the Buddha–Dharma, and may be depicted in many forms. In China, Korea, and Japan he became overtly female in character in the later medieval period, but at this earlier period his appearance is still that of a handsome youth, as are the

88 Side view of bodhisattva figure, from *Shaka Triad*, by Tori Busshi, in the *kondō*, Hōryūji. Dated 623. Gilt bronze; height 35 ¾ in. (90. 7 cm).

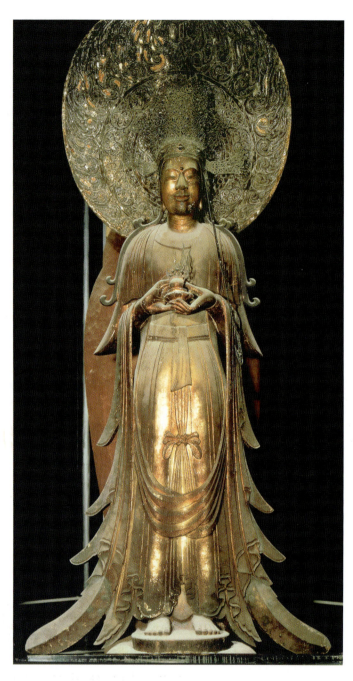

89 *Yumedono Kannon*, in the *Yumedono* (Hall of Dreams), Hōryūji, Ikaruga, Nara prefecture. Early 7th century. Gilt wood; height 77 ½ in. (197 cm).

images of most other bodhisattvas. As non-earthly denizens, the bodhisattvas are depicted in all the splendor of the heavens and Buddhist paradises, and this has been interpreted in an earthly way by showing them as Indian princelings, clad in elegant skirts, bedecked with elaborate jewelry and crowns, and having long curly tresses and mustaches.

The Yumedono sculpture has always been one of the most treasured images at Hōryūji, and was hidden away for so many years in a closed wooden shrine that even the monks of the temple had lost memory of it. The shrine was opened in the late nineteenth century on the occasion of a visit by the American scholar Ernest Fenollosa, one of the Western scholars most influential in encouraging the Japanese to preserve their cultural heritage at a time of strong pressure toward Westernization. Because it was so seldom exposed to view and to the elements, the camphor-wood statue is in a remarkable state of preservation. Made of a single shaft of wood—only the lowest ends of the drapery scarves and the lotus pedestal are made of separate pieces—the image still retains much of the gold leaf that was applied over the entire surface, as well as the red pigment that tinted the lips, the black of the eye pupils, and the dark blue of the mustache.

ASUKA PAINTING: THE TAMAMUSHI SHRINE

The Tamamushi Shrine is one of the most important objects surviving from the Asuka period, not only because it affords us a three-dimensional glimpse of an accurately detailed building from this period (see page 65), but also because it is the only example of Buddhist painting surviving from the early seventh century (Fig. 90). This portable shrine in the Daihōzōden, or Great Treasure House, at Hōryūji consists of a *kondō* in miniature atop a tall rectangular plinth, which is

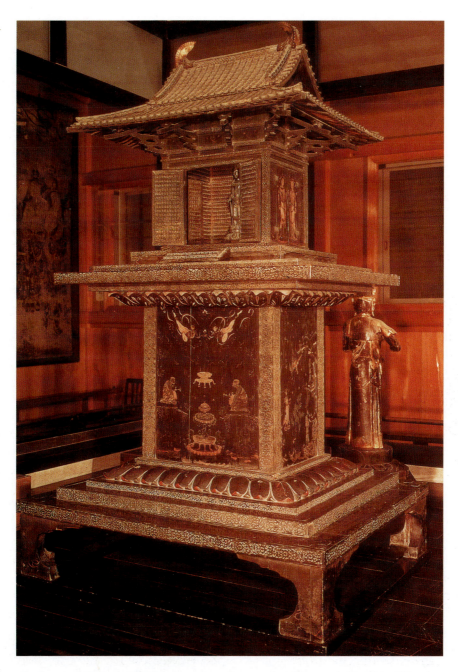

90 Tamamushi Shrine. c. 650. Cypress and camphor wood, with lacquer; height 84 in. (213 cm).
Now in Hōryūji Treasure House, Hōryūji, Ikaruga, Nara prefecture.

raised off the floor by a broad sturdy pedestal. The outer surfaces of the *kondō* and the four sides of the plinth are decorated with paintings of bodhisattvas, the Four Guardian Kings (**Shitennō**), and Buddhist narratives. The edges of the panels and the projecting upper and lower horizontals of the pedestal are covered with strips of openwork metal, and the name of the shrine comes from the iridescent wings of the *tamamushi* beetle, which originally underlaid the openwork design of the metalwork. One can imagine that the iridescence of the beetle wings must have made striking contrast with the strong pure colors of the paintings—reds, yellows, light browns, and greens applied to a black ground. Scholars now generally

agree that the shrine was made in Japan; the types of cypress and camphor wood out of which it is crafted are native to Japan, and the materials used in the paintings—lacquer mixed with red or black pigment and vegetable oil from the *shiso* plant added to lead oxide—are common in indigenous work.

On the two front doors of the *kondō* are two of the Four Guardian Kings (JAP. Shitennō). These kings, one for each of the four directions, are some of the most enduring guardians of the Buddhist Dharma, and found particular popularity in East Asia—Prince Shōtoku's first Buddhist temple, the Shitennōji, was established in honor of them. Normally sculptures of the Shitennō can be found at the four corners of a

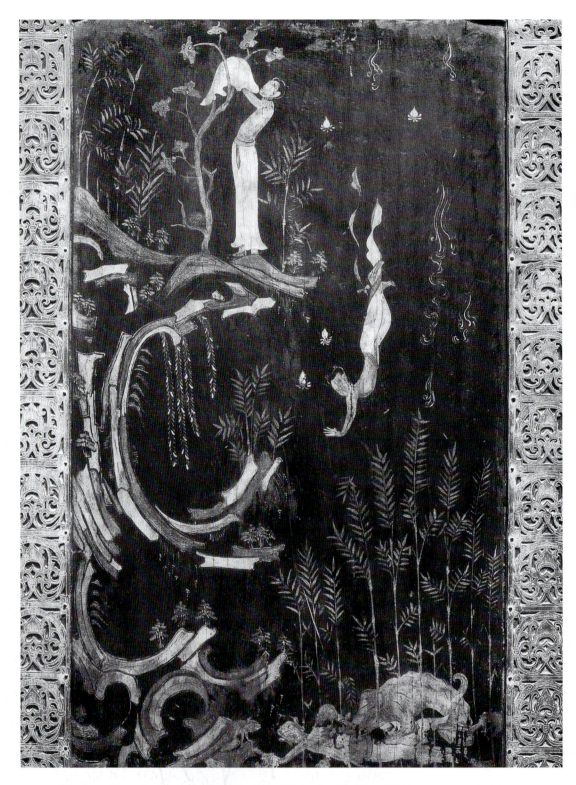

91 *Hungry Tigress Jataka* panel, from the Tamamushi Shrine (see Fig. 90). *c.* 650. Lacquer on wood, with open metalwork borders. Hōryūji Treasure House, Hōryūji, Ikaruga, Nara prefecture.

temple's altar platform. The armor-clad images of the Kings on the doors of the Tamamushi Shrine seem to sway in space as though they are stepping forward, their scarves swinging out behind them. On the two sets of side doors graceful bodhisattvas are depicted, each holding a lotus blossom, a symbol of compassion and the special attribute of the bodhisattva Kannon. The interior walls of the building are decorated with rows of tiny seated Buddhas, suggesting the one thousand Buddhas of the past who accompany some Shaka and Birushana Buddha images. The sculpture now contained

92. *The Hungry Tigress Jataka*, wall painting, cave 254, Dunhuang, China. Early 6th century.

in the shrine is an image of the bodhisattva Kannon, and is a later replacement.

The rectangular pedestal supporting the miniature *kondō* of the shrine is decorated with traditional Buddhist themes: on the front, relics are worshiped by two monks offering incense; on the back is Mount Sumeru, the mountain at the center of the universe that holds apart the heavens, the earth, and the oceans. The two side panels depict *jataka* tales (JAP. *bosatsu honjō manron*), stories of the previous incarnations of Shaka before the lifetime in which he achieved Enlightenment. The Hungry Tigress *jataka* is typical of the general theme of self-sacrifice these tales present (Fig. 91). The Buddha-to-be, or the Bodhisattva as he is generally referred to in these tales, is riding through the forest and comes upon a starving tigress and her cubs. Distressed by her plight, he offers his own body as food, but she is too weak even to take the first bite. The Bodhisattva thereupon climbs a nearby mountain and jumps from it, so that the smell of blood from his crumpled body might rouse the tigress enough to feed. In the panel, he first appears up on the mountain, taking off his robe. Then, in a system of continuous narrative, he is shown flying down to his death, and at the bottom of the cliff the tigress and her cubs begin their meal.

The circular movement of the narrative is particularly appropriate for the vertical panel on which it is painted. Even when the viewer is standing still, the sequence of the story's episodes is clear. This method of storytelling can be found on

93 View of the altar, *kondō*, Hōryūji.

the balustrades of Indian stupas such as Bharhut (second century B.C.E.) and on the walls of the cave temples at Dunhuang, such as the sixth-century painting of Cave 254 (Fig. 92). Both types of monument were designed to permit the practitioner to move in circumambulation, and, while doing so, to meditate on the illustrations decorating the walls.

Interestingly, the painting of the Tamamushi, unlike the sculptures of the Asuka period, does not hark back to Wei prototypes. The Shitennō and the bodhisattvas with their lively sense of volume and movement demonstrate a style much more in keeping with that of contemporaneous China. There was clearly an aesthetic and stylistic division between the painted and sculpted image at this point, which later in the century would be brought closer together.

HAKUHŌ SCULPTURE: HŌRYŪJI

Apart from the Shaka Triad and the Yumedono Kannon, the other sculptures of Hōryūji date to the Hakuhō period, and almost certainly not after 711, when its rebuilding was officially completed. Of these, the earliest in date and style are the Shitennō installed at the corners of the altar which dominates the center of the *kondō* (Fig. 93). Each king is distinguished by his attribute. Tamonten (SKT. Vaishravana; CH. Duowen), later known as Bishamonten, the king of the north, holds a halberd and a reliquary stupa (Fig. 94). Zōchōten (SKT. Virudhaka; CH. Zengzhang) is the king of the south and holds a long and a short halberd (see Fig. 93). Jikokuten (SKT. Dhrtirashtra; CH. Chiguo), king of the east, supports a jewel in his upraised right hand and a halberd in the other, while Kōmokuten (SKT. Virupaksha; CH. Guangmu), the king of the west, holds a scroll

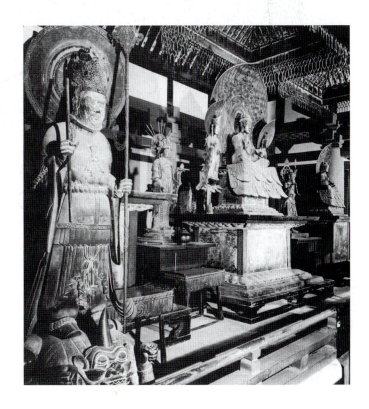

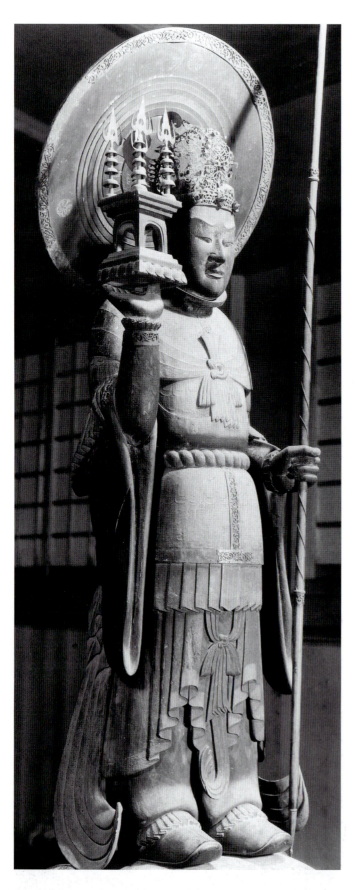

94 *Tamonten*, in the *kondō*, Hōryūji. *c.* 650. Wood, with paint and gold leaf; 52 ⅞ in. (134.2 cm).

of paper and a brush. These kings are made of single blocks of wood. The conquered demon—symbolic of the enemies of Buddhism—on which each stands and their halos are separate pieces of wood, as are the forward-flaring scarves at the feet of each figure. Each sculpture still has traces of its original coloring and gilding. The crown and the strips of openwork metal attached to the halo and skirt of the armor are made of cut gold.

Although there is no suggestion of the vitality of the Shitennō on the front of the Tamamushi Shrine, the scarves at the base of the rigidly erect statues do flare forward instead of to the sides, giving a stronger sense of roundness and three-dimensionality than did their Asuka predecessors. The closest continental equivalent to this set of Shitennō is found in the columnar style of the Chinese Northern Qi dynasty (550–77). The Hōryūji pieces are dated to around 650 on the basis of an inscription on the back of the Kōmokuten halo and a separate entry in the *Nihon shoki* for 650, mentioning a commission of Shitennō given to a certain Ōguchi Aya Yamaguchi Atai. Since the name of another craftsman, Tsugi Konmaro, is also inscribed on the halo, it is open to question what role the two men played in the creation of these images. Nevertheless, the date of 650 seems appropriate for these figures.

The Kudara Kannon (Fig. 95) preserved in the Great Treasure House of Hōryūji with the Tamamushi Shrine has several points in common with the Shitennō sculptures of the *kondō*. It is a tall, slender wooden image, the details of its drapery shallowly indicated on the surface, the drapery scarves at its feet curving forward instead of flaring out to the side. Appropriately enough for the Bodhisattva of Compassion, it does not convey the same sense of weighty volume as the Shitennō, but instead displays a gentle roundness that suggests a more naturalistic treatment of the body.

The statue possesses a number of puzzling features, starting with its name, the Kudara Kannon. Kudara was an alternate Japanese name for Paekche, leading some art historians to speculate that the sculpture may have been made in Korea. However, the camphor wood used for the body, the cypress used for the lotus pedestal, and the water vase attached to the left hand are indigenous to Japan. The garment covering the bodhisattva's torso is unique in that it crosses from the right shoulder to the lower left, rather than the reverse which is the norm. The crown and necklace are made of openwork metal, but the designs are heavier, less exuberant than those of the king images. Despite these atypical details, there is no reason to think that the statue is of foreign origin. Kudara was the name of a region to the north of the Asuka Valley as well as a synonym for Paekche.

An image that conveys some of the same grace and gentility as the Kudara Kannon is an image of Miroku as a bodhisattva preserved in the convent of Chūgūji just to the east of Hōryūji (Figs 96 and 97). Of a type that had long been popular in Korea, the figure is shown seated upon a throne with one leg pendant and the other bent, the ankle resting on the opposite knee, on which its right arm is propped, the hand

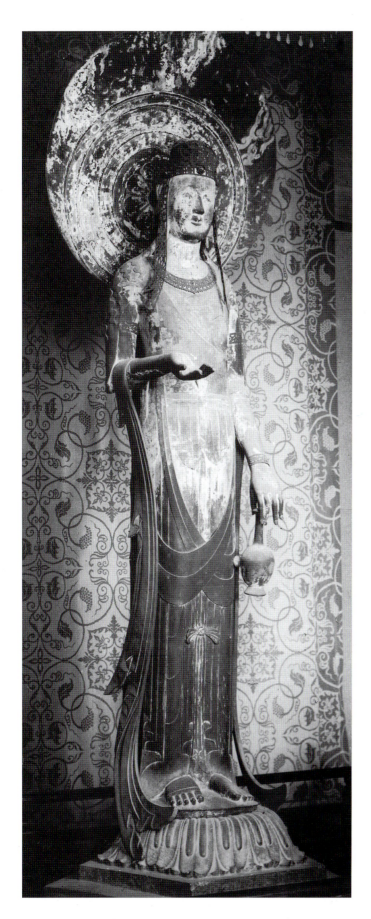

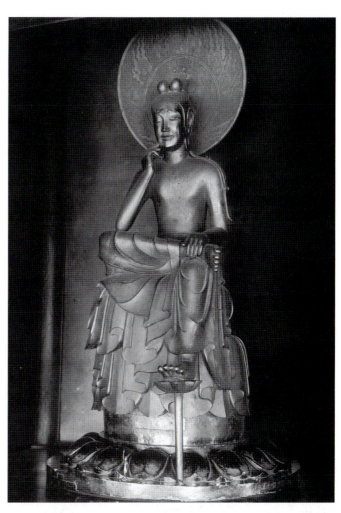

96 *Chūgūji Miroku.* 7th century. Camphor wood; height 52 in. (132 cm).
Treasure Hall, Chūgūji convent, near Hōryūji.

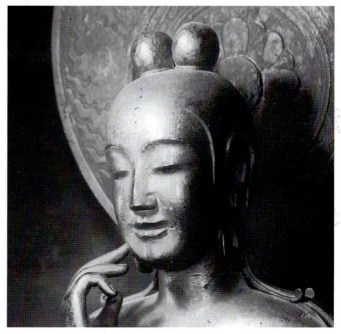

95 *Kudara Kannon.* Early 7th century. Wood, with remains of paint; height
83 in. (210 cm). Hōryūji Treasure House, Hōryūji.

97 *Chūgūji Miroku,* detail of Fig. 96.

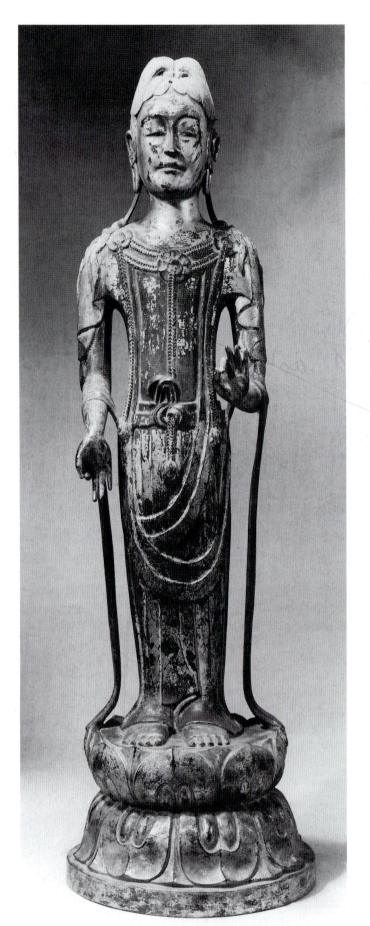

raised to the face in a pensive gesture. It eloquently and elegantly conveys the image of the Future Buddha in his paradise meditating upon the true nature of things until he will descend as the next Buddha. Chūgūji was originally the residence of Prince Shōtoku's mother and was converted into a convent after her death in the early seventh century. However, the statue can clearly be recognized as a work of the Hakuhō period, with its gently swelling torso, its softly modeled face, and its naturalistic pose.

It is within this relaxing of the linear geometry of the Wei style that the Hōryūji Yakushi Buddha alleged to be by Tori Busshi (see Fig. 85) should also be considered. Most scholars have now concluded that it is a work of Hōryūji's rebuilding, and in replacement of the Busshi original, which was possibly lost or damaged beyond repair in the fire that destroyed Wakakusadera in 670. This would account for the archaic elements of its style, which recall Asuka sculptural pieces in contrast to Hakuhō-period sculptures such as the Shitennō, Kudara Kannon, and Miroku. However, several stylistic features point equally to the Northern Qi style of the Hakuhō period. For example, the face of the Yakushi is much more softly modeled than the Shaka Triad, but not unlike the Shitennō. Further, the eyes have neither the linearity nor the teardrop quality of the Shaka Triad and the Asukadera Buddha. Also the patterns of the skirts imitate the earlier style of the Shaka Triad, but those on the Yakushi are fewer in number and conform closely to the rectangular form of the base underneath, lacking the vivacious and serrated outline of the drapery on the Triad.

A group of six bodhisattvas at the Hōryūji demonstrate the next development within Hakuhō-period sculpture, and in particular an image of the bodhisattva Kannon (Fig. 98). The six images are crafted according to the single-block technique (*ichiboku zukuri*, see page 134) out of camphor wood and have been coated with lacquer and gold leaf, a common form of decoration, but in addition certain details such as the jewelry, tresses of hair, and hair ornaments have been modeled solely out of lacquer and affixed to the sculptures before the gold leaf was applied. This is the first-known use of lacquer in Japanese sculpture for a purpose other than protective coating. In the succeeding Nara period, whole images would be constructed out of lacquer-soaked cloth, and in the ninth century, when Japanese sculptors returned to wood as the preferred material, lacquer would be used again in just this way to build up surface details (see Fig. 165).

Originally, the group of bodhisattvas consisted of eight, not six, statues, and it has been suggested that they were produced as flanking images for a group of Buddhas of the four directions (with Birushana as an implied fifth in the center). The images stand squarely without any shift of weight, yet they have a strong three-dimensional presence. Their draped

98 *Kannon Bosatsu*. 711. Camphor wood, with lacquer and gold leaf; height 30 ⅝ in. (77.9 cm). Hōryūji Treasure House, Hōryūji.

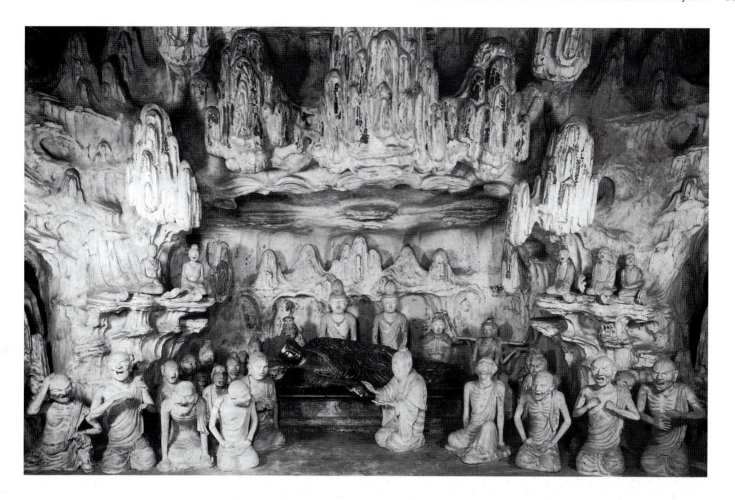

99 Tableau of the death of Shaka, north side of the five-storied pagoda, Hōryūji. 711. Clay over wood and metal.

shoulders swell outward below the neck, while the torsos have a gentle inward curve. Their garments flow around and between their limbs. Their faces, too, are more naturalistically modeled, with high brows and full cheeks. The six bodhisattvas are youthful, serene figures, projecting the idea of compassion for the believer. Their form still harks back to the Northern Qi style, but there is a further relaxation of rigidity in their pose which comes that little bit closer to the elegant curves and vitality of the early Tang dynasty, as expressed in the Tamamushi Shrine paintings.

The last group of sculptures to have been installed at Hōryūji during its rebuilding are clay figures in tableaux on the first floor of the pagoda and a pair of guardian Niō images in the chūmon. The latter have been discussed earlier in the context of the chūmon architecture (see pages 62–63), and preserve little of their original flavor having been extensively restored, but the tableaux in the pagoda are in better condition. Strictly speaking these tableaux, completed in 711, belong to the Nara period, but their installation so soon after the relocation of the capital in 710 suggests that the technique used in their manufacture—clay modeled over wood and metal armature—was coming into popularity in the last

years of the Hakuhō period. The sculptures found in the pagoda are placed informally in groups and set against fantastic rock shapes, which have been built up around the central pillar of the pagoda.

Each tableau recounts a particular Buddhist theme. The north tableau depicts the passing into nirvana (SKT. parinirvana) of Shaka (Fig. 99). The Buddha's golden body lies on a platform, while his disciples and various bodhisattvas look on. Even his mother who predeceased him, Queen Maya, has come down from the heaven where she resides to witness the moment of her son's joyous release (she sits on the left edge of the scene). Disciples ranged in the front, who have not fully mastered the Buddha's teachings, fall into violent demonstrations of grief. Those who do understand, like the bodhisattvas behind the reclining body of the Buddha, sit calmly. The other three tableaux are equally vividly modeled. The western one depicts the distribution of the Buddha's relics after his cremation, while the one to the east depicts the famous debate by the erudite layman Yuima (SKT. Vimalikirti) and the Bodhisattva of Wisdom, Monju (SKT. Manjushri) (Fig. 100). This was an important subject at the time the tableaux were made, not just in Japan, but also in China—Yuima, who wins the debate, being a clear demonstration that Enlightenment could be achieved by the laity, and not just within the confines of a monastic life.

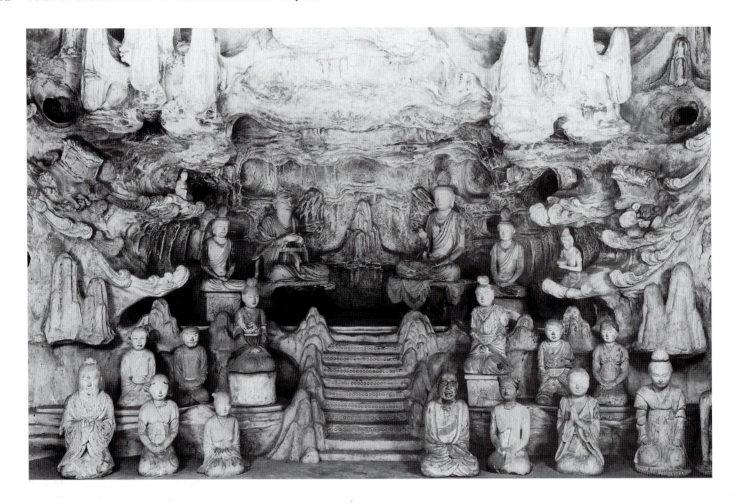

100 Tableau of the Yuima-Monju debate, east side of the five-storied pagoda, Hōryūji. 711. Clay over wood and metal.

HAKUHŌ PAINTING

In addition to preserving the only masterpiece of Asuka-period painting, Hōryūji also has the best of the few examples of painting from the Hakuhō period. These fragments come originally from the interior walls of the *kondō*, which were decorated with a series of twelve murals. The wide panels depict the four Buddhas who are emanations of Birushana to the four directions enthroned in their paradises of the four directions: **Amida** (SKT. Amitabha; Buddha of the west), Ashuku (SKT. Akshobhya; Buddha of the east), Fukūjōju (SKT. Amoghasiddhi; Buddha of the north), and Hōshō (SKT. Ratnasambhava; Buddha of the south). The narrower panels support images of eight bodhisattvas to flank the Buddha images. However, a disastrous fire in 1949 left most of the paintings too blackened to be readable.

There is some disagreement about the identification of the various Buddhas because, although they should appear in the four cardinal directions, the space used by the entrance doors

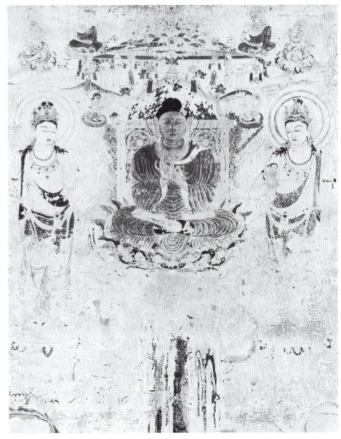

101 *Amida Triad*, wall painting from the *kondō*, Hōryūji. c. 710. Hōryūji Treasure House.

causes a slight skewing of the whole arrangement. The one painting about which there is general agreement is the wide panel on the west wall, which has been identified with the Buddha of the west, Amida (Fig. 101). Amida sits on a high-backed throne festooned with jewels. To his left is the bod-hisattva Kannon, recognizable by the Amida Buddha image in his crown. Within the ordering of the Buddhist cosmos, Kannon is an emanation of Amida Buddha, and images of this bodhisattva usually depict in the crown a figure of the seated Amida. To Amida's right is the bodhisattva Seishi (SKT. Mahasthamaprapta), who is normally paired with Kannon as an attendant bodhisattva to Amida.

The technique employed in the execution of these paintings, required that the plaster wall be first built up by using ever finer and finer layers of the material, which were allowed to dry. Next the design was transferred from cartoons onto the wall surface using the technique of pouncing, in which tiny holes are pierced along the lines of the cartoon, which is then placed against the wall and colored powder pressed through the holes, thus transferring the design to the wall. Finally, pigments were applied to the design on the dry wall. There are two traditional technical elements of Buddhist painting in these works: the use of red rather than black to outline the figures, and a type of line called "**iron wire**" that does not vary in width and lacks all calligraphic flourish. There is also a strong admixture of Indian elements in the luxurious jewels and hair, especially of the two bodhisattva figures. Like the Tamamushi painting, the style of the murals is more advanced in terms of the naturalistic delineation of figures than the sculptures of the Hakuhō period. The flanking bodhisattvas sway in a life-like manner, but also display a greater roundness than the lithe figures of the Tamamushi Shrine, which is in keeping with painting styles of the late seventh and early eighth-centuries in China.

Hakuhō Sculpture: Yakushiji

The movement of Japanese sculpture into fully Tang styles is finally achieved by the principal images preserved at the Yakushiji's hondō (Figs 102 and 103): a seated image of the Yakushi Buddha flanked by his attending bodhisattvas—Nikkō (SKT. Suryaprabha) to the left and Gakkō (SKT. Chandraprabha) to the right. Cast in bronze, these figures have acquired a rich black patina made particularly striking by the contrast with their bright gold halos, which are Edo-period replacements for the originals that had been damaged repeatedly by fires and earthquakes. A 1954 analysis of the bronze alloy revealed that it contains a particularly high proportion of tin and arsenic. No doubt the rich color of the images today is due to oxidation of the tin.

Like the Amida Triad painting at Hōryūji, the Yakushi and the two bodhisattvas are full, fleshy figures conceived in the round and treated as completely natural forms. The Nikkō and Gakkō display a hip-slung pose (SKT. tribhanga) that is one of the signatures of the Tang International Style and is meant to

suggest that the figures are actually moving in space. They are dressed in skirts and scarves that cling like water-soaked cloth, revealing the bodies beneath. The bodhisattvas also have rich jewelry—intricate necklaces, jewelled strands accenting the flow of the scarves, and crowns with three large jewel motifs. The Buddha, as is the norm with such figures, wears no jewelry, and his long robe flows over the edge of the platform in a rich pattern of irregular folds. His left arm is extended, the fingers crooked to hold a medicine jar, now lost, and his right hand is raised in the ani-in gesture (SKT. vitarkamudra), indicating explication of a teaching.

He sits on a rectangular throne decorated with a variety of designs: on the uppermost horizontal band a scroll of grape leaves, a Tang motif we have also seen on the leather wrapping-cloth in Figure 57, and rich jewel patterns on the other narrow horizontal and vertical strips. On each of the four sides of the dais are also depicted the dragon, tiger, phoenix, and tortoise/snake adopted long before from Chinese mythology. The most interesting motifs on the dais, however, are the pairs of squat, fat figures contained within the bell-shaped arches. They have been interpreted by some as the twelve yaksha generals associated with Yakushi's heavenly retinue. The yaksha (JAP. yasha) is a genus of earth divinities of

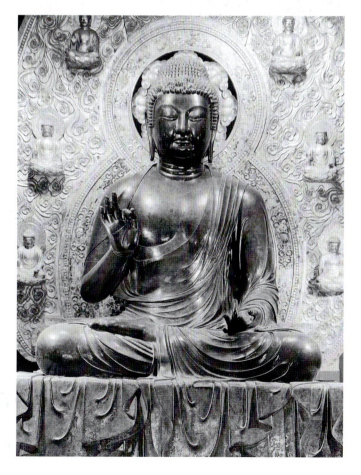

102 *Yakushi*, central figure of Yakushi Triad. Bronze; height 100 in. (254 cm).

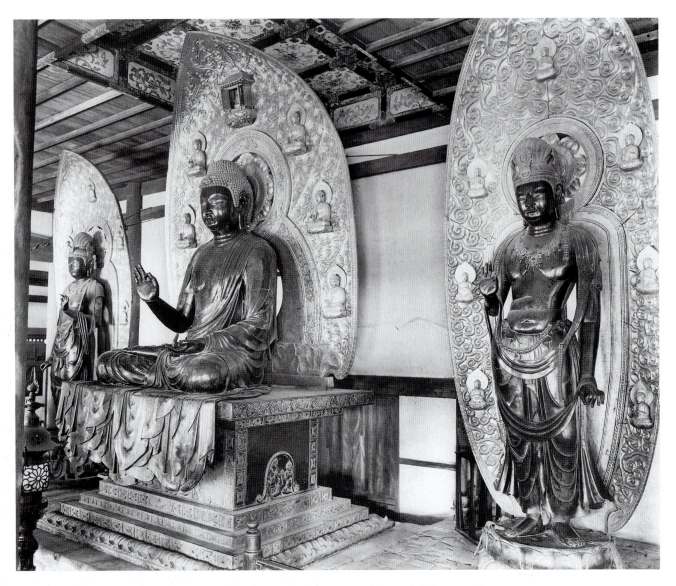

103 *Yakushi Triad*, in the *hondō*, Yakushiji. Late 7th or early 8th century. Bronze.

ancient India, the males of which are often portrayed as squat powerful figures. In Buddhist tradition, they were converted to the Dharma and number amongst its guardians.

The date of the triad has been the subject of much debate. The controversy arises from the relationship of the Yakushiji at Fujiwara and its refoundation in Heijō. A record of 1015 states that the statue of Yakushi in the *hondō* was made as the result of a vow by the original temple's founder, Emperor Tenmu, and when the capital moved to Heijō it was brought by wagon from the old Yakushiji, a trip that took seven days. While some take this at face value, others question the veracity of a document written three hundred years after the fact. In the absence of solid documentation, art historians must turn to an examination of style. Here the preponderance of evidence is on the side of the earlier date for the images. They have the same fleshiness seen in the Hōryūji's wall paintings, which date after 670 and before 711.

EARLY NARA SCULPTURE AND PAINTING

With the eighth century and the removal of the capital to Heijō, Japanese Buddhist sculpture steps into the full realism of the mid-Tang period, and in many cases equals if not surpasses it. Aside from the medium of bronze, the materials of choice for the native Japanese sculptor are wood, lacquer, and clay. From Kōfukuji survive two sets of sculptures that afford us a glimpse of this change in style in the early Nara period. These are six images from a set of the Ten Disciples of Shaka and eight sculptures of the Eight Classes of Beings, depicted at Kōfukuji as guardians of the Buddha. Originally these sculptures belonged to a group of twenty-seven images, including a Shaka flanked by the bodhisattvas Monju and Fugen (SKT. Samantabhadra), the Shitennō, and the divinities Bonten and Taishakuten, installed in the western *kondō*, the first of the main worship halls to be built at the request of Empress-

consort Kōmyō and dedicated to her mother, Lady Tachibana Michiyo. According to reliable records, the images were completed in 734 by a group of craftsmen including a *busshi*, or sculptor of Buddhist images, by the name of Shogun Manpuku, a woodworker, a painter, a metals specialist, and a craftsman in paper, probably members of a guild of artisans attached to the temple.

The most interesting aspect of these sculptures is the new technique used to craft them; adopted from China, it is called hollow dry-lacquer, or **dakkatsu kanshitsu** (see page 86). Dry-lacquer sculpture is not only durable, it is also light enough to permit it to be moved more easily than bronze or solid wooden images. The craftsmen attached to Kōfukuji had obviously fully mastered the dry-lacquer process, as demonstrated by the altar images of the western *kondō*. These works display both a great realism in form and a great sensitivity in the modeling. All six extant images from the set of ten disciples, stand on rock-shaped bases and are clad in simple monkish robes. However, in contrast to the pensive faces of the other five, the face of Kasenen (SKT. Katyayana) is contorted in an open-mouthed grimace which, together with his emaciated chest, powerfully evoke his prolonged self-denial on the road to Enlightenment (Fig. 104).

Mid-Nara Sculpture: Tōdaiji

From the middle of the eighth century, the great project that occupied everyone was the foundation of the Tōdaiji temple compound and the numerous images and accoutrements required for each of its buildings. The most important Tōdaiji commission of all, however, was the colossal image of Birushana, the Daibutsu. The casting for this enormous image was completed in 749, but the manufacture of the snail-shell curls and the gilding of the statue took two further years. In the spring of 752 a magnificent eye-opening ceremony was held for the Birushana. Not only did court and government officials participate, but also Buddhist dignitaries from China and India were present, including a monk from China and an Indian monk who performed the painting in of the Buddha's eyes. Work on the halo was not completed until 771. The image enshrined in the Daibutsuden today is a reconstruction of 1192, following the destruction of the original in 1180 during the Genpei Civil War. The present image is reputed to be slightly smaller than the original, but even so is some 53 feet (16 m) tall, its size augmented by the large gold halo that sits behind it, which is decorated with innumerable seated Buddhas and bodhisattvas.

It is uncertain how much the present image reflects the original, and the sculpture, tightly encased by the Daibutsuden, is hard to photograph in one shot. However, something of the impact of the original on the viewer can be

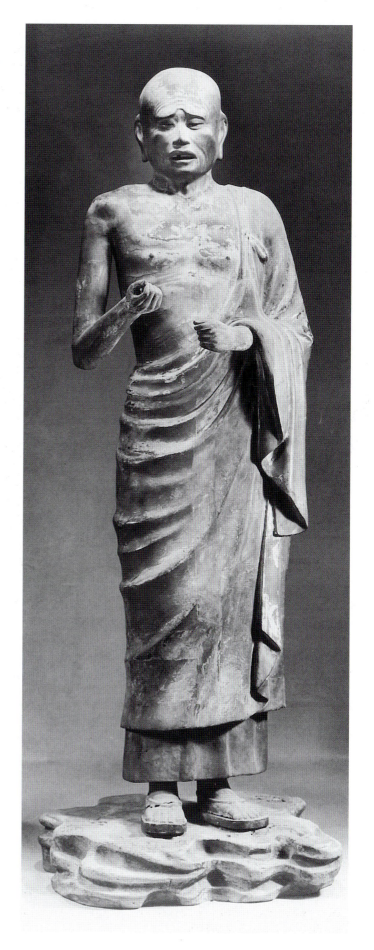

104 *Kasenen*, in the *saikondō* (western golden hall), Kōfukuji. Dry lacquer, with paint; height 58 ½ in. (148.8 cm). Kofukuji Temple, Nara.

Dry-Lacquer and Clay Sculpture

Three favored techniques for making temple sculpture in eighth-century Japan were hollow-core dry lacquer (*dakkatsu kanshitsu*), wood-core dry lacquer (*mokushin kanshitsu*), and clay (*sozo*). Lacquer (*urushi*) is a varnish-like resin obtained from an Asiatic sumac bush (*Rhus verniciflua*). All three techniques are additive processes, meaning that the forms are built up, not carved away.

Introduced from China during the early seventh century, hollow-core dry lacquer begins with a wooden form (A), an armature, which is then covered with clay (B). Next, layers of lacquer-soaked hemp or linen cloth—from three to ten of them—are applied and modeled (C). Each layer must be completely dry before the next one is applied, a time-consuming process. Before the final details are added, the sculpture is cut open at the back and the clay is removed. The original wooden armature may be left in, or it may be replaced by another. Large members, such as arms and feet, are modeled out of wood and joined to the armature (D). Details such as earlobes and fingers are modeled over iron wire and attached. The finest, most subtle details—including facial features, tresses of hair, jewelry, and raised fabric patterns—are modeled from a paste called *kokuzo urushi*, made of kneaded lacquer,

incense, clay powders, and sawdust. Finally, the image is coated with either black lacquer, over which gold leaf may be applied, or with a compound of fine clay mixed with animal glue (*hakudo*), on which colors composed of mineral pigments and animal glue may be painted.

Wood-core dry-lacquer sculpture, which is simpler to make than hollow-core, appears in Japan towards the end of the eighth century. It uses a roughly carved piece of wood (E) instead of a clay-covered armature to support the dry-lacquer layers (F). To discourage cracks in the lacquer surface caused by the expansion and contraction of a solid-wood core, sculptors usually hollowed out the core (G). Otherwise, the surface treatment of wood-core and hollow-core images is the same.

The fabrication of large-scale clay sculpture is comparable to that of hollow-dry lacquer images. A wooden armature is wrapped in rice-straw filaments to give it bulk. Three layers of clay are applied to this support: first, a coarse clay mixed with rice-straw fibers; second, a finer clay; and third, a very fine clay mixed with paper fibers. The sculpture is allowed to dry thoroughly, but it is not fired. Colors and gold leaf are applied to the surface.

105 *Shaka on a Lotus Petal*, engraved on the base of the Daibutsu (Great Buddha), Daibutsuden, Tōdaiji. 8th century.

gained from the depiction of it in the *Shigisan engi* discussed above (see Fig. 79). Some idea for the original appearance of the Birushana can also be found in the engravings of Shaka Buddha on the bronze lotus petals surviving from the original pedestal. Each petal, according to the iconography stipulated in the *Kegonkyō* (*Kegon Sutra*), represents a universe administered by Shaka Buddha and his attendant bodhisattvas (Fig. 105). Here Shaka appears as a fleshy figure with a swelling chest and the suggestion of a double chin above the three beauty rings of his neck. A surprising detail is the elaborateness of the Buddha's garment, which falls in a welter of swirling folds over his lap. Nevertheless, the figure preserves the increased naturalism and the elegance common to sculptures of the period.

The other structure of the Tōdaiji compound containing important images from the Nara period is the Hokkedō. The statues on the main altar of the Hokkedō are something of a hodgepodge in terms of both the iconography of the images and the sculptural techniques employed (Figs 106 and 107) (see page 86), combining both dry-lacquer and clay images . The central image is of dry-lacquer and is a Fukūkenjaku Kannon, an eight-armed figure representing one of the thirty-

three forms Kannon can assume (Fig. 108). A large statue, this Kannon is thought to have been made in the 740s, in response to a decree from Emperor Shōmu that provincial temples should install statues of the divinity. There is further evidence that in 746 a studio for making Buddhist sculpture was set up at the temple under the direction of Kuninaka Kimimaro (d. 774).

The Fukūkenjaku Kannon is one of the most powerful and austere manifestations of the bodhisattva from the Nara

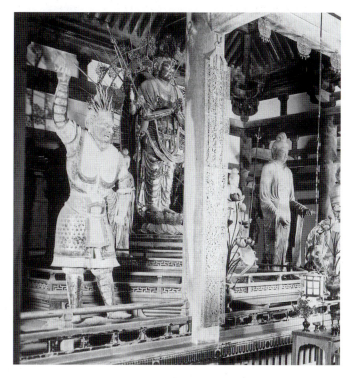

106 View of altar, Hokkedō, Tōdaiji.

107 Plan of the altar, Hokkedō, Tōdaiji.

1 Tamonten	6 Shūkongōjin	10 Gakkō	13 Kōmokuten
2 Bonten	7 Kichijōten	11 Kongō Rikishi	14 Taishakuten
3 Fudō Myōō	8 Fukūkenjaku	Ungyō	15 Jizō
4 Jikokuten	Kannon	12 Kongō Rikishi	16 Zōchōten
5 Benzaiten	9 Nikkō	Agyō	

87

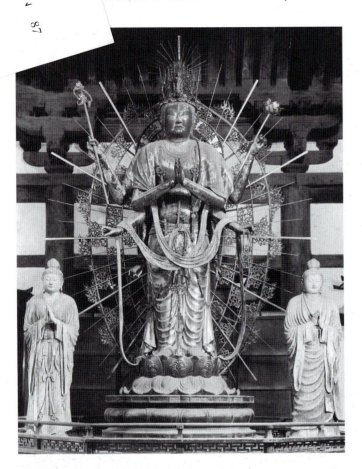

108 *Fukūkenjaku Kannon* (flanked by Gakkō and Nikkō), in the Hokkedō, Tōdaiji. 740s. Dry lacquer, with gold leaf; height 142 in. (362 cm).

Kimimaro, mentioned above. This artist's name appears frequently in the documents of the mid-Nara period. He was the second-generation son of a Korean from Paekche who emigrated to Japan in 669. Because Kimimaro received a number of significant promotions during the time work on the main images for the Daibutsuden was being carried out, it is assumed that he played a major role in that project as well as in the dry-lacquer sculptures for the Hokkedō.

Two images flank the Fukūkenjaku Kannon; they are known today as the bodhisattvas Nikkō and Gakkō (Figs 109 and 110), whom we have previously encountered flanking the image of Yakushi in the Yakushiji. Crafted in clay over a wooden armature, these two images are some of the most superb examples of Japanese clay sculpture since the Hōryūji pagoda tableaux. Because they are much smaller than the Fukūkenjaku Kannon and made of a different material, Japanese art historians regard them as "guest" sculptures on the platform, probably not originally intended for the Hokkedō. They are serene and gentle, their smooth, round faces articulated by elongated, barely opened eyes, and closed, full lips. Their bodies are covered by an undergarment with narrow sleeves and an outer robe that falls in soft, pleasantly irregular folds. Yet the images have been subtly individualized. Nikkō's garment is open across the chest and closed toward one side like a monk's robe. His crown is placed low on his head, so the jewel in the center just touches his forehead. Gakkō wears an outer robe caught at the neckline by a lotus-blossom ornament and tied at the waist with a long ribbon that falls almost to the ground. His crown is placed higher on his head, and the central jewel touches only his hair.

Scholars today consider that, in addition to their guest status, these two images were probably not originally intended to be Nikkō and Gakkō, but instead are representations of Bonten and Taishakuten. These two are the ancient Vedic Indian gods Brahma and Indra, who in Japanese Buddhism became chiefs among the guardian king figures, largely made up of deities incorporated into Buddhism from other religions that it encountered. Although these deities have not as yet achieved full Enlightenment, they have pledged themselves to the guardianship of Buddhism. Among these, we have already been introduced to the Shitennō (Four Guardian Kings), who rank just below Bonten and Taishakuten. The names Nikkō and Gakkō were probably attached to these two images at a later time, when the pair of dry-lacquer images of Bonten and Taishakuten were made for the Hokkedō altar (see Fig. 116). One of the reasons scholars have identified the Nikkō and Gakkō images as originally having been Bonten and Taishakuten is their similarity to these more definitely identified lacquer images.

In Tōdaiji's **kaidanin** (ordination hall) is another important set of clay sculptures of the Shitennō (Four Guardian Kings) that bear a striking resemblance to the two clay sculptures of Nikkō and Gakkō in the Hokkedō. Like those images, the Shitennō are modeled in clay over a wooden armature, and are of roughly the same dimensions, about 6 feet (2 m)

period. The name means "Kannon of the never-empty lasso" and derives from the concept that this figure has the strength to lasso beings ensnared in delusion and bring them to the safety of Enlightenment. To further emphasize his power, the deity has an additional eye in the middle of the forehead and eight arms. Two are pressed together in front of the chest; the other six radiate out around the figure, holding symbols of this manifestation: the lotus blossom of Buddhist wisdom, often carried by Kannon; a pilgrim's staff; and the lasso. Behind the figure is an openwork metal halo consisting of flame patterns attached to metal bands that repeat the oval outline of the figure and to smaller straight wires that radiate out, suggesting the golden light Kannon's body emits. The Fukūkenjaku Kannon wears an openwork silver crown, to which is attached a silver image of a standing Amida Buddha, of whom he is a manifestation. Eight-armed images of entities are related to the introduction of the so-called esoteric or tantric teachings that in the next century would begin to play such a prominent role in Japanese Buddhism. The statue is a beautifully realized image creating the impression of energetic tension, particularly in such details as the hands.

The quality of the materials and technical skill used suggest that the figure was made in the official government-controlled Buddhist atelier under the direction of Kuninaka

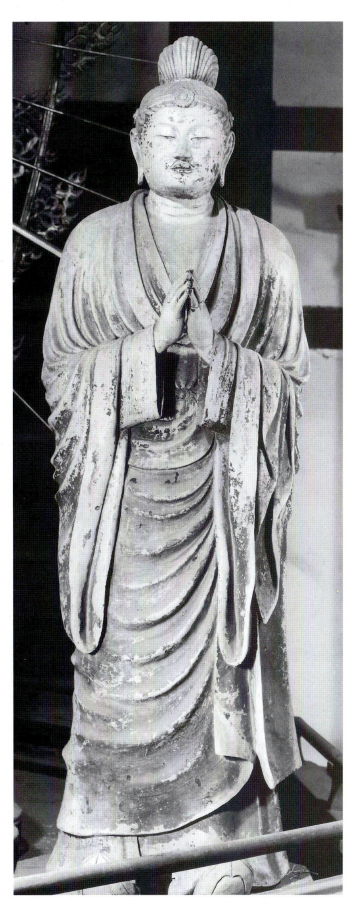

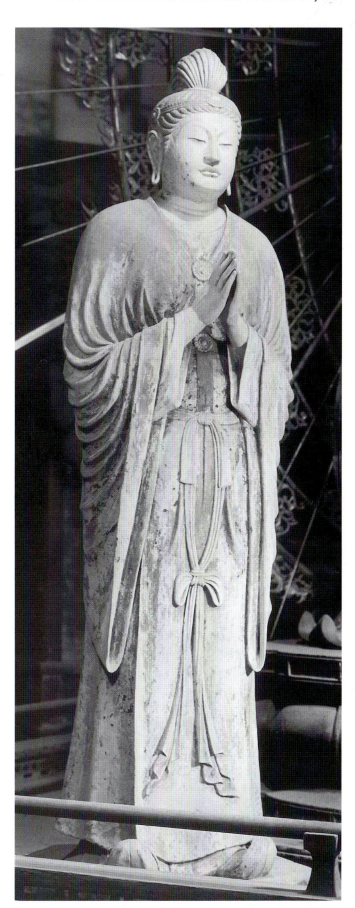

109 *Nikkō*, in the Hokkedō, Tōdaiji. Mid-8th century. Clay with remains of paint; height 81 ⅛ in. (206 cm).

110 *Gakkō*, in the Hokkedō, Tōdaiji. Mid-8th century. Clay with remains of paint; height 81 ½ in. (207 cm).

tall. The Shitennō are superb sculptures, displaying great sensitivity of handling and an effort on the part of the artist to create individualized images. The figures all wear armor over—rather than under—cloth robes, and no two images are quite the same. Each figure holds his specific attribute: Tamonten the reliquary (Fig. 111), Kōmokuten brush and scroll (originals now lost) (Fig. 112), Jikokuten a long sword (Fig. 113), and Zōchōten's right arm is raised to hold a lance (Fig. 114), although the present weapon is a later replacement. All the sculptures stand in hip-slung poses, each

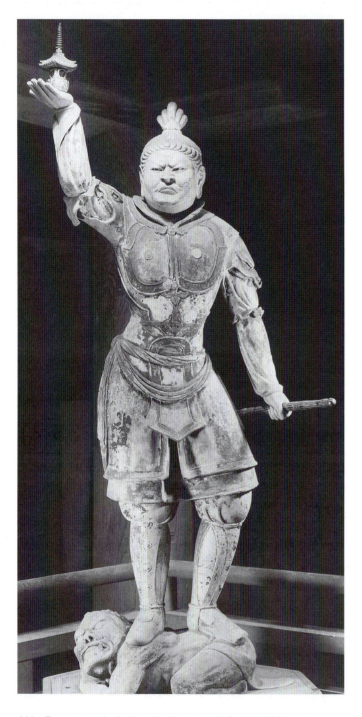

111 *Tamonten*, in the *kaidanin* (ordination hall), Tōdaiji. Mid-8th century. Clay with remains of paint; height 64 ¾ in. (164.5 cm).

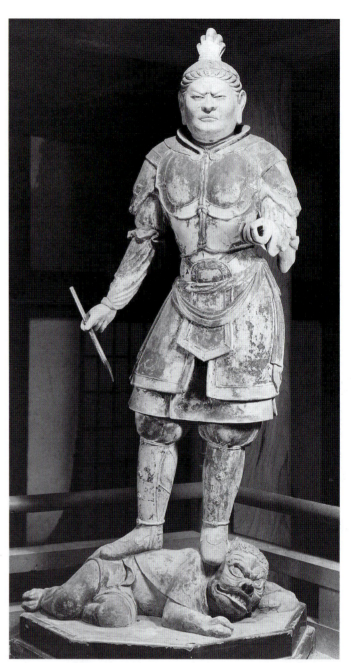

112 *Kōmokuten*, in the *kaidanin* (ordination hall), Tōdaiji. Mid-8th century. Clay with remains of paint; height 64 in. (162.7 cm).

trampling a subdued demon. Undoubtedly these four guardians were made for a small platform with intimate viewing conditions, where the similarities and dissonances of form could be appreciated.

Another clay image in the Hokkedō, but perhaps not originally meant for this building, is also a guardian image (Fig. 115). This sculpture of Shūkongōjin (SKT. Vajrapani) is associated with the establishment of Rōben's original temple of Konshōji, in 733, and presumed identical with the Hokkedō. According to the *Nihon ryōiki*, a collection of Buddhist narratives compiled around 820 by the monk Kyōkai, in Rōben's original hermitage was installed an image of Shūkongōjin,

Shūkongōjin is one of the *kongōjin*, the lowest ranking of all the Guardian Kings, and amongst whom are also the Kongō Rikishi (often presented as a pair and called the Niō, or Two Kings). They are generally portrayed as fierce muscular deities, as demonstrated in this instance by the glaring, grimacing figure clutching a diamond thunderbolt, or **kongō**(SKT. **vajra**). When not on display, the Shūkongōjin is installed in a lacquer cabinet in a screened-off area behind the main altar of the Hokkedō. Because of this, the sculpture is in a remarkable state of preservation, and its clay surface still retains a great deal of the original gold leaf and painted detailing. The

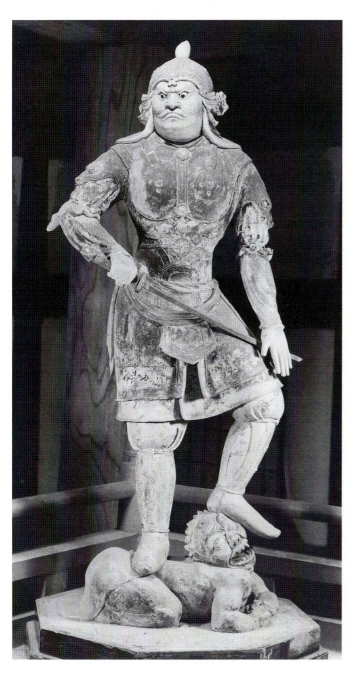

113 *Jikokuten*, in the *kaidanin* (ordination hall), Tōdaiji. Mid-8th century. Clay with remains of paint; height 60 in. (152.4 cm).

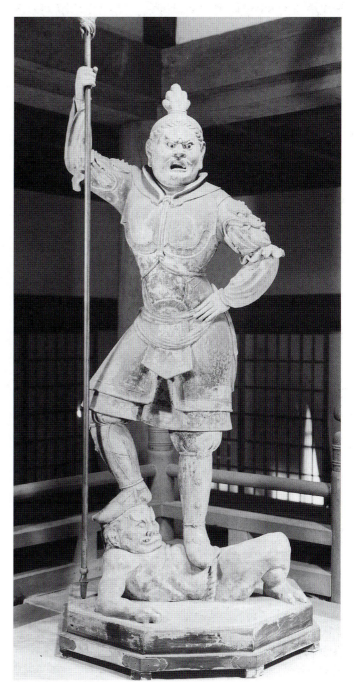

114 *Zōchōten*, in the *kaidanin* (ordination hall), Tōdaiji. Mid-8th century. Clay with remains of paint; height 64 ¾ in. (164.5 cm).

who is the embodiment of the power of Enlightenment. When Rōben read his sutras, holding a rope he had tied around the leg of the image, the image glowed and the light reached the imperial palace down in the city below. Emperor Shōmu sent an official to discover its source, and, learning that the light appeared when Rōben was praying to become a monk, Shōmu granted his wish and had a temple, the Konshōji, built for him. This treasured image is associated with the one originally in Rōben's hermitage, although it was probably created for the Konshōji. The Shūkongōjin, therefore, has the distinction of being a secret treasure of the temple, and is displayed only once a year.

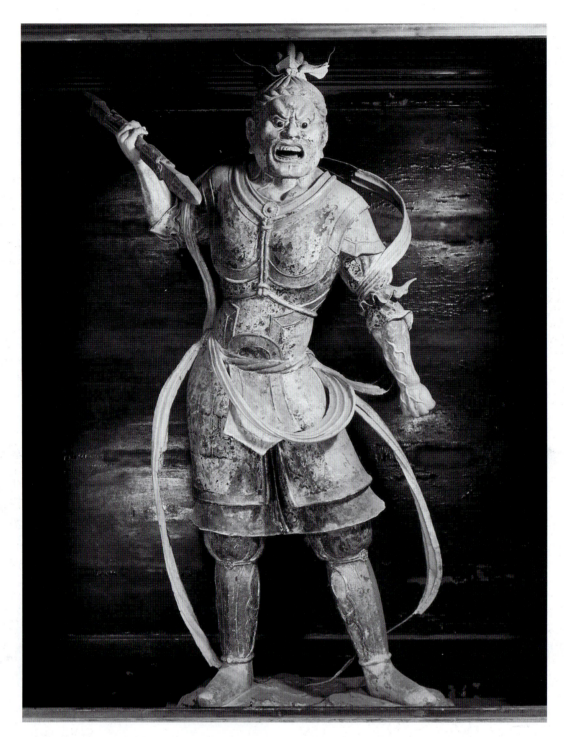

115 *Shūkongōjin*, in the Hokkedō (Sangatsudō), Tōdaiji, Nara. 733. Painted clay; height 68 ½ in. (173.9 cm).

Shūkongōjin is slightly larger than the Shitennō, standing at around 6 feet (2 m), but it is clad in the manner of the Shitennō figures in a robe decorated with brightly colored floral patterns under Chinese-style armor. Shūkongōjin's face, however, has the exaggerated qualities common to the *kongō jin*. The deity stands with both feet flat on the ground, but he seems to move in space, his scarves swinging out behind him.

The Shūkongōjin and the Nikkō and Gakkō of the Hokkedō share with the Shitennō of the *kaidanin* a certain quality of naturalism. Whether or not these seven images were made to be placed together on a particular altar cannot be established, but it seems likely that they were all made by the same atelier and should be dated to the second quarter of the eighth century. They are truly some of the finest pieces that were produced in the Nara period.

The six guardian figures that stand on the Hokkedō altar around the Fukūkenjaku Kannon, Nikkō, and Gakkō are all of dry lacquer and are almost 10 feet (3 m) in height. The Niō

and Shitennō figures share a common style, with solid, three-dimensional bodies and drapery that falls in graceful patterns. Their faces are molded convincingly in scowling expressions, but in contrast to the clay guardian figures discussed above they appear a little stiff. However, the images of Bonten and Taishakuten (Fig. 116) form a sharp contrast with the other dry-lacquer guardians images on the altar, mainly because of their size—they are both about 13 feet (4 m) tall. In addition, however, whereas there is an energetic vitality in the Fukūkenjaku Kannon and the other six guardian figures, these two stand quietly, with their arms gracefully extended forward. They are impressive because of their over-lifesize dimensions, not their inner vitality. Bonten and Taishakuten figures began to appear in conjunction with the Shitennō in the Nara period. This large pair was probably made in the official Buddhist workshop, but whether or not they were intended specifically to accompany the Kannon and the other guardians on the Hokkedō altar or whether like the Nikkō and Gakkō they are guest sculptures is difficult to say. Many scholars place the dates for these images in the late 750s, on the basis of slight differences in style from the Kannon, which was made in the 740s, and on the assumption that work on the statues in the Daibutsuden demanded so much time and

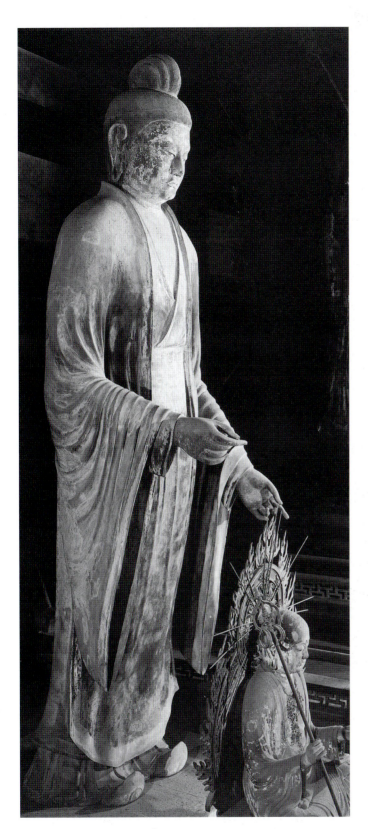

116 (above) *Taishakuten* (with Jizō below), Hokkedō, Tōdaiji. 2nd half of the 8th century. Dry lacquer with paint; height 159 in. (401 cm).

117 (right) *Tanjo Shaka* (Shakyamuni Buddha at birth), Tōdaiji. Nara period, 8th century. Gilt bronze; height 18 ¾ in. (47.5 cm). Tōdaiji temple, Nara.

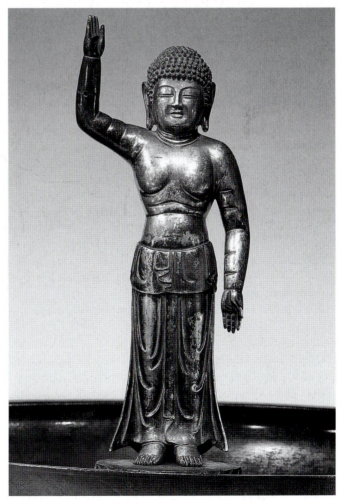

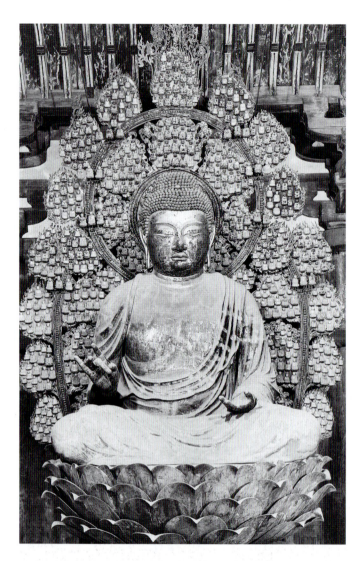

118 *Birushana Buddha*, in the *kondō*, Tōshōdaiji. 2nd half of the 8th century. Dry lacquer with gold leaf; height 120 in. (304 cm).

money that no other projects were undertaken until the work on the main *hondō* was finished.

Before leaving the Tōdaiji, it is worth looking at one of its smaller sculptural treasures, a small gilt-bronze image of Tanjo Shaka, Shakyamuni Buddha at birth (Fig. 117). The image was a popular one of the period, and is meant to represent the moment that the new-born Shaka, already with all the marks of a Buddha, raises his left arm towards heaven and lowers his right arm to the earth and proclaims that he is the lord of all that is above and below the heavens. According to Tōdaiji's traditions, this image was made for the eye-opening ceremony for the great Birushana image in 752. However, Tanjo Shaka images were specifically the centerpiece of a ritual practiced annually on the anniversary of the Buddha's birth, when five-colored water is ladled over the image. The round basin, in which the image stands and which receives this libation, is incised with landscapes and figures according to the Tang style and not unlike those seen on the leather wrapping-cloth in Figure 57. The image itself wears a simple

skirt and is modeled with the full form and curves typical of this period, although it does not attain to the plasticity of either Tōdaiji's dry-lacquer or clay sculptures.

ARTS OF THE LATE-NARA PERIOD

Another important site for Nara-period sculptures is the temple built for the Chinese monk Ganjin, the Tōshōdaiji. It is here that we first see a shift from the elegant realism that reached its greatest expression in the first half of the eighth century to a more sober and stylized aesthetic. Key images in this new style are the central image of the *kondō*'s altar of Birushana Buddha, which was probably made around 759 when the temple was first pledged, and a sculptural portrait of Ganjin in the Founder's Hall, dated to the year of his death in 763. Both statues were made by the hollow dry-lacquer technique.

The seated Birushana is a large image, some 10 feet (3m) tall, and is completely covered with gold leaf (Fig. 118). It is the largest example of seated Buddha made of dry lacquer extant from the Nara period. However, it is its style that truly distinguishes it from contemporary images. The body is fully formed in three dimensions, but the modeling in this case is not intended to evoke the naturalism seen in sculptures earlier in the eighth century. Instead, it espouses a stylized aesthetic of heavy fleshiness. The neck is short and almost as thick as the head, and the profile of the face curves up and outward from the receding chin to the eyes and eyebrows, which are greatly elongated, extending almost to the hairline near the ears. In contrast to the abstraction of the body and the face, the drapery flows in a simple pattern of irregular folds across the torso and the lap of the figure. This Birushana is set against a wooden halo that is covered with hundreds of tiny images of seated Buddhas, and the petals of the lotus-flower base originally were decorated with painted representations of Buddhas and their attendant bodhisattvas. These images emphasize Birushana's position as the Universal Buddha, of whom all else is an emanation.

Another unusual attribute of this Birushana Buddha is the fact that we know something about the people who made it. In 1917, when repair work on the statue was undertaken, an ink inscription was uncovered, listing the names of Mononobe Hirotari, Nuribe Otomaro, and Jōfuku. The scholar Sugiyama Jirō has suggested this means that Hirotari was an administrative assistant in the government-controlled Buddhist workshop who supervised the probably Korean workers who actually did the job; that Nuribe Otomaro was responsible for the lacquer work; and that Jōfuku was the monk from Tōshōdaiji who oversaw the progress of the project. Sugiyama's conclusion—that the Birushana was made in the official Buddhist atelier sometime in the early 760s—is certainly supported by the quality of the image and the luxuriance of its halo.

The portrait sculpture of the monk Ganjin preserved in the Founder's Hall at Tōshōdaiji (Fig. 119) is the earliest extant example of true portrait sculpture in Japan, although the urge

toward capturing a lifelike image can be seen as early as 711 in the tableaux sculptures in the Hōryūji pagoda (see Figs 99 and 100). Ganjin is shown sitting cross-legged, his hands in the position for meditation, the lids of his blind eyes almost closed. The dry-lacquer medium has been used for maximum effect. The planes of the face, the musculature of the neck, the ribs, and the folds of the drapery have been carefully and nat-uralistically modeled, but with a minimum of specific detail, which would otherwise detract from the impressiveness of the form. The surface of the sculpture has been painted and the brocade patterns of the outer robe clearly delineated, forming a strong contrast with the flesh tones of the face and the solid red of the undergarment.

Two works that can be dated to the years between the late 760s and the early 770s because of their subject matter are representations of Kichijōten, the Indian deity Lakshmi, the goddess of wealth and good fortune. Worship of this divinity became popular in the years after 767, and prayers were offered to her in order to secure adequate rains and an abun-dant harvest. A clay image of Kichijōten dated to 772, when full-scale services were held in her honor at the temple, has been preserved in the Hokkedō of Tōshōdaiji (Fig. 120), and a painting of the deity, dated to the same general period, exists in Yakushiji (Fig. 121). Both works depict a beautiful

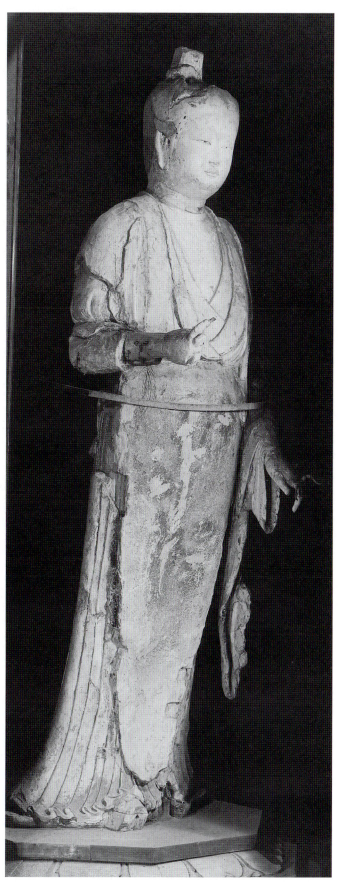

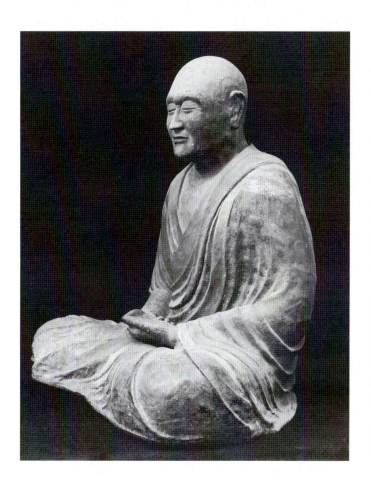

119 *The Priest Ganjin*, in the *mieidō* (founder's hall), Tōshōdaiji. 763.
Dry lacquer with paint; height 31 ¾ in. (80.6 cm).

120 *Kichijōten*, in the Hokkedō, Tōshōdaiji. 772.
Clay; height 78 in. (202 cm).

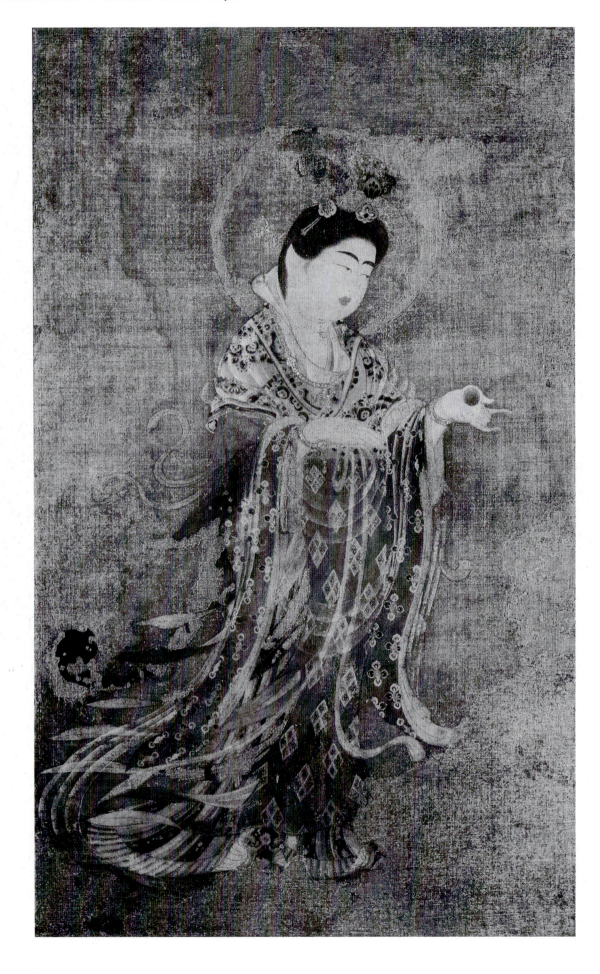

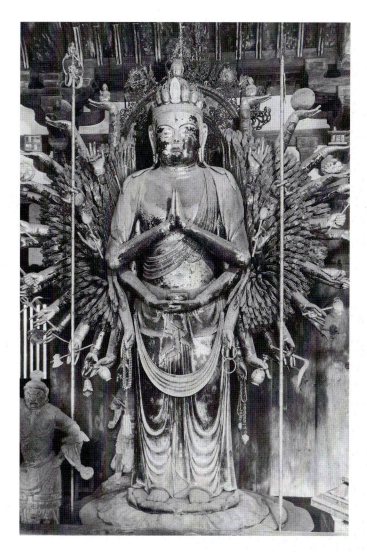

122 *Thousand-Armed Kannon*, in the *kondō*, Tōshōdaiji. 2nd half of the 8th century. Dry lacquer over wood; height 211 in. (536 cm).

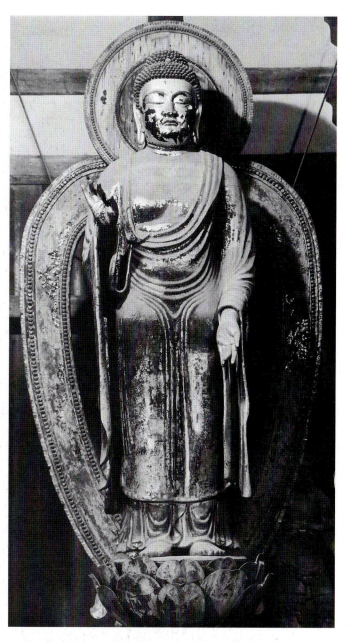

123 *Yakushi*, in the *kondō*, Tōshōdaiji, Nara. Late 8th to early 9th century. Dry lacquer over wood; height 132 in. (336 cm).

"full-figured" court lady typical of Tang Chinese tastes. The sculpture, which has suffered considerable damage, presents the epitome of eighth-century female beauty—a full round face, long narrow eyes, a tiny rosebud mouth, and a full, elegantly curving body. The painting, in bright colors and gold on hemp cloth, depicts the same ideal of Chinese beauty as a seemingly weightless figure moving through the air, her diaphanous scarves trailing behind her.

Two sculptures stylistically close the Nara period: an eleven-headed, thousand-armed Kannon (Fig. 122) and a standing Yakushi (Fig. 123), both of which flank the Birushana Buddha in the *kondō* of Tōshōdaiji. The Yakushi can be securely dated to some time after 796—officially after the removal to Heian—because one of the three coins placed in the cavity of the image is inscribed with that date. The thousand-armed Kannon, a form of the bodhisattva revered

121 (opposite) *Kichijōten* in Yakushiji, Nara. 3rd quarter of the 8th century. Color on hemp; height 20 ⅞ in. (52.9 cm).

by Ganjin as the protector of travelers, is thought by its style to be somewhat earlier, perhaps from the 780s. Both statues are of dry lacquer, but, instead of this being modeled over a clay core which is taken out after the lacquer shell dries, these two sculptures are modeled on a wooden core that remains inside the finished statue (see page 86). Probably the technique was first brought over by monk-sculptors who accompanied Ganjin on his journey to Japan. Its appearance in the late eighth century signals a new direction in Buddhist image-making, a return to wood as the preferred material in which to produce sculpture.

The eleven-headed, thousand-armed Kannon is the only such image in Japan to have actually had a full one thousand

魔益念懟更增戰力
菩薩觀之如童子戲
日切齒或橫飛亂擲
威力摧破菩薩或角
魔眾手相推切各盡
決定當成正覺是諸
奇我未曾有也菩薩
鹿羣甘忿歎言嗚呼
異相猶如師子處於
動天地菩薩心定顏無
繞菩薩發大惡聲震
魔軍眾无量无過圍
是來下側塞虛空見
慈悲心而愍傷之於
此惡魔慅亂菩薩以
孔雀流淨居天眾見
念魔眾瞋恚增盛毛
法天人諸龍鬼等恋
大海水一時涌沸謹
火炬塵暗无所見四

124 Detail of *Temptation of Mara*, detail from *E inga kyō*, in Daigoji, Kyoto. Mid-8th century. Sutra scroll, ink and color on paper; height 10 ⅜ in. (26.3 cm).

arms. Today, forty-seven have disappeared, but the remainder can be divided into three groups according to size. Six arms are normally proportioned for the figure. In addition, there are thirty-four of slightly smaller size, all holding attributes, and 913 tiny hands. Taken together, they seem to surround the image like a second halo. Above the crown there are eleven heads, and in the middle of them a standing image of Amida Buddha, of whom Kannon is an aspect. The multiplication of heads and arms expresses the great efficacy of the deity. Continuing the trend first seen in Tōshōdaiji's Birushana, the Kannon is stockily modeled, and the drapery, particularly that of the skirt, is stretched tightly over the thighs and falls in thick, stylized folds.

In the Yakushi the stylization has gone a bit further. The drapery swathing the stocky body is articulated with deep folds, repeated in groups of three over the chest. Below the waist the robe is pulled tightly over the thighs and falls in vertical folds on either side of the legs. The figure is not merely stockier than earlier statues, but has a somewhat square head,

which seems to be set directly in the middle of the shoulders with hardly any neck. It is only a short step stylistically from this Yakushi image to the possibly contemporaneous standing Yakushi at Jingoji, outside Kyoto (see Fig. 160).

From these last decades of the eighth century comes the earliest extant example of a painting format that would prove one of the most enduringly popular over the next millennium —the horizontal, illustrated narrative scroll, or *emakimono* (literally "rolled pictures"). The *E inga kyō*, or more formally *Kako genzai inga kyō* (*Sutra of Cause and Effect*), is comprised of eight illustrated scrolls depicting the life of Shaka Buddha from his youth in his father's palace to his preaching to the faithful after he had attained Enlightenment, as well as some *jataka* scenes from his previous incarnations (Fig. 124). These eight scrolls belonging to the temples of Jōbonrendaiji in Nara and Daigoji in Kyoto are in fact fragments surviving from several different sets, each produced by a different hand. Nevertheless they provide some of the flavor of this first-known *emakimono*.

龍頭熊羆虎光及諸
獸頭或一身多頭或
面各一目或衆多目或
大腹長身或羸瘦无
頭或長脚大膝或大
脚肥腨或長牙利介
或頭在匈前或兩乏
多身或大面傍面或
色如灰土或身放烟
爛或鳥耳擔山或被
髮裸形或復面色半
赤半白或肩垂至地
或上褰面或身著
膚皮或師子蛇皮或
蚰遍纏身或頭上大
燃或瞋目怒辟或傍
行跳擲或空中掟轉
或馳擲或吼噬有如是
等諸惡類形不可稱
數圍繞菩薩或復有

In this format, text and illustration appear in close proximity on the surface of a horizontal scroll, which is unrolled from right to left. Here, in this eighth-century scroll, the illustrations appear above the text rather than next to it, as they will in *emaki* of the late Heian and Kamakura periods. Furthermore, the amount of space allotted to each illustration is controlled by the text below, so that the two are strictly coordinated. It is generally accepted that the *E inga kyō* scrolls were stylistically based on a Chinese prototype from the late sixth or early seventh century, and were copied sometime during the years between 749 and 756. In the *E inga kyō*, the scenes are separated into space cells; in the case of the fragment illustrated in Figure 124, the framing motif is a pair of tall mountains capped with trees. The colors used are unshaded areas of red, orange, green, white, and black.

One of the most dramatic scenes amongst the eight scrolls is the temptation of Mara, who is the embodiment of all of Buddhism's enemies. As Shaka approaches Enlightenment, Mara tries to deflect his attention by sending his daughters to seduce the Buddha-to-be, and subsequently hordes of demons to frighten and attack him. Shaka's concentration is nevertheless unshaken and he achieves Enlightenment, touching the ground in front of him to ask the earth to be witness of his spiritual transcendence. As he does this, a spring of water begins to flow in front of him. This image of the Buddha calling the earth to witness by touching the ground is one of the most popular images of Shaka. The particular "earth witness" hand gesture is known as *sokuchi-in* (SKT. *bhumisparshamudra*), and is commonly used on other Buddhist images in addition to those of Shaka, and always with the same reference to Enlightenment.

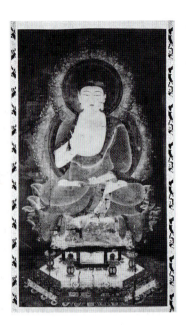

CHAPTER 3
Capital of Peace and Tranquillity

THE HEIAN PERIOD AND THE COMING OF AGE OF A NATIVE AESTHETIC

Lasting from the mid-sixth through the eighth century, the Asuka, Hakuhō, and Nara periods had been centuries of strong Chinese and Korean influence on Japanese religious and secular institutions. Buddhism grew to dominate Japanese culture during these two and a half centuries, exerting great power in the spiritual and political affairs of the nation. The process of absorbing all of this foreign influence also sparked within the Japanese consciousness a desire to consolidate and develop it into their own distinctive artistic and cultural forms, a transformation that would be completed to stunning effect in the Heian period. The Heian period (794–1185) takes its name from the new capital established in 794 at Heian, or Capital of Peace and Tranquillity, a variation on the Tang Chinese capital's name of Chang'an (Everlasting Peace). The city's present name, Kyoto, simply means "capital" and was an alternate name applied to an imperial city as early as the Nara period. Heian was primarily known as such for the three hundred years after its foundation, but from the end of the eleventh century it would come increasingly to be known simply as Kyoto.

Overbearing Monks and Vengeful Ghosts

The reason for moving the seat of government from Heijō has been traditionally ascribed to the decision of Emperor Kanmu (r. 781–806) and the court to distance the seat of secular power from the centers of the six Buddhist schools, taking warning from the career of the ambitious monk Dōkyō and his pretensions to the throne in the reign of Empress Koken (749–59, 765–70). A new capital was begun in 784 at Nagaoka, southwest of present-day Kyoto and now a suburb of the city. However, after only ten years of occupation the site was abandoned. The reason was a series of fires and other

calamities, the cause of which was held to be the ghosts of two political enemies whose mutual nemesis had been involvement in Nagaoka's founding. The first ghost was that of Fujiwara no Tangetsu, who had chosen and purchased for the emperor the site of Nagaoka. The second was his arch enemy, Sawara, a prince of the imperial house. Both men met untimely and violent deaths due to their feud, and their baleful influence was felt by the emperor and court to have permanently tainted the Nagaoka site.

The place chosen for the new capital of Heian was a gently sloping plain just to the north, and almost 25 miles (40 km) northwest of Heijō (which had been renamed Nara) and the great Buddhist temples which remained there. Heian's location satisfied all the requirements of Chinese geomancy: as with Fujiwara and Heijō, it was flanked on three sides by mountains and in addition was bordered by two relatively large rivers, the Kamo to the east and the Katsura to the southwest. Over time, the mountains came to be called the Eastern, Northern, and Western Hills (Higashiyama, Kitayama, and Nishiyama). Kyoto remained the capital of Japan for more than a thousand years, until the emperor moved the court to Tokyo in 1868.

The Heian period embraces four centuries that have been divided into three distinct phases: Early Heian (794–951), Middle Heian or Fujiwara (951–1086), and Late Heian or Insei (1086–1185). The shift in power from the Buddhist community back into the hands of the powerful aristocratic families is fully realized early in this period, and by connection the court culture that had begun to develop with the influx of all the Tang Chinese cultural influences achieves—in the reckoning of many—its greatest refinement. Buddhism, allowed only a limited presence within the capital itself, reorients itself into esoteric cults focused on complex philosophies and rituals as

well as into more populist "saviour" movements that helped for the first time spread the religion widely amongst the common people.

EARLY HEIAN PERIOD

The Heian period begins with a continued adherence to Chinese secular and religious precedents, but by the end of its first century there is an overwhelming sense on the part of the Japanese that they have nothing more to gain from contact with China, and that their country has, in fact, surpassed its model. In 894, imperially sponsored embassies to Tang China were abolished, and a little more than ten years later that dynasty fell and the Chinese mainland once again descended into political chaos. While keeping up trade contacts with the continent, the court and aristocracy looked increasingly to themselves as the center of all things, until to leave the capital's environs for more than a very limited time could be interpreted by "society" as practically ceasing to exist. The Japanese people began to examine afresh their artistic environment—their architecture, painting, and sculpture—and to rework old styles and techniques to suit a newly emerging national taste. At the same time, the provinces which in the seventh century had been taken back under direct imperial control had largely, by the beginning of the Heian period, been gifted out to various aristocratic clans—most prominently the Fujiwara—in the form of *shōen*, or estates.

MIDDLE HEIAN OR FUJIWARA PERIOD

The Fujiwara, who from the mid-seventh century onward had taken an active and dominant role in the new Chinese-style imperial government, came to dominate it almost entirely from the late ninth century until the end of the eleventh century, and continued to be a powerful political force until the middle of the twelfth century. And it is for this reason that the Middle Heian period (951–1086)—the height of their influence—is often referred to as the Fujiwara period. In 858, the Fujiwara established a new form of government in direct opposition to that of the Taika Reforms of 645; appointing themselves regents (*sesshō*) and civil dictators (*kanpaku*), they ruled in the name of the emperor. By this time, the Fujiwara clan had intermarried with the Yamato so extensively that the head of the Fujiwara clan, acting as *sesshō* or *kanpaku*, would usually be either the grandfather or uncle and probably also father-in-law of the emperor. With the institution of the *sesshō* and *kanpaku* system, once a Fujiwara consort of an emperor produced an heir apparent, the emperor was encouraged to abdicate and his Fujiwara father-in-law was named initially *sesshō* for the new emperor, and then *kanpaku* when the young ruler came of age. Apart from giving them a stranglehold on government, this structure also enabled the Fujiwara clan leaders to circumvent the mandate for government taxation by the emperor as it was set out in the Taika Reforms.

In order to avoid paying onerous taxes to the central government, other powerful clan leaders and Buddhist temples also pressed the emperor to have their *shōen* lands made tax exempt. The *shōen* of other aristocratic families or temples could then become a kind of vassal-estate of one of these tax-exempted *shōen* in exchange for similar protection from government intrusion. Many of the *shōen* owners themselves were increasingly loathe to leave the capital to oversee even occasionally this important basis for their wealth, and the affairs of the *shōen* were left more and more to local estate managers, who could be lesser members of the clan or simply a local, but capable strongman or even shopkeeper. Under these managers were the peasant farmers, who worked their land more or less as bonded serfs. A single *shōen* often consisted of separate holdings scattered over a large area—a legacy of each clan's original imperial "gifts," as well as the result of centuries of intermarriage and inheritance. By careful manipulation of this *shōen* system, the Fujiwara maintained control not only of the government, but also of the best source of revenue at the time.

In the Fujiwara period, Japanese culture flourished as never before. From the advent of their control over the government in 858 until the civil wars of the mid-twelfth century, peace prevailed in Heian, and the aristocracy had the leisure and the financial means to undertake aesthetic pursuits such as writing poetry, playing the *biwa* (lute) and the *koto* (zither), and blending incense, and religious activities such as copying Buddhist sutras and making preparations for elaborate Buddhist ceremonies. Poetry became an essential means of polite communication between noblemen and noblewomen, and prose, most notably the **Genji monogatari** (**Tale of Genji**) achieved a very high level of literary expression. The Fujiwara period also witnessed the construction of lavish temples, modeled to a large extent after mansions built for the aristocracy. These times have been described by the historian Sir George Sansom as "The Rule of Taste."

LATE HEIAN OR INSEI PERIOD

From the mid-eleventh century, the imperial clan actively sought to wrest control of the government from the Fujiwara and to rebuild its own financial strength by developing ways to generate income outside the system of taxation established by the Taika Reforms of 645, a system more honored in the breach than in the observance. Emperor Go Sanjō (r. 1068–72) was the first emperor in many decades to be born of a non-Fujiwara mother. Being therefore relatively immune to the dictates of the Fujiwara clan, he was able to formulate the concept that led to the establishment of the *insei*, or government by cloistered, retired emperors. His idea was to abdicate the throne, withdraw to a Buddhist temple of his own founding, and become a monk. However, he also expected to continue to govern the country through his son, the reigning emperor. Since he no longer held an official position within the hierarchy, he could receive donations of land to the *shōen* he

controlled, and thus also the income they generated, through the intermediary of the temples he and his family had founded. At the same time, members of the aristocracy who wanted to amass merit in both this life and the next could make donations to an imperially sponsored temple, with benefits accruing to all. Thus begins the Late Heian, or Insei, period (1086–1185).

Because Emperor Go Sanjō died shortly after abdicating the throne in 1072, he was unable to put his concept of government by cloistered ex-emperors into practice. However, his son Shirakawa (1053–1129) followed his lead with great success. Ascending to the throne in 1072, Shirakawa ruled as emperor until 1086, when he retired. For the following forty-three years he very effectively directed the government from his cloistered retirement. Shirakawa was without doubt the most effective leader among the three retired emperors of the Late Heian period. His son Toba (1103–56; r. 1107–23), who succeeded to the position of *insei* in 1129 continued the *insei* government for twenty-seven years, but by the time of his death in 1156, the imperial clan was badly split by a succession dispute. Nevertheless, the courts of Shirakawa and Toba outrivaled in opulence those of the most powerful members of the Fujiwara clan.

REBELLION

After Toba's death in 1156, a series of succession disputes within the imperial Yamato and the Fujiwara clans resulted in two rebellions, the **Hōgen** (1156) and the **Heiji** (or Heike; 1160), in which the opposing factions sought the aid of two military clans, the Taira and the Minamoto. Both clans were descended from minor imperial princes of the ninth century, and they had gained considerable power as managers of *shōen* in the provinces, which they had been given to oversee by the imperial house. For three hundred years the aristocracy in the capital had ignored the provinces, leaving such managers to oversee their affairs there. As a consequence, these managers slowly garnered not only wealth but considerable military power, and were called on by the court and capital to put down any peasant rebellions or resolve any political disputes. The disputes among the imperial Yamato, the Fujiwara, and the Taira and Minamoto were finally resolved through the Genpei Civil War, which lasted from 1180 to 1185 and which was bitterly fought throughout the country, not excluding the capital or the ancient Buddhist center of Nara. Its close, in 1185, marks the end of the Heian period and the control of the government through the emperor and the court. The Taira clan was almost completely wiped out in an epic sea battle which ended with the women of the Taira household leaping to watery graves clutching the infant Emperor Antoku.

The victorious Minamoto established a new form of military dictatorship, the **bakufu**, which under one military clan or another would oversee the governing of the nation until 1868 and the imperial restoration. They also removed the center of actual government to the eastern coast of Honshū at

A	Daidairi (greater Imperial Palace)	6	Rashōmon)	10	Nishi Shanjōdono
1	Dairi (Imperial Residence)	7	Shinsenen	11	Western Market
2	Chōdōin	8	Ukyō-tsukasa (office of the right side of the capital)	12	Eastern Market
3	Barakuin			13	Saiji (Western Temple)
4	Shingonin	9	Sakyō-tsukasa (office of the left side of the capital)	14	Kyōōgokokuji (Tōji, Eastern Temple)
5	Suzakumon				

125 Plan of Heiankyō (Kyoto as originally laid out).

Kamakura. Although largely powerless, the system of *insei* did continue until the faction of the last cloistered emperor, Go Toba (1179–1239; r. 1184–98), was defeated in the **Jōkyū Rebellion** of 1221. Until the restoration of 1868, the emperor and his court faded at times into an almost provincial irrelevance—a bitterly ironic twist of fate.

THE ARTS IN THE LATE HEIAN PERIOD

Although the Late Heian period concluded with the demise of the glitter and elegance of court life, it had begun with an opulence far greater than that seen under the rule of even the most powerful Fujiwara clan leaders. The chief focus of the imperial family was, not surprisingly, on the founding of Yamato clan temples. It has been calculated that between the late eleventh and the middle of the twelfth century the retired emperor, his kin, and his loyal subjects dedicated a new Shinto worship hall every year and founded a Buddhist temple every five years. During this period a great deal of time and money were devoted to secular projects as well. A lavish set of perhaps one hundred paintings illustrating excerpts from the *Genji monogatari* has survived to the present, and quite probably many more were produced (see Figs 140 and 141). Poems of the so-called thirty-six immortal poets, the Sanjūrokunin, were copied onto scrolls made of gorgeous colored papers decorated with gold and silver designs (see Fig. 136).

The Taira family made a richly ornamented set of thirty-three scrolls of the *Lotus Sutra* (JAP. *Myōhōrenge kyō*) and four other Buddhist texts, copying the Chinese characters with gold and silver ink onto decorated paper, and in addition frequently designing and painting elaborate frontispieces. Where, in the Middle Heian, the ladies of the court devoted themselves to writing romances, during the Insei period they apparently devoted considerable time to painting. Some of the frontispieces of the Taira's *Lotus Sutra*, known as the *Heike nōkyō* (*Sutra Offering of the Taira Family*), were painted by Taira ladies (see Fig. 194), and in a journal entry for 1130 mention is made of a *nyōbo no edokoro*, a painting bureau staffed by women, within the imperial palace. Some aristocrats in the Late Heian period, unlike their predecessors in the previous centuries, took great interest in folktales, in a few cases secular, but most often centered on miraculous events related to temples; and they went so far as to compile them in anthologies. The most famous of these is the *Konjaku monogatari*, an alternate reading of the first two words of each story, "*Imawa mukashi*" (A long time ago). The Late Heian period may have seen the final flowering of Heian court culture, but it was a very rich flowering indeed. Fortunately for later generations, quite a few remnants of that extraordinary Japanese century have survived to the present day.

Heian and the Imperial Palace

As with Fujiwara, Heijō, and Nagaoka before it, Heian was laid out in a rectangular grid—here measuring about 3 miles (5 km) from east to west and 4 miles (6 km) from north to south (Fig. 125). Its streets were plotted in a hatchwork of wide avenues running from north to south and smaller streets crossing from east to west. The palace precinct, which included the government buildings, occupied the four central blocks at the extreme north of the city, while the commercial districts were relegated to an area just to the north of the two major

Buddhist temples that were allowed within the boundaries of the city, Tōji and Saiji in the city's original plans. These were positioned near the southern boundary of the city and ostensibly served as spiritual guardians of Heian's primary entrance, but were also positioned as far away from the emperor and the bureaux of government as possible. The Kyoto of today looks very different from its Heian ancestor. The modern city has shifted to the east and centers on the Kamo River, with its shallow, swiftly running water and cool summer breezes.

The imperial palace complex that exists today has moved to a more central position within the city, located to the east of the original site, and none of the original buildings in the palace enclosure still stand. However, research has established the original layout of the ninth-century imperial residence. The most imposing building within the walled enclosure remained the Chinese-style Daigokuden (Great Audience Hall). Even more enormous than its Fujiwara or Heijō predecessors, it became largely obsolete within several decades of its construction as the official receptions it used to host instead occurred in more intimate and comfortable buildings within the emperor's residential sector of the palace. The Daigokuden stood derelict for much of the period until it burnt down in 1177. It was never rebuilt, but a tribute to it can be found in a scaled-down version at the Heian Shrine of 1895. The two buildings which took on a great many of the functions of the Daigokuden were the Shishinden, used for major ceremonies of state, and, to its northwest and connected by roofed corridors, the Seiryōden, where the emperor lived and held informal audiences. Other buildings, housing the emperor's consorts and ladies-in-waiting as well as such essential structures as the kitchen, a doctor's office, and storerooms for the imperial regalia, extended to the north and east of the two main buildings and were linked to them by covered walkways. The government buildings, as in previous palaces, were located to the south of the Daigokuden near the main entrance gate.

The current Shishinden and Seiryōden date to the nineteenth century and not the early ninth century, but at the time

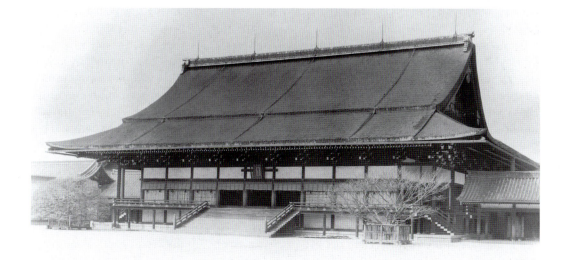

126 View of the Shishinden (Throne Hall), Imperial Palace, Kyoto. Rebuilt in 1855 in the early Heian *shinden* (palace) style.

127 Illustration from *Ban Dainagon ekotoba*, scroll 1, scene 2, showing the interior of the Seiryōden, Imperial Palace, Kyoto, attributed to Tokiwa Mitsunaga. 2nd half of the 12th century. Hand scroll, ink and color on paper; height 12 ⅜ in. (31.5 cm). Idemitsu Art Museum, Tokyo.

of rebuilding every effort was made to reproduce the originals (Fig. 126). The contrast between the two structures offers considerable insight into the way in which Tang culture was assimilated in Japan in the ninth century. The Shishinden, being intended for ceremonial use, is an imposing building supported on tall pillars and capped with a massive double roof of cypress bark. The interior has a wood-plank floor and large wooden platforms; panels depicting Confucian sages stand behind the platforms, forming a wall. The Seiryōden, on the other hand, is much more intimate in scale. It is set on low pillars and has a single cypress-bark roof. Their common roofing material of cypress bark, however, signals another important change. Where great public buildings like the Daigokuden were roofed with tiles, there now is a volte-face in courtly taste for the previously humble and native cypress bark.

Inside these buildings, life continued to be lived on the floor with tatami mats used for sitting and sleeping surfaces. Some idea of the original appearance of the room can be obtained from an illustration in a twelfth-century narrative scroll, the *Ban Dainagon ekotoba* (Fig. 127). In this scene, the emperor, conducting an informal audience with the retired prime minister of the Fujiwara clan, sits on a pillow placed on a low, tatami-covered platform. His back is to a wall formed by

sliding doors (*fusuma*) decorated with Japanese-style (*yamato-e*) landscapes. Outside, on the veranda, a messenger awaits their decision. Behind him is a standing screen decorated with a Chinese-style, or *kara-e*, painting of Lake Kunming, the lake to the south of the Tang emperor's summer retreat. In the last analysis, the Japanese court of the Heian period still looked to China for certain models, but both its public and private rooms become increasingly indigenous in flavor, with occasional Chinese touches to demonstrate its sophistication and education, such as the Lake Kunming screen.

LIFE AT COURT

During this period, the aristocracy living in Heian numbered perhaps no more than one thousand people, but the choices they made about where and how they lived, what they did with their abundant leisure time, and even how they worshiped set the tone for artistic creation in the Heian period and permeated almost every aspect of life in the capital. The ideal of beauty for a woman was to have a round face with tiny features framed by long, flat black hair, her face powdered white, her eyebrows plucked and re-pencilled in, and her teeth blackened. She would dress in the voluminous (and certainly heavy), many-layered silk robes of the period (see Fig. 137). The ideal man would also have a round face and tiny features, and would dress in carefully chosen silk robes of several layers, but of a different cut (see Figs 127, 133, 134, and 135). Both the Heian gentleman and gentlewoman were expected to be the products of, and contribute to, a highly refined courtly

aesthetic, the language of which was expressed in poetry which any one of character and breeding could compose at the drop of a hat. As well as their calligraphy, their clothes and how they wore them and the incense with which they perfumed themselves would all be observed and judged by their peers on both private and public occasions.

Much of the flavor of court life in this era derives from the practice of polygamy. For several reasons, within Heian society it was desirable for a nobleman to have more than one wife. Women often died young, in childbirth, and it was essential that the Heian nobleman have many children as they were the best way for him to gain advancement in rank through the arrangement of an advantageous marriage between a daughter and a courtier of higher rank than himself. The status of a man's wives was strictly governed by their rank within the society of the court. A man was expected to take on as principal wife a woman whose family rank was at least equal to his. The marriage was usually arranged between the parents of the couple, who were often mere children at the time. The preferred minimum age for marriage was fourteen for a boy, twelve for a girl, but it was not uncommon for the bride or groom to be younger. A man was also free to take other women as secondary wives, in openly announced and accepted marriages. He might also have dalliances with women he had no intention of taking under his wing. The example of Fujiwara no Kaneie (929–90) is instructive. In addition to his principal wife, he had eight others. One of them, a nameless woman known only as the mother of the painter Fujiwara no Michitsuna was the author of a diary—the *Kagerō nikki* (*Gossamer Years*), which records that Kaneie had at least one affair with a noblewoman who was of embarrassingly low rank and probably a good many more that the diarist did not bother to record.

The quality of life for a noblewoman in the Heian period was not one most twenty-first-century women would envy at all. From diaries, we know that custom required her to remain hidden from the eyes of all men except for her father and her husband. Consequently, she rarely went outdoors, and indoors she lived in the shaded world of the **shinden**, or mansion, with its large overhanging eaves, its curtains of state, and the folding screens used to partition off areas of the inner space. Since she had a household of servants, she was seldom troubled with routine housekeeping or even the raising of her children, and she was rarely called upon to care for her husband beyond preparing for his occasional visits. Festivals and ceremonies did provide a welcome break, and calligraphy practice and music lessons also occupied some of her hours. Noblewomen, although they were allowed to inherit property and were taught reading, writing, and the cultural pursuits of the day, did not oversee the administration of their economic affairs. A woman, therefore, needed the help of either a husband or male relatives, lovers, or retainers to survive. Thus polygamy was not only an accepted custom among the Heian aristocracy, it was considered to be a social responsibility and also a political necessity.

Shinden

Normally, a nobleman did not at first establish his own household, but rather visited his principal and secondary wives in their own or their parents' residences. However, if after the death of his father the husband succeeded to the position of head of the family or leader of the clan, he would build his own palace and install his wives in separate apartments within the residence. To accommodate live-in wives, a nobleman's *shinden* consisted of a series of halls and smaller buildings linked by covered walkways (Fig. 128). The lord's own quarters were to the south of the other halls. Directly behind and to the north was the hall allotted to the principal wife, the residence from which she derived her title of *kita no kata*, or the person to the north. Behind her hall were the kitchen, servants' quarters, and storerooms. Other wives might be housed in separate halls to the east and west of the mansion's central, north/south axis, but certainly at a discrete distance from the operational center of the principal wife's northern wing. Personal communication between the wives was not the norm, and indeed they could live and die in their lord's mansion without ever laying eyes on one another. In front of each wife's residence hall was a small courtyard garden, and to the south of the lord's quarters was a magnificently landscaped one centered on an artificial pond.

Interior Decoration

Most of life for either the nobleman or noblewoman in the Heian period took place inside these mansions. Built of wood and roofed with bark, none of these original structures or their interiors survive in present-day Kyoto. However, the ample literature of the period, such as the *Genji monogatari* (*Tale of Genji*) and the *Makura no Sōshi* (*The Pillow Book*), as well as illustrated scrolls, such as the *Ban dainagon ekotoba* and *Genji monogatari emaki*, provide a surprising amount of description and illustration of the typical *shinden* interior during the Heian period. As demonstrated by the illustration of the imperial Seiryōden in the *Ban Dainagon* scroll (see Fig. 127)

128 Diagram of *shinden zukuri* architecture, looking from the garden onto the southern quarters belonging to the lord of the house. (After Dr. Mori Ōsamu.)

and another of the aristocratic interior of the Ōtomo house-hold (see Fig. 147), the *shinden* room was subdivided into spaces by large folding screens often painted with kara-e themes or by hanging panels of cloth (often silk), known as curtains of state. The exterior walls of these rooms were actu-ally great latticed wooden shutters covered on the interior with a thick semi-translucent paper which, if the weather was good, could be cantilevered up, exposing the room to the gar-den or courtyard outside. Privacy would be provided by hang-ing bamboo blinds or cloth panel curtains that could be raised or dropped at will (for example, see Figs 133, 134, 140, 141, and 147). As life was still conducted from the floor, the interi-or furnishings continued to develop as clever and highly portable variations on small raised tables and storage boxes (see Fig. 147). From the Asuka to Nara periods the craze for Chinese culture was such that for the elite the greatest prize was to have as many of one's possessions as possible imported from the continent. In the Heian period, while the demand for imported *kara-e* screens seems to have continued unabated, aristocratic preference in other crafts—particularly lacquer and metal wares—seems to have shifted to those of Japanese manufacture and, increasingly, of Japanese-style decoration.

Given their daily use and the wear and tear of time, these objects are better preserved in painting than they are as arti-facts. However, one well-preserved example of a food stand in red lacquer of the eleventh or twelfth century has survived (Fig. 129), and varies only slightly from the one depicted in the center of the room at the Ōtomo family's *shinden* (see Fig. 147). Plain red and black remain the standard colors of Japanese lacquer to this day, and are known as **negoro** wares. The red food stand in Figure 129 is modeled on a wooden core as it would be expected to take the weight of other vessels.

130 Cosmetic Box. Heian period, 12th century. Black lacquer with gold lacquer and mother-of-pearl inlay; 5 ⅓ x 12 x 8 ⅚ in. (13.5 x 30.6 x 22.4 cm). Tokyo National Museum.

However, lightness and plasticity were at a high premium in lacquerware, and many objects eschew wood for a hempen core, the dried layers of lacquer providing rigidity to the final shape of the piece.

The cosmetic box in Figure 130 has almost certainly a hempen core, and in addition is decorated with gold lacquer in a style that is known as **maki-e**, meaning literally "sprinkle painting." The gold design is achieved by sprinkling gold (and often also silver) powder onto the damp lacquer layer covering the previously drawn motifs. Depending on the density of the sprinkled gold dust, the object can appear to be either made of or inlaid with gold. Another layer of black—but also some-times red—lacquer is then applied and polished until the underlying gold reappears. Finally, the entirety is covered in a coat of transparent lacquer effectively to seal it. In the instance of this cosmetic box of the twelfth century, mother-of-pearl and **kirikane**, or cut gold, have also been included in the creation of the motif of wooden wagon wheels left to soak in water as part of their curing process. This popular motif of the Heian period is purely Japanese in concept and design and is derived from poetic imagery.

Another rare survival of the Heian period is an example of one of the larger pieces of lacquer furniture to be found in either a private *shinden* or in a public building or temple. A black lacquer altar table from the provincial temple of Chūsonji in Hiraizumi (Fig. 131) represents the standard type of chapel altar in public temples as well as in the private chapels that noblemen's houses were required to have. There is a row of such altar tables depicted inside the imperial chapel of Shingonin in a scene from the *Nenjū gyōji emaki* (*Scroll of Events Throughout the Year*) (see Fig. 191). The overall design of this style of altar table remains Chinese in flavor as its prototype

129 Food stand. Heian period, 11th/12th century. Red lacquer; height 12 ½ x 15 ¼ x 16 ¼ in. (31.6 x 38.7 x 41.2 cm). Kyoto National Museum.

undoubtedly was. In addition the dense floral pattern of the Chūsonji table is Chinese in character, and possibly derived from brocade designs, but its execution in mother-of-pearl inlay and its almost gaudy *horror vacui* betray a Japanese taste in Chinese style decoration. The native Japanese taste in Japanese-style decoration, however, is a great deal more elegant and finely balanced, as demonstrated by a saddle of black lacquer also inlaid with mother-of-pearl (Fig. 132). The design of clover sprays and spider webs—once again derived from poetic imagery of nature and the seasons—cover the entire surface of the saddle, but do not overcrowd it. This saddle, probably made for a ceremonial procession in the capital and never used outside it, and the cosmetic box are excellent examples of Japanese decoration and both demonstrate how fully the poetic sensibility permeates almost everything in Heian culture.

Gardens

Because Kyoto is situated on a well-watered, slightly sloping plain, it was possible for almost all Heian's *shinden* to be provided with a stream flowing southward to feed a pond merely by digging down in the right spot. Thus there was an even greater explosion of gardens throughout the city than had been the case in either Heijō or Fujiwara. Usually a stream was

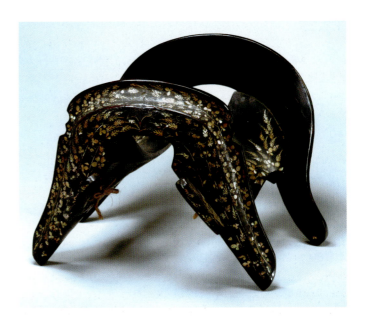

132 Saddle. Heian period, 12th century. Black lacquer with mother-of-pearl inlay; height 11 ⅖ in. (30 cm), width 17 ¼ in. (44 cm). Tokyo National Museum.

131 Altar table. Heian period, early 12th century. Black lacquer with mother-of-pearl inlay; 30 ½ x 26 ⅛ x 13 ⅛ in. (77.5 x 66.5 x 33.5 cm). Chūsonji, Iwate.

made to flow underneath the short pilings on which the residence was built, and to curve gracefully through the yard to the pond. Covered walkways attached at right angles to the lord's quarters in a typical *shinden* extend east and west toward the pond, and the west corridor usually ends in a small building that functioned as a boathouse. An excellent image of what such a garden would look like and how it would be viewed is supplied by a scene from a **hand scroll** in which the lord of the manor—in this case Sugawara no Koreyoshi (812–80)—receives the miraculous manifestation of his yet unborn son while he sits gazing out at his garden (Fig. 133). The meandering stream cuts through the garden, finding its way through miniature landscapes of moss-grown rocks and dwarfed trees. At the front of the veranda there is a broad step for making one's way into this world in miniature, although one feels that its appreciation was more often enjoyed from the vantage of the veranda than by taking a stroll or sitting in the garden.

If the *shinden* and its grounds were grand enough, however, then the pond could become instead a small lake, where boating parties of fanciful craft might be held. A scroll illustrating the diary of a lady-in-waiting in service to Empress-consort Shōshi (988–1074), a daughter of Fujiwara no Michinaga (966–1027), who was the most powerful leader of the Fujiwara clan, depicts just such a festivity. Celebrating the birth of his grandson and the imperial heir, the great statesman Michinaga stands on the veranda of his boathouse, which extends over the lake, watching courtiers enjoying themselves in the elaborate boats he has provided (Fig. 134). The lady-in-waiting, Murasaki Shikibu, would go on to compose the first great masterpiece of Japanese prose, the *Genji monogatari* (*Tale of Genji*).

133 (above) Scene of the future Sugawara no Michizane (845–903) mani-
festing as a child in front of his father Sugawara no Koreyoshi (812–80) as
he sits in his hall looking out onto his garden, *Kitano Tenjin-engi*, scroll 1,
scene 2. Kamakura period, *c.* 1219. Ink and colors on paper; height 20 ½ in.
(52.1 cm). Kitano-Tenmangu, Kyoto.

134 (below) Section of *Murasaki shikibu nikki emaki*, Fujita scroll, scene 5,
showing Michinaga on a veranda observing two boats. 1st half of the 13th
century. Hand scroll, color on paper; height 9 ⅜ in. (23.9 cm).
Fujita Art Museum, Osaka.

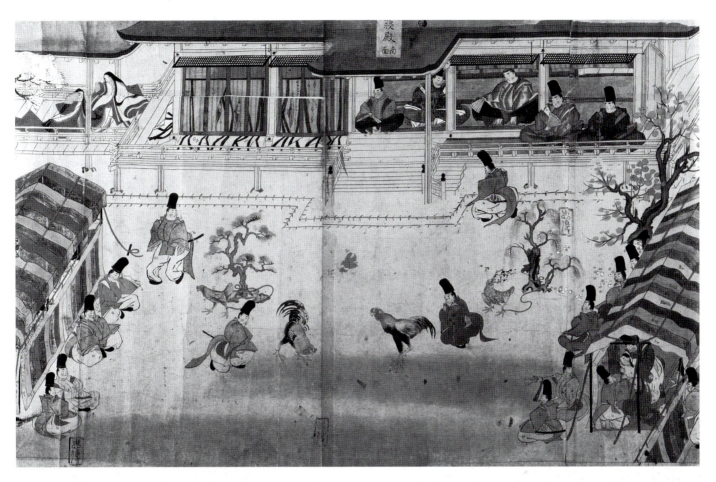

135. Section of *Nenjū gyōji emaki*, scroll 3, scene 3, showing a cockfight at a nobleman's house. 17th century copy by Sumiyoshi Jokei of the mid-12th century original by Tokiwa Mitsunaga. Hand scroll, color on paper; height 12 ½ in. (31.8 cm). Private collection, Tokyo.

In another scene from the *Nenjū gyōji emaki*, a scroll depicting annual ceremonies and celebrations of the imperial court, there is an illustration of a cockfight in the garden of a typical *shinden* (Fig. 135). The latticed shutters on the south side of the lord's own quarters have been raised, and he and his guests can be seen seated, the lord in formal court dress, holding a fan, the others well positioned for watching the activities in the garden. On the left side of the hall, female faces are visible through lowered blinds between the blind panels that have been placed to shield them from public view. Just to the right of the *shinden* veranda stands a tree with gnarled branches, and to the left is a cherry tree. A cockfight is traditionally held on the third day of the third month according to the lunar calendar, when all the trees are bursting into bloom.

LITERATURE AND CALLIGRAPHY

The standard of the Japanese gentleman's and gentlewoman's education was possibly never higher than in the Heian period. Although by the end of the ninth century official contact with the continent had ceased, the curriculum at the imperial university was still one rigorously based on studies of the Chinese classics and history in the Chinese language, much as Greek and Latin literature and language remained the basis of Western education until relatively recently. Although the aristocratic Heian lady could not hope to study at the university—and would have been actively discouraged from studying the Confucian classics even at home—she was still expected to be able to read and write. At the beginning of the ninth century, the *manyōgana* system of writing—using Chinese characters phonetically to spell out the inflections of Japanese grammar or the language's many polysyllabic terms—was replaced by the invention of a purely Japanese syllabary known as **hiragana**. Its creation has been traditionally attributed to the monk Kūkai (774–835), who founded the Japanese **Shingon** Buddhist sect. It is this syllabary that Heian gentlewomen were encouraged to use; indeed, they were discouraged from learning or using the Chinese characters that their seventh- and eighth-century female ancestors would have known. Great Japanese works of literature by women, such as the *Genji monogatari*, were therefore almost entirely composed in *hiragana* script. The use of *hiragana*, however, was of such convenience that it also proved very popular with men, who would often mix Chinese characters and *hiragana* "letters" together in their writing, especially in their composition of **waka**, thirty-one-syllable poems.

Poetry

Poetry figured in Heian aristocratic society not simply as a personal accomplishment which could prove the quality of a gentleman or gentlewoman, as it had been since at least the Nara period. It had evolved by the Heian period into almost a form of communication used between friends, family, lovers, and even government officials. In addition to the Chinese poetry forms, many different Japanese forms had developed, with the *waka* (literally "poetry of Wa," or Japan) and its thirty-one syllables in five lines being the basic form from which most of the others derived. The most famous Japanese poetry form of all, and the most popular since the sixteenth century, is the **haiku**, which evolved out of the first three verses that make up the standard *waka*. Using a rich, but set, fund of imagery often drawn from nature and the changing of the seasons and established as poetic motifs by several centuries of court poetry collected in the *Manyōshū*, the poet could create anything from a wry or biting observation about another person to a more abstract evocation of the mood of a particular moment or season. A *waka* by one of the great masters of the early Heian period, Ki no Tomonori (act. 850–904), neatly sums up the spirit of his age.

> This perfectly still
> Spring day bathed in the soft light
> From the spread-out sky.
> Why do the cherry blossoms
> So restlessly scatter down?

Donald Keene, ed., *Anthology of Japanese Literature*, New York, 1955, 80.

The poet, looking out of his comfortable abode, sees the cherry blossoms, and projects his own feelings onto the scene in front of him, with nature serving as a mirror in which he contemplates his own elegant and indolent reflection.

Poems were written primarily for a single viewer, a friend, colleague, or lover, and usually a reply was expected. If one could not compose a decent poem or produce respectable calligraphy, then it was better for a man to seek a career outside the capital, and for a woman to remain completely cloistered. One's reputation hinged more crucially on these two accomplishments than on any other aspect of conduct or aesthetic judgement. Many gatherings at the court were for the occasions of poetry competitions, and many members of the lower-ranking aristocracy basically became professional performers at these displays of what was supposed to be a purely amateur accomplishment. In addition many of the private social gatherings in the aristocratic *shinden* also took the form of poetry parties, at which the guests imbibed copious amounts of rice wine. From early in the Heian period, imperial collections of *waka* were commissioned.

In one compilation of poetry dating to around 1112, each verse of the poem has become a complete mixture of **kana** and *hiragana* with the difference between them blurred by the use of a **running-grass script** (JAP. *sōsho*) for both (Fig. 136). This particular collection is known as the *Sanjū rokunin kashū*—the poetry of the thirty-six immortal poets. These poets date from the eighth up to the end of the tenth century, and in addition to including several male masters, such as Ki no Tomonori, there is also a significant minority of poetesses.

Women of Letters

The page illustrated here is of a poem by the earliest female master, known only as Ise (c. 877–c. 940), although she was a daughter of the Fujiwara clan and a favorite of Emperor Uda (r. 889–98). The decorated paper of which this page is made demonstrates one of the crafts which first came to great prominence in the twelfth century, and for which even contemporaneous Chinese connoisseurs and aesthetes expressed admiration and envy. A collage of different colored papers is molded together to suggest a hilly landscape. Details of clouds, birds, trees, vegetation, fences, and buildings have been added in gold and silver ink. Over this runs the Lady Ise's poem in black ink in an elegant running-grass script, offering the reader a rich and many layered experience.

Another of the *Sanjū rokunin* was the imperial consort Saigo Nyōgo Yoshiko (929–85), who is depicted in an early Kamakura-period picture scroll of the thirty-six immortal

136 Page from the *Ise shū* from *San jūrokunin kashū*. Late Heian period, c. 1112. Page from a book mounted as a hanging scroll; ink, silver and gold ink on paper, with collage of colored papers; 7 ⅞ x 6 ¼ in. (20 x 15.8 cm). Yamato Bunkakan, Nara.

137 *Portrait of the Poetess and Imperial Consort Saigo Nyōgo Yoshiko* (929–85), with at right a brief biography in "standard cursive" characters followed by one of her poems in "running-grass" script, attributed to Fujiwara no Nobuzane (1176–1268). Late 12th/13th century. Ink and color on paper; 11 × 20 ⅛ in. (27.9 × 51.1 cm). Freer Gallery of Art, Smithsonian Institution, Washington DC (Purchase F1950.24).

poets—the *Sanjū rokunin emaki* attributed to Fujiwara no Nobuzane (1177–1265). The painter and calligrapher of the image has inscribed the empress's name and biography in Chinese characters in a clerical script, followed by one of her most famous pieces in *hiragana* using a running-grass script (Fig. 137). The empress herself is then depicted, according to propriety behind a curtain of state, almost engulfed by her many-layered robes. Reclining on her tatami, with her head modestly obscured, she leans to the edge of her dais, where there rests a black lacquer writing-box. The scene fairly accurately evokes the position in which Heian ladies would have composed a great deal of their poetry, or the diaries or romantic novels for which they were equally famous.

Sometimes appended to the list of thirty-six are the names of two other prominent women of letters: Murasaki Shikibu and Sei Shōnagon. Mention has already been made of the diary of Fujiwara no Michitsuna's mother, the *Gossamer Years*, but the greatest and most famous diarist of the entire Heian period is undoubtedly a lady-in-waiting to the imperial-consort Teishi (970–1001), known as Sei Shōnagon (965?–after 1000). Her *Makura no Sōshi* (*Pillow Book*) in fact inaugurated its own literary form, the *zuihitsu* ("by the line of the brush"), which in addition to recording events, includes

various thoughts, opinions, observations, and stories by the author on any manner of subject. The *Pillow Book* is particularly famous for its lists of "things." For example, her "Embarrassing Things" include:

> A man whom one loves gets drunk and keeps repeating himself.
> Parents, convinced that their ugly child is adorable, pet him and repeat things he has said, imitating his voice.
> A man recites his own poems (not especially good ones) and tells one about the praise they have received—most embarrassing.
> Lying awake at night, one says something to one's companion who simply goes on sleeping.
> An adopted son-in-law who has long since stopped visiting his wife runs into his father-in-law in a public place.
>
> Ivan Morris, trans., *The Pillow Book of Sei Shōnagon*, London, 1967, vol. 1/155.

If Sei Shōnagon's work offers us the best account of imperial court life at the height of the Heian period, Murasaki Shikibu's

epic romance, the *Genji monogatari* (*Tale of Genji*) provides a more personal, in-depth look at the aristocratic culture of the period. Several **monogatari**, or "tales told," emerged from the Heian period, written by both men and women. However, Murasaki Shikibu's *Genji* is unquestionably the greatest, its psychological exploration of its characters launching its own kind of literary genre in Japan, and having no real parallel elsewhere until the eighteenth century in Europe. In the *Genji*, the entire world of the Heian aristocrat is brought to life in three dimensions, and even arguably for all five senses, so powerfully does the author evoke even the sounds and smells of her world. We know the author today by the name of the novel's heroine, Lady Murasaki, in which her contemporaries recognized the author's own personality. Aside from that, we know she was a lady-in-waiting at the imperial court, in her case to the imperial-consort Shōshi (988–1074), and, as previously mentioned, she kept a diary of her life at the court (see page 107).

Her fictional tale of Genji, the Shining Prince, recounts the story of an imperial prince born of the emperor's favorite wife, a lady too low in rank for her son to be designated an heir to the throne. Nevertheless, Genji was a handsome, cultured, and sensitive man, one who not only loved women but continued to care for them even when he no longer loved them. His intrigues and affairs take up two-thirds of the novel; the last third deals with the lives and loves of two young men, Genji's heirs, after his death. That her prose powerfully conjured up the Heian world is evinced by the immediate acclaim with which it was received by contemporaries. It was almost immediately copied into illustrated editions which will be discussed in the next section (see Figs 140 and 141), and continues to this day to be widely read and to provide the inspiration for numerous other works of art.

THE RISE OF YAMATO-E

In painting, as in poetry and literature, the Heian period was a time in which the Japanese no longer unquestioningly accepted Chinese models and aesthetic standards. In painting they wanted to see the world as they knew it: the low hills and gentle valleys of the area around the capital of Heian, the flowering shrubbery they enjoyed in spring, the maple leaves scarlet and orange against the green pines in autumn. In Japan, as in China and Korea, calligraphy is the basis of all painting, and, given the high level to which the Heian aristocrat had taken the former, it also followed that many noblemen and women also turned their hands quite successfully to painting. As there were poetry competitions and parties, so were there contests and gatherings specifically devoted to painting. Murasaki's hero Genji, that paragon of the Heian gentleman, is an accomplished amateur painter who could hold his own against the great masters at court competitions. However, the foundation of painting in the Heian period is still to be discovered among largely non-aristocratic professionals, who made visible the tastes and favorite subjects of their aristocratic patrons.

The terms *yamato-e* and *kara-e* were coined in the Heian period to distinguish between the Japanese and Chinese pictorial traditions. In the broadest sense, Yamato means Japan and Kara means China. More specifically, Yamato is the ancient name of both the imperial family and the homeland centered on the Kansai region, of which Heian/Kyoto is also a part. Therefore, in the Heian period Yamato meant what today we call Japan. The *yamato-e* style is characterized not only by a softer contoured landscape, but also by a rich, but not brash palette of colors. Its themes, drawn largely from the imagery of nature evoked in poetry, were primarily secular, although *yamato-e*-style landscapes do begin to appear in religious imagery (see Fig. 177). *Kara-e* refers to the contemporaneous tradition of Chinese-style painting, in which Chinese narrative themes, ferocious mythical creatures, and landscape of rugged mountains are the chief subject matter.

A large-scale work that demonstrates one stage in the transition from *kara-e* to *yamato-e* is a group of ten paintings on silk, the *Shōtoku taishi eden*, illustrating events in the life of Prince Shōtoku (574–622), the imperial prince who played such an important role in establishing Chinese-style government and cultural reforms and in introducing Buddhism to Japan. In the eleventh century, the veneration of Shōtoku developed into a full-blown cult, and pictures depicting important events in his life were painted as wall decorations in temples associated with him, particularly Shitennōji and Hōryūji. However, these pictorial biographies were complicated paintings and needed to be explained to the faithful. Thus the custom of *etoki* developed. The term is used to refer to either the explanation or the explainer. A monk would memorize an account of Shōtoku's life and, much like a museum docent today, would present it orally to adherents as they looked at the pictures. At one time, Shitennōji, the temple founded by Shōtoku after 587, possessed a major cycle of Shōtoku paintings, but today the earliest extant pictorial biography is the one originally made for the prince's temple, Hōryūji. This was painted in 1069 on silk panels attached to three walls of the *edono* (picture hall) in the eastern precinct by Hata Chitei, an itinerant painter from Settsu province.

The paintings, now removed from the walls and fashioned into ten panels installed in the Hōryūji Treasure House of the Tokyo National Museum, present events in the life of Prince Shōtoku in a geographical sequence (rather than in a chronological one), moving from right to left, with each episode labeled in a cartouche affixed to the painting. Thus, in one panel, the prince is depicted at the ages of sixteen, seventeen, twenty-one, twenty-seven, and thirty-five. The narrative elements are fitted into pockets of open space between mountains, rocks, and trees, and the vertical composition is held together by the landscape, which flows around the episodes and leads the eye upward and back into the distance at the top of the panel. This use of mountain-defined space cells to unify a composition while at the same time separating figurative passages is a Chinese pictorial convention seen frequently in paintings of the Tang dynasty (618–907).

138 Section of the fifth panel, showing Shitennōji and, above, Prince Shōtoku crossing the Japan Sea to China, from the *Shōtoku taishi eden*. One of five panels by Hata Chitei, originally in the *edono* (picture hall), Hōryūji. 1069. Color on figured silk; 73 x 116 in. (185 x 291 cm). Hōryūji Treasure House.

However, even though the artist uses a Chinese pictorial convention, he also makes a clear distinction between the landscape of Japan and that of China. In the two panels to the extreme left of the set of ten, Shitennōji is shown surrounded by the low lands of Naniwa, in what is now Osaka (Fig. 138). A sturdy ocean-going vessel is tied up in the harbor, while further to the left three demons of the deep can be seen bobbing among the waves of the Japan Sea. Along the left edge of the painting are the mountains of China, tall and irregularly massed together, some of them displaying the sharply undercut faceting frequently seen in *kara-e* landscapes, but seldom in *yamato-e*. At the top of the two panels Shōtoku appears in a magical flying chariot, crossing the Japan Sea to China. In a dream he has remembered where, in a previous incarnation, he saw a particularly important Buddhist text, and upon waking he sets off to retrieve it.

The panels of the *Shōtoku taishi eden* represent a stage in the Japanization of secular painting, in which a native theme, the prince's biography, is set forth in a composition that still makes considerable use of a Chinese pictorial convention, the space cell. Nevertheless, new elements, such as a recognition of the difference between Chinese and Japanese mountain styles, herald the beginning of the Japanese style.

Another transitional painting dated to the Middle Heian period is the *Senzui byōbu* (Fig. 139). *Byōbu* means folding

screen, and this six-panel screen depicts an elderly gentleman, usually identified as the Chinese poet Bo Juyi (JAP. Hakurakuten; 772–846), seated on a fur rug outside a thatch-roofed hut and holding an ink-dipped brush as though he had just looked up from writing something. The theme of this screen is thought to be the Chinese poet who has retired from life in the capital but is constantly visited by young men wanting to learn his skills. And approaching from the right is a young gentleman who has just dismounted. Bo Juyi also held office in the Tang government and was a man who spoke his thoughts plainly and forcefully. As a result he was banished from the capital of Chang'an for several years. When he was permitted to return, he did so only to retire formally from service to the emperor. He then moved back to the country, built a simple hut from which he could see his favorite mountain, Mount Lu, and devoted himself to the pleasures of writing poetry and drinking wine. Bo Juyi was arguably the favorite of all the Chinese poets during the Heian period, and Lady Murasaki in *Genji monogatari* makes reference to his poem

139 Detail of *Senzui* (landscape) *byōbu*, a six-panel screen from Kyōōgokokuji (Tōji). 11th century. Color on silk; each panel 57 ⅝ × 16 ¾ in. (146.4 × 42.7 cm). Kyoto National Museum.

"The Song of Everlasting Sorrow" as though it was something with which her audience would themselves be completely familiar and required no introduction.

The Middle Heian period even produced a great Bo Juyi expert, Fujiwara no Tametoki (949–1029), who wrote a commentary on his poems and is also known to have commissioned a painting on the theme of the poet in retirement. This particular screen has, since the fourteenth century, been an essential ritual object in Shingon *kanjō*, or initiation, ceremonies at Tōji, a fact that has long puzzled modern scholars, as its secular literary theme contains no discernible esoteric Buddhist symbolism. Its acquisition by the temple is best explained by the theory that a nobleman attending a Buddhist ceremony at Tōji, perhaps someone like Tametoki, brought it with him to screen himself from the view of other worshippers, and afterward donated it to the temple.

The screen represents a transitional phase in the development of *yamato-e* because it combines a Chinese theme and Chinese-style figures in a landscape that is distinctly Japanese. The poet's hut is set among wisteria-covered pines and other

Emakimono and Papermaking

Emakimono (literally, "pictures rolled") are hand scrolls presenting a narrative in both words and pictures. Sheets of paper or, occasionally, silk are joined horizontally; the left end is attached to a dowel around which the scroll is rolled for storage. The other end of the *emaki*, to the right of the first passage of text, bears a frontispiece, usually decorated paper, backed with a fragment of silk which protects the scroll when it is not in use. For viewing the *emaki*, a braided silk cord holding the roll together is untied; the right hand holds the opening section while the left unrolls the scroll, exposing a portion of text and pictures, usually about 12 inches (30 cm) at a time before the right hand rolls up the section and the left hand reveals the next.

An *emakimono* usually begins with a passage of text followed by a picture which may be either relatively short, depicting only a single scene, or as long as the artist wishes. Illustration programmes dealing with love stories are usually less extensive than those of folktales or battle stories, which may involve the repetition of major characters to suggest a more complex sequence of events and the passage of time. However, whether the illustrations are long or short, they all have one element in common: a leftward momentum established by the direction in which the scroll is unrolled. Japanese artists were particularly successful at realizing

the possibilities of the *emakimono* for depicting moments of deep emotion and fast-flowing dramatic action, and the *emakimono* of the Late Heian and Kamakura periods represent the complete Japanization of both religious and secular painting.

Emaki are around 8–20 inches (20–50 cm) high and may be up to 66 feet (20 m) long. The individual sheets of paper vary in width from one scroll to another and are joined by a narrow overlap. *Emaki* papers were usually made either from *kōzo*, the bark of the paper-mulberry tree, or *ganpi*, thin rice paper from the *Wickstroemia canescens*. The raw material was broken down into fiber, refined into pulp, and then suspended in water in a large vat. The main papermaking device, still used today, consists of two frames: the *su* with a bamboo screen and a second frame of identical size but without the screen. With the second frame resting on top of the *su*, the two are dipped into the vat to scoop up pulp. While the screen allows the water to drain off, the upper frame holds the pulp within the rectangle. The pulp is then allowed to meld and dry to form paper. Sheets for a particular *emaki* were all the same size. Careful checking of the horizontal dimensions of the sheets of paper in a scroll provides clues to the history of its preservation. If a sheet differs from the norm, the scroll's intactness should be questioned.

140 Illustration 3 from the Kashiwagi chapter of the *Genji monogatari emaki*. 1st half of the 12th century. Ink and color on paper; 8 ⅝ x 18 ⅞ in. (21.9 x 48.1 cm). Tokugawa Art Museum, Nagoya.

trees in spring blossom. To the left of the hut is a multi-faceted rock, the sort much prized in China. In the upper half of the screen an inlet can be seen, its surface ruffled by a breeze, and on either side gentle green hills are dotted with dark-green pine trees. The core of the painting, Bo Juyi outside his hut, is inserted into the Japanese context of these flowering spring trees and low hills, a *kara-e* gem in a *yamato-e* setting.

EMAKIMONO

The horizontal illustrated narrative scroll, the *emakimono*, is a uniquely East Asian picture format, and, although such illustrated scrolls were produced in China, it was in Japan that the narrative potential of the horizontal scroll was carried to its highest levels of expression. Both the Chinese and Japanese languages have traditionally been written in vertical lines from right to left, so the horizontal format of the *emakimono*, laid out and unrolled from right to left, provided a natural way to relate text to image. These scrolls come generally in two distinct painting styles often referred to as **otoko-e**, men's pictures, and **onna-e**, or women's pictures. Originally, these terms evolved out of picture-painting parties and competitions, where the quickly sketched subjects of the *otoko-e* often proved to be quite rude in nature. However, *otoko-e* later came to refer to monochrome or lightly colored pictures that relied on the Chinese style of calligraphic line to convey the visual image, and is used in such *emakimono* as the *Chōjū jinbutsu giga* and *Shigisan engi*. *Onna-e* was a reaction to this genre and is exemplified by a more *yamato-e* style of painting, in which **tsukuri-e** —images of built-up color dominate, such as in the illustrations to the *Genji monogatari* and similar pieces of fiction.

Four precious *emakimono* fragments have survived from the Late Heian or Insei period: an illustrated version of the *Genji monogatari*; an ink-drawn caricature of animals behaving like people, the *Chōjū jinbutsu giga*; a folktale relating miracles associated with the founding of a temple, the *Shigisan engi*; and an historical account of intrigue at court, the *Ban Dainagon ekotoba* (*ekotoba* being an alternate term for *emakimono*). Little is known about the production of these scrolls, and in only one case, the *Ban Dainagon*, is the artist identified by a believable attribution. Lacking specific documentary evidence, art historians have been hard put to establish the approximate dates of the scrolls. One approach has been to evaluate the internal evidence: the styles of garments, and the architectural details of the imperial palace and well-known Buddhist temples. The style of calligraphy used to copy the texts is also a reliable index for dating the scrolls. Finally, it is not uncommon for an artist to "quote" or "rephrase" passages of images from an earlier scroll; once this before-and-after type of relationship is established, any documentary information available for the later scroll can establish the last possible date for the creation of the earlier scroll. Using various combinations of the above methodologies, scholars have tentatively concluded that the *Genji monogatari emaki* was produced in the first half of the twelfth century, probably before 1140; the *Chōjū jinbutsu giga* before 1150; the *Shigisan engi emaki* after 1150; and the *Ban Dainagon ekotoba*, which is attributed to the court painter Tokiwa no Mitsunaga, between 1157 and 1180.

The *Genji Monogatari emaki*

The creation of the *Genji* scrolls must have been a monumental project. The novel in its English translation is nearly one thousand pages long. Today only twenty *Genji* pictures survive, but it is assumed that originally all fifty-four chapters were illustrated, with between one and three paintings per

141　Illustration from the Minori chapter of *Genji monogatari emaki*. 1st half of the 12th century. Ink and color on paper; 8 ⅝ x 19 in. (21.9 x 48.3 cm). Tokugawa Art Museum, Nagoya.

chapter, and that the total number of scrolls in the set was about ten. Scholars trying to determine how the scrolls were made have come to the conclusion that five teams worked on the project, each team consisting of an aristocrat noted for his calligraphy as well as his cultural sophistication, and a group of painters, including the principal artist (the *sumigaki* or painter who draws in black ink) and specialists in the application of traditional pigments.

Once a particular episode was chosen, the *sumigaki* would plan the composition and sketch it on paper in fine black-ink lines. At the same time he would make notes on the sheet about the colors he wanted used. Then the pigment specialists would go to work, applying layer upon layer of paint within, but obscuring, the *sumigaki*'s original outlines. In the final stage the *sumigaki* would look once again at the illustration, perhaps changing a few details—the expanse of a court robe, the incline of someone's head—and would then paint in the details of the faces. These so-called details are minimal—to say the least—tiny red mouths, slit-like eyes, and noses indicated by a single bent line. The men usually had thin mustaches and sometimes short beards as well. This abbreviated treatment is called "a line for the eye, a hook for the nose," or *hikime kagibana*. The painting technique used in the *Genji* pictures, that is, the application of layers of paint over an underdrawing, is called *tsukuri-e*, a word mostly translated as "made-up." However, the Chinese character usually used to write this term is better translated as "construction," something built up. This painting technique was used with great success in the Heian and Kamakura periods for illustrating romantic tales.

The most important theme of the *Genji monogatari*—the concept of *mono no aware*, best translated as "the pathos of things" or "the moving quality of experience"—is not an easy idea to convey visually. The five *sumigaki* who planned the compositions used pictorial conventions—possibly invented by them, but probably not—that were particularly effective in illustrating moments of high emotional intensity. The blown-off roof, or *fukinuki yatai*, was used not just to depict an indoor activity in an outdoor setting; the odd angles created by the walls, sliding doors, and folding screens when seen from above were also metaphors for the emotions felt by the characters in the illustrations. The relative absence or presence of space in which the figures could move also contributes insight into their feelings. Finally, colors and patterns heighten the mood of the scene. All of these elements taken together create for the viewer a strong impression of *mono no aware*—whether it be the pleasure one experiences looking at a garden bathed in moonlight and hearing the sound of someone playing the flute, or the pain one feels at the thought of losing a loved one.

A second major theme in the tale is the chain of karmic consequences Genji generated when he committed one great sin against his father. In his youth Genji fell in love with his father's youngest wife, a woman he was encouraged to see because she looked so much like his mother, who had died while he was still an infant. A child was born out of Genji's liaison, a beautiful baby boy who was passed off as the emperor's own son and who eventually succeeded to the throne. The full force of Genji's karma hits him in middle age. His youngest wife, a woman he was cajoled into marrying but in whom he has no interest at all, has an extramarital affair that results in a son Genji decides he must publicly accept as his own, even as the old emperor had done with Genji's son.

The ceremony of acknowledgment is depicted in the third illustration from Kashiwagi, the fourth volume's eighth chapter (Fig. 140). As the scroll is unrolled and the illustration comes into view, the first thing to appear is the brown surface of a courtyard—originally painted silver, now tarnished—and a veranda placed at such a sharp angle that it has nearly the force of a vertical line hindering the eye's movement leftward. Next the wall of the building appears. The lattice panels enclosing the interior space have been removed and their function taken on by thin slatted bamboo blinds and by curtains of state, the black tie-ribbons of which hang loosely. The next clues to the scene are the bottom of a twelve-layered robe, and, above, red and black lacquered plates heaped with food. The colors in the robe and the use and careful placement of the lacquered dishes indicate that a ceremony is in progress. Finally, nearly two-thirds of the way across the illustration, figures appear, Genji at the top holding the baby in his arms, ladies-in-waiting below, and in the extreme upper-left corner, the baby's mother, her presence indicated by a mound of fabric.

The text accompanying this illustration consists of Genji's thoughts as he goes through the painful ritual. He knows that his wife's attendants are well aware that he is not the child's father. His emotional discomfiture is suggested by the physical awkwardness of his placement at the top of the very sharply slanting floor. Further, the space he occupies is so constricted that should he wish to raise his head from the baby in his arms, he could not do so. In this scene the architecture plays a key role. At first, interrupting the leftward momentum of the illustration and at the same time shielding the figures from view, it suggests the guilty knowledge that reverberates throughout the room during the ceremony, not only of the wife's adultery but also of Genji's cuckolding of his father many years before. Next, as it forces Genji into a cramped position, it suggests the pressure of society coercing him to put a good face on a bad situation. ˙

An illustration that brilliantly evokes the sometimes conflicting facets of grief appears in Minori (The Rites), the fourth volume's eleventh chapter (Fig. 141). The true love of Genji's life, Lady Murasaki, is dying. A young woman she raised as her own, who is actually Genji's daughter by another wife, has come back from the imperial palace to be with her. One stormy evening Genji visits Murasaki, and the three sit together, watching as the wind makes whips of the shrubs and grasses in her garden. When Genji first built his mansion, he planned this garden to be beautiful the year round, reaching its peak in springtime, Murasaki's favorite season. Now, as they gaze at it, it seems to be nothing but a tangled mass of vines.

The text presents Genji's thoughts: his knowledge that Murasaki is gravely ill, his dread that she will die, his sense that his grief will be nearly too much to bear. Again architecture plays an important role, with the angles nearly as steep as those of the scene described above. Here, however, the figures appear almost immediately as the scroll is unrolled, Murasaki near the top leaning on an armrest, her adopted daughter just below in the angle formed by the upper beam of the wall and

a cloth curtain of state. Genji appears at the bottom of the incline, nearest to the veranda. Lastly, as the architecture disappears at the bottom of the picture, we see the wind-ravaged garden. The anguish Genji feels about Murasaki as she drifts toward death is suggested by the position he occupies at the bottom of the diagonal, her disappearance from his world by the treatment of the architecture, his fear of being overwhelmed by his own grief by the tangled shrubbery.

The *Chōjū jinbutsu*

The first two scrolls of the four-roll set known as the *Chōjū jinbutsu giga* (*Scroll of Frolicking Animas and Humans*) provide a striking contrast to the *Genji monogatari emaki*. First of all, the illustrations are presented as a continuous narrative. There is neither an opening text nor passages inserted between the illustrations, the figural motifs flowing to the left without interruption. Secondly, the scrolls have no color, but are drawn with black ink on paper. Finally, they are satirical throughout and at times bitingly so.

The first two scrolls of the *giga* depict animals disporting themselves as human beings: a rabbit holding his nose does a back flip into a lake; two frogs dance to a beat marked by the split-bamboo twangers they both hold (Fig. 142); frogs and rabbits compete in an archery tournament, while a shy bystander, a fox, gets so excited that his tail seems to burst into flames (Fig. 143). The final scene of the first scroll depicts what seems to be a memorial service (Fig. 144), with an animal congregation arranged in a semicircle behind a monkey clad in monk's robes, who is chanting in front of an altar on which a frog has been enshrined. The scene continues to the left, past a tree in which an owl is perched looking directly out at the viewer. In the next section is another monkey in ecclesiastical garb, sitting with a supercilious smile on his face as presents are brought to him in payment for the ritual he has just performed. Can this scene be anything other than a

142 Detail from scroll 1, *Chōjū jinbutsu giga*, showing dancing frogs. Mid-12th century. Ink on paper; height 12½ in. (31.8 cm). Kōzanji, Kyoto.

143 Detail from scroll 1, *Chōjū jinbutsu giga*, showing animals watching an archery contest. Mid-12th century. Ink on paper; height 12 ½ in. (31.8 cm). Kōzanji, Kyoto.

144 Detail from scroll 1, *Chōjū jinbutsu giga*, showing final scene of a religious service. Mid-12th century. Ink on paper; height 12 ½ in. (31.8 cm). Kōzanji, Kyoto.

comment on religion and the clergy? Since no text accompanies this *emaki*, we can only guess at what or whom the artist intended to satirize. Nevertheless, we can enjoy the humor of individual scenes and appreciate the lively calligraphic strokes of the artist.

But the *giga* as we know it today is something of a hodgepodge. In contrast to the superbly executed drawings of animals cavorting in a natural setting that characterize the first two scrolls, the third and fourth are later in date and depict various types of contests between monks and laymen, as well as animals imitating humans, and are clearly by another, less competent hand. Furthermore, there are many passages in the first two scrolls that do not seem to flow together, either because a piece of the illustration is missing or because a mistake was made in the sequence of sheets of paper when the scrolls were repaired over the years. Several sections have

certainly become separated from the scrolls and have turned up in private collections. Scholars examining the two early scrolls have concluded that originally, in the Late Heian period, there were three *emaki* in this set, and at some point they suffered serious damage that led to the remnants being fashioned into the two scrolls we have today.

Traditionally the commissioning of this work—and sometimes its authorship as well—has been ascribed to the dynamic Emperor Go Shirakawa (1127–92; r. 1155–58), whose thirty-four year tenure as *insei* ended with the Genpei Civil War and the establishment of the *bakufu* (see page 102). A cunning and unscrupulous politician, he was also renowned as a broad-minded patron of the arts. He is credited with commissioning the *Nenjū gyōji emaki* by, among others, Tokiwa no Mitsunaga (see Figs 135 and 191). Mitsunaga was active about 1173 and undertook a number of projects for the imperial family during the Late Heian period. The *Nenjū gyōji emaki*, which was commissioned to celebrate the revival of important ceremonies at court, has not survived except in a seventeenth-century copy, and depicts annual ceremonies and celebrations in the capital. It has been suggested that the *Chōjū jinbutsu giga* was Mitsunaga and Go Shirakawa's satirical version of this scroll. Recently, however, scholars such as Mimi Yiengpruksawan have also suggested that the set could as easily have been the product of the city's non-aristocratic community of affluent merchants. At this period, the urban culture in the capital saw a flowering of performing and visual arts aimed at the lower classes, and this "animal" scroll-set ridiculing the rites and conceits of the aristocrats and clergy would have been perhaps most amusing to them. Given the lack of firm documentation concerning the *Chōjū jinbutsu giga* and the vast changes that society in the capital would have undergone in the twelfth century, it can so far only be said that both the traditional and newer attribution have equal merit.

The *Shigisan engi emaki*

The *Shigisan engi emaki* (*Scroll of the Legend of Mount Shigi*) is one of the earliest extant examples of a type of narrative that became very popular in the Late Heian and succeeding Kamakura periods—the *engi*, which is the history of the founding of a particular Buddhist establishment. Unfortunately, nothing about the artist or the circumstances of production of the *Shigisan engi emaki* has been documented. The temple concerned, however, is the Chōgosonshiji, deep in the mountains north of Nara, and its founder was a monk named Myōren from mountainous Nagano prefecture to the north of the Kansai region. When still a young boy, Myōren left his family and traveled to Nara to study Buddhism, later building himself a small hermitage on Mount Shigi. The first two scrolls deal with miracles Myōren wrought: first, chastizing a wealthy farmer for his greed by making his granary fly through the air to the top of the mountain, and second, healing Emperor Daigo (r. 897–930) when all other attempts had failed by causing a rare Buddhist entity, a sword boy, to appear to the emperor. The last scroll focuses on Myōren's sister, a nun who

145 Illustration from *Shigisan engi emaki*, scroll 1, showing Myōren ordering a servant to place a rice bale into a begging bowl. 2nd half of the 12th century. Ink and color on paper; height 12 ½ in. (31.8 cm). Chōgosonshiji, Nara.

comes down from the mountains in search of her brother so they may live out the remainder of their days together. One night she prays in front of the great Buddha at Tōdaiji (see Fig. 79). The next morning she sees in a vision Mount Shigi encircled by a purple cloud. She takes it as a signpost to her brother's whereabouts, and she goes off to join him.

The *Shigisan engi* is a charming tale of simple people and miraculous events, and as such was included in a thirteenth-century anthology of folktales, the *Uji shūi monogatari* (*A Collection of Tales from Uji*). The text also served as a legitimization of Chōgosonshiji, indicating that worshippers there would benefit from the magical powers of its founder, Myōren. Because of the odd change of protagonists in the third scroll, from the monk to his sister, it is tempting to seek a more complex didactic meaning for the work. The scrolls may be suggesting human frailties—greed, self-aggrandizement—to be overcome before the individual can attain Enlightenment, the latter suggested by the nun's seeing a purple cloud encircling Myōren's mountain. However, since the artist and circumstances of production of the work are undocumented, this interpretation can only be speculative.

The principal artist of the *engi*, probably the only artist, painted the outlines of his figures, and the natural scenery that served as their setting, in dark-grey brush strokes, and for color he used thin pigments that did not obscure his earlier lines. This permitted him to depict figures in active stances and to utilize the character of the calligraphic stroke to suggest movement. For example, in a scene from the first scroll, Myōren stands near a wealthy farmer and directs one of the

squire's servants to put a bale of rice into his golden begging bowl so that Myōren can send it and the other bales of rice from the granary back down the mountain to the squire's house (Fig. 145). The illustration has a lively, fresh quality in perfect harmony with its subject matter.

The *Ban Dainagon ekotoba*

The last major *emaki* surviving from the Late Heian period, the *Ban Dainagon ekotoba* is less of an enigma than the other works discussed above. Although its exact date is not known, and it does not bear an artist's signature, it has been attributed to Tokiwa no Mitsunaga on the basis of its stylistic similarity to the *Nenjū gyōji emaki*.

The plot of the *Ban Dainagon ekotoba* is well documented. In 866 the Ōten Gate of the imperial palace burned down, and after many months facts came to light proving that the head of the Ōtomo clan—Major Counselor Ōtomo no Yoshio, whose name and court title can also be given a Chinese-style reading of Ban Dainagon—had set fire to the gate in an attempt to discredit a court rival, the Minister of the Left, Minamoto no Makoto. Once his guilt was established, Lord Ōtomo was punished by being sent into exile. The incident is recorded in a history of the period with approximately the same details. Why this particular story was chosen for illustration in the midst of the political upheavals of the mid-twelfth century has been much speculated upon, but, whatever the circumstances of its production, it can be understood and appreciated today as an excellent example of narrative painting.

The opening passage of text has been lost, and the scroll now begins with an illustration, a long passage of figures all running leftward with the flow of the scroll, only to be stopped abruptly by the sight of the gate in flames. Inside the palace enclosure to the left, Emperor Seiwa (r. 858–76) and his grandfather, Fujiwara no Yoshifusa (804–72), can be seen in

146 Illustration from *Ban Dainagon ekotoba*, scroll 2, showing the children's fight, attributed to Tokiwa no Mitsunaga. 2nd half of the 12th century. Ink and color on paper; height 12 ⅜ in. (31.5 cm). Idemitsu Art Museum, Tokyo.

the Seiryōden, discussing the rumor circulating at court that "a certain Minamoto lord" was responsible for setting the fire (see Fig. 128). The two decide to withhold action until more is known, and a few months later the truth comes out in quite a surprising way. One day in the market district, two boys begin to fight. One boy's father, a retainer of Lord Ōtomo, rushes out to break them apart and beats the other child severely. When the second father, a low-ranking government worker, rages at the first for hurting his son, the retainer assumes an arrogant manner. The second father, beside himself with anger and anguish, blurts out that if the world knew what he knows about the retainer and his master, Lord Ōtomo, they would be severely punished. His veiled threat, heard by everyone in the neighborhood, is discussed in whispers in an ever-widening circle until it finally comes to the attention of the metropolitan police. The second father tells the authorities that he saw the retainer and Lord Ōtomo climb down from the palace gate just before it burst into flames.

The artist's retelling of the children's fight and its repercussions is masterly (Fig. 146). The scene takes place in a bustling commercial and residential section of the capital. People on their way to market fall back as the children begin to fight, creating a diagonal line that serves as a frame to the right of the action. The retainer rushes out of his house and toward the fracas. Next he is seen below, physically separating the two boys and kicking the other man's child. There is no depiction of the later conversation between the two fathers. Instead, five people are shown grimacing at the beating being given to a mere child. Just to the left of this group is a single figure looking away from the fight, his mouth is wide open as if he is shouting. By this simple device the artist establishes the next pictorial theme for the reader, the passing of a whisper from one person to another until it reverberates throughout the district. With amazing economy of space and illustrative detail the artist is able to suggest where the children's fight took place, what it looked like, who observed it, and how it turned out.

Another passage that demonstrates Mitsunaga's skill as a narrative artist comes toward the end of the tale. The sentence of exile for Lord Ōtomo has been handed down, and the police have come to his home to escort him from the capital. The women of the household are heartsick at the thought of separation from their lord. Using the convention of the blown-off roof, the artist depicts them indoors, in various postures of grief (Fig. 147). One lady is so overcome that she rolls on her back with her mouth open, as if she were shouting out her feelings. In the lower left corner of the scene, Lord Ōtomo's principal wife and son weep openly, while above them is an old woman we may take to be Lord Ōtomo's wet nurse. She sits, her hair and clothing in disarray, her face in a grimace of pain, hugging her legs, like her grief, to her body. Among the narrative *emakimono* that have survived to the present day, it is hard to think of a more moving depiction of a human being in anguish. In the *Genji* pictures, Genji's grief at the thought of losing Lady Murasaki is discreetly suggested by elements within the composition that become visual metaphors for his emotions. In *Ban Dainagon* the old woman's sorrow is expressed directly, through her facial expression and body language.

The *Ban Dainagon ekotoba* uses the human figure as the basic module and the grouping of images in a leftward procession as its primary mode of composition. The figures may be shown running, held in check by an obstacle such as the blazing gate, or even standing still, facing left or looking back to the right, but it is consistently on them that our attention is focused. The way they look, their facial expressions, and the way they place themselves speak directly of their feelings. In terms of technique, the *Ban Dainagon ekotoba* is an interesting blend of the *tsukuri-e* seen in the *Genji monogatari emaki* and the free *otoko-e* style of the *Chōjū jinbutsu giga* and *Shigisan engi emaki*. The artist uses a calligraphic line to sketch out his figures, a more elegant and controlled line than that of the *Shigisan engi*, but he also uses bright colors applied thickly on the paper, almost as in the constructed-paint technique of the *Genji emaki*. Finally, the artist combines in a single illustration a lively, free-flowing outdoor composition like those found in the *Shigisan engi* with a cramped indoor scene dealing with human emotions reminiscent of the *Genji* scrolls.

The observation of unidealized human behavior plays a central part in both the *Shigisan engi* and *Ban Dainagon*, and

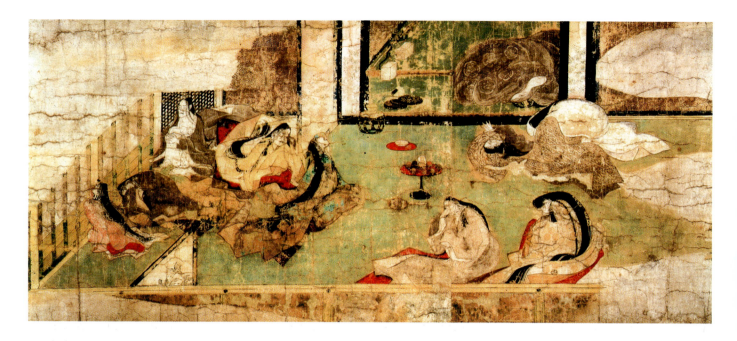

147 Illustration from *Ban Dainagon ekotoba*, scroll 2, showing the Ōtomo household. Attributed to Tokiwa no Mitsunaga. 2nd half of the 12th century. Ink and color on paper; height 12 ⅜ in. (31.5 cm). Idemitsu Art Museum, Tokyo.

heralds the growth of a distinct new culture in the capital that acknowledged and even celebrated all levels of society. By the end of the Heian period, the cloistered world of the court was beginning to collapse, and perhaps the awareness and interest in a greater society demonstrated by these *emakimono* can be seen, at least on the part of some of the aristocracy, as an attempt to break through the bars of their gilded cage.

Buddhist Arts

BUDDHISM OF THE TENDAI AND SHINGON SCHOOLS

One of the major events of the Early Heian period, the introduction into Japan of **Tendai** and Shingon Buddhism was precipitated by the same loss of direction on the part of the Buddhist community that had led to the relocation of the capital. It was felt by some that the teachings and rituals of the **six schools of Nara** were aimed primarily at securing material benefits for the state and for their wealthy aristocratic patrons, and not at spiritual attainment and Enlightenment. These two new schools refocused Japanese Buddhism on the serious matter of philosophy and practice, and by connection the temples, sculpture, and painting that they produced in the first century of the Heian period tended to address this new seriousness in Buddhist matters, leaving behind the light and cool elegance of eighth-century Heijō.

In his desire to curtail the power of the great Buddhist foundations in Nara, Emperor Kanmu (r. 781–806) singled

out and gave strong support to Saichō (767–822)—also known by his posthumous title of Dengyō Daishi—a Buddhist monk who rejected the worldly atmosphere of Nara Buddhism. Saichō was ordained in Nara, but he withdrew to Mount Hiei to the northeast of the site of the future Heian in 788, founding a hermitage in the pure mountain air far removed from the secular world of the court. When the capital was relocated to Heian in 794, Saichō's temple, today the extensive complex known as Enryakuji, was in a most propitious location, according to Chinese principles of geomancy, for acting as the spiritual guardian of the new city while also being at some distance from it.

In 804, Emperor Kanmu gave Saichō permission to join an imperially sponsored embassy to China so that he could study Tendai (CH. Tiantai) Buddhism at its source, Mount Tiantai, and bring back to Japan copies of as many Tendai texts as possible. Because Saichō had already achieved imperial recognition as one of ten Japanese monks allowed to serve in the palace, before he left for China he received all due formalities, a stipend, and a specific directive from the emperor. In China, although he focused on Tendai doctrine, Saichō also studied Ritsu (SKT. Vinaya), **Zen** (CH. Chan) and Shingon Buddhism. The latter was a tantric school of Buddhism, recently arrived in China, and was more thoroughly taken up by Saichō's younger contemporary Kūkai. Ultimately Saichō emphasized in his Tendai school the teachings of the Chinese Tiantai sect, which was centered on the *Lotus Sutra* (JAP. *Myōhōrenge kyō*). The *Lotus Sutra* is one of the principal Buddhist sutras, and it had been introduced into Japan some time earlier, the Hokkedō of Tōdaiji being intended as a hall for the teaching of this sutra. A dramatic text, it presents the all-embracing concept of Buddhist salvation. Saichō elaborated on this concept and included tantric, Zen, and Ritsu philosophies and disciplines as part of his own teaching.

Basic to Saichō's philosophy was the concept that all human beings possess the Buddha nature—the inherently enlightened true nature of beings—and can become enlightened by realizing this nature within themselves. Because his Tendai doctrine is syncretic, synthesizing the sometimes competing doctrines of many different schools and texts of Buddhism into a unified system, it has been hospitable to new schools of Buddhist thought.

Saichō returned to Japan in 805 and immediately began to teach the Tendai doctrines he had studied in China. He already had the backing of the emperor and so was able to move quickly to establish a monastic community at Enryakuji. Since he had received full ordination at Mount Tiantai, Saichō could ordain others, and in 807 on Mount Hiei he performed the first Tendai *ichijōtai kai* ordination ceremony in Japan, ordaining some one hundred followers. This ordination into the "unique vehicle" represents a synthesis through the teachings of the *Lotus Sutra* of all the other Buddhist traditions. Although this ritual was very similar to the ordination ceremony introduced half a century earlier by Ganjin, it is more in the nature of an initiation, necessary before the believer could commence studies. The Nara clergy objected strenuously to this new ordination rite, and further ordinations were not sanctioned by the court until 827, five years after Saichō's death. Nevertheless, in the years after that first ordination, Saichō was able to attract capable disciples who went on to advance the teachings of Tendai.

On the same voyage of 804 that took Saichō to China, there was a student-monk by the name of Kūkai (774–835)— also known by his posthumous name of Kōbō Daishi—who journeyed to the Chinese capital of Chang'an to study with the Buddhist master Huiguo (JAP. Keika; 746–805). Huiguo was a great master who had gathered the elements of tantric Buddhism which had recently arrived in China into a coherent system, but not into an independent sect. He is therefore not the founder of a school, but is considered the eighth patriarch of the Shingon sect (CH. Zhenyan). Shingon, or True Word teaching, is based not on the *Lotus Sutra* but on two other texts, the *Mahavairocana Sutra* (JAP. *Dainichi kyō*) and the *Vajrasekhara Sutra* (JAP. *Kongōcho kyō*). Although called sutras, both of these texts in fact belong to the class of tantra. Like the sutra, the tantra is considered to be the word of the Buddha, but unlike the sutras, which are the collected words of Shaka, tantra are revealed as visions, and often directly from the universal Buddha, Birushana (SKT. Vairochana).

At the heart of tantric teachings is the concept that the Buddha possesses two aspects: the phenomenal body (SKT. *nirmanakaya*; JAP. *keshin*), manifested in the earthly emanations of such Buddhas as Shaka, and the absolute or ineffable body (SKT. *dharmakaya*; JAP. *hosshin*), which is expressed by the supreme or transcendental Buddha, such as Birushana. The concept of the nonduality of the Buddha—that the phenomenal and the transcendental bodies of the Buddha were not separate entities but rather different manifestations of the same absolute principle—found expression in what the Japanese call the Mandalas of the Two Realms (Ryōkai **Mandara**). The Sanskrit word "mandala," originally meaning "circle," refers in Hinduism and Buddhism to a diagram of the spiritual universe, portrayed abstractly in the mind, in three-dimensional sculptural and architectural forms, and in two-dimensional images. The Vajradhatu Mandala (Diamond World Mandala), known in Japanese as the Kongōkai Mandara, focuses on Birushana as the central transcendental Buddha **Dainichi Nyorai** (SKT. Mahavairochana, or "Great" Vairochana), and places him in relation to the various phenomenal Buddhas who have appeared at different times and in different places. The Garbhadhatu Mandala (Womb World), or Taizōkai Mandara in Japanese, depicts the phenomenal appearance of the various aspects of Buddha's nature: the merciful side is frequently represented by bodhisattvas with many heads and arms, and the aspect symbolizing the power to subjugate evil is expressed often by wrathful figures with ferocious expressions and multiple eyes, heads, and limbs.

According to Shingon doctrine, the true mandala is the full perfection of Buddhahood, Enlightenment itself, and the Womb and Diamond mandalas are diagrams of this spiritual universe. Kūkai taught that any person could attain Enlightenment in this existence through contemplation and rituals using the paired mandalas. The practitioner learns to visualize the symbols of the spiritual world that are depicted in the mandala and in so doing learns the Three Mysteries of body, word, and thought, which cannot be expressed in words. In early Shingon, the ability to read Buddhist texts was not necessary, but a good teacher and diligent attention to his instruction were crucial. The first of these rituals is one of initiation, *kanjō* (SKT. *abhisheka*), in which the initiate is made a pure receptacle by five libations of water, symbolizing the Five Wisdoms of the Buddha.

In the course of the *kanjō* ritual, the initiate would establish a personal relationship with the mandalas by tossing a blossom at each one. The deity's image on the mandala touched by the flower then became the believer's personal deity, and the teacher would give the student a special **mantra** (JAP. *shingon*), a group of mystic syllables for recitation, and particular hand gestures to be used in meditation. By meditating on and performing rituals in front of the two mandalas, and through the repetition of one's secret mantra, anyone could become one with Dainichi Nyorai and achieve Enlightenment.

Integral to such ritual practice were the *kongō* (SKT. *vajra*; diamond scepter) and *suzu* (SKT. *ghanta*; bell). The *kongō* is a potent symbol in tantric Buddhism, originally derived from the ancient Indian emblem for a thunderbolt; in Shingon ritual it is held in the right hand, symbolizing the Kongōkai Mandara, and specifically the indestructible nature of truth which disperses the shadows of ignorance. The Nara National Museum preserves just such a ritual *kongō* dating from the twelfth century and made of cast and gilded bronze (Fig. 148). The five prongs at either side represent the five transcendental Buddhas, of whom Dainichi Nyorai is the most important with

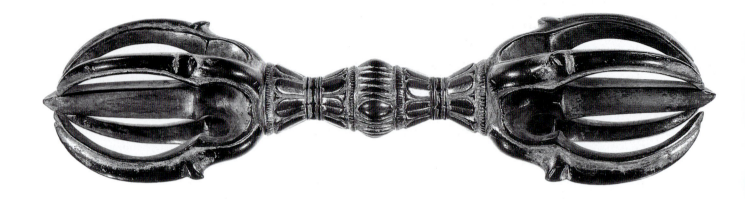

148 Five-pronged *vajra*. Late Heian period, 12th century. Bronze; length 6 ⅝ in. (17 cm). Nara National Museum.

the other four being his manifestations to the four directions. The companion implement—the *suzu*, or bell—is held in the practitioner's left hand, representing the Taizōkai Mandara. The two implements held together symbolize the union of the two mandalas or the Ryōkai Mandara. Shingon contained the essential elements for developing a code of ethical behavior, but the ritual of worship and the recitation of one's mantra provided an easy and aesthetically pleasing way of striving for Enlightenment, and the hard discipline of practices that expressed the philosophy Kūkai developed was often ignored by his aristocratic adherents.

When Kūkai returned from China in 806, he was not allowed by Emperor Kanmu to come to the capital, even though in China he had been acknowledged as the successor of the Shingon patriarch. Eventually he was permitted to come to Heian, and was instructed to join the monastery of Jingoji in the mountains northwest of the capital, where he spent a good deal of the next fifteen years, lecturing on the doctrines of Shingon and performing Shingon initiation ceremonies. At first Kūkai and Saichō were willing to share their knowledge with each other, and, in the years immediately following his return to Japan, Saichō's perception of Buddhism shifted toward the Shingon concepts as preached by Kūkai. However, Kūkai was adamant in insisting that Shingon was the only "true word" of the Buddha, and that Saichō should give himself up to the study of it exclusively, while Saichō held to the Tendai understanding that, along with the esoteric practices of which Kūkai was the acknowledged master, it was also necessary to study meditation and such texts as the *Lotus Sutra*. In the end a bitter rivalry developed between the two, and they went separate ways. However, it was Saichō who enjoyed the court's favor, so it was not until 816 that Kūkai successfully petitioned Emperor Saga (r. 810–24) for a grant of land on Mount Kōya, to the south of present-day Osaka, on which to build his monastery, Kongōbuji. And it was only in 823, the

year after Saichō's death, that Kūkai was given a temple in the capital. He converted Tōji, as it is still popularly known today, into a teaching center for the Shingon sect, renaming it Kyōōgokokuji—Temple for Defence of the Nation by Means of the King of Doctrines. For a period of one hundred years or so, Shingon would remain the dominant school of Buddhist thought in Japan.

Although the characters of Saichō and Kūkai were very different, their philosophies and the Tendai and Shingon schools they established were united in one respect that made them distinct and in advance of the six Nara schools. Both Tendai and Shingon were a synthesis of a wide variety of different Buddhist traditions, each seeking to create an all-encompassing framework within which all the different Buddhist concepts and philosophies could be assigned a place. Ultimately this extended to non-Buddhist philosophies and belief systems as well, and created the environment that would lead to the fusion of Buddhist and Shinto concepts that took place during the course of the Heian period, and which will be discussed in the section on Shinto Arts at the end of the chapter.

SHINGON ARCHITECTURE

As already demonstrated in terms of ritual implements, Shingon tantric practices, whether as taught by Kūkai's Shingon school or included in the more catholic rituals of Saichō's Tendai school, brought many new ideas concerning temple planning and buildings as well as new Buddhist entities. Since the site for Tōji (Fig. 149) had been selected long before it was turned over to Kūkai to convert into a Shingon temple, it reflects the symmetrical layout of religious institutions constructed on flat land, rather than Kūkai's new formulation for the school's mountain temples. In 823, when Kūkai became abbot, only the *kondō* ("golden hall") and a few other buildings had been completed. Shortly after Kūkai's appointment, he produced a design for the temple compound that included a single pagoda, and a *kōdō* (lecture hall) in which he planned to install twenty-one images in a sculptural

149 Aerial View, looking north, of Kyōōgokokuji (Tōji) compound, Kyoto.

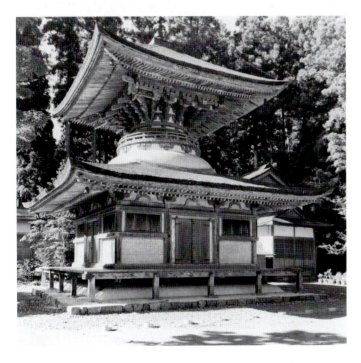

150. *Tahōtō* (pagoda of many treasures). Kongō Sanmaiin, Kongōbuji, Wakayama prefecture. 1222–4.

mandala. The pagoda was completed in 826, but the *kōdō*, unfinished at the time of his death in 835, was not officially opened until 839. His foundation of Kongōbuji, south of Osaka, better reflects his influence, particularly in the structure known as the **tahōtō** (pagoda of many treasures). The original buildings constructed under Kūkai's direction no longer survive, but in the Kongō Sanmaiin, a precinct of Kongōbuji on Mount Kōya, a *tahōtō* built between 1222 and 1224 has been preserved (Fig. 150). The building takes its name from one of the Seven Buddhas of the Past, Tahō (SKT. Prabhutaratna), who is said to have come down from heaven

in a similarly shaped reliquary when Shaka began preaching the *Lotus Sutra*.

The structure consists of a square first floor topped by a partial roof. Rising out of this shingled roof is a truncated hemisphere coated with white plaster, a direct reference to the shape of the Indian stupa. Capping this is a round wooden neck with a false gallery. Another square shingled roof completes the building. The hemisphere symbolizes the daily movement of the sun as well as the appearance of the earth to an individual looking toward the horizon. The square represents the world restructured to include the cardinal directions. The interior of the building is provided with a single square room on the first floor, and in the center an image of Dainichi Nyorai is placed with the four transcendental (sometimes also referred to as the "directional") Buddhas in an arrangement similar to that in the *kōdō* at Tōji (see page 129). Directly above the ceiling of the room a heart pillar rises to the spire atop the building.

SHINGON MANDALA PAINTINGS

Among the new Shingon objects for worship were the pairs of mandala images: the Ryōkai (Two Realms) Mandara made up of diagrams of the two worlds, the Taizōkai (Womb World) and the Kongōkai (Diamond World). Usually these two paintings are hung in the inner precinct of a Shingon temple, the Kongōkai to the east, the Taizōkai to the west of a low altar (Fig. 151). The adherent is encouraged to concentrate on the paintings, first the Taizōkai, then the Kongōkai. Through meditating on the meaning of specific Buddhist entities, the practitioner learns to recreate their likeness in the mind's eye and thus internalize their visual appearance and the concepts they symbolize.

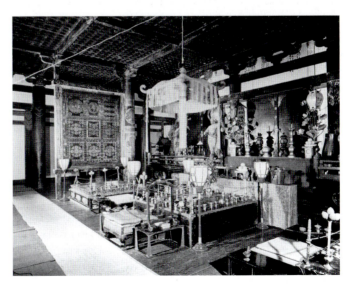

151. Interior of the *kondō*, Kanshinji, Osaka, with Kongōkai (Diamond World) Mandara seen to the east (at left) of the altar.

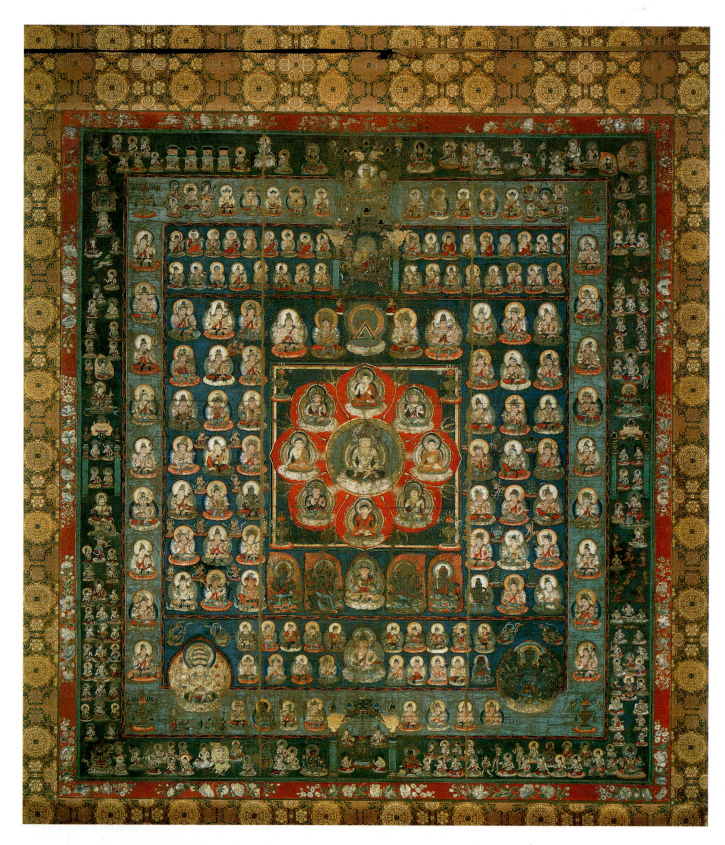

152 *Taizōkai* (Womb World) of Ryōkai Mandara, Kyōogokokuji (Tōji), Kyoto. 2nd half of the 9th century. Hanging scroll, color on silk; 72 x 60 ⅝ in. (183 x 154 cm). Kyōogokokuji, (Toji), Kyoto.

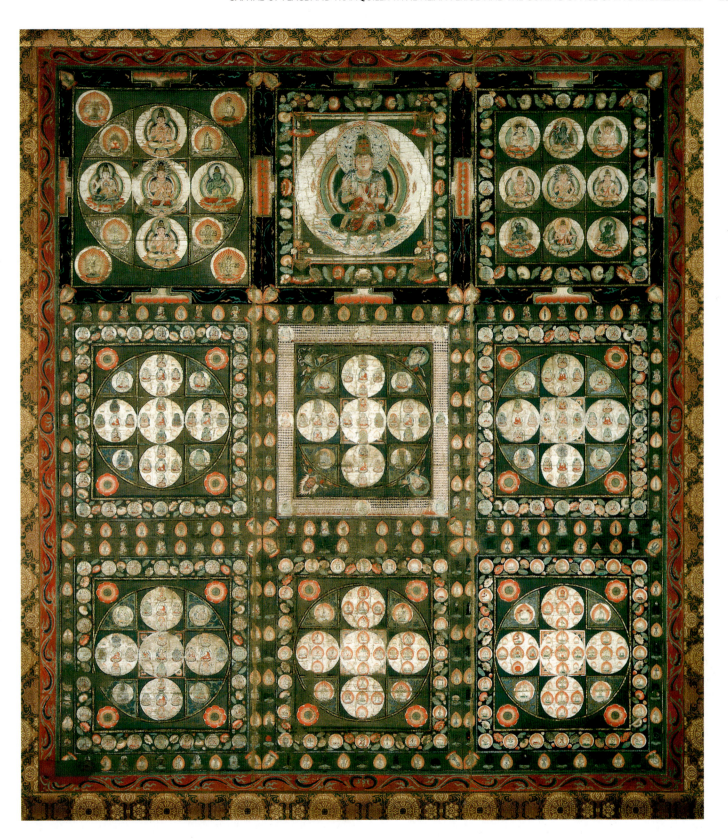

153 *Kongōkai* (Diamond World) of Ryōkai Mandara, Kyōogokokuji (Tōji), Kyoto. 2nd half of the 9th century.
Hanging scroll, color on silk; 72 x 60 ⅝ in. (183 x 154 cm). Kyōogokokuji, (Tōji), Kyoto.

The Taizōkai Mandara is composed of twelve precincts or courts arranged in concentric zones and expresses the many facets of Buddha nature (the potential in each of us to become a Buddha), and by extension human nature, from the viewpoint of the Buddha's compassion (Fig. 152). In the Court of Eight Petals in the very center of the rectangular painting, Dainichi Nyorai sits at the center of an eight-petaled lotus flower, his hands in a gesture of meditation. To the north, south, east, and west are images of the four transcendental Buddhas, and on the petals in between there are four bodhisattvas. In the rectangles framing this central court are four additional precincts: immediately above the central rectangle is the Court of Universal Knowledge, and below it is the Court of Wisdom. The former depicts the inner forces that correctly channel the individual's emotions, while the latter presents the Godai **Myōō**, the Five Kings of Higher Knowledge who destroy the practitioner's illusions. Enclosing these three rectangles are the Vajra Holders' Court to the right and the Lotus Holders' Court to the left. The images holding *vajra* (JAP. *kongō*) represent the power of the intellect to destroy human passions, while the figures in the Lotus Holders' Court symbolize the original purity of all beings. The images in the second and third layers of the mandala are courts of bodhisattvas, and the fourth, outermost layer, contains a multitude of guardian figures.

The Kongōkai Mandara consists of nine rectangles or Buddha worlds and embodies the adamantine, or diamond-like, wisdom that pervades the universe (Fig. 153). All the deities depicted are fully enlightened beings. In the center of the painting is the Attainment of Buddhahood Assembly, with Dainichi Nyorai in the center of the middle circle, surrounded by four bodhisattvas. At the center of each of the four circles around this central one are the four transcendental Buddhas, surrounded by bodhisattvas making manifest the multiple functions of the four Buddhas. At the center of the upper register is a single image of Dainichi, his hands in the gesture most characteristic of him, the wisdom fist or *chikenin* (SKT. *vajramudra*). In this gesture the thumb of the right hand is folded into the palm and encircled by the other four fingers, while the index finger of the left hand is inserted from below into the fist. Whereas the Taizōkai Mandara's basic symbol is the lotus of compassion, the Kongōkai Mandara's is the *kongō*.

The pair of mandalas described above are owned by Kyōōgokokuji (Tōji) and are considered to be the oldest and best-preserved mandala paintings still extant in Japan. Research by Yanagisawa Taka demonstrates that these are Japanese copies of a set made in China on a commission from Emperor Montoku (r. 850–58) and brought back to Japan by the Tendai monk Enchin in 859. The only comparable work thought to be older is the pair of Takao Mandaras preserved in Jingoji (named for Mount Takao, the site of the temple), which were executed in gold and silver pigment on damask dyed a deep purple. According to a temple tradition, these were made by Kūkai himself between 829 and 833 in response to a request from Emperor Junna (r. 823–34).

Whether or not one believes the attribution to Kūkai, the figures in the pair of Takao Mandaras do reflect an earlier style than that of the Tōji Mandaras and may be considered to have a more direct relationship to the mandalas Kūkai brought back from China. Scholars generally agree that the Tōji paintings were made sometime after the Takao Mandara, probably in the late ninth century. An examination of the Dainichi Nyorai from the Tōji Taizōkai Mandara provides an excellent index to the changes in style that occurred during the second half of the ninth century. The figures in the Tōji Mandara project a tense energy. They are defined by red iron-wire lines, but they do not have the three-dimensional quality of earlier painting. Shading is used, but rather than modeling the figures, it seems to create a decorative pattern over the surface of the painting. Some of the deities in the Tōji Ryōkai Mandara are depicted with animated hand gestures, but their bodies display no capacity for movement.

EARLY PORTRAIT PAINTING

Tōji also preserves a group of paintings that were actually executed in China during the late Tang period (618–907). This set of seven paintings depicts the Shingon patriarchs, both legendary and historical figures. Such paintings legitimized the age and authenticity of Shingon teachings and served as nonverbal confirmations of the importance of the master–pupil relationship. A set was given to Kūkai by his Chinese teacher Huiguo sometime before 806, when the

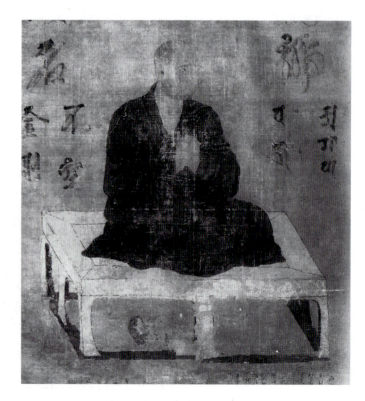

154 The patriarch *Amoghavajra*, by Li Chen (Chinese, act. *c.* 800), from the set of seven portraits of Shingon Patriarchs. Hanging scroll, ink and color on silk; height 81 in. (211 cm). Kyōōgokokuji (Tōji), Kyoto.

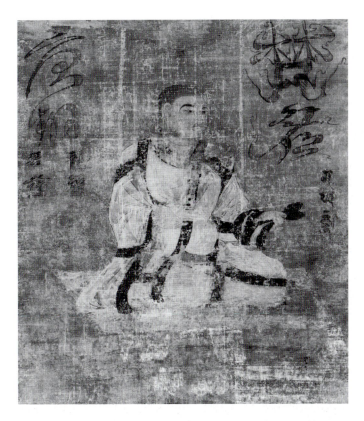

155 The patriarch *Nagabodhi*, by a Japanese master, from the set of seven portraits of Shingon patriarchs. 1st half of the 9th century. Hanging scroll, ink and color on silk; height 81 in. (213 cm). Kyōōgokokuji (Tōji), Kyoto.

Japanese monk left for home. However, in 821 Kūkai commissioned two additional portraits. In all probability Kūkai received a complete set, given that the seventh patriarch was Huiguo himself, and simply commissioned a Japanese artist to replace two paintings that were damaged. From an inscription on one of the best-preserved paintings, that of the sixth Shingon patriarch Amoghavajra (Fig. 154), we know that the Chinese artist Li Chen (act. c. 800), a painter who worked in the traditional Buddhist style of the period, was associated with the production of the Chinese set. Amoghavajra (JAP. Fukusanzo; 705–74) was born in India but was taken by his mother to Chang'an, where he studied with Vajrabodhi (JAP. Kongōchi), the fifth Shingon patriarch, until the latter's death in 741. He devoted the last years of his life to the translation of Buddhist sutras from Sanskrit into Chinese and is regarded as one of the four greatest translators of Buddhist texts in China.

Given a gap of more than thirty years between Amoghavajra's death and Li Chen's work, it is unlikely that the artist considered this or most of the other paintings in the set to be portraits in the Western sense of the word. Nevertheless, he has created a very realistic image which, given the identifying inscriptions on the painting, was understood by believers to be a representation of the person named. The depiction presents a monk deep in meditation. He has removed his shoes and sits on a rectangular raised dais, his hands in the "outer bonds" or *gebakuin* (CH. *waifu*) gesture, the

hands pressed together, the fingers interlocked, a gesture signifying release from the bondage of passions. His head and hands are delineated by black iron-wire lines, and his protruding cheekbones and large nose are modeled through the use of grey over the flesh tones. The shading of his robe, dark blue to black, suggests the volume of the body. This portrait is not a flattering one in the conventional sense. The revered monk is depicted as a non-Chinese with a knobby head. The artist even shows a tuft of hair growing in the patriarch's right ear. However, the painting succeeds on its own terms in presenting the image of a great teacher meditating intensely, his thoughts symbolized by the position of his hands.

A painting of a Shingon patriarch made in Japan presents a remarkable contrast to the Amoghavajra. Nagabodhi (JAP. Ryūchi) was an Indian monk who became the fourth Shingon patriarch (Fig. 155). Not much is known about him except that he was thought to have been the best pupil of Nagarjuna (JAP. Ryūmyō), the third patriarch of this teaching transmission, but its first human master. There are many different Indian Buddhist masters by the name of Nagarjuna in the first millennium C.E., but this patriarch of the Shingon school is held in Shingon tradition to be identical with the first Nagarjuna, who is most famous for formulating the philosophies upon which many of the teachings of the six schools of Nara are based. Nagarjuna received his transmission of the Shingon teachings directly from the bodhisattva Kongōsatta (SKT. Vajrasattva), who received it from Dainichi Nyorai.

The painting of Nagabodhi depicts a portly Japanese-looking monk, sitting on a raised dais. The figure wears a red robe with narrow bands of black and in his right hand he holds a notebook, symbolic of the teachings he is transmitting; his left grasps a piece of his garment. His head is outlined with the same type of iron-wire line as used in the Amoghavajra painting, but there is very little shading to suggest the bone structure of the face. The garment is likewise described in terms of line with very little shading. Finally, the ear of Nagarjuna is rendered as an abstract pattern of curves undulating under and over each other. The ear canal is indicated by a grey tone applied in the upper part of the design, but the cartilage formation just to the right is treated as a linear design without any shading. The painting is a study of flat forms, lacking the intensity of the Chinese portraits.

SCULPTURE

Another group of works that demonstrate the transition from a classic Nara-period style to that of the Early Heian period are the twenty-one sculptures set on a large altar in the *kōdō* of Tōji (Figs 156 and 157). The nearly life-sized images represent Buddhas, bodhisattvas, and Myōō, as well as the Shitennō (the Four Guardian Kings) and Bonten and Taishakuten (Brahma and Indra), and are arranged on a low altar as a kind of sculptural mandala. The Myōō and the Godairiki Bosatsu (Five Power Bodhisattvas) are like traditional bodhisattvas in being fully enlightened, but differ in being wrathful forms of

156 View toward the Myōō precinct of the altar, in the *kōdō* (lecture hall) Kyōōgokokuji (Tōji). Zōchōten is at the extreme right.

A GODAI BOSATSU	B GODAI BUTSU	C GODAI MYŌŌ	16 Tamonten
1 Kongō Haramitsu	6 Dainichi	11 Fudō Myōō	17 Bonten
2 Kongō Satta	7 Ashuku	12 Kongō Yasha	18 Jikokuten
3 Kongō Hō	8 Hōshō	13 Gōzanze	19 Kōmokuten
4 Kongō Gyō	9 Fukūjōju	14 Daiitoku	20 Taishakuten
5 Kongō Hō	10 Muroju	15 Gundrai	21 Zōchōten

157 Diagram of the sculptural mandala, in the *kōdō* (lecture hall), Tōji.

compassion, using their great powers and terrific energy to vanquish evil.

In the center of the platform is Dainichi Nyorai surrounded by the four transcendental Buddhas: Muryōju (SKT. Amitayus; Buddha of the west—identical with Amida Buddha), Ashuku (SKT. Akshobhya; Buddha of the east—also identified with Kongōsatta), Fukūjōju (SKT. Amoghasiddhi; Buddha of the north), and Hōshō (SKT. Ratnasambhava; Buddha of the south). To the east is a set of the Godai Kokūzō Bosatsu (Five Limitless Wisdom Bodhisattvas; SKT. Akashagarbha Bodhisattva), with four of them arranged around the most important, Kongō Haramitsu (SKT. Vajraparamita). The Godai Kokūzō Bosatsu are the five manifestations of aspects of the Kokūzō Bosatsu (SKT. Akashagarbha), known in Japan since the eighth century, and associated with wisdom as vast as the limitless sky. To the west on the altar are the Godai Myōō, again with four of them grouped around the most important of their number— **Fudō** (SKT. Acala; the Immovable One). At the four corners of the dais are the Shitennō figures, and between them Bonten and Taishakuten.

This arrangement, combining deities given a greater prominence in the Shingon school with more traditional figures from the six schools of Nara (such as the Shitennō, Taishakuten, and Bonten), is not based upon any known sutra. It therefore probably represents Kūkai's own concept, and one meant to combine the old and the new into a synthetic whole. The *kōdō* in which they are installed was envisioned in Kūkai's original plan of Tōji, formulated shortly after he was appointed abbot in 823, but the eye-opening ceremony for the sculptures was not performed until 839, four years after his death. Of the original twenty-one images, the five Buddhas and the Kongō Haramitsu are later replacements. Today all of the images face south. However, the altar is located in the middle of the *kōdō*, facilitating circumambulation of the entire set of sculptures, and we know that in earlier times the statues to the extreme east and west of the mandala faced the viewer, who moved around the periphery of the hall and experienced their physical reality more immediately.

Fudō presents the wrathful aspect of Dainichi, a parallel to the Kokūzō bodhisattvas, who represent his limitless wisdom. The Fudō sits on a base composed of rectangular shapes intended as an abstraction of a rock formation (Fig. 158). In his left hand he holds a lasso, and in his right he holds a sword with a *vajra* handle. His hair is pulled into a braid on one side of his head, and he has two tusks, which point upward. His eyes are wide open, but they appear to be looking down rather than at the viewer, and the expression on his face suggests power that is alert but held in check. His head is slightly

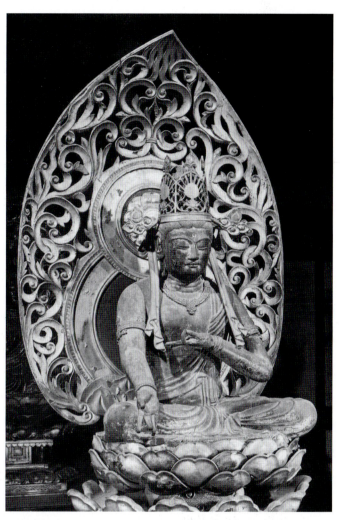

159 *Bodhisattva Kongō Hō*, in the *kōdō* (lecture hall), Kyōōgokokuji (Tōji). 1st half of the 9th century. Wood, with lacquer and gold leaf; height 37 ¾ in. (96 cm).

turned, so he seems to be looking to his right. In spite of his frightening appearance, this divinity projects an impression of solidity and calmness. He is indeed the immovable one. The four other Myōō are Gōzanze (SKT. Trailokyavijaya; Subduer of the Three Worlds), Gundari (SKT. Kundali; Treasure–Producer), Daiitoku (SKT. Yamantaka; Great Awe-Inspiring Power), and Kongō Yasha (SKT. Vajrayaksha; Diamond Demon) but their images are delicate by comparison to the Fudō, despite having strong poses and animated drapery.

The bodhisattva Kongō Hō (SKT. Vajraratna), in the southeast corner of the bodhisattva precinct, is very similar in appearance and technique to some sculptures of the Nara period (Fig. 159). Seated in the lotus position on his throne, the calm figure creates the impression of a gentle, compassionate deity capable of turning and bending in order to reach out to the believer. The elaborate patterns of his necklace, arm

158 *Fudō Myōō*, in the *kōdō* (lecture hall), Kyōōgokokuji (Tōji). *c.* 839. Wood, painted; height 68 ¼ in. (173.2 cm).

bands, and crown, combined with the gentle, natural folds of his garment, give the bodhisattva an elegance that rivals that of similar sculptures of the Nara period.

The technique used for the Myōō and the bodhisattvas is very similar. The majority of each sculpture—the head, the body, and the heart of the pedestal supporting the figure—is carved from a single block of wood, with cavities scooped out of the back of the head and the torso to prevent the wood from drying unevenly and causing surface cracks. The forearms and the fronts of the knees are carved from separate pieces of wood and joined to the central part of the statue. More pieces of wood were used for the Fudō than for the bodhisattvas, undoubtedly because of the size of the image. Details of the hair, the face, the upper part of the body, and the feet have been modeled in lacquer and glued to the plain wood surface. Next, the bodhisattvas were coated with lacquer and covered with gold leaf, while the Myōō were covered with *gofun* (gesso) and decorated in bright colors and rich textile patterns. This technique is very similar to that used for wood-core, dry-lacquer statues, such as the late Nara-period standing Yakushi in the *kondō* of Tōshōdaiji (see Fig. 123). It seems highly probable that the sculptors of the Tōji pieces were artists trained in a temple atelier at the end of the eighth century.

However, despite the stylistic and technical similarities between the Tōji bodhisattvas and the classic sculpture of the Nara period, there are several points of difference. The Tōji bodhisattva figures have greater bulk and more solid volume than earlier works. Also they have a sensuality that the earlier works lack. Sawa Takaaki associates this latter characteristic with Kūkai's preferences in sculptural style. A group of Buddhist statues reputed to have been installed at Kongōbuji by Kūkai himself and destroyed in a fire there in 1926, including two bodhisattvas, a Kongō Satta (Vajrasattva), and a Kongō Hō (Vajraratna), had much the same sensuality as the Tōji figures.

The Myōō, being new to the Japanese Buddhist pantheon, derive from a separate tradition of images, probably first imported into Japan as iconographic drawings. It has been suggested that the Fudō, in particular, may have been sculpted following a drawing Kūkai brought back from China. The slight twist of the head is a device frequently found in such drawings, but one that makes little sense in the treatment of a sculpture used as the central motif in a constellation of five statues. The major characteristics of the image, the treatment of the hair and the tusks, and the pose of the figure on a rectilinear rock formation constitute the beginning of a unique tradition of Fudō paintings and sculptures known today as the Daishi (or Kōbō Daishi) lineage of images, which have been handed down in the Shingon sect.

TEMPLE ARCHITECTURE

Jingoji

The earliest temple to reflect the teachings of the Shingon and Tendai schools is Jingoji, near Mount Takao. In a beautiful,

mountainous region to the northwest of Kyoto, it is far from the secular atmosphere of the clergy in Nara and the court in Heian. The temple had been pledged by Wake no Kiyomaro (733–99) in connection with his efforts to block the monk Dōkyō's ambition to become emperor. Kiyomaro had been asked by Dōkyō's patron Empress Shōtoku (Kōken) to travel to Kyūshū to ask the Shinto divinity of the Usa Hachiman Shrine about the propriety of making Dōkyō emperor. Kiyomaro made the journey, at the same time promising to build a temple and make a Buddha image, in addition to having certain sutras copied and some ten thousand other sutras chanted. However, when the god's negative reply was reported to the court, Dōkyō had Kiyomaro stripped of his ranks and sent into exile. It was not until after the empress's death and Dōkyō's exile in 770 that he could begin construction. The temple he built, Jinganji, was completed by 793, but in 824 it was moved to the slopes of Mount Takao and renamed Jingoji.

In 809, when Kūkai was finally allowed to return to the environs of the capital, he was ordered to take up residence at Jingoji, located as it was just outside the city. In 812 the temple provided the facilities for Kūkai's performance of the Shingon *kanjō* initiation rituals, the first being for Saichō and the sons of the temple's founder, Wake no Kiyomaro. This ritual is performed several times as a pupil progresses, and is intended to confer an aptitude for further study. Jingoji remained an important focus of the Buddhist community throughout the ninth century, but by the middle of the twelfth century, at the end of the Heian period, the temple had fallen into such disrepair that it required the nearly superhuman efforts of the monk Mongaku to make it a viable religious institution again.

A standing Yakushi image in Jingoji is thought to be the main icon of Kiyomaro's previous Jinganji, probably completed by 793 and subsequently moved to the later structure of Jingoji (Fig. 160). This figure of the healing Buddha is life-size and heavy-set, its drapery cut into deep folds but pulled tight over the widest part of the thigh. Holding a medicine jar in the left hand, Yakushi makes the fear-not or *semui-in* gesture with the right. At first glance, the Yakushi may appear to be facing directly forward, but in fact the left shoulder and drapery folds are slightly higher than those on the right and give him the appearance of turning slightly to the left. The heavy-set features of the face give this Yakushi a brooding quality, while the slight turning of the figure imbues it with a sense of movement. The overall effect is a strange, supernatural, and not quite welcoming appearance.

Like the slightly later sculptures of the Tōji *kōdō*, the sculpture is carved out of a single block of *hinoki* wood (Japanese cypress). However, because cavities were not hollowed out of the back of the sculpture, the surface has sustained some serious cracks, which have now been repaired. Traces of paint remain on the face: red on the lips, black over white for the pupils of the eyes, and blue on the snail-shell curls over the top of the head, with the remainder of the body left unpainted. The largely unadorned nature of the wood surface has led

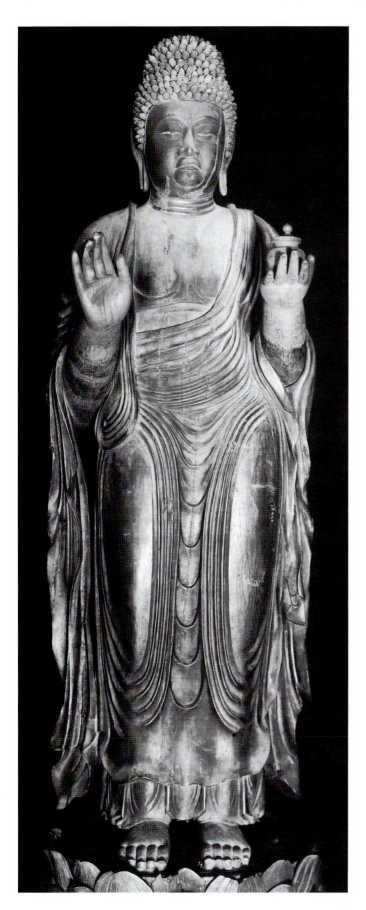

160 *Standing Yakushi*, at Jingoji, Kyoto. *c.* 793. Cypress wood with traces of paint; height 67 in. (170.3 cm).

scholars to believe that this Yakushi may be one of the earliest examples of **ichiboku**, or single-block, construction. A number of theories have been advanced to account for the appearance at this time of *ichiboku* as a sculptural technique, and an important feature of them is the fact that single-block sculptures appear primarily in rural or suburban temples, such as the Jingoji. These temples lacked the monetary resources of such establishments as Tōji, having perhaps a single patron, and wood was the most available material from which to fashion images. A corollary to this explanation is the notion that provincial and untrained artisans, perhaps even monks, carved these sculptures, thus accounting for the crudeness of their execution and their ungainly proportions. Another, and not necessarily contradictory, explanation is that these less elegantly executed *ichiboku* sculptures are part of a movement to return to the fundamental disciplines of Buddhism encouraged by Emperor Kanmu and favored by Kūkai himself, and this might explain their appearance in the *kōdō* of the very metropolitan Tōji.

This plain-wood style actually seems to have begun in the late eighth century in the Nara workshop at Tōshōdaiji, which was the center for Ganjin's Ritsu school (SKT. Vinaya), the first school to reassert the need for a return to discipline in Buddhist practice. The standing Yakushi on the altar of the Tōshōdaiji *kondō*, dated to the years after 796, has a wood core with dry lacquer applied to the surface (see Fig. 123). However, preserved in the temple's *kōdō* (lecture hall) is another standing Yakushi dated to 760 that is completely unpainted. Because of Ganjin's Chinese connections, the Tōshōdaiji workshop had greater access to styles and techniques being produced on the continent. In both China and India there is a long tradition of plain-wood sculptures executed in aromatic sandalwood. According to legend, the first image of Shaka Buddha was carved in sandalwood, and there is a lineage of Shaka sculptures thought to duplicate that image. Indeed the Shaka statue brought to Japan in 987 by a Chinese monk, Chōnen, now installed in Seiryōji in Kyoto, was thought by the Japanese to be part of this lineage. The Jingoji Yakushi, with its heavy facial features, fleshy body, and distinctive drapery patterns, clearly reflects this continental plain-wood style.

Another factor contributing to the appearance of *ichiboku* as a sculptural technique at this time was the fact that the new rural mountain temples of Shingon and Tendai Buddhism were returning to the native Japanese taste for humble materials. Plank flooring was replacing stone, and cypress-bark shingles were preferred to ceramic tiles. Wood was readily available and cheap, and therefore a logical choice for sculpture as well as for architecture. In addition, the Jingoji Yakushi is a visual statement of religious renewal and discipline—an austere and brooding, fleshy image which required serious efforts at communication on the part of the worshiper. The fact that it was fashioned in the Indian and Chinese tradition of plain-wood sculpture made it a more authentic image, while paradoxically this also brought it closer to the simpler aesthetics of Shinto *kami* imagery.

Single-block and Multiple-block Wood Sculpture

There are two main techniques associated with wood sculpture in Japan: *ichiboku zukuri,* the carving of a single block, and **yosegi zukuri,** the assembly of multiple carved blocks. In carving an image from one block of wood, the sculptor must determine the final size of the piece before seeking the single wood block. This stage is known as *kidori,* literally, "taking from the tree." Next, is the *arabori* stage, when the sculptor carves away what is not needed from the block, producing a rough approximation of the final image. In the *kosukuri* stage, the block is carved into a nearly final form; and in the *shiage* stage, delicate details, such as drapery folds and facial features, are carved and the surface is usually coated with lacquer and gold leaf or *gofun* (gesso) and paint.

Ichiboku sculpture has one major flaw. The exterior of the image dries faster than the core and causes unsightly cracks, particularly if the surface has been treated, for example, with paint or lacquer. In order to prevent or minimize such damage, two other techniques were developed. One involves cutting into the block either from behind or below and removing the wood at the center. With the other method, the finished statue is split once or several times along the grain of the wood and each section is hollowed out.

The technique that most effectively dealt with the cracking problem was *yosegi zukuri,* in which several rectangular blocks were individually selected and carved into the needed shapes—the back of the head, back and front of the image, crossed legs, and so on. This multiple-block technique had many advantages, including producing a sculpture that was much lighter than an *ichiboku* work. Each type of piece could be assigned to an artisan-specialist (the carver of knees, for example), permitting the development of a true studio and of an "assembly-line" production. This, in turn, enabled the atelier to turn out large-scale images in a relatively short time.

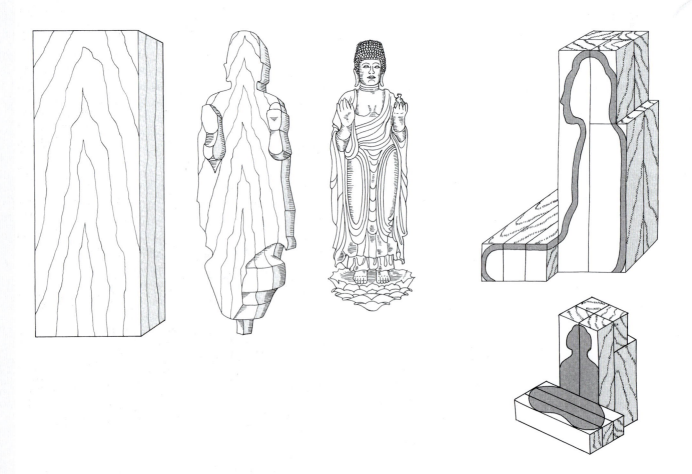

Muroji

Another mountain temple roughly contemporary with Jingoji, but better preserved, is Murōji, located in the mountains to the southeast of Nara. Even before the site was chosen for the construction of a Buddhist temple, it was considered sacred by the locals because of its unusual configuration of rocks and streams, created by volcanic action. The site was reputed to be the home of the dragon spirit Ryūkesshin and an efficacious place at which to pray for rain. In the late 700s the monk Kenkyo from Kōfukuji, the Nara temple of the Fujiwara clan and a center of the Hossō school (SKT. Yocacara), founded Murōji there largely because of the auspiciousness of the site, and throughout most of its history the temple has maintained this connection with Kōfukuji.

The buildings of the temple have been laid out on three levels (Fig. 161). At the base of the mountain next to the Murō River are the residence halls for the monks. Midway up the mountain are the main buildings for worship: a *kondō* ("golden hall") a mirokudō or hall dedicated to the Future Buddha Miroku (SKT. Maitreya), a building for the *kanjō* initiation rites known as the *kanjōdo*, and a five-storied pagoda. At the top of the mountain is the inner precinct. Of these structures, only the *kondō* and the five-storied pagoda of the middle precinct have survived from the Early Heian period. They are attractive buildings, sensitively fitted into small plateaus that are carved out of the mountain face.

The five-storied pagoda is considered to be the oldest structure in the temple complex, dating to the late Nara period or the early years of the ninth century (Fig. 162). The building is extraordinarily slender and about half the height of most pagodas, and the use of native materials such as cypress-bark roofing gives it a more informal appearance than the tiled roofs of earlier pagodas and enables it to fit easily into its natural environment. Severely damaged in a typhoon in recent years, it has since been restored. However, only the lower stories now truly date from the Early Heian period. The *kondō*, like most buildings of a comparable age, has undergone innumerable repairs over the centuries and no longer has the graceful outlines and balance of the original structure (Figs 163 and 164). The hipped-gable roof and the façade of the first building are gone, because by the late Kamakura period (late

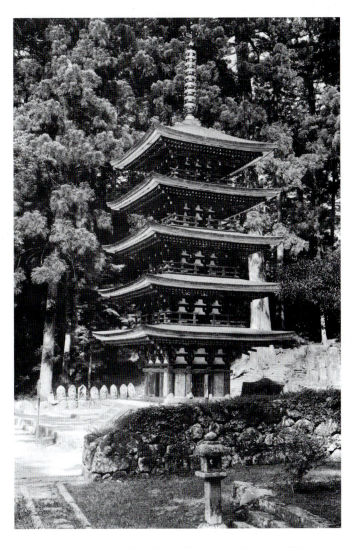

162 Five-storied pagoda, Murōji. Late 8th or early 9th century. This photograph was taken in the late 1980s before the pagoda was damaged and rebuilt in the late 1990s.

1 five-storied pagoda
2 Kanjōdō (Initiation Hall)
3 *kondō*
4 Mirokudō
5 Niō Gate
6 Muro river
7 Goeidō
8 Hall of Eternal Light

161 Plan of Murōji, Nara prefecture.

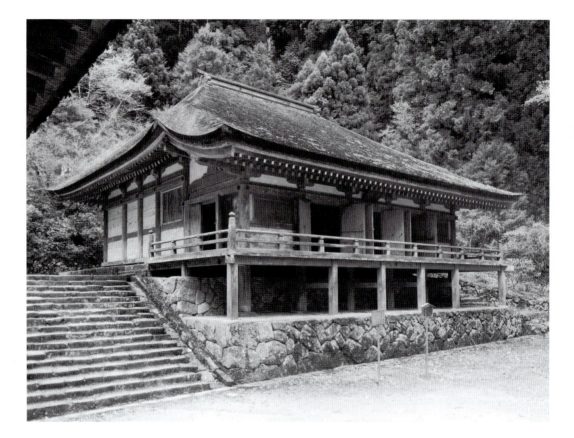

163 *Kondō*, Murōji. Early 9th century, with modifications of the early 13th century.

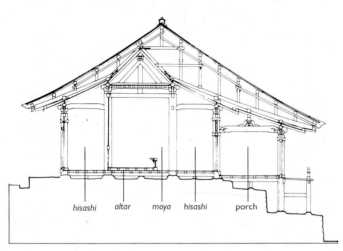

hisashi altar moya hisashi porch

164 Cross section of the *kondō* of Murōji, showing *moya*, *hisashi* (corridors), and added front porch.

thirteenth to early fourteenth century) a kind of worship hall known as a *raidō*—actually a one-bay-wide porch—was added across the front, extending the roof line outward in an ungainly manner.

Nevertheless, the building provides us with at least a glimpse of its appearance in the Early Heian period. It is set into a recess sculpted out of the mountain, the front supported by a masonry foundation. The original hall consists of a central rectangle, the **moya**. Three bays wide and one bay deep, encircled by a one-bay-wide corridor, this central rectangle is further distinguished from the remainder of the hall by a separate latticework ceiling. Dominating the interior space of the *moya* is a low altar, backed by a tall wooden screen, on which five large standing Yakushi images have been installed, with diminutive images of the twelve *yaksha* (JAP. *yasha*) generals of Yakushi in front of them. The impression one gains is of an intimate space, articulated by simple wood forms and a bracketing system set parallel to the walls and supported on round pillars.

Murōji houses several major sculptures of the Early Heian period, but surely the most impressive among them is the seated Shaka installed in the neighboring Mirokudō (Fig. 165). The figure, except for the knees and the forearms, is carved out of a single piece of *hinoki* wood. However, this image, unlike the Jingoji Yakushi, has cavities hollowed out of the head and the chest, the holes covered with pieces of wood sculpted to fit neatly into place. In the constricted space of this satellite building, the Shaka seems austere and overwhelming. The horizontal line of the crossed legs provides an ample base for the figure, but the heavy, massive torso and the huge head—which would have been even larger had its snail-shell curls not been lost—create a strong vertical. The fact that the sculpture is just barely in balance—he tilts as if falling forward—creates a tension between the viewer and the image, and this very tension makes the viewer look at the sculpture in a new way. In carving the statue, the sculptor has used a pattern of folds known as the rolling-wave style, or *honpa shiki*, in which one drapery fold is thick and sharply undercut at the crest of the

wave, and the next is a shallow, single fold. The insistent repetition of this motif over the torso and legs creates an intricate pattern against the smooth surface of the body. Finally, the statue was painted, first with white *gofun*, or gesso, and then with colorful textile designs. Today only the white undercoat and a patch of vermilion remain on the figure. Even so, the seated Shaka of Murōji testifies to an advance in the *ichiboku* technique, and to a renewed interest in sculptural decoration in the second half of the ninth century.

Daigoji

The complex of temple buildings known as Daigoji, or Temple of Buddha's Excellent Teachings, represents the last major temple construction in the Early Heian period. The founder of the temple was Shōbō (832–909), a monk trained in the old Nara school of Sanron (Three Treatises), who later turned to Shugendō, or the way of the mountain ascetic, which was a uniquely Japanese blend of tantric Buddhist, Chinese Daoist, and Shinto beliefs. Followers of Shugendō believed that through the solitary practice of religious austerities such as fasting, immersion in ice-cold streams, and the recitation of sutras in the mountains, they could achieve great spiritual powers. In 874, Shōbō established a seminary at the top of Mount Kasatori, to the southeast of Heian, for the teaching of the Shugendō way and thereafter he received the support of Emperor Daigo (r. 897–930). This seminary was the beginning of Daigoji, which eventually became a major center of the Shingon school. So great was the emperor's involvement with the temple that after his death the temple's name became the posthumous title by which he is known to history. Unfinished at the time of Shōbō's death in 909, the temple at the top of Mount Kasatori was not completed until 913. Its location proved to be a problem for its imperial sponsor, since it was situated on a peak 1500 feet (457 m) high. Consequently, a Shimo, or Lower, Daigoji was commissioned, and its first building, a Shakadō, or Shaka Hall, was completed in 926. Work on the Shimo Daigoji proceeded slowly even though the project received the sponsorship of the next two emperors, Suzaku (r. 931–47) and Murakami (r. 947–68), and the complex was not completed until 951. All that survives today of the original Kami, or Upper, Daigoji is a Yakushi Triad—Yakushi Buddha and his attendants, the bodhisattvas Nikkō and Gakkō—begun around 907 and completed by 913. Even the Yakushidō (Yakushi Hall) in which the three statues are currently installed is not the original structure, but one dating to 1121, making it the second oldest building at the temple. Of the original Shimo Daigoji, a five-storied pagoda completed in 951 has been preserved, and has elaborate wall paintings depicting the Ryōkai Mandara and portraits of the Shingon patriarchs.

Because the Yakushi Triad is securely datable to the earliest years of the tenth century, it provides an excellent benchmark in the development of Buddhist sculpture (Fig. 166). The Yakushi is a large statue, a seated figure slightly taller than the standing Yakushi at Jingoji (see Fig. 160). Its size is further emphasized by its placement on a tall lotus-flower base, in contrast to the flanking bodhisattvas, who stand on much lower pedestals. The head and the body seem almost like blocks, the transition between them made by the shortest and widest neck imaginable. However, the spread of the knees creates a very solid base for the vertical projection of the body, and the drapery falls in gentle folds over the legs, creating an irregular but completely natural pattern over the crossed feet. In the final analysis, the Yakushi seems to be a powerful, calm, enduring, if remote, figure as it looks beyond the entrance doors to the hills and valleys below the Kami Daigoji. The flanking statues of Nikkō and Gakkō are much shorter than the Yakushi, and, although somewhat plump, they are graceful figures, standing in gently hip-slung poses. Their faces, particularly the lips, are less full than the Buddha's, giving them a softer, less dour expression. Their garments fall in decorative folds over the body, complementing the linear patterns of the jewelry—necklaces and arm bracelets. They add a soft, decorative accent to the solidity of the Yakushi.

The technique employed in sculpting the Yakushi Triad is primarily *ichiboku*, but more of the volume of the statues is rendered in added blocks than was the norm in earlier years. In this work, the sides of the hips are made of different pieces

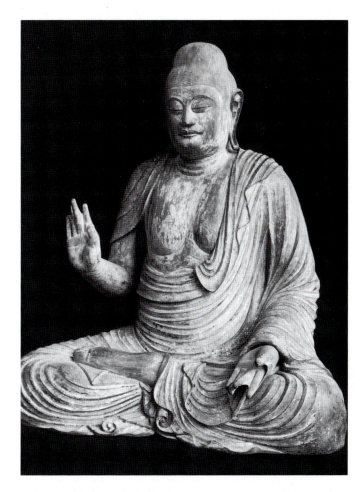

165 *Seated Shaka*, in the Mirokudō, Murōji. 2nd half of the 9th century. Cypress wood, with traces of *gofun* and paint; height 41 in. (104.1 cm).

of wood, as are the forearms and the knees. Large cavities have been scooped out of the back of the torso and head of the Yakushi, and out of the flanking bodhisattvas. Finally, the sculptures were painted with lacquer and covered with gold leaf. What has been accomplished in these three sculptures is a marriage of advanced *ichiboku* technique with a new expressive formula, in which the Buddhist deity asserts power through his calm demeanour and over-life-size dimensions alone, without patterning of drapery or exaggerated treatment of the body, as seen in the Jingoji Yakushi and the Murōji Shaka.

The five-storied pagoda at Shimo Daigoji, completed in 951, is an impressive building standing apart in the temple grounds (Fig. 167). Its placement is such that, in ascending a gentle incline toward the heart of the Shimo Daigoji complex, the visitor sees its soaring dimensions; yet it cannot be viewed from above, which would diminish its architectural effect. Although the pagoda breaks no new ground in terms of its design, it is a thoroughly satisfying building and the only example of its type remaining from the tenth century. The interior of the pagoda presents a striking contrast to the dull red of the building's skin. Wooden casings have been placed around the four sides of the central pillar, or heart pillar, to square it off, and these casings and the wall surfaces, even the insides of the doors, are decorated with luminous paintings of the Ryōkai Mandara and the Shingon patriarchs, Kūkai's

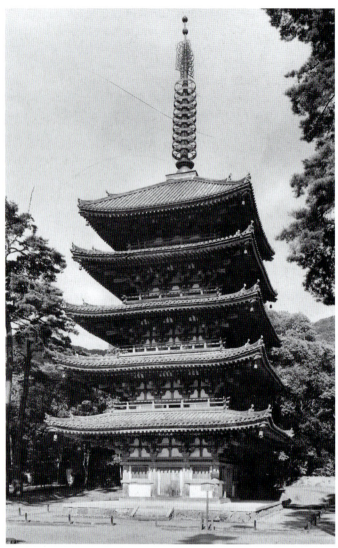

167 (above) Five-storied pagoda, Shimo Daigoji, Kyoto. Completed 951.

portrait by this point having been added to the series. A hierarchy of deities is established by the placement on the heart pillar of the central motifs from the two mandalas, the Taizōkai Dainichi Nyorai on the west face, the Kongōkai Dainichi Nyorai on the east face. Secondary motifs from the two realms are depicted on the inner sides of the window shutters, while the patriarchs, clearly based on the earlier portraits at Tōji, are placed on the lower panels of the wainscoting.

Best preserved of the mandala paintings is the Dainichi Nyorai from the Taizōkai (Fig. 169). The figure is defined by the red iron-wire lines typical of traditional Buddhist painting, but a palette of cool greens and reds and quiet flesh tones has been used instead of the bright reds and oranges of the Tōji mandala. Evidence of *kirikane*—in this case, fine lines of gold foil applied to the painting surface to suggest textile designs—

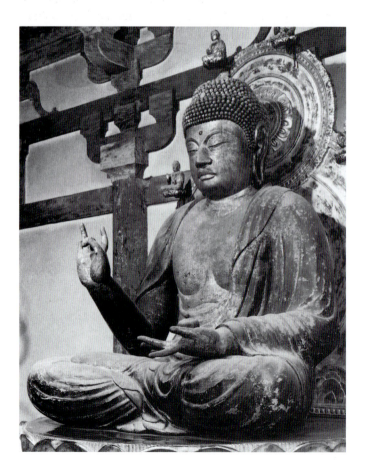

166 (left) *Yakushi*, in the Yakushidō, Daigoji, Kyoto. 907 to 913. Wood, with lacquer and gold leaf; height 69 ½ in. (176.5 cm).

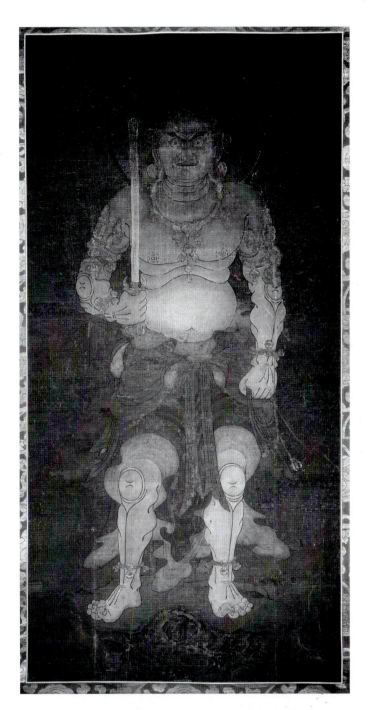

168 *Fudō Myōō*. 12th century copy of 9th century original at Onjōji. Color on silk; 70 ⅛ × 31 ⅝ in. (178.1 × 80.3 cm). Manju-in, Kyoto.

towards a more tranquil elegance—not unlike that fostered in the Nara period.

FUDŌ AND THE GODAIRIKI BOSATSU

Works that bracket in date the Ryōkai Mandara paintings at Daigoji are a painting of Yellow Fudō, the most important of the Myōō preserved as a secret treasure (*hibitsu*) of Onjōji, on the southwest shore of Lake Biwa and to the north of the capital, and one of three paintings surviving from a set of five scrolls depicting the Godairiki Bosatsu (the Five Power Bodhisattvas) in the Jūhakkain of the Yūshi Hachiman Association on Mount Kōya. The Yellow Fudō is first mentioned in the *Tendaishū Enryakuji Enchin den*, a biography of the monk Enchin (814–91) compiled in 902. Enchin was a great scholar and the fifth head abbot of the Tendai school at Enryakuji. The painting of Fudō is said to be an artist's recreation of an image of a yellow Fudō seen in a vision by Enchin in 838 while in deep meditation. The image is unique among surviving examples of Fudō. He stands solidly facing the viewer, his powerful body filling the picture plane, his feet wide apart and apparently supported by air. Because this painting is a sacred icon of Onjōji, the temple no longer allows it to be reproduced.

The best alternative for study is a copy from the early thirteenth century, in which a rock has been included to provide a base for the figure (Fig. 168). The Fudō's hands hold the traditional attributes, a *vajra*-handled sword and a lasso, but his hair is treated as a halo of ringlets around his head, rather than as the usual single braid hanging down one side of his face. His features display a ferocious expression, and his eyes, which are outlined in gold and have pupils made of gold leaf, appear to glow as they stare straight ahead at the viewer. His body, too, appears to give off a yellow radiance against the dark-gray ground. Considering the dates mentioned in the available documents, 838 and 902, it seems most likely that the original painting is a work from the second half of the ninth century.

The set of paintings of the Godairiki Bosatsu preserved on Mount Kōya are dated to the second half of the tenth century on the basis of style (Fig. 170). These wrathful deities are the focus of worship in the ceremony of the Benevolent Kings, performed to assure the protection of the nation, and they find their scriptural derivation in the *Ninnōhannya haramitsu kyō* (*Benevolent Kings' Sutra*). Of the three surviving paintings, one presents a seated image of Kongōku, or the Adamantine Howl. Behind the figure, an aureole of red flames glows against the background. Black, moderately calligraphic lines define the body, adding an impression of vitality, yet in the treatment of the drapery there seems to be a conscious effort to deny the three-dimensionality of the image. The artist has created a marvellous tension between the volume and vitality of the deity and the flat patterning of the drapery and flame halo. He has blended the awesome strength of the Onjōji Fudō with decorative detail. If we can assume that this set of five

can be found. Coincidental with the gentle harmony and richness of the pigments is a new calmness in the treatment of the figures. The Dainichi sits cross-legged, supporting the wheel of the Law—a traditional image of the Buddha's teachings—with both hands. Soft shading is used to model his form, but the figure displays a quietude in sharp contrast to the exuberant vitality of the oddly flat and two-dimensional Tōji mandala figures. Indeed, the Daigoji murals reveal a new direction in Japanese painting, away from the earlier heavy-set severity or two-dimensionality of the first decades of the Heian period

169 *Taizōkai Dainichi*, west panel of the heart pillar in the five-storied pagoda, Shimo Daigoji. 951.
Color on wood; height 104 in. (264 cm).

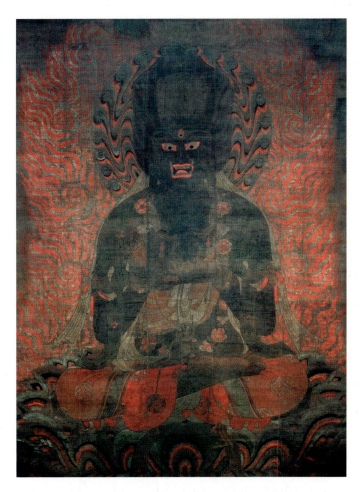

170 *Kongōku Bosatsu*, one of the Five Power Bodhisattvas, from a
set of five paintings. 2nd half of the 10th century. Ink and color on silk;
120 × 60 in. (305 × 180 cm). Yūshi Hachiman Association of Mount Kōya,
Jūhakkain, Wakayama prefecture.

deities was intended to be viewed in a symmetrical grouping,
it seems likely that the extant paintings of figures in dynamic
movement were originally hung to the left of the seated bod-
hisattva, while those to the right have been lost. A similar set
of Myōō paintings can be seen in an illustration of the
Shingonin, a hall used for the performance of Shingon rituals,
in the Imperial Palace in Kyoto (see Fig. 191).

ARCHITECTURE OF THE MIDDLE HEIAN

In the Middle Heian period, the great taste-setter in temple
building, as in the secular world, was Fujiwara no Michinaga
(966–1027), and the foremost example of his temple-building
activities was the now-lost Hōjōji (Fig. 171). Established in
Heian and begun in 1019, the temple was meant to be the
place of Michinaga's retirement. The greatest statesman of the
entire Heian period, Michinaga was in poor health by this
point, and like many Heian aristocrats before and after him
resolved to "renounce the world" in his old age and become a
monk. The temple evolved over the next thirty-nine years into
the first great Buddhist structure undertaken by the Fujiwara

regency and the standard against which all later temples
would be measured. Unfortunately, it was destroyed by fire in
1058, but enough documentary material remains for us to
recognize what a monumental project it was. From the very
beginning, the temple was designed according to the prece-
dents of the nobleman's residence. A pond fed by a natural
spring was excavated, leaving an islet in the middle; hillocks
were built up, shrubs and trees were planted, and the temple
buildings were distributed around this central focal point. The
first hall to be completed was the Amidadō, or Amida Buddha
hall, a long, narrow building to the west of the pond, designed
to house nine over-life-sized Amida images. Year after year,
buildings were added. Then, in 1027, when Michinaga was
near death, he was taken to the Amidadō, where he died hold-
ing a cord made of threads tied to the hands of the nine Amida
images on the platform in front of him. After his death, the
temple became a memorial to him, with new halls being added
by his heirs, until the whole compound was destroyed by fire
some thirty years later.

The religious concepts motivating the leaders of the
Middle Heian period were very different from those that had
stirred Emperor Shōmu in the eighth century or Emperor
Daigo in the ninth century. Ultimately the Buddhism of the

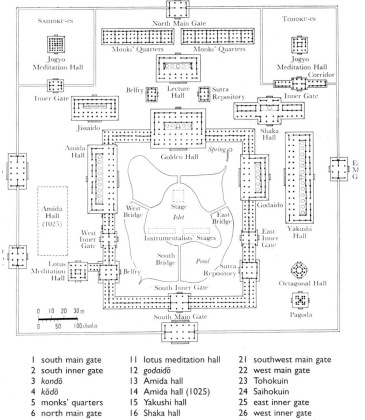

1 south main gate	11 lotus meditation hall	21 southwest main gate
2 south inner gate	12 *godaidō*	22 west main gate
3 *kondō*	13 Amida hall	23 Tohokuin
4 *kōdō*	14 Amida hall (1025)	24 Saihokuin
5 monks' quarters	15 Yakushi hall	25 east inner gate
6 north main gate	16 Shaka hall	26 west inner gate
7 sutra repository	17 Jissaidō	27 instrumentalists'
8 belfry	18 inner gate	stages
9 octagonal hall	19 meditation hall	28 inner gate
10 pagoda	20 east main gate	29 stage islet

171 Plan of Hōjōji, Heiankyō (Kyoto). 1st half 11th century
(no longer extant).

new and old schools alike succumbed to the concerns with image and elegance that permeated secular aristocratic life. Some of the sumptuous elegance that came once again to characterize Japanese Buddhism—at least in the capital—in the Middle Heian period can be gathered from a passage describing a dedication ceremony at Hōjōji found in the *Eiga monogatari* (*A Tale of Flowering Fortunes*), a narrative about the Fujiwara clan at the peak of its splendor.

> Very much at ease, the Emperor gazed at the scene inside the temple compound. The garden sand glittered like crystal; and lotus blossoms of varying hues floated in ranks on the fresh, clear surface of the lake. Each blossom held a Buddha, its image mirrored in the water, which also reflected, as in a Buddha domain, all the buildings on the east, west, south, and north, even the sutra treasury and the bell tower.... Next the monks filed in from the south gallery, forming lines on the left and right; and tears came to the eyes of the speechless spectators at the sight of that great multitude of holy men moving forward in unison, each group headed by a marshal.... Not even the bodhisattvas and the holy multitude at the assembly on Vulture Peak could have rivaled those monks in appearance and bearing. Nor could one restrain tears of joy at the thought that even the sermons of the Buddhas of the Three Periods were unlikely to have equaled these ceremonies. Innumerable bodhisattva dances were presented on the platform, and children performed butterfly and bird dances so beautifully that one could only suppose paradise to be little different—a reflection that added to the auspiciousness of the occasion by evoking mental images of the Pure Land.
>
> William H. and Helen Craig McCullough, trans., *A Tale of Flowering Fortunes*, Stanford, Calif., 1980, 553-7.

The focus of aristocratic worship in the Middle Heian period shifted from Dainichi Nyorai and the mandalas of Shingon Buddhism to a belief in rebirth in the Western Paradise, or **Pure Land**, of one of the Dainichi's transcendental Buddhas, Amida. This Buddha had been a familiar figure in the Buddhist pantheon from the Asuka period onward, but in the tenth century, through the efforts of several messianic monks, attention came to be focused on Amida and worship of him as a separate and more compelling rite than praying to a whole host of divinities. One of these teachers was Kūya (903–72), a monk of the Tendai sect who preached a doctrine of universal salvation through belief in Amida and the recitation of the **nenbutsu** mantra, "Namu Amida Butsu," or "Hail to Amida Buddha." In contrast to the complex and strict disciplines and rituals demanded by the Shingon school, one merely had to repeat this mantra to be reborn in Amida's paradise.

Kūya's teachings not only spread through the ranks of the aristocracy, but his Amida cult was the first Buddhist sect to begin to extend to the lower ranks of society—the vast majority of the population. Before the introduction of the *nenbutsu*

mantra, the effective practice of Buddhism required the reading of texts, usually in Chinese, a skill still almost exclusively limited to the aristocracy. For most of the common people, therefore, Buddhism was a matter of magic rituals that might bring their world under control, prevent calamities, promote a good harvest, and above all ease the path of loved ones into the next world. The appeal of the *nenbutsu* mantra was arguably not much different from previous magic rituals, but its promise of a better afterlife, where the peasant would live like the aristocrat in Amida's paradise, was an irresistible offer at a time in Japanese history when the polarity between aristocrat and commoner was perhaps never more accentuated. Some two hundred years later Hōnen would turn Amida Buddhism into a truly popular movement that would dominate Buddhism throughout the medieval period.

Another, and for the aristocracy more influential, figure in Amida Buddhism was Genshin (942–1017), a monk of the Tendai sect at Enryakuji who codified belief in Amida and the Pure Land in a work known as the *Ōjō Yōshū* (*The Essentials of Salvation*). This essay, which was widely disseminated among the clergy and the aristocracy, set forth in graphic terms the delights of the Western Paradise and the rigors of the afterlife if salvation were not achieved. The aristocracy—and it must be remembered that a significant number of the clergy were born into aristocratic homes—read the *Ōjō Yōshū* and clove to its teachings. In addition, they and their servants and the peasants on their *shōen* constantly repeated to themselves the *nenbutsu* mantra. All assumed that they would be going to paradise and that it must be as rich and colorful, and as decorative and elegant, as the world of the imperial court. Taking this idea a bit further, they believed that death must be a glorious ceremony, called a **raigō**, during which Amida would descend from heaven and joyously welcome the deceased into paradise. As Genshin described it:

> The great vow of Amida Nyorai is such that he comes with twenty-five Bodhisattvas and the host of one hundred thousand monks. In the western skies purple clouds will be floating, flowers will rain down and strange perfumes will fill the air in all directions. The sound of music is continually heard and the golden rays of light stream forth.... At the time of death, the merciful Kannon, with extended hands of a hundred blessings and sublimity and holding out a lotus seat of treasures, will appear before the believer. The Bodhisattva Dai-Seishi and a numberless host say in one voice: "Blessed art thou!" Uttering these words, he places his hand upon the believer's head and with the other hand draws him to himself. At this time the believer beholds Amida with his own eyes and his heart is filled with great joy. His mind and body are at ease now and he is happy as in a state of ecstasy.
>
> A.K. Reischauer, "Genshin's *Ōjō Yōshū*: Collected Essays on Birth into Paradise," Transactions of the Asiatic Society of Japan. 2nd series, vol. 3 (December 1930), 68-9.

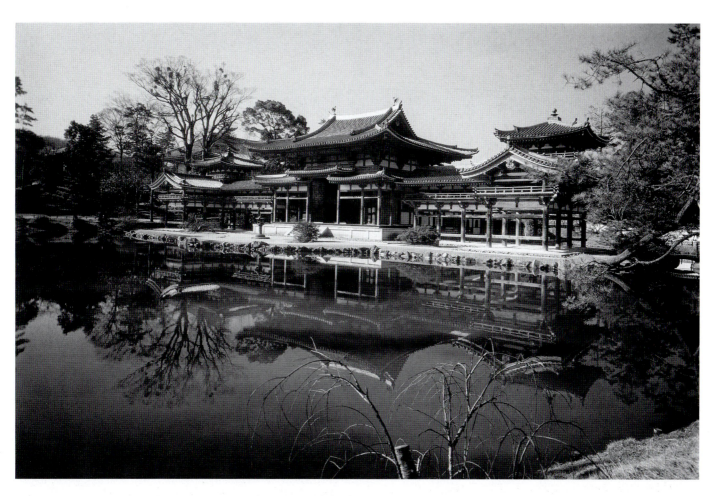

172 *Hōōdō* (Phoenix Hall), Byōdōin, Uji, Kyoto prefecture. 1053.

The Phoenix Hall

The extant structure that best illustrates the Heian court's belief in Amida and rebirth in his Western Paradise is the Phoenix Hall, or Hōōdō, of the Byōdōin, a temple situated on the banks of the Uji River to the southeast of Heian (Fig. 172). The site had been purchased by Fujiwara no Michinaga in 998 and was inherited by his son Yorimichi (990–1074), who used it as a summer retreat from the heat and humidity of the capital. However, in 1052 Yorimichi converted it into a temple, and in 1053 the Hōōdō was dedicated.

The Phoenix Hall houses a famous Amida image, and in its overall concept attempts to make manifest on earth the totality of the *raigō*. The hall is situated on a semi-detached "island" in the center of a large artificial pond, with land "bridges" on either side of the hall, and, a much later addition, an actual bridge to the rear. This configuration is an interesting departure from the precedent of buildings surrounding a lake and islet, established in the *shinden zukuri* style of secular residences and also in the Hōjōji. A second feature of the Hōōdō's placement is that it is close to the edge of the pond and is reflected on the surface of the water. Further, although the structure is actually a single-storied building, its exterior is treated as though there were two stories, with covered walkways extending on either side of the central hall and then turning forward at right angles toward the pond directly in front. Following the precedent of the central-hall façade, the walkways are treated like two-storied structures, with single-storied towers at their turning points. When this total image is reflected in the pond, it has an appearance similar to the many halls of Amida's paradise as they were depicted in paintings and relief carvings. Further, the walkways on the sides of the hall suggest bird wings. It is as if a gigantic red bird has flown down from the sky, just as Amida and his host would do, and has alighted by the pond. To make this reference explicit, the roof of the Hōōdō was fitted with a pair of gilt bronze *shibi* finials in the shape of phoenix.

Every aspect of the interior of the Hōōdō further contributes to this concept of the *raigō* (Fig. 173). An over-life-size Amida Buddha is installed in the center on a tall lotus-blossom pedestal, and attached to the upper part of the walls are Amida's host—small wooden images of *apsaras* (JAP. *tennin*; a celestial nymph), monks, and musicians. When the doors of the hall are open, the visitor standing on the opposite side of the lotus pond can see Amida and his host enthroned in a sumptuous building hovering at the opposite shore. The insides of the doors are decorated with paintings depicting the welcome given to the nine categories of humans who are permitted to be reborn in the Western Paradise.

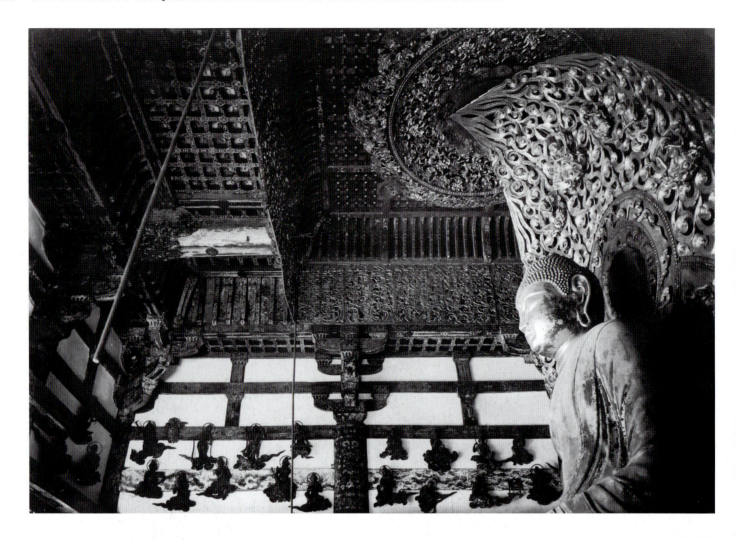

173. Interior of the *Hōōdo* (Phoenix Hall), Byōdōin, Uji, Kyoto prefecture, *c.* 1053.

The Amida image inside the Hōōdō was created by the foremost sculptor of the period, Jōchō (d. 1057), one of the most innovative artists Japan has ever produced. Jōchō's reputation must have been established by 1020, because Michinaga commissioned him to produce most of the sculptures for the Hōjōji, and then rewarded him with the title of Hōkkyō, Master of the Dharma Bridge, a rank within the Buddhist hierarchy that was rarely accorded a sculptor. Later he was promoted to the rank of Hōgen, Master of the Dharma Eye, a great honor for this outstanding artist. Unfortunately, none of his early works have survived, but the Byōdōin Amida is a more than adequate example of his achievement (Fig. 174). First of all, Jōchō created a new canon of proportions for this figure. The height of the head from the chin to the brow at the hairline is taken as a basic unit for the entire figure, and the vertical projection of the statue from the bottom of the legs to the hairline is exactly equal to the distance between both knees. This new canon gives the figure a remarkable feeling of stability and calm.

The Amida image is sculpted using *yosegi*, or multiple blocks, a technique probably developed from the Chinese split-and-rejoin method of construction. Instead of using a single piece of wood for the main part of the body as in *ichiboku zukuri* and scooping out the core in the chest and the head, the sculptor created his image using fifty-three pieces of wood. The multiple-block technique did not permit deep carving of drapery or facial details, but Jōchō turned this limitation to his advantage here by creating a style of sculpture that was light and ethereal, rather than heavy and overbearing, like the style of the Jingoji Yakushi. It also permitted a sculptor to create an image in dynamic movement—a capability not needed for this Amida image—and it facilitated the production of a work in the studio tradition. The master could sketch an image, indicate where the joining parts should be, and entrust to his apprentices the preliminary sculpting of the various parts. When that was done, the pieces could be transported to the temple site, assembled, and finished by the master sculptor.

This Amida is a truly remarkable work. It sits serenely on its pedestal, its hands in the meditation gesture, its eyes in an unfocused gaze. Behind the figure an openwork gold halo of flames rises upward to meet a round canopy suspended beneath a square baldachin. The contrast between the

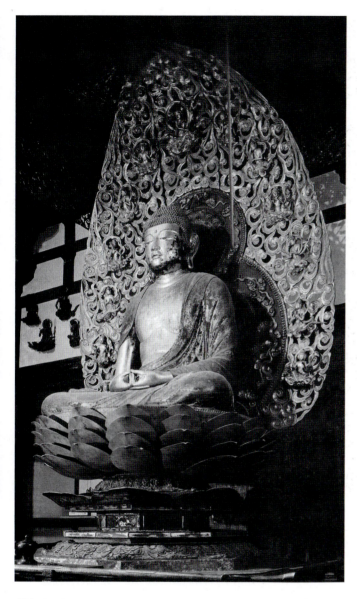

174 *Amida Nyorai*, by Jōchō, in the Hōōdo (Phoenix Hall), Byōdōin.
c. 1053. Cypress wood, with lacquered cloth and gold leaf;
height 110 in. (279 cm). Hōōdo (Phoenix Hall), Byōdōin.

Sutra, explaining its significance. Unfortunately, the years have not been kind to these paintings, and in an effort to preserve what little remains, they were removed from the Hōōdo. Copies were made and mounted as long paper scrolls, and are displayed along with the original doors at various times during the year. One of the most interesting and well-preserved of the originals depicts the welcome given to those who were accorded the Middle Class, Upper Rank. In the painting we see Amida Buddha descending on a white cloud toward the veranda of a nobleman's house (Fig. 176). Beneath the Amida—that is, on the same door—is a view of the hills of Heian, with horses gamboling in the shallow water of a pond (Fig. 177). The pine-capped hills are the gentle slopes of Japan rather than the tall, sharply faceted mountains depicted in Chinese painting, and the motif of horses not only indicates the scale of the painting, but also creates a sense of the habitability of the landscape. The *raigō* paintings in the Phoenix Hall provide some of the earliest datable examples of *yamato-e*, or Japanese-style landscapes, in combination with a Buddhist theme.

smooth, undecorated surfaces of the Amida and the multiplicity of decorative motifs on the halo and the canopy above serves to underline the calm, quiet demeanor of the image itself. The small sculptures attached to the walls around the Buddha figure reflect Jōchō's basic style. They sit or stand on cloud forms, some playing musical instruments, some dancing, some merely contemplating the scene. A dancing *apsaras* is a particularly lively and graceful piece (Fig. 175). Her foot is slightly raised, as though she is about to step forward in time to a stately tune.

The final element completing the *raigō* in the Hōōdo is, as already mentioned, the set of paintings that originally decorated the inner surfaces of the doors. Included with each picture was a long inscription, an excerpt from the *Kanmuryōju kyō* (*Buddha of Infinite Life Sutra*), known as the *Amitayus*

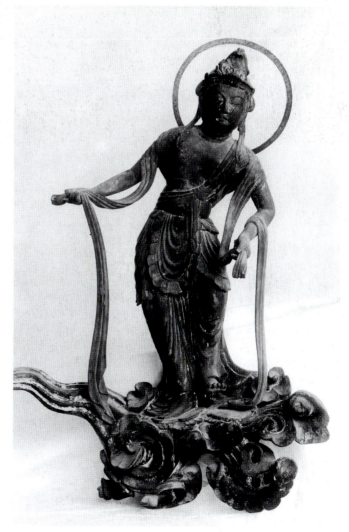

175 *Dancing Apsaras* (celestial nymph), by Jōchō, in the Hōōdo, Byōdōin.
c. 1053. Wood, with traces of *gofun* and paint.

176 Section of a painted wood door of Middle Class and Upper Rank rebirth, in the Hōōdo, Byōdōin, showing Amida and a celestial host descending toward the house of the deceased. c. 1053. Byōdōin temple, Uji, Kyoto prefecture.

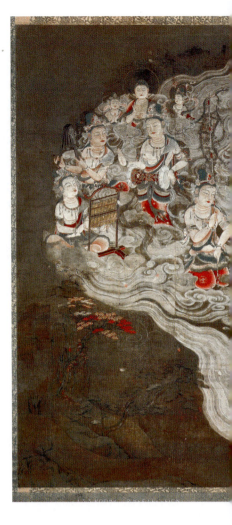

178 *Amida raigō* triptych. Late 11th century. Color on silk; height 81 in. (211 cm). Yūshi Hachiman Association of Mount Kōya, Jūhakkain, Kongōbuji, Wakayama prefecture.

177 Section of a painted wood door of Middle Class and Upper Rank rebirth, in the Hōōdo, Byōdōin, showing landscape with horses in *yamato-e* style. c. 1053.

In summary, the Phoenix Hall presents the adherent with a complete materialization of the *raigō*, from the exterior of the building reflected in the pond to the Amida sculpture on the central platform, where the host of celestial attendants is suggested by the figures attached to the walls. The paintings on the doors offered the final touch, depicting as they did the nine levels of welcome accorded believers admitted to the Western Paradise. The building is remarkable for the consistency of planning it displays; it is a perfect microcosm of a complex religious concept.

INDEPENDENT *RAIGŌ* PAINTINGS

A *raigō* triptych in the Jūhakkain of the Yūshi Hachiman Association of Mount Kōya demonstrates the development of this genre after the Byōdōin paintings. Dated to the end of the eleventh century, it depicts *raigō* as a very public ceremony,

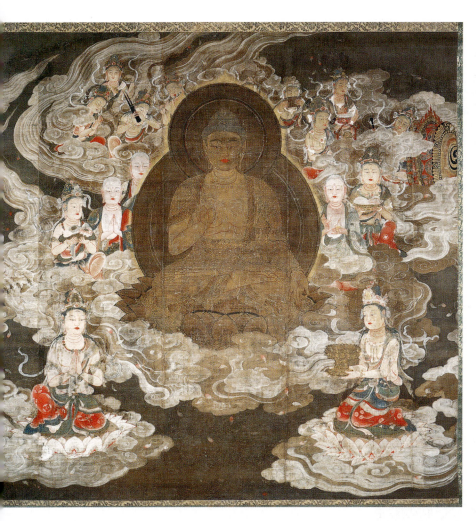

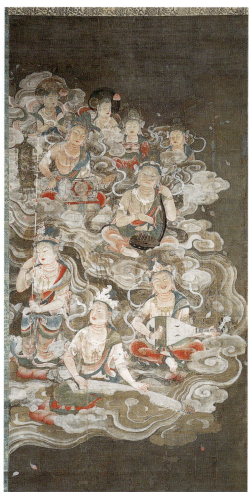

much more in keeping with Genshin's description of Amida's welcome (Fig. 178). Amida Buddha, a resplendent gold figure seated in a formal, cross-legged position on a golden lotus-blossom platform, faces the viewer directly. However, he is supported by a grayish lavender cloud that seems to have swept first to one side and then to the other as it descended from above. In front of him are Kannon, to his left, holding the lotus pedestal for the deceased, and to his right, Seishi, his hands pressed together in prayer. Directly to the Amida's left is the bodhisattva Jizō (SKT. Kshitigarbha), and to his right is the legendary master Nagarjuna. Jizō is always represented as a shaven-headed monk. A bodhisattva particularly sympathetic to human frailties and the protector of children, he is often worshiped apart from his Buddhist context. In the Japanese countryside, it is quite common to see Jizō represented by a stone tied with a red apron. These informal shrines are actively worshiped, with fresh flowers and fruit left as offerings next to the Jizō stones or figures. In addition to these five entities, twenty-eight accompanying figures—monks, bodhisattvas, and *apsaras* who are playing musical instruments—complete the retinue.

The divinities and their celestial host are delineated in red iron-wire outlines, clothed in garments of bright red, pink,

purple, green, and blue, and ornamented with crowns, necklaces, and arm bracelets of *kirikane* (cut gold). The musicians are depicted in animated poses, their bodies responding to the rhythm of the music, their facial expressions reflecting the joyousness of the occasion. Beneath Amida and his host is a lake, its wave pattern visible amid marsh grass, and to the left is a gentle hill with pines and maple trees at the height of their autumn color, clearly the landscape of Heian. The Mount Kōya *raigō* presents not only a dramatic, fully developed concept of the Amida welcome, but also a comfortable fusion of religious imagery with the secular *yamato-e* theme of the native landscape, characteristics suggesting that the painting should be dated sometime after the Byōdōin door panels of 1053, probably to the late eleventh century.

SHAKA PAINTINGS

A painting dealing with the death of the Historical Buddha dates from 1086 and is preserved in Kongōbuji (Fig. 179). The death of the Buddha (SKT. panininvana), when he passed into a state of nonbeing, or nirvana, is a common theme in Buddhist painting. Here the Buddha is shown lying on a wooden platform in a grove surrounded by bodhisattvas, his

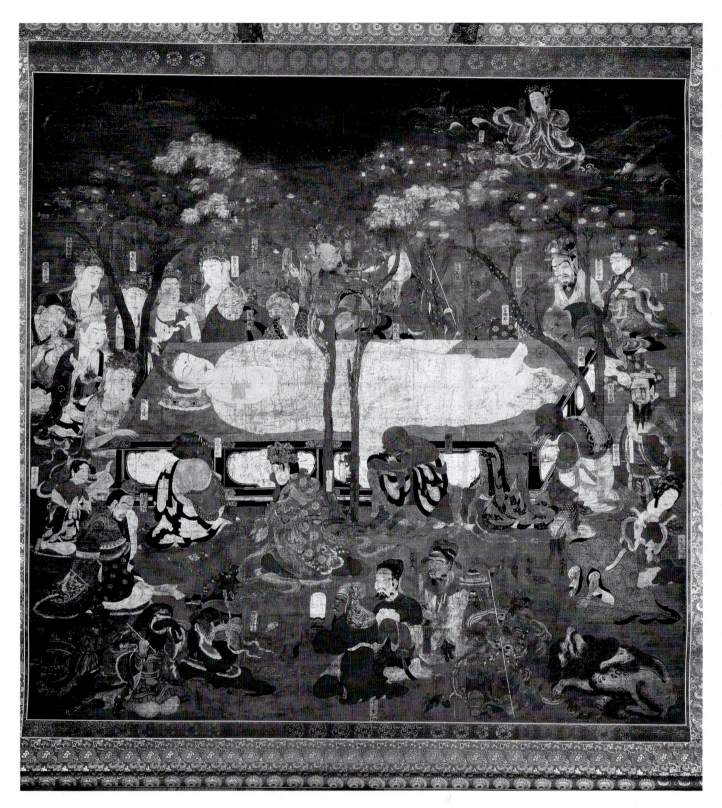

179 *The Death of Shaka.* 1086. Hanging scroll, color on silk; height 106 in. (269 cm).
Yūshi Hachiman Association of Mount Kōya, Kongōbuji, Wakayama prefecture.

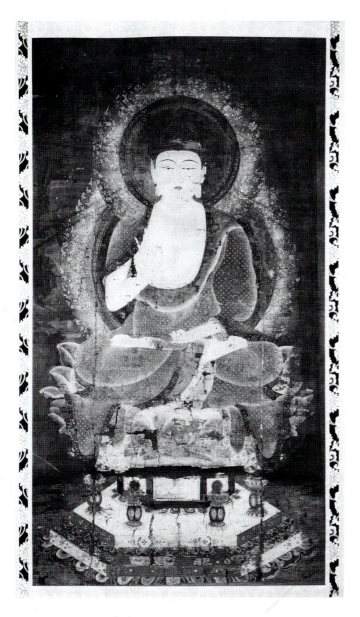

180 *Shaka Nyorai.* 12th century. Hanging scroll, color on silk;
62 ¾ x 33 ⅝ in. (159.4 x 85.5 cm). Jingoji, Kyoto.

disciples, and the eight classes of beings. The significance of his death is suggested by the different responses of the onlookers. The bodhisattvas, including Miroku, the Buddha-to-be, closest to the Buddha's head, plus Jizō, Kannon, Monju (SKT. Manjushri), and Fugen (SKT. Samantabhadra) nearby, remain calm and impassive, knowing the full reality of what this being has accomplished. The disciples, positioned along the sides of the platform, demonstrate only their own sorrow at losing contact with their teacher. The lion, representing the animal kingdom, writhes on his back in grief. In the upper right Queen Maya, Shaka's mother, has descended from heaven to watch the momentous event. All of the figures are carefully delineated in red iron-wire lines and are distinctly separated one from another, each with his or her name written nearby.

The death scene is a meticulously detailed historical document from the mainstream of Buddhist painting as it existed in the late eleventh century.

In Jingoji is a remarkable painting of Shaka Buddha of the twelfth century (Fig. 180). In Japanese painting, Shaka is normally depicted in a scene from his life, but in this instance he is depicted as the image's sole subject seated on a brightly colored lotus-blossom throne, his gesture is the *semui-in*, or fear-not, the only key to his message. Shaka's body, outlined in red, is painted golden yellow. Set against a dark ground, it seems to radiate light, an effect heightened by the *kirikane* floral design of his halo and the actual rays drawn across it. The figure is clad in a red robe decorated with an overall pattern in *kirikane* and circles containing eight-petaled blossoms. All in all, it is a style of iconography more familiar in Amida Buddha images, and they have clearly influenced this image of Shaka. While the artist makes no deliberate attempt to deprive the body of a sense of volume, he does emphasize the play of textile patterns across a seemingly flat surface. The circle motif extends across both legs and onto that part of the garment hanging over the lotus pedestal. The painting presents Shaka as a beautiful, luminous being contained in a net of gold lines.

BUDDHIST TEMPLES OF THE LATE HEIAN PERIOD

After the establishment of Hōjōji, the flood gates were reopened for the foundation of Buddhist temples much closer to the capital and even within its boundaries. The pacesetting for temple building during the Late Heian period, however, shifted from the Fujiwara clan and back to the imperial family, and particularly to the person of the retired emperor, or *insei*, who held the actual reins of government. The most successful of the *insei*, Emperor Shirakawa (1053–1129; r. 1072–86), was also the greatest of the temple founders. He began in 1077, even before he retired from the throne, by establishing Hosshōji to the east of the Kamo River, in the vicinity of a small stream known as White River (JAP. Shirakawa). So closely did the emperor identify himself with this area and the imperially sponsored temples there that he requested Shirakawa as his posthumous name.

Unfortunately, Hosshōji, like Michinaga's Hōjōji, which it was meant to outrival, is no longer standing; its only reminder is the name of a bus stop near Okazaki Park. However, its size and appearance can be understood from contemporary records. It was built on a plot of land measuring 61 acres square (25 ha), the same size as the site of Hōjōji. Like Michinaga's temple, its grounds were laid out following the design of a nobleman's mansion and garden, with a pond fed by an underground spring and in the center a man-made islet. Hosshōji was provided with a *kondō* ("golden hall") situated just north of the pond, where the lord's quarters would be in a *shinden*-style residence, and to the north of that was the *kōdō* (lecture hall) instead of the first consort's residence. Roofed corridors were set at an angle from either side of the *kondō* toward the pond and terminated in a sutra repository on the

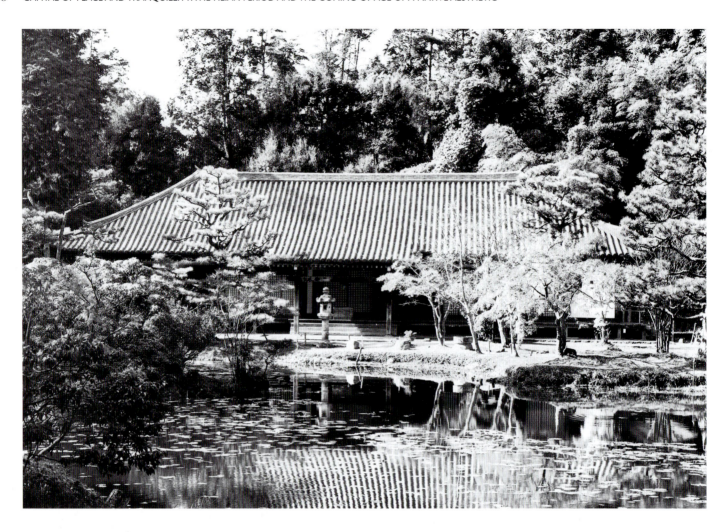

181 Amidadō (Amida hall), Jōruriji, Nara. 1107; moved to present site 1157.

182 Plan of Amidadō, Jōruriji.

east and a belfry on the west instead of a nobleman's fishing pavilion. In addition, there was a long narrow Amidadō (Amida hall), housing nine Amida Buddha images, and the Godaidō, a hall for statues of the Five Kings of Higher Knowledge. However, the most impressive building in the complex was surely the nine-storied, octagonal pagoda erected on the islet. Given the fact that the *shinden* residences of the aristocracy were only a single story, and most temple pagodas had three or five stories, Shirakawa's tower must have been a very remarkable structure, visible from all parts of the city, a constant visual reminder of the retired emperor and his power.

Jōruriji

None of the temples built for Shirakawa, Toba, or their relatives and devoted subjects have survived, but Jōruriji (the Temple of Pure Lapis Lazuli) in the hills to the north of Nara, still stands, providing us with some idea of the beauty of larger Buddhist complexes (Fig. 181). Of the more than thirty halls for sets of nine Amida images built during the Insei period, only the Amida hall of Jōruriji remains intact, and it was

probably not built to house the images now installed on the altar. Nevertheless, in its present setting on the west bank of an artificial lake, this Amidadō is a very beautiful building, rather like a *shinden*, with its black lattice and white paper-paneled interior, which is visible when the wooden doors are opened. Had its cypress-bark roof not been replaced with tiles in the Edo period (1615–1868), this impression would be even stronger. The building, first constructed in 1107 but moved to the Jōruriji site in 1157, consists of a central *moya* nine bays long and one bay deep, surrounded by a corridor one bay in

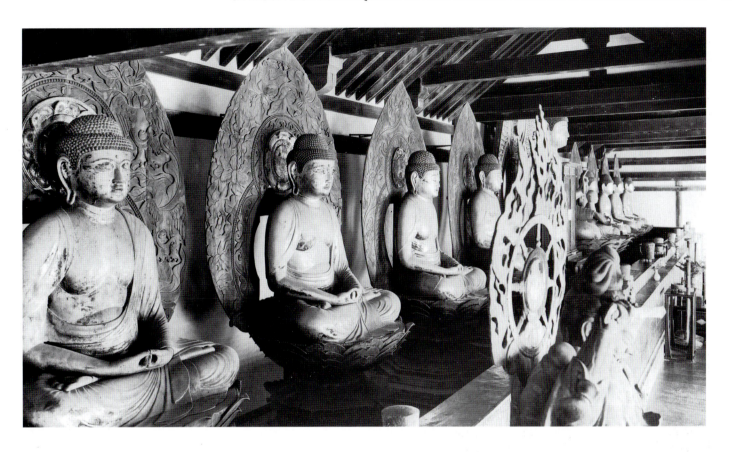

183 Altar with Amida images, Amidadō, Jōruriji.

width and by a veranda, also a single bay in width (Fig. 182).
An easement was made in the structure in order to accommo-
date the central Amida, which is much larger than the other
eight Amida images flanking it (Fig. 183). The central bay is
twice the size of the other bays and is marked off as a separate
space by two triangular plaster walls between the upper beams
and the roof. There is no ceiling; the sloping beams supporting
the roof are left exposed.

Little is known about the Amida images in the hall except
that they are said to be in the style of Jōchō, who created the
images at the Hōōdō of the Byōdōin. The central image is
about 39 inches (1 m) taller than the side images, and it is fur-
ther differentiated from them by its gesture, the *raigōin*, a wel-
coming of the faithful to the Buddha's Western Paradise (Fig.
184). In style it is very similar to the Amida in the Hōōdō of
the Byōdōin, but the horizontal of the crossed legs is smaller
than that in Jōchō's work, giving the impression of a figure
less solid and placid. Also, the drapery patterns and the facial
features are more sharply articulated than Jōchō's. In sum,
the figure is a step away from the mid-Heian image and sug-
gests a fresh approach on the part of the sculptor.

Lacking any firm documentation for the date of the nine
Amidas, art historians have had to fall back on stylistic analy-
sis to determine the period of production. Differences in the
technique and the handling of the flanking sculptures and the
central Amida, mean that the latter is judged to be somewhat
earlier in date than the others. It may have been made for

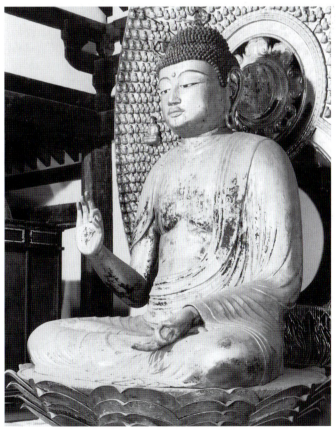

184 *Amida Nyorai*, main image of a set of nine, Amidadō, Jōruriji.
Late 11th to early 12th century. Cypress wood, with lacquer and gold leaf;
height 88 ⅛ in. (224 cm).

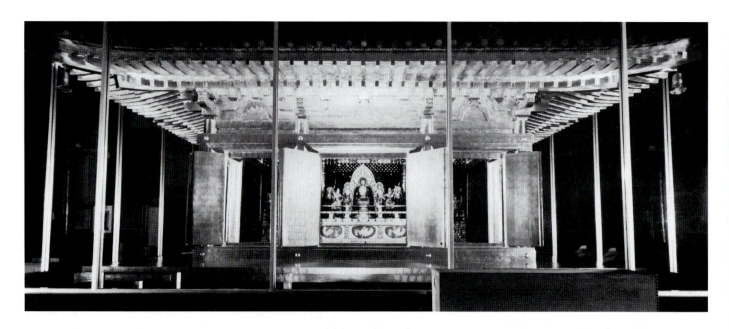

185 Konjikidō, Chūsonji, Hiraizumi, Iwate prefecture. 1124.

another building, or even for another temple; and the smaller images may have been sculpted to accompany it around the time the hall was first built in 1107, or when it was moved to the Jōruriji site in 1157. It is unlikely that the statue dates to 1047, when Jōruriji was founded, because the image reflects a post-Jōchō style. Though the exact date of production of these Amida figures remains a mystery, they clearly belong, along with the building in which they are installed, to the early years of the Insei period.

Chūsonji

During the centuries that the provincial clans had been left to their own devices, they had grown in strength and were rivals of the court aristocracy not only in wealth and power, but perhaps also in their ability to surround themselves with the trappings of culture. Not surprisingly, their self-assurance led from time to time to overt acts against the central government. In 940, Taira Masakado declared himself to be the Japanese emperor of the north, and it required a major military campaign for the government to regain control. In the eleventh century two rebellions, minor from the point of view of the government in Kyoto, broke out and had to be suppressed—the Early Nine Years' War (1051–62) and the Later Three Years' War (1083–7). A warrior who emerged in a position of strength from the power struggles of the eleventh century was Fujiwara no Kiyohira (1056–1128), the head of the non-courtly branch of the Fujiwara clan who held their ancestral territories in the north of Honshū, centered on Hiraizumi. He decided to make of the latter a "cultural capital of the north," with temples that could rival the most elaborate projects undertaken in Kyoto. His son Motohira (d. 1154) and his grandson Hidehira (1096–1187) both held to the same vision.

In its heyday in the late twelfth century, Hiraizumi must have been a remarkable sight, its palaces built on the plains bordering the Koromo River, the halls of its temple, Chūsonji, red and gold amid the green pines of the hills to the northwest of the city. Today Hiraizumi is remembered not for its days of glory but for its hour of defeat. In the aftermath of the Genpei Civil War (1180–5), the rivalry between two brothers, the head of the Minamoto clan, Yoritomo, and his youngest brother, Yoshitsune, came to the point of confrontation when the elder demanded the presence of his younger brother, a handsome, daring, and ingenious general, in the new military capital of Kamakura on the eastern coast of Honshū. Yoshitsune fled north to Hiraizumi and the protection of the northern Fujiwara, and the fate of the cultural capital of the north was sealed. In 1189 Yoritomo's troops destroyed Hiraizumi, only to find that Yoshitsune had taken his own life rather than suffer the humiliation of capture by the enemy. As the historian Ivan Morris has pointed out, Yoshitsune is remembered fondly by the Japanese today as a hero noble in his failure. Hiraizumi was fortunate in having the master of haiku poetry, Matsuo Bashō (1644–94), write its epitaph:

> The summer grasses
> Of brave soldiers' dreams
> The aftermath

Donald Keene, ed., *Anthology of Japanese Literature*, New York, 1955, 369.

In spite of the destruction caused by men and the forces of nature, a single Amida hall at Chūsonji, the Konjikidō (Gold-colored Hall), certainly one of the most extravagant temple buildings undertaken during the Late Heian, has survived at Hiraizumi (Fig. 185). When it was completed in 1124, the Konjikidō was only one of more than forty buildings on the site, and not even the main worship hall at that. Originally it

followed the pattern of a *jōgyōdō*, or ceaseless-practice hall, that is, a hall constructed so that adherents could recite their prayers to Amida while circumambulating a central altar. The hall is square, three bays on each side, capped by a pyramidal roof. The *moya*, a single bay at the core of the building, contains an altar with an Amida surrounded by the bodhisattvas Kannon and Seishi, six statues of Jizō, and two armor-clad guardian figures (Fig. 186). When Kiyohira died in 1128, his embalmed body was entombed inside the altar. Two similar structures now occupy the corner bays at the back of the shrine and serve as the tombs for his son Motohira and his grandson Hidehira, and also as the final resting place of his great-grandson Yasuhira's head, the man having been decapitated by Minamoto Yoritomo's forces when they destroyed Hiraizumi in 1189.

There is some difference of opinion among scholars as to whether or not the Konjikidō was originally intended as a meditation hall or a mausoleum—which is what it became. However, the use of a temple building as a burial place was not out of keeping with practices in the capital. Exactly how and when the concepts of an Amida hall and a mausoleum were combined is difficult to establish. In 1027, Fujiwara no Michinaga died facing the nine images in his Amida hall at Hōjōji, and by the time of the *insei* it had become the custom for members of the imperial family to be entombed in or near the temples they had founded. Thus when the northern branch of the Fujiwara family used the Konjikidō as their mausoleum, they may have taken as a point of departure the practice established by the imperial clan in Heian.

Although the Konjikidō is small in scale, it is incredibly extravagant in its decoration. Fortunately for visitors today, this small jewel of a building was painstakingly restored by the Japanese government in the mid-1960s. All of the surfaces in the interior were coated with lacquer and gold leaf. The four columns forming the bay at the core of the building, the beams supporting the coved and coffered canopy over the altar, the bracketing system, and even the frog-leg struts under the eaves were lavishly decorated with inlaid mother-of-pearl *hosoge* ("flowers of precious appearance"), an abstract floral design that richly interweaves jewel and petal motifs. The sides of the altar below the wooden balustrade were covered with sheets of gilt bronze depicting birds and flowers, while the central pillars were provided with images of Dainichi Nyorai in *maki-e*, lacquer densely sprinkled with gold and silver powder.

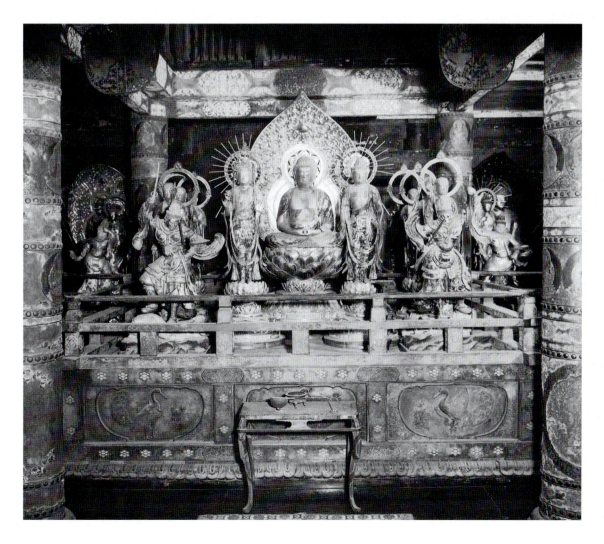

186 Central altar, Konjikidō, Chūsonji.

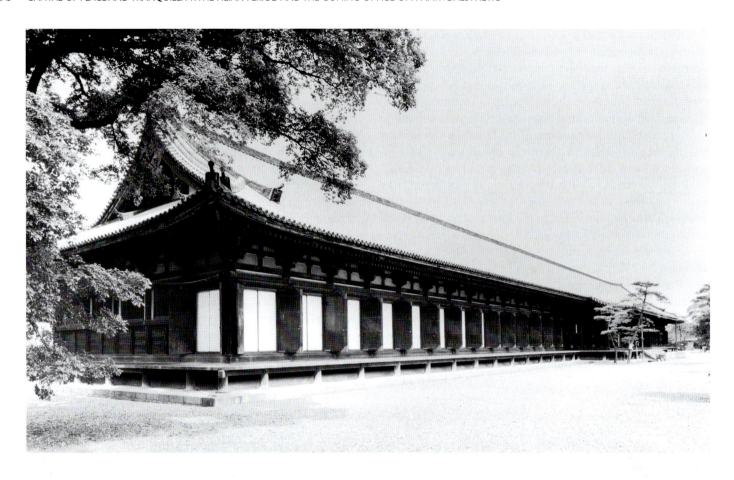

187 Sanjūsangendō, Kyoto. 1266.

To complete the embellishment of the building, the exterior was coated with lacquer and covered with gold leaf. To enter the Konjikidō when it was first built must have been like stepping into a jewel box, and today, even though it has been enclosed in a climate-controlled glass shell within a modern concrete building, this gold-colored hall still imparts something of the same impression.

Sanjūsangendō

The last major innovation in Buddhist architecture in the Late Heian period was the hall built to house a thousand and one images of the eleven-headed, thousand-armed Kannon, the Senju Kannon. Perhaps the idea of merit through conspicuous replication of images grew from the concept of the nine types of welcome into the Western Paradise and the nine Amida statues installed within a single hall to symbolize it. At any rate, as early as 1132 there is a reference to the construction of a *sentai kannondō* (hall of one thousand Kannon images), the Tokuchōjuin, commissioned by the retired emperor Toba and built near his residence-temple, Hōjūji. In 1164, shortly after he defeated the Minamoto clan in the Heiji Rebellion, Taira Kiyomori built the Rengeōin (Temple of the Lotus King), a *sentai kannondō* for the retired emperor Go Shirakawa

(1127–92; r. 1155–58). Unfortunately, neither of these mammoth halls has survived, but the Sanjūsangendō, or Thirty-three Bay Hall, that stands today in Kyoto's eighth ward is a reliable substitute. Go Shirakawa's hall was destroyed by fire in 1249, and rebuilding efforts were undertaken immediately. Though minor changes were made to accommodate the tastes of the thirteenth century, the motivation behind the Sanjūsangendō was the reproduction of the twelfth-century Rengeōin and the reinstallation of the Kannon images that had been saved from the fire, along with sufficient replacement statues to complete the arrangement of one thousand deities flanking a central thousand-armed Kannon. The building was finished by 1253, the main image installed in 1254, and the final dedication held in 1266.

The Sanjūsangendō is clearly an architectural oddity, consisting of a central *moya* thirty-three bays wide but only three bays deep, surrounded on all four sides by a corridor one bay wide (Fig. 187). From its earliest days, the temple's yard seems to have been used for training imperial guards. In the Edo period (1615–1868) archers competed there as well, using the 387 feet (118 m) length of the building as a gauge of distance. An archer would stand at the south end of the veranda and aim at the north end anywhere between the floorboards and the eaves. The contest lasted for twenty-four hours and was won by the man who could shoot the most arrows the length of the building without touching any part of it. According to temple authorities, the record-holder shot

13,053 arrows, of which 8133 met the requirements. This was in 1686.

The interior of the building is treated simply, with heavy beams spanning the three bays of the *moya* and gently arched rainbow beams—single curved beams that narrow at the ends —connecting the main pillars with those on the outside of the corridor (Fig. 188). At the back of the altar is a wood-and-plaster wall marking off one side of the long central rectangle; behind it is an enclosed corridor formed by the wall. No separate ceiling was provided for the hall. Instead, exposed beams support the roof. The simplicity of construction in the Sanjūsangendō presents a strong contrast to the complicated details of the myriad Kannon images and the twenty-eight powerful statues of Kannon's attendants.

When the original Rengeōin of 1164 burned down, miraculously one hundred and fifty-six Kannon sculptures were saved, and they formed the nucleus of the Sanjūsangendō installation. Most of the images stand in a frontal position, although some carry the suggestion of a slight shift of weight.

The pair of arms largest in size is folded across the body above the waist, the hands pressed together in prayer (Fig. 189). A smaller set of arms is held gracefully just below waist level, one hand cradled in the other, while a third pair holds long-handled implements: a monk's staff and a trident-topped staff, a common Buddhist iconographic symbol of the defence against evil. The rest of the Kannons' arms are treated separately, their main interest being the implements they hold. The skirts and scarves are shallowly carved and fall in soft folds over the body.

There are two main differences between the Late Heian images and those added in the thirteenth century, as evidenced by a sculpture attributed to Tankei, the master in charge of the new installation (Fig. 190). The later images have slightly heavier drapery folds over the legs, and the patterns created by the garments flow over the entire area between the waist and the feet. There are also more gradations in the size of the arms. Those grasping staffs and those held in front of the abdomen are smaller than those in prayer, but larger than the hands displaying attributes. The rescued images reflect the elegant detailing and the abstraction of form seen in Late Heian pieces, while the added sculptures

188 Interior, Sanjūsangendō.

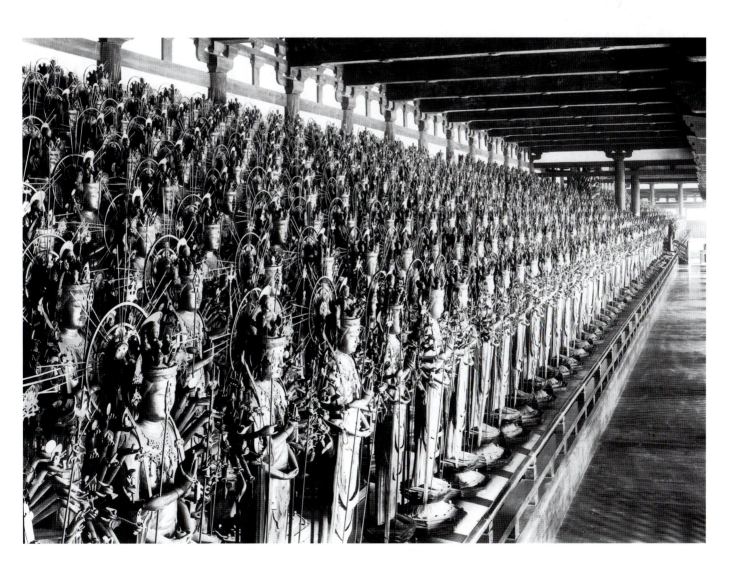

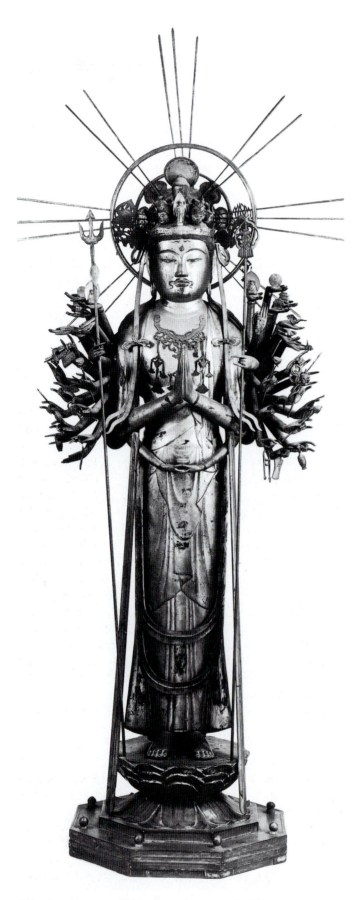

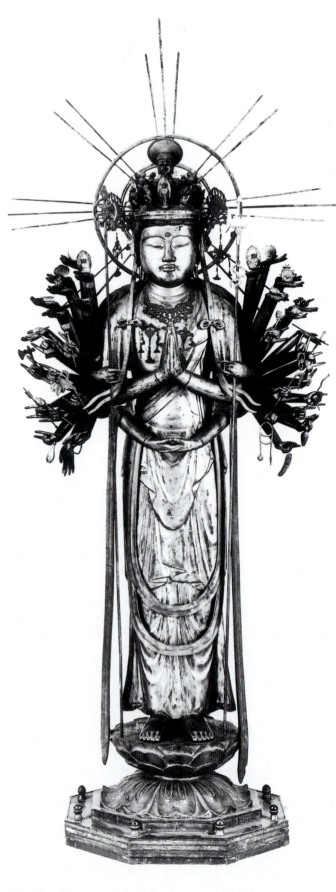

189 *Senju Kannon no. 390*, by Shōen. Sanjūsangendō. 12th century.
Wood, with lacquer and gold leaf; height *c.* 65 in. (*c.* 165 cm).
Tokyo National Museum.

190 *Senju Kannon no. 40*, by Tankei. Sanjūsangendō. 13th century.
Wood, with lacquer and gold leaf; height *c.* 65 in. (*c.* 165 cm).
Tokyo National Museum.

13,053 arrows, of which 8133 met the requirements. This was in 1686.

The interior of the building is treated simply, with heavy beams spanning the three bays of the *moya* and gently arched rainbow beams—single curved beams that narrow at the ends—connecting the main pillars with those on the outside of the corridor (Fig. 188). At the back of the altar is a wood-and-plaster wall marking off one side of the long central rectangle; behind it is an enclosed corridor formed by the wall. No separate ceiling was provided for the hall. Instead, exposed beams support the roof. The simplicity of construction in the Sanjūsangendō presents a strong contrast to the complicated details of the myriad Kannon images and the twenty-eight powerful statues of Kannon's attendants.

When the original Rengeōin of 1164 burned down, miraculously one hundred and fifty-six Kannon sculptures were saved, and they formed the nucleus of the Sanjūsangendō installation. Most of the images stand in a frontal position, although some carry the suggestion of a slight shift of weight.

188 Interior, Sanjūsangendō.

The pair of arms largest in size is folded across the body above the waist, the hands pressed together in prayer (Fig. 189). A smaller set of arms is held gracefully just below waist level, one hand cradled in the other, while a third pair holds long-handled implements: a monk's staff and a trident-topped staff, a common Buddhist iconographic symbol of the defence against evil. The rest of the Kannons' arms are treated separately, their main interest being the implements they hold. The skirts and scarves are shallowly carved and fall in soft folds over the body.

There are two main differences between the Late Heian images and those added in the thirteenth century, as evidenced by a sculpture attributed to Tankei, the master in charge of the new installation (Fig. 190). The later images have slightly heavier drapery folds over the legs, and the patterns created by the garments flow over the entire area between the waist and the feet. There are also more gradations in the size of the arms. Those grasping staffs and those held in front of the abdomen are smaller than those in prayer, but larger than the hands displaying attributes. The rescued images reflect the elegant detailing and the abstraction of form seen in Late Heian pieces, while the added sculptures

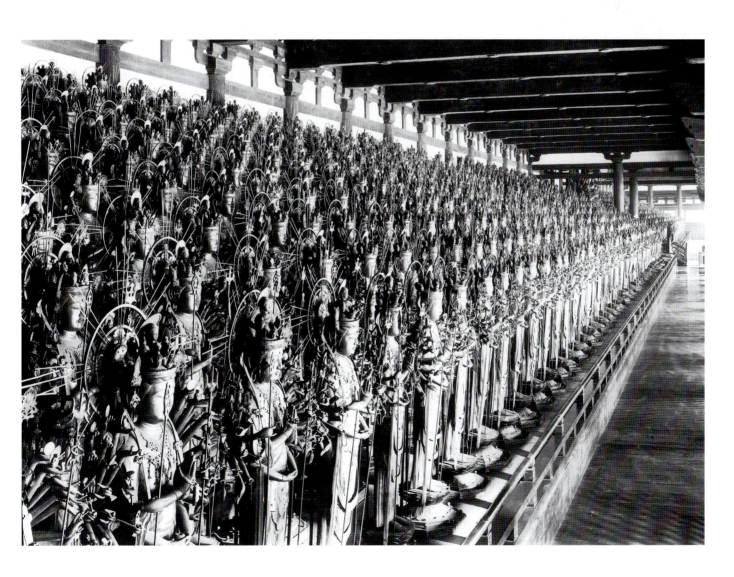

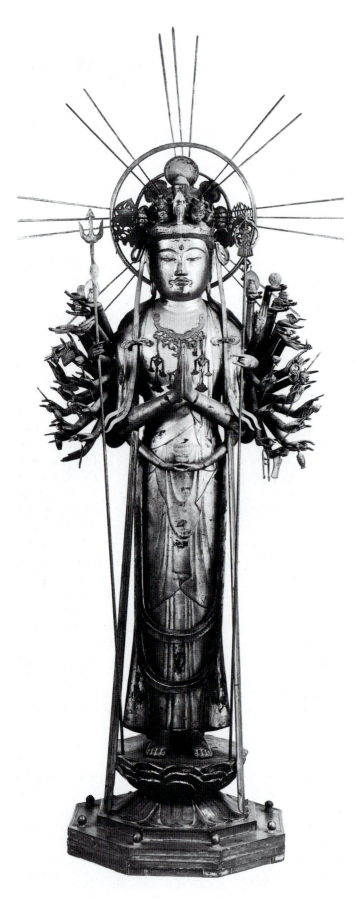

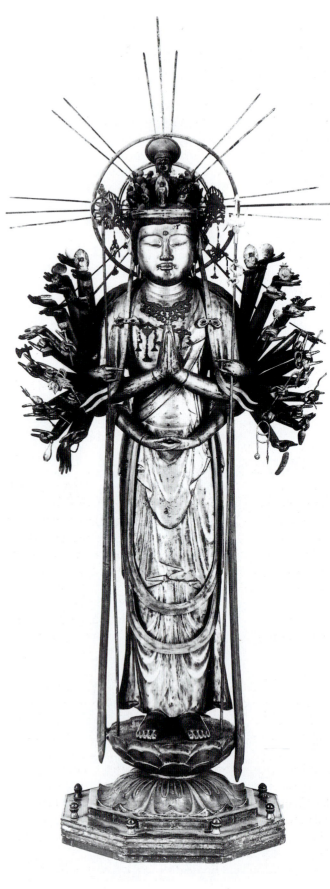

189 *Senju Kannon no. 390*, by Shōen. Sanjūsangendō. 12th century.
Wood, with lacquer and gold leaf; height *c.* 65 in. (*c.* 165 cm).
Tokyo National Museum.

190 *Senju Kannon no. 40*, by Tankei. Sanjūsangendō. 13th century.
Wood, with lacquer and gold leaf; height *c.* 65 in. (*c.* 165 cm).
Tokyo National Museum.

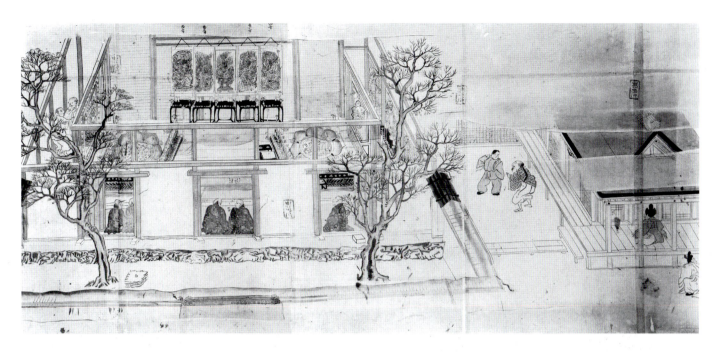

191 Section of *Nenjū gyōji emaki*, scroll 6, section 4, showing the Shingonin of the Imperial Palace. 17th century copy by Sumiyoshi Jokei of the late-12th century original hand scroll by Tokiwa no Mitsunaga. Color on paper. Private collection, Tokyo.

demonstrate the new interest in volumetric figures realistically presented which developed in the Kamakura period. However, more than anything else, a comparison of images from both periods demonstrates that fidelity to the older forms was a primary concern of the scores of sculptors working under Tankei. The final impression one takes from the Sanjūsangendō is a sense of being overwhelmed by the mammoth size of the hall and the huge number of Kannons packed on the ten stepped levels of the altar. What one encounters is a veritable sea of figures too vast to be comprehended from any single place.

LATE HEIAN HANGING SCROLLS AND ILLUSTRATED SUTRAS

During the Late Heian period, the charm and ethereal beauty that reasserted itself in Buddhist sculpture and painting in the Middle Heian period is brought to its most decorative fulfillment. Late Heian Buddhist imagery is peopled with serene figures clad in garments of the richest fabrics, decorated with gold geometric patterns and bright floral designs. Set against dark backgrounds, they even seem to give off an unearthly radiance. They must have been gorgeous embellishments for what were already highly sumptuous temple buildings such as the Chūsonji.

A group of paintings that clearly documents this maturation of style is a set of Godai Myōō (Five Kings of Higher Knowledge), images made in 1127 for use in the imperial palace. Beginning on the eighth day of the new year and

continuing for seven days, the Mishihō (Latter Seven Days' Rites) were held in the Shingonin of the palace, and mandala paintings, as well as images of the five Myōō and twelve *ten* (SKT. *deva*; celestials or divine beings), including Bonten and Taishakuten and the Indian gods of wind, water, and fire, were displayed as ritual furnishings. An illustration from the *Nenjū gyōji emaki* (*Scroll of Events Throughout the Year*) shows the Shingonin and the paintings hung for the Mishihō service (Fig. 191). The hand scroll is a seventeenth-century copy of a Late Heian period series of hand scrolls attributed to Tokiwa no Mitsunaga and documenting the calendar of imperial ceremonial. The Mishihō service had been initiated in 834 by Kūkai, and was continued through the Late Heian period. However, by 1040 the original paintings for this ceremony provided by Tōji could no longer be used, and a new set was made. These were lost in a fire in 1127, and immediately another set was commissioned. The first replacement paintings were rejected by Emperor Toba as being too rough and violent, and the present group was executed based on a model other than that provided by Kūkai. The Kongō Yasha from this set (Fig. 192) leaps into space and wears a garment decorated with *kirikane* (cut gold) adhered to the silk surface, more suitable for a court visit than for a battle against evil, and his aura of flames seems more like a curtain hung behind him than a materialization of the heat of his body. He is an elegant little creature, nothing like the "rough and violent" image of the Kongō Bosatsu from the Early Heian period in Figure 170.

The production of sutras remained an important feature of the Buddhist arts throughout the Heian period, with an official bureau for their copying within the imperial palace, as well as ateliers in the great temple–monasteries of Nara and the area around Heian. In addition, the accruing of spiritual merit by copying sutras was a standard pastime of the Heian aristocrat, and particularly of the ladies—providing as it did

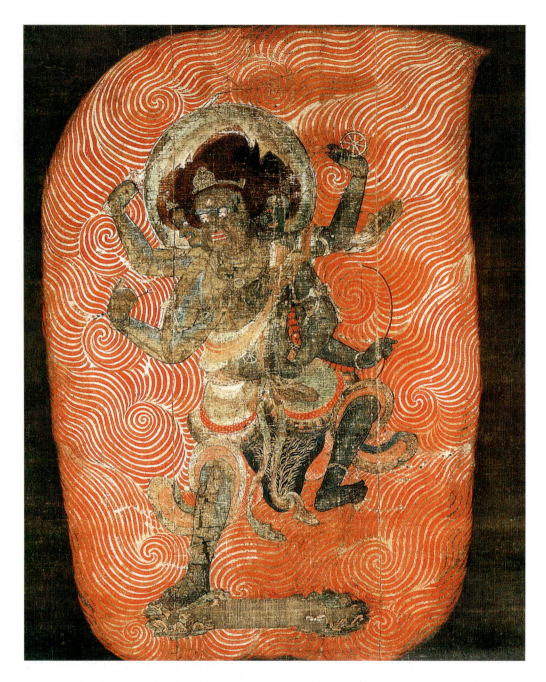

192 *Kongō Yasha*, from a set of five Myōō. 1127. Hanging scroll, color on silk; 60 ¼ x 50 ¾ in. (153 x 128.8 cm).
Kyōōgokokuji (Tōji), Kyoto.

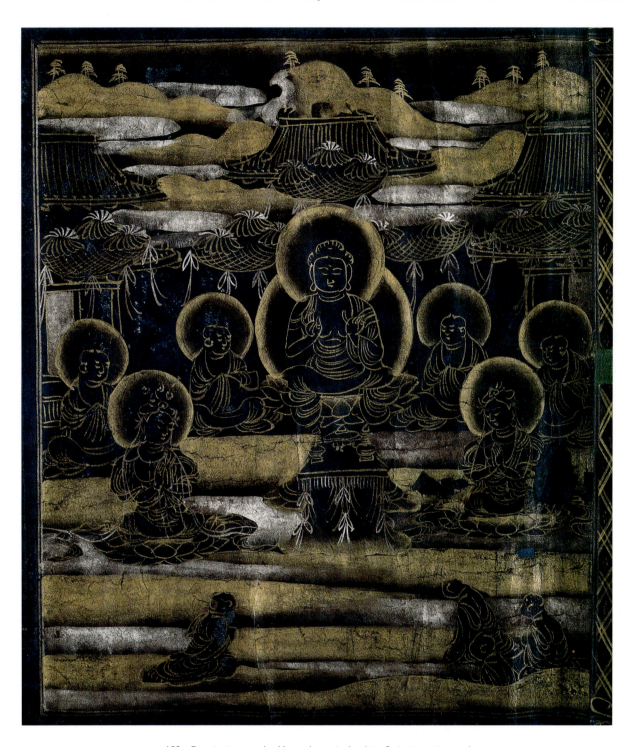

193 Frontispiece to the *Hannyaharamita kyō* (SKT. *Prajnaparamita sutra*).
Late Heian period, 12th century; originally conserved at the Chusonji, Iwate prefecture.
Silver and gold ink on indigo paper; height 10 ⅛ in. (25.9 cm), total length 314 in. (797.7 cm). Nara National Museum.

ample opportunity to practice and refine their calligraphy. The establishment of sumptuous temples which was such a hallmark of the Late Heian period entailed, amongst other furnishings, the production of gorgeously copied and illustrated sutras. One example is preserved at the Nara National Museum, but was previously kept at the Chūsonji in Hiraizumi (Fig. 193). Sutras inscribed in gold and silver ink on indigo-

dyed paper were a fashion shared by Japan's continental neighbors, and particularly by Korea. The latter was considered by the Chinese the unconditional master of this type of production. Certainly, many of the extant Korean examples are conserved in Japan, but it would be rash to consider that this form of illustrated sutra was simply an import from the peninsula, given the longstanding expertise that the Japanese

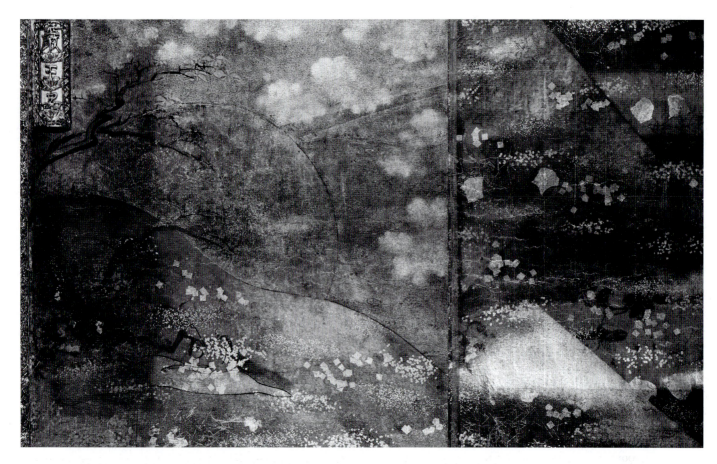

194. Cover of chapter 27 of *Heike nōkyō*. 1164. Color on paper;
10 ⅝ x 10 ⅛ in. (27 x 25.8 cm). Itsukushima Shrine, Hiroshima prefecture.

had by the Heian period in both papermaking and in the use of gold and silver. And undoubtedly the Chūsonji sutra is a Japanese production.

The left end of a sutra scroll is attached to a *jiku*, usually a wooden dowel with decorative caps of ivory or other materials at the top and bottom. The right end begins with a frontispiece, usually a figurative painting, and on the reverse side there is a piece of strong, decorated paper or heavy silk. When the scroll is rolled up for storage, this end sheet becomes its cover, with a label in a cartouche at the top and a woven cord at the midpoint; this is tied around the roll to keep it securely in place. When the roll is untied and opened, the first thing to come into sight is the frontispiece. A key element of these sutra scrolls, the frontispiece gives a visual clue to the meaning of the words to follow.

The *Chūsonji sutra* is a copy of the *Hannyaharamita kyō* (SKT. *Prajnaparamita Sutra*), a selection of different texts credited to Shaka when he was preaching "the second turning of the wheel of Law" on the Vulture Peak. The frontispiece illustration therefore depicts Shaka in gold ink seated on a high lotus throne with his hands in the gesture of "turning the Wheel of the Law." He is flanked by two bodhisattvas and also by several of his disciples. A group of tiny worshippers—perhaps the commissioners of this sutra scroll—are in the foreground, and the divine grouping is framed by a palace structure reminiscent of the paradise scenes of Amida imagery. Behind this are softly rounded hills dotted with trees that are in a pure *yamato-e* style. Furthermore the gold and silver is applied in thick, opaque washes in a kind of *tsukuri-e* technique—very different from the wholly linear style of Korean sutra illustration.

During the Late Heian period the concept of **mappō**, the degenerate phase at the end of the age of Shaka Buddha, became a pressing religious issue. According to Buddhist teachings, after a set number of years had elapsed following the death of Shaka, the world would pass into a period in which his teachings were no longer followed and souls could no longer achieve Enlightenment. The date for the beginning of *mappō* was calculated to be 1052, and by the twelfth century, given its political and military upheavals, all were becoming increasingly concerned about what might await them in the days ahead and in the afterlife. In an attempt to control fate, people sought to accrue merit by copying the *Lotus Sutra* and placing the copies in sutra mounds in a symbolic attempt to help preserve this important Buddhist teaching. Others made copies of the sutra on decorated paper, having the pages fashioned into horizontal scrolls, and dedicating them to a particular temple.

Without question the most elaborate and beautiful of the *Lotus Sutra* scrolls produced during the Insei period was the *Heike nōkyō* (*Sutras Dedicated by the Heike*), the set of thirty-four separate rolls copied by members of the Taira family and donated to the clan's Shinto shrine at Itsukushima, in Hiroshima prefecture. Although questions have been raised about the identities of the scribes, the traditional view is that each scroll text was copied by a different member of the Taira clan and its chief vassals, from the leader of the clan, Kiyomori, and his sons on down, and that they were officially presented by Kiyomori to the Itsukushima Shrine in the ninth month of 1164, the same year in which the Taira leader built the Rengeōin for the retired emperor Go Shirakawa.

Each sutra roll in the *Heike nōkyō* consists of separate sheets of lavishly decorated paper, on which the Chinese characters of the text have been copied in gold and silver ink. In order to make these sheets into a scroll, they were joined horizontally, and a decorated backing paper was added to strengthen the roll. Also, to frame the sheets, a binding of decorated paper was added above and below the main sheets.

One of the most carefully considered and movingly executed frontispiece covers of the *Heike nōkyō* is that of the Myōshōgonō, or King Myōshōgon, chapter (Fig. 194), which is about a king who vowed to attain Enlightenment and become a bodhisattva. Traditionally the frontispieces have been attributed to the women of the Taira clan. The circular shape of a huge silver moon can be seen rising behind a low hill and an old gnarled tree. The enormity of the moon, its silver glow barely distinguishable from the hill and the sea, and the barrenness of the tree silhouetted against it, give this picture a desolate, almost eerie quality. Woven into the pattern of the old tree's roots in the lower left are the Japanese *hiragana* characters that mean "that long night." This type of lettering in the midst of a waterside scene is called *ashide*, or reed writing, and was used to add the resonance of a literary allusion to a painting. Here the words refer to the long night of darkness, the *mappō*, before Miroku Buddha appears and through his teachings restores world order. This *ashide* message added to the image of a luminous moon suggests that the *Lotus Sutra* will help to illuminate that long night of darkness before the dawn of a new era and the rule of Buddhist Law. When completely understood, this frontispiece painting is no longer simply a pretty moonlit seascape, but rather a very moving religious message.

Shinto Arts

During the Heian period, the whole conception of Shinto underwent a radical transformation. In the Nara period there had been concerted efforts by the state to create a harmonious relationship between belief in Japan's ancestral and natural *kami* and in the new teachings of Buddhism and its pantheon of celestial entities. The great turning point in this process occurred in the mid-eighth century when the sun goddess

Amaterasu was consulted, via her shrine at Ise, on the appropriateness of a state foundation to the Buddha Birushana—Tōdaiji. Her response, that she and Birushana were simply emanations of one another, not only cleared the way for the building of Tōdaiji but also started a process of philosophically melding together the two belief systems that during the Heian and Kamakura periods would have Shinto and Buddhism working together in greater harmony than often the different Buddhist schools achieved. Simplistically speaking, this philosophical system—known as the Theory of Origin and Manifestation (*honji suijaku*)—expanded on Amaterasu's statement and identified each Buddhist entity and its appropriate Shinto *kami* as manifestations of each other. This found an important resonance in Shingon and Tendai theories—based on the precedent of adopting ancient Indian Vedic deities as guardians of Buddhism—that the Shinto deities also in some way fitted into the Buddhist universe. In this way, certain Shinto *kami*, such as Hachiman and Zao Gongen, became just as important guardians of Buddhism in Japan as the Myōō and Kongō Bosatsu.

The climate of the Heian period was a particularly fertile one for developments in Shinto architecture and sculpture. Shinto sculpture began to be made in the second half of the Nara period in response not only to Amaterasu's statement but also to the thriving tradition of Buddhist sculpture in the capital. Prior to this, *kami* imagery belonged to an aniconic tradition, an implement—such as a mirror—standing in for the presence of the deity. During the Heian period, it became standard practice to give the many *kami* a human form in the style of Buddhist entities. Sculptures of these gods were executed in wood, in the *ichiboku* technique, so the images could be seen as a materialization of the spirit out of the type of material in which the *kami* preferred to reside on earth.

An early example of Shinto sculpture is the set of three images made for the Yasumigaoka Hachiman Shrine on the grounds of the Yakushiji in Nara. Hachiman is traditionally the god of war, and is considered to be the deification of Emperor Ōjin (r. 270–313), the father of Emperor Nintoku (313–400) and a great unifier of the early Yamato state. Hachiman therefore has an intimate relationship with the imperial clan and cult, and he is normally represented as Emperor Ōjin, but it is not clear whether all statues of Hachiman are representations of Ōjin. In the Heian period, the Hachiman cult came to be closely associated with Shingon Buddhism, in which he was regarded as a bodhisattva and a protector of Buddhism, as well as a protector of the nation. Already, in the eighth century, it had been believed that he vowed to watch over Tōdaiji while the great Buddha there was being cast, and for this reason one of his shrines was established in the grounds of that great temple. In sculptures, Hachiman can also, therefore, be dressed as a monk.

In the center of the Yasumigaoka Triad is a monk flanked by two female figures in court costume (Figs 195–7). The monkish figure is usually identified as Hachiman, but the identification of the two female images has been problematic.

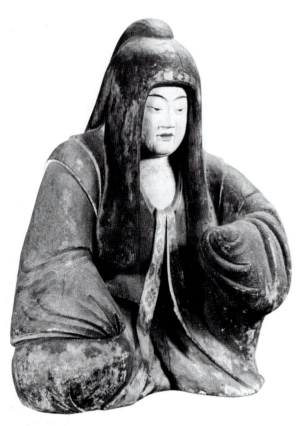

195 *Shinto goddess personifying Empress Jingū*. From Hachiman Triad, at
Yakushiji, Nara. Late 9th century. Wood, painted; height 13 ⅜ in. (33.9 cm).

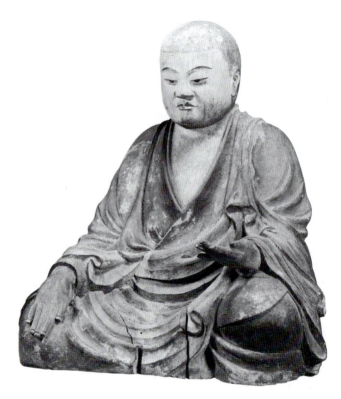

196 *Shinto god Hachiman as a monk*. From the Hachiman Triad, at
Yakushiji, Nara. Late 9th century. Wood, painted; height 15 ¼ in. (38.8 cm).

However, recent research has now provided a more specific
identification of the three. A clan associated with the Usa
Hachiman Shrine in northern Kyūshū particularly venerated
Emperor Ōjin and his mother, Empress Jingū (r. 210–70). The
clan also venerated a local female deity, Himegami, the protec-
tor of sea travel and agriculture. These three images in the
Yasumigaoka Shrine perhaps therefore represent Emperor
Ōjin as the monk-garbed Hachiman, flanked by his mother,
Empress Jingū, and a second female figure who is either
Himegami or Ōjin's wife, Nakatsu. However, whether or not all
such Hachiman triads may be recognized as representations of
these three personages is not clear.

The set of sculptures made for the Yasumigaoka
Hachiman Shrine are small wooden images. Hachiman is
shown seated in a cross-legged pose, his right hand laid over
his knee, his left hand raised. His garment falls over his body in
a simple pattern of drapery folds. The figure is quite small and
is carved out of a single block of wood. The female figures sit
in relaxed poses, their hands tucked demurely into their
sleeves. They, too, are executed in the *ichiboku* technique. In
fact, it seems that all three statues were carved out of the same
tree trunk, perhaps a tree with some special significance. On
the basis of the sculpting method and the style in which the
figures are carved, they are usually dated to the later years
of the ninth century, about the time the original shrine
at Yakushiji was built, in the years between 889 and 897.

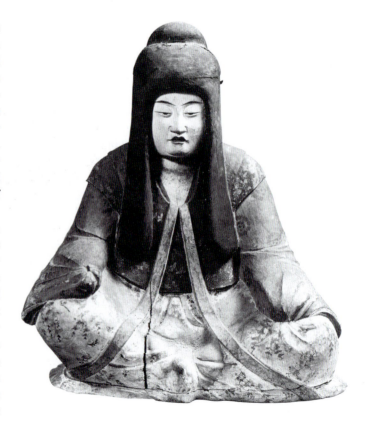

197 *Princess Nakatsu*. From the Hachiman Triad, at Yakushiji, Nara.
Late 9th century. Wood, painted; height 14 ½ in. (36.8 cm).

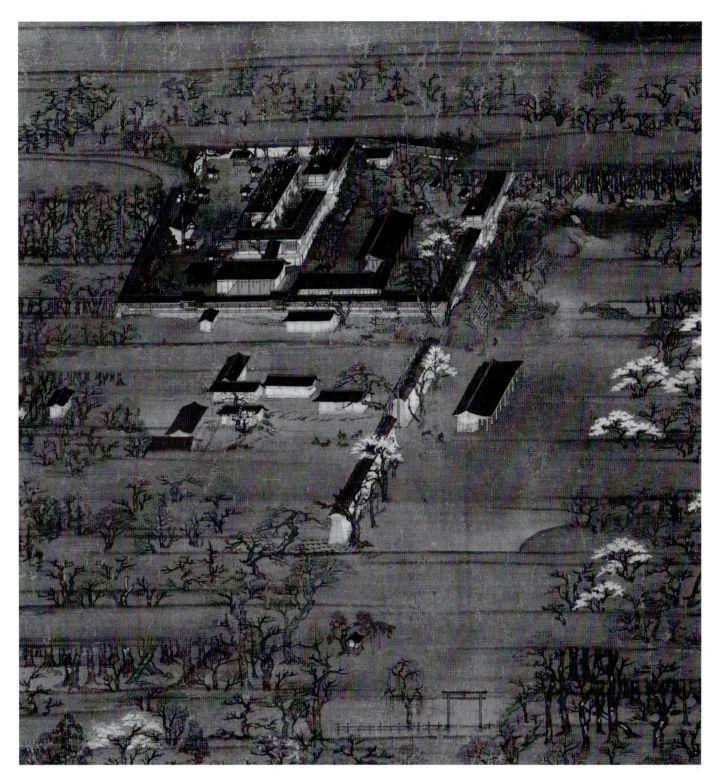

198 Detail of a Kasuga mandara showing the layout of the Kasuga Shrine. Kamakura period. Date unknown. Hanging scroll, color on silk; 44½ x 27 in. (113.1 x 68.7 cm). Tokyo National Museum.

The simple, but elegant forms of these Hachiman sculptures retain a sense of the original trunk from which they were fashioned, which is an aesthetic that would be maintained among Shinto sculptural imagery over the centuries and even in different materials.

With all of these changes in the basic conception of Shinto and the *kami*, including the creation of guardian Shinto shrines within the grounds of Buddhist temple complexes, it was inevitable that Shinto architecture would also be transformed. While the shrines at Ise and Izumo retained their

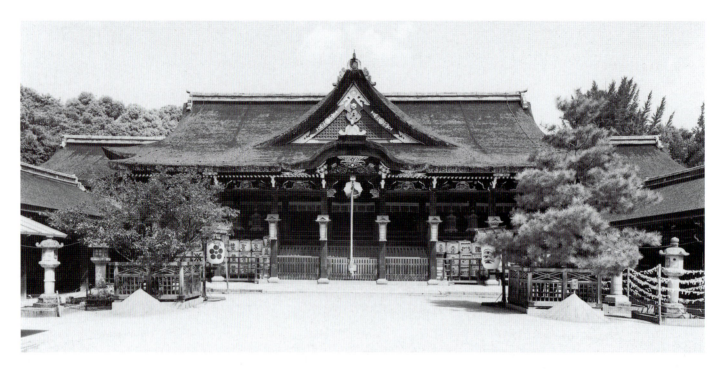

199 *Haiden* (worship hall), Kitano Tenmangū, Kyoto. Rebuilt 1607 after the original of 947.

antique *taisha* and *shinmei zukuri* configurations for their principal *honden*, many other shrines were altered and renovated (see Fig. 62) in order to accommodate the new requirements of worshippers. In the *nagare* type, epitomized by the Kamigamo Shrine built north of Heian, a traditional raised building three bays wide by two bays deep is provided with a roof extending forward to shelter the stairs leading to the upper level. In the Hachiman type, this porch is made into a whole new, roofed building added in front of the main hall, the two joined at the eaves. This appended hall for worship may have derived from similar modifications in Buddhist temple construction.

The Kasuga type, named after the four, small, aligned buildings in the Kasuga shrine complex at Nara, consists of a one-bay square building raised on piles and capped by a gabled roof, and, on the gable end, a roof extending forward and downward in a sloping curve over the stairs (Fig. 198, and see Fig. 62). The Kasuga Shrine is actually the Fujiwara family's Shinto foundation and complements the Fujiwara's Buddhist foundation of Kōfukuji, both being established on the slopes of Mount Mikasa, the latter actually being within Heijō's official Gekyō suburb. During the Heian period, as the Fujiwara family came constantly to hold the reins of power, so the shrine came to be seen as of "national" importance in the way that the Shinto shrines associated with the imperial clan were. The four aligned buildings were meant to house four primary deities of the shrine. The central two belong to the Fujiwara/Nakatomi clan's male and female *kami* ancestors, who played key roles in trying to coax Amaterasu back out of the cave in which she had hidden herself. The two other shrine buildings are for two guardian *kami*, who were associated in

the mind of the populace with the final "pacification" of northern Honshū island. The layout and structure of the Kasuga Shrine also demonstrates how far Shinto complexes came to mirror Buddhist ones. The simple fencing which had distinguished the shrines of Ise and Izumo is now replaced by roofed and corridored cloister walls, in addition to numerous subsidiary buildings for the monks and the treasures.

The Heian period also witnessed the creation of an entirely new *kami*. Sugawara no Michizane (845–903), a leading poet and scholar of the Chinese language at the end of the ninth century, was exiled to Kyūshū in 901 through the plotting of the Fujiwara family and died there in disgrace two years later. According to the beliefs of the time, the soul of a person who died with a falsely clouded reputation would come back as an angry spirit, or *onryō*. When Michizane's enemies began to die unexpectedly—Fujiwara no Tokihira, the head of the Fujiwara clan, at the young age of thirty-eight, and Minamoto no Hikaru in a hunting accident—it was thought that Michizane's spirit had returned to wreak vengeance on those who had connived against him. To propitiate his spirit, in 923 he was posthumously reappointed Minister of the Right. However, it was believed that his spirit took the form of the God of Thunder in a black rain cloud that passed over the palace, killing one nobleman and scorching the face of another, and in 947, the forty-fourth anniversary of his death, a shrine, the Kitano Tenmangū, was built in Kyoto in his honor. Kitano, meaning "northern fields," derives from the area in Heian where this first shrine to Michizane was built. Finally, some forty years later he was accorded the designation of **tenjin** or heavenly deity, and eventually he came to be regarded

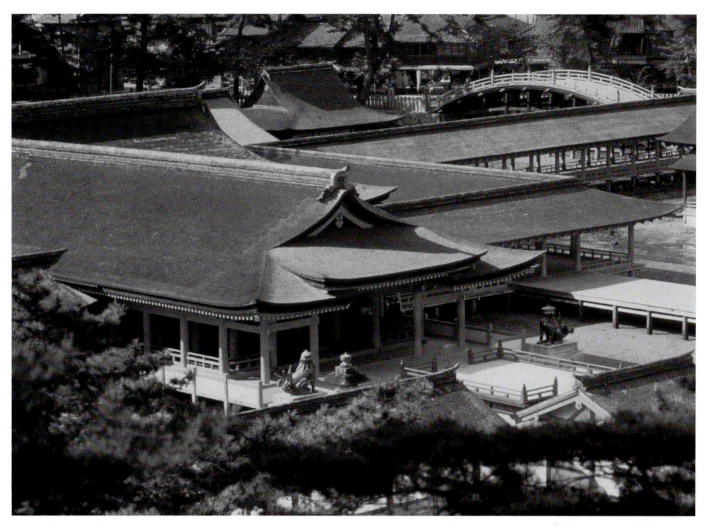

200 View of the Itsukushima Shrine, Miyajima Island, Hiroshima. Rebuilt 1556 on the model of its 12th century construction.

as the patron god of learning, literature, and calligraphy. Some thirty-five hundred shrines have been erected in his honor throughout Japan. Today, students facing an important examination visit a Kitano shrine and pray to Michizane.

The plan of his Kitano shrine developed out of the Hachiman shrine type but, because of its association with this still very popular Shinto deity, it was used repeatedly in the Momoyama (1573–1615) and Edo (1615–1868) periods for the mausoleums of other historical figures, such as the shoguns Toyotomi Hideyoshi (1536–98) and Tokugawa Ieyasu (1543–1616), and is now known as *gongen zukuri*, a name taken from an honorific title, Incarnated One, given to Ieyasu as the first Tokugawa shogun. The distinguishing feature of the *gongen zukuri* type of building is the fact that two parallel structures, the **haiden** (worship hall) and the shrine, are joined by a passageway, a small enclosed room with a gable roof and a stone floor; it is on the same level as the *haiden* but lower than the shrine (Fig. 199). This space is known as the *ishinoma*, or stone room. As the *gongen* type of shrine evolved over the years, only the treatment of the roofs in the *ishinoma* changed. In the Kitano Tenmangū, the eaves of both halls can

be seen inside the *ishinoma*, but in later structures such as the Tōshōgū Shrine at Nikkō, Ieyasu's mausoleum, the connecting room has been provided with its own ceiling. The present Kitano Tenmangū was built in 1607, but it is thought that the *ishinoma* evolved in the latter part of the Heian period.

A final type of shrine compound is exemplified by the shrine at Itsukushima (Fig. 200). Dedicated to three daughters of Susanō-ō, these *kami* became the tutelary deities of the Taira family. The shrine, completely rebuilt by Taira no Kiyomori after his elevation to governor of Aki province, created a kind of dream-palace, extending out over the sea in front of Miyajima Island. Although it has been destroyed many times, it has always been rebuilt in the same design. During the Heian period, Shinto *kami* were frequently conferred with court rank, and their shrines were accordingly equipped with many of the same furnishings that a Heian aristocrat would have in his *shinden*. In the case of Itsukushima, this concept was extended to the building. Long after the clan's destruction, and the loss of the refined and pampered world of the Heian period, the Taira clan's tutelary *kami* still inhabit this ultimate pleasure palace on the shores of the Inland Sea.

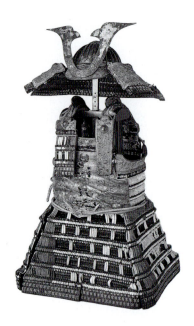

Changing of the Guard

THE RISE OF THE SAMURAI AND THE TWILIGHT
OF THE IMPERIAL ORDER

*In the middle of the twelfth century, the centuries-long competition for control of the Japanese nation between the Fujiwara clan and the imperial house—between government by civil dictator (kanpaku) and that by retired emperor (insei)—entered a long, violent and messy end game. By the end of the century, power would slip irrevocably from the grasp of either faction and into that of the military elite who had long served them. The wars that wrought this revolution tore the very fabric of Heian-period society apart, leaving the glorious capital in ruins, the great temples in Nara burned to the ground. In the aftermath, a new age of military government was instituted, and in the following four centuries civil war would follow civil war as different military clans and factions fought with each other for the new title of **shogun** and the leadership of the nation. The imperial court and aristocracy, having no political power and increasingly cut off from sources of wealth, became like ghosts, growing paler and paler with each passing generation, feeding on the memories of their former glories.*

Cultural Flowering from Chaos and Upheaval

And yet out of all this social and political upheaval the evolution and development of Japanese culture continued apace. In each of the arts new heights were achieved, and arguably in the field of sculpture a pinnacle was reached that has never since been matched in Japan and perhaps even elsewhere in East Asia. New forms of Buddhism reinforced the religion's role both within the philosophical and intellectual life of the nation, but also within the life of the common man. The imperial court and metropolitan aristocracy, stripped of their political role, focused even more on their cultural pursuits, especially as concerned music, literature, poetry, calligraphy, and painting. While their wealth lasted they continued their long

tradition as art patrons, and when it finally ran out they not infrequently fell back on their education and cultural accomplishments to find a way of keeping rice in the bowl. The new aristocracy of the military—or **samurai**—clans also became important patrons of the arts, and by the end of the medieval period they were even more important than the imperial court as arbiters of taste in all things cultural.

From whence had this new military elite sprung? Early in the Heian period, the court and metropolitan aristocracy had become reluctant to venture far from the palaces and mansions of the capital. However, their primary source of revenue was their country estates, or *shōen*, scattered throughout the provinces. As mentioned in Chapter 3, to remedy this, they appointed agents to oversee their provincial properties, and these positions often became the hereditary privilege of certain clans. These provincial clans could be subbranches of the great aristocratic houses that actually owned the *shōen*, or even of the imperial family. Equally they could have a commoner ancestor who had proved particularly able in overseeing his lord's affairs, and the hereditary nature of these positions meant the establishment of new clans. It was the duty of these provincial clans to enforce their lord's will within the domain of the *shōen* and also to defend his rights against the encroachment of any neighboring *shōen*. They therefore maintained a level of martial capability that had long been abandoned, even in form, in the capital. Furthermore, the imperial provincial government established in the seventh and eighth centuries became little more than a series of stipends and titles to be competed for at the court. But, anyone who attained such an office would often fail to depart for his newly acquired post—instead sending a proxy in his name to oversee affairs. By the twelfth century, provincial administration had become lax to the point of nonexistence, and power had

devolved naturally, but haphazardly, into the hands of the provincial clans.

All of the great reforms of the seventh and eighth centuries that had made life so pleasant for the court and aristocracy had done nothing for the Japanese peasant, who worked his land basically as a bonded serf attached to a *shōen*. Whenever imperial taxation or the demands of the *shōen* lords became too great, an uprising would occur, and one or other of the provincial clans would be called on to quash the rebellion. When such uprisings occurred among the common townsfolk in the capital or elsewhere, once again these provincial clans would be ordered to put down the unrest. By the tenth century, they were known as samurai—literally "one who serves"— a reference to their role as military policemen.

End of an Epoch: The Hōgen, Heiji, and Genpei Wars

Two of these samurai clans, the Taira and Minamoto, both descended from imperial princes of the ninth century, came to prominence in the first great conflict of the twelfth century, the Hōgen Rebellion of 1156 to 1159. The occasion was the scramble for power on the death of the *insei*, retired emperor Toba (1103–56), and the accession of the new emperor Go Shirakawa (1127–92; r. 1156–8), and of the new *insei*, retired emperor Sutoku (1119–64). As had happened in the previous several reigns, government control should have shifted smoothly to the new *insei* Sutoku, but the head of the Fujiwara clan tried to reassert his role as *kanpaku* and he found a willing ally in the new emperor, Go Shirakawa. The latter recruited the services of members of the Taira and Minamoto clans, while the *insei* Sutoku was supported by other factions within the Fujiwara and Minamoto clans. After three years of civil war Go Shirakawa and his Minamoto and Taira allies proved successful. The *insei* Sutoku was sent into exile, and his Fujiwara and Minamoto supporters executed. Go Shirakawa then established himself as the new *insei*, and both his allies, Taira no Kiyomori (1118–81) and Minamoto no Yoshitomo (1123–60), were given important positions at court.

However, the Fujiwara *kanpaku's* renewed attempts to take control of the government were frustrated by the now retired emperor Go Shirakawa's intention of wielding power himself. The next year, the Fujiwara recruited Minamoto no Yoshitomo to organize a coup and imprison Go Shirakawa (see Fig. 213). What is now known as the Heiji Rebellion was quickly quashed by Taira no Kiyomori. Yoshitomo was killed, but his sons Yoritomo (1147–99) and Yoshitsune (1159–89) fled to their provincial domain in the east of Honshū island, and thus out of Taira control. With the Fujiwara leadership now effectively out of the picture as well, for the next twenty years the Taira managed the affairs of the capital and court with the blessing of Go Shirakawa. The latter throughout his long career as *insei* skillfully played the Taira and Minamoto against each other, and in 1180—with the Taira growing ever more complacent and arrogant in their power—he encouraged the

two Minamoto brothers to launch a bid to wrest control from the Taira clan. Thus began the five-year Genpei civil war.

In 1185 the Minamoto army under the brilliant leadership of Minamoto Yoshitsune decisively defeated the Taira at Dannoura, a small village near the port of Shimonoseki. The male members of the Taira clan were almost completely wiped out, as well as a great many of the women. The infant emperor Antoku was plunged to a watery grave in the arms of his Taira grandmother when she saw from their boat that their cause was lost. The story of the Taira family's tragic fortunes is immortalized in one of the great works of the fourteenth century, the *Heike monogatari (Tale of the Heike)*. Yoshitsune's elder brother Yoritomo had sat out most of the war in far off Kamakura, where he had established the Minamoto power base in 1180. When the war ended, Yoritomo launched a campaign against his remaining samurai rivals in the northern provinces of Honshū, and also against his brother Yoshitsune, of whom he was jealous. Yoshitsune was hunted down in the province of Iwate and committed suicide before his brother's troops could capture him. Yoritomo made an example of Iwate's samurai clan—a subbranch of the Fujiwara—destroying their city of Hiraizumi, known as the "capital of the north" (see pages 152–4). The other samurai lords were soon brought to heel by Yoritomo and either pledged their allegiance to him or were wiped out.

The First Shogun: Minamoto no Yoritomo

Yoritomo thus succeeded in bringing all the archipelago, except for Hokkaidō, under his control, and established a military form of government called the *bakufu*. Unlike the Taira, he decided to forego the pleasures of the capital, and made Kamakura the center of his government. He thus removed the function of power from the sphere of influence of the imperial court and metropolitan aristocracy and of the great Buddhist centers around the capital and in Nara. For this reason the period of time that the Kamakura *bakufu* ruled the country is known as the Kamakura period (1185–1333).

Finally, in 1192, the imperial court were obliged to grant Yoritomo the title of Seiitai Shogun, literally "Barbarian-subduing General," and therefore the *bakufu* is also referred to in English as the shogunate. Yoritomo carried out extensive land reforms in the provinces. Although he preserved the ancient imperial bureaucracy there, these offices remained the mere honorary titles and stipends they had long ago become. The only difference was that they were handed out by the *bakufu* instead of the imperial court. Yoritomo's land reforms consisted of the granting of *shōen* that had previously belonged to his enemies, or simply to powerless members of the old aristocracy, as gifts to his lieutenants and allies. These great lords, who owed their first allegiance to the Shogun, came to be known as **daimyo**, which literally means "great name." The term made its first appearance in the eleventh century, and was applied to any lord (whether court aristocrat

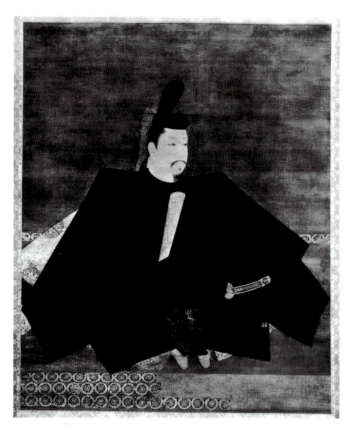

201 *Portrait of Yoritomo.* Late 12th century copy of the original of 1179 attributed to Fujiwara No Takanobu. Hanging scroll, color on silk; height 54 ⅞ in. (139.3 cm). Sentōin, Jingoji, Kyoto.

or samurai) of a large estate. By the Kamakura period, as most of these great estates passed into samurai hands, the title daimyo took on a totally military association. The primary retainers of a Shogun, therefore, were by definition daimyo, and by the fifteenth century they came to be officially recognized by this title. Yoritomo obliged his daimyo to reside with him in Kamakura, and to appoint stewards (JAP. *shugo*) to oversee their estates—thus giving rise to a whole new crop of military class established by the stewards.

This system meant that by the end of the medieval period in the sixteenth century there were literally hundreds of little "lords" sitting on their own fiefs scattered across the archipelago. The phenomenon has given rise to the characterization of the post-imperial period until the restoration of 1868 as feudal. However, for all intents and purposes this term, with its concept of fiefs and their supposed obligation to a central ruler, could as easily be applied to the organization of the *shōen* which came before. For the great mass of the peasantry, it made little difference whether they were bonded to an estate whose lord was a court aristocrat or a samurai.

Yoritomo himself played a delicate game with the imperial court, and the *insei* Go Shirakawa. His official position, even as Shogun, was as the emperor's servant—as had been that of the Fujiwara *kanpaku* who had come before. However, Go Shirakawa was, by 1185, an old man and it rapidly became

clear that his *insei* government, which was supposed to operate alongside the *bakufu*, was increasingly one of mere form. Nevertheless, the Minamoto never tried themselves to usurp the imperial throne, nor did any of the other shogunal dynasties which followed. The emperor and court aristocracy remained at the top of the social order, the samurai elite below them, followed by the peasants, and last of all the craftsmen and merchants in the towns. However, by 1185 it had been centuries since real power had actually resided with the imperial throne, and the Shogun, like the earlier *kanpaku* and *insei*, became the position and title with which that real power lay.

There has survived a pair of portraits of Yoritomo, dating one from the beginning of his career and one from near the end of his life, after he had taken the title of Shogun. The first is in the Sentōin, the Hall of the Retired Emperor, built in Go Shirakawa's honor at Jingoji and is part of a group of three portraits from a set of five commemorating *insei* Go Shirakawa's role in the restoration of the temple and the support of his four most trusted advisers. These painted portraits are thought to be early thirteenth-century copies of a set traditionally attributed to the artist Fujiwara no Takanobu (c. 1146–c. 1206) and executed in 1179, a year in which all of the subjects were still alive and Go Shirakawa at the height of his power. They are among the earliest extant examples of portraiture in the secular *yamato-e* (or Japanese) style. The painting traditionally identified with Minamoto no Yoritomo shows a relatively young man—Yoritomo was thirty-two in 1179—dressed in formal court costume and seated on three layers of tatami mats (Fig. 201). Extending from a fold of one sleeve and held by an invisible hand is a cream-colored *shaku*,

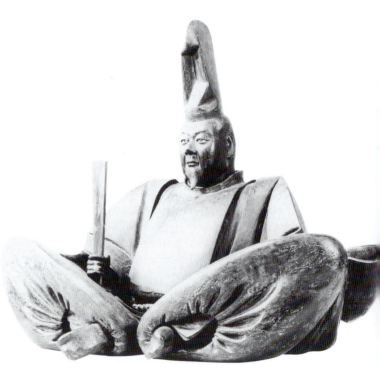

202 Portrait sculpture of Minamoto no Yoritomo. 13th century. Wood with paint; height 35 ½ in. (90. 3 cm). Tokyo National Museum.

a thin piece of wood emblematic of Yoritomo's court rank and carried on ceremonial occasions.

The sculpted portrait of Yoritomo as shogun is dated to the end of the thirteenth century and exemplifies the translation of the *yamato-e* style of portrait painting into a three-dimensional form (Fig. 202). Such sculptures and paintings became increasingly common within the ancestral shrines of the great clans. In this sculpture, now in the Tokyo National Museum, the pale, alert face of the young courtier has given way to the plump jowls and sharp, confident gaze of the shogun. For this posthumous portrait, Yoritomo is shown wearing less formal attire, an upper robe known as a *kariginu* (hunting jacket) and below it baggy pantaloons over a more form-fitting undergarment. His head is covered by a tall black hat made of starched gauze. Images such as this were habitually made for the ancestral shrines of the great clans, and presumably this sculpture once held its place amongst a pantheon of images in a Minamoto family shrine, or perhaps in one dedicated solely to Yoritomo.

Repairing the Damage: Cultural Revival in the Early Kamakura Period

After 1185, the whole of the capital and the Kansai region had been laid waste, the battle zone extending all the way to the southwestern tip of Honshū and east into the Kantō region. In particular, the Taira had set fire to both Tōdaiji and Kōfukuji as these temples had allied themselves with the Minamoto. By the twelfth century, it was not only the court and aristocracy that needed to have their property protected, but the Buddhist foundations as well. Some of the great monasteries, such as the Tendai center of Enryakuji, even created their own monk militias to rival the forces of the samurai lords. The Enryakuji monks were known to march down in force and threaten the emperor in order to obtain some favor or concession. Thus, whether they defended themselves or had others defend them, the great temples and monasteries were often as politically involved in these civil wars as the court and samurai. Nevertheless, the destruction by the Taira of the national temple of Tōdaiji was met with profound shock. It was agreed that both should be rebuilt immediately, and Minamoto no Yoritomo pledged the lion's share of funding, with the rest made up by emperor and aristocracy. The rebuilt temples and their refurbished images—largely by the **Kei school** of sculptors—are arguably Japanese Buddhist sculpture's most sublime expression.

Minamoto no Yoritomo, doubtless with an eye to consolidating his reputation as the nation's shepherd, also made sure that the imperial palace and capital were returned to something like their former prosperity. Commerce returned to normal within the city now most commonly known by the name of Kyoto, and the aristocrats in their mansions and the emperor and *insei* pursued with even more attention their cultural pursuits. Some aristocrats, deprived of their *shōen* and,

therefore, their income, became professional tutors in the Confucian classics, calligraphy, painting, or the playing of the *koto*. Some of their clients would have been other aristocrats or samurai, but as their poverty increased they would not be above teaching the sons and daughters of prosperous merchants and craftsmen. While Kyoto retained its central position within Japan's social and cultural structures, the division of power among a number of samurai daimyo tied to the *bakufu* meant that a number of provincial towns began to grow in influence as well. Not least of these was the seat of the Minamoto *bakufu*, Kamakura, which (as already mentioned) grew in the late twelfth and thirteenth centuries from an obscure fishing village to the second city of the nation.

There was also renewed interest in Chinese culture. By the end of the tenth century, China had reunited under the Song dynasty (960–1279), but in 1126 the Song lost half of its empire to foreign dynasties from the northern steppe, and in 1279 all of China would fall into the domain of the Mongol empire. However, for the first century of the Kamakura period, the Song empire still retained the rich, cultural south of China, and furthermore they had an enterprising merchant navy. The overall aesthetic of Song China was a great deal more sober and introspective than the comparatively gaudy exuberance of the Tang empire (618–907). After the upheavals of the twelfth century, the Japanese elite in the medieval period—whether courtly or samurai—were extremely receptive to this new sobriety.

Its greatest proponent within Japanese culture was the new Buddhist school of Zen (CH. Chan), which was imported from its Chinese centers by several different figures in the late twelfth and early thirteenth centuries. Zen looked for its sponsorship within the new samurai elite, and in particular the Minamoto *bakufu*. Zen monks became important advisers within the shogunate and the various retinues of the daimyo. They became great figures in poetry and painting, introducing the spare literary and visual formats of the Song literati very successfully to their samurai patrons, and ultimately setting the tone and taste for these matters even within Kyoto. While the imperial court remained largely immune to the allure of Zen, they were receptive to other aspects of Song intellectual culture in poetry and painting, and their art—even when it celebrated the lost golden age of Heian—was tinged with a sadness born of experience that gave their works a depth never quite obtained during the long prosperity of the Heian period.

While Zen was shaping the intellectual life of the samurai elite, another Buddhist movement was lighting up the lives of the peasantry and merchant classes. Amida Buddhism had begun in the Middle Heian period (951–1086) as a movement that preached the repetition of the *nenbutsu* mantra calling on Amida Buddha as the practitioner's best method for obtaining release— in this instance rebirth into the Pure Land of Amida. With the descent into chaos in the twelfth century, this recipe for salvation gained even greater currency as people became increasingly convinced that the *mappō* (the degenerate phase at the end of the Buddha age) was upon them. In the first

century of the Kamakura period a variety of charismatic fig- ures arose who organized this "Pure Land" Buddhism into a variety of different sects, all of which proved remarkably pop- ular with the oppressed peasantry and merchant class.

When Yoritomo died in 1199, his two sons, Yoriie and Sanetomo, were too young and inexperienced to control the Kamakura shogunate, and a power struggle ensued between their mother, Hōjō Masako, her father, Hōjō Tokimasa, and her brother Hōjō Yoshitoki. At first Tokimasa won out, forcing Yoriie into exile and assuming the office of regent for Sanetomo, who was elevated to the position of shogun. However, in 1205 Masako joined with her brother and forced Tokimasa into exile, the brother assuming the regency him- self. The Hōjō family would control the Kamakura shogunate until its fall in 1333. There is a subtle irony in the fact that this family, an offshoot of the Taira clan, was able to achieve through guile the supremacy that the leaders of the Taira had failed to attain, and a further ironic twist of fate in that they were eventually toppled by Ashikaga Takauji (1305–58), who traced his ancestry back to a great Minamoto general of the Late Heian period.

Following Go Shirakawa's death in 1192, the *insei* gov- ernment continued to function as a powerless partner of the Kamakura regime for three more decades. Following the assassination of Sanetomo in 1219, the *bakufu* fell into disar- ray, and in 1221 the *insei*, retired emperor Go Toba (1179–1239; r. 1184–92), rallied samurai and court aristo- crats loyal to the imperial house and attacked Masako and her brother. Known as the Jōkyū Rebellion, it was speedily quashed by the Hōjō, Go Toba was sent into exile to the island of Oki off the west coast of Honshū, and those who had sup- ported him were executed and their property confiscated. After this, the Kamakura *bakufu* made sure that the *insei* was no more than a retired emperor, and tried to ensure that the imperial throne itself was held by either a child or an imbecile. After Sanetomo's death, the office of shogun passed first to a Fujiwara of the Samura branch in Iwate, who passed it on to his son. Then the title was given to a series of imperial princes sent out to Kamakura. The real power in the *bakufu*, however, remained with the Hōjō family.

Decline into Perpetual Civil War: The Nambokuchō and Muromachi Periods

By the end of the thirteenth century, the Kamakura *bakufo* had lost control of its alliances with the other samurai clans, and by 1319 they had allowed an able emperor to take the throne. Go Daigo (r. 1319–39) first tried to stage an overthrow of the *bakufu* in 1324, but his plans were discovered and stopped. In 1331, he actually attacked Kamakura, but once again his forces were foiled, and he was deposed and sent in exile to the island of Oki. He escaped in 1333 and managed to gain one of the Kamakura generals as his ally—Ashikaga Takauji (1305–58). Together they finally crushed the failing

Kamakura regime, and Go Daigo returned to Kyoto fully intending that the *bakufu* was gone forever and a new golden age of imperial rule had begun. However, the period that has come to be known as the **Kenmu Restoration** was short-lived. In 1335, Takauji, feeling that he had been poorly recom- pensed by the emperor, led a revolt and chased Go Daigo from the capital. Takauji then placed the fourteen-year-old Kōmyō (r. 1335–80) on the throne and in 1338 assumed the title of shogun. Go Daigo fled to the mountains of Yoshino, south of Nara, taking with him the imperial regalia. With the support of other clans opposed to Ashikaga supremacy, he set up a southern court (JAP. *nanchō*) in opposition to the northern court (JAP. *hokuchō*) of the Ashikaga puppet in Kyoto. Thus was inaugurated the Nambokuchō period (1336–92) and a civil war that lasted for nearly sixty years.

Although the country could hardly be considered under the control of either party, the Ashikaga maintained a firm control over Kyoto and the area around the capital. Ultimately, in 1392 the Ashikaga shogun Yoshimitsu (1358–1409) per- suaded the emperor Go Kameyama (r. 1373–92) of the south- ern court to relinquish his claim and to turn over the imperial regalia to Go Komatsu (r. 1384–1413), the emperor in Kyoto. Yoshimitsu promised that the position of emperor would alter- nate between the southern and northern lines of the imperial family, but this was a promise never kept. Yoshimitsu, arguably the most astute of the Ashikaga shoguns, had succeeded to that position in 1368, when he was only ten years old, but a decade later he was sufficiently in control to move the seat of his government from Takauji's original Kyoto headquarters to the Muromachi district of Kyoto. The name of the period fol- lowing the reunification of the imperial lines is therefore known as the Muromachi period (1392–1573).

Even though Kyoto was relatively unscathed by actual warfare during the Nambokuchō, it nevertheless went into a steep decline, the result of commercial stagnation caused by the constant conflict and by a series of natural disasters, namely earthquakes, fires, and plagues. Aristocrat and mer- chant alike suffered. The fortunes of the aristocracy had, in particular, been distinctly diminished by the arrival of the Ashikaga in Kyoto. Most of those who still retained *shōen* with- in the Kansai region had these stripped from them by the new military elite of the Ashikaga *bakufu*. Those with properties further afield often had them confiscated by the war lords who set up what were, in fact and function, independent states. The emperor, to whom all at least professed allegiance, became lit- tle more than a forgotten figurehead, sitting in a palace that was rapidly falling down around him. By the end of the four- teenth century, many of the capital's literati and craftsmen— whether impoverished aristocrat, monk, or commoner—had fled, looking for provincial patrons and a safer existence.

In 1395, Yoshimitsu relinquished the position of shogun, and retired to a palace now famously known as the Kinkakuji (Golden Pavilion) in the Kitayama (Northern Hills) district of Kyoto (see Fig. 262). Unlike the *insei* of the late Heian and early Kamakura periods, the retired shoguns really did

relinquish the direction of political affairs, although perhaps not their political interests. Yoshimitsu, however, in his golden pavilion set in a beautiful and (for the time) modern park had the resources and the time to cultivate the arts. This he did with a certain gusto, which he handed on to his grandson Yoshimasa (1430–90). These Ashikaga shoguns and their courts built palaces inside and outside Kyoto, where they hoped to create little islands of splendor amidst the chaos and decay beyond their walls. In these efforts they were assisted by a new class of men, known as *tonseisha*, who had become monks in order to escape low social rank, but who did not affiliate with any particular Buddhist temple. In fact, the Ashikaga were noted for cultivating associates from all ranks of society, including those at the time considered the very lowest. Among the arts, the Ashikaga particularly fostered the development of *renga* (linked verse), **Nō** drama, **tea ceremony**, and **flower arranging**, and were famous for their collection of Chinese paintings. Yet Kyoto was not revived by this patronage but fell into even greater neglect and disarray. Yoshimasa was so keen on his pleasures that in 1459 he started construction of a new, vast, and luxurious palace to replace the shogunal residence in the Muromachi district. In a city where people were starving in the streets, there was an immense public outcry, and Yoshimasa ceased construction out of shame when the emperor sent him a poem in reproof. Less than ten years later Yoshimasa would launch the capital into a war that would leave almost half of the city in ruins.

Yoshimasa's retirement from the position of shogun in 1467 triggered factional disputes between the daimyo which culminated in the **Ōnin War** of 1467 to 1477. The principal theater of this conflict was Kyoto, the northern half of which, including the precinct of the imperial palace and the Muromachi district, were completely destroyed. After the war, Yoshimasa immediately set about creating a little paradise for himself and his coterie to the east of the city, as his grandfather had done to the north (see Fig. 263). However, the city itself would not recover and be rebuilt until the succeeding Momoyama period (1573–1615), almost a hundred years later, as the Ōnin War was followed by a series of civil wars between the daimyo called the **Sengoku Jidai** (Age of the Country at War). The Ashikaga *bakufu* survived in name only, and few parts of Honshū were left unaffected as the different daimyo conquered their rivals, and in turn were conquered themselves. Finally, one of the daimyo, Oda Nobunaga (1534–82), burnt the capital yet again and chased the last Ashikaga shogun, Yoshiaki (r. 1568–73), from it. On the final departure of the Ashikaga from Kyoto, the city's remaining citizens instituted a curious ritual at the Ashikaga clan's funerary shrine, where for a small fee one could beat the effigies of Takauji and his descendants. This particular custom lasted as late as 1887. Nobunaga succeeded in uniting the country under his rule, but it would be his successor Toyotomi Hideyoshi (1536–98), who would rebuild the capital and imperial palace and restore both of them to something of their former glory.

Rakuchū Rakugai

Paradoxically, the darkest hour of Kyoto's history also proved to be one that united its citizens—from emperor down to the homeless in the street (of which there were many at this period)—in a sense of the city as an entity unto itself, and of which each and every one of them was a component part. In terms of the visual arts this gave birth to a new subject in genre painting known as *rakuchū rakugai*—literally "scenes in and around the capital," Raku being another of Kyoto's many epithets. The invention of this subject matter is attributed to Tosa Mitsunobu (1434–1525), the foremost painter of the imperial court through the tumultuous events of the Ōnin War and its aftermath. The **Tosa school** was founded at the end of the twelfth century by Fujiwara no Tsunetaka, or as he came to be known—Tosa Tsunetaka. It became the leading school of *yamato-e* painting at the imperial court until the Meiji Restoration of 1868. Masters of this school usually have the surname of Tosa, although this does not necessarily indicate that they are Tsunetaka's blood descendants—only his spiritual ones, adopting the name as one did a court title. Critics have often characterized the seven hundred years of the Tosa tradition as one hidebound to the conventions of Heian-period *yamato-e*, churning out stale and trite images for a court stagnating in memories of the past. However, the format of *rakuchū rakugai* demonstrates that these *yamato-e* conventions could still be implemented to innovative and dazzling effect.

The standard device of scenes seen from a bird's eye view and framed by gold-dust clouds is with *rakuchū rakugai* applied to a vast panorama of the imperial capital, normally spread over two massive six-panel folding screens (JAP. *byōbu*). A sea of golden clouds breaks at particular points in order to reveal the streets and buildings of the city. The right-hand screen normally bears a vista of the eastern, and principal, section of the city, stretching from the southern boundary to the imperial palace in the north, while the upper sections of the panels look into the Eastern Hills, where many of the more important Buddhist foundations are located. The left-hand screen normally details the region to the north and west of the imperial palace. On these screens three areas are given particular prominence: in the first panels of the right screen, the Gion festival procession and the merchant district through which it passes, and in the last panels the imperial palace and the neighborhoods where the mansions of the court aristocrats were traditionally sited; and on the left screen, the first panels comprise the headquarters of the *bakufu* in the Muromachi district and the mansions of the powerful daimyo. These areas might be seen as references to the three classes present in Kyoto at that time: the townsmen, the court aristocracy, and the samurai.

Unfortunately no actual *rakuchū rakugai* screens known to be by Tosa Mitsunobu have survived to the present day. One of the earliest surviving is a pair in the National Museum of Japanese History (JAP. Nihon Rekishihaku Butsukan) and datable to between 1525 and 1535 on the basis of the buildings

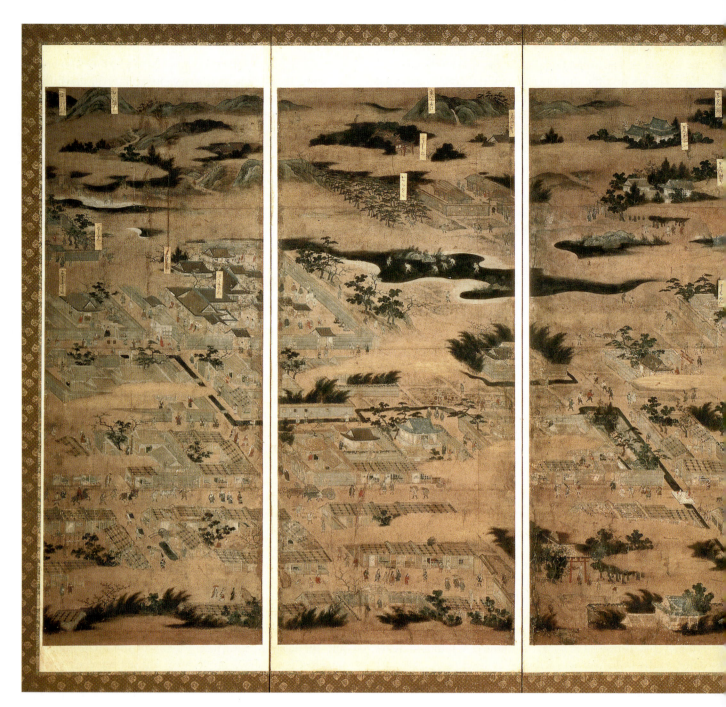

203a Right screen of a pair of six-panel *rakuchū rakugai zu* screens, known as the Rekihaku screens. 1520s. Ink and color on paper; each screen;
54 ⅜ x 135 ¼ in. (138 x 341 cm). National Museum of Japanese History, Sakura City, Chiba prefecture.

depicted (Figs 203a and b). This pair has been known alternately as the Machida and as the Sanjo screens, both these names being those of collections to which the screens formerly belonged. It is now, therefore, known as the Rekihaku set. While Tosa Mitsunobu would doubtlessly have painted the first *rakuchū rakugai* screens for the imperial court, they soon became favorite items with the samurai elite as well as the wealthier members of the merchant class. As such, these screens generally offer an idealized view of the city through its different seasons. With the Rekihaku screens, the viewing

begins from the right on the right screen with summer progressing over six panels toward the fall at the imperial palace. The left screen then takes the viewer through winter and into spring. Another feature of these screens is that they provide a canvas to depict the different festivals that take place over the course of the year. Therefore, the first three panels of the right screen display the *mikoshi* (portable shrines) of the many festivals of Kyoto's summer months, not least the Gion festival. The overall desire of the artist is to project a peaceful, joyful, and even prosperous image of the city. While this image would

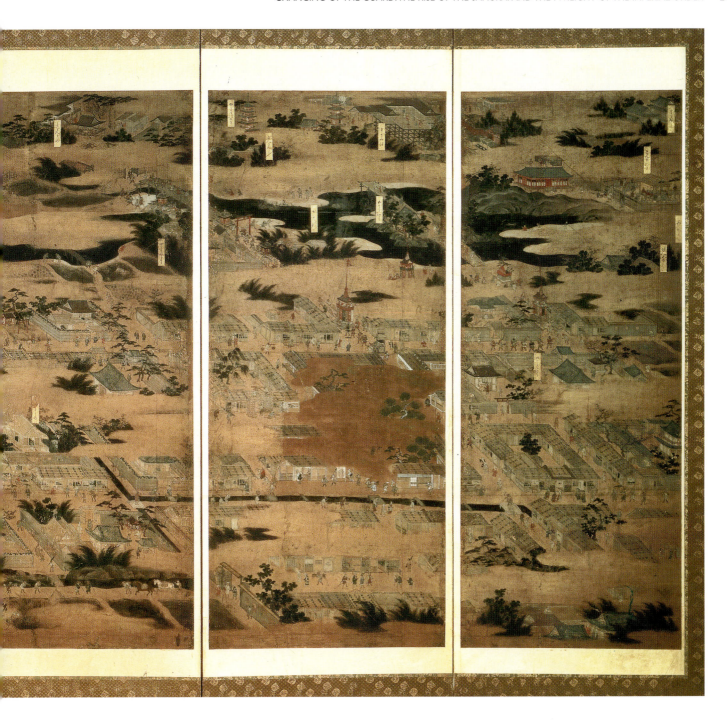

be largely factual in *rakuchū rakugai* of the later sixteenth cen-
tury and seventeenth century, the Kyoto the Rekihaku screens
depict existed mostly within the minds of the artist and his
commissioner. A first glance gives no idea of a war torn city,
half destroyed, or of the shanty towns that covered areas of
the city, or the starving and the dead in the streets.

 A second glance, however, does provide some clues. First
of all, the cloud cover becomes conspicuously thick over the
second panel in the middle of the capital's commercial district.
Another clue lies in the fields being cultivated just in front of
the imperial palace—where before the Ōnin War would have
been the mansions of high-ranking court aristocrats. Then
there are the festivals themselves. Summer festivals such as

the Gion date back to the Heian period, and were instituted in
response to the rash of diseases that broke out in the city dur-
ing the humid summer months. A key feature of the Gion fes-
tival today is the display by the old merchant families of Kyoto
of their treasures and heirlooms outside their houses, a left-
over from the custom of systematically cleaning and airing of
a premise and its contents. In the war-ravaged Kyoto of the
early sixteenth century, summer plagues that left dead rotting
in the streets had long become an annual event, giving festi-
vals such as the Gion a more serious and urgent purpose—
both in the cleaning up of the city and its houses, and in the
propitiation of the gods. Various Shinto *kami* were paraded
through the streets in their portable shrines in the hope that

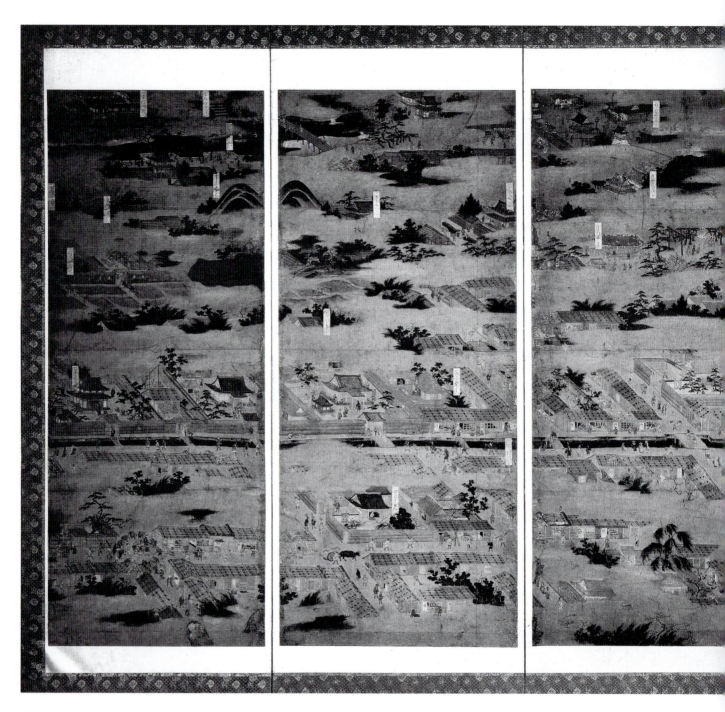

203b Left screen of a pair of six-panel *rakuchū rakugai zu* screens, known as the Rekihaku screens. 1520s. Ink and color on paper; each screen; 54 ⅜ x 135 ¼ in. (138 x 341 cm). National Museum of Japanese History, Sakura City, Chiba prefecture.

they would be appeased and lift whatever pestilence was then afflicting the city. Another small detail can be found at the bottom of the second panel, where the entrance to a neighborhood street is fronted by a makeshift wooden gate. Before the fifteenth century such gates were not features of Kyoto's neighborhoods. However, as the civil war raged on and more of the city was destroyed, citizens created their own militia and barricaded their streets. At the time of the screen's manufacture, Kyoto was merely a patchwork of such barricaded communities, with empty abandoned spaces or shanty towns

in between, such as those presumably hidden by the heavy cloud-cover of the second panel or by the well-cultivated fields that surrounded the imperial palace. The gates of these communities would be shut at night and carefully guarded against all strangers.

Notable as well is the nature of house construction throughout the city, from that of the humble shopkeeper to the great mansions. Almost all buildings are single storied. This was certainly a prominent feature of *shinden* construction for both the imperial palace and the mansions of the elite,

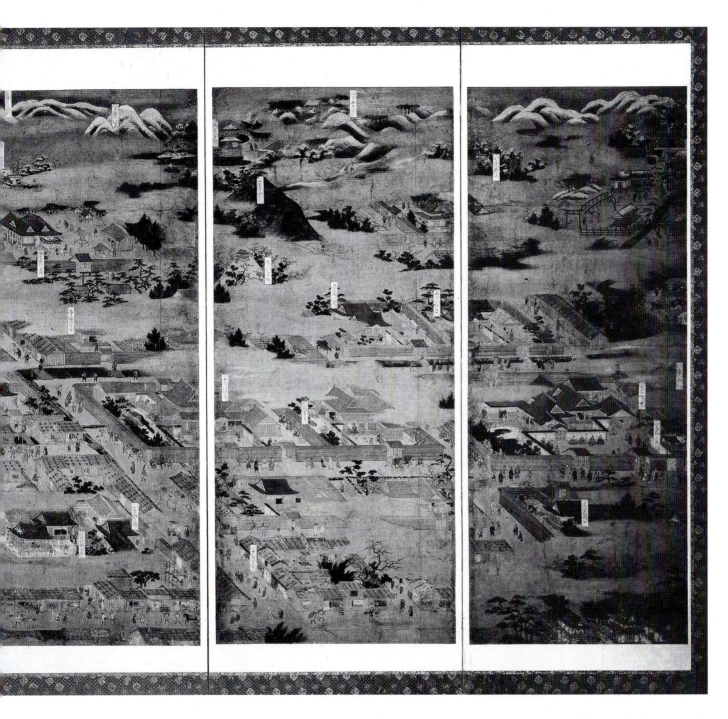

and seems also to have been standard for the merchants and craftsmen. In later centuries, however, the cityscape would change radically as the merchants began constructing two-story dwellings, the first story housing their commercial premises, with the upper story being for domestic use.

Although the Rekihaku screens provide poignant clues to the drastic deterioration of Kyoto's material fabric following the long years of civil war, they also still manage to convey the primary objective of the *rakuchū rakugai,* which was to depict the famous sights and events of the city. There is some evidence that these earliest surviving *rakuchū rakugai* screens from the aftermath of the Ōnin War were in fact commissions

by powerful daimyo families who had given funds for the rebuilding of the imperial palace and other landmarks of the capital. The Rekihaku screens in part support this—although they gloss over the more depressing aspects of Kyoto in the 1520s, they did not include, for example, the aristocratic mansions that disappeared in the conflagration that also razed the imperial palace. At the top of the first panel of the right screen can be found images of the most famous Zen foundation of the period, Tōfukuji, while just below it is the Sanjūsangendō. Both these structures miraculously survived the civil wars, although like many of Kyoto's buildings they had burnt down and been rebuilt at different times in the past.

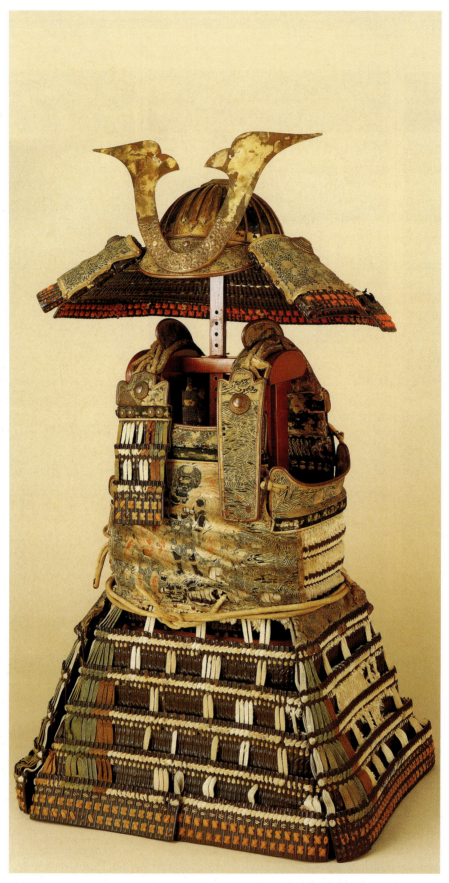

204 *Yoroi* suit of armor. Late Kamakura period, early 14th century. Lacquered iron and leather, silk, stenciled doeskin, and gilt copper; height of ensemble 37 ½ in. (95.3 cm). The Metropolitan Museum of Art. Gift of Bashford Dean. (14.100.121).

Just to the left of the Sanjūsangendō is a Nō performance. Nō, evolved in part out of the *kagura* dances which had been performed at the imperial court and imperial-cult shrines since time immemorial. These and both ancient and more recent peasant dance traditions were combined to create a unique dramatic art. Narrated by a chorus to the sounds of drums and wind instruments, the actors convey their thoughts and emotions through a combination of chanted dialogue and dance. The dramas usually focus on a single character whose inner conflicts must be resolved before his or her soul can achieve peace. Secondary Nō characters enable the main character to accomplish this goal. Credit for the development of Nō goes to the father and son Kan'ami and Ze'ami, who in the fourteenth and fifteenth centuries formulated this dramatic art under the patronage of the Ashikaga shoguns, and particularly that of Yoshimitsu.

Two other of Japan's enduring performance arts also have their roots in these tumultuous centuries, although they would be more properly established in the more peaceful seventeenth century. However, the prototypes of both Bunraku and Kabuki began as entertainments in summer festivals such as the Gion. They probably developed from street performances dating as far back as the Heian period, but they began to take on something like their modern format in the fifteenth and sixteenth centuries. The first are the puppet shows that grew out of simple performances on a level with the Western Punch and Judy, evolving into a sophisticated art form using large figures manipulated by puppeteers clad in black to render them inconspicuous. Now known as **Bunraku**, these shows also featured a seated chanter, who would recount the plot and speak the dialogue while a *samisen* (a kind of lute) player provided musical accompaniment. **Kabuki**, still the most popular of the traditional theater forms, developed alongside the puppet shows and took on its definitive form around 1603. It employs live actors—males who specialize in either *onnagata* (female roles) or *tachiyaku* (male roles)—and features gorgeous costumes and elaborate sets. Musical accompaniment is usually provided by an offstage musician playing a *samisen*. The plots of Bunraku and Kabuki plays are very similar, dealing with historical events, moral conflicts, duty, and personal desire, and even ghost stories—frequent summer fare because the shivers they produce trick one into feeling cool.

At the bottom of the first panel on the right-hand screen of the Rekihaku set begins Muromachi Street, which leads into the district on the first part of the left screen where the Ashikaga made their base from the end of the fourteenth century onward. At the top of the right screen's third panel is the Gion shrine, with people pulling a *mikoshi* from it across the river and into the city as part of the festival. In the middle of the fourth panel is the Buei *shinden*, one of the few mansions left standing in an area that would remain largely abandoned until the seventeenth century. In the middle of the fifth and sixth panels is the imperial palace. It is in some respects easily overlooked amidst the other buildings, no longer supported by the massive structure of the Daigokuden and other great public buildings. The palace was almost completely destroyed during the civil wars, and one suspects that even this much reduced image is something of an idealization. During the late fifteenth and sixteenth centuries, refugee shanty towns were known to have sprung up within the imperial grounds. In the Momoyama and Edo periods, peace and prosperity would once again bring the Capital of Flowers into bloom, as the *rakuchū rakugai* screens of that period amply testify (see Fig. 281).

Decorative and Applied Arts

As can often happen in human societies, these periods of great social turbulence were also times of great artistic innovation. Certainly the general course of development in the decorative and applied arts hardly seems to pause throughout all the wars, plagues, and natural disasters of the medieval period. At first the center of all fashion in the decorative arts remained the imperial capital, but, as time wore on and patronage shifted increasingly to the *bakufu* and daimyo, the craftsmen grouped into guilds in Kyoto began to disperse to regional centers where their samurai clients were based, and which, by the fifteenth century, might be considerably safer than Kyoto itself. By the end of the period, when Toyotomi Hideyoshi reunified the nation under his rule and set about restoring the capital to its former glory, he was able to draw on an artisan class expert in creating anything a great lord could possibly desire.

ARMOR AND LACQUERWARE

Armorers and lacquer craftsmen, in particular, made great advances in their art during the medieval period. Both found ample patronage from the newly wealthy samurai class. Armorers especially were never out of favor. Where in the Heian period there was often a division in arms and armor between those sumptuously worked pieces made for aristocratic patrons, and meant for court ceremonial, and those expertly crafted tools meant for the battlefields of the provinces, once power shifted into samurai hands, much more attention was given to combining these two approaches, so that the strong and deadly weapon also became something of great aesthetic beauty.

The Japanese armorers excelled especially in the manipulation of metal alloys. Their steel blades were renowned throughout Asia for their combined elegance and durability, and the swordsman's accoutrements—from the sword handles and handgrips to the hairdressing tools for his elaborate *chignon*—were made of special alloys utilizing gold, silver, copper, and lead that created a luxurious but deeply masculine aesthetic. Suits of armor became no less opulent, and a *yoroi* suit from the early fourteenth century provides an excellent example of how a daimyo would be attired for battle (Fig. 204). The main part of the armor is a densely woven padding of lacquered iron and leather, the decorative areas being

205 Toiletry box with scene of Mt. Hōrai. Kamakura period, 13th century. Black lacquer on wood with a *maki-e* (gold) design; 9 ⅗ x 12 ⅘ x 7 ¼ in. (24.4 x 32.5 x 18.5 cm). Kyoto National Museum.

constructed from silk, gilt copper and doeskin. In the center of the breastplate is a beautifully stenciled and colored image of Fudō, the Immovable, on lacquered doeskin. Although this suit could well have been present at the battles attending the collapse of the Kamakura *bakufu*, the intactness of the decoration on the doeskin probably indicates that it never received a single sword stroke or arrow. Great daimyo, like their European equivalents, did not—contrary to romantic fiction—constantly ride into the thick of battle, but often watched and directed events at a distance.

Lacquerware of the medieval period continues to draw on the landscape imagery of the aristocratic poetry traditions, but the shapes of the different boxes and vessels become even more refined, as do the methods of decoration. A small thirteenth-century toiletry box in black lacquer (Fig. 205) is

206 Inkstone case with poetic scenes of *Shio no yama*. Muromachi period, 15th century. *Maki-e* (gold) lacquer on wood; 1 ⅞ x 10 ⅛ x 9 ⅗ in. (4.8 x 25.7 x 23.8 cm). Kyoto National Museum.

painted on four sides with gold designs of flying geese and trees which are pure *kara-e*. The scenes are meant to be of Mount Hōrai (CH. Fenglai), one of Chinese Daoism's mythical mountains from whence the elixir of immortality might be obtained. Asymmetrically placed at one side of the composition, a weathered rock with a stunted cypress tree growing out of it sits on the shore of a lake. Towards it, from the left, fly two groups of geese. However, such weathered rocks were reputedly derived from a specific lake in southern China, not far from the then capital of the Chinese Southern Song (1126–1279) at Hangzhou. And the image of geese flying south for winter speaks of the gentle melancholy felt at this annual event, evocative as it is of the passage of time and the coming of winter.

A no less refined image of birds over a landscape can be found in a stunning *maki-e* inkstone case of the fifteenth century (Fig. 206). An essential part of the well-equipped writer's or painter's paraphernalia are such cases. Inside the sparkling gold-lacquer casing would be the slanted stone slab into which, when some water has been added, the stick of dried ink is rubbed in order to dissolve it (see page 220). The gold *maki-e* design has been created on a red lacquer base with inset silver rock forms in a landscape meant to evoke scenes of Shiogama, a coastal site in northern Honshū noted for its production of salt. These salt flats became a favorite image in poetry and were meant to evoke a beautiful, but melancholy solitude. Not surprisingly, Shiogama imagery made its way also into garden design, and some enthusiasts would even install a peasant in their garden who would burn salt on the shore of their miniature sea.

TEXTILES

Although imperial court costume remained frozen in the style of the Heian period, some adjustments were made. The twelve layers of robes a lady was expected to wear were significantly reduced. Indeed, great ladies of the samurai class often wore only one silk or cotton robe under their beautifully decorated outer **kimono**. Samurai men would wear more masculine versions of the same two robes, and over both of these pull on a pair of trousers known as **hakama**. Textile survivals from the medieval period are rare, but one such pair of *hakama* from the fifteenth century has survived (Fig. 207). Woven of bronze and white silk and decorated with floral roundels of green, yellow, and orange, these trousers would have been complemented on samurai of high rank with a short highly starched jacket, whose shoulders bore the circular clan crest, or *mon*.

CERAMICS

In the thirteenth to fourteenth centuries three elements combined to profoundly affect Japanese ceramics, which had previously languished behind the other applied arts in terms of development. The first element involved the increase of private trade with China and Korea. In the tenth century, both of

these countries had begun producing ceramics of a far more refined nature. While ceramic vessels and containers were a staple of any household, they were usually not fine enough to be placed on the imperial or aristocratic table. Their table settings would have been either of metal or lacquer ware. However, with the passing of the Tang empire and its glamorous and exuberant culture, the elites of China and Korea looked to furnish their tables in accord with the new sobriety that characterized the intellectual and artistic life of both countries. At the same time, advances in ceramic technology had perfected the firing of a strong, durable stoneware that could be decorated with equally durable high-fire glazes. The colors of these glazes ranged from the transparent to dark and glistening black, but the most famous were a range of greenish-blue glazes with a jade-like quality to their finish that were collectively called celadon. Sei Shōnagon mentions beautiful celadon ceramic vases already in the late tenth century, and by the twelfth century kiln output of ceramic wares on the continent had increased enough to be able to meet the increased and enthusiastic demand that came from Japan's new samurai elite.

The second element in the Japanese ceramic revolution was the importation of this new, more efficient kiln technology from the continent. In the Nara and Early Heian periods, ceramics were typically fired in a reduction kiln—that is, a kiln in which no air was permitted to enter the oven after the firing had begun. As the wood fire burned, the oxygen in the combustion chamber was reduced and the strength of the flame diminished. In tenth-century Japan, an oxidation kiln was developed that permitted air to enter during the firing process, making it possible to control the intensity of the flames more effectively and thereby maintaining them at the higher temperature levels that yielded a more durable ceramic. However, during the political disruptions of the twelfth century, ceramic production declined, some kiln sites were abandoned, and the full potential of the native developments of this type of kiln was not realized. In the new, more sober climate following the Genpei Civil War, ceramics gained a new prominence in the arts, as they had on the continent, and this renewed demand provided the impetus for further advances in oxidation-kiln technology, specifically separating the combustion chamber from the oven proper, and thereby improving the efficiency and controllability of the kiln. This permitted firing at the high temperatures needed to produce a native stoneware.

The third element was the native development of glazes to imitate those on the continent. Before this, natural glazing had occurred as an accident of the firing process, when ashes from the fire fell on the vessel surface creating a glossy patch. Potters began experimenting with wood ash suspended in a watery solution and then applied before firing either evenly to the surface of the vessel, yielding an overall color, or unevenly with the desired result of an irregular pattern of streaks. When fired in an oxidation kiln, these ash glazes produced a brown or amber surface; in a reduction kiln, they produced a greenish-yellow one.

207 Pair of men's trousers. Muromachi period, 15th century. Silk; 51 ¾ x 18 ¾ in. (131.5 x 47.5 cm). Kyoto National Museum, National Treasure.

A narrative, most probably apocryphal, attributes these innovations to the potter Katō Shirozaemon Kagemasa, also known as Tōshirō. In 1223, Tōshirō traveled to China in the entourage of the Zen monk Dōgen (1200–53), founder in Japan of the Sōtō school of Zen, and he stayed on in China for several years after Dōgen's return to study Chinese ceramic techniques. When he came back, he settled in the region known as Seto, near the modern-day city of Nagoya in Aichi prefecture (to the east of Kyoto). It is a region rich in the type of clay that makes stoneware. So famous was this region for its wares that its name forms the root for the Japanese word for ceramics, *setomono*. Although we may not accept the Tōshirō story as fact, it does account for a number of the characteristics of ceramics of the thirteenth to fourteenth centuries.

Until recently, ceramic production in this period was thought to have been concentrated in six "old" kiln sites: three in the area around Nagoya (Seto, Tokoname, and Shigaraki); two further to the west (Tamba and Bizen), the former close to Kyoto, the latter near modern-day Okayama; and Echizen on the west coast, not too far from modern Kanazawa. However, in recent years archaeologists have discovered more than thirty centers for the production of unglazed stoneware in locations ranging from Miyagi prefecture in the north to Okayama in the south of Honshū. Even further south, on the

208 Jar with peony design. Ko Seto ware. 13th to 14th centuries. Ceramic with yellow glaze; height 12 in. (30.5 cm). Tokyo National Museum.

firing, the shape is further embellished by a pattern of streaks achieved by the over-application of the glaze. This particular vessel would not pass muster in China, but the fact that it was produced in the Seto region and preserved over the centuries is a clear indication that Japanese potters were not attempting merely to copy Chinese ceramics, but rather to adapt elements which interested them into a native vernacular.

A vessel typical of the period is a storage jar thought to have been produced in Shigaraki in the fourteenth to fifteenth centuries (Fig. 209). The vessel was formed out of coils of clay that were built up and then formed into the final jar shape. Because the clay had a high iron content when it was fired, the unglazed portion became brick colored, but the shoulders of the vessel, which were ash glazed, turned grayish and produced a small, bib-like patch of shiny greenish glaze.

The aesthetics of roughness and simplicity embodied in the Zen concept of **wabi** had a profound influence on ceramic production during this period. Indeed, Zen masters and adherents would be some of the greatest clients for high-quality stoneware, and particularly tea bowls—even before the development of the tea ceremony in the fifteenth century, which will be discussed below (see Fig. 269).

209 Storage Jar. Shigaraki ware. 14th to 15th centuries. Stoneware with natural ash glaze; height 18 ⅜ in. (46.7 cm). The Metropolitan Museum of Art, New York. Collection of Asian Art, Gift of Harry G.C. Packard and Purchase, Fletcher, Rogers, Harris Brisbane Dick and Louis V. Bell Funds, Joseph Pulitzer Bequest, and the Annenberg Fund, Inc. (1975.268.428).

islands of Shikoku and Kyūshū, a further two kiln sites have been uncovered.

Of these many sites, Seto is undoubtedly the most important, producing in the last decade of the thirteenth century a unique style of ceramics known as Ko Seto, or Old Seto, to distinguish it from wares made in the region in succeeding periods. Ko Seto wares exhibit a refinement of shape, a perfection of technique, and an elegance of decoration not found in ceramics from the other kiln sites. In large measure this is due to the receptivity of local potters to the techniques and aesthetics of Chinese Song-dynasty ceramics.

A Ko Seto jar, in a shape most often identified as a wine bottle or saké decanter, displays not only the distinctly Chinese peony design, but also the shape known in China as *meiping* (Fig. 208). The jar is taller than it is wide, and contrasts a narrow neck, articulated by the horizontal lines formed by an upper and lower lip, with a long body that swells at the shoulder and re-forms itself into a narrow circle at the base. Apart from the design of peony blossoms, incised in the clay before

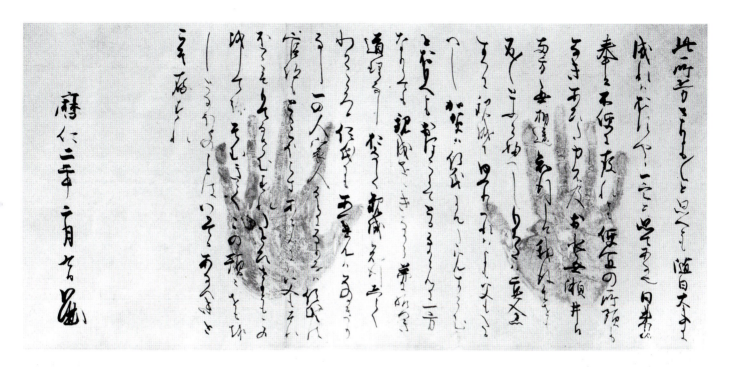

210 Last will and testament of Emperor Go Toba (1179–1239) with handprints. Kamakura period, 1239. Hand scroll, ink and red seal ink on paper; height 12 in. (30.4 cm), length 42 ⅘ in. (108.8 cm). Minase Shrine, Osaka prefecture, National Treasure.

Literary and Calligraphic Arts of the Imperial Court

Literature and the calligraphic arts continue to be the point of reference concerning subject and fashion in all the arts of the medieval period. Stripped of political power and of much of their wealth, the emperor and court aristocracy still remained for the first half of the medieval period the cultural heart of the nation, and they did it largely with the brush. The poets of the court still set the fashion in verse, and the main form that it took was a format of strung-together *waka* (see page 110) known as *renga*. The point of *renga* was that a number of distinct *waka* could be connected to construct a chain of ideas. They could grow into veritable epics a thousand stanzas long. However, the composition of *renga* was not the sole province of court poets, and it became popular with the poet–monks of the different Japanese orders, not least the new Zen school, as well as the men and women of the samurai class. The Ashikaga shogun Yoshimitsu was a particular patron of the form, gathering at his palace retreat of the Kinkakuji the greatest *renga* practitioners of the day. Prose forms also flourished, with the numerous diaries and travel journals by both men and women providing us with much of what we know about life during this period. The key conflicts of the twelfth century, such as the Heiji and Genpei, were dramatized in such epics as the *Heike monogatari*, introducing the war epic to the *monogatari* format. This marked a departure into more aggressive and masculine territory in the medieval period, and a leave-taking—to a certain extent—of the courtly romances of the Heian period, which in the new climate came to be considered by some as too "womanly."

The emperors, in particular, took very active roles in this literary culture, where before they often had been content to be merely its patrons. The first of the great poet–emperors of the medieval period was the tragic Go Toba (1179–1239; r. 1184–92), whose ill-fated Jōkyū Rebellion was brutally quashed by the Hōjō in 1221. Go Toba was sent into exile and many members of his court were executed or stripped of their property. However, for almost forty years before this, Go Toba's court, both as emperor and *insei*, was the great star in the literary firmament. He reestablished the imperial poetry bureau (first created in the Heian period) and fostered the early movement toward *renga* there. After his exile to the remote island of Oki, Go Toba devoted himself almost entirely to poetic pursuits, revising poetry collections and producing volumes on poetic theory and criticism. His own collection of poems from this period is the *Entō hyakushu* (*Hundred Poems from a Distant Isle*), of which one of the most famous is the following:

> The sorrow of one
> at the limit
> of cares he cannot flee—
> lamenting all the while,
> I still go on.

Seni'ichi Hisamatsu, *Biographical Dictionary of Japanese Literature*, Tokyo, 1976, p. 120.

Possibly even more poignant a relic of this emperor is his last will and testament, composed a few months before his death in 1239 (Fig. 210). The calligraphy of this document is arguably of the most refined to be found in a tradition replete with great

211 Detail of *Shinsen rōeishū shō*, by Emperor Go Enyū (1358–93). Hand scroll, ink, gold, and silver on paper mixed with blue and purple fiber; height 12 ⅜ in. (32 cm), entire length 254.5 in. (646.5 cm). The Tokugawa Art Museum, Nagoya.

masters. The combination of the seemingly effortless with exquisitely judged intent make every stroke and character an eloquent witness to Go Toba's character and tragic circumstances. The hand prints were long reputed to be of blood, but, as John Carpenter has pointed out, they are in fact of red seal ink, and were even touched up by Go Toba with a brush. Even so, they provide, almost eight centuries later, an almost intact set of finger and palm prints of the exiled emperor—so hard did he press his hands onto the paper.

In the next two hundred years the emperors would not abandon their poetic obsessions, and it is thanks to their efforts and the members of their courts that much of the poetry of the Asuka to Heian periods has been handed down to us today. A page from Emperor Go En'yu's (r. 1372–82; 1358–93) *Shinsen rōeshū shō* (*Excerpts from the New Selection of Chinese and Japanese Poems*) demonstrates that the craft of beautiful papermaking had not died in the flames of war, but continued to thrive (Fig. 211). Go En'yu was one of the last emperors of the northern, Ashikaga-controlled court before the reunification of the two courts in 1392. During this early period, the Ashikaga had not gained their reputation for letting both the imperial court and capital go to rack and ruin. However, one of Go En'yu's descendants, Go Nara (1527–58),

would be reduced to selling his calligraphy in order to pay household bills. By the sixteenth century, this was a circumstance all too familiar to every family of the court aristocracy.

Importantly, however, calligraphy and poetry also found enthusiasts amongst the samurai. Although it would have been easy for these warriors to hide bad handwriting on the battlefield, it was considered an important and defining accomplishment amongst their upper ranks. Their protégés in poetic and calligraphic pursuits would often be Zen monks, who introduced new fashions from China, using their talents with brush to evoke in both words and image their poetry and philosophies (see Figs 252–61). In the second half of the medieval period they would almost eclipse the court in their accomplishments.

Emakimono of the Medieval Period

The thirteenth century was a particularly lively period for the production of *emakimono* at the imperial court. In the early Kamakura, pictures illustrating the *Genji monogatari* continued to be popular, and there was increased interest as well in the author, Murasaki Shikibu herself. According to the

Meigetsuki (Chronicle of the Bright Moon), the diary of the noted poet and scholar Fujiwara no Teika (1162–1241), in 1233 a group of noblemen centered on the *insei* ex-emperor Go Horikawa (1212–34; r. 1222–32) launched a project to make new *emaki* of the *Genji monogatari* and an illustrated version of Murasaki's diary, the *Murasaki Shikibu nikki (Diary of Murasaki Shikibu)*. Such an *emaki* of the diary has survived to the present day, although it has not been established whether or not it is the same one mentioned in Teika's diary. The four scrolls, now in several different collections, correspond to only fifteen percent of the original diary, and are not in sequence. It is presumed that the original set of illustrations must have included many more rolls.

Like Sei Shōnagon's *Pillow Book* Murasaki's diary deals with her life at court as a lady-in-waiting to an imperial consort, in her case Fujiwara no Shōshi, the daughter of the great statesman Michinaga (966–1027). The scene from the diary's *emaki* where he holds celebrations on the lake of his *shinden* on the occasion of his daughter giving birth to the imperial heir was discussed in Chapter 3 in terms of what it can tell us about the great *shinden* estates of early Heian (see Fig. 134). It should be looked at again here—as a nostalgic illustration for the thirteenth-century imperial court of a lost golden age. In spite of the gaiety and splendor of the central event, the scene is permeated with a sense of the fleeting nature of joy and pleasure. Murasaki's diary is distinguished by the author's feeling of loneliness and of being subject to the will of people who outrank her. On one occasion she has been enjoying the sight of the moonlit garden outside her apartment. Two drunken courtiers come along and try to get into her room, and she must hold her windows shut against them (Fig. 212).

The pictorial compositions adopted in these two scenes are very similar to those of the Heian-period illustrations of *Genji monogatari* (see Figs. 140 and 141), but the effect in the

thirteenth-century scroll is entirely different. The landscapes are not used as a reflection of the characters' emotions; the figures instead express themselves directly, and the landscape becomes a pictorial element to be appreciated apart from the events in the narrative. The *tsukuri-e* technique is employed for these thirteenth-century scrolls as it was in the Heian period (see page 117), but without the same care. To cite two examples out of many, silver is used less frequently, and less attention has been given to interior architectural details, such as designs on sliding doors.

Another illustrated scroll-set that grew out of the nobility's interest in the recent past is the *Heiji monogatari emaki*, dated to the second half of the thirteenth century. The tale deals with the events of 1160, when Minamoto no Yoshitomo led a Fujiwara-planned coup and imprisoned the *insei* Go Shirakawa. The coup was brutally quashed by Taira no Kiyomori, and Yoshitomo executed, his two sons fleeing to their domain in eastern Honshū. One of the most dramatic episodes in the *emaki* is the occasion when Go Shirakawa was taken prisoner and his Sanjō Palace burnt to the ground (Fig. 213). Troops led by Fujiwara no Nobuyori (1133–60) attacked the palace in the middle of the night. Killing two majordomos and bundling Go Shirakawa into a carriage, they then set fire to the buildings. The servants and ladies-in-waiting all tried to flee the flames, many jumping into a well in the courtyard. The first to try this were drowned, the last were burned by the flames. Others of the palace staff were trampled under the hoofs of Nobuyori's horses.

The picture illustrating this episode is unusually long and is uninterrupted by text. In the organization of motifs, the

212 Illustration from *Murasaki Shikibu nikki emaki (Illustrated Scroll of Lady Murasaki's Diary)*, scroll 1. 13th century. Hand scroll, color on paper; height 8 ¼ in. (21 cm). Gotō Art Museum, Tokyo.

213 Illustration from *Heiji monogatari emaki* (*Scrolls of Events of the Heiji Period*), showing troops fighting as Sanjō Palace burns. 13th century. Hand scroll, ink and color on paper; height 16 ¼ in. (41.3 cm).
Museum of Fine Arts, Boston. Fenellosa-Weld Collection. (11.4000).

unidentified artist owes a debt to the twelfth-century *Ban Dainagon ekotoba* (see Fig. 146). Although not shown in Figure 213, the illustration of the attack on the Sanjō Palace has an opening passage similar to that of the older scroll, with a group of people moving to the left until halted by the wall of the burning palace. However, the thirteenth-century *Heiji monogatari* artist has established a much faster pace for the events, concentrating the flames in the upper part of the scroll, but continuing the human action in a narrow register along the lower edge. The painting technique relies on bright pigments for the armor, the costumes of the women, and, of course, the flames, but the artist allows his brushwork to describe the grotesque faces of the warriors perpetrating this outrage. Sadly, no information can be gleaned about the scroll's artist, calligrapher, or patron, but the burning of the Sanjō Palace remains one of the finest extant examples of Japanese narrative illustration.

The thirteenth and early fourteenth centuries also witnessed an explosion of biographical *emakimono* concerning the lives of Buddhist monks and saints, which will be discussed below in the sections on Kegon and Pure Land Buddhism (see Figs 230, 231, 234–7, and 240). These scrolls, like the *Shigisan engi* before them (see Figs 79 and 145), largely abandoned the *tsukuri-e* technique of the Genji *emaki* and instead turned to a modified version of the *otoko-e* style of line-brushed images with relatively light coloring, a style also shared by the *Heiji emaki*. This style would become the predominant painting technique for *emakimono* later in the medieval period.

The Rebuilding of Tōdaiji and Kōfukuji

In the first years after the Genpei Civil War, one of the country's top priorities was renewal: the revitalization of the nation's traditional religious foundations, the rebuilding of Buddhist temples damaged or destroyed during the fighting, and the modification of existing religious institutions to satisfy newly emerging constituencies of the faithful. The project with the highest priority was the rebuilding of Tōdaiji in Nara.

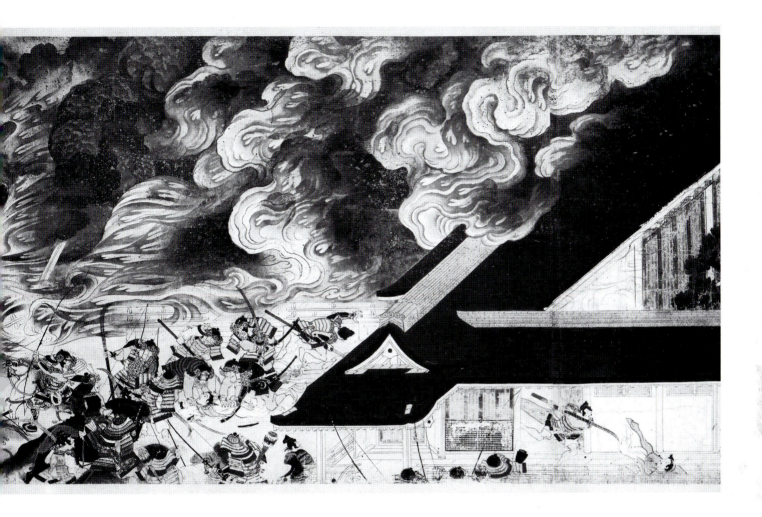

The Daibutsuden (Great Buddha Hall) was burnt to the ground in 1180 by the Taira army as a punishment for the temple giving support to the Minamoto clan at the beginning of the civil war. This wanton destruction of an imperially sponsored and greatly revered temple had shocked the country, and, even before the war had ended, the *insei*'s government began the reconstruction process.

Placed in charge was Shunjōbō Chōgen (1121–1206), a priest trained in Shingon who later became a proponent of Pure Land Buddhism. With his appointment, a countrywide campaign was initiated to raise funds for the project, and Chōgen, then in his sixties, took to the road to solicit contributions. Even the renowned priest–poet Saigyō (1118–90) was encouraged in 1186 to make his last pilgrimage to the northernmost provinces of Honshū to collect in the name of Tōdaiji. One of the most generous donors was Minamoto no Yoritomo, who traveled from Kamakura to the Kansai region in 1195 not only to attend the dedication ceremony but also to pay a formal courtesy visit to the emperor, military ruler to sovereign. Of the buildings constructed during this period, the Nandaimon (Great South Gate) best preserves the grandeur of Chōgen's concept (Fig. 214). It was built in 1199, and the Kongō Rikishi, the guardians of the gate, were installed in 1203.

Chōgen was unusual among the Buddhist clergy for having made three trips to China between 1167 and 1176 to continue his Buddhist training. During his stays he apparently informed himself about contemporary Chinese Buddhist architecture, because the style employed in the new construction at Tōdaiji, known as *daibutsuyō* (Great Buddha style—a name derived from the fact that it was used for the Tōdaiji Daibutsuden), had not been seen in Japan before the Genpei Civil War, and aside from this project was little used afterwards. During his travels to raise funds for Tōdaiji, Chōgen built three provincial temples, including the Jōdoji in Hyōgo prefecture west of Kyoto, in this same *daibutsu* style, before he undertook the Nara project. The physical appearance of this extraordinary man is preserved in one of the most starkly realistic portrait sculptures of the medieval period (Fig. 215). Executed by an obviously talented artist, the sculpture was probably made shortly after the priest's death in 1206 to be used in memorial services in his honor. It shows him as an old man, sitting in a slightly hunched-forward position reciting the *nenbutsu* mantra, as he keeps count of his recital by fingering the prayer beads of his rosary. Strings of beads made of bone, wood, or nuts were an originally Indian aid to meditative repetition of a sacred name or mantra. Buddhist rosaries have

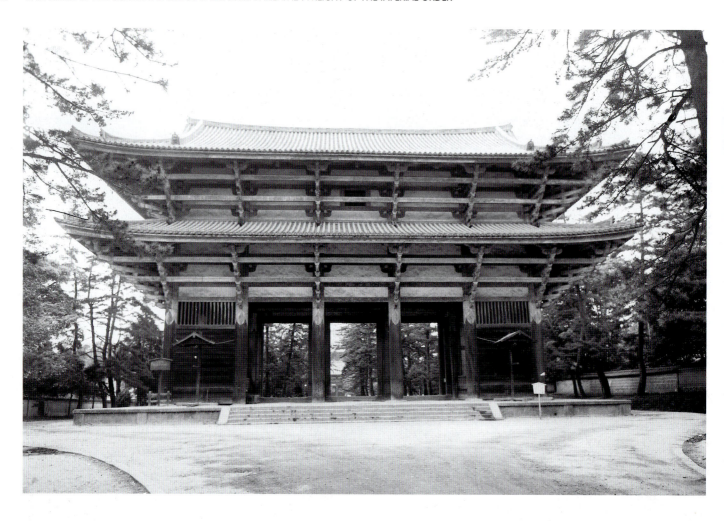

214. The Nandaimon (Great South Gate), Tōdaiji, Nara. 1199.

108 beads, said to represent the 108 delusions that people are prey to. The Christian rosary is thought to derive from the same source.

The statue is made of *hinoki*, Japanese cypress, in the *yosegi*, or multiple-block, technique and is decorated in the simplest way, with flesh tones for the head and black for the priest's robe. Chōgen's face is a wonderful study of age, with prominent cheekbones, wrinkled flesh around his mouth, pursed lips, and deep eye cavities under bony eyebrows. The eye treatment is particularly interesting. It became the custom from the late twelfth century on to inset crystal for the eyeballs, but here the sculptor has rejected the new technique in favor of an even more realistic depiction of the eyes, with one opened slightly wider than the other. The priest's hands are not the thin, elegant ones of someone dedicated to sedentary pursuits, but instead have the thick fingers of a man used to manual labor. Unfortunately, no artist's name has been recorded for the sculpture, but because it was made at a time when the Kei school of artists, whose hallmark was graphic realism, was active in Nara, it is possible that it may

215 *The Priest Shunjōbō Chōgen.* Shunjōdō, Tōdaiji, Nara. Early 13th century. Wood, with paint; height 32 ⅜ in. (82.2 cm).

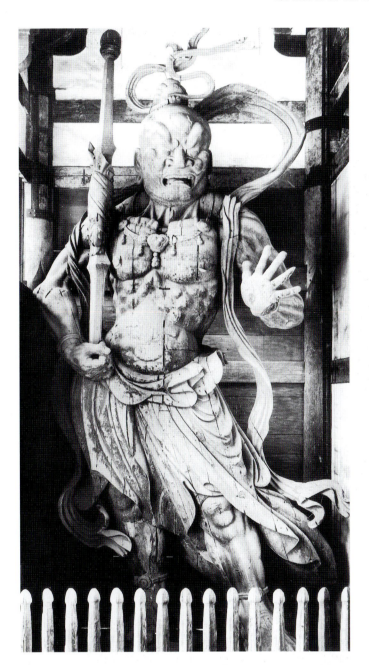

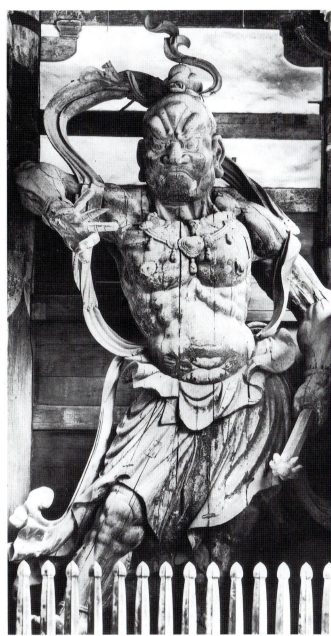

216 Pair of Niō figures, by Unkei and Kaikei. a.) (left): Agyō. 1203. Wood with paint; 329 in. (836 cm).
b.) (right): Ungyō. 1203. Wood with paint; 331 in. (842 cm). Outermost bays of Nandaimon (Great South Gate), Tōdaiji.

have been made by one of the Kei masters. In any case, the sculpture is a beautifully realized image of an old priest who is physically and emotionally tough and wholeheartedly committed to his religious vocation.

The Nandaimon, or Great South Gate, of Tōdaiji is the exemplar not only of Chōgen's building campaign but also of the union of realistic Kei-style sculpture with new temple construction, in the context of the former capital and its classic Buddhist art. The original gate had been demolished by a typhoon in 962 and never rebuilt, but, given Chōgen's vision for the new Daibutsuden, a major entry gate was clearly in order. As mentioned above, the building itself was completed

in 1199 and the two gigantic Kongō Rikishi statues, Agyō and Ungyō, both about 28 feet (8.5 m) tall, were installed in 1203.

The Kongō Rikishi installed in the two outermost of the gate's five bays are dynamic sculptures that hold their own against the vertical projection of the building (Figs 216a and b). Their placement is unusual in that they face toward the center of the gate rather than toward the entrance path, a positioning that may have been determined in the early eighteenth-century restoration of the temple. So great is the height of the gate's first story that a traditional placement of the statues, facing the entrance pathway, would have afforded them little protection from the elements. The sculptures are

the result of a collaboration between two of the most talented Kei-school artists, Unkei (d. 1223) and Kaikei (act. 1185–1223), and were produced in the incredibly short span of seventy-two days, a testimony to the efficiency of the Kei school's studio system and the potential of the *yosegi* technique. Records indicate that, in addition to the two named artists, two other sculptors of master status and sixteen assistants worked on the statues.

The two guardians stand in dramatic, hip-slung poses, giving the impression of arrested motion. It is as if they have each just seen a potential danger, stepped out, and raised an arm in a strong, protective gesture. Their scarves and skirts sweep out to one side, as if lagging behind the movement of the wearers. The Kongō Rikishi faces, which emphasize strongly three-dimensional features, and the sense of movement in their poses are reminiscent of the clay Shūkongōjin image of 733 in the Hokkedō of Tōdaiji, a work to which Unkei and Kaikei must have had access (see Fig. 102). One of the hallmarks of the Kei school is realism, but another is classicism, a knowledge of the sculptural style developed in Nara in the eighth century, and an attempt to rework it into a mode appropriate for the new age. The primary difference between the eighth-century works and those of the Kei school is a stronger sense of realism in the latter to the point of exaggeration, providing a heightened feeling of drama.

Kōfukuji—one of the two head temples of the Hossō school (and one of the six schools of Nara) and the family temple of the Fujiwara—was razed in 1180 by the same Taira raid that set fire to Tōdaiji. The priests of the two temples bore such great enmity toward the Taira lord responsible—Shigehira (1157–85)—that when he was captured at the end of the war the Minamoto handed him over to the monks of Kōfukuji, who promptly executed him. When the construction campaign for Tōdaiji was initiated, Minamoto no Yoritomo also provided his direct support for the rebuilding of Kōfukuji. The Kei sculptors resident in Nara received commissions not only to repair seventh- and eighth-century sculptures that had been damaged, but also to create new works to replace the most important of those lost over time.

The Kei School of Sculptors

The Kei school of sculptors traced its origins to the sculptor Raijo (1044–1119), a second-generation disciple of Jōchō (d. 1057). Although Jōchō's studio was located in Kyoto, after Raijo completed a commission from Kōfukuji in 1096, he decided to remain in Nara rather than return to the capital, where he would have to compete for work with the conservative but powerful sculptural schools there. Raijo's descendants stayed in Nara conserving their relationship with Kōfukuji and producing sculpture. At the end of the twelfth century, when the great rebuilding programs began, the studio's head was Kōkei (act. 1175–1200), who is generally credited with organizing his son and many disciples and assistants into the

Kei school. The most prominent artists working under him were his son Unkei (d. 1223) and his disciples Kaikei (act. 1185–1223) and Jōkei. Once the rebuilding campaigns of Tōdaiji and Kōfukuji were completed in the early thirteenth century, Unkei moved the Kei studio to Kyoto. The most important of the Kei masters after Unkei's generation were his own sons, Tankei, Kōun, Kōben, and Kōshō. This group of talented men had had the opportunity to work together in heady proximity to the greatest sculptures of the Nara period, and with that powerful influence over them they created the most innovative and accomplished works to emerge from the Kamakura period.

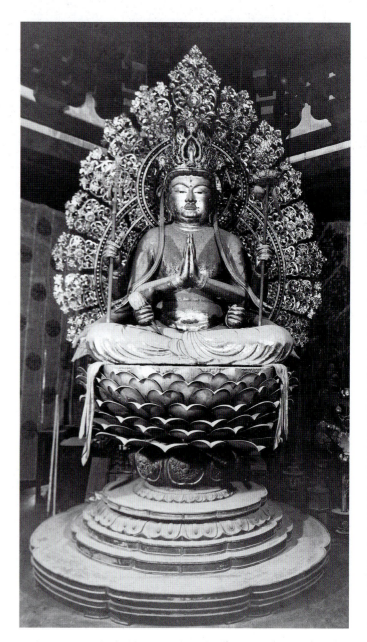

217 *Fukūkenjaku Kannon*, by Kōkei. 1189. Wood with paint and gold leaf and inlaid eyes; height 132 in. (336 cm). Nanendō (South Octagonal Hall), Kōfukuji, Nara.

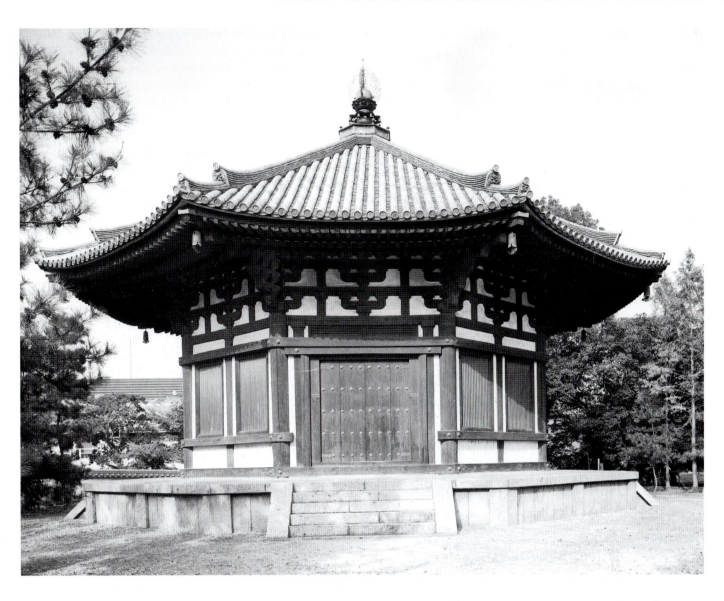

218 Hokuendō (North Octagonal Hall), Kōfukuji, Nara. 1210.

Kōkei's artistry is represented by the statues he made in 1189 for the Nanendō, or South Octagonal Hall, at Kōfukuji. The central image is a gigantic Fukūkenjaku Kannon (Fig. 217), the same type of image, albeit seated, as the main divinity of the Hokkedō platform at Tōdaiji (see Fig. 109). The statue was made to replace the original Fukūkenjaku Kannon, thought to date from 746, which was lost in the fire that consumed the temple. Stylistically, the image stands between Jōchō's Amida of 1052 (see Fig. 174) and Unkei's Miroku of 1212 (see Fig. 219). The proportions are very much those of Jōchō's statue, having a wide baseline, provided by the stretch of the lower legs, and a comparable vertical projection of the torso. The face, too, retains the squarish shape of the earlier style. New elements have been introduced—or example, the crystal used for the eyes and the *byakugo* (SKT. *urna*). Also, the carving of facial and drapery details is deeper than was the case in earlier *yosegi* sculptures. However, in essence the statue is a graceful reworking of the Middle Heian style established by Jōchō.

Aside from the massive guardians in Tōdaiji's Nandaimon (see Fig. 214), which he executed in conjunction with Kaikei and at least two other masters, Unkei's mature style can be found in the sculptures he made for the Hokuendō, or North Octagonal Hall, of 1210. The Hokuendō stands on the site of the memorial hall constructed in 721 on the first anniversary of Fujiwara no Fuhito's (659–720) death (Fig. 218). The altar centerpiece illustrated in Figure 219 is a Miroku Butsu (SKT. Maitreya Buddha) that was originally attended by a large retinue of two bodhisattvas, Shitennō (Four Guardian Kings), and two Indian **rakan** (SKT. **arhats**). Of these only the Miroku and the two standing *rakan*, Muchaku (SKT. Asanga) and Seshin (SKT. Vasubandhu) in Figures 220 and 221, have survived the centuries and date to c. 1212.

The image of the Future Buddha was doubtless chosen as the central image to replace the Miroku sculpture of the original octagonal hall. He sits cross-legged on a tall octagonal platform, an elaborate openwork halo behind his head. This

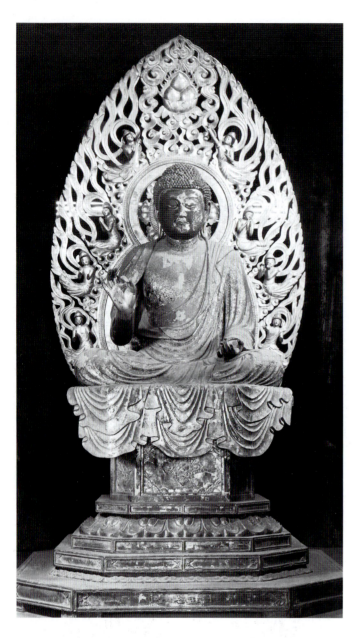

219 *Miroku Butsu*, by Unkei. 1212. Wood with paint and gold leaf and inlaid eyes; height 55 ⅞ in. (141.9 cm). Hokuendō, Kōfukuji, Nara.

has created an entirely new style of Buddha sculpture, an image that projects approachability, a gentle, almost human deity with whom the worshiper can hope to communicate.

Within Buddhism, *rakan* operates as a rank within Enlightenment. While *rakan* have not yet achieved the complete Enlightenment of the Buddha, they are nevertheless far along the path to it, and are already free from rebirth. The brothers Muchaku and Seshin are two of the most famous figures of Indian Buddhism in the early centuries C.E., and would have achieved this rank in their lifetimes. The philosophies they formulated have been central to many schools of Japanese Buddhism, not least the Hossō of Kōfukuji Muchaku (Fig. 220) is depicted as a slender figure holding a cylindrical object, perhaps a reliquary, wrapped in a piece of cloth, while Seshin (Fig. 221) is a more fleshy individual, whose hands appear to be gesturing as he speaks. One figure appears to be reflective and introverted, while the other is outgoing, seeming to make eye contact with the viewer. Both wear priest's robes that fall in deeply carved and irregularly patterned folds. They are completely natural images, freestanding and not frontally posed. Unkei has created imaginary portraits of the two early Indian Buddhists that are completely believable in the context of Japan in the thirteenth century.

Kaikei's own projects also have a gentle aspect, and are distinguished by their rich embellishment with numerous details. Kaikei was adopted by Kōkei into the family, and his life followed a somewhat different pattern from that of the other Kei sculptors. Although both he and Unkei were devout Buddhists, Kaikei involved himself more completely in the teachings of the Pure Land school of Amida Buddhism. He came under the influence of Chōgen at Tōdaiji, who gave him the Buddhist name Anamidabutsu and favored him with a number of sculpture commissions. Toward the end of his active life, Kaikei seems to have worked primarily on Amida images, and his style at that time is known as *anami* after his Buddhist name.

One of the most memorable works Kaikei created on commission from Chōgen is the 1201 statue of the Shinto god Hachiman in the guise of a monk, for Tōdaiji's newly rebuilt Hachiman Shrine (Fig. 222). Originally Chōgen had conceived of installing in the shrine a painting of Hachiman originally owned by Jingoji but which had since come into the possession of the *insei* ex-emperor Go Toba (1179–1239). Jingoji's restorer, Mongaku, beat Chōgen to the post and persuaded Go Toba to return it to Jingoji. Kaikei is thought to have based his sculpture on the Jingoji painting. Kaikei's "second-choice" image sits cross-legged on a lotus base, one hand in his lap, the other holding a priest's staff. Known in Japanese as a *shakujō*, this is a tall walking stick topped by a three-lobed copper ornament to which six metal rings are attached. As the bearer walks using the stick, the rings jingle together, making a sound that is thought to warn insects and other small animals so they might get out of the way and avoid being crushed underfoot. It is also said to repel poisonous insects. The *shakujō* is also characteristically held by images of the bodhisattva Jizō.

sculpture presents the mature Buddha of the Future, and Unkei has achieved a new balance of proportions, as compared to the Amida Nyorai by Jōchō in the Byōdōin, in which the torso of the figure has a greater vertical projection than the horizontal spread of the legs. Yet unlike such earlier statues as the seated Shaka of Murōji (see Fig. 165), this figure does not appear top-heavy. The facial features and the drapery are more deeply carved than those of the Jōchō Amida, giving the image a more natural look. The eyeballs are made of crystal, and the pupils seem to be focused downward, suggesting a facial expression the Japanese sometimes describe as melancholy. The technique of carving is *yosegi* (multiple block) and the wood is *katsura*, a dense, even-grained hardwood ideally suited for carving. Using methods pioneered by Jōchō, Unkei

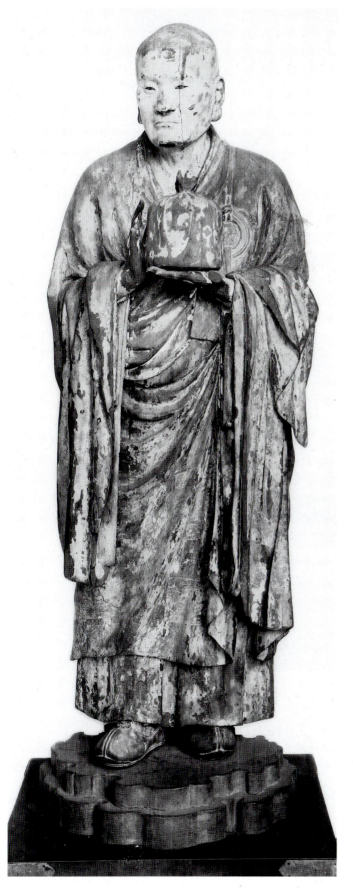

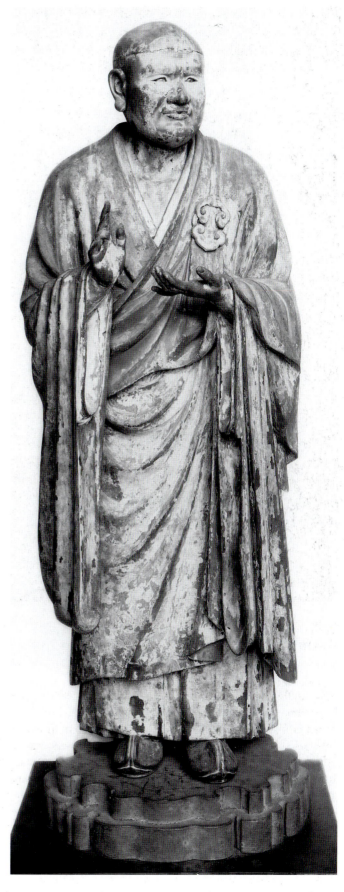

220 *Muchaku*, by Unkei. 1212. Wood with paint and inlaid eyes; height 74 in. (188 cm). Hokuendō, Kōfukuji, Nara.

221 *Seshin*, by Unkei. 1212. Wood with paint and inlaid eyes; height *c.* 74 in. (187.9 cm). Hokuendō, Kōfukuji, Nara.

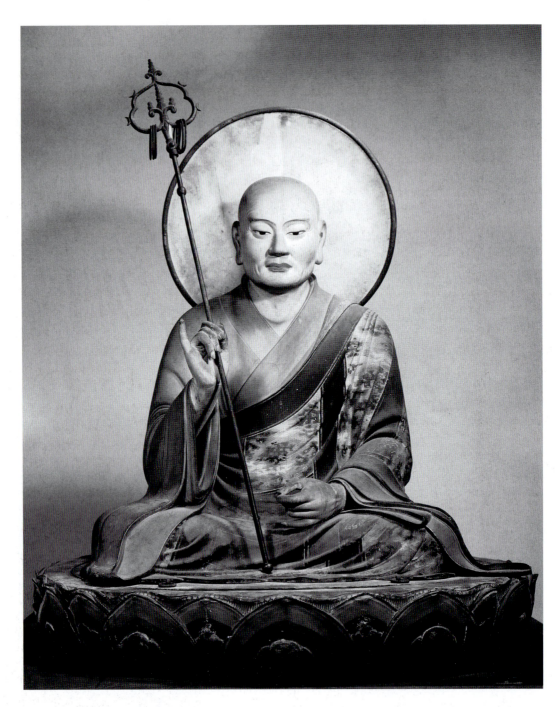

222 *Hachiman in the Guise of a Monk*, by Kaikei. 1201. Wood with paint; height 34 ½ in. (87.5 cm).
Hachimanden, Tōdaiji, Nara.

Although Hachiman's face shows the wrinkles of age, it is the idealized countenance of a divinity. The piece has a strong three-dimensional presence, but the potential strength of the war god has been subordinated to the calm, ethereal elegance of the monk.

Like Kaikei, the sculptor Jōkei is believed to have been a disciple of Kōkei's but not a blood relation. However, very few details concerning this artist can be confirmed, and there even seem to have been two sculptors with this same name active in Nara in the 1200s, one around the turn of the century, the other towards the middle. From the works that can be securely attributed to the earlier Jōkei, it is clear that he was a talented artist who most probably had seen examples of Chinese Buddhist sculpture of the Song dynasty (960–1279). Perhaps he, like Kaikei, had contact with Chōgen and was able to tap the old man's store of knowledge about Chinese Buddhist art and architecture.

Jōkei's image of Yuima (SKT. Vimalikirti) is of a pair with an image of his debating partner the bodhisattva Monju (SKT. Manjushri) of 1196 in Kōfukuji's eastern *kondō*. The Yuima is

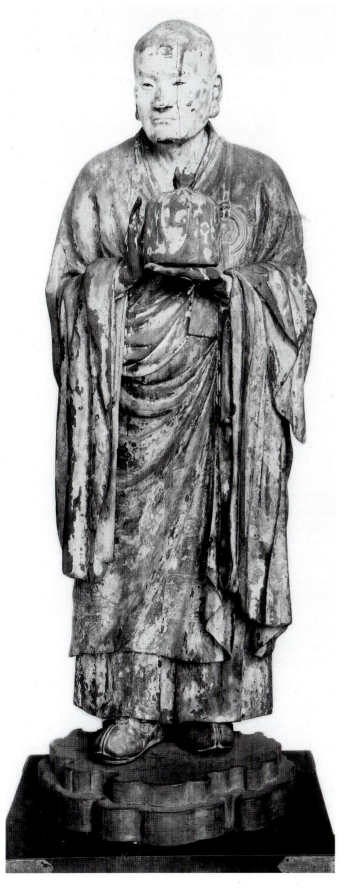

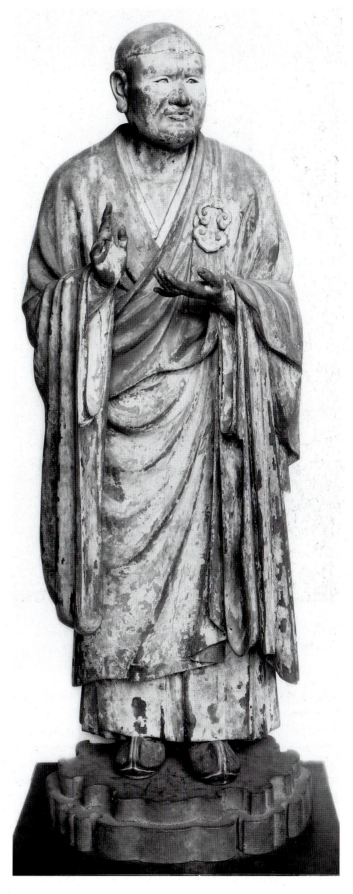

220 *Muchaku*, by Unkei. 1212. Wood with paint and inlaid eyes; height 74 in. (188 cm). Hokuendō, Kōfukuji, Nara.

221 *Seshin*, by Unkei. 1212. Wood with paint and inlaid eyes; height *c.* 74 in. (187.9 cm). Hokuendō, Kōfukuji, Nara.

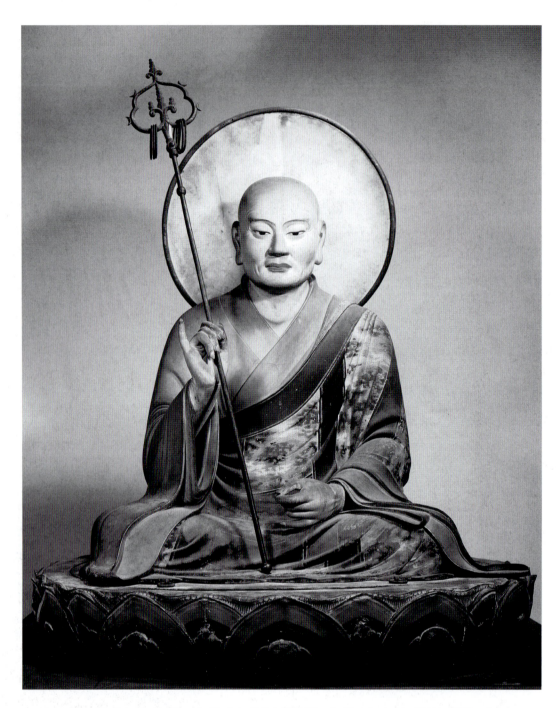

222 *Hachiman in the Guise of a Monk*, by Kaikei. 1201. Wood with paint; height 34 ½ in. (87.5 cm).
Hachimanden, Tōdaiji, Nara.

Although Hachiman's face shows the wrinkles of age, it is the idealized countenance of a divinity. The piece has a strong three-dimensional presence, but the potential strength of the war god has been subordinated to the calm, ethereal elegance of the monk.

Like Kaikei, the sculptor Jōkei is believed to have been a disciple of Kōkei's but not a blood relation. However, very few details concerning this artist can be confirmed, and there even seem to have been two sculptors with this same name active in Nara in the 1200s, one around the turn of the century, the other towards the middle. From the works that can be securely attributed to the earlier Jōkei, it is clear that he was a talented artist who most probably had seen examples of Chinese Buddhist sculpture of the Song dynasty (960–1279). Perhaps he, like Kaikei, had contact with Chōgen and was able to tap the old man's store of knowledge about Chinese Buddhist art and architecture.

Jōkei's image of Yuima (SKT. Vimalikirti) is of a pair with an image of his debating partner the bodhisattva Monju (SKT. Manjushri) of 1196 in Kōfukuji's eastern *kondō*. The Yuima is

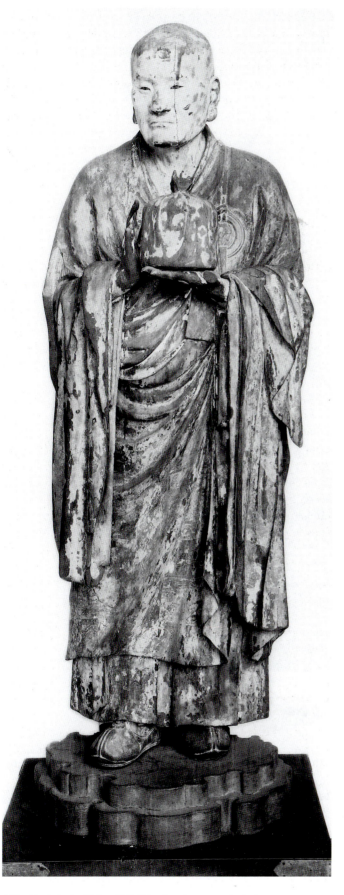

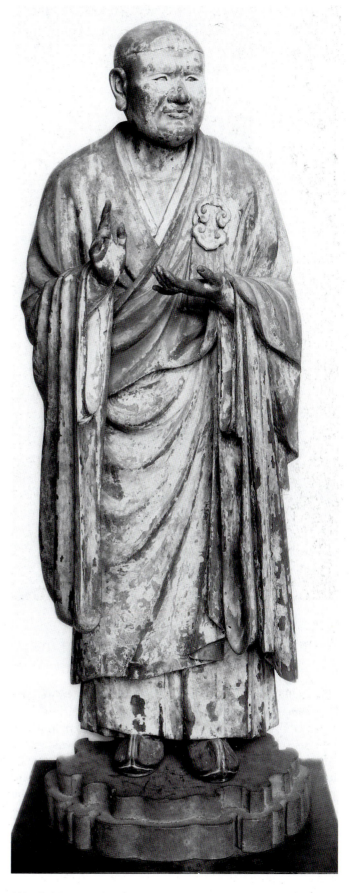

220 *Muchaku*, by Unkei. 1212. Wood with paint and inlaid eyes; height 74 in. (188 cm). Hokuendō, Kōfukuji, Nara.

221 *Seshin*, by Unkei. 1212. Wood with paint and inlaid eyes; height *c*. 74 in. (187.9 cm). Hokuendō, Kōfukuji, Nara.

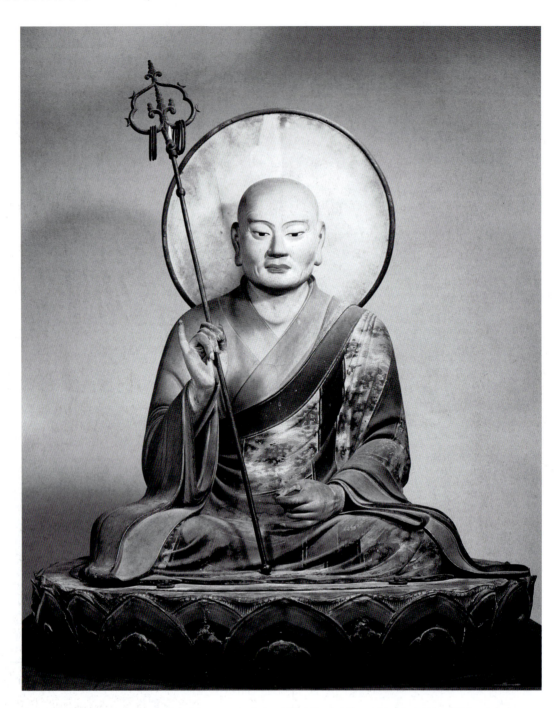

222 *Hachiman in the Guise of a Monk*, by Kaikei. 1201. Wood with paint; height 34 ½ in. (87.5 cm).
Hachimanden, Tōdaiji, Nara.

Although Hachiman's face shows the wrinkles of age, it is the idealized countenance of a divinity. The piece has a strong three-dimensional presence, but the potential strength of the war god has been subordinated to the calm, ethereal elegance of the monk.

Like Kaikei, the sculptor Jōkei is believed to have been a disciple of Kōkei's but not a blood relation. However, very few details concerning this artist can be confirmed, and there even seem to have been two sculptors with this same name active in Nara in the 1200s, one around the turn of the century, the other towards the middle. From the works that can be securely attributed to the earlier Jōkei, it is clear that he was a talented artist who most probably had seen examples of Chinese Buddhist sculpture of the Song dynasty (960–1279). Perhaps he, like Kaikei, had contact with Chōgen and was able to tap the old man's store of knowledge about Chinese Buddhist art and architecture.

Jōkei's image of Yuima (SKT. Vimalikirti) is of a pair with an image of his debating partner the bodhisattva Monju (SKT. Manjushri) of 1196 in Kōfukuji's eastern *kondō*. The Yuima is

colors were executed in a period of fifty days by an artist named Kōen.

Works by two of Unkei's younger sons suggest the poles of representation possible within the context of Buddhist sculpture in this period: the statue of the Amida Buddhist master Kūya by Kōshō and the two lantern-bearing demons by Kōben. The Kūya is an exercise in realism taken to the limits of literal representation (Fig. 224), the demons a humorous study of imaginary creatures materialized into solid three-dimensional forms (Figs 225a and b). In his zeal to spread the message of Amida Buddhism throughout the island of Honshū, Kūya (903–72) lived an itinerant existence, teaching the *nenbutsu* mantra at each village and town in a ritual of worship that included chanting the mantra while dancing to the accompaniment of gongs and bells. A story, perhaps apocryphal, has it that Kūya was converted to **Amidism** after he killed a deer and then realized the enormity of his act. He made himself a pilgrim's walking staff and affixed one of the deer's antlers to the top to remind him of his reason for becoming a priest. Kōshō's statue shows the man in a walking stance, a gong held to his chest by a yoke over his shoulders, the staff topped with deer antlers in his left hand. Attached to

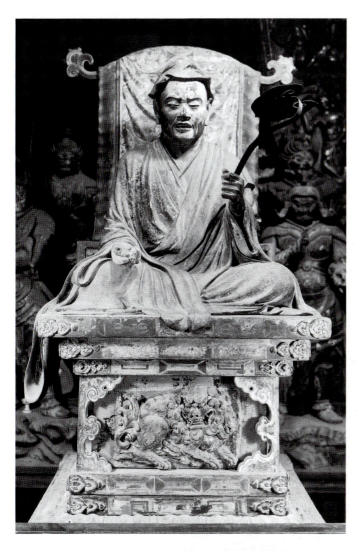

223 *Yuima*, by Jōkei. 1196. Wood with paint and inlaid eyes; height 34 ⅝ in. (87.9 cm). East *kondō*, Kōfukuji, Nara.

particularly interesting for what it reveals about the artist and also about the technical procedures involved in making a piece of sculpture (Fig. 223). The classic theme of the debate from the *Yuima kyō* (SKT. *Vimalikirtinirdesha Sutra*) between Monju and Yuima can be traced back in Japanese sculpture to the tableaux of clay figures of 711 in the pagoda of Hōryūji (see Fig. 100), but Jōkei's treatment of it is entirely new. His Yuima is a robust figure rather than the sick old man described in the sutra, and sits on a tall rectangular platform backed with a wooden structure, over which a decorated brocade has been draped. This high back and the motifs of the lion throne are particularly Chinese in flavor. In the chest cavity of the statue is a lengthy inscription written by Jōkei stating that the work was sculpted by him in 1196 in a period of fifty-three days, and that the surface preparation and the application of

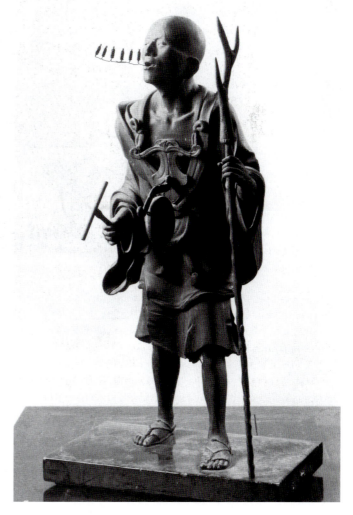

224 (right) *The Priest Kūya*, by Kōshō. Early 13th century. Wood with paint and inlaid eyes; height 46 ¼ in. (117.6 cm). Rokuharamitsuji, Kyoto.

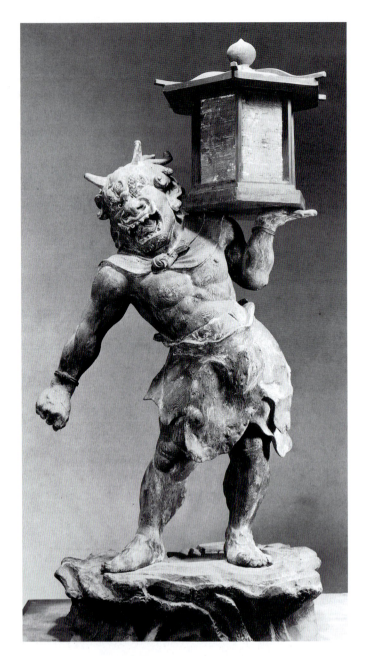

225 a.) (left): Tentōki, by Kōben. 1215. Wood with paint and inlaid eyes; height 30 ¾ in. (78.2 m).
b.) (right): Ryūtōki, by Kōben. 1215. Wood with paint and inlaid eyes; height 30 ⅝ in. (77.8 cm). Kōfukuji, Nara.

a wire coming out of the priest's mouth are six standing Amida Buddha figures, symbolizing the six syllables of the mantra. It is a beautifully imagined portrayal of Kūya's dedication and faith.

According to an inscription on one of them, Kōben's depictions of the demons Tentōki and Ryūtōki holding lanterns were commissioned by the monk Shōshō of Kōfukuji, executed by Kōben, and completed in 1215. Until the building was lost in a fire, they stood as lanterns in front of the main altar in the western kondō. Kōben has combined the theme of the guardians of the gate, one open-mouthed and the other with pursed lips, with that of mischievous little demons, treating the result with exaggerated realism. Tentōki, a squat,

muscular little fellow, stands in a hip-slung pose and holds a lantern aloft, balancing it on his left hand and shoulder. Two horns that project from the curls on his head are also painted on the surface of the sculpture. His eyebrows are bushy, and there is evidence that wires were inserted in them originally to suggest an even more scraggly texture. The Ryūtōki balances his lantern on the top of his head, while a menacing, spitting snake curls around his body and neck. The facial expressions of the two figures are so realistic that one is tempted to read emotions into an interpretation of them: the Ryūtōki a petulant little boy, the Tentōki a taunting brat. They are remarkably effective sculptures that take grotesque realism to its humorous extremes.

A restoration project of significant dimensions undertaken toward the middle of the thirteenth century was the rebuilding of the Sanjūsangendō in Kyoto. The original hall of 1164 containing a thousand and one images of Kannon was destroyed by fire in 1249, and only 156 of the original images survived. The primary motive in its reconstruction was to reproduce as exactly as possible what had been created almost a hundred years previously. The task of replacing the rest of the thousand-armed, eleven-headed bodhisattva sculptures was assigned to the Kei school, whose head at this point was Unkei's eldest son Tankei (1173–1256). Tankei had learned his craft working with his father on the sculpture projects undertaken by the workshop in Nara. He had moved to Kyoto when Unkei decided to relocate, and, after his father's death in 1223, he took over the directorship of the studio. The Sanjūsangendō project was of such huge dimensions that Tankei had to reach beyond his own craftsmen and employ members of his rivals, Kyoto's traditional In and En schools. A few of the standing Kannon images have been attributed to Tankei (see Fig. 190 and page 155), but his magnum opus in the temple is the seated thousand-armed Kannon in the center of the altar (Fig. 226). The figure was begun in 1251 and completed three years later when Tankei was eighty-two years of age; it was his last sculpture and required the help of two assistants. The statue is made using the *yosegi* technique in *hinoki* and is covered with lacquer and gold leaf. The eyes are quartz insets. The thousand arms of the bodhisattva are grad-uated in size: the six largest arms are placed close to the body and given a completely natural treatment; those in a second group, which are slightly smaller and hold attributes, radiate out around the image; finally, there is a group of much smaller hands. The image projects an impression of dignity and serenity, though its artistic quality tends to be overlooked in the sea of statues around it.

Much more interesting aesthetically are the two sculptures of the God of Wind (Fujin) and Thunder (Raijin) that are placed toward the outer ends of the platform in front of the thousand and one Kannons (Figs 227a and b). These statues are usually grouped with twenty-eight additional images of adherents of Kannon who are dedicated to helping true believers. Sculptures of the latter are arranged in front of the standing Kannon images and are assumed to have been made by artists from Tankei's studio in the 1250s while work was going forward on the statues for the altar. Both gods appear to be climbing up out of dark, swirling thunderclouds, and their wide-open eyes look down as if on the world, including the viewer, below them. The God of Wind, with four-fingered hands, grasps the ends of a bag of wind slung around his neck. The God of Thunder is surrounded by a ring of small drums which he hits with *bachi*, or dumbbell-shaped instruments, clenched in his three-fingered hands. In terms of technique, both figures are standard in their execution: *hinoki* wood carved in the *yosegi* technique and inset crystal eyes. However, in terms of subject matter and expression, their unnamed sculptor has produced something quite fresh and new. He has used Kei-school realism to create dramatic, anthropomorphic materializations of the force and sound of a thunderstorm.

The Revival of Jingoji and Kōzanji

Jingoji, on beautiful Mount Takao, was one of the first of the Early Heian-period temples built in an environment far from the intrigues of the capital. About a hundred years later, on a neighboring mountain, Jūmujinin, a subtemple of Jingoji and the forerunner of Kōzanji, was established in an area known as Toganō. Dedicated to Shingon worship, Jingoji and Jūmujinin prospered initially, but by the twelfth century both had fallen into disrepair. Jingoji was almost completely destroyed by fire in 1149. The project of reconstruction and, more fundamentally, of revitalization of the two precincts was undertaken in the late twelfth century by Mongaku (act. c. 1100–1203), a monk of prodigious strength and dedication. Before his conversion to Buddhism, Mongaku was a warrior in service to a daughter of the emperor—and subsequently *insei*—Toba (1103–56, r. 1107–23). Mongaku fell deeply in

226 *Senju Kannon*, by Tankei. 1254. Wood with gold leaf and painted and metal details; height 132 in. (334 cm). Central image on altar of Sanjūsangendō, Kyoto.

227 a.) (*left*): *Fūjin* (God of Wind) on altar of Sanjūsangendō. 13th century.
Wood with lacquer, gold leaf, and paint and inlaid eyes; height from base of right knee 43 ⅞ in. (111.5 cm).
b.) (*right*): *Raijin* (God of Thunder) on altar of Sanjūsangendō. 13th century.
Wood with lacquer, gold leaf, and paint and inlaid eyes; height from base of right knee 39 ⅜ in. (100 cm).

love with a married woman and planned to free her by killing her husband. She, a loyal samurai wife, changed places with her husband, and Mongaku, by mistake, killed her. In penance he withdrew from the court and began a wandering existence until finally he took the tonsure around 1168 and settled at Jingoji. One senses in Mongaku a restless energy that needed to be harnessed and channeled lest it burst forth destructively. So passionately did he press for funds to rebuild Jingoji that the retired emperor Go Shirakawa had him exiled to the rocky peninsula of Izu from 1173 to 1178. There he met a fellow exile, the future shogun Minamoto no Yoritomo, who was beginning to formulate his plans for rebellion. After Mongaku was permitted to return to Kyoto, he pressed again for support. Through the good offices of Yoritomo, Go Shirakawa was persuaded to provide them, and the rebuilding project was completed in the midst of civil war in 1182. Go Shirakawa and Yoritomo were both honored by portraits installed in the rebuilt temple (see Fig. 201).

The revitalization of Jūmujinin in addition to Jingoji was more than Mongaku could accomplish in his lifetime, and it

fell to his disciple Myōe (1173–1232) to complete the project. The young man was the offspring of a Fujiwara mother and a father who, as a child, had taken the name of his adopted family, the Taira. Orphaned at the beginning of the Genpei Civil War in 1180, Myōe was adopted a year later by his uncle Jōkaku, a monk at Jingoji, and there the child spent his formative years. In 1206, after Mongaku's death, the retired emperor Go Toba granted the site of Jūmujinin to Myōe so that he could reestablish it as a center of the Kegon school (one of the six schools of Nara) with the new name of Kōzanji. However, Myōe was of a reclusive nature and had no interest in the rebuilding projects that were going forward after the civil war. He preferred to distance himself from the Buddhist establishment and instead to devote his time to forming a new Buddhist doctrine based on a combination of elements from Shingon and Kegon. A chief feature of his doctrine was the practice of meditation, through which the individual could achieve remarkable states of superconsciousness, not unlike the practices of the Zen school which was just establishing itself in Japan at this period.

The painted portrait of Myōe Shōnin—*shōnin* meaning saint—is traditionally attributed to Jōnin, a monk resident at Kōzanji, and shows Myōe seated on his meditation platform in a tree (Fig. 228). Clad in a black robe, Myōe sits in the crotch of a twin-trunked tree, his hands in his lap in a meditative position. All around him are scraggly pines. To his left, hung on thin branches, are his rosary and an incense burner emitting a thin stream of smoke that spirals upward into the mountain air. The painting, based on a pattern developed in China for *rakan* paintings, is almost naive in its composition, nothing like the complicated study of forms that are seen in the *yamato-e* portrait of Yoritomo (see Fig. 201). The technique relies heavily on calligraphic ink brushstrokes to delineate the images, which are then embellished only with thin washes of color, a treatment that contrasts strongly with the fine lines and delicate colors used to describe the priest's face. In sum, for its time the painting is unique in expression, but one that prefigures the painting style of the **Nanga** school in the eighteenth century.

A sculpted portrait of Myōe Shōnin from the thirteenth century has also been preserved at Kōzanji (Fig. 229). The artist is unknown and the date is thought to be before 1253, when the first reference to it was made. Myōe is shown seated, rosary in hand, his robes carefully arranged around him. By all accounts Myōe was a handsome man, and this sculpture presents him as such. It also clearly details the missing tip of

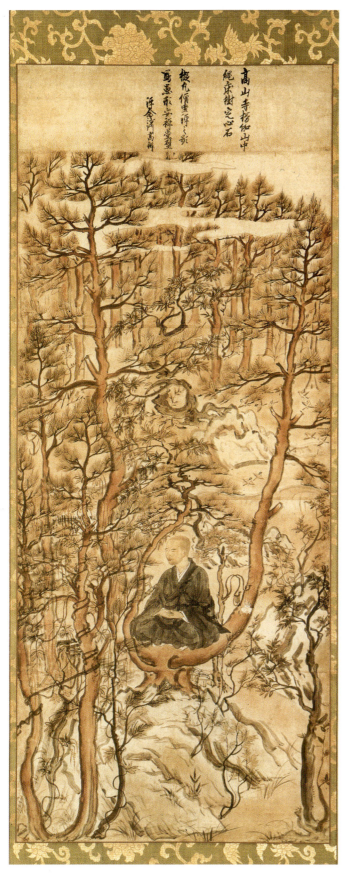

228 *Portrait of Myōe Shōnin*, attributed to Jōnin. 13th century. Hanging scroll, color on silk; height 57 ½ x 23 ⅛ in. (146 x 58.8 cm). Kōzanji, Kyoto.

229 Portrait of sculpture of Myōe Shōnin. 13th century. Wood with inlaid eyes; height 32 ⅝ in. (83 cm). Kōzanji, Kyoto.

his right ear, which he cut off in 1196 in a moment of despairing grief that he had not been born during the lifetime of Shaka Buddha. However, when this sculpture is compared to the portrait of Abbot Chōgen (see Fig. 215), it is clear that the sculptor was less interested in capturing the appearance of the real man than in accenting the simple beauty of the face by setting it off with a complicated pattern of drapery folds.

Three remarkable works of art were commissioned in connection with Kōzanji's reorientation toward Myōe's synthesis of Shingon and Kegon teachings. The first is a narrative scroll depicting the life of the Korean monk Ūisang (JAP. Gishō; 625–702), and the second is another narrative scroll on the life of another Korean monk, Wōnhyo (JAP. Gangyō; 617–86). These two are the founders of the Korean Kegon school, from whence the Japanese school is derived. The third piece is a sculpture attributed to Tankei of Zenmyō, a Chinese woman who became a protector of Gishō during his return journey from China. Traditionally, the two sets of narrative scrolls were thought to belong together, and were identified under the collective title of the *Kegon engi (Legends of the Kegon School)*, more accurately called the Tales of Gangyō and Gishō. It was believed that the text for these scrolls was written by Myōe himself from accounts of the two priests in a Chinese collection of biographies, the *Song gaoseng zhuan*. However, more recently information has surfaced that has caused scholars to revise these traditional attributions.

The tales of Gangyō and Gishō both begin with the two monks leaving the Korean kingdom of Silla, intending to travel together to China. However, after spending their first night in a burial cave, taking shelter from a driving rain, Gangyō decides that his best course of action is to look within himself for wisdom. He has seen a gruesome single-horned demon in his dreams, a vision that convinces him to abandon his plans for travel. Gishō, however, continues on to China, where he has many adventures; just before returning to Korea he meets the beautiful Zenmyō, who falls in love with him. Being devoted to the Dharma, he ignores her attentions, causing her great emotional anguish. She finally comes to terms with her beloved's religious dedication and turns herself into a dragon to protect his ship as it returns to his homeland (Fig. 230). Several scenes precede the climax seen in this illustration. First Zenmyō journeys to the port from which Gishō is to depart, carrying a box with vestments and ritual objects as a farewell present. Next, realizing that Gishō's ship has already left, she throws herself down on the embankment and weeps. Then, reconciled to fate, she places her gift on the water so that it may be carried by the waves to the departing boat. Finally, she dives into the water, transforms herself into a dragon, and, swimming under the boat, cradles it on her back for the return voyage. This final scene is a wonderfully dramatic combination of swirling blue waves, the ferocious green and red dragon with its incredibly long "whiskers," and the small boat with its tiny human passengers.

The Gangyō pictures are quite different in character, more naive in composition. One of the high points of this set of scrolls is the passage in which a royal messenger of Silla journeys to the bottom of the sea to receive the *Kongō sanmai kyō (Sutra of Meditations on the Adamantine)*, a sutra with the

230 Illustration from *Kegon engi emaki*, concluding passage of Gishō Scrolls III, showing Zenmyō as a dragon. Early 13th century. Hand scroll, ink and color on paper; height 12 ½ in. (31.8 cm). Kōzanji, Kyoto.

power to heal the gravely ill queen of Silla (Fig. 231). The envoy appears behind an old man, who turns back to explain that the sword-nosed fish to the left will not hurt him. This exchange is written in vertical lines above the figure of the old man, and just below his foot is the corner of a palace roof, the residence of the King of the Sea, from whom the sutra is to be obtained. This unusual inclusion of textual dialogue in *hiragana* script with a minimum of Chinese characters is a feature of passages in both scrolls, and heightens the immediacy of each event.

The circumstances surrounding the production of the Gishō and Gangyō scrolls have been studied in detail by Karen Brock, and they provide a valuable glimpse into patterns of patronage in the early thirteenth century. Brock identifies the

231 Illustration from *Kegon engi emaki*, scroll 2, scene 1 of the Gangyō Scrolls III, showing an imperial messenger descending toward the palace of the king of the sea. Early 13th century. Hand scroll, ink and color on paper; height 12 ½ in. (31.6 cm). Kōzanji, Kyoto.

probable patron of the tales of Gishō as Fujiwara no Tokiko, known as Lady Sanmi, the sister of one of the retired emperor Go Toba's favorite consorts. Over the years she formed a close relationship with Myōe and Kōzanji, donating money for construction and for the performance of specific ceremonies. Lady Sanmi's connections with Myōe became particularly close when in 1218 the monk was able to heal her daughter. The Jōkyū Rebellion of 1221—when Go Toba tried unsuccessfully

232 *Zenmyō*, attributed to Tankei. *c.* 1225. Wood with paint and gold leaf, inlaid eyes, and metal details; height 12 ⅜ in. (31.4 cm). Kōzanji, Kyoto.

a logical place for the numerous homeless widows and grieving mothers to seek refuge. In 1223 a parcel of land was ceded by Jingoji to Kōzanji for the establishment of a nunnery, which was called Zenmyōji. Brock argues convincingly that the Gishō scrolls were made at the instigation of Lady Sanmi, perhaps for her own edification or that of the new nuns, around the time of the Jōkyū Rebellion. In any case, with its emphasis on Zenmyō as a protector of the Korean monk, the tale was an appropriate work for a female audience.

However, the actual authorship of the Gishō scrolls remains unknown, although one has been suggested for the Gangyō scrolls. Several scholars have noted a resemblance in the brushwork of the scrolls to that of the portrait of Myōe in Figure 228. The latter has been attributed to Jōnin, and it seems that the Gangyō scrolls should be as well.

The third work of art associated with Kegon worship at Kōzanji is a tiny, gemlike sculpture of Zenmyō paired with a statue of Byakkō Jin—a god associated with snowy mountains, originally the Himalayas—commissioned by Myōe in 1225 and attributed to Tankei (Fig. 232). Depicted as a classic Chinese beauty, Zenmyō is shown standing on a rock, holding the box containing her farewell gifts to Gishō. She appears calm and assured, as if, having brought her grief under control, she is determining her next course of action. Her clothing consists of a green, shawl-collared outer robe with double sleeves and a white undergarment, and attached to her head is an openwork metal ornament with long festoons that frame her face. This image of Zenmyō projects a calm and serene presence, a person at peace with the conditions of her life, her passive demeanor animated by the gentle curving patterns of her sleeves.

The Cult of Kūkai and the Fashion for *Chigo* Imagery

The headquarters of the central strain of Shingon Buddhism remained at Mount Kōya, the monastery to the south of Osaka founded by Kūkai (774–835) in 816. Kūkai—or Kōbō Daishi, his most common epithet—was himself the center of a major cult within the school. A painting of him as a child, now in the Art Institute of Chicago (Fig. 233), is one of the more popular icons of his cult, far outstripping portraits of him as a patriarch. Such images are known as Chigo Daishi (Kōbō Daishi as a child or novice monk), and commemorate the moment that the young Kūkai experienced a vision and first communicated his desire to become a monk. His parents obliged, and Kūkai took holy orders as a child and went on to travel to China and bring back the Tantric teachings which he would formulate into Shingon Buddhism. The medieval period witnessed a whole rash of literature and art concerning *chigo* (boys), and other famous Buddhist *chigo* images are of Shōtoku Taishi and the bodhisattvas Kannon and Monjū. In the fourteenth and fifteenth centuries groups of stories began being collected called *chigo monogatari*, which relate tales of novice monks.

to wrest control of the affairs of the nation from the Kamakura *bakufu*—is the second element in the making of the illustrated scrolls. Those who had assisted Go Toba were either killed in the fighting or executed, and their property confiscated by the *bakufu*. Because of Myōe's connection, through his mother, with the Fujiwara, and his own contacts with high-ranking members of the nobility, his temple of Kōzanji seemed

233 *Chigo Daishi* (Kōbō Daishi as a child). Kamakura period, 14th century. Hanging scroll, ink, color, and gold on silk; 34 ⅛ x 19 ¼ in. (86.7 x 48.9 cm). The Art Institute of Chicago. Gift of the Joseph and Helen Regenstein Foundation. (1959.552).

These tales grew out of the tradition within Buddhism for Enlightenment tales (JAP. *hosshin mono*), and concerned the affection of an older, senior monk for a novice, and how the loss of the beloved leads the senior monk to a moment of Enlightenment. Usually the boy is also revealed to be a manifestation of a bodhisattva such as Kannon or Monjū. Some scholars, such as Margaret Childs, consider that paintings of Chigo Daishi also are an expression of this type of bond between an elder and younger monk, and Kūkai has often been credited with introducing *wakashūdō* (the way of youth) into Japanese monasteries from China. *Chigo* imagery continued to be popular well into the eighteenth century.

Pure Land Buddhism

Amida Buddhism captured the zeitgeist of the court and nation from the Middle Heian period onward, notably through the teachings and work of Genshin (942–1017) and Kūya. At first the court aristocracy had attempted to recreate Amida's Western Paradise—or Pure Land—on earth, assuming that it would more or less mirror the lifestyle that they enjoyed already. But, as already mentioned, the horror and suffering of war so dominated the Japanese social landscape from the mid-twelfth century onward that, instead of imagining Amida's Pure Land recreated here on earth, the Japanese perceived themselves to be living in the time of *mappō*.

According to Buddhist tradition, the end of the age of the present Buddha, Shaka, is the time of *mappō*, a degenerate period of ten thousand years, distinguished by conflict, cruelty, and despair. In the *mappō* phase, evil was supposed to be so pervasive that conventional strategies for attaining nirvana—reading and copying the sutras, meditation, and good works—would be of no avail. Responding to this nihilistic mood, several Buddhist masters had reworked the concepts of Amidism into a new movement called Pure Land Buddhism, which centered on the belief that salvation—or rebirth in Amida's paradise—could be achieved through faith in Amida Buddha and the practice of the *nenbutsu* mantra.

Amida cults originated in the early centuries C.E. in India, and spread along the Silk Roads to China and Korea. Already in the Chinese Tang period (618–907), belief in Amida and hope for rebirth in his paradise was a powerful movement within the Chinese Buddhist community. In Japan, Amida was known from early on as one of the four directional or transcendental Buddhas who are emanations of the Universal Buddha Birushana. It was not really until the late tenth and eleventh centuries, with Genshin and Kūya, that Amida was first introduced to Japan as the center of a salvation cult. However, once it caught on, the cult had a massive impact, not only with the aristocracy, but also with the common people.

Out of the violent upheavals of the twelfth century emerged three Buddhist masters who revitalized the movement in the face of the social insecurity and general pessimism that had become the norm in all strata of society. They were Hōnen (1133–1212), from whose teachings the Jōdo Shū, or Pure Land sect, developed; Shinran (1173–1263), founder of the Jōdo Shin Shū, or True Pure Land sect; and Ippen (1239–89), whose followers organized the Ji sect. The teachings of Hōnen and Shinran, in particular, are often dismissed as "easy salvation," but in the context of thirteenth-century Japan, they offered a sure path to salvation for men and women whose entire society had been turned upside down, and for whom the other Buddhist schools offered little solace.

Hōnen was a priest who had begun his religious development within the Tendai school, but, feeling dissatisfied with its teachings, had struck out on his own to study Amidism. He initiated a reformation of Buddhism in the thirteenth century, making the achieving of Enlightenment an act of personal

234 Fragment of the *Hōnen Shōnin eden*, an illustrated hand scroll
mounted as a hanging scroll, showing Hōnen inscribing a copy of his
portrait for his disciple, Shinran. Early 14th century. Ink and color on
paper; 16 ⅛ × 23 ¼ in. (41 × 59 cm). The Metropolitan Museum of Art,
New York. Gift of Mrs Russell Sage, by exchange and funds from various
donors. (1980.221).

faith, rather than the result of reading sutras or meditating. In
1175, Hōnen read the *Amitayurdhyana Sutra* (JAP. *Kanmuryōju
kyō*; *Sutra on the Meditation of the Buddha of Infinite Life*), and
the commentary on it by the great Chinese master of Amida
Buddhism, Shan Dao (JAP. *Zendō*; 613–81). On the basis of
these two works he began openly to advocate the *nenbutsu*
mantra as the direct path to salvation, and in so doing cut
himself off from traditional Buddhism. This is the year in
which he is said to have established the Jōdo Shū. His fame

spread and he gathered about him many disciples, not least of
whom was Shinran, and even became the spiritual adviser to
both ex-emperor Go Shirakawa and ex-emperor Go Toba.
Eventually members of the Tendai and Hossō school hierarchy
rose against Hōnen and persuaded Go Toba to exile him to
Shikoku Island from 1207 to 1211, until just a few months
before his death. Nevertheless the school he founded contin-
ued to thrive long after his death.

An illustration from the *Hōnen Shōnin eden* (*Legend of the
Holy Man Hōnen*), the pictorial biography of Hōnen, shows
him with his disciples in a temple room enclosed by sliding
doors decorated with landscape paintings (Fig. 234). Hōnen,
seated with his back to the wall, inscribes a copy of a scroll
containing his own portrait to be given to his disciple Shinran,
who kneels in front of him. Behind Shinran can be seen the
original. With the advent of Shingon and Tendai Buddhism,

and their lineages of patriarchs and teachers, increasing importance had been placed on the role of the master. By the thirteenth century, it had become the custom for a Buddhist master to reward his best students with an inscribed portrait of himself as proof that the student had learned all the master had to teach.

This illustration is a fragment of one of the most elaborate of the many illustrated versions of the *Hōnen Shōnin eden*, originally in forty-eight scrolls compiled over a ten-year period beginning in 1307. It is believed that it was edited by Shunshō, a priest from Mount Hiei, based on earlier records of Hōnen's life and teachings. It had the express purpose of presenting not only a biography of the master, but also the history of the Jōdo sect, and of the Chionin temple in Kyoto, as the most important locus for Amida worship. The project, undertaken at the request of the retired emperor Go Fushimi (1288–1336; r. 1299–1301), obviously had the support of the nobility, since the calligraphy was executed by eight men associated with the court, including Go Fushimi and emperor Go Nijo (r. 1302–8). The primary purpose of the illustrations was to document specific events, which the scene of Hōnen with Shinran does successfully, but they are not particularly telling in terms of narrative technique or expressiveness.

The second great master of Japanese Pure Land Buddhism was Hōnen's disciple Shinran. He believed that, considering the overwhelming weight of each individual's fundamental materialistic self-interest, compounded by the accretion of misdeeds over many lifetimes, one's only hope was to perform the *nenbutsu* mantra. And the desire to do so would come as a result of Amida Buddha's call, awakening in the hearer understanding and compassion. Enlightenment and rebirth in Amida's paradise would take place not because of an individual's actions, but rather through Amida's inherent benevolence. This doctrine became the basis of the new Jōdo Shin Shū.

Shinran's life, like that of his master, was the subject of an illustrated biography, the *Zenshin Shōnin-e* (*Pictorial Biography of the Holy Man Shinran*). The original text was written by his great-grandson Kakunyo in 1295 and illustrated by an unknown artist, most probably a monk–painter. Two separate episodes are represented within the scene reproduced here (Fig. 235). This first episode is essentially a retelling of that depicted in Figure 234. To the right, Hōnen kneels before a hanging scroll on which a portrait of himself has been mounted, and writes an inscription for Shinran on a separate sheet of paper mounted below. To the left, however, the master hands Shinran a box containing the *Senjakushū*, a collection of Hōnen's writings on the effectiveness of the *nenbutsu*, which he is allowing Shinran to copy. The honor of being permitted to make his own copy of Hōnen's book, in addition to being given a personally inscribed portrait, indicates the confidence the master felt in this, his brightest pupil. The illustration style is that of straightforward description enlivened only by a passage to the left showing Hōnen's garden, in which blooms a lotus flower—like those to be found in Amida's paradise.

The third of the great Pure Land teachers was Ippen, a monk who is thought to have founded the Ji school in 1274, when, like Kūya in the eleventh century, he took up the life of a wandering monk, carrying the message of the *nenbutsu* throughout Japan. His particular contribution was the development of Kūya's practice of chanting the mantra while dancing. In Ippen's ceremony of *nenbutsu odori* a number of people danced in a circle beating drums, ringing bells, and chanting the *nenbutsu* mantra, and it was popular particularly amongst the common people with whom Ippen largely mixed. The ecstasy that might be achieved in such a performance would be a symbol to the believer of the joy of salvation achieved through Amida.

The *Ippen Hijiri-e* (*Pictures of the Holy Man Ippen*), an illustrated set of twelve scrolls depicting Ippen's life and travels, is arguably the best of the biographical scrolls devoted to monks. The text was composed in 1299 by Ippen's younger brother

235 Illustration from *Zenshin Shōnin-e*, scroll 1, scene 4, showing Hōnen inscribing a portrait scroll for Shinran and then presenting his writings to Shinran. Late 13th century. Hand scroll, ink and color on paper; 12 ⅝ in. (32 cm). Nishi Honganji, Kyoto.

弘安五年乃春鎌倉にいつてさまよそ

236 Illustration from *Ippen Hijiri-e*, scroll 5, scene 4, by Eni, showing Ippen and his followers crossing the snow-covered fields of the Kantō. Late 13th century. Hand scroll, ink and color on paper; height 15 in. (38.2 cm). Kankikōji, Kyoto.

237 (below) Illustration from *Ippen Hijiri-e*, scroll 6, scene 3, by Eni, showing Ippen leading a religious ceremony. Late 13th century. Hand scroll, ink and color on paper; height 15 in. (38.2 cm). Kankikōji, Kyoto.

Shōkai, himself a monk and an adherent of the Ji sect, and was illustrated by an artist named Eni, possibly a monk–painter or more probably a professional artist employed by Shōkai for this project. Many sections of the scrolls detail Ippen's travels and provide extremely accurate depictions of well-known places around Japan, making the set a particularly valuable historical document. Eni has brought to this work a lyric quality not found in most priest-biographies. One illustration of Ippen and his followers crossing snow-covered fields in the Kantō far exceeds the needs of documentation (Fig. 236). A thin layer of snow coats the low hills with their marsh grass and pine trees. The palette of colors is reduced to white

and soft shades of brown and green, suggesting something akin to monochrome landscape painting, while the clear delineation of space within the scene suggests a familiarity with Chinese landscape ink-painting of the Song dynasty (960–1279). In his treatment of Ippen conducting a *nenbutsu odori* ceremony demonstrates Eni's skilful depiction of crowd scenes in the excited throng that is gathered in the two pavilions (Fig. 237).

Pure Land Devotional Paintings

As the popularity of Pure Land Buddhist schools increased, two types of religious paintings—mandalas and *raigō* paintings—took on renewed importance in the course of devotional practice. Their imagery centers on the depiction of Amida Buddha's Western Paradise, and contemplation of these paintings is intended to aid the practitioner in visualizing the promised land.

Taima Mandara

The primary icon of Pure Land Buddhism as taught by Hōnen is a mandala, one of the earliest of which is preserved in a tapestry version in the Taimadera, a temple in the village of Taima in Nara prefecture, and therefore the mandala is known as the Taima Mandara. The traditions associated with the mandala suggest that it was executed in the eighth century during the latter half of the Nara period, but scholars believe

it more likely that it was imported from China, perhaps at that time. It is an accurate translation into visual images of the teachings of the Chinese patriarch Shan Dao as set forth in his commentary on the *Kanmuryōju kyō*. Strangely, there is no reference to it in documents of the Nara or Heian periods. It was rediscovered in the thirteenth century and became the prototype for a series of mandala paintings of Amida's Western Paradise. One of the best documented of these is a work executed in rich colors, including gold and silver as well as *kirikane*, or cut gold (Fig. 238).

The central element of the mandala is an image of the Court of Essential Doctrine, or Gengibun, depicting Amida's paradise with a wealth of detail. The Buddha is seated on a high octagonal throne flanked by the bodhisattvas Kannon and Seishi, who occupy lower lotus-blossom thrones. Numerous smaller bodhisattvas and deities wearing skirts, scarves, and crowns surround the triad. Behind this multitude rise multi-storied palaces, and in front of them a large lotus pond, out of which the souls of the blessed will be reborn into the paradise on lotus blooms. Boats are poled between the blossoms to collect the small children and other human figures who represent the reborn souls.

In the narrow strips along the sides and the bottom of the painting, the basic concepts of the *Kanmuryōju kyō* are given visual form. Along the left side—the Court of the Prefatory Legend, or the Jobungi—the circumstances that caused Shaka Buddha to preach the *Kanmuryōju kyō* are related. A wicked

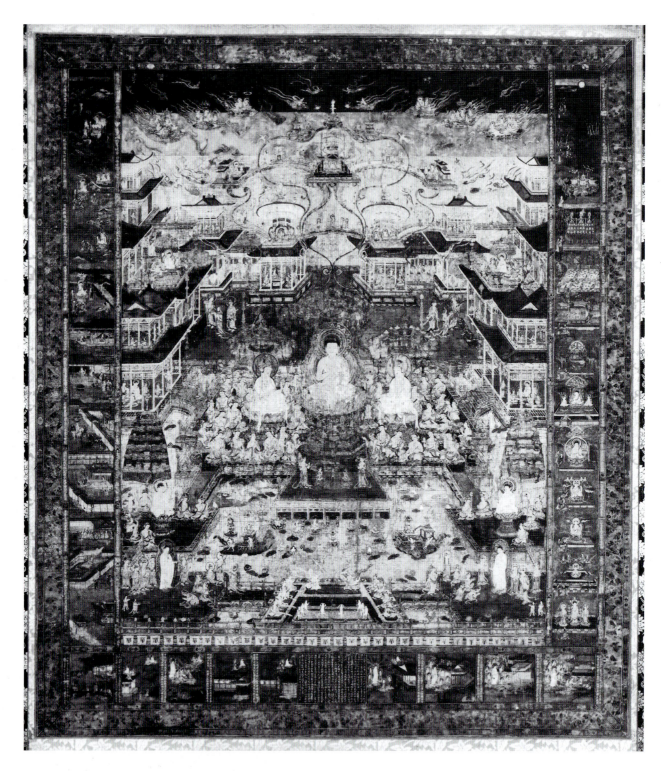

238 *Taima Mandara*. 13th century. Color on silk; 71 ⅜ x 70 ⅝ in. (181.3 x 179.3 cm). Nara National Museum.

crown prince, Ajaseō (SKT. Ajatashatru), had ordered that his father, King Hinbasara (SKT. Bimbisara), be imprisoned and starved to death. However, the old king's principal wife and Ajaseō's mother, Ideiki (SKT. Vaidehi), schemed to bring him food and keep him alive. Learning of this, Ajaseō had his mother imprisoned. She prays to Shaka for deliverance, and the Buddha is so moved by her plight that he appears before

her and shows her the paradises of the ten directions, from which she selects the Western Paradise of Amida.

Along the right side of the mandala is the Court of the Thirteen Meditational Concentrations, the Jōzengi, detailing the various wonders of the Western Paradise—the sun, the water, the jeweled earth, the jeweled tree and so on—which Ideiki must visualize in order to attain rebirth there. The

239 Detail, *Taima Mandara*, showing lapis lazuli earth of the Western Paradise.

visualization of the lapis lazuli earth of the Western Paradise, the third section from the upper right, is a particularly beautiful scene (Fig. 239). To the left of a large platform, sits the Ideiki, her hands pressed together in a gesture of worship. Rising like smoke from the platform are cloud forms that support five of the buildings in the Western Paradise. Between the three largest, strands of jewels appear, held aloft by *apsaras* (JAP. *tennin*).

In addition to the thirteen visualizations detailed in the right border, three more are included in the Court of General Meditations, the Sanzengi, illustrated in the band at the bottom of the painting. These are the meditations on the three levels of rebirth in the Western Paradise, and each of these three levels is subdivided into three degrees. This same idea was depicted on the doors of the Phoenix Hall of the Byōdōin (see Fig. 176). Thus, along the bottom of the Taima Mandara there are representations of nine different types of *raigō*.

A narrative painting that sets forth the legendary origins of the original tapestry mandala is the *Taima Mandara engi emaki*, a set of two illustrated scrolls dated to the mid-thirteenth century by an unknown artist (Fig. 240). The story centers on the figure of Princess Chūjō (753–81), the daughter of the statesman Fujiwara no Toyonari (704–65) and a devout Amida adherent. On becoming a nun at Taimadera at the age of ten, she made a vow that she would not leave the temple until she saw Amida in living form, and she set herself a limit of seven days in which to accomplish her goal. By devoting herself single-mindedly to the worship of Amida, her desired vision is bestowed upon her. When she died at the age of twenty-eight, no one doubted she would be reborn in the Western Paradise.

The setting for the climax of the scroll is the interior of the convent. The first room to appear as the scroll is unrolled is that of Princess Chūjō. Dressed in her nun's habit, she sits close to the right wall and listens as an elderly nun talks to a beautiful young woman whose long black hair and costume suggest that she is a visitor from the court. According to the text, the topic of their conversation is the thread the old nun

240 *Taima Mandara engi emaki*, scroll 2, scene 1, showing Princess Chūjō weaving the Taima Mandara. Mid-13th century. Hand scroll, color on paper; height 19 ¼ in. (48.8 cm). Kōmyōji, Kamakura, Kanagawa prefecture.

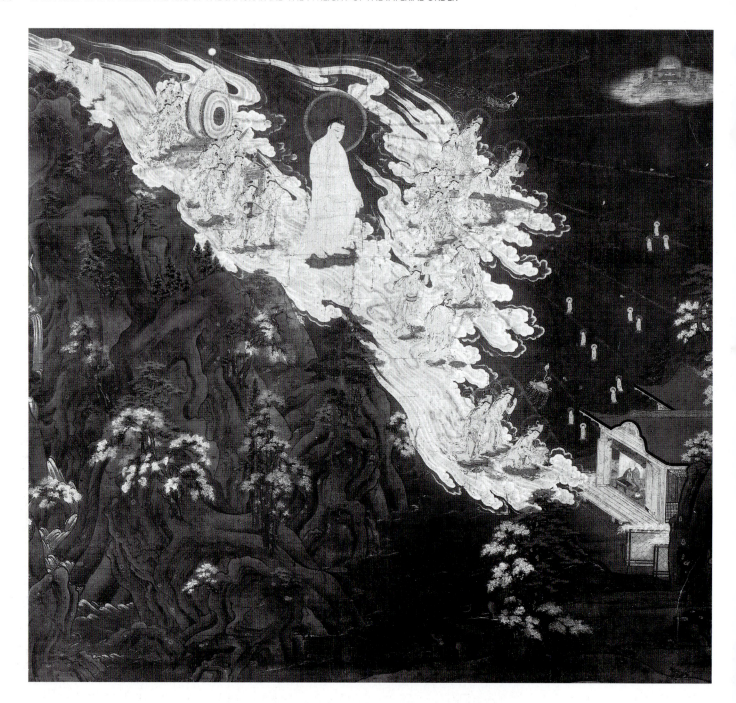

241 *Descent of Amida and the Twenty-five Bodhisattvas,* a *haya raigō.*
Early 13th century. Gold and color on silk; height 57 in. (144.7 cm).
Chionin, Kyoto.

has made of lotus stems picked by the princess and which the nun has dyed five different colors in a magic well she dug herself. These preparations have been made so the court lady can weave a tapestry. To the left this same weaver can be seen three more times: first, having passed through a paneled wooden door, she advances leftward toward the weaving room; next, she is seated before the loom on which in nine short hours she weaves the Taima Mandara tapestry. The last scene of the sequence shows the old nun seated in a rather masculine pose,

leaning with her left arm on her bent knee, her right hand is free to gesture as she explains the meaning of the mandala to the princess, who is sitting before the resplendent gold and brightly-colored tapestry, her hands pressed together in a gesture of worship. Far to the left, carried upward on a brilliantly colored cloud, the court lady is revealed as a manifestation of the bodhisattva Kannon. The nun, who is revealed to be Amida Buddha, recites a poem, that includes the following two lines:

You earnestly desire the Western quarter: therefore I come. Once you enter this place, you eternally forsake suffering.

Elizabeth ten Grotenhuis, *The Revival of the Taima Mandala in Medieval Japan*, New York, 1985, p. 162.

Aspects of the *shinden* interior and the blown-off-roof technique both have the potential to separate the elements of a narrative episode, and are well used here to suggest the passage of time. Also, the contrast between the small size of the princess's room, enclosed by sliding doors decorated with a busy pattern of waves, and the openness and plainness of the weaving room invests the latter with an otherworldly, almost ethereal quality. In the last scene the brilliant gold of the tapestry and the bright red, blue, and green of the weaver's cloud hint at the beauty and splendor to be experienced in the Western Paradise.

The Taima Mandara and the *Taima mandara engi emaki* afford a rare glimpse of the important role of women within Japanese Buddhism. The thirteenth and fourteenth centuries were a particularly favorable time for women to espouse Buddhism. Pure Land sects strove to spread the mantle of Amida's compassion to all, men and women alike. Shinran went so far as to assert that priests should marry and himself took a wife, the nun Eshin (1182–1270), whom he made a party to his work. The new sect of Zen Buddhism would also prove hospitable to women, creating convents of nuns headed by abbesses. The scholar Barbara Ruch has brought to light the nun Mugai Nyodai, who was so esteemed by her followers that a statue was made of her in the style of those of great Zen masters.

Raigō

Two types of *raigō* paintings developed in the late twelfth and the thirteenth centuries, due in part to Hōnen's teachings. One is the *haya*, or swift, *raigō*, in which Amida and his host of bodhisattvas descend to earth in the twinkling of an eye. The other is the *yamagoshi*, or mountain-crossing, *raigō*, which depicts only three figures, Amida, Kannon, and Seishi, above a range of mountains that they will cross to complete their descent to earth. The classic example of the *haya raigō* is the hanging scroll showing the descent of Amida and the twenty-five bodhisattvas owned by Chionin (Fig. 241). Entering the picture on a diagonal from the upper-left corner is a line of white cloud shapes supporting a golden Amida and his host of attendants, including musicians. The procession is led by Kannon, who is kneeling and bending forward toward the deceased, a man clad in a gray monk's robe seated behind a low table, on which sutra rolls of indigo paper have been set out. In the lower-left corner of the painting are green mountains dotted with pines and flowering cherry trees, and in the upper right there is a glimpse of a tiny building not unlike the Byōdōin, suggesting Amida's many-storied palace in the Western Paradise. Compared to the Heian-period *raigō* preserved at Mount Kōya (see Fig. 178), the descent in this

242 *Amida*, a *yamagoshi raigō*. 13th century. Hanging scroll, color on silk; 51 ⅛ × 46 ½ in. (130 × 118 cm). Zenrinji, Kyoto, National Treasure.

painting seems precipitous, and the variety and poses of accompanying figures significantly simplified. The emphasis is clearly placed on the quick and sure descent of the Buddha to gather up the soul of the deceased.

The most famous of the *yamagoshi raigō* is the painting owned by Zenrinji in Kyoto (Fig. 242). The golden head and torso of Amida can be seen glowing against a dark sky, his halo suggesting the moon. Below him to the right and left are the bodhisattvas Kannon and Seishi, who have already crossed the mountain and are bending forward as if to greet the newly deceased. In the lower center of the painting can be seen the blue water of a river, and, opposite each other on its banks, two boys pointing up at the divinities. To right and left at the sides of the painting, the Shitennō are grouped in pairs. Finally, in the upper-left corner is the Sanskrit character for the first syllable of Amida's name. If a dying person can visualize this syllable or the Amida and his host, that person will be reborn in the Western Paradise—but it is likely to require years of preparation to be able to perform such visualizations at so difficult a moment. Similarly, one completely wholehearted recitation of the *nenbutsu* mantra suffices for rebirth in paradise, but that totally selfless moment may require lifetimes of practice. The color scheme of the painting is particularly pleasing. The Amida is clad in a white robe with bands of gold and pale green, the bodhisattvas in gold, green, blue, and pink. Subtly placed among the mountains are small trees with the orange and red leaves of the fall.

243 *The Six Realms of Existence*, one of fifteen hanging scrolls illustrating the *The Essentials of Salvation*. 13th century. Color on silk; 61 ¼ x 26 ¾ in. (155.5 x 68 cm). Shōju Raigōji, Shiga prefecture.

ROKUDŌ-E

A grotesque and sometimes shocking type of painting emerged in the years after the Genpei Civil War—*rokudō-e*, or pictures of the six types of existence into which human beings

might be reborn if unable to achieve salvation. These are the realms of unenlightened heavenly beings, humans, animals, constantly fighting demons, hungry ghosts, and beings in hell. The six worlds of existence were an important part of the Amida Buddhist master Genshin's essay *Ōjō yōshū*, as being the unhappy alternative to rebirth in the Western Paradise. Few enough amongst Genshin's aristocratic audience in the Middle Heian period considered that they would be reborn anywhere but the Western Paradise. However, in the new, less optimistic climate of the medieval period, people actually saw horrors comparable to those described in Genshin's text, and no longer felt it unlikely that they might indeed be reborn into one of these six realms. By contemplating *rokudō-e*, they hoped to remind themselves of the suffering that might lie ahead; the better to avoid it.

One of the best-known illustrations of the six realms is a set of fifteen hanging scrolls owned by Shōju Raigōji in Shiga prefecture (Fig. 243). In small rectangles at the top of each painting are excerpts from *Ōjō yōshū* explaining the scenes depicted below. Particularly graphic is the treatment of decaying bodies. In the upper right a newly deceased woman has been laid out on a straw mat. She still wears a white-figured garment, but it is in disarray and her hair looks unkempt. To the left under a blossoming tree, the figure appears again. This time the garment has fallen away, and the woman's belly is swollen with the gases of decay. Below a layer of mist, and sheltered under a maple tree in autumn leaf, the same female body is depicted in two further states of decomposition. Finally, at the bottom of the painting three more female corpses can be seen, one a fresh body being picked at by black birds and various wild animals, the other two mere skeletons. While this particular scroll has a strong *yamato-e* flavor, especially in the treatment of the landscape, others among the set display a more Chinese style of ink painting. Based on this combination of styles, and records of the repairs done on the set, the first dating to 1313, scholars have identified these scrolls as works of the thirteenth century.

It is clear from two different groups of *rokudō-e* paintings that this was a popular and diverse genre in the medieval period. Dated by scholars to the end of the twelfth century, the small format of these paintings is particularly interesting, the vertical dimension of each sheet of paper being only just over 10 inches (27 cm), as opposed to the approximately 12 inches (31 cm) of the *Ban Dainagon ekotoba*, the *Shigisan engi*, and the *Kegon engi*. Clearly these hand scrolls were made for intimate viewing, perhaps by one person alone.

The *Yamai no sōshi* (*Notebook of Illnesses*), is a genre dating back at least to the Heian period and depicts some of the physical problems human beings must endure, from toothaches to hallucinations to insomnia (Fig. 244). In a bedroom peopled with three soundly sleeping women, the sufferer props herself up on one arm. Bending the fingers of her other hand in sequence, she appears to be counting, trying to quiet her active mind. To her left is a black stand holding a bowl of oil that has been ignited to give some light. This single vertical

244 Illustration from *Yamai no sōshi* (*Notebook of Illnesses*), scroll 2, showing a woman suffering from insomnia. Late 12th century. Hand scroll, color on paper; height 10 ⅛ in. (25.8 cm). Private collection.

motif echoes the position of the woman's torso, reinforcing the impression that she, alone in the house, is awake in the dead of night.

The *Jigoku zōshi* (*Hell Scrolls*), depicting the eight sections of hell to which human beings can be consigned, convey a powerful impression of suffering. The hell for those who cheat their customers by short-weighting is overseen by a frightening three-eyed, white-haired old crone who looks on as two women and a man pick metal boxes filled with hot coals from a fire and attempt to judge their weight (Fig. 245). The atmosphere in this hell is dark and smoky, the only real light being

provided by the fire in the center. The supervisor is a looming presence, her sagging body described with broad calligraphic brushstrokes. The sufferers are pale, naked figures, totally consumed by the pain of their torture.

Zen Buddhism

Equally important to the religious life of the Kamakura period was the establishment of Chan (JAP. Zen) Buddhism in Japan at the end of the twelfth century. Although elements of Chan Buddhism featured in Saichō's formulation of Tendai doctrine in the ninth century, it did not flourish as an independent sect within the worldly Heian period. In the more sober times following the Genpei Civil War, this sect's emphasis on the stern self-discipline needed to be able to perceive the true nature of things found a welcome reception amongst the period's scholars and warrior elite. It continues to have a significant influence on Japanese intellectual thought and behavior even in the twenty-first century.

The school's origins are connected with one Bodhidharma (JAP. Daruma), who arrived in China during the sixth century. In the earliest texts he was a Persian monk who arrived via the Silk Roads in the Wei capital of Luoyang, while another, later, history claims he was an Indian prince who sailed on a reed, arriving in southern China. For Daruma, the key to Enlightenment was intense meditation, and "meditation" is the name of the school he established—Zen in Japanese (CH. Chan; SKT. Dhyana). Daruma is famed for having

245 Illustration from *Jigoku zōshi* (*Hell Scrolls*). Late 12th century. Section of a hand scroll, color on paper; height 10 ½ in. (26.7 cm). Nara National Museum.

meditated in a cave facing its back wall for so long that his image was impressed in the rock wall, and his legs atrophied and fell off.

During the Tang dynasty, Chan Buddhism had accrued a greater and greater following. Adherents were distinguished from other Chinese schools of Buddhism by their unworldliness and comparative poverty. Subsequently, in the great proscription of Buddhism of 842, which broke the back of other schools of Chinese Buddhism, the Chan sect escaped relatively unscathed, and after the proscription was lifted became one of the most important schools in China. It was particularly important during the Song period (960–1279), when it had attracted the serious attention and admiration of the Chinese intelligentsia, who often held Buddhism to be otherwise a mess of foreign superstition. Visiting Japanese monks were also drawn to the Chan sect, which relied not on scripture, dogma, or conventional ritual, but on the practitioners' direct intuitive perception of reality. Such a belief left room for an uncomplicated code of ethics, just as it demanded a stern self-discipline. Both qualities found a receptive audience among both Japan's cultural and military elite.

Of the two Zen sects introduced into Japan in the twelfth to thirteenth centuries—**Rinzai** and **Sōtō**—Rinzai was particularly well received by the daimyo and shogunate with its belief in the possibility of sudden Enlightenment, the efficacy of the *kōan* as a teaching tool (see below), and the ritual drinking of tea. Sōtō, in advocating a balance of meditation and physical activity as a route to moments of understanding and a more gradual Enlightenment, had especially strong appeal amongst the peasantry and the samurai of the provinces. It is this less glamorous branch of the school which truly integrated Zen into the very fabric of social function, especially in its devising of funeral and memorial services. The Rinzai, with its high-ranking samurai patrons and temples located near Kyoto and other power centers, produced many of the great artists and poets of the medieval period.

The goal of Zen is a deep awareness of truth, often framed as the truth of life and death, to be reached through two main practices: first, **zazen**, meditation while sitting straight-backed with legs crossed, and, second, the study of **kōan**, questions or exchanges with a master that cannot be understood or answered with rational thought. The aim of *zazen* is to be completely present in the here and now, with the mind focused yet free of images or concepts—object-less thought. The purpose of the *kōan* is to break through rational patterns of thought to the clarity of intuitive Enlightenment. The student must constantly hold the thought problem in mind until the tension between the rational and the irrational produces a breakthrough in understanding. The goal of Zen practice is, of course, Enlightenment, but it is characterized as **satori**, an ineffable experience some have described as the feeling of becoming one with the universe.

As in Shingon, Zen masters put a great emphasis on person-to-person teaching: their purpose to avoid dependence on written scriptures, and thus to transmit Zen principles directly to students through the generations. During the twelfth to fifteenth centuries, they were also influential in matters of state, advising on internal and foreign policy and on trade with other nations. Zen monks, although required to live austerely within the temple complex, were allowed the freedom to engage in cultural activities of a primarily secular nature, such as poetry, painting, calligraphy, a distinctively Zen ink-and-brushwork tradition, and garden design. Over the centuries, Zen thought and practice, placing a high value on simplicity, economy of means, and the perception of beauty in the natural world, have had a profound effect on Japanese culture. Perhaps Zen's greatest contribution was its blurring of the boundaries between the secular and sacred in both art and poetry.

THE AESTHETICS OF *WABI*

Developing out of the intellectual climate associated with Zen is *wabi*, an aesthetic concept that greatly values pleasure taken in austerity and solitude, beauty perceived in simplicity, and an appreciation of objects weathered by time. One of the greatest Zen masters and scholars of this period was the lay master Yoshida Kenkō (1283–1350). Born into a family that had traditionally supplied Shinto diviners for the imperial family, Kenkō in his early adulthood served as a steward to a family related indirectly to Emperor Go Nijo (r. 1302–8). However, at some time before 1313 he withdrew from court circles and established himself as a Buddhist monk, although without a temple affiliation. His *Tsurezuregusa* (*Essays in Idleness*), written some twenty years later, provides a perceptive and beautifully expressed statement of the aesthetic ideals that had been formulated by the early fourteenth century and that continued to dominate the arts in Japan until the end of the sixteenth century. The most famous passage of his work sets forth a concept that is a logical extension of the value he placed on impermanence, and also a statement of a fundamentally Japanese aesthetic ideal recognizable even today.

> Are we to look at cherry blossoms only in full bloom, the moon only when it is cloudless? . . . Branches about to blossom or gardens strewn with faded flowers are worthier of our admiration, . . . People commonly regret that the cherry blossoms scatter or that the moon sinks in the sky, and this is natural; but only an exceptionally insensitive man would say, "This branch and that branch have lost their blossoms. There is nothing worth seeing now." In all things, it is the beginnings and ends that are interesting.
>
> Donald Keene, trans., *Essays in Idleness*, New York, 1967, 115.

Elsewhere Kenkō elaborates on the *wabi* aesthetic of understatement and transience:

> A screen or sliding door decorated with a painting or inscription in clumsy brushwork gives an impression less of its own ugliness than of the bad taste of the owner. It

is all too apt to happen that a man's possessions betray his inferiority.... Possessions should look old, not overly elaborate; they need not cost much, but their quality should be good.

Somebody once remarked that thin silk was not satisfactory as a scroll wrapping because it was so easily torn. [X] replied "It is only after the silk wrapper has frayed at top and bottom, and the mother-of-pearl has fallen from the roller that a scroll looks beautiful." This opinion demonstrated the excellent taste of the man.

Ibid, 70.

The concept of *wabi* initially referred to the quality of the life led by an ascetic, but over time it developed into an aesthetic ideal to be sought after in one's daily life. The element of *sabi*, often paired with *wabi*, adds the notions of detachment and tranquillity, such as one achieves at the end of life. These two aesthetic concepts became fundamental to the performance of the tea ceremony, which developed in the fifteenth century out of the Zen practice of drinking strong tea in order to stay awake while meditating, and are clearly apparent in the literature and painting of the period.

THE ZEN TEMPLE

The composition of the Buddhist temple changed fundamentally under Zen. Most importantly, there developed a central complex for public ceremonies and alongside it a series of private subtemples, or *tatchū*, built to accommodate religious leaders, often retired abbots, and their monastic and lay adherents. Today, Zen temples rarely have more than twenty-five subtemples, but it is known that toward the end of the sixteenth century they routinely had many more, several temples counting more than a hundred. These smaller complexes normally had space, either rooms or separate buildings, for the essential elements of daily life: a reception room, quarters for the monks, rooms for Zen study, meditation, and the chanting of sutras, a space devoted to the memory of the temple founder, and often a garden for contemplation.

Within the public sector of the Zen temple, many changes were effected in the traditional names, types, styles, and layout of the buildings in the temple compound. A new type of gate was introduced, the *sanmon*, or mountain gate, a two-storied structure with three entrance doors and a functional second story—accessed by covered stairways outside the basic building and which usually contained sculptures of the sixteen *rakan*, who as great practitioners who had achieved Enlightenment were particularly revered in Zen. The main hall, the *kondō* or *hondō* in traditional Buddhist temples, was renamed simply the *butsuden* (Buddha hall) and used for public ceremonies, while the lecture hall, or *kōdō*, was renamed the *hattō* (Hall of the Law) and was used for regular assemblies of all the monks belonging to the parent temple. These two buildings were placed along a central axis extending from the *sanmon* to the residence of the abbot, the *hōjō*, which served as the headquarters and chief reception building of the temple. Although the term "*hōjō*" refers to the small hut of a recluse monk, in Japanese Zen temples it is usually a large and well-appointed building. Finally, the public complex may be provided with a *shariden*, or relic hall, in which to honor Shaka Buddha and revered Zen masters, and a *kaisandō*, or founder's hall, dedicated to the temple's or precinct's founder.

Tōfukuji, one of the first Zen temples to be built in Kyoto, preserves something of the appearance of an early Zen monastic complex on the site of the long disappeared Hosshōji of Emperor Shirakawa (1053–1129). It was founded in 1236 with the support of the Kamakura regent Kujō Michiie (1193–1252). Although the first construction campaign was not completed until 1255, in 1243 the noted Zen master Enni Benen (1202–80), a central figure in the development of Rinzai Zen in Japan and known posthumously as Shōichi Kokushi, took up residence at the temple. Throughout the following centuries Tōfukuji prospered, and when the complex

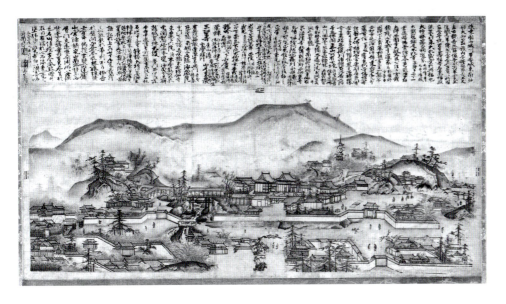

246 Ink painting of Tōfukuji, by Sesshū Tōyō. 15th century. Horizontal hanging scroll, ink and color on paper; 32 ⅜ x 59 in. (83 x 150 cm). Tōfukuji, Kyoto.

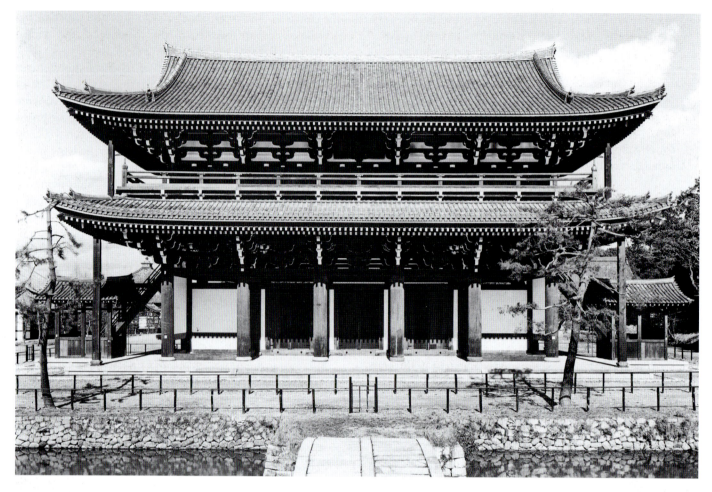

247 *Sanmon* (entrance gate), Tōfukuji, Kyoto. 1384–1425.

was severely damaged by fires in 1319 and again in 1334, rebuilding was undertaken quickly, with the support of *bakufu* leaders. Although the fortunes of Tōfukuji declined after the Meiji Restoration of 1868, at one time it had more than fifty subtemples. Some idea of the earlier complex can be gleaned from a fifteenth-century ink painting by Sesshū Tōyō (1420–1506) seen in Figure 246. Located in the foothills of Kyoto's Eastern Hills, or Higashiyama, its buildings are sited over uneven terrain, and a fair-sized stream, the Sengyokukan, is included within its boundaries. The view of the foliage from the roofed bridge over the stream, the Tsutenkyō, is one of the most famous in Kyoto in the fall.

The *sanmon* of Tōfukuji, the earliest extant example of the new type of gate, was built over a period of roughly forty years, from 1384, when materials were pledged by the *bakufu*, to 1405, when the roof tiles were put in place, to 1425, when the outer staircases were added (Fig. 247). The building is two bays wide by five bays long and is capped by a two-tiered, hipped-gable roof. Although the exterior of the gate preserves the more restrained and sober aesthetic of the Chinese Southern Song period (1126–1279) building, the interior of the second floor turns to the bright ornamentation typical of Chinese decoration in the fourteenth and fifteenth centuries,

with designs painted in green, red, brown, black, and gold (Fig. 248). Enshrined in the single room are sculptures typical of a *sanmon*—images of Shaka and the sixteen *rakan*.

The architectural style adopted for Zen temple construction is known in Japan as **karayō**, or Chinese style, in contrast to the traditional manner that over time had come to be regarded as a purely Japanese, or **wayō**, style. *Karayō* buildings use such decorative details as bell-shaped windows with a rippling top line, transom windows with delicate wooden grilles, and an extraordinarily complicated pattern of bracket supports and fanned rafters. Columns in this style usually narrow in diameter toward the top and rest on stone bases set directly on the stone tiles of the floor.

The earliest extant example of a building in the *karayō* style is the *shariden* of Engakuji in Kamakura (Fig. 249). The hall was built in 1285 as the *butsuden* of a local nunnery, Taiheiji, and was moved to the founder's *tatchū* of Engakuji, the Shōzokuin, in 1563. The core of the building is three by three bays square, with a *mokoshi* (double-roof system) added around the perimeter. The roof is a two-tiered, hipped gable; it is thought that the original roof was made of tile in the traditional Chinese style rather than the thatch that now covers it. The rafters, visible from the inside, appear to radiate out from

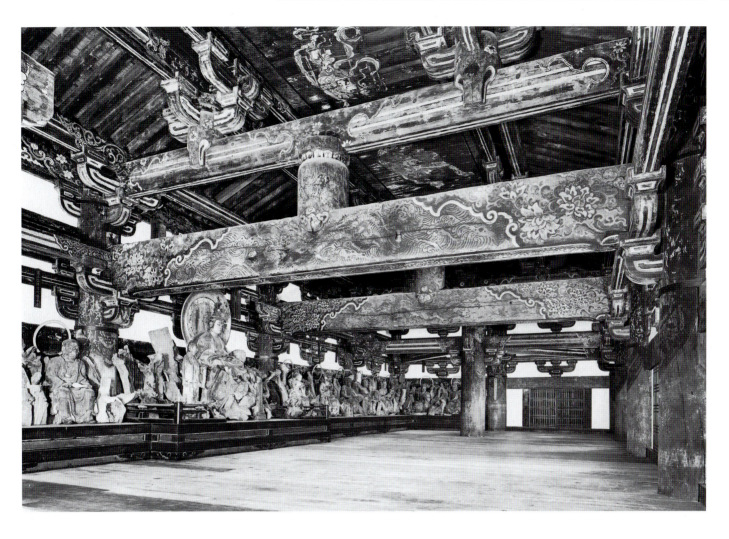

a central point hidden above a flat ceiling panel. The *shariden* of Engakuji has a delicate, almost jewel-like interior in comparison with the large halls found in most Zen temples, and the decorative detailing of the *karayō* style seems to add just the right amount of architectural embellishment.

One of the most innovative concepts given expression in the Zen temple is the landscape garden as an aid to meditation. By the Middle Heian period, gardens were incorporated into temple compounds that were laid out in imitation of the residences of the nobility. However, the gardens associated with Zen subtemples are very different. They are constructed in a limited amount of space, and this very limitation is used as an asset in their design, which is kept extremely simple. Furthermore, as aids to Zen practice, the objects they contain seem to invite metaphysical interpretation. Finally, most of them are constructed largely from small pebbles and rocks, with live plantings limited to moss and simple shrubbery, and are called **karesansui**, or dry landscapes, although some Zen gardens also incorporate water features such as ponds.

By far the most famous *karesansui* is that of Ryōanji (Fig. 250), and it has come to be considered the epitome of Zen tranquillity and reflection. The temple was founded on the western outskirts of Kyoto in 1450, ironically enough by one of the principal instigators of the Ōnin War—Hosokawa

248 (above) Second floor of *sanmon*, Tōfukuji.

249 (below) *Shariden* (relic hall), Engakuji, Kamakura. 1293–8.

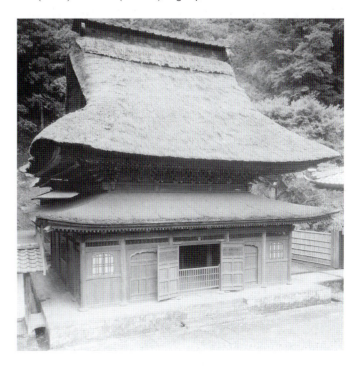

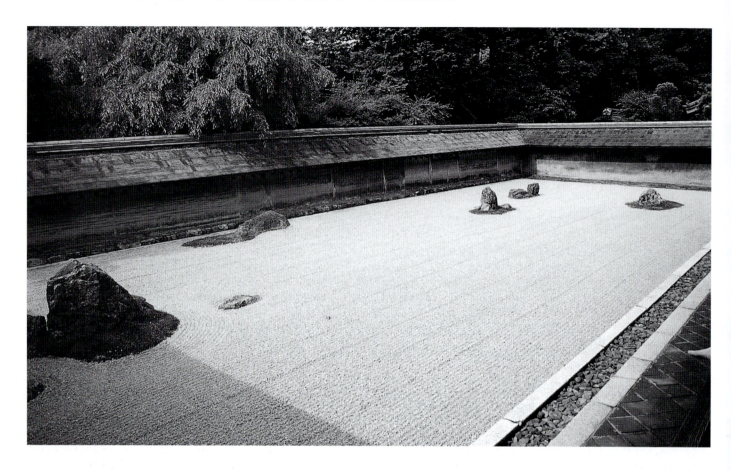

250 View of the garden of the Ryōanji. First established c. 1500.

Katsumoto (1430–73). Like much of the rest of Kyoto, it did not survive the war intact, but by 1488 it had been rebuilt by his son Masamoto and perhaps the astonishing garden, some 75 x 29 feet (23 x 9 m), was created at this time—certainly no later than 1500. The temple burnt down once again in the late eighteenth century, and the present garden dates from that time. Made up entirely of rocks set amidst raked pebbles, one interpretation of its imagery is that it is a seascape, not unlike that seen either in Chinese-style painting or in *yamato-e* images of subjects like the coastline of Shiogama. Another interpretation has been of a tigress leading her cubs across a river. Whatever the image evoked, the spare, simple beauty of the design has seldom been equalled.

Its design has traditionally been accredited to one of Ashikaga no Yoshimasa's artists, Soami (1455–1525), who was famed for his paintings of Chinese-style landscapes, but there is no direct evidence to support this. It has also been credited to various Zen monks of the period, but most curiously credit is perhaps in addition due to two gardeners who inscribed their names on one of the stones, Kotara and Seijiro. Both men belonged to a sub-class of Kyoto citizenry known as *kawaramono*, literally "river bed people." Traditionally they lived along the beds of the Kamo and Katsura rivers and performed the city's most demeaning tasks, such as the skinning and tanning of hides. Some of the Ashikaga's cultural advisers and connoisseurs came from this lowest class, and

kawaramono had also become noted by the fifteenth century for their placement of decorative stones in gardens, taking on a role formerly allotted to Buddhist monks and Shinto priests. It seems likely that the design of Ryōanji is a collaboration between these two *kawaramono* and a Zen monk of the temple, or perhaps even with Soami.

Among the most complicated gardens in terms of its design elements is the enclosure within the precinct of Daisenin, a subtemple of Daitokuji (Fig. 251). The Daisenin complex was founded in 1509 by Kogaku Sōkō (1465–1548),

251 View of the *hōjō* garden of the Daisenin, Daitokuji, Kyoto. Established *circa* 1513.

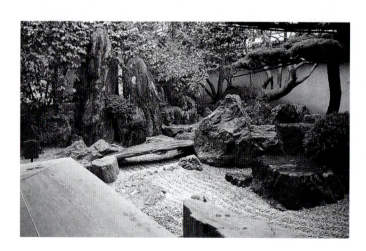

upon his retirement as abbot of Daitokuji. Its main building, the *hōjō*, was completed in 1513, and several gardens were arranged around it and are considered also to date from around that time. The design of one of these gardens is attributed to Sōkō himself, and extends along the east and part of the north side of the *hōjō* adjoining the room used for formal gatherings. The river, the organizing motif of this Daisenin garden, begins with two large rocks placed vertically, close to the northeast corner of the enclosing wall. The pattern of the veining in the taller of the rocks suggests water cascading down the side of a mountain, and the pebbles at its base can be interpreted as the river. A thin, flat rock has been laid on two small stones to represent a bridge, and a smooth, humpbacked stone set into the pebbles resembles a fish surfacing as it swims upstream. Viewing the garden in quiet contemplation one can extrapolate endlessly on themes suggested by these basic shapes to construct whatever landscape one prefers, focusing on the central motif of the pebble river as a metaphor for the passage of one's life. This part of Zen meditation practice, imagining a panorama of nature, helps to free the mind of mundane concerns so that one may concentrate on spiritual matters. A favorite activity of Zen monks and the upper echelons of the samurai was to get together to compose *renga*, or linked verses. Thus the room in the northeast corner of the Daisenin *hōjō* was provided with a pleasant contemplative garden as a background for such assemblies. Similarly, the *hōjō* of Ryōanji has a viewing platform onto its dry garden.

ZEN PAINTING

The division of the temple into public and private sectors permitted several different kinds of imagery to coexist in Zen paintings: traditional Buddhist themes being used for objects on public view, motifs and styles more directly related to Zen thought for objects in the subtemples. Zen Buddhism's focus on universal truth expressed in the present moment vastly widened the range of themes painted by monks and for temples—from paintings of famous Zen eccentrics to evocative landscapes and themes reflecting the evanescence of nature. Furthermore, artists connected with particular temples developed considerable skill at working in very different styles and using different kinds of materials.

The monk–painter Kichizan Minchō (1352–1431), a remarkably versatile artist, flourished in this environment. He was born on the island of Awaji, which is located in the Inland Sea between Honshū and Shikoku, and there became a student of the island's Zen master. When the latter was appointed to Tōfukuji in Kyoto, Minchō accompanied him and became *chōdensu*, the superintendent of buildings and supplies for the entire temple compound. It was his responsibility to see that the proper Buddhist equipment was provided for public worship. In this connection he produced a very important painting, an extraordinarily large depiction of the death of the Shaka Buddha to be displayed each February on the anniversary of his death (Fig. 252). Executed in 1408, according to its inscription, the picture is essentially conservative in style and treatment, and necessarily so given its use in public ceremonies. Even so, it also displays a somewhat free style of brushwork, using outlines of slightly varying width and some shading to model the old and emaciated faces of the Buddha's disciples, and the color scheme, while certainly not monochromatic, relies primarily on red as an accent against the different flesh tones of the humans and divinities and the black of their hair and robes.

The types of Zen paintings found in the private subtemples are exemplified by two monochrome ink paintings by Minchō: a 1421 painting of Kannon in a white robe (Fig. 253) and a landscape of 1413 attributed to him (Fig. 254). The white-robed Kannon belongs to the **dōshakuga** tradition of imagery—depictions of Buddhist themes intended to convey the subjective experience of receiving spiritual insights or revelations. The subject matter of *dōshakuga* includes bodhisattvas such as Kannon, as well as great Zen masters and eccentrics such as the Chinese eccentric Kanzan (CH. Hanshan) and his friend Jittoku (CH. Shide), who in the seventh century worked in the kitchen of a Chan temple in addition to composing poetry immortal in the simplicity of its form and depth of its concepts. These two embody the Zen concept of the untrammeled soul. Other such eccentric figures are the monk Bukan (CH. Fenggan), who raised Jittoku and was reputed to ride in the mountains on a tiger; Hotei (CH. Putai), another monk thought to be an incarnation of Miroku, the Future Buddha; and the school's founder Daruma—as well as patriarchs of the Chinese and Japanese lineages shown at the moment they achieved Enlightenment. Minchō's white-robed Kannon, typical of the treatment of this theme, sits in an informal pose in a grotto, her traditional abode, and gazes out over the ocean. The bodhisattva is treated as a beautiful, languid and feminine figure, clad in a simple white robe and bedecked with gold jewelry, divinity suggested only by the crown and halo, the latter being a perfect circle of mist through which part of the rock behind can be seen. This image also serves as a useful marker for the feminization of Kannon, a process that had begun earlier on the continent, and which, with paintings such as this, is almost complete. The Bodhisattva of Compassion will from this point onward usually be depicted as a beautiful but matronly figure.

Minchō's landscape is an example of another type of painting: **shigajiku**, a hanging scroll combining poetry—often composed and copied by several different priests—with a monochrome image of an imaginary landscape. Such landscapes derive from Chinese precedents. China's educated elite had long expressed themselves through poetry and calligraphy, but during the Tang dynasty (618–907) they had also begun to turn the calligraphic brush to painting landscapes (and less frequently figures) as another way of expressing their feelings on a subject, or to commemorate a particular event, such as an informal literary gathering. Such paintings would often have colophons of poems or comments by the painter's friends brushed directly onto their surface. The subsequent

252 *Death of the Buddha*, by Minchō. 1408. Hanging scroll, color on silk; height 344 x 208 ¾ in. (876 x 531 cm). Tōfukuji, Kyoto.

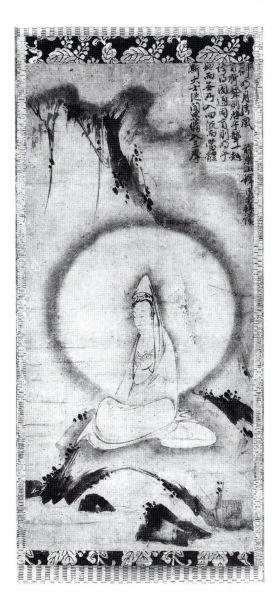

253 *White-robed Kannon*, by Minchō. 1421. Hanging scroll, ink on paper; 24 x 10 ⅞ in. (60.9 x 27.6 cm). Museum of Art, Atami, Shizuoka prefecture.

Song dynasty (960–1279) was the first great golden age of landscape painting by these scholar–officials, known in Japanese as **bunjin** (CH. *wenren*; or literati) During this period the Chan school in China was culturally very close to the *bunjin*, and Chinese monk–painters also began to paint personal calligraphically-brushed monochrome landscapes as expressions of Zen thought and practice. The relationship between the Chinese intelligentsia and Chan became so close that literati painters later adopted Chan terminology to describe the difference between themselves and professional, and relatively uneducated, artisan painters.

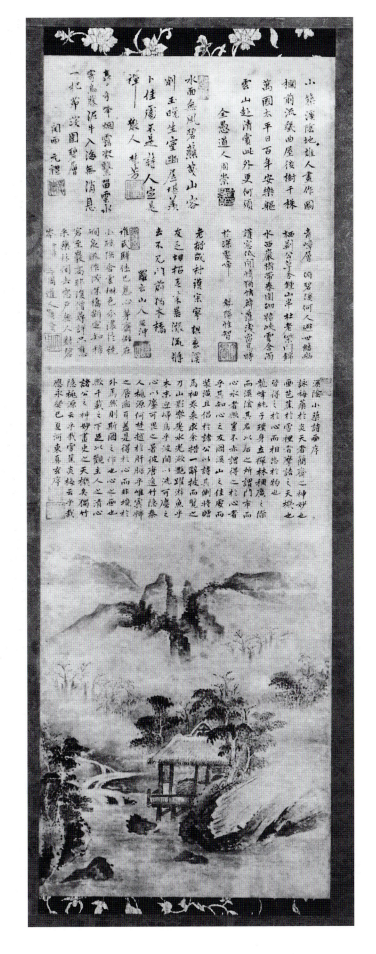

254 *Cottage by a Mountain Stream*, by Minchō. 1413. Hanging scroll, ink on paper; 40 x 13 ⅝ in. (101.5 x 34.5 cm). Konchiin, Kyoto.

Kakemono and Ink Painting

Like the hand scroll (*emakimono*), the *kakemono*, or **hanging scroll**, consists of a painting or a piece of calligraphy executed on paper or silk mounted on a paper backing that is strong enough to support the weight of the artwork yet flexible enough to be rolled for storage.

To prepare the artwork for display, it is set into a frame of figured silk or brocade. Above and below this rectangular frame, contrasting pieces of silk are attached. The lower edge of the whole is provided with a round dowel, around which the scroll can be rolled; at the top there is a much lighter wooden slat, from which the painting is suspended when exhibited. Traditional Japanese mountings have *futai*, two narrow bands of silk that hang from the top of the hanging scrolls when it is displayed. Mountings for Chinese-style paintings do not use *futai*.

Kakemono produced under the influence of Zen Buddhism were usually *suibokuga*—paintings executed in black ink (*sumi*). This type of ink is made by collecting the soot from burning pine twigs and, after the addition of resin, forming it into a long, flat-sided ink stick. To produce ink, the stick is dipped in a little water in the well of the flat inkstone and then rubbed on the adjacent slope of the stone. The process is repeated until the desired ratio of pigment to water has been achieved.

The hanging scroll format first appeared in the Heian period in conjunction with Buddhist painting but came into its own in the thirteenth to fifteenth centuries in association with Zen imagery and the practice of the tea ceremony. The chief advantage of the hanging scroll is that it is small and lightweight enough to be easily hung or re-rolled and replaced by another.

While literati amateur landscape painting became established during the Song period as practically the highest expression of the Chinese arts—only calligraphy was higher—in Japan the secular educated elite remained more attached in the Kamakura and succeeding Muromachi periods to *yamato-e* and the more professional styles of *kara-e* painting. The introduction of the first true monochrome landscapes belongs to the monk–painters of the Zen school. The landscape of a cottage by a mountain stream, traditionally thought to be Minchō's work, is particularly interesting from a historical point of view. It is one of the oldest dated examples of a *shiga-jiku*, and it constitutes a record of a particular event. Junshihaku, a priest at Nanzenji in Kyoto, in 1413 built himself a study and invited a few of his friends to a celebration. He had named his new retreat Keiin, literally "valley shade," and several of his friends wrote poems praising it. These poems appear in the two topmost portions above the landscape, together with a lengthy preface describing the circumstances of the painting's creation. The landscape itself, at the bottom of the *kakemono* (hanging scroll), depicts the Chinese scholar's romantic ideal of a study, a simple room extending out over a small mountain stream that meanders through hills. The architecture is simple, with such *karayō* architectural elements as a stone-tiled floor and a bell-shaped window. The study is set in a grove of trees, and behind it is a range of tall Chinese-style mountains, the nearest capped with trees. The artist has combined two separate images: the cottage nestled gently into a hilly region not unlike Kyoto's environs and the Chinese-style mountains seen from a distance. As the genre of monochrome landscapes developed, one problem artists had to solve was how to link this foreground and background space in a believable way. The painting has no inscription identifying it as a work by Minchō, but most scholars accept the traditional attribution. In these two types of paintings, *dōshakuga* and *shigajiku*, the Zen monk–artist could give his brush and imagination free rein to create images that embodied his religious beliefs and goals.

The priest–painters Kaō Ninga (act. mid-fourteenth century) and Mokuan Reien (act. first half fourteenth century), while less versatile than Minchō, left excellent ink figure-paintings in the *dōshakuga* tradition. There is considerable confusion about the exact identity of the painter using the Kaō and Ninga seals, and it has been suggested that he was a professional Buddhist painter affiliated with a school of artists known as Takuma. The latter was founded at the end of the tenth century by Takuma Tameuji and his sons in Kyoto, espousing a *yamato-e* style. By the fourteenth century, the school's artists had diversified considerably and their output included copying the style of literati painting of China's Song dynasty. However, judging by the work bearing his seals, Kaō was not a trained professional artist, but rather a monk–painter with an excellent calligraphic hand and well versed in Zen and literati imagery. His depiction of the poet Kanzan captures the eccentricity of the man and also his strength of character (Fig. 255). Kanzan lived in a cave behind

255 *Kanzan*, by Kaō. Before 1345. Hanging scroll, ink and color on paper; 40 ⅜ x 12 ⅛ in. (102.5 x 30.9 cm). Freer Gallery of Art, Smithsonian Institution, Washington DC. (Purchase F1960.23).

256 *Crane, Kannon,* and *Monkey,* a triptych of three hanging scrolls by Mu Qi (Chinese, act. 1279). Ink on silk; height 70 in. (177.8 cm). Daitokuji, Kyoto.

Guoqing (JAP. Kokuseiji) monastery on Mount Tiantai, the locus of Tendai worship in China. The kitchen worker Jittoku would bring him food, and the two men would amuse themselves in the evening with poetry and moon viewing. One example of Kanzan's poetry describes the life he led:

> I divined and chose a distant place to dwell—
> T'ien-t'ai: what more is there to say?
> Monkeys cry where valley mists are cold;
> My grass hut blends with the color of the crags.
> I pick leaves to thatch a hut among the pines,
> Scoop out a pond and lead a runnel from the spring.
> By now I am used to doing without the world.
> Picking ferns, I pass the years that are left.
>
> Burton Watson, trans., *Cold Mountain,* New York, 1962, 61.

Kaō shows Kanzan standing, gazing upward as if at the moon and smiling at some unknown amusement. Broad, quickly executed brushstrokes define the upper garment, while wide strokes of lighter ink suggest the skirt. Fine, light gray lines have been used for the details of the face and the feet. There is a pleasing balance between the dark ink used for Kanzan's unkempt hair, his clothing, and his sandals, and the lighter ink used for the finer details.

More information about Mokuan has survived than about his contemporary Kaō. Mokuan was ordained as a priest in Kamakura before 1323 and journeyed to China about 1327 to perfect his knowledge of Zen. He lived in several different monasteries in southern China and died there about 1345. Since most of the paintings bearing Mokuan's seals also have inscriptions by Chinese Zen masters, it is thought that they were first owned by these men and brought to Japan only at a

257 *Four Sleepers*, by Mokuan Reien. 14th century. Hanging scroll, ink on paper; height 27 ½ x 14 ⅛ in. (70 x 36 cm). Maeda Foundation, Tokyo.

later date. Mokuan clearly had achieved a significant reputation as an artist, because he was identified as "a second Mu Qi" (JAP. Mokkei), the greatest of the Chinese Chan monk–painters, many of whose works are preserved in Japan.

Active in the thirteenth century, Mu Qi began as a scholar well acquainted with China's literati culture. In mid-life he took the tonsure, founding the temple Liutongsi, near Hangzhou in southern China. Japanese priests who had the opportunity to see his work were greatly impressed and took several of his paintings back to Japan. His triptych of a white-robed Kannon, flanked by a crane striding forward as if from a bamboo grove and a monkey on a dead tree branch cradling her baby (Fig. 256), found its way into Daitokuji, where it had a significant influence on Japanese artists, not only in the four-teenth and fifteenth centuries, but later on as well, extending into the twentieth century. No other Chinese artist has had such a profound impact on the development of Japanese painting. Further, the imagery of the crane and the monkey

became associated in Zen illustration with the idea of Enlightenment—the crane (the Chinese symbol for a Daoist immortal) representing the independent spirit who has achieved *satori*, the monkey, hugging her child as she sits on the dead tree, expressing the soul still tied to worldly concerns.

The "second Mu Qi," Mokuan's hanging scroll of *Four Sleepers* depicts Kanzan and Jittoku entwined in slumber with the monk Bukan and his tiger (Fig. 257). The colophon by a Chinese monk at the top of the painting has been translated as follows:

Old Fenggan [Bukan] embraces his tiger and sleeps,
All huddled together with Shide [Jittoku] and Hanshan [Kanzan]

258 *Catching a Catfish with a Gourd*, by Josetsu. *c.* 1413. Hanging scroll, ink and color on paper; 43 ⅞ × 29 ⅞ in. (111.5 × 75.8 cm). Taizōin, Myōshinji, Kyoto.

They dream their big dream, which lingers on,
While a frail old tree clings to the bottom of the cold precipice.
Shaomu of the Xiangfu [temple] salutes with folded hands.

Jan Fontein and Money Hickman, *Zen Painting and Calligraphy*, Boston, 1970, 73.

Mokuan has followed a formula for brushstrokes and ink similar to that seen in Kaō's painting. Medium gray, fairly broad lines describe the bodies of the sleepers, while fine strokes are used for the facial features, and dark ink accents such details as shoes, belt, and hair. Only the briefest of details are supplied about the setting. A light wash suggests rocks beside the figures and the shoreline in front of them, while darker strokes are used for vines, tree branches, and river rocks. But the painting evinces a more sophisticated use of ink than Kaō's painting of Kanzan.

A contemporary of Minchō was the priest–painter Josetsu, and his major work, *Catching a Catfish with a Gourd* (Fig. 258), was made about the same time as Minchō's

attributed *Cottage by a Mountain Stream*. The former was commissioned by the Ashikaga shogun Yoshimochi (1380–1428) and executed as a decoration for a small Chinese-style standing screen. When it was presented to the shogun, thirty Zen monks composed poems praising the work and copied them onto a sheet of paper that was attached to the reverse side of the screen. The introduction to the collection of poems was written by Taigaku Shūsū, one of the monks who had added a poem of praise to Minchō's landscape. Josetsu's painting can be dated to the years around 1413 on the basis of the dates of these thirty monks. Not long after it was made, the painting and accompanying text were refashioned into a single hanging scroll, with the poems placed in the area immediately above the painting.

The painting is a *dōshakuga* of a fairly unusual kind, the depiction of a *kōan*, a thought problem used as an aid to attaining Enlightenment. The puzzle is how to catch a slippery catfish in a gourd. The figure in the center of the foreground is shown holding a pale orange gourd in front of him as if measuring it against the longer length of the wriggling gray fish swimming in the stream at his feet. The man cuts a strange and solitary figure, with his porcine face, his oddly animated clothing, and his stiff-legged stance, placed alone in the flat, barren landscape. Far in the distance the pointed tops of three mountains can be seen above the mist. One of the inscriptions refers to the new manner of the painting, which scholars usually have interpreted to be a comment on the inclusion of a detailed, multiplanar landscape setting in this *dōshakuga*; in Kaō's and Mokuan's work, the setting is usually executed in swift brushstrokes, with only the briefest description of a background setting.

Little is known about Josetsu beyond the fact that he was a monk living in the temple of Shōkokuji. A diary reference identifies him as a stonecutter employed by Ashikaga Yoshimochi to carve an inscription on a stone stele for the subtemple of Rokuonin in honor of the Zen master Musō Soseki (1275–1351), founder of Shōkokuji and one of the most influential men of his time. However, Josetsu was obviously an artist of some skill, and is known to have taught one of the next generation's most outstanding monk–painters, Shūbun.

Tenshō Shūbun (d. *c.* 1460) was also a monk at Shōkokuji, serving in one of the top administrative positions within the temple. In 1423, he took part in a diplomatic mission to Korea, specifically charged by the *bakufu* with securing a printed edition of the Korean Buddhist canon. He is also credited with designing and painting Buddhist sculptures. Clearly Shūbun was a man of many talents. By the 1430s, he had achieved a significant reputation as a painter and received commissions from lay patrons as well as from his own temple.

Few of the paintings attributed to Shūbun are generally accepted as authentic examples of his work, but *Reading in the Bamboo Study*, of about 1446, is one of the few (Fig. 259). The painting is a *shigajiku* with a long introduction at the top of the scroll and five brief inscriptions, each by a different person. The illustration depicts a scholar's study, almost hidden in a

bamboo grove. The building has a thatched roof and a large window, through which the scholar can be seen holding something, perhaps a book. Close to the house, a sharp bluff is capped by two pine trees, one straight, the other oddly bent near the base of the trunk and crossing over the first. The bluff and the trees are painted in a darker shade of ink than the house and bamboo grove, and are echoed at the top of the overhanging cliff by a similarly shaped rock formation sketched in dark ink. The motifs of rocks and the scholar's study occupy the right half of the painting. To the left at the base of the bluff is an expanse of flat land at the edge of a body of water, and on a short bridge an older man appears to walk ahead of a young male attendant toward the bluff, a scholar and his serving boy going to visit their friend in the "Bamboo Study." Far in the distance to the left can be seen the other shore, with two fishing boats tied together behind a low spit of land and two more to the right, moving through the water. The tiled roofs of a temple complex may be seen hidden among the trees.

In this landscape Shūbun has clearly solved the problem of believably depicting planes of spatial depth. Indeed, the painting suggests an almost unending procession of motifs, carrying the eye far back into space. The short, repetitive strokes that characterize the brushwork describe the natural elements but also give the painting a somewhat decorative effect. It is clear that Shūbun was familiar with Song dynasty landscape painting because he uses several stock motifs, such as the scholar and his attendant crossing the bridge, the scholar visible through the window of his study, fishing boats close to land, and the temple buildings in the distance. Also, the dominant motif of crossed pine trees and the placement of most of the elements to one side are devices frequently used by the Southern Song (1126–1279) painter Xia Gui (act. first half thirteenth century), whose works were highly prized by Japanese collectors, not least of whom were the Ashikaga shoguns. It is also clear that Shūbun was depicting an ideal and Chinese landscape composed of many different elements, rather than a natural landscape he might have seen around the city of Kyoto.

The greatest Zen monk–painter of this period was Sesshū Tōyō (1420–1506), who emerged from the creative atmosphere of Shōkokuji, having learned his craft from Shūbun. Sesshū was born in what is today Okayama prefecture and at a very early age made his way to Kyoto and the temple of Shōkokuji. In 1464, Sesshū emigrated from Kyoto to Yamaguchi, Honshū's westernmost prefecture, where he came to the attention of the ruling Ōuchi family. His move was symptomatic of the period. Not a few Kyoto-based artists, sensing the increasing political unrest leading up to the Ōnin War, sought opportunities to withdraw from the confines of their monasteries and the city. Sesshū established a studio, the

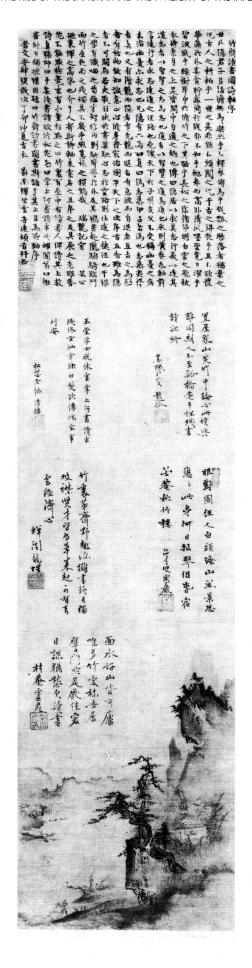

259 *Reading in the Bamboo Study*, by Shūbun. *c.* 1446. Hanging scroll, ink and color on paper; 53 ¾ x 13 ¼ in. (136.5 x 33.6 cm). Tokyo National Museum.

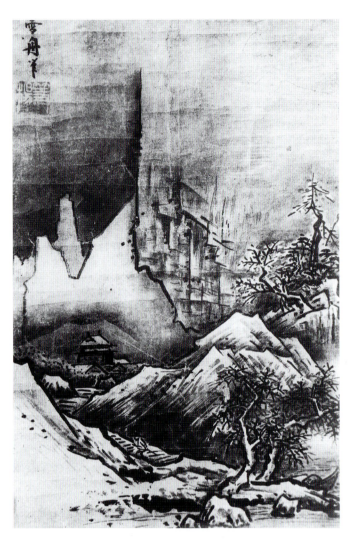

260 *Winter Landscape*, one of four hanging scrolls of the four seasons, by Sesshū Tōyō. c. 1470s. Ink on paper; 18 ¼ x 11 ½ in. (46.4 x 29.4 cm). Tokyo National Museum.

One of his most characteristic landscapes is a winter scene (Fig. 260), probably part of a set of landscape hanging scrolls of the four seasons and thought to date to the 1470s. In this painting, Sesshū has combined motifs frequently found in Chinese Southern Song landscape painting to create an original and typically Japanese statement. Beginning in the lower right with the motif of two trees growing at the edge of the water, the viewer's eye is led back into space by the diagonal lines of a stepped pathway, along which a man with a wide-brimmed hat is climbing, presumably journeying toward the temple complex visible above him. The hills through which he travels and the mountains in the background surround the temple buildings, making them seem like a warm oasis in a cold, icy wasteland. The foreground passages of rocks and trees are described with firm, dark brushstrokes, while the distant mountains are only outlined against the gray sky. An interesting detail in the painting is the rock formation that appears in the upper-right quadrant. An undercut bluff, similar to the one in Shūbun's painting, appears behind the midground hills. It is described quite accurately toward the bottom in Chinese fashion, but the outline stops short of the top of the painting, as if the upper part of the mountain is lost in the mist. With this single detail the artist succeeds in changing our perception of the landscape depicted in the painting. He shows that it is not an eternal, never-changing scene, but rather one that reveals the immediacy of the moment as the mountain top disappears from view, snow on the stairway crunches underfoot, and the warmth of the temple beckons the traveler home.

A work that demonstrates Sesshū's facility with brush and ink is the *haboku* landscape of 1495 (Fig. 261). *Haboku*, literally broken ink, is a term denoting the very free and rapidly executed style in which ink seems to have been splashed on to the surface of the paper. While this may look easy, it is not. Very few *haboku* paintings are as successful as this one. With incredible economy of means, Sesshū has suggested land at the edge of water, large trees, and tall background mountains, and has even peopled his composition with two figures in a boat close to shore and a village of houses with the distinctive flag-bearing pole of a saké house.

This hanging scroll has an interesting history. It was executed by Sesshū as a farewell gift for a pupil, Josui Sōen (act. 1495–9), a monk–painter from the Kamakura temple of Engakuji. Above the landscape is a long inscription by Sesshū, giving the date of the painting and the circumstances of its production and also detailing the artist's experiences in China and specifying Josetsu and Shūbun as the artists whose work had most influenced him. The painting functioned almost like a portrait given by master to pupil, certifying that Sōen had indeed completed his training under Sesshū and was judged by the master ready to be an independent artist. On Sōen's way back to Kamakura, he spent several years in Kyoto, and during that time so appreciated was it that six high-ranking Zen monks added colophons of praise for the painting, above Sesshū's own inscription.

Unkokuan, but did not affiliate himself with any particular Zen temple. A second factor in Sesshū's decision to leave Kyoto was probably his hope to travel to China with the backing of the Ōuchi family, a trip he was able to accomplish between 1467 and 1469. Journeying with a trading mission privately sponsored by the Ōuchi, he arrived at the port of Ningbo and from there traveled to the newly established capital of China's Ming dynasty (1368–1644) Beijing, visiting Buddhist monasteries and famous scenic spots along the way. No reliably attributable paintings survive from the period before Sesshū went to China, but from his later work it is clear that he studied contemporary Ming landscape paintings as well as earlier Southern Song and also Yuan dynasty (1279–1368) pictures. When he returned to Japan, Sesshū at first settled in the southern island of Kyūshū and established a new studio, the Tenkai Togaro, but eventually moved back to his Unkokuan studio in Yamaguchi. Throughout his later life, he was a much-sought-after artist and continued to function productively, even making long pilgrimages about the country, until his death in 1506.

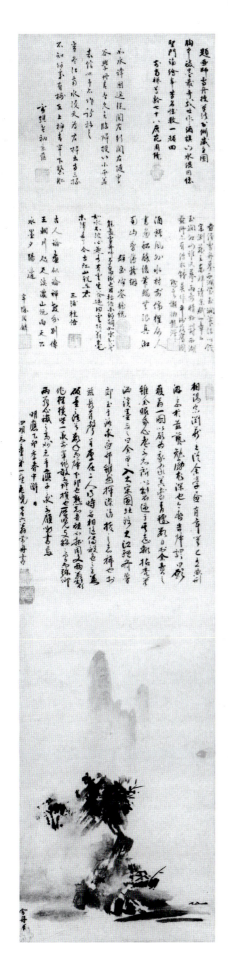

ASHIKAGA PATRONAGE AND THE ARTS

As has been demonstrated already, the Ashikaga were great patrons of the arts, and particularly those espoused by Zen masters. During the Muromachi period two distinct cultural environments grew up around the retreats of two of the retired Ashikaga shoguns: the villa of Yoshimitsu (1358–1409) in the Kitayama (Northern Hills) district of Kyoto, which became the temple known as Kinkakuji, or Temple of the Golden Pavilion; and the villa of his grandson Yoshimasa (1430–90) in the Higashiyama (Eastern Hills) district, the Ginkakuji, or Temple of the Silver Pavilion. These names are more properly nicknames given later by others; the names of these buildings when they were built were Rokuonji for the Kinkakuji, and Jishōji for the Ginkakuji. Both were constructed as elegant settings for retirement, where Yoshimitsu and Yoshimasa could devote themselves to leisure pursuits. Not until after their deaths were the buildings converted into temples and given the names that their builders' had selected as the titles to be used in their own funeral rites.

The Kinkakuji is a magnificent three-storied structure covered with gold foil, set at the edge of a large artificial lake (Fig. 262). In 1397, Yoshimitsu took possession of the site, which at one time had been a *shinden,* or mansion, and gardens. Proceeding to construct his own pleasure retreat for retirement in 1399, he placed within extensive gardens various buildings including two pagodas and a large three-storied pavilion overlooking a lake. The original Kinkakuji was set alight and completely destroyed in 1950 by a crazed acolyte protesting the commercialization of Buddhism after World War II. The structure was rebuilt quickly and restored to something like its original appearance.

Modeled on a Chinese prototype not infrequently to be seen in *kara-e* painting, the pavilion is a three-storied, double-roofed structure four bays by five, designed to house several different types of activities. The first floor, intended for informal relaxation and contemplation of the lake and garden, is provided with Heian *shinden*-style hinged lattice panels that can be raised so that the interior is opened up for viewing. The second floor—in the style favored by the warrior elite—is an enclosed L-shaped space with a deep veranda three bays long along the lake to serve as a kind of moon-viewing platform. The top floor—only three bays square—was designed as a temple room to be provided with statues of Amida Buddha and twenty-five bodhisattvas as well as a Buddha relic acquired from Engakuji in Kamakura. The building, with its Chinese-style bell windows and grilled transoms, and its shiny gold covering, seems like a delicate jewel that is moored at the edge of the lake.

261 Landscape in the *haboku* technique, by Sesshū Tōyō. 1495. Hanging scroll, ink on paper; height 58 ¼ x 12 ⅞ in. (147.9 x 32.7 cm). Tokyo National Museum.

262 Kinkakuji (Temple of the Golden Pavilion), Rokuonji, Kyoto. Rebuilt 1964 after the original of the 1390s.

Yoshimasa's Ginkakuji is nothing like its so-called twin, and the notion that it was to have been covered in silver is false (Fig. 263). However, the second floor was designed as a chapel dedicated to Kannon, and it may have been Yoshimasa's intention to have that interior covered in silver. Ginkakuji is on the site of an abandoned Tendai temple acquired by Yoshimasa in 1465. Most of the twelve buildings that form his retreat were completed, and the retired shogun was in residence, by 1483. The Ginkakuji is a two-storied, two-roofed building three bays by four on the first floor, and three by three on the second. The first floor was used by Yoshimasa for meditation and had walls composed of sliding doors which could be opened up to a view of the lake and extensive gardens.

Unlike gardens designed for the aristocratic mansions of the Nara and Heian period, or the viewing gardens of Zen sub-temples, the gardens of Kinkakuji and Ginkakuji were more like parks intended for leisurely walks, during which it was most important to be able to view the pavilions from different viewpoints. The gardens are still intricately laid out as miniature landscapes to be wandered through and enjoyed.

Both Yoshimitsu and Yoshimasa established their retreats as cultural centers and with themselves as arts patrons, Yoshimitsu encouraging the development of Nō drama and *renga* (linked verse), Yoshimasa lending his support to the development of the tea ceremony and flower arranging. Yoshimitsu affiliated himself with the arts as a matter of policy in an attempt to give himself legitimacy as a national ruler, and to eclipse entirely the imperial court, whose role as the nation's cultural center was the last shred of function it maintained. In these efforts he relied upon a new class of men known as *tonseisha* (see page 171), men who had taken monastic vows because they were dissatisfied with the social rank to which they had been born, but who did not affiliate with any particular Buddhist temple. By nominally becoming monks, they removed themselves from the class system, gained freedom of access to the privileges denied them by the circumstances of their parentage, and were able to participate fully in the wide variety of cultural events that took place under the Ashikaga. Yoshida Kenkō, author of *Essays in Idleness*, was a *tonseisha*.

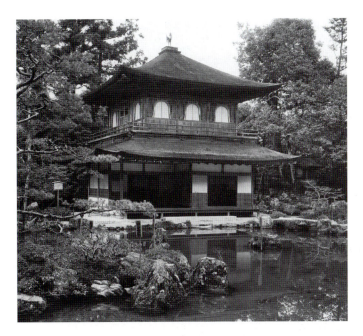

263 Ginkakuji (Temple of the Silver Pavilion), Jishōji, Kyoto. 1489.

Yoshimasa continued to rely on the *tonseisha*, but by the end of the fifteenth century, with the role of the *bakufu* and the capital becoming increasingly unstable, an entirely new system of patronage had developed. When many *tonseisha* and other Zen monks like Sesshū left the capital for more settled and safer environments, a family known as the San'ami took their place as the advisers and curators of the Ashikaga art collection. This family had affiliated with Pure Land Buddhism and used the suffix *ami* to indicate a nominal clerical status. However Nōami (1397–1471), Geiami (1431–85), and Sōami (1455–1525) had little to do with any Buddhist functions. They did produce a catalog of the Chinese paintings in the Ashikaga collection, which is also the first volume of art criticism in Japan, the *Kundaikan sayū chōki*, giving an evaluation and ranking of Chinese artists and instructions for the proper display of their paintings. In addition to their other skills, the San'ami were painters, basing their style, known as the Ami school, especially on the two great Southern Song masters Ma Yuan (act. 1190–1225) and the abovementioned Xia Gui. Sōami, perhaps the most innovative of the group, developed a second, softer style that combined elements from the paintings of Mu Qi with the dot strokes and gray washes of ink favored by a school of Chinese literati artists who traced their stylistic lineage to Mi Fu (1051–1107) and his son Mi Youren (1072–1151). Sōami's style is well represented by the sliding-door panels in the Daisenin compound of Daitokuji, which depict the confluence of the Xiao and Xiang rivers in China, a popular theme in Chinese literati painting (Fig. 264). The mountain forms are modeled with gray washes and given sharper definition with short strokes in darker ink.

Contemporary with the formation of the Ami school of painters was the **Kanō school**'s rise to prominence in the person of Kanō Masanobu (1434–1530). The Kanō, whose heyday was more properly in the second half of the sixteenth century and in the seventeenth century, continued to be an influence in *kanga*, or Chinese painting-style (essentially a more modern term for *kara-e*), circles well into the modern period. By the Edo period (1615–1868), however, their work had become the conservative standard against which more innovative artists rebelled.

The Kanō were descended from a low-ranking samurai family from the area around Shizuoka prefecture and had an affiliation not with Zen but with the Nichiren or Hokke sect of Buddhism. Nichiren Buddhism began with yet another strong and charismatic thirteenth-century religious leader, Nichiren (1222–82). Based exclusively on the *Lotus Sutra* (*Myōho renge kyō*), it emphasizes the recitation of the *Lotus Sutra*'s title— "*Namu myōho renge kyō*"—in much the same way the *nembutsu* mantra is chanted in Pure Land Buddhism. Nichiren saw himself as a great patriot and savior of Japan, and he vehemently denounced all schools of Buddhism that did not believe in the *Lotus Sutra*, particularly the Pure Land sects— which he blamed for disasters such as the attempts by the Mongol Yuan dynasty to invade in the thirteenth century. Kanō Masanobu was appointed official painter to the Ashikaga shogunate in 1481, but it was not until his son Motonobu (1476–1559) matured as an artist that a Kanō style was formulated and the school became firmly entrenched as the chief painters to the shogunate. Motonobu was a remarkably versatile painter, capable of working in the brightly colored *yamato-e* style of narrative painting, in a meticulous Chinese genre of bird and flower paintings, and in a freer style of *kanga*, combining figural and landscape motifs.

This latter style was fully developed by the early sixteenth century and is well represented in six panels by Motonobu depicting Zen patriarchs, originally designed as wall and door paintings but now refashioned into hanging scrolls. These paintings were executed around 1513 for the abbot's room in the **kyakuden**, or guest hall, of Daisenin. Although these are only a portion of the paintings that originally decorated this room, they represent a continuous sequence moving from right to left. First are four narrow panels, which were mounted on *fusuma* (sliding-door panels) installed along the south side, followed by two wider panels, which were attached to solid, wood panels forming the east wall of the room. With the exception of the second, each panel depicts one or two Chinese Zen patriarchs engaged in various activities such as sweeping, gazing at peach blossoms, and bidding a friend farewell, set in strongly delineated Chinese-style landscapes.

The most charming among the six panels is unquestionably the one that shows Kyogen (CH. Xiangyen; d. 898) achieving Enlightenment while sweeping with a bamboo broom (Fig. 265). Kyogen was asked by his master about his life before birth in his present incarnation. Unable to reply, Kyogen set himself single-mindedly to find the answer. When Buddhist texts failed to help, he burned his library and sought the answer through meditation. Finally, while he was tending his garden, a tile fell off the roof of his house, and at the sound

264 *Four of the Eight Views of the Xiao and Xiang Rivers*, by Sōami. Early 16th century. Four *fusuma* panels, of a total of sixteen panels now mounted as hanging scrolls. Ink on paper; each: 68 ⅞ x 55 in. (174.8 x 139.7 cm). Daisenin, Daitokuji, Kyoto.

Kyogen achieved Enlightenment. The painting shows him sweeping the area of his yard; at his feet is the tile shattered into three pieces. Startled by the noise, he has taken a step backward and raised his right hand in amazement at the event and at his sudden Enlightenment.

To date, the source for this and the other five Zen themes at Daisenin has not been identified, but it is clear from Motonobu's handling of the composition of each panel that he thought of them as separate narrative units rather than as a continuous and three-dimensional landscape featuring individual figures. As a general rule, Motonobu established the center of the composition with a single motif, such as here with Kyogen's house. Then, to create interest or tension, he placed secondary elements on diagonals, such as the large boulder to the right and the bamboo grove; this also suggests recession into the picture while challenging the primacy of the central image. What he achieved is a series of figure-and-landscape compositions based on small-scale Chinese models but enlarged and made dramatic to enliven the walls of Japanese-style architecture.

THE DEVELOPMENT OF *CHANOYU*

Towards the end of the fifteenth century, under the stewardship of Murata Shukō (1423–1502), the commonplace act of drinking tea and offering it to guests was formalized into a

265 (above)
Zen Patriarch Kyogen Sweeping with a Broom, by Kanō Motonobu.
c. 1513. Hanging scroll, ink and color on paper; 67 ⅜ x 34 ¾ in. (175.1 x 88.4 cm). Tokyo National Museum.

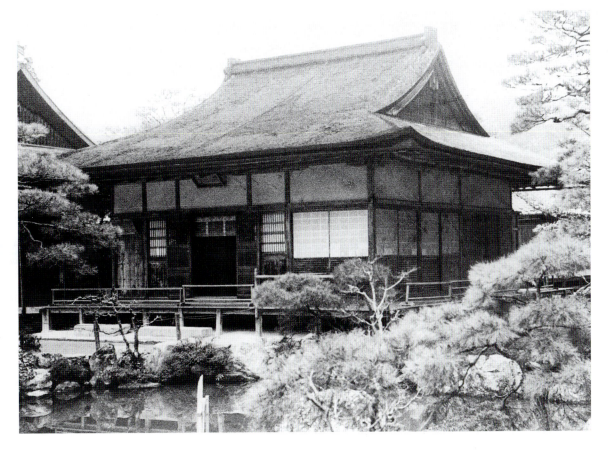

266. (left) Tōgudō, Jishōji (Ginkakuji), Kyoto. 1486.

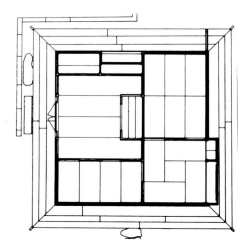

267 Plan of Tōgudō, Jishōji (Ginkakuji), emphasizing Dōjinsai (tearoom).

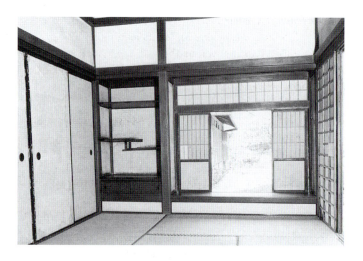

268 Interior of Dōjinsai (tearoom) in the Tōgudō, Jishōji (Ginkakuji). 1486.

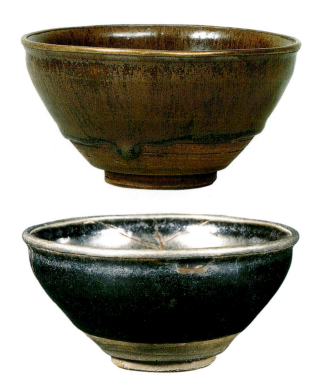

269 Two *Tenmoku* Tea Bowls. Muromachi period, 16th century.
Seto ware; diameter of each 5 in. (12.6 cm), height of each 2 ¼ in. (5.8 cm).
Daigoji, Kyoto.

ritual, *chanoyu*. The space in which the ceremony was held was redefined to express the aesthetic concepts of individual tea masters, Murata's ideas being expressed in the Dōjinsai tearoom in the Tōgudō at Ashikaga Yoshimasa's retreat of Ginkakuji. The building, completed in 1486, was modeled on the western Amida hall of Saihōji and is a single-storied

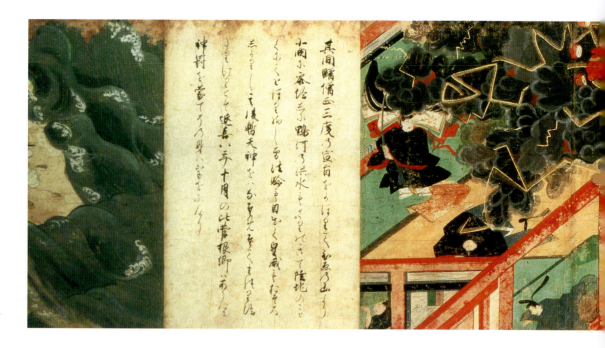

270 Illustration from *Kitano Tenjin engi emaki*, Jōkyū version, Ohara scroll 2, scene 3, showing Sugiwara Michizane as the God of Thunder and Lightning striking down courtiers in the Imperial Palace. Early 13th century. Hand scroll, ink and color on paper; height 20 ¼ in. (51.5 cm). Kitano Tenmangu Shrine, Kyoto, National Treasure.

structure capped by a hipped-gable roof (Figs 266 and 267). The interior displays many of the design features that in the succeeding Momoyama period (1573–1615) are incorporated into the *shoin* style of architecture: a *chigaidana*, a group of shelves interconnected at different heights, a *tsuke shoin*, a shallow alcove with a wide ledge used as a desk, and sliding *shoji* windows (Fig. 268).

The objects used to make and serve the tea, a thick green tea known as *matcha*, were carefully chosen to suggest age and a Chinese aura of simplicity and understated elegance. In response to the changing aesthetics of the times, Japanese potters attempted to imitate the Chinese Jian ware known in Japan as *tenmoku*. The name is derived from Mount Tianmu in China—the Chan monasteries where this type of ceramic was first created for drinking tea were sited here— and in China it originally designated tea bowls decorated with matte black and brown iron glazes. In Japan, the term took on a wider meaning, referring to a tea bowl, usually somewhat conical in shape, that could be decorated with any number of different glazes, ranging from matte to iridescent black and brown (Fig. 269). These glazes could also carry streaks of dark or silvery color, or even almost blue star bursts. The entire effect was meant to appear as a fortuitous accident, and to a certain extent it was. Certainly it was something close to a miracle when the potter was able to get an iridescent effect in the glaze. Such masterpieces were highly prized and given names.

Shinto

As evidenced in the Rekihaku *rakuchū rakugai* screen (see Fig. 193), Shinto remained an integral component in the way that the Japanese approached the spirit world. The many summer festivals, such as the Gion, were to propitiate Shinto *kami* in the hopes that they would save the population from pestilence, earthquake, and warfare. Although shrines associated with the imperial cult were allowed to fall into neglect in the fourteenth to sixteenth centuries, other *kami* cults—particularly those that protected particular communities or that had some influence on natural events—received as much reverence from the common man as that given to Pure Land Buddhism.

In the first half of the medieval period, however, the court and aristocracy still retained enough funds to continue to patronize the Shinto arts, although certainly not on the scale that they had in the Heian period, when family *kami* were equipped with mini-*shinden* and furnishings. One of the *kami* whose popularity continued to grow both at court and among the samurai and populace was the ninth-century deified statesman Sugawara no Michizane, or Kitano Tenjin. A scroll set that purports to be his biography, as well as the story behind the founding of his Kitano Shrine in Kyoto, is the *Kitano Tenjin engi emaki*, dated to around the year 1219. The first scroll relates auspicious incidents leading to Michizane's birth (see Fig. 133) as well as the sad story of his career at court, where as a poet and scholar of Chinese literature he was falsely accused of a crime against the emperor and exiled to Kyūshū, where he died of despair at his undeserved disgrace. His vengeful ghost comes back to kill those responsible for his disgrace. The last scrolls in the set are *rokudo-e* (depicting the six realms of existence), and have little to do with Michizane's life or his revenge. The most exciting scene in the entire set depicts Michizane's vengeful spirit as the red-skinned God of Thunder, riding on a swirling mass of black clouds and wreaking havoc on his enemies in the palace (Fig. 270). The image of the god draws on the same tradition as the sculptures of Fujin and Raijin in the Sanjūsangendō (see Figs 227a and b) and is a vivid depiction of a demon venting his vengeance.

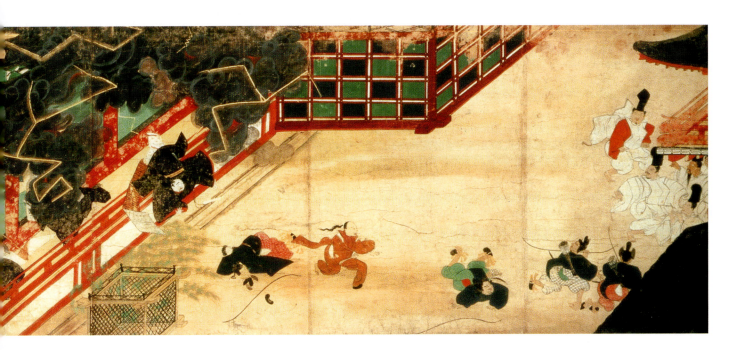

Mandala paintings depicting the paths of pilgrimage to Shinto shrines and Buddhist temples became very popular during this period. However, the most typical of Shinto mandala images is that of the Kasuga Shrine, the family shrine of the Fujiwara (Fig. 271). Although the power of the courtly Fujiwara had been eclipsed in the twelfth century, they were a very large clan with many subbranches within both the court aristocracy and the samurai. The imperial household to this day is still dominated by members belonging to this clan, and the Fujiwara of Iwate province, though tamed by Minamoto no Yoritomo, remained important samurai of the daimyo rank, two generations even serving as shogun of the Kamakura *bakufu* after the assassination of Yoritomo's son. Furthermore, during the Fujiwara's long centuries of power in the Heian period, the Kasuga Shrine expanded in importance from merely family to national significance. In the upheavals of the medieval period, the Kasuga deities were still forces to be reckoned with and turned to for help.

Instead of showing a path of pilgrimage, this Kasuga mandala features a large white deer, manifested on a cloud above the *torii* gate to the compound of the Kasuga Shrine. From its saddle rises a branch of the *sakaki* tree, which is framed behind by the image of a mirror. Standing each on a branch are the five Kasuga *kami*, depicted in their Buddhist forms as Buddhas and bodhisattvas. The mirror, of course, is a reference to Amaterasu, and the part played by the two Fujiwara ancestors in coaxing her out of her cave. The deer is an animal often considered sacred within Japan. From a Buddhist perspective, the Buddha gave his first sermon in a deer park in northern India. Tōdaiji, at the foot of Mount Mikasa, recreates in its grounds such a deer park. However, deer were considered sacred to Mount Mikasa even before the arrival of Buddhism on Japan's shores, and the Kasuga Shrine further up the slopes also has a park overrun with deer. Deer, in fact, have become in Shinto iconography a specific reference to the Kasuga deities, and an essential part of their imagery.

With the close of the Muromachi period, Japan's medieval epoch also comes to an end. Although the system of military dictatorship, or *bakufu*, would continue for the better part of three centuries, Japan's society and culture enter into a new age which elsewhere in the world has been characterized as Early Modern. What this means in terms of Japan is an increasing secularization of all the arts. Buddhism and Shinto will still remain important social and political influences, but culturally they take a back seat as the breakdown of boundaries between the sacred and profane begun by the Zen monk–painters continues. An important component of this process is the rise of the merchant and artisan classes. In the Kofun to Heian periods cultural patronage was dominated by the emperor and aristocracy. In the medieval period, this was transferred to the daimyo and shoguns. While the latter continue to dominate the political and social spectrum in the Momoyama and Edo periods, it is the merchants and artisans— the lowest of the four classes—who begin to take their place, not only as creators of Japanese art, but also as its leading patrons.

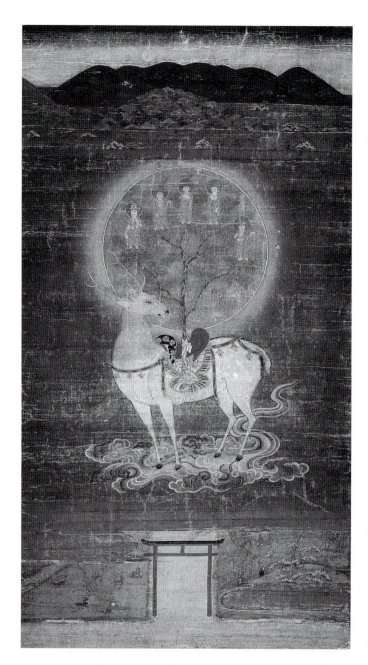

271 *Kasuga Deer Mandala*. Kamakura period, 13th/14th century. Color on silk; 30 ⅛ x 16 in. (76.5 x 40.5 cm). Nara National Museum.

Splendor Regained

THE CREATIVE REVOLUTION OF THE MOMOYAMA AND EARLY EDO PERIODS

Although a period of cultural flowering, the Muromachi period (1392–1573) had also witnessed Japan's most extended and destructive period of social and political disorder. The Ōnin War of 1467 to 1477 and the ensuing century of the Sengoku Jidai (Age of the Country at War) devastated Kyoto and raged over the length and breadth of the country. By the middle of the sixteenth century, all power had long slipped from the hands of the Ashikaga bakufu and the provinces were held more or less autonomously by the daimyo who had survived the wars. Mirroring their official regard for the emperor as head of the nation, most of the daimyo of the first half of the sixteenth century professed at least in words, if not in action or heart, allegiance to the Ashikaga shogun. The battles of the Sengoku Jidai were primarily concerned with clan feuds and territorial rights evolving out of the Ōnin war. However, a few daimyo began to consider ways in which the country could be united under themselves, and even how they might snatch the titles of government to which the Ashikaga and their retainers still clung.

From Azuchi to Momoyama

It was the daimyo Oda Nobunaga (1534–82), the son of a minor vassal, who managed to forge the alliances and win the battles necessary to unify the nation once again under a single administration. By 1568 his formidable army could march on Kyoto and take control of the government, and five years later he was able to chase the last of the Ashikaga shoguns from the city. Among his generals were Toyotomi Hideyoshi (1536–98) and Tokugawa Ieyasu (1542–1616). The political course of the nation would be shaped by these three men over the course of next fifty years, and their patronage and tastes would determine aesthetics and fashion from literature to the visual arts.

Given Kyoto's poor condition—it had burnt again in 1573 when the Ashikaga were chased from the city—Nobunaga decided in 1576 to start anew, and established the headquarters of his government on the shores of Lake Biwa to the north of Kyoto at a small village named Azuchi. The village soon grew into a small city as Nobunaga's magnificent palace took shape. A great many of Kyoto's and the nation's best craftsmen and artists had converged on the site, but Nobunaga also obliged Kyoto's principal merchants and his own retainers to establish their bases there. The palace–castle was seven stories high and he employed the most renowned artist of the period, Kanō Eitoku (1543–90), to oversee the decoration of its walls, screens (*byōbu*), and sliding doors (*fusuma*). After more than a century of political chaos, Nobunaga's overlordship was, to say the least, an uneasy position. While he had pacified the principal, eastern half of Honshū, the daimyo of the western half and the islands of Shikoku and Kyūshū—the so-called western provinces—were either unreliable allies or openly against him. One of the reasons he had decided on Azuchi as his headquarters was so that he could better oversee this western frontier. Although Nobunaga laid the foundation for unification, he cannot be said to have completed it. He never assumed the title of shogun or established his government as a *bakufu*. In June 1582, Nobunaga made an ill-fated journey to Kyoto. While there, Akechi Mitsuhide (1526–82), one of the western daimyo but also one of Nobunaga's main allies, led a surprise attack on him in his residence at Honnōji. Trapped and wounded in the fighting, Nobunaga took his own life in the depths of the burning temple. Mitsuhide then marched on Azuchi and burnt it to the ground.

A month later Mitsuhide's coup was utterly crushed by another of Nobunaga's generals, Toyotomi Hideyoshi. He quickly consolidated his former lord's holdings, and advanced

Nobunaga's plan for unification by subjugating the daimyo of Kyūshū in the following year. It would take fourteen more years to bring the entire archipelago under his control, but that was finally achieved with the help of Tokugawa Ieyasu in 1591. The latter had begun as one of his main competitors in the bid for leadership, but quickly conceded the contest to Hideyoshi, deciding to wait and try again another day. The character of Hideyoshi was both unique and extraordinary within the ranks of Japan's ruling elite at that time. While both Nobunaga and Ieyasu came from daimyo families of middle or low status, Hideyoshi's pedigree was of such low rank amongst the samurai class that his family were virtually peasants. Joining the service of Nobunaga as a foot soldier, he worked his way up through the ranks by his own wits and bravery. He was noted for his exceptional ugliness, and was given by Nobunaga the apparently affectionate sobriquet of "The Monkey" (Saru). He was also noted for his unusual energy. In 1592, he launched the first of two invasions of the Choson kingdom of Korea (1392–1910). Both invasions were ultimately unsuccessful, achieving primarily the utter devastation of Korea's cities and countryside. Perhaps the most notable acquisition the Japanese made from these invasions, aside from a sense of themselves as a conquering nation, was the many thousands of slaves brought back as war booty. In particular, hundreds of Korean potters were captured, and it is due to them that great advances in ceramic—and particularly porcelain—production would be made in the succeeding Edo period (1615–1868).

Significantly, although Hideyoshi did not form a *bakufu* or take the title of shogun, he did take the title of *taikō*, or retired regent—a title once held by former Fujiwara *sesshō* in the Heian period (794–1185)—conferred on him by the imperial court in 1592. His energy was directed not only toward military conquest but also toward administrative and cultural affairs. He took a very active role in the rebuilding of Kyoto, from such grand schemes as the imperial palace and city walls to smaller projects involving Buddhist temples and Shinto shrines. Indeed to prevent the city of Kyoto from becoming once again a battleground for large armies, he commanded the narrowing of the broad Tang Chinese-style avenues laid out when the capital was first built in the late eighth century. Fundamental to Hideyoshi's administrative and cultural policies was his desire to project himself as an effective ruler who governed by virtue of his wisdom, his knowledge of historical precedents, and his respect for tradition. By 1583, he had already completed his elegant mansion of Jurakudai in Kyoto, entertaining the emperor there in the same year. To further publicize his noble virtues, he often engaged in lavish displays: pilgrimages in the company of his daimyo vassals and their servants to view the cherry blossoms at Yoshino, elaborate tea ceremonies for all the people of the Kyoto area at the Kitano Shrine, organized by his tea master Sen no Rikyū (1522–91).

Rikyū, the son of a merchant family from Sakai, near Osaka, served as tea master to Nobunaga before serving Hideyoshi and significantly influenced the development of the tea ceremony, moving it toward his own concept of *wabi*. Rikyū's delineation of the paraphernalia required for the appropriate practice of the ceremony was an especial boost to the ceramic and lacquer industries. However, given Hideyoshi's taste for splendor and excess, Rikyū had a sometimes troubled relationship with his lord. Ultimately in 1591 he was obliged to commit suicide, some sources attributing Hideyoshi's displeasure to Rikyū's refusal to give his daughter to the *taikō* in marriage.

Hideyoshi built several castles, but the most important was his castle–palace of Momoyama, built in 1593 on the hill of Fushimi to the south of Kyoto. By all reports, it outdid in sumptuousness Nobunaga's Azuchi, and has given its name to the period of Nobunaga's and the Toyotomi family's regimes (1573–1615)—also known as the Azuchi–Momoyama period. Although no longer extant today, parts of Momoyama Castle can still be found all over Kyoto, because when it was dismantled in the subsequent Tokugawa regime whole sections of its fabric were gifted to different Buddhist temples in the city. One measure of Hideyoshi's success is that, unlike other samurai leaders of the time, his death in 1598 was a natural one. Hideyoshi left a five-year-old son, Hideyori, as his heir and a council of daimyo vassals to govern during the child's minority. Disputes soon broke out within the council, and it split into two factions, one loyal to Hideyoshi's son, the other to one of the council members, Tokugawa Ieyasu. In 1600, the situation came to a head in the battle of Sekigahara, with Ieyasu achieving a tentative victory. Once again, it was the indecisiveness of the coalition of western daimyo about which faction to support that ultimately gave Ieyasu his complete victory.

Tokugawa Ascendancy

Hideyori's supporters withdrew with him to another of Hideyoshi's great strongholds, Osaka Castle. Like Nobunaga before him, Ieyasu had the certain loyalty of the eastern half of Honshū, but in the western half and the islands of Shikoku and Kyūshū his influence was much less significant. For this reason he did not move immediately to eradicate Hideyori, who still held the title of *taikō* inherited from his father. Instead, he played the political game that has shaped so much of Japanese history—paying lip service to an opponent while preventing him the exercise of power and taking that privilege upon himself. Therefore, in 1603 Ieyasu had the emperor confer on him the title of shogun, and reinstated government by *bakufu*, installing it at his fortress at Edo, present-day Tokyo. In 1590, when Hideyoshi had awarded Ieyasu with the entire Kantō region of eastern Honshū as his domain, Ieyasu had established a stronghold on the coast at Edo, to the northeast of Kamakura. Once he became shogun, he obliged his principal daimyo to send him family members as hostages to be kept in Edo to ensure their loyalty to him. Such hostages had become a standard transaction between the daimyo of the

medieval period to seal bonds of alliance and loyalty. Ieyasu himself had spent almost his entire childhood and youth as a hostage to ensure his family's loyalty to a more powerful daimyo. Then, in 1605, he avoided Hideyoshi's mistake of leaving unprepared heirs and passed the position of shogun to his adult son, Hidetada (1579–1632).

As retired shogun, however, Ieyasu kept his hands very much on the reins of power. Nine years later he finally judged the time right and moved against the Toyotomi at Osaka Castle. Hideyori's support had diminished somewhat, but this last battle was not brief. It lasted from the winter of 1614 and into the summer of 1615, with Hideyori's 90,000 men arrayed against Ieyasu's 180,000. The winter campaign cost Ieyasu's forces alone 35,000 lives and in the summer he resorted to deceit, and thereby managed to take Osaka Castle. Hideyori committed suicide, his young sons killed, his supporters executed, and the castle razed to the ground. Two hundred and fifty years of uncontested Tokugawa rule then began.

Ieyasu died a year later and the sons and grandsons who succeeded him as shogun carried on his work of bringing the daimyo and nation firmly under their control. In the first part of the seventeenth century the bakufu formulated a series of edicts meant rigidly to restructure the class system which had broken down in the chaos of the previous century. One of Oda Nobunaga's first acts in the 1570s had been to disarm the peasants and townsfolk who armed themselves out of self-defence during the desperate times of the Sengoku Jidai. Hideyoshi reinforced this policy, and Ieyasu and his heirs set it in stone. The sixteenth century had also been a period of Japanese travel and of many foreigners coming to trade in Japan. Not all the roaming Japanese were merchants or pilgrim monks; the Japanese had a nasty reputation, long before the invasion of Korea, for piracy along the Korean and Chinese coasts. It was at this time that the first European traders arrived, and with them came Christian missionaries, in particular priests of the Franciscan and Jesuit orders. There is a genre of screen painting, known as namban screens, devoted to images of these outlandish foreigners. The missionaries had a certain amount of success, even converting some leading daimyo, however they were largely met with suspicion by the ruling elite. In 1587, Hideyoshi prohibited the practice by Japanese of Christianity, and chased the Jesuits from the port of Nagasaki—they had been given it by the local daimyo. Then, in 1598, the year of his own death, he created Japan's first Christian martyrs at Nagasaki with the execution of twenty-six Spanish and Japanese Jesuits and Franciscans.

Ieyasu and his heirs also took a dim view of Christianity and by extension the foreign influence exerted by the Portuguese and Dutch traders at the nation's ports. In particular the Europeans favored the ports of the island of Kyūshū, the loyalty of whose daimyo the Tokugawa were the least sure. The island's main port of Nagasaki, however, was closest to the European traders' continental markets, and Ieyasu was unsuccessful in trying to persuade them to come instead to the port of Edo. The conversion of another of these Kyūshū daimyo to Christianity further compounded the problems. Ieyasu's heirs issued a series of edicts in the 1620s and 1630s gradually reinforcing the prohibition of Christianity and increasingly limiting the population's access to foreign influences. This seclusion policy was completed between 1635—when Japanese were forbidden to travel abroad—and 1641—when the Dutch, alone of the Europeans, were allowed to stay, but limited to a trading post on Deshima Island in Nagasaki harbor. The Chinese were also confined to a quarter within the city itself. This hermetic sealing up of the nation marks the end of the relatively freewheeling social and cultural spirit that dominated the Momoyama and very early Edo periods. Over the following two hundred years, Japan and the Japanese would turn in on themselves, and yet, true to their fashion, would still manage to enjoy one of the most vibrant periods in the history of their culture.

Urbanization and the Seeds of Social Transformation

In large part this was due to the urbanization of Japanese society that occurred between 1580 and 1640. Kyoto itself was returned by Hideyoshi to its previous splendor, and Edo after 1603 became a rapidly growing metropolis as the center of the Tokugawa bakufu. Ports such as Nagasaki in Kyūshū and Osaka (formerly Naniwa) also flourished during this period. However, other new cities grew up around the castles of several of the major daimyo. Among the most important of these castle towns were Himeji, Kanazawa, Wakayama, Kōchi, Hiroshima, Okayama, Kōfu, Sendai, Kumamoto, Hikone, Yonezawa, Shizuoka, and Nagoya. Their creation during this period has been characterized by the historian John Whitney Hall as perhaps the most intensive urban construction in world history. Although peace had returned to the nation, the lot of the farming peasants could not be said to be an improvement on their situation in either the Heian or medieval periods. They were still little better than bonded serfs and the burden of taxation only increased as the Edo period went on. Furthermore, the upheavals of the Sengoku Jidai had deprived many of them of their traditional land holdings. Thousands fled to the new towns to find work in the craftsmen's guilds or as merchants.

Although these two groups of townsfolk, or **chōnin**, represented the very lowest rank of the social order, they had also already begun in the late medieval period to represent the wealthier portion of Japanese society. By the Momoyama and early Edo periods the wealthier, educated sections of the artisans and merchants had formed a distinct demographic within the chōnin class. Throughout Japanese history there had always been a group of nonpolitical but grand families primarily involved in manufacture and trade. The most prominent example were the Hata, who in the fifth century are credited with the first real development of sericulture and silk weaving in Japan. Of foreign origin, possibly Chinese or Korean, the

Hata nevertheless from the fifth century onward had close relations with the imperial court, intermarrying with the aristocracy, albeit with those of lower rank. The abortive capital of Nagaoka was built on land purchased from the Hata, and during the Heian period they established many Buddhist temples and Shinto shrines in the capital and the surrounding area.

By the late sixteenth century, quite a few such manufacturing and trading families had grown up in the cities and formed close ties with both the samurai and the court aristocracy. They looked ultimately to the latter, however, as their cultural model. Many impoverished aristocrats had turned to such merchants to resolve their financial difficulties, and not infrequently ended by tutoring their children. The first evidence for these lower-class literati can be found in the *tonseisha* or monks of low birth, and then simply in men of low birth whom the Ashikaga cultivated as their cultural advisers from the late fourteenth century onward. By the Momoyama and early Edo, not a few acknowledged experts in calligraphy, the classics, Chinese painting of the professional and literati styles, the ancient traditions of *yamato-e* and of newer traditions such as the tea ceremony (*chanoyu*) and the dramatic arts were men of the *chōnin* class.

The most famous cultural hero of the time, Sen no Rikyū, came from a wealthy *chōnin* family, the artists of the Muromachi period Ami school were certainly of the *chōnin* class, and the authenticity of the Kanō school's claim to a samurai ancestor has been questioned. By the time Nobunaga took control in the 1570s, the Kanō school had eclipsed the Tosa artists of the imperial court and reigned supreme as the artistic force in the capital. The artists who studied in their ateliers came almost totally from the *chōnin* class and would in the course of the late sixteenth century become the arbiters of taste for *taikō*, shogun, and daimyo.

Unlike the Ashikaga, the samurai elite of the late sixteenth and early seventeenth centuries were self-made men who did not look overmuch to either the court or the great religious establishments for their advisers. Indeed, many of the religious establishments themselves—a great many of which were rebuilt and resuscitated during this period—also increasingly looked to the secular culture of the *chōnin* for their artistic inspiration. The art of this time, therefore, is notably more secular in its themes. It has two distinct phases. The first phase is roughly contiguous with the regimes of Nobunaga and Hideyoshi and is characterized by their exuberant expansiveness, the second begins with the Tokugawa ascendancy and is marked by self-assurance, a spirit of reflective introspection, and a calculated return to historical precedents.

Men such as Nobunaga and Hideyoshi were pragmatic and astute with little formal education, but with confidence in their military prowess and their administrative ability. While taking guidance from others, they also had their own ideas of what they wanted from art, and that was a brash and bold statement. The arts most characteristic of this first phase employed brilliant colors, gold-leaf grounds, and strong decorative patterns. In painting, the preferred formats were sliding-door panels, known as *fusuma*, and folding screens, or *byōbu*. One reason for this is the large castle residences being built during this period. Because they retained a primarily defensive nature, they often had dark interiors. Filling the rooms with screens and door panels painted with scenes on golden backgrounds not only changed them into impressive palaces, but also made optimum use of any light that might penetrate into a given room. The collective term for this type of painting is **shōhekiga** (or alternately *shōbyōga*). The average screen is about 5 feet (1.5 m) tall and around 12 feet (3.5 m) long, while *fusuma* are tailored to fit a specific architectural space, with sets of them that can range up to thirty feet or more in length.

Although the second phase of this artistic revolution actually overlaps with the last decade of Hideyoshi's regime, it gained its true momentum with the Tokugawa ascendancy. Particularly important for setting the mood of this second phase were a group of artists whose tastes had been formed within the world of the wealthy and educated *chōnin* and who imposed their ideas on their patrons. In their work can be found a return to older traditions of painting, although reworked and adapted to the desire for monumentality or eye-catching design so much enjoyed in the late sixteenth and early seventeenth centuries. The greatest of these artists, Hasegawa Tōhaku (1539–1610), Kaihō Yūshō (1533–1615), and Hon'ami Kōetsu (1558–1637), were all apprentices in the Kanō atelier, but went on to careers in which they created their own distinct and refined aesthetic. Tōhaku and Yūshō did this largely within the traditions of Chinese-style paintings, but Kōetsu, in partnership with the artist Sōtatsu (act. 1600–40), revived *yamato-e* style in both calligraphy and painting. Tokugawa Ieyasu was so taken with Hon'ami that, in the same year he wreaked utter destruction on the Toyotomi, he granted Hon'ami an estate to the northwest of Kyoto where he could create a quasi-Buddhist community of artists and craftsmen. As an artistic community, Takagamine would thrive until Hon'ami's death two decades later, and out of the traditions established there would grow the **Rinpa school**, the stylistic repercussions of which are still being felt in the Japanese arts today.

Architecture

Two new forms of building were developed during the sixteenth and early seventeenth centuries to meet the needs of the new elite: the castle and the *shoin*. The former encapsulated the country's military vigor while the latter established a form of residential building that has proved a model for Japanese architecture ever since.

CASTLES

The period of constant warfare launched by the Ōnin War caused the creation of a unique and wholly indigenous building—the Japanese castle. Before the late Muromachi period,

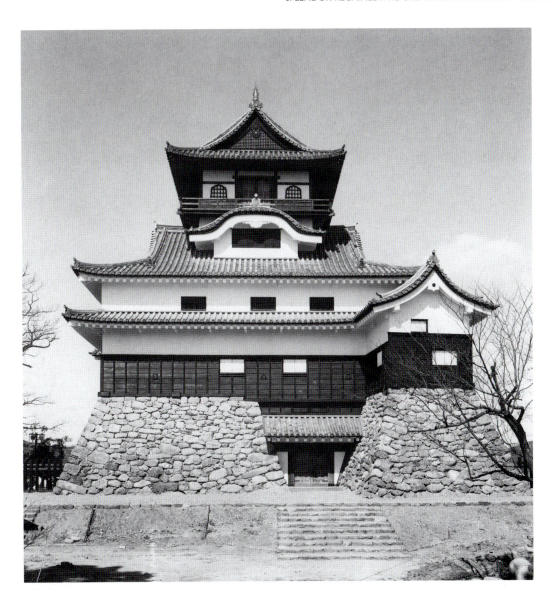

272. *Tenshu*, Inuyama Castle, Inuyama, Gifu prefecture. Early 17th century, with some remodeling.

military fortifications were simple wooden stockades at strategic sites—staging areas from which to launch attacks and in which to take shelter in time of siege. In the course of the sixteenth and early seventeenth centuries, a new type of permanent stronghold was developed that could serve as the seat of government for the domain, the residence for the local daimyo, a garrison for his army, and a fortress impregnable to arrows, catapults, and, toward the end of the period, the firearms introduced by European traders. The first of these castles can be dated possibly as early as the 1530s, and within the space of forty years had evolved into such edifices as Oda Nobunaga's Azuchi, incorporating a palace into defensive fabric capable of conducting the business of state, as well as the enjoyment of leisure pursuits. Above all, palace–castles such as Azuchi, Momoyama, Osaka, and later Edo were a stage set that proclaimed the power and importance of their lord. When a castle changed hands, it was often deemed incumbent upon the new proprietor to enlarge the building as proof of his military superiority. Most of the castles surviving today were built

in the years 1600 to 1615—between the battle of Sekigahara and the final destruction of the Toyotomi clan—when this architectural form reached its maturity. After their victory over the Toyotomi, the Tokugawa wasted no time in issuing an edict regulating the building of castles and limiting the number a single daimyo could maintain, and finally, in 1620, they issued an outright ban on new castle construction.

One of the few structures thought to preserve the flavor of early castle construction is located at Inuyama, a town on the Kiso River north of Nagoya (Fig. 272). Once dated as early as 1469, it is now believed to be no earlier than the late sixteenth century. Nevertheless, it is thought that the lowest two floors are similar to the early sixteenth-century structures. Castles were usually built on hills, at the crest of which would be placed the *tenshu*, or keep, a defensible residence and refuge of last resort within the complex as in European castles. The other basic component of the castle structure was the massive stone wall lower down the hill's slope, punctuated by an entrance gate overlooked by a watchtower.

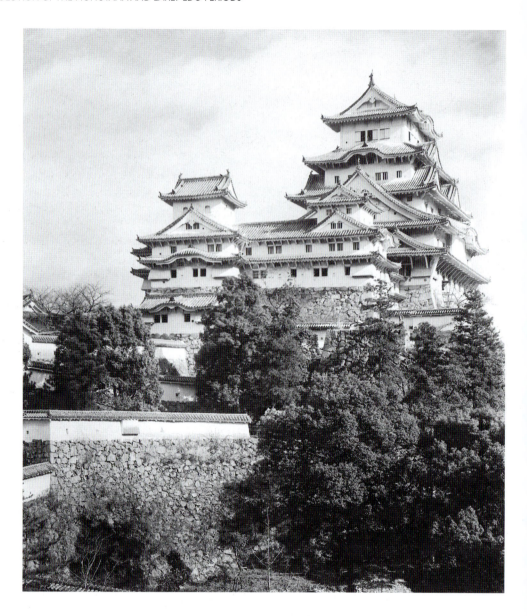

273 Himeji Castle, Hyōgo, near Osaka.
1601–9.

Today, only the *tenshu* of Inuyama Castle survives, a four-storied structure set on a tall, tapering stone base. To facilitate drainage, the walls around the castle and the base of the *tenshu* were of dry-stone construction (i.e., no mortar was used), employing a series of different materials. The external layer, the outer face of the wall, is roughly dressed stone, the next is smaller crushed rock, then gravel, and finally there is a core of sand. Not only did this building method allow rain water to drain away effectively, but it also proved resistant to earthquakes; mortared stone walls would have more easily cracked and shattered. The interstices of the outer face, however, would have been tightly crammed with gravel and sand in order to prevent the wall being easily scaled by the enemy. The main body of the Inuyama *tenshu* has two stories constructed of wood and white plaster, and a single, hipped-gable roof. A much smaller watchtower surmounts the *tenshu* and is capped by a hipped-gable roof with its ridgeline at right angles to the ridgeline of the roof below it. The curved, so-called

Chinese gables to the north and south were added during a renovation of 1620. The roofing material today is ceramic tile, but evidence suggests that early castles were roofed with wooden shingles.

Unfortunately none of the great castles of the period—Azuchi, Momoyama, or Osaka—have survived to the present and what remains of Edo castle reflects much later alterations. Himeji, popularly known as White Heron Castle, is therefore arguably the most beautiful surviving example of this architectural form in Japan today (Fig. 273). In 1581, at the site of the present structure to the west of Osaka, Hideyoshi built a three-storied *tenshu* on land belonging to a daimyo he had bested in combat. In 1601, after the Toyotomi defeat at Sekigahara, the castle was transferred by the victorious Ieyasu to his son-in-law Ikeda Terumasa (1564–1613), who was charged with governing the western provinces and keeping an eye on the Toyotomi in Osaka Castle. Between 1601 and 1609, Himeji was rebuilt in its present form. Several of the most

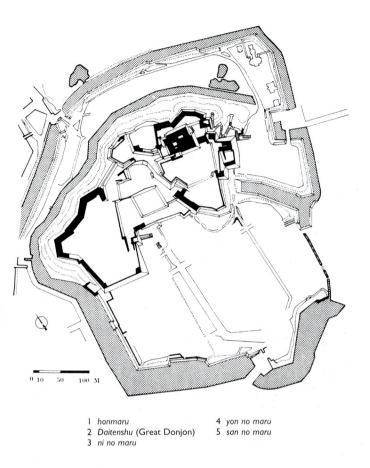

I *honmaru*
2 *Daitenshu* (Great Donjon)
3 *ni no maru*

4 *yon no maru*
5 *san no maru*

274 Plan of Himeji Castle. (Pierre and Liliane Giroux, after Ōta Hirotarō, from *The Art of Ancient Japan*, Editions Citadelles, Paris.)

SHOIN

The second architectural innovation in the Momoyama period was the *shoin*, an elaborate form of residence that evolved out of the aristocratic *shinden*. Its development begins with the political ascendancy of the samurai class in the medieval period, but it reached its mature form in this period. *Shoin* architecture, and particularly the living–reception room, reflects the formalized relationship between samurai lord and retainer. The most important room in a *shoin*, whether that of a shogun, daimyo, or retainer, was the space where the master might entertain either his lord or his vassals. In its most developed form it consisted of two levels, the floor of the upper section elevated a few inches above the lower. The highest-ranking samurai, whether he was the master of the house or not, sat on the upper level. Behind where he sat was a **tokonoma**, a shallow raised alcove where a scroll might be hung and a flower arrangement or objects of value might be displayed (Fig. 275). Next to the *tokonoma* there was usually another alcove, a recess of comparable depth with compartments above and below, and in the center a *chigaidana*, or group of interconnected shelves at different heights. At right angles to these two alcoves was a small room known as the *tsuke shoin*, or attached study, which projected from the wide veranda outside. In the wall facing the veranda was a large window, often circular or bell-shaped in the Chinese style and covered with opaque paper. Below it would be a set of cabinets, often used as a desk. At right angles to the window wall was another set of shelves, on which books and writing implements could be displayed. Opposite the *tsuke shoin* there was usually a set of four *fusuma* in the wall of the main room, about two-thirds of its

important figures of the period had a hand in its construction, and the scale of the buildings and the intricacy of their configuration are in stunning contrast to the simplicity of Inuyama Castle.

The entire complex consists of several maze-like enclosures arranged around the central enclosure, or **honmaru**, where the *tenshu* stands (Fig. 274). Castle enclosures could be laid out in a number of different ways: in a ladder-like progression up a hill, as a series of concentric rings with the *honmaru* at the heart, or in a number of interlocking units as at Himeji, this last being the most effective militarily. To approach the *tenshu* of Himeji Castle, would-be attackers had to cross broad open areas, follow paths at odd angles to the main structure, and pass through narrow gates flanked by strongly fortified watchtowers. The *honmaru* itself consists of four main buildings: three three-storied keeps linked by crossing towers and a five-storied *tenshu*. This rectangular complex surrounded what was originally a working garden. The *honmaru* is virtually impregnable, yet the *tenshu*, its sequence of tiled roofs punctuated by curved Chinese gables and sharply pointed triangular gables, has a light, ascending rhythm that suggests the graceful white heron, or *shirasagi*.

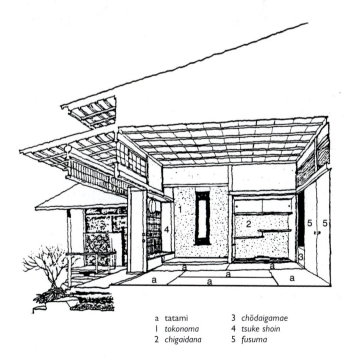

a *tatami*
1 *tokonoma*
2 *chigaidana*

3 *chōdaigamae*
4 *tsuke shoin*
5 *fusuma*

275 Cutaway drawing of main room in *shoin* building.

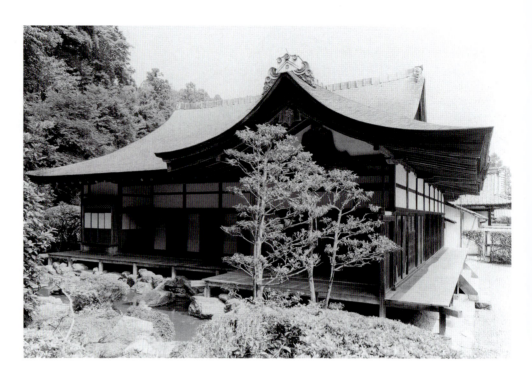

276 Kyakuden (Guest Hall), Kōjōin precinct, Onjōji, Shiga prefecture. 1601.

height. The purpose of the area behind the doors, known as the *chōdaigamae*, depended on the needs of the lord. In daimyo mansions the doors might conceal a waiting room for bodyguards. In less official structures, they might lead to a bedroom, and sometimes they served merely as ornamentation. It is also in this period that the tatami mat began to be used to carpet the entire floor surface of a room. Tatami came in standardized sizes, although these standards can differ from region to region. Room dimensions from this period onward, therefore, would be set with an eye to how the tatami mats could be configured to cover the floor surface. It soon became standard to describe a room as being so and so many mats—a five-mat room, a seven-mat room, and so forth.

A simple form of fully developed *shoin* architecture is seen in the *kyakuden*, or guest hall, of the Kōjōin precinct within Onjōji, a temple on Lake Biwa (Fig. 276). Just like the court aristocracy, samurai would use temples as places of retreat or permanent retirement, and in the late sixteenth and early seventeenth centuries a great many *shoin* retreats were established in temples famous for their tranquillity or scenery. This was one of the important ways in which many suburban or provincial temples damaged during the Sengoku Jidai could obtain the patronage of wealthy daimyo—vital if they were to carry out rebuilding and refurbishment. Built in 1601 by a samurai who had been ordained and retired to Onjōji, the *kyakuden* is one of the earliest surviving examples of the *shoin*. The oblong building is divided into five rooms of differing dimensions. The entrance is on one of the narrow sides of the structure. One ascends the stairs in front of a carriage rest—a spot where a two-wheeled carriage can be left once the oxen have been released from their shafts—and enters a small vestibule; ahead is the master's reception and living room. Opposite its entrance door are a *tokonoma* and *chigaidana*, and

at the left a *tsuke shoin* with its own *tokonoma*. To the right of this main room are smaller rooms, the master's sleeping quarters being set behind the *chōdaigamae*. A veranda surrounds the building, wider on the long side facing the garden to permit sheltered viewing of nature in its seasonal changes.

One of the grandest examples of *shoin* architecture at the beginning of the Momoyama period would have been Hideyoshi's Jurakudai residence behind the imperial palace in Kyoto. However, he had it dismantled in 1595 after the suicide of his nephew there. Fortunately, Nijō Castle, the residence of the Tokugawa in Kyoto—although the shoguns primarily resided in Edo—has survived to the present. The Ōhiroma, or Great Audience Hall, was remodeled around 1625, and includes the elements already seen in the Kyakuden, but on a grand scale appropriate for formal interviews with the shogun

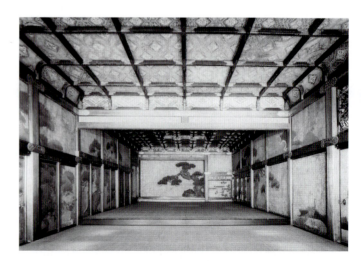

277 Ōhiroma (Great Audience Hall), Nijō Castle, Kyoto. *c.* 1625.

(Fig. 277). This room occupies the long side of the building facing the garden and consists of two main areas: the lower level for the shogun's vassals, and the upper level, where the shogun sat, backed by a *tokonoma* painted with a massive pine tree set against a gold ground, a visual metaphor for the strength and enduring nature of his *bakufu*. To the right of the *tokonoma* is a *chigaidana*, and—on the long wall facing the garden—a *chōdaigamae* leading to a waiting room for bodyguards; to the left, an abbreviated attached study, or *tsuke shoin*. The ceiling is elaborately coffered, and the panels above the decorated sliding doors are deeply carved and brilliantly painted with flower and cloud motifs.

Katsura Imperial Villa

Both Hideyoshi and the early Tokugawa shoguns subscribed to the importance of a stable and fairly prosperous emperor and court, albeit one with a cultural rather than a political role. They therefore ensured that the imperial house and its leading courtiers had the means to keep themselves in a manner appropriate to their station. The tradition of the aristocratic mansion also experienced a revival during this period, and one of the most superbly designed buildings of the early seventeenth century is a palace retreat, the Katsura Imperial Villa located on the Katsura River to the southwest of Kyoto (Fig. 278). Built originally between 1620 and 1624 for Prince Toshihito (1579–1629), the buildings and surrounding grounds combine a style of artlessness known as *sukiya*—a subdued and unostentatious effect achieved through painstaking attention to detail—with specific elements recreated from the *Genji monogatari*, one of the prince's favorite books (see pages 116–118). The last palace that Genji built was called Katsura because it too was located along the Katsura River. As described in the novel, Prince Toshihito's villa has in its grounds a large lake with several artificial islands, a rustic fishing pavilion, and a lodge next to the racecourse for the games held in conjunction with the festival at the Kamigamo Shrine in Kyoto. The buildings of the original villa consisted of a main *shoin* (known today as the old *shoin*, or *koshoin*) with a bamboo-floored moon-viewing platform, a smaller *shoin*, and a music room set in the garden grounds. In 1642, a new *shoin* was built onto the southwest side of the older structure, greatly extending the horizontal nature of the building. Inside, no provision was made for emphasizing the rank of individual guests by different floor levels or by connotative images in the *tokonoma*. The palace was designed for the informal assembly of courtiers and the imperial family, as a place where they could put aside issues of class and in a relaxed atmosphere enjoy the few gentle cultural pursuits the Tokugawa *bakufu* permitted them.

Especially notable at Katsura are the surprising, but pleasing, visual and spatial dissonances that occur in the design of the buildings and in the disposition of decorative patterns. Viewed from the front, the *koshoin* appears to be a stable, rectangular structure capped with a hipped-gable roof

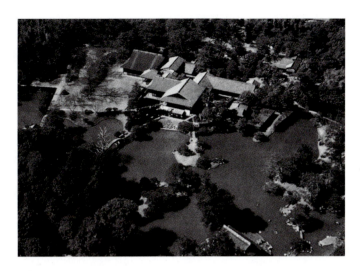

278 Aerial View of Katsura Imperial Villa, Kyoto. 1620–23.

(Fig. 279). However, the section on the extreme lower right, which looks like a solid wall, is actually a wood-and-plaster panel concealing the stairs leading to the moon-viewing balcony. To the left of the balcony are grouped a number of irregular stones that obscure the base of the building, making it seem to float above the ground. If you follow the path around the lake, you notice similar spatial dissonances. As you pass through a wooden gate, nature at first appears neatly manicured. Moss surrounds the stones of the path, and trees border the area in a regular pattern. The space then narrows between path and trees, and you must duck under overhanging branches. Suddenly the path curves sharply, and interrupting an open vista of the lake you see an island with a replica of Mount Horai—of Chinese Daoist mythology—and Katsura Villa beyond. Along the path around the lake, interesting contrasts of textures also arrest the eye. Cleanly

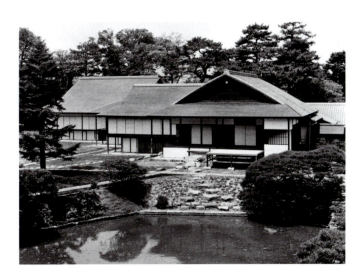

279 General view of *shoin*, Katsura Imperial Villa. 1620–4.

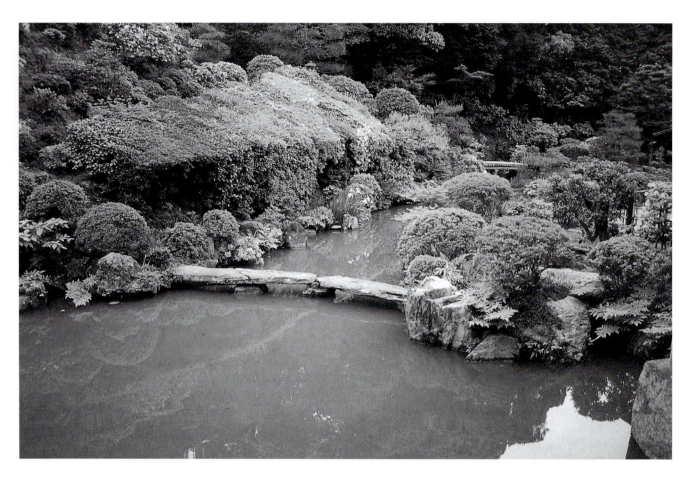

280 View of the gardens seen from the tea house of the abbot's residence, Chishakuin, 17th century.

dressed stones lie next to irregularly shaped rocks. Different patterns of bamboo are juxtaposed in fences and walls. To see Katsura is to experience an almost symphonic variety of patterns, discordant shapes, and surprising contrasts of spatial elements.

Nijō Castle, though in the heart of Kyoto, was also provided with a large park containing a lake, but the miniature gardens meant to be viewed from the veranda of a temple residence or tearoom—first created within the Zen subtemples of the late Muromachi period—also remained an important art form. One of the more beautiful is the garden created beside the abbot's residence of the Chishakuin (Fig. 280). This Shingon temple of the Chizan sect was founded in 1601 at the base of Higashiyama to the west of Kyoto. It was built on the site of a temple destroyed by Hideyoshi in 1585 because its warrior–monks were considered a challenge to the capital's newly reestablished peace. The temple is most famous for a series of wall paintings by Hasegawa Tōhaku (see Fig. 301), but the garden designed by one of its early abbots, Zuio Hakunyo, is a masterpiece of early-Edo garden design. The main part of this viewing garden is a long, narrow pond ranged off the veranda of the residence, which at one end has a tearoom. Although designed for contemplation, this is most definitely not a dry garden of stones and gravel. The pond is bordered by careful plantings, some of which have been sculpted in shapes to suggest the rolling foothills typical of the Kyoto region.

Genre Painting

Scenes of contemporary life are an important element of the secular themes in the art of the time. Such genre imagery dates back to at least Heian times, but its revival in the sixteenth century is a consequence of Tosa Mitsunobu's (1434–1525) invention of the *rakuchū rakugai* with its panoramic vision of life in Kyoto. Genre imagery from the *emakimono* was reformatted to the large canvases of screens and door panels favored in the sixteenth and early seventeenth centuries. For the next century and a quarter, genre paintings were a favorite form of pictorial expression, and scenes ranged from panoramas of Kyoto and Edo, through special occasions such as viewing the cherry blossoms in spring or the red-leafed maples in the fall, the festivals such as the Gion, and theatrical performances, to the interiors of samurai and wealthy *chōnin* households, and even of the brothels of the pleasure districts, and also the comings and goings of Europeans in their exotic costumes. The Kanō school, as in the

Fusuma, Screens, and *Shoji*

Shōhekiga (or *shōbyōga*), paintings on sliding doors (*fusuma*) and freestanding folding screens (*byōbu*), while not unique to Japan, were developed into major formats for painting in the Momoyama and Edo periods. The basic module for both *fusuma* and screens is a panel consisting of a light wood frame enclosing a lattice of thin wood strips. Over this foundation, pieces of paper are pasted to build up a backing that can support the surface, usually paper, but occasionally silk, on which a painting has been executed. Each fusuma door is provided with an outer frame, usually black-lacquered wood, and a metal handhold near one edge, enabling the door to be pushed back and forth without damaging the painted surface. Screen panels are narrower than *fusuma* and are joined together with a complicated system of hinges. The perimeter of the whole is framed, usually with wood that is lacquered black.

During the Momoyama period, screens and *fusuma* came into wide use in residential architecture for the nobility, the daimyo and samurai, and wealthy townsmen. In conjunction there developed a new aesthetic of bright colors, including gold and silver paint on a ground of gold leaf or occasionally silver leaf. It has been suggested that gold leaf became popular because it reflected and augmented the dim light in castles. Another theory is that specific landscape screens using gold leaf and bright colors were intended to suggest the gold and jeweled environment of Amida's Western Paradise. While both of these conjectures are justifiable, it is also true that gold grounds were a natural expression of the sudden affluence of the Momoyama period.

Japanese gold leaf is known to be the thinnest in the world, and the technique for making it is labor intensive. There are three stages in the process: the preparation of the alloy and its shaping into squares; the *zumiuchi*, the initial beating process, in which the squares are thinned out; and the final beatings and finishing of the leaves. At the *zumiuchi* stage, thin sheets of gold are placed between specially prepared leaves of paper, bundled in paper and then in cat skin, and beaten by hand or machine. The whole process is repeated about five times and is very time-consuming. The process of preparing the beating papers alone takes a total of six months.

The application of gold leaf to the papered surface of a screen changed over time. The size of the individual leaves decreased from about 5 x 5 inches (12 x 12 cm) in the fifteenth and sixteenth centuries to 4 x 4 inches (9 x 9 cm) in the Edo period. In the sixteenth century, the paper to which the leaf was adhered was usually painted red to give the gold a richer tint. The edges of gold clouds were scalloped and slightly raised over a narrow rim of gesso.

Another door and window treatment popular from the Momoyama period onward is the *shoji*. What distinguishes the *shoji*, whether fixed in place or used as sliding doors, is the translucent white paper pasted over one side of a wood lattice-work, like that at the core of the *fusuma*. *Shoji* give a Japanese room a soft, diffuse light and a sense of separation from the outdoors or the adjoining space.

fusuma

byōbu

shoji

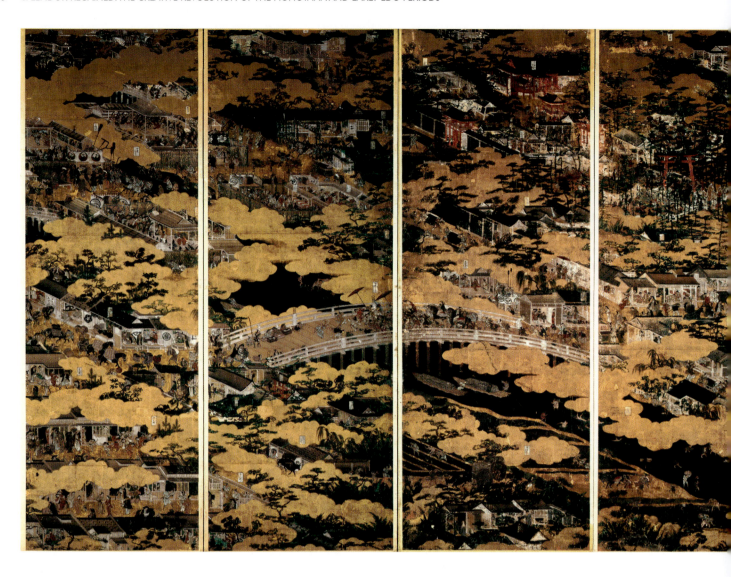

281 Right screen of a pair of six-panel *rakuchū rakugai* screens known as the Funaki screens. 1614–15. Ink and color with gold leaf on paper; each screen: 63 ¾ x 134 in. (162 x 340 cm). Tokyo National Museum.

rest of painting, led the way in genre subjects, but there was a great mass of independent painters and minor schools also actively engaged in producing these images. Unfortunately their names have been lost to history.

The pair of *rakuchū rakugai* screens known as the Funaki set (Fig. 281) are dated to the years 1614 to 1615, when the Tokugawa were making their final assault on Osaka Castle to the south of the capital. However, the images of the city depicted in these screens could not be more different than those shown on the Rekihaku screens of the 1530s (see Fig. 203) and are some of our best evidence for Hideyoshi's reconstruction of the city. Both are idealized visions of Kyoto, but where in the Rekihaku screens large banks of clouds or fields covered areas that more than likely were instead barren wasteland, in the Funaki screens there are no fields and the clouds are ranged in ranks to frame a city replete with well-kept edifices and streets teeming with people. Of course, part of this

effect is created by the more intimate view of the city provided in the Funaki screens. Where, for the Rekihaku screens, the bird's-eye view was taken at quite a height above the city, the viewer for the Funaki screens flies, as it were, at a much lower altitude. One consequence is that much less of the city is covered by the Funaki set, but it also gives the impression that the city is now of such dimensions that it could hardly be encompassed by two almost 7 feet (2 m) long screens.

In terms of buildings, the focal point of the right-hand screen is the image in the first two panels of Hōkōji, Hideyoshi's challenge to the Daibutsuden of Tōdaiji. Begun in 1584 and finished in 1587, the temple contained a monumental bronze image of the Buddha even larger than the one in Nara, and furthermore was completed in three years instead of twenty. Destroyed in 1596 in an earthquake, it was put up again in 1612, but once again destroyed by an earthquake in 1622. At the top of the two middle panels is his mausoleum, the shinto shrine known as the Hōkōkubyō. On the last two panels of the left screen is depicted Nijō Castle of the Tokugawa, and in the first panels of this screen the portable shrines of the Gion procession. The sandwiching of the city

Fusuma, Screens, and *Shoji*

Shōhekiga (or *shōbyōga*), paintings on sliding doors (*fusuma*) and freestanding folding screens (*byōbu*), while not unique to Japan, were developed into major formats for painting in the Momoyama and Edo periods. The basic module for both *fusuma* and screens is a panel consisting of a light wood frame enclosing a lattice of thin wood strips. Over this foundation, pieces of paper are pasted to build up a backing that can support the surface, usually paper, but occasionally silk, on which a painting has been executed. Each fusuma door is provided with an outer frame, usually black-lacquered wood, and a metal handhold near one edge, enabling the door to be pushed back and forth without damaging the painted surface. Screen panels are narrower than *fusuma* and are joined together with a complicated system of hinges. The perimeter of the whole is framed, usually with wood that is lacquered black.

During the Momoyama period, screens and *fusuma* came into wide use in residential architecture for the nobility, the daimyo and samurai, and wealthy townsmen. In conjunction there developed a new aesthetic of bright colors, including gold and silver paint on a ground of gold leaf or occasionally silver leaf. It has been suggested that gold leaf became popular because it reflected and augmented the dim light in castles. Another theory is that specific landscape screens using gold leaf and bright colors were intended to suggest the gold and jeweled environment of Amida's Western Paradise. While both of these conjectures are justifiable, it is also true that gold grounds were a natural expression of the sudden affluence of the Momoyama period.

Japanese gold leaf is known to be the thinnest in the world, and the technique for making it is labor intensive. There are three stages in the process: the preparation of the alloy and its shaping into squares; the *zumiuchi*, the initial beating process, in which the squares are thinned out; and the final beatings and finishing of the leaves. At the *zumiuchi* stage, thin sheets of gold are placed between specially prepared leaves of paper, bundled in paper and then in cat skin, and beaten by hand or machine. The whole process is repeated about five times and is very time-consuming. The process of preparing the beating papers alone takes a total of six months.

The application of gold leaf to the papered surface of a screen changed over time. The size of the individual leaves decreased from about 5 x 5 inches (12 x 12 cm) in the fifteenth and sixteenth centuries to 4 x 4 inches (9 x 9 cm) in the Edo period. In the sixteenth century, the paper to which the leaf was adhered was usually painted red to give the gold a richer tint. The edges of gold clouds were scalloped and slightly raised over a narrow rim of gesso.

Another door and window treatment popular from the Momoyama period onward is the *shoji*. What distinguishes the *shoji*, whether fixed in place or used as sliding doors, is the translucent white paper pasted over one side of a wood lattice-work, like that at the core of the *fusuma*. *Shoji* give a Japanese room a soft, diffuse light and a sense of separation from the outdoors or the adjoining space.

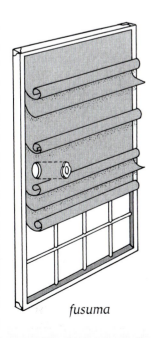

fusuma

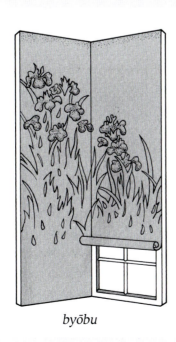

byōbu

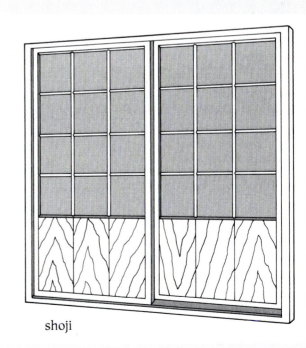

shoji

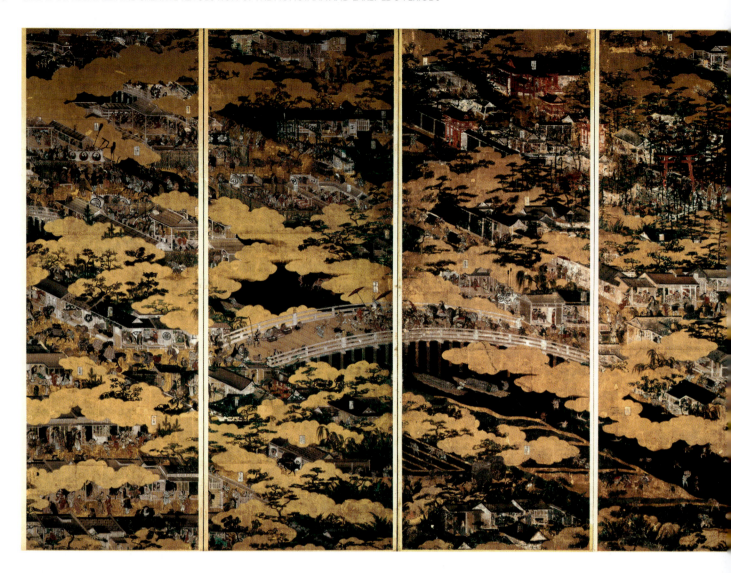

281 Right screen of a pair of six-panel *rakuchū rakugai* screens known as the Funaki screens. 1614–15. Ink and color with gold leaf on paper; each screen: 63 ¾ x 134 in. (162 x 340 cm). Tokyo National Museum.

rest of painting, led the way in genre subjects, but there was a great mass of independent painters and minor schools also actively engaged in producing these images. Unfortunately their names have been lost to history.

The pair of *rakuchū rakugai* screens known as the Funaki set (Fig. 281) are dated to the years 1614 to 1615, when the Tokugawa were making their final assault on Osaka Castle to the south of the capital. However, the images of the city depicted in these screens could not be more different than those shown on the Rekihaku screens of the 1530s (see Fig. 203) and are some of our best evidence for Hideyoshi's reconstruction of the city. Both are idealized visions of Kyoto, but where in the Rekihaku screens large banks of clouds or fields covered areas that more than likely were instead barren wasteland, in the Funaki screens there are no fields and the clouds are ranged in ranks to frame a city replete with well-kept edifices and streets teeming with people. Of course, part of this

effect is created by the more intimate view of the city provided in the Funaki screens. Where, for the Rekihaku screens, the bird's-eye view was taken at quite a height above the city, the viewer for the Funaki screens flies, as it were, at a much lower altitude. One consequence is that much less of the city is covered by the Funaki set, but it also gives the impression that the city is now of such dimensions that it could hardly be encompassed by two almost 7 feet (2 m) long screens.

In terms of buildings, the focal point of the right-hand screen is the image in the first two panels of Hōkōji, Hideyoshi's challenge to the Daibutsuden of Tōdaiji. Begun in 1584 and finished in 1587, the temple contained a monumental bronze image of the Buddha even larger than the one in Nara, and furthermore was completed in three years instead of twenty. Destroyed in 1596 in an earthquake, it was put up again in 1612, but once again destroyed by an earthquake in 1622. At the top of the two middle panels is his mausoleum, the shinto shrine known as the Hōkōkubyō. On the last two panels of the left screen is depicted Nijō Castle of the Tokugawa, and in the first panels of this screen the portable shrines of the Gion procession. The sandwiching of the city

depiction of the procession of the ship's captain and his crew through the streets of the city to the church in the upper-right corner must be preceded by the arrival in port of the foreign ship in the left screen.

The interest in representing common people in their everyday life, first evident in *emakimono* such as the *Ban Dainagon ekotoba* (see Fig. 146), became in the early Edo period a subject in its own right. An intriguing example of this type is the Hikone screen, a single six-panel screen of figures against a gold-leaf ground (Fig. 283). The setting is a house of courtesans in the city's entertainment district, and the two panels to the right depict its exterior with two courtesans and a child attendant talking to a samurai, who leans languidly on his sword. The remaining four panels depict the interior with groups of men and women passing time in cultural pursuits. Three pluck the strings of their *samisen*, an instrument sometimes described as a three-stringed banjo which had become popular in the course of the sixteenth century for narrative and lyrical music, including folk music. Another three figures play a game of Japanese checkers, and yet a third group of three figures is engaged in reading aloud, listening, and writing as if by dictation. The figures in these left panels may illustrate a version in contemporary dress of a favorite Chinese theme in painting and the decorative arts: the Four Gentlemanly Accomplishments (music, art, scholarship, and games of skill). There are few clues to authorship. However, the superb monochrome ink-landscape screen behind the blind musician appears to be in the Kanō style. The subdued and elegant color scheme as well as the controlled and delicate brushwork that delineates the forms, drapery folds, and textile patterns also suggest the accomplished hand of an artist trained in the Kanō atelier. Dated to between 1624 and 1644, the Hikone screen is perhaps the last of the great genre paintings in the Momoyama tradition. Two of its major themes—the surface expressions that mask powerful human emotions and the pleasure district as a setting for figures—will resurface later in the seventeenth century, when such genre paintings move from the screen to the wood-block print.

Decorative and Applied Arts

CERAMICS

During the Momoyama period, ceramic production underwent several profound changes. First of all, the wars of the Sengoku Jidai caused many potters in the important center of Seto near Nagoya to move their kilns further north, away from this main arena of fighting, and into the region known at that time as Mino (present-day Gifu), a more secluded area under the protection of the Toki daimyo. In the relative peace that followed Oda Nobunaga's assumption of power in the 1570s, the Mino kilns began to produce a wide variety of glazed ceramics for the tea ceremony (*chanoyu*), and the associated service of food, the *kaiseki ryōri*, which preceded it. This is a light meal normally consisting of raw and cooked fish, soup, and rice,

between these edifices of the old and new regimes has been interpreted by some scholars as a demonstration of the tensions existing in the city during the pivotal period between the winter of 1614 and the summer of 1615. It also seems likely that, unlike the Rekihaku screens, this set was not commissioned by a daimyo, but instead by a wealthy member of the *chōnin* class.

One of the more famous kinds of genre painting of the Momoyama and early Edo periods, and one which pretty much disappears after 1641, is the so-called *namban* (southern barbarian) screen painting, depicting the Dutch and Portuguese missionaries and traders. Tall, mustachioed Europeans in pantaloons and flowing capes appear occasionally in *rakuchū rakugai* paintings, but they are the principal subject matter of the *namban* screen. In this category there are several types of composition, but the most popular is the arrival in a Japanese port of a many-masted foreign galleon, and the visit of the ship's crew to Nambanji, the Jesuit church in Kyoto. As a nod to European habits, and contrary to normal Japanese practice, these folding screens are clearly intended to be read from left to right (Fig. 282): the right-hand screen's

282 Pair of six-panel *namban byōbu*. Early 17th century. Color and gold leaf on paper; each screen: 61 x 132 in. (155 x 334 cm). Imperial Household Agency.

283 Hikone screen, a six-panel *byōbu*. Between 1624 and 1644. Color, ink and, gold leaf on paper; each panel: 37 x 18 ⅞ in. (94 x 48 cm). Li Naoyoashi, Hikone, Shiga prefecture.

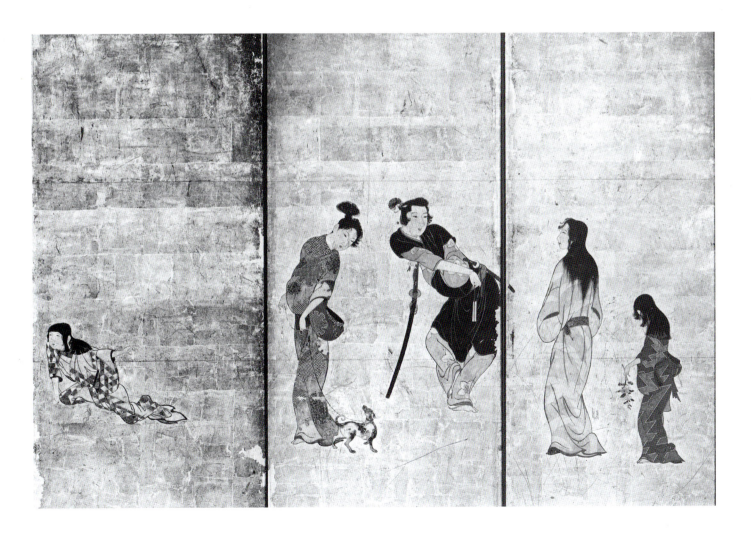

284 Tea Ceremony water jar, called Kogan, E Shino Mino ware. 16th century. Stoneware painted with feldspar glaze; height 7 in. (17.8 cm). Hatakeyama Memorial Museum, Tokyo.

With this kind of stimulation, the production of ceramics for the tea ceremony burgeoned. The kilns at Mino responded to the demand by developing several new kinds of ceramics: Yellow Seto (Ki Seto) and Black Seto (Seto Guro)—which are variations of traditional *setomono*, and Shino and Oribe wares. Among these, Shino ware was the most distinctive and popular in the Momoyama and early Edo periods. Even within the Shino designation there are several different types: unornamented or White Shino; E Shino, decorated with representational motifs; and Nezumi Shino, so-called because the surface is the color of a mouse (*nezumi*). One of the most famous pieces of E Shino ware is a tea-ceremony water jar called *Kogan*, or *The Bank of an Ancient Stream*, a reference to the design painted on the surface (Fig. 284). Like most Shino ware, this piece is made from fine white potting clay and is coated with a thick, crackled, white glaze containing feldspar. Over this a design of marsh grass has been painted in iron brown. The combination of the simply sketched motif, the thick white glaze that seems almost like water, and the cracks in the fabric of the vessel, as well as the crazing in the glaze, suggest at once great age and a quality of agelessness.

The other outstanding type of ceramic produced at Mino is Oribe ware, which takes its name from the tea master Furuta Oribe (1544–1615). Oribe, a disciple of Sen no Rikyū, was well known for his preference for ceramics newly made in Japan and reflective of Japanese taste in contrast to the older tea master's appreciation of both locally-made wares and imported Chinese ceramics. They are the most colorful of the wares used in the tea ceremony, providing a strong contrast with the sober pieces of an earlier age. Oribe ware juxtaposes an unevenly applied, bright copper-green glaze with recognizable

although it may also be completely vegetarian. The food is served in small portions on dishes, both ceramic and lacquer, chosen for their understated elegance. Under the influence of such renowned tea masters as Takeno Jōō (1502–55) and Sen no Rikyū (1522–91), simple utensils such as the bamboo ladle and tea scoop and the tea whisk and locally made ceramics came to be preferred for use in the tea ceremony. Their goal was to achieve the aesthetic effects of *wabi* and *sabi*, the beauty of simplicity seen in austerity and age (see pages 212–13). The works produced in Mino in response to their ideas represent a departure from the controlled shapes and modestly decorated surfaces of Ko Seto and the simply articulated large storage vessels of other kiln sites.

The new creative energy at Mino coincided with a rather surprising development, the popularization of the tea ceremony by Hideyoshi and Sen no Rikyū. In the Muromachi period, this ritual was practiced primarily by the upper echelons of the samurai and the Zen clergy, but, in the course of the sixteenth century, the correct performance of the tea ceremony became an essential attribute of cultural sophistication for all of the rough new daimyo emerging from the civil wars. Both Nobunaga and Hideyoshi associated themselves with the tea ceremony to demonstrate their appreciation of culture and thereby their right to rule. In 1587, after Hideyoshi returned from a campaign in Kyūshū, he held a gigantic tea ceremony on the grounds of the Kitano Shrine, which was planned to last for ten days and was open to the entire population of Kyoto to attend. A proclamation issued before the Kitano event stated that:

> ...devotees, whether they are military attendants, townspeople, farmers or others should come and each should bring a kettle, a water bucket, a drinking bowl and either tea or *kogashi* [a poorer grade of tea]

Murai Yasuhiko, "The Development of Chanoyu: Before Rikyū" in *Tea in Japan*, Honolulu, 1989, 40.

285. Lobed dish, Oribe Mino ware. Early 17th century. Stoneware painted and glazed; diameter 14 ⅝ in. (37.1 cm). The Freer Gallery of Art, Smithsonian Institution, Washington DC. (Purchase F1973.6).

designs, such as sailboats or plants, executed in brown against a white or softly colored surface. Usually Oribe ware is molded rather than thrown on a wheel and retains traces of the weaving patterns of the cloth used to line the molds. One of the best extant examples of Oribe ware is a five-lobed dish with floral and geometric decoration (Fig. 285). Bamboo stalks and leaves cover about two-thirds of the flat circle of the dish, while a geometric pattern of hexagons, each with a five-petaled blossom at its center, fills the remainder. The rim is decorated with a garland of vines and small flowers. Irregular flows of green glaze at three places on the surface contrast strongly with the representational aspects of the decoration.

Another ceramic innovation of the Momoyama period was *raku* ware, which originated in Kyoto for use in the tea ceremony and was associated with the aesthetic principles of Sen no Rikyū. The name *raku*, originally designating both the type of ceramic and also the specific line of potters making it, was bestowed by Hideyoshi. *Raku* simply translated means "pleasure," but it was also the middle character in the name of Hideyoshi's Kyoto palace, Jurakudai. *Raku* ware is coated with a black, a transparent, or occasionally a white glaze, and is fired in a small, single-chamber oxidation kiln at relatively low temperatures. But unlike most other ceramics, it is removed from the kiln while it is still hot, which introduces an element of chance into the process. The potter cannot know exactly what effect the cooler air outside the kiln will have on a bowl, and can further enhance the unpredictability by placing the vessel in a reduction kiln, submerging it in cold water, or placing it in organic matter like straw, which is ignited by the pot's heat. All these processes affect the glaze and the surface of the vessel. The aesthetic of sudden change seemed to fit with the idea of Zen Enlightenment, and the roughly modeled quality

287 Tea bowl, called *Muichimotsu* ("Holding Nothing") by Sasaki Chōirō, *Raku* ware. Late 16th century. Earthenware with transparent glaze; height 3 ⅜ in. (8.5 cm). Egawa Museum, Hyōgo prefecture.

of the *raku* tea bowl agreed with Sen no Rikyū's preference for simple, unelaborate ceramics.

The potter credited with the development of *raku* ware is Sasaki Chōjirō (1516–92), who began as a specialist in the making of roof tiles, particularly the animal shapes placed along ridgelines. An ornamental lion figure dated by inscription to 1574 has been preserved and is of particular interest since it bears Chōjirō's name (Fig. 286). One of Chōjirō's most famous tea bowls is the red *raku* piece named *Muichimotsu*, translatable as "Holding Nothing" (Fig. 287). It is made of red clay, hand-formed rather than wheel-thrown, like all classic *raku* tea bowls, and coated with a transparent glaze. It is the epitome of simplicity, rising abruptly from a narrow base to a cylindrical bowl with a wide mouth.

Because the technical means for producing *raku* ware was relatively simple and did not require large or elaborate kilns, it was possible for "gentleman potters" to dabble in its manufacture. Hon'ami Kōetsu, known for his collaboration with Sōtatsu in the revival of *yamato-e* style in painting, was also an accomplished amateur potter who experimented with *raku* ware. The tea bowl called *Mount Fuji* is unquestionably his premier ceramic work (Fig. 288). Like the mountain for which it is named, the bowl is white around the top and grayish black below. It has been shaped by hand and the crude marks of the shaving knife around the base and the lip are proudly on display. To fully appreciate the aesthetic of this bowl, it must be visualized at the moment when it is raised to the lips half full of foamy green tea—the liquid is then drunk from within the crater of the volcano.

The last major innovation in ceramics of this period is the high-fired, glazed pieces produced in northern Kyūshū and named Karatsu, after the city around which the kilns were distributed. Unlike the other ceramics used in the tea ceremony, Karatsu wares were made by Korean, not Japanese, potters.

286. *Chinese Lion*, by Sasaki Chōirō, *Raku* ware. 1574. Earthenware with transparent glaze; height 14 in. (35.5 cm). Raku Museum, Kyoto.

288 Tea bowl, called *Mount Fuji*, by Honami Kōetsu, *Raku* ware. Early 17th century. Earthenware with glaze; height 3 ⅜ in. (8.5 cm). Private collection.

289 Plate with pine tree design, Karatsu ware. Late 16th to 17th century. Earthenware with glaze; diameter 14 ⅜ in. (36.3 cm). Idemitsu Art Museum, Tokyo.

Some of these had certainly emigrated before Hideyoshi's invasions, though the earliest dated piece of Karatsu ware is a jar inscribed with a date equivalent to 1592, the year of the first campaign. A particularly charming example of painted Karatsu ware is a plate with a slightly raised outer rim (Fig. 289). The piece is formed of sandy clay with a high iron content. It is decorated with an image of a pine tree painted in an iron-brown glaze, and then coated with a white glaze. The

curving lines of the tree trunk and limbs complement the circular depression of the bowl of the plate and its regular, curved rim. Although its early history in Japan is hard to document, it is clear that Karatsu ware, with its simple painted decoration and warm, yellow–brown color, fits very well with the aesthetics of the tea ceremony. That there was considerable demand for it is demonstrated by the fact that in 1592 and 1597, when Hideyoshi launched his campaigns against Korea, the daimyo of Kyūshū and western Honshū accompanying his troops took hundreds of potters as prisoners of war with the intention of establishing their own profit-making kilns. Due to the efforts of these captive potters, Japan's important porcelain industry would be born in the next century.

LACQUERWARE

Sen no Rikyū's organization of the paraphernalia for the tea ceremony and its *kaiseki ryōri* meal also produced a great deal of business for the lacquer industry. Daigoji on Mount Kasatori, to the southeast of Kyoto, preserves a set of lacquer implements for the tea ceremony bearing Hideyoshi's crest as well as one of the more classic examples of Hideyoshi's flamboyant taste—a pair of gold *tenmoku* tea bowls (Fig. 290).

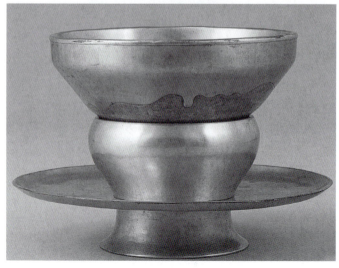

290 Two gold *tenmonku* tea bowls. Momoyama period, 16th century. Gold plate on wood; each: height 2 ⅓ in. (5.9 cm), diameter 5 in. (12.6 cm). Daigoji, Kyoto.

Hideyoshi's relationship with Daigoji began very late in his life, in fact in the year of his death. The monk Shōbō's great ninth-century foundation for the practice of Shugendō, the way of the mountain ascetic, had by the late sixteenth century fallen on very hard times. Its only items of note were its tenth-century pagoda (see Fig. 167) and a grove of cherry trees. It was to see the latter in bloom that Hideyoshi traveled to the temple, and he was so charmed by the location that its abbot Gien (1558–1626) was able to persuade him to rebuild the lower, Shimo, part of the mountain temple complex. This he did by moving halls from other temples and constructing several new ones. The most important of these new buildings is the rebuilt Sambo-in, which was intended to serve as his pavilion for future cherry-blossom viewings. As such it was fitted out in true Hideyoshi style with walls covered with paintings, and a garden graced with eight hundred ornamental rocks.

That same year, however, the *taikō* fell ill with the sickness that would ultimately prove fatal. The pair of gold *tenmoku* bowls were given to the abbot Gien in thanks for his prayers for Hideyoshi's recovery. Although aping the ash-glazed stoneware tea bowls of the Chinese and then Seto traditions, these bowls have wooden cores covered with hammered sheets of gold. The gold plating very cleverly imitates the dripping of the glaze down the sides of the bowl as found on ceramic examples. The pair originally also had gilt-bronze cup stands, of which one remains. Hideyoshi created a famous tearoom completely covered with gold at Momoyama Castle, and it is possible that these bowls were originally intended as part of its furnishings.

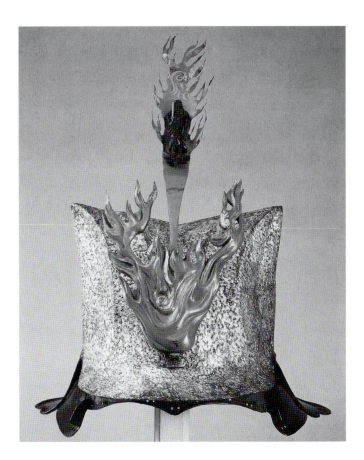

291 *Kabuto* helmet in the shape of an old man's hat. Momoyama period, late 16th century. Lacquered iron and copper; height 16 ⅛ in. (41 cm). The Metropolitan Museum of Art. Bequest of George C. Stone. (36.25.81a–c).

ARMOR AND COSTUME

Another example of the flamboyant imagination that prevailed in the Momoyama period is a samurai helmet, or **kabuto**, of the late sixteenth century (Fig. 291). Instead of the standard design of the medieval period—a metal bowl surrounded by a skirt of leather and silk padding—this example takes the relatively whimsical form of an old man's cloth cap. The main difference being, however, that this cloth cap is made out of gilded iron alloy and fronted by a three-pronged flame bearing an image of Fudō Myōō. It is unclear whom this helmet was made for, but at least one aspect of the message is clear. Whatever other attributes of an old man were appropriate to the wearer, weakness and feebleness are not among them.

The Hikone screen gives some idea of how both men and women dressed during this period (see Fig. 283). Although the women are courtesans and the men either *chōnin* or samurai, their garments nevertheless indicate the general cut of robes and how they were worn on a day-to-day basis in all ranks of society. With the return of peace and stability, clothing as much as screens and *fusuma* became an important surface for painting and decoration. Textile weavers and decorators were —like the other craftsmen of the time—virtuosos and eager to demonstrate their talents. One of the more interesting textile

survivals from the Momoyama period is a fragment of a robe mounted on a screen (Fig. 292). The practice of taking a treasured robe and mounting it on a two-paneled screen as if it were hanging on a lacquer clothes rod began around this time and continued throughout the Edo period. In this example is the robe of a samurai lady, decorated with plants of the four seasons, in addition to wisteria branches, mountain shapes, and snowflake roundels. The robe is known as a **kosode**, a term applied since the Meiji period (1868–1912) to traditional robes antedating the end of the Edo period. Literally meaning "small sleeves," *kosode* began in the Nara and Heian periods as an undergarment of the elite, and the primary over-garment of the lower orders. By the sixteenth century it had become the topmost layer of costume in all classes. Since the Meiji period, these traditional robes have been known as kimono. The particular style of this textile is known as Keichō–Kan'ei, indicating that it was fashionable during two imperial reigns: Keichō (1596–1614) and Kan'ei (1624–44). The style is distinguished by a palette of crimson, black, purple, and brown for the ground of the design. Compared with other fashions of the Momoyama period, it was intended to represent a relative sobriety. The techniques and materials used to create the

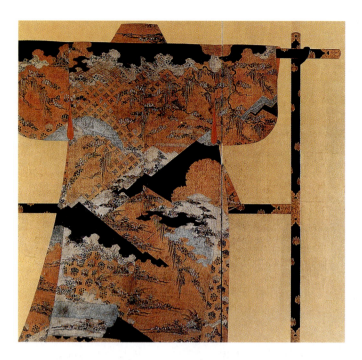

292. *Kosode* fragment with a design of mountains, snowflake roundels, wisteria, and plants of the four seasons mounted on a screen. Momoyama period, early 17th century. Tie-dyeing, silk thread embroidery, and traces of stenciled gold and silver leaf on red, black, white, and blue parti-colored figured silk satin; Screen: 74 ¾ x 67 ⅞ in. (189.9 x 172.4 cm). Nomura Collection, National Museum of Japanese History, Sakura city, Chiba prefecture.

details of the design, however, tend to detract from its desired simplicity: tie-dyeing, silk-thread embroidery, and stenciled gold and silver leaf on red, black, white, and blue parti-colored figured silk satin. Such lavish robes were the taste of samurai ladies, and cheaper versions (or not, depending on their patrons) were worn by the courtesans of the entertainment district. They were also used in the dramatic arts, particularly in Nō theater at this time, but later in the seventeenth century also in the newly emerged Kabuki.

The court aristocracy tended towards more subtle and refined decoration, and in this they were often copied by the older, established families of the *chōnin* class. The latter trend was later reinforced in the Edo period by sumptuary edicts prohibiting those below the samurai class from wearing clothes of excessive luxury. The courtesans of pleasure districts regularly flouted these laws, but the upstanding daughters of wealthy merchants exercised their taste and wealth in ever more subtle and rich shades of the colors they were allowed to wear, and similarly in ever more refined patterns of weaving. Thus developed in textiles, as in the rest of the Japanese arts, the parallel aesthetics that continue to define Japanese culture today: on the one side the bold, dynamic, and colorful, and on the other the subtle, understated, and elegant.

Painting

THE KANŌ SCHOOL

What the Momoyama period is most famous for artistically are the grand compositions painted on gold and spread across the broad canvases of folding screens and *fusuma*, and the uncontested master of this form in the late sixteenth century was the Kanō school of artists. The school had first attracted Ashikaga patronage in the late fifteenth century, and was particularly famous for its ability to paint *kanga*, both in the older professional styles as well as in the more modern styles represented by the Zen monk–painters and also the work of the Chinese Zhe school associated with the Ming imperial court (1368–1644). As the sixteenth century progressed, two distinct types of paintings began to emerge in addition to the genre painting discussed above. In the first, which modern scholars have labeled the blue-and-gold style, landscapes and figural themes were depicted on a monumental scale in brilliant colors on a gold or silver background. The second type maintained the monochromatic tonalities and often the Chinese pictorial themes of the Muromachi period, but the compositions were bolder and more decorative. Both of these styles at the beginning of the Momoyama period were the province of the Kanō school, and were particularly developed by the greatest master of the period, Kanō Eitoku (1543–90).

However, the masters of the Kanō school did not limit themselves only to grand commissions of room interiors and folding screens, and one example of this is a votive plaque (Fig. 293) at the Kamigamo Shrine attributed to Kanō Hideyori, the son of Kanō Motonobu (1476–1559). In the second half of the sixteenth century, it became the fashion amongst the daimyo to pledge at Shinto shrines votive paintings of their

293 *Votive Horse Painting*, attributed to Kanō Hideyori. Dated 1569. Colors on wood; 19 ⅝ x 22 ⅞ in. (50 x 58 cm). Kamo Shrine, Shimane.

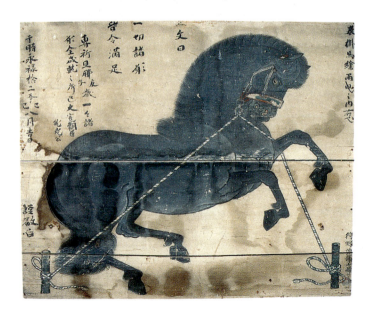

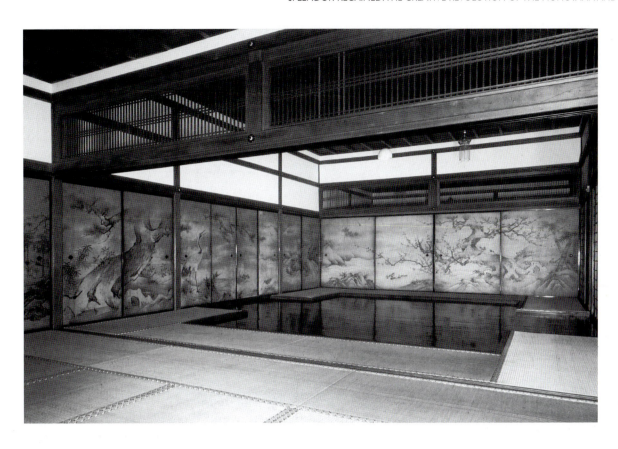

294 View of *hōjō* (central room) of the Jukōin, Daitokuji, Kyoto, showing plum tree panels by Kanō Eitoku. 1566.

prize horses. If they could afford it, they would commission a Kanō master to paint the image. The plaque bears a date equivalent to 1569, and the signature "Kanō Jibu Shōyū." Jibu Shōyū is an imperial court rank, and the only Kanō master to hold it at this time was Hideyori, whose exact dates are uncertain. Such horse imagery comes ultimately from Chinese prototypes of the Tang dynasty (618–907), and the Japanese emperors and *insei* of the eleventh to thirteenth centuries were known to have images painted of their prize bulls (oxen having been the essential drawer of the aristocratic carriage throughout Japanese history). Votive images of samurai war steeds are meant to convey fierceness and vigor, and this the artist has achieved by combining the Chinese tradition for depicting such images with a native Japanese taste for strong outlines.

Kanō Eitoku

The artist who single-handedly created the two major pictorial styles of the first phase of the Momoyama period was Kanō Eitoku. Grandson of Kanō Motonobu and nephew of Hideyori, Eitoku was trained by Motonobu and his father Shōei and introduced to the daimyo who patronized the Kanō workshop. While still in his early twenties, Eitoku began receiving commissions from several of the most powerful daimyo in the Ashikaga *bakufu*. One of these was that given by Miyoshi Yoshitsugu, steward to the Hosokawa family, to Eitoku and Shōei in 1566 to paint *fusuma* panels for the Jukōin, a small compound within the Zen temple of Daitokuji in Kyoto. Shōei

was by this point the nominal head of the Kanō school, yet Eitoku, the more gifted of the two artists, was given the most important area to decorate—the central room facing the garden (Fig. 294). In this three-sided space he created a new architectonic formula for distributing motifs around the three interior walls. Landscapes of the four seasons are depicted across sixteen panels enclosing the east, north, and west walls of the room. They are executed in vigorous ink brushstrokes against a ground delicately streaked with gold.

Eitoku's formula for *fusuma* decoration differs from earlier treatments in that he chose not to place vertical motifs, such as tree trunks, at the four corners of the room to echo the wooden corner posts. Instead, he used three massive trees—a gnarled plum symbolizing spring, and two pines suggesting winter—in diagonally opposite corners of the room, southeast and northwest, and distributed other motifs—ducks swimming in the water, rocks, and marsh grasses—so as to draw the viewer's eye deeper into the pictorial space. Motifs in the middle ground and foreground are increasingly emphasized, and the composition climaxes in the pine tree panels (Fig. 295). So, while the artist makes dramatic use of large-scale motifs and strong brushwork, at the same time he subtly depicts space and delicately contrasts gray ink, white paper, and pale gold mists. Quite probably Eitoku used some of Motonobu's paintings as his point of departure, but his *fusuma* panels go beyond the more reserved spatial formulas of his grandfather's work and establish the direction for later Momoyama painting.

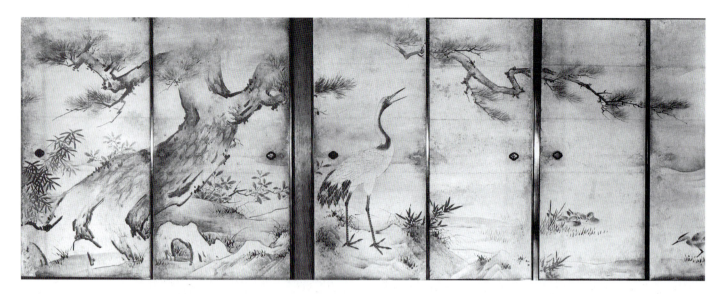

295 *Pine Tree and Crane*, six of sixteen *fusuma* panels, by Kanō Eitoku. 1566. Ink on paper;
height of each panel 69 ⅛ in. (175.5 cm), width varies. Central room facing garden, Jukōin, Daitokuji, Kyoto.

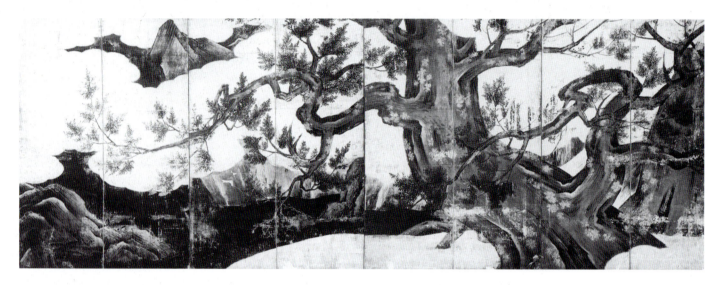

296 *Cypress*, an eight-panel *byōbu* attributed to Kanō Eitoku. 1590. Color, ink, and gold leaf on paper;
66 ⅞ x 181 ½ in. (170 x 460 cm). Tokyo National Museum.

The high point of Eitoku's creativity was reached in the screens and wall paintings he made for Nobunaga's Azuchi Castle between 1576 and 1579. They perished when the castle was destroyed in 1582, but descriptions of Eitoku's paintings are preserved in documents of the period. On the first four floors were decorations with familiar landscape and figural motifs, including birds and flowers and the classic Chinese theme of Confucian sages, mostly executed in bright colors on a gold ground. A hexagonal room on the fifth floor was used as a Buddhist worship hall. The pillars were lacquered in red, and on the walls were paintings showing Shaka Buddha and his ten disciples, the path to Buddhahood, and *rokudō-e* images of hungry ghosts and demons. A small room on the sixth floor was covered inside and out with gold leaf, the pillars decorated with dragons and the walls ornamented with Confucian themes, such as the Ten Wise Men and the Seven Sages of the

Bamboo Grove. Eitoku devoted three years to this project, and, although he must have relied heavily on assistants for some of the work, one painting is identified in descriptions of Azuchi Castle as entirely his own creation, a depiction in ink of plum trees, presumably against a gold ground. It is interesting to imagine how his style would have changed during the ten years since he had painted the same subject on the *fusuma* panels of the Jukōin.

In the last eight years of his life, Eitoku and his studio undertook a great number of paintings for two of Hideyoshi's newly constructed living quarters, Jurakudai in Kyoto and Osaka Castle. In addition, many daimyo called upon him to paint *fusuma* and folding screens for their residences. In 1588, he was asked to restore the enormous ceiling painting in the main worship hall of the first great Zen complex, Tōfukuji—a dragon amidst clouds, first executed about two hundred years

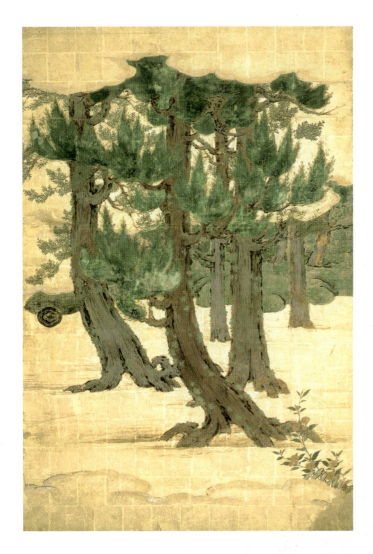

297 *Cedars and Flowering Cherry Trees*, on two *fusuma* panels, by Kanō Mitsunobu. *c.* 1600. Ink, color, and gold leaf on paper; each panel 70 ½ x 44 in. (179 x 111.6 cm). South wall of room in *kyakuden*, Kangakuin, Onjōji, Shigo prefecture.

before by the monk–artist Kichizan Minchō (1352–1431). Eitoku began the assignment, but became ill and had to turn over the job to his adopted son, Kanō Sanraku. Although Eitoku had the support of a large studio of assistants, the records of his many commissions make it clear that he was forced to work at an almost inhuman pace during his two remaining years. To meet these heavy demands he developed a formulaic style for his blue-and-gold works, exemplified by *Cypress*, a single, eight-panel screen (Fig. 296). Scholars question whether this work was by Eitoku himself or by a pupil, but it is generally accepted as representative of his late style. It is thought that the painting was executed in 1590 as a series of *fusuma* for the mansion of Prince Toshihito, who commissioned the Katsura Villa thirty years later. Subsequently remodeled into an eight-panel folding screen, the painting has been trimmed along its short sides, somewhat distorting our view of the original composition. Today, the right half is

dominated by a massive tree, the left by a pond and sharply faceted rocks, and the whole is unified by a gold-leaf ground. The elements are arranged much as in the Jukōin paintings, but the naturalism and playfulness of the 1566 work are absent here. Now the emphasis is on solid sculptural forms against a flat backdrop of gold.

Kanō Mitsunobu

Within less than thirty years, Kanō Eitoku had established himself as the commanding artistic presence of the early part of the Momoyama period. His work evolved from a somewhat predictable combination of elements from the Kanō and Tosa traditions to a new compositional scheme for the Jukōin, and it seems probable that his work at Azuchi Castle was the best expression of his mature style. After Eitoku's death in 1590, his son Mitsunobu (1561 or 1565–1608) became head of the main branch of the Kanō school. Before emerging into the limelight, Mitsunobu seems to have learned his craft in relative obscurity. In 1571, at the age of ten, he was designated Eitoku's direct successor, and in the 1570s he worked with Eitoku on the Azuchi Castle paintings, while Eitoku's brother Sōshu (1551–1601) took charge of the Kanō school.

298 View into room of *kyakuden* (guest hall), Kangakuin precinct, Onjōji, Shiga prefecture, showing *tokonoma* flanked by *fusuma* panels by Kanō Mitsunobu. *c.* 1600.

Collaboration with his father seems to have been the pattern of Mitsunobu's activity until Eitoku's death; it is known that they worked together on the decoration of commissions in Hideyoshi's rebuilding of the imperial palace and at his residences of Jurakudai and Osaka Castle. However, when Mitsunobu took charge of the Kanō studio, it became clear that his was a very different artistic temperament. He was a less ambitious entrepreneur than his father, and, though he inherited a number of Toyotomi family commissions, he lost some of the best of them to a former pupil in the atelier, Hasegawa Tōhaku, and to his own adoptive brother, Sanraku. He turned away from his father's dramatic monumental style, preferring to work in a flatter, more elegant and detailed manner, depicting such *yamato-e* themes as birds and flowers of the four seasons. During the first decade of the seventeenth century, he worked for both the Toyotomi clan and the Tokugawa. His work for the latter required him to make frequent trips to Edo, and it was while returning from such a trip that he died.

One of Mitsunobu's most successful paintings is the series of designs he executed for the *tokonoma* and *fusuma* panels in the main room of the *kyakuden* in the Kangakuin enclosure of Onjōji on Lake Biwa (Fig. 298). The building, commissioned in 1600 by Hideyoshi's son Hideyori, is very similar in plan to the *kyakuden* of the neighboring Kōjōin enclosure (see Fig. 276) except that the Kangakuin building lacks a *tsuke-shoin*, *chigaidana*, and *chōdaigamae*. Instead, the room is dominated by the *tokonoma* occupying the entire west wall. Mitsunobu's solution for decorating this space was the antithesis of his father's preferred formula. Instead of trying to unify the room as a single architectural entity, and to create the impression of

walls dissolving into natural space, Mitsunobu stressed the differences between various parts of the room—the tall, wide *tokonoma* and the shorter, smaller *fusuma*—and reasserted the flatness and unitary quality of the individual *fusuma* panels. His pictorial theme, flowers and trees of the four seasons, begins on the east wall to the right of the *tokonoma* with plum blossoms and camellias followed on the south by a grove of cedar and flowering cherry trees (Fig. 297). The west wall of the room is devoted to the flowers of summer and the russet leaves of the fall. The sequence climaxes in the last *fusuma* panel, on the north wall, and the focal point of the room: the winter landscape of the *tokonoma* is a waterfall descending between evergreens and mixing with roiled waters along a snow-rimmed shore. Broad areas of flat gold leaf indicate ground or clouds and contain the floral motifs within a shallow space. Through the frequent use of gold, the isolated flowers and trees, and their organization in a sequence that unfolds right to left, against the usual direction, Mitsunobu has stressed the flatness of the wall surface and the somewhat awkward proportions of the room at the Kangakuin, presenting an interesting counterpoint to his father's handling of the similar space of the Jukōin some thirty-five years earlier.

Kanō Sanraku

The most talented artist of the Kanō school who continued to work in the dramatic style pioneered by Eitoku was Kanō Sanraku (1559–1635). Originally Sanraku was a page in the service of Hideyoshi, who recognized the boy's artistic talent and placed him in Eitoku's studio. Eitoku subsequently adopted him. Sanraku's contribution was to retreat from some of

299. *The Carriage Fight*, a scene from the Hollyhock chapter of the *Tale of Genji*, remounted on a four-panel *byōbu*, by Kanō Sanraku. Early 17th century. Color and ink on paper; 68 ⅞ x 145 ½ in. (175 x 370 cm). Tokyo National Museum.

Eitoku's dynamic imagery, substituting first a naturalism of expression and then a quality of elegant ornamentation. This brought the Kanō style into line with the second phase of painting at this time as it reassessed the *kanga-e* and *yamato-e* styles of the Heian and medieval periods. It was a phase that represents a more intellectual approach to pictorial content on the part of the artist—and often also of the commissioner—whether in reworking *yamato-e* themes or in interpreting complex and unfamiliar subjects from Chinese literature.

After Eitoku's death, Sanraku remained closely associated with Hideyoshi and his son. From 1590 to 1615 he was kept busy with commissions for the Toyotomi family, including wall paintings for the castle at Momoyama, and for many temples and shrines in the Kyoto area. When the Toyotomi clan was destroyed in 1615, Sanraku removed himself from Kyoto's artistic circles and took the tonsure, changing his name from Mitsuyori to the priestly Sanraku. He spent several years in seclusion in remote country temples, but was back in Kyoto by 1619, at work on a commission from the shogun Tokugawa Hidetada (1579–1632) for *fusuma* panels to be used in the latest refurbishment of the imperial palace—in preparation for the marriage of his daughter Kazuko to the emperor Go Mizuno (1596–1680; r. 1611–29). For fifteen years more Sanraku continued to paint in the style he had developed in his heyday, a style less dramatic than Eitoku's, but more natural in composition and more elegant in detail. This style became the model for the Kyoto branch of the Kanō school in the seventeenth and subsequent eighteenth centuries.

In the early seventeenth century, Sanraku was asked by the Kujō family, one of the five houses of the most prestigious branch of the Fujiwara clan, to paint *fusuma* panels depicting scenes from the *Genji monogatari*. Four panels from the set still exist, now refashioned into a single screen. The episode depicted is "The Carriage Fight" (Fig. 299), one of the most famous incidents of the first part of the novel. Sanraku has successfully adapted the techniques of narrative *emakimono* to the large-scale format of the *fusuma*. The essentials of the story in these screens are clear from a distance, but a closer view brings a wealth of interesting details. The carriage attendants of Lady Rokujō, a lover of Prince Genji, scuffle with those accompanying that of Genji's wife, Lady Aoi, as both groups jockey for a good vantage point along the route of the Kamigamo festival parade. In the right half of the screen, the procession of noblemen escorting the vestal virgin of the Kamigamo, an unmarried young woman from a noble family, moves leftward, toward the mêlée of carriage attendants that dominates the left half. The composition and style of the painting, as well as the figure types and poses, are reminiscent of *emaki* of the Tosa style of the mid-thirteenth century—not the tightly contained *tsukuri-e* style of the early twelfth-century *Genji* illustrations. Government officials and the nobility are clearly distinguished by their fine features, elegant costumes, and stately poses from the coarse-featured, brawling, lower-class attendants clad in plain white garments. But the artist goes beyond class distinctions, individualizing each image.

INDEPENDENT MASTERS OF THE *KANGA* STYLE

Hasegawa Tōhaku

A great independent practitioner of the decorative style in the Momoyama period was Hasegawa Tōhaku (1539–1610). His

300 *Monkey Reaching for the Moon*, two of four
fusuma, by Hasegawa Tōhaku. Late 16th century.
Ink on paper; each panel 67 ⅜ x 35 in.
(171 x 89 cm). Konchi-in, Kyoto.

301 *Maple Tree*, on four *fusuma*, by Hasegawa Tōhaku. Late 16th century.
Color and gold leaf on paper; each panel: 67 ⅞ x 54 ½ in.
(172.5 x 138.5 cm). Chishakuin, Kyoto.

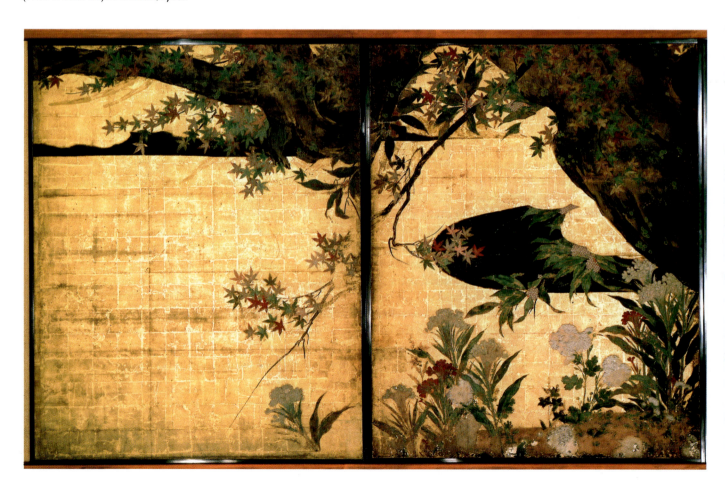

early life is poorly documented, but scholars generally agree that he was born in Ishikawa prefecture in central Honshū and adopted by the Hasegawa family, who were in the cloth-dyeing business. In 1571, after the death of his adoptive parents, Tōhaku departed for Kyoto with a letter of introduction to Honpōji, and took up residence in its subtemple of Kyōgōin. His Buddhist connections in Kyoto had a lasting effect on his art, for Nichigyō, the eighth abbot of Honpōji, was a noted calligrapher and master of the tea ceremony. Through him Tōhaku came to know the great tea master Sen no Rikyū, and his family. It was Rikyū who made it possible for Tōhaku to frequent Daitokuji, which had been reconstructed after the civil wars with donations from the merchants of Sakai. The temple had a rich collection of paintings, including not only the great masters of the Muromachi period, but also Chinese masterpieces of the Song (960–1279) and Yuan (1279–1368) dynasties—not least of which was Mu Qi's (act. 1279) famous and influential triptych of a white-robed Kannon, a crane, and a monkey (see Fig. 256).

Tōhaku's painting on four *fusuma* of *Monkey Reaching for the Moon* (Fig. 300) in the teahouse of Konchi-in in Kyoto is clearly based on Mu Qi's painting of the female monkey protectively cradling her child. However, Tōhaku has addressed the Zen idea of the monkey as a symbol for the unenlightened human being and created an allegory of the impossibility of possessing absolute knowledge. The monkey, an impractical romantic, reaches out to catch the moon, believing it to be in the pond below him as he mistakes the reflection for the "real thing." The viewer may intuit the further meaning that the moon itself is made visible from the earth only through the reflected light of the sun. The animal clings with one long, furry arm to the thin branch of a tree, its claws digging into the bark of the trunk, and reaches futilely with its other arm toward the surface of the pond.

A second influence on Tōhaku's artistic development was the brilliantly colored, decorative style of the Kanō school. He worked in the studio of Kanō Shōei, Eitoku's father, when he first arrived in Kyoto, and, though he later left to establish himself as an independent artist, he had to compete with the Kanō school and adopted some characteristics of its blue-and-gold style. Tōhaku had first collaborated with the Kanō in 1587 on the paintings for Hideyoshi's Jurakudai mansion, but Eitoku managed in 1590 to block Tōhaku's maneuvers to win part of the commission for the decoration of Hideyoshi's reconstructed buildings of the imperial palace. After Eitoku's death, Tōhaku received greater recognition as an artist. In 1592, he was given exclusive charge of the painted decoration of Shōunji, a temple built by Hideyoshi for the salvation of his three-year-old son Tsurumatsu. Following the fall of the Toyotomi faction in 1615, the temple was destroyed, and the few paintings that survived were installed in the Shingon temple of Chishakuin, where they were cut down to fit the smaller

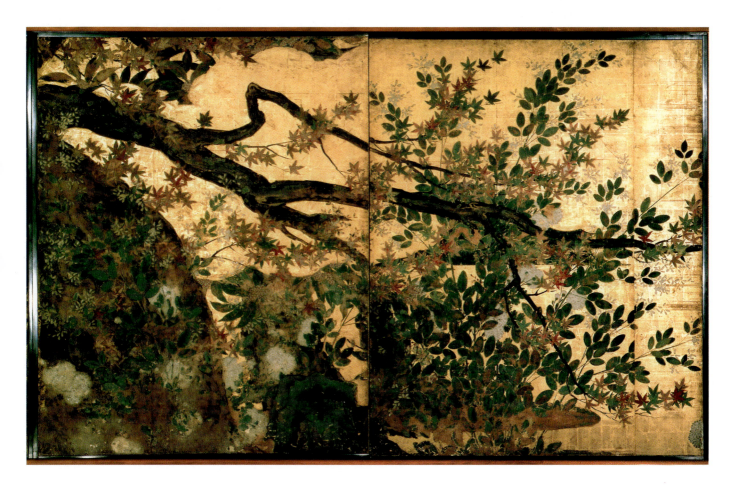

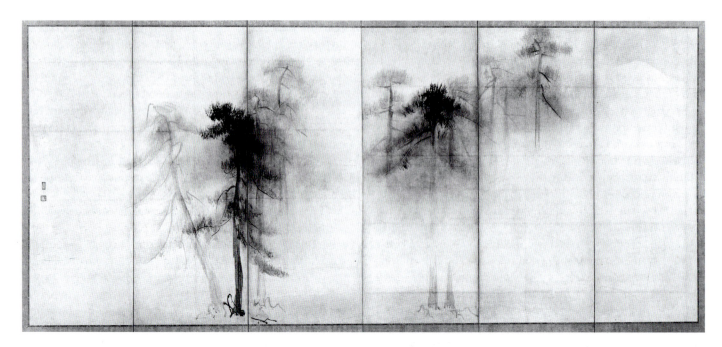

302 *Pine Forest*, one of a pair of six-panel *byōbu*, by Hasegawa Tōhaku. Late 16th century. Ink on paper; 61 ⅜ x 136 in. (156 x 347 cm). Tokyo National Museum.

dimensions of *fusuma* there. Unquestionably, these paintings are Tōhaku's masterworks in the blue-and-gold style, as well as being one of the first reworkings of *yamato-e* themes, particularly the four panels depicting a single maple tree, its leaves just beginning to turn color (Fig. 301).

In contrast to Eitoku's location of plum and pine trees near corners of the central room in the Jukōin (see Fig. 295), Tōhaku locates his massive trunk of his maple on a diagonal across the two central panels, and the branches are like arms extending gracefully to the sides of the painting. Flowers of the fall, including chrysanthemums and cockscomb, create a solid base for the tree, along with a low rock and bush clover, whose green-leafed branches mingle with the green, orange, and brown leaves of the maple. The gold background of the painting, interspersed with passages of deep blue, at one moment appears to be terra firma, at another to be clouds obscuring the blue water of a lake or river. There is tension between the massive, enduring trunk and the delicate, star-shaped leaves that will soon become brilliant, then fade and fall to the ground. The painting suggests metaphors from Japanese poetry, yet it does not illustrate a specific poem. The artist has created an image in the Japanese tradition that encourages phrases of poetry to surface in the mind, blending with and enriching one's perception of the painting.

303 Detail of *Plum Tree*, three of four *fusuma*, Kaihō Yūshō. Early 17th century. Ink on paper; each panel 68 ⅛ x 46 in. (173 x 117 cm). Zenkoan, Kenninji, Kyoto.

Tōhaku's greatest contributions to the development of a decorative reinterpretation of former styles, however, were his amalgam of monumental forms, his subtle use of monochrome ink without additional gold or color, and his ability to infuse simple plant and tree motifs with a sense of tradition and timelessness. This unique combination appears at its best in his *Pine Forest*, a pair of six-panel screens (Fig. 302). Tall trees are seen as if from a distance. Thick mist flows amongst and around them, obscuring the lower half of some, the mid-trunk area of others. The viewer knows that when the mist clears the trees of the forest will appear tall and straight, with deep green needles, but at this moment they barely assume recognizable forms before they disappear again, or remain partially visible like ghostly gray apparitions. Tōhaku has taken the motif of pine trees, possibly remembering Mu Qi's bamboo in the mist (see page 222), and worked it into this format. By contrast, his screens depicting the maple tree in the fall show nature in a riot of color, creating an atmosphere suitable for festivities, dancing, and saké drinking. Nature in both these paintings is gentle and hospitable. It is not meant to overpower or to create an awe-inspiring backdrop for a warlord, but instead to harmonize with and perhaps inspire human activities.

Kaihō Yūshō

Kaihō Yūshō (1533–1615) is another artist trained initially by a Kanō master, either Motonobu or Eitoku, but who developed his own style in both the monochrome and the blue-and-gold modes of painting. The third or fifth son of a samurai—the records are unclear—he was made a ward of the Zen temple of Tōfukuji as a young child, a circumstance that saved his life when his father and elder brothers were killed in a battle between their feudal lord, Asai Nagamasa, and Oda Nobunaga in 1573. Becoming a monk effectively removed him from the samurai class and therefore from the burden of his family's loyalty to the losing side. Forty-one at that time, Yūshō took the opportunity to leave the temple and begin a career as an artist. He then seems to have developed contacts with a wide circle of people in Kyoto, including the nobility, the Zen hierarchy, and the samurai, and he executed screens and *fusuma* for each group.

The Zen influence experienced in his childhood is evident in his series of twelve *fusuma* paintings for the Zenkoan, a sub-temple within the Kenninji complex, dated about 1599. The motifs are familiar—a single plum tree (Fig. 303), a gnarled old pine (Fig. 304), and a grove of bamboo—as is the

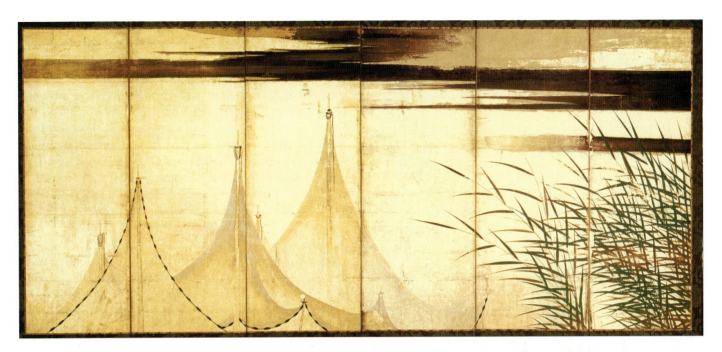

305 *Fishnets Drying in the Sun*, a pair of six-panel *byōbu*, by Kaihō Yūshō. 17th century. Color and gold leaf on paper; each screen: 63 × 138 in.` (160 × 351 cm). Imperial Household Agency.

technique of quickly executed, calligraphic inkstrokes on a white ground. However, Yūshō gives each motif a shape and character of its own. The plum tree is a contained image, clearly defined by relatively flat ink washes, the thick, round trunk growing vertically except for the extremely thin, spiky branches jutting out at sharp angles from the upper part of

304 (opposite) Detail of *Pine Tree*, on four *fusuma*, by Kaihō Yūshō. Early 17th century. Ink on paper; each panel 68 ⅛ × 46 in. (173 × 117 cm). Zenkoan, Kenninji, Kyoto.

the trunk. This is not the usual plum, but a rough-barked, ancient tree miraculously producing delicate white or purple blossoms, the harbingers of spring. It is a trunk onto which young thin branches seem to have been grafted, and they extend almost like swords, defending the core of the tree. In contrast, the pine is indistinct, painted with broad, dry brush-strokes. Its thick trunk curves gently upward, and wide sheltering branches extend to left and right. So soft and hospitable is this tree that two black mynah birds perch on a curve of its trunk, enjoying the protection of its branches. The isolation of each tree and the variety of brushwork that depicts them encourage the viewer to distinguish their individual characteristics, and in so doing to reaffirm the Zen ideal of unity between humanity and the natural world.

306 *"Daily Tenjin" (Nikka Tenjin)*, by Konoe Nobutada. Momoyama period, early 17th century. Hanging scroll, ink on paper; 29 ⅝ x 14 in. (75.4 x 35.5 cm). Imadegawa Yūko, Shiga.

set against gold leaf, which serves as the shore and also the sky. The other half of the right screen is dominated by fishing nets hung out on poles to dry. The left screen repeats the same three elements—grass, water, and fishnets—placing more emphasis on the nets than on the grass in the foreground, but restating it as a tangled mass overlapping the water in the background. The natural repetition of grass fronds contrasts with the controlled forms of the nets and the soft, indistinct flow of the water along the shoreline. The screens, devoid of figures, suggest an ethereal realm far from the hurly-burly of a fishing village.

Konoe Nobutada

Tōhaku and Yūshō did not only draw their inspiration from the Japanese and Chinese masters of the past. Although overshadowed by the decorative painting of the time, the more contemplative paintings and calligraphic exercises of the imperial court and monk–painters continued to be quietly pursued. One of the masters of these literary arts was Konoe Nobutada (1565–1614). The Konoe are one of the sub-branches of the Fujiwara clan that have remained among the emperor's principal courtiers even to the present. At court, Nobutada led an active career as an imperial official, holding the posts of Sadaijin (Minister of the Left) and Udaijin (Minister of the Right), as well as that of *sesshō* (regent). With the imperial court caught between the factions of the samurai, he played an important role in the politics of the Momoyama period. However, he is equally famous for his contributions to calligraphy, being known as one of the Three Master Calligraphers of the Kan'ei era, the other two being Shōkadō Shōjō (1584–1639) and Hon'ami Kōetsu. Hon'ami will be discussed below in relation to the *yamato-e* revival in decorative painting, but Shōjō, a Shingon monk, and Nobutada were, in addition to their poetry and calligraphy, also famous for their paintings in the style of those by the Chinese literati, the so-called *wenren hua* (JAP. *bunjinga*).

Although the Japanese term **bunjinga** would not be applied to a native painting style until the eighteenth century, Nobutada certainly qualifies as a scholar–painter very much in the Chinese tradition of such men of letters—one who has served the state and whose artistic expressions in painting and calligraphy were for his own philosophic pleasure and that of his friends. One such image is an icon of the Shinto *kami* Kitano Tenjin, the patron deity of all Japan's scholars (Fig. 306). It is known as Nikka Tenjin (Daily Tenjin) because every day Nobutada painted a fresh image of the deity. This one is preserved in the Imadegawa Yūko Shrine in Shiga prefecture, and Nobutada's inscription in his relaxed and confident hand reads:

> [Kitano Tenjin] is one to whom the destiny of the empire
> may be entrusted. If there is sincerity of mind, even
> without prayers, the gods will provide protection.

Christine Guth Kanda, trans., *Shinto Arts*, New York, 1976, 134.

A pair of screens depicting fishing nets and marsh grass along the shore, a work executed in color on a gold-leaf ground, displays the restraint and elegance of the style Yūshō developed for work in bright colors (Fig. 305). The set of screens begins at the right with a boldly stated stand of marsh grass in bright green and a narrow band of water above, both

THE *YAMATO-E* REVIVAL

Sōtatsu and Kōetsu

The artists most closely associated with the revival of *yamato-e* themes in the late sixteenth and early seventeenth centuries are Hon'ami Kōetsu and his kinsman Tawaraya Sōtatsu (act. 1600–40). Hon'ami, as discussed above, was a dynamic figure in all the arts of the Momoyama and early Edo periods. He is a good example of the new kind of educated man emerging from the *chōnin* class. Kōetsu was the descendant of a Kyoto family that cleaned, polished, and appraised swords for the military. Gradually their appraisals extended to other areas of connoisseurship for their samurai patrons, including calligraphy. Kōetsu is most famous for his calligraphy, although we have already encountered him as an amateur potter and devotee of the tea ceremony. Clearly, he was a man of many artistic accomplishments, even including working in the Kanō atelier as a young man. Sōtatsu's biographical details are not as clear; he was reputed to have been related to Kōetsu by marriage but it is uncertain in what way exactly. The two of them, however, engaged in many collaborations, combining Kōetsu's calligraphy with Sōtatsu's design and painting.

Not even Sōtatsu's birth and death dates are known and his family name may have been Nonomura or Kitagawa. As an artist, he seems to have begun his career as a commercial painter and proprietor of the Tawaraya fan shop. He grew beyond this, however, and went on to execute superb, large-scale, decorative screen and *fusuma* paintings in the blue-and-gold manner. His major works date to the third decade of the seventeenth century, and clearly represent the last flowering of Momoyama painting. He is first mentioned in 1602 as participating in the repair of the *Heike nōkyō*, sutra rolls created by the Taira family in the twelfth century and preserved in their family shrine of Itsukushima near Hiroshima (see Fig. 194). He repainted several motifs on the endpapers in gold and added entire new paintings, such as the frontispiece of a gold deer bending down to nibble grass on a silver slope (Fig. 307). To be commissioned to work on such an old and valuable set of scrolls, he must already have been known and respected as a technician. Dealing with a masterpiece of early *yamato-e* certainly had a great effect upon his stylistic development, as his subsequent work with Kōetsu amply reveals.

In 1615, Tokugawa Ieyasu granted to Kōetsu some land to the northwest of Kyoto on the banks of the Kamogawa River. Kōetsu's purpose was to create an artistic community of painters, calligraphers, potters, and other craftsmen with a fairly nominal Buddhist focus. It was there, at Takagamine, that Sōtatsu collaborated with Kōetsu on a series of hand scrolls, producing texts of classical works of literature from the Heian and Kamakura periods written in ink across bold floral and figural motifs in gold and silver. Because so little is known for certain about either Kōetsu or Sōtatsu, the role of each in the creation of these scrolls has raised considerable controversy. Generally, however, Sōtatsu is credited with the visual imagery and Kōetsu with the calligraphy, and both share responsibility for the delicate combinations of form, texture, and color that make these collaborations some of the greatest masterpieces of Japanese art.

A particularly beautiful example of their collaboration is a page from their transcription of poems from one of the imperial collections of poetry, the *Shin kokinshū* of 1206 (Fig. 308). The poem, by the great poet of the late twelfth century, Kamo no Chōmei (1155–?1216), reads:

307 Deer frontispiece from *Heike nōkyō*, by Sōtatsu. c. 1602. Color and gold and silver paint on paper; height 10 ⅞ in. (27.5 cm). Itsukushima Shrine, Hiroshima prefecture.

308. Poem by Kamo no Chōmei from *Shin konkinshū*. Calligraphy by Hon'ami Kōetsu and under-decoration chiefly by Tawaraya Sōtatsu, early 17th century. One of 36 *shikishi*; ink on paper decorated with ink, gold, and silver; 7 ⅛ × 6 ⅜ in. (18.3 × 16.2 cm). Museum für Ostasiatische Kunst, Berlin.

The autumn wind blows on all sleeves,
Why then is mine alone
So wet with tears
Upon this evening?

H.H. Honda, trans., *The Shin kokinshu*, Tokyo, 1970, 102.

309. *Deer* scroll, and hand scroll by Sōtatsu; calligraphy by Hon'ami Kōetsu. c. 1615. Ink and gold and silver paint on paper; height 13 ¾ in. (34.925 cm). Seattle Art Museum, Gift of Mrs Donald Frederick.

As Miyeko Murase in her study of this work has noted, Kōetsu's writing of the poem is both vigorous and sensuous, filling the entire page, while Sōtatsu has created an underlying image on the paper in green, gold, and silver showing a close-up view of a rice paddy, where the plants are hanging heavy with grain—not unlike a sleeve wet with tears.

One of the last such collaborations between the two men is the *Deer Scroll* (Fig. 309). Deer, some running, some standing, others feeding gracefully, are depicted in gold and silver paint on paper, and written on the scroll are twenty-eight poems, once again from the *Shin kokinshū*. Two different artists' hands can be recognized in the underdrawings, one accomplished in using gold paint and adept at rendering delicate nuances of thin and opaque shades, the other a much less skilled artist who lays on gold paint in even, heavy strokes and adds single elements to long passages by the first artist. It has been conjectured that the skilled hand is Sōtatsu's, and that Kōetsu, who probably commissioned the scroll from Sōtatsu, but was not entirely pleased with the final work, may have added an occasional deer to fill out the scroll, thinking perhaps that the voids between motifs were too large.

During the second decade of the seventeenth century, Sōtatsu added a new element to his repertoire, the human figure. Using several thirteenth-century narrative *emakimono* as models, he reproduced single figures and whole figural scenes in fan paintings. His fan shop, the Tawaraya, was so well known for its fans bearing themes from classical literature that it is referred to in the *Chikusai monogatari*, a novel written in 1622 and noted for its descriptions of Japan's most celebrated sites. To adapt figural compositions to the curving shape of the folding fan required careful placing of the motifs and voids in order to achieve balance and yet maintain the dramatic tension of the narrative scenes. His work with the fan format may have led him to experiment with the positioning of motifs and voids on the horizontal surface of the *Deer* Scroll, to the displeasure of his patron and collaborator Kōetsu.

Sōtatsu's use of *emaki* motifs can be understood by comparing a single theme in two of his paintings. The first work is a fan, one of forty-eight pasted across a pair of screens owned by the imperial family. The second is a pair of two-panel screens in the collection of Kenninji in Kyoto. The fan at the

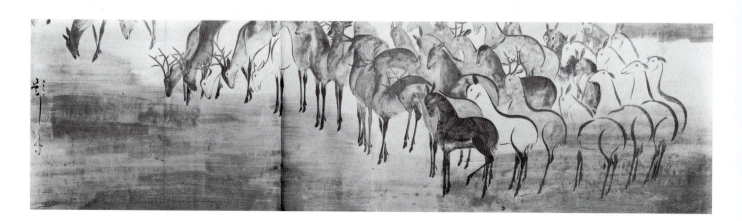

310 Section of a screen painted with fans, from a pair of eight-panel *byōbu*, by Sōtatsu. *c.* 1630. Color on paper; height 53 ½ in. (136 cm). Imperial Household Agency.

top of the panel shows an episode from the *Ise monogatari (Tales of Ise)*, attributed to the ninth-century aristocrat Ariwara no Narihiri. In this scene, a nobleman, who has fallen in love with a girl designated to become the future imperial consort, spirits her away in the night (Fig. 310). Caught in a heavy rainstorm, they take shelter in a ruined storehouse, the girl sleeping inside, the man guarding the door from the outside. At dawn he enters to see how his love has passed the night, but she is not there. A demon has eaten her up, the thunder muffling her cries for help. In Sōtatsu's rendering, the demon is to the left, climbing through the air above the storehouse roof, while the young man, barely visible in the lower-right corner of the fan picture, sleeps peacefully on the other side of the massive, dark-brown roof. The storehouse dominates the painting, cutting across the surface at a sharp angle and providing a formidable barrier between the demon and the man depicted. The demon is the twin of the God of Thunder and Lightning in the *Kitano Tenjin engi emaki*, a scroll Sōtatsu is known to have studied (see Fig. 270). Sōtatsu has extracted one motif from the earlier narrative scroll and combined it with other pictorial elements to illustrate an episode from a totally unrelated narrative.

The second work that uses the demon motif is monumental in comparison with the fan. A pair of two-panelled screens

311. Right screen of a pair of six-panel *byōbu*, known as the *Matsushima screens*, by Sōtatsu. 17th century. Ink, color, and gold leaf on paper; each screen: 59 ⅞ x 140 ½ in. (151.9 x 356 cm). The Freer Gallery of Art, Smithsonian Institution, Washington DC. (F1906.231 and 232).

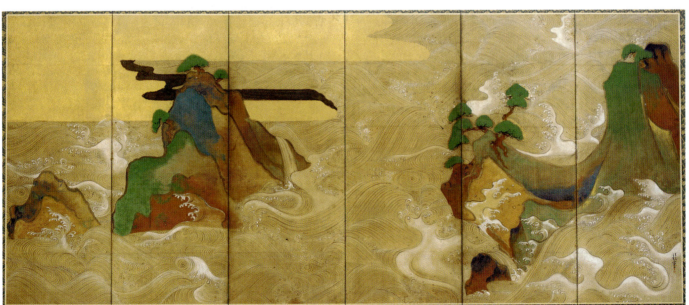

312 *God of Thunder* (Raijin, left) and *God of Wind* (Fūjin, right), a pair of two-panel *byōbu*, by Sōtatsu. After 1621.
Color and gold and silver paint on paper; each screen: 58 ⅞ x 69 ¾ in. (152 x 177.2 cm). Kenninji, Kyoto.

depict Raijin, God of Thunder, and Fūjin, God of Wind (Fig. 312). The screens were probably made sometime after 1621, the year in which Sōtatsu was commissioned by the wife of shogun Hidetada (1579–1632) to decorate certain wooden doors and *fusuma* for the Yōgenin, a building being refurbished as the mausoleum for her father. The fact that Sōtatsu received the patronage of the shogun might explain why at about this time he seems to have turned from decorating fans and scroll papers to creating screens and *fusuma* paintings for specific patrons. It is generally assumed that Sōtatsu, coincident with this shift in career, turned over the Tawaraya to his successor, Sōsetsu. From his surviving screens and *fusuma*, however, it is clear that he continued to pursue his interest in themes from classical literature.

As the model for his God of Thunder, Sōtatsu used the same demon image from the *Kitano Tenjin engi emaki* scrolls. The source of the God of Wind is not known for certain. He may have taken it from a section of the scroll no longer extant, or he may have taken the pair of thirteenth-century Kei-school statues in the Sanjūsangendō depicting the two gods as his inspiration for the theme and the treatment of his God of Wind (see Figs 227a and b). The God of Thunder in the upper-left corner of the left screen is a striking white figure against the gold ground and the silver rain clouds. His garments are depicted in flat, solid colors—blue, green, and orange—but his horns, a subtle blend of black ink and beige and green color, are executed in **tarashikomi**, Sōtatsu's technique of applying one color over another not yet dry, to make them blend in a rich and irregular fashion. Sōtatsu's god is another direct descendant of Sugawara no, Michizane's ghost, here divorced

from any narrative. Indeed the composition of the two screens —the God of Wind striding forward to the left and the God of Thunder climbing upward to the left—suggests the course of a thunderstorm, the wind rising, the storm climaxing in the gold void between the figures, and the thunder and lightning disappearing into the distance. It seems that Sōtatsu never discarded an interesting classical image, but played with it in one composition after another as he expanded his pictorial style from small-scale fans to large screen and *fusuma* surfaces.

In one of his masterworks, the so-called *Matsushima Screens*, Sōtatsu has transcended his classical sources (Fig. 311). Matsushima is the name of one of the *sankei*—the three most beautiful landscapes in Japan—and is meant to conjure up the bay dotted with small, pine-capped islands near Sendai in the Tōhoku region far to the north of Kyoto. It is possible that Sōtatsu was recreating the scenery of this bay. However, because the artist based so many of his paintings on works of literature from the Heian and Kamakura periods, when there was scant interest in northeastern Japan, this identification seems unlikely. Another possibility is that he was drawing on the tradition of paintings depicting pines along the shore, a popular theme during the Momoyama period. However, because the islands in the right screen resemble the Wedded Rocks, an unusual configuration at Futamigaura along the southeast coast of Honshū near Ise, it has been suggested that the screens illustrate a poem from the *Tales of Ise* dealing with the feelings of a courtier banished from the capital, "gazing at the foaming white surf as he crossed the beach between Ise and Owari provinces."

How poignant now
My longing
For what lies behind—
Enviable indeed
The returning waves.

Helen Craig McCullough, trans., *Tales of Ise*, Stanford, 1986, 73–4.

To the right, the first screen begins with a richly colored rocky outcrop, the coastline surrounded by raging white-capped water. Towards the left appears a golden cloud, and then a group of rocks capped by pines. In the first five panels the seascape resembles the natural formations at Futamigaura except for the strange, cloud-shaped form articulated with wave patterns that projects to the left behind the rocks, between two layers of gold clouds. It is as if Sōtatsu, responding to the loneliness and longing for home of the courtier in the Ise poem, has intuited how such feelings can cause a momentary loss of focus, a slipping of the grasp on reality. In the last panel the gold clouds become clouds again, and the water bubbles and boils around a single, pointed rock, as if normal perception has been restored. In the left screen, reality is once again completely distorted; what may look like gold clouds turn into island shores, from which pine trees grow. In the white-capped water, two golden islands devoid of vegetation are ringed with silver and black ink beaches. Throughout,

the waves continue to well up, crest, and break, flowing inexorably back toward the capital.

If the poetic connection is correct, Sōtatsu has stepped beyond his classical models in illustrating this poem. Heian-period illustrations of works like the *Genji monogatari* used elements of the natural world to reflect the emotions of human beings. In these screens Sōtatsu penetrates beneath the words of the poem to the psychological state of the man who is alone on the beach, staring at the water and longing to return to his home, his friends, and the known world from which he has been expelled. Magnificent in their own right, these screens, when associated with the poem from the *Tales of Ise*, become an awesome metaphor for the deep emotion experienced by the undepicted courtier.

In the second half of the seventeenth century Sōtatsu's and Kōetsu's aesthetics and techniques would be enlarged upon by several artists, but most particularly by two brothers of the Ōgata family. The Rinpa style which grew out of Ōgata Kenzan's work would take Sōtatsu's abstraction of forms to its logical limits. Similarly, although the passion for gold screens and *fusuma* abated somewhat, all of the achievements of the artists of the late sixteenth and early seventeenth centuries would be drawn on continually by those of the next three hundred years, who would look back on this time as a renaissance of native style.

CHAPTER 6

Pax Tokugawa

CLOSED BORDERS, OFFICIAL ORTHODOXY, AND THE INEXORABLE RISE OF POPULAR CULTURE IN THE EDO PERIOD

The late sixteenth century and first decade or so of the seventeenth century had witnessed the consolidation of authority under a succession of dynamic leaders: Oda Nobunaga (1534–82), Toyotomi Hideyoshi (1536–98), and Tokugawa Ieyasu (1542–1616). In 1603, the last of the three, Ieyasu, established a shogunate centered on his fortress at Edo (present-day Tokyo) that was to last for two hundred and fifty years. Edo is therefore the name of the period (1615–1868), although it is also often referred to as the Tokugawa period. A key factor in this longevity was the success of Ieyasu's immediate heirs in transforming some 250 independently-minded daimyo and their samurai retainers from fighting machines into a unified bureaucracy capable of maintaining peace and order throughout the country under Tokugawa leadership. During the first four decades of the seventeenth century, the new bakufu developed and promulgated a system of laws designed to ensure national political stability and the unquestioned rule of the Tokugawa shogun. As already described in Chapter 5, these measures included forbidding Japanese to travel abroad and foreigners freedom of movement in Japan, and, ultimately, the proscription of a new religion, Christianity. Equally important, however, was its reassertion of a rigidly defined class system and the development of codes of moral and ethical behavior on every stratum of society. The Tokugawa shoguns used their bakufu as a strong, central executive to oversee the regional authority asserted by each daimyo over his domain (ryō or **han**)*, and achieved a uniquely successful balance of power that modern historians have named the* **baku-han***.*

Confucianism and Social Stability

Where Zen Buddhism had been the philosophical heart of the first *bakufus* of the medieval period, Confucianism played a significant role in the policies formulated by the Tokugawa. The Confucian classics had been the basis of the education of imperial officialdom from the seventh to twelfth centuries, and the Tokugawa's espousal of Confucianism reflected both their desire to identify themselves with ancient tradition and the renewed vigor of Confucian philosophies on the continent. Central to Confucianism is a firmly structured society in which the individual knows and feels secure in his or her place. In its Japanese interpretation, the emperor and his court were at the top of this structure, with the samurai just below, followed by the primary producers, the agricultural peasantry, and then by the secondary producers, the artisans and merchants or townsmen (*chōnin*). This hierarchy had been in place for over a thousand years, and the Tokugawa easily adapted it to suit their purposes. The emperor and his court retained their pre-eminent social position, but their role was to act as the cultural and spiritual heart of the nation. This they had gradually become accustomed to in the medieval period, and for the most part they continued in their acquiescence. When the outside world—that is, the European powers, the Qing empire of China (1644–1911), and the Choson kingdom of Korea (1392–1911)—had occasion to address themselves to the emperor of Japan, they meant, in fact, the Tokugawa shogun. The samurai class, which had now for many centuries held the real power, became under the Tokugawa a highly educated elite of scholar–soldier–officials. Within this new bureaucracy, the shogun and his *bakufu* formed a federal administration, with the two hundred and fifty or so *han* of the daimyo representing the regional authorities. The latter's samurai retainers, who previously had been military officers, functioned now primarily as officials of these regional governments.

Ironically, as the samurai left their warlike lifestyle further and further behind, many of them came to identify themselves even more intensely as warriors. Equally curiously, the old

imperial regional administration established in the seventh century also continued to live on as a series of titles and stipends to be given and taken away as favors by the shogun's *bakufu*. Although this administration had long been defunct, it meant that technically there were two parallel bureaucracies administering both the old provinces and the new *han*. However, the overall success of the *baku-han* system is proven by the longevity of the Tokugawa regime, and the relative peace and prosperity that large sections of the population enjoyed under it. The long period of peace and stability of the *baku-han* had certainly been the aim of the Minamoto and the Ashikaga governments, but it was the Tokugawa who achieved it.

The rebuilding of temples had begun as soon as the Sengoku Jidai (Age of the Country at War; c. 1480–1573) ended, and continued throughout the seventeenth century as one of the Tokugawa regime's primary tools of legitimization and consolidation. It also found accord with their antagonism toward Christianity, and one of their edicts required all Japanese to register as members of a specific religious institution—Buddhist, Shinto, or Confucian—and undergo annually an examination of their religious beliefs. In each *han*, schools for teaching the administration's favored Confucian doctrine and temples for Confucian worship were erected. A Shinto mausoleum was built for Ieyasu at Nikkō, north of Edo, and small-scale replicas of it were erected in each *han*. Tokugawa conservatism can be seen also in the paintings commissioned by the shoguns and their daimyo, works by established masters of the Kanō school depicting traditional themes from the Muromachi (1392–1573) and Momoyama (1573–1615) periods—Chinese subjects, such as the patriarchs of Confucianism and the *Teikan zu* (*Mirror of Emperors*); a popular treatise on good government), and such Japanese themes as birds and flowers of the four seasons. In contrast to the bold forms and gold backgrounds of the regimes of Nobunaga and Hideyoshi, Tokugawa imagery spoke to a solid, serious conservatism, invoking awe through tradition instead of glamor.

Below the samurai administrators and their elite culture were the peasants, and below them the townsmen, or *chōnin*. The latter was divided into the artisans who created the objects—the buildings, the clothing, the utensils—and the merchants and tradesmen who, according to Confucian thought, merely handled the fruits of others' labors. Throughout Japanese history, however, it has been in this lower part of the social hierarchy that appearances deceive. Although in a relatively exalted position, the Japanese peasant had always been obliged to work his land for one lord or another, whether court aristocrat or samurai, and this did not change under the Tokugawa. From the end of the Sengoku Jidai, however, the *chōnin* had been growing both in number, with the massive spate of urban construction that characterized the late sixteenth and early seventeenth centuries, and in wealth. Although they also had to pay the *bakufu*'s taxes, they did not bear the brunt of them, which were reserved for the peasantry and their main crop of rice—the primary currency

by which the samurai officials were paid. Already in the sixteenth century, peasants had been abandoning the land in droves, turning to the cities to step down the social ladder and hopefully step into prosperous security. In the Edo period, as taxation became more and more crippling, this demographic shift continued unabated.

Therefore, although the Tokugawa intended to set the social classes in concrete, restricting movement between the levels entirely, the reality is that social mobility did still exist, but it is usually considered in negative terms. As already mentioned, technically, going from peasant to *chōnin* was a slip down the ladder, and samurai also could suffer a fall from social grace. *Rōnin*, or masterless servants, were samurai who had lost or forfeited their positions. In the tumultuous past this had frequently occurred when their lord had somehow disgraced himself and was forced to commit ritual suicide, and, although this could still occur in the Edo period, masterless samurai increasingly were individuals who wished to free themselves from the responsibilities and constraints of service to their daimyo and engage in the new life of the cities. Not a few such *rōnin* would become significant figures in the literary and artistic circles of the period. The older type of *rōnin* became a romantic fantasy figure in literature and folklore, a kind of pathetic hero. Still, one of the best ways to take oneself out of one's class remained either to become a Buddhist monk or enter the Shinto priesthood.

Mention here should also be made of the least desirable position within Japanese society, and that was to be outside it altogether. Since at least the thirteenth century, there had developed a whole array of such outcasts, although simply speaking they were divided between the *eta* (impure) and the *hinin* (non-human). These unfortunates could be peasants or townsmen who had lost their positions on the land or in the guild, but a large proportion of them were from ethnicities such as the Ainu, who were not considered properly Japanese, or the descendants of the many thousands of Korean captives taken during Hideyoshi's campaigns in the 1590s. The *kawaramono* of the medieval period were classified as *hinin* in the Edo period. They were allowed to work at jobs considered unclean in both Buddhism and Shinto, such as grave digging and leather tanning. Obliged to live in ghettos, the *hinin* also had a dress code which dictated that their robes were not allowed to descend below the knee. These outcast ranks and the restrictions upon them were officially abolished in 1871, but it would take the better part of another century to begin to wipe out the enormous stigma attached to these communities.

A Bourgeois Paradise

By the end of the seventeenth century, the prosperity of the cities, which had enjoyed almost a century of peace, had made the upper ranks of the *chōnin* some of the wealthiest families in the land. By contrast many of the samurai/officials were forced to subsist on fixed incomes paid primarily in rice, the

value of which not infrequently plummeted. Many were therefore on the verge of bankruptcy. The vitality of the *chōnin*, already witnessed in the arts of the Momoyama and early Edo periods, only increased with their affluence, and their exuberant enjoyment of life produced a climate in which the arts prospered. These people were astute and pragmatic businessmen, sensitive to minute political, social, and even climatic changes that could mean financial gain if they were assessed and handled correctly, or ruin if mismanaged. Their attention was focused on the world around them, and they cared little for the glories of the long-dead past. They were well educated and rich in worldly experience, and, although they indulged with abandon their fondness for saké, women, and the theater, they were extremely demanding about the quality of the entertainment for which they paid their hard-earned money.

Their exacting standards served as a stimulus to a new breed of writer and artist; notable among the former were the novelist and poet Saikaku Ihara (1642–93) and the playwright of the puppet theater Chikamatsu Monzaemon (1653–1724). They looked to painting and to the developing art of the woodblock print for illustrations of scenes from their favorite plays and novels, and for a format of genre imagery known as *ukiyo-e*—"pictures of the floating world," a reference to both the pleasures to be had in the theaters and teahouses of this new society as well as to their fleeting nature. The concept of art as a means of expressing philosophical or religious ideals or of capturing the essence of a great work of classical literature was of relative unimportance.

The first great artistic flowering following the Momoyama period occurred in the imperial reign era known as Genroku (1688–1703), but, even though the Edo period had its episodes of natural disaster and political instability, for the majority of the constantly expanding urban population life could be good, and fortunes could be made. At the higher end of this artistic milieu were the older *chōnin* families of Kyoto and Osaka, with their longstanding connections with the court aristocracy and the ancient Buddhist foundations. This is the world to which Takagamine, the artistic community established by Hon'ami Kōetsu (1558–1637), belonged. From it also would emerge the brothers Ōgata Kōrin (1658–1715) and Ōgata Kenzan (1663–1743), who would create a dynamic continuation of both Sōtatsu's concepts of painting and design, and Kōetsu's calligraphic excellence and interest in ceramics and the tea ceremony. However, in the newer cities such as Edo the artistic expression of choice was *ukiyo-e* with its depictions of famous male actors and female entertainers, and its illustrated guides to the local brothels and the activities that went on behind their closed doors.

The exuberant prosperity of this *chōnin* culture often gave the authorities pause for thought, especially as it reflected on the ranks of the samurai officials, who seemed to grow only more impoverished as the period progressed. The sumptuary edicts of the *bakufu* and the *han*, aimed at curbing displays of wealth by the newly rich merchants, should be seen in this context. For example, *chōnin* men and women could be limited

in their dress to somber shades of brown and gray and only to certain varieties of very ordinary silk. The upper levels of the *chōnin*, whose culture looked much more to the subdued and understated aesthetics of the imperial court, made a virtue out of such restrictions, spending money on the refinement of the silk and its weave pattern, in addition to discovering deep and rich shades of what the authorities hoped were neutral, uninteresting colors. Another option was to spend lavishly on accessories such as the Edo-period version of the wallet—the *inro* box, which was suspended from the belt of a man's *kosode*, and the ivory or bone **netsuke** carving that hung from its cord. Objects such as these, which could be easily hidden from a government patrol's view, could be brought out in the company of one's peers and served as miniature canvases demonstrating one's wealth or culture. Finally, one could simply flout the laws, as not infrequently occurred amongst the courtesans of the pleasure districts, who depended on glamor to attract their customers. Once promulgated, many of these sumptuary edicts quickly fell into abeyance due to the effort it took simply to enforce them. Also as their enforcement was in the hands of local officials, the wealthier *chōnin*—or courtesans with wealthy patrons—could often fairly easily secure the blind eye of the law. Nevertheless, the existence of such laws was a significant factor in the forming of the period's aesthetic in the decorative and applied arts, keeping alive both craftsman's and client's creativity in their efforts to circumvent officially imposed limitations.

At the center of the new urban culture was the shogunal capital of Edo. Founded only after 1603, the city had blossomed with amazing rapidity. In 1657, it suffered a disastrous fire, but rebuilding began immediately, and, with an eye to preventing another such disaster, large open spaces were planned within the new city. At the heart of its floating world were the entertainment quarters such as Asakusa and Yoshiwara, and they became the natural settings of a great many of the *ukiyo-e*. Around 1800, the woodblock print master Katsushika Hokusai (1760–1849) made these districts the focus of a series of images entitled *Shinban Uki-e* (*New Images of the Floating World*). In one print from the series, a view of courtesans and other citizens bustling around a temple gate guarded by enormous Niō figures gives some sense of the vibrancy of the culture and its delight in its own vitality (Fig. 313). The hordes of people to be seen even on the gate's upper balcony point also to another social development of the Edo period—leisure tourism.

To be sure, tourism of a sort had long existed in Japan. There were the outings by groups of aristocrats to view the scenery of suburban temples or shrines in the Nara (710–94) and Heian (794–1185) periods, as well as the more devout pilgrimages to great Buddhist temples and Shinto shrines by all ranks of society throughout Japanese history. Yet, in the course of the Edo period, the prosperity-endowed leisure of the wealthier *chōnin* and the relative safety of the roads opened up the concept of travel for pleasure. Shinto or Buddhist pilgrimages remained an important feature, but a whole new group of

313 Scene in Asakusa, Tokyo from the series *The Niomon of Kinryuzan* (New Images of the Floating World), by Katsushika Hokusai. c. 1800s. (*Oban* format, after *Hokusai Katsushika Exhibition, 4–11 January 1984*, Seiji Nagata ed., Sansai Shinsha Pub. Co., Tokyo, 1984, Plate 8.) Katsushika Hokusai Museum, Tsuwano, Shimane.

attractions also developed, from places of great scenic, cultural, or historical significance to the wonders to be found in the modern, bustling metropolis. A large portion of the credit for promoting this new tourism belongs to informative printed guide books and also to woodblock print illustrations. Japan's poetic traditions had always lionized the Japanese scenery, but the woodblock print made it come to life for even the most prosaic of minds.

Another feature of this leisure was a democratization of the garden, previously the province of aristocratic, samurai, or abbatial residences. While wealthy *chōnin* families had doubtless built large houses and cultivated ornamental gardens throughout Japan's history, in the Edo period there was a growing eagerness to create within the new cities public garden spaces where one could enjoy nature and see and be seen. One of the first of these municipal parks was the Rikugien Gardens, established between 1699 and 1706 in Edo (Fig. 314). The project of a favorite of the shogun Tsunayoshi (1680–1709), Yanagisawa Yoshiyasu, it covers almost 25 acres (10 ha), featuring a lake and artificial hills laid out and planted like a traditional aristocratic or daimyo garden, but writ on a vast scale. It was in such spaces that the population of Edo could gather for festive holidays, not least of which

would be viewing the changing of the leaves in the fall or the cherry blossoms in the spring. The Rikugien Gardens was also one of the important stages on which courtesans could display themselves outside the pleasure districts.

The entertainment, or pleasure, districts to be found in any Japanese city of decent size were in many ways the spiritual center of Edo-period popular culture. Although hardly the haunts of respectable citizens, and certainly not of ladies of good name, the entertainment districts are the single most popular topic of *ukiyo-e*, whether they illustrate the courtesans who lived and worked there, or the actors in the Kabuki theaters which also made their home in or near these areas. A key establishment within these districts was the teahouse, which served as a social forum for the Edo-period male, serving not only tea, but also saké and food of all descriptions. The teahouse was the proper place of business for the courtesan, who was often indentured to the proprietor, or at least gave them a percentage of their takings. The geisha, who had been trained in traditional singing, dancing, and playing of musical instruments, were the cream of the courtesans. They were (and are) hostesses and companions, providing company and conversation for men at the teahouses and at private parties. In the Edo period, geisha were the pinnacle of the pleasure

314 View of the Rikugien gardens, Tokyo. Established 1699–1706.
Tokyo Metropolitan Park Association Department.

district's society of indentured women—which included servants and various levels of prostitutes—and they were the trendsetters for women's styles in general. Some of these women even became noted connoisseurs of poetry, painting, and of the theater.

The image by Utagawa Toyoharu of a snow-viewing entertainment at a teahouse (Fig. 315) gives some idea of the atmosphere of relaxed enjoyment such places were supposed to provide. In a series of tatami-covered rooms open to the snow-covered garden, groups of people are served food and drink by comely young ladies. Many of the figures are engaged in games of Japanese checkers or in conversation, while one makes a gigantic snowball. The entire scene is one of of quiet leisure. This same spirit of leisure and entertainment—or *asobi* (literally "play")—infuses a great deal of *ukiyo* imagery and literature, as well as the more refined aesthetics of the Rinpa school, based in Kyoto, and indeed in all the design of the decorative and applied arts of the period—from ceramics to lacquer and metalware to textiles.

In the course of the eighteenth century, leadership in cultural affairs passed from the power brokers to the intellectuals within the samurai class and the elite among the *chōnin*. The samurai, encouraged by the tenets of Confucianism,

embarked on a quest for knowledge that led them far beyond the boundaries of conventional philosophy. This spirit of inquiry was encouraged in particular by shogun Yoshimune (1716–45), who lifted many of the restrictions on the importation of foreign books, thus opening up new sources of information and ideas, both Chinese and European, to which the cultural leaders of the period turned with enthusiasm. The works that excited the greatest interest on the part of the intelligentsia were—and still are—those associated with Confucianism, Chinese **literati painting** (*bunjinga* or *nanga*), pictures in Western styles, called *yōfuga*, and paintings by the **Maruyama–Shijō school** of Japanese realism.

An Eclipse Long Deferred

In the nineteenth century, the Tokugawa *bakufu*'s grip on Japanese society began to slip. The dependence on rice as the sole agricultural crop had bankrupted the lower orders of the samurai, and only further oppressed the peasantry. Many more peasants abandoned their land and moved to the cities, and by 1840 those remaining on the land were in revolt against the central government. Merchants were also tired of

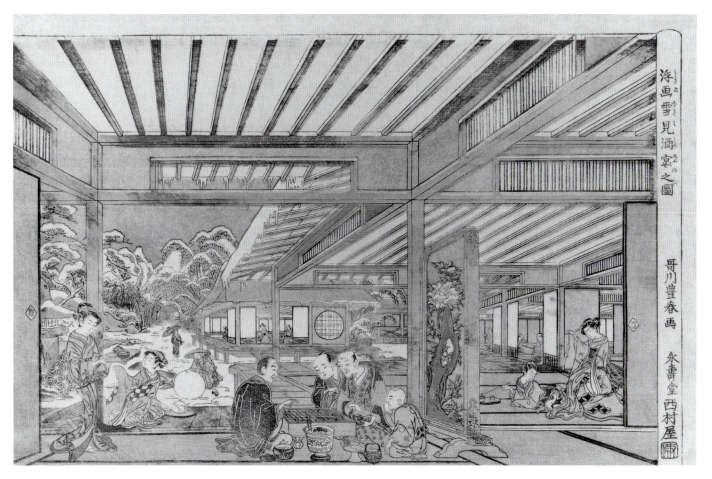

315 *A Perspective Picture of Viewing the Snow and Drinking Saké (Uki-e Yukimi Shuen no zu)*, Utagawa Toyoharu.
Color woodblock print; 10 x 15¼ in. (25.5 x 39 cm).
The Art Institute of Chicago. Clarence Buckingham Collection. (1925.3184).

being lowest in the social hierarchy although the nation's wealthiest citizens. Furthermore, when the shogunate ran short of funds, it would exert levies on the merchants living in cities such as Osaka, Edo, and Nagasaki which were under the direct control of the Tokugawa *bakufu*. On other occasions the *bakufu* would "invite" the merchants to lend money, which it then often refused to repay, issuing Acts of Grace that amounted to repudiations of all or part of the debt. Although aware of the rising discontent at every level of society, the Tokugawa *bakufu*, terrified to alter too much the structure established in the seventeenth century, seemed to have no solutions.

Another contributing factor to the government's instability was the growing presence of the European powers in East Asia. By the early nineteenth century Britain had already gained control of much of India, and the Dutch of Southeast Asia, and the British were about to trigger the century-long collapse of the Qing empire through the agency of the Opium War and enforced trade concessions in the main Chinese ports. Perhaps wisely, considering the colonization of the rest of East Asia by the European powers, the Tokugawa government dealt harshly with any foreign interlopers trespassing on their domain outside the Dutch concession on Deshima Island. However, feeling increasingly besieged on all fronts, the regime

vacillated between the hard-line policy it had instituted in 1825, which ordered daimyo with coastal lands to drive off foreign vessels by force and to kill any crew members who came ashore, and the softer policy of 1842 that instructed local authorities to supply foreign ships with food and fuel and urge them to go away. But the trend of international events was moving against the policy of isolation. In 1842, the English defeated the Chinese in the Opium War and forced the opening of Canton and other ports to trade. Finally, in 1853, Commodore Matthew Perry sailed into Uraga harbor at the mouth of Edo Bay with four warships and a letter from the president of the United States urging that American mariners be given good treatment by the Japanese. The following year the government formally ended its isolationist policy.

There had also been increasing awareness throughout the eighteenth and nineteenth centuries that Western technology far surpassed that of the Japanese. Of great interest were advances in weaponry and, as visits from Western ships became more numerous and more threatening, many factions within Japan began to push for open access to Western technology. Others realized that trade with the West could provide an alternative to the one-crop dependence of the Japanese economy, the source of perennial economic problems. Both of

these factors—the dislocations within the society and the pressure from technologically more advanced nations—led to a mood of discontent and uncertainty among the Japanese that is reflected in the arts of this period, which is known as the *bakumatsu*, (or waning of the *bakufu*). While there were no major artistic innovations in the years before the fall of the Tokugawa shogunate in 1868, the foremost artists of each school of painting were rethinking their approaches to pictorial expression and seeking fresh inspiration in an effort to revitalize their work.

Images of the Floating World: *Ukiyo-e*

Ukiyo-e is the type of pictorial expression most characteristic of the Edo period, depicting as it does the world of the theater, the pleasure district, and the *chōnin* and samurai who frequented both. The word *ukiyo* had first appeared in the context of Buddhism, where it was used to describe the impermanence of the world of humans—the sense that all things are illusory and ephemeral—but in the Edo period the word took on a different tone: now this ephemeral character was to be savored with gusto by a society devoted to sensual pleasures all the more exciting for their constantly changing nature. In addition *ukiyo* was used to refer specifically to the demimonde of the pleasure district—a quarter of the city which housed courtesans, their attendants, and the theaters, where Kabuki plays and Bunraku performances were presented. By the Genroku era the principal vehicles for literary and artistic expression were the *ukiyo zōshi*, prose stories of the floating world; *ukiyo-e*, paintings and woodblock prints of genre subjects; *bijinga*, paintings and prints of courtesans; and Kabuki and Bunraku plays.

The artist traditionally credited with parentage of the entire *ukiyo* genre of illustration is Iwasa Matabei (1578–1650), although the only extant works attributed to him are paintings. The best explanation yet advanced for the references in Edo-period documents to "Ukiyo Matabei" is that the artist pioneered a style of painting in which wiry black outlines and bright colors were combined with themes depicting human beings in moments of extreme emotion—caught in the noise, excitement, and confusion of a festival, or even crimes of passion—and that this mode of painting was transmitted by him from Kyoto to Fukui prefecture, where he worked for the daimyo Matsudaira Tadanao (1595–1650) and his son, and finally to Edo, where he moved in 1637. Matabei was the illegitimate son of the samurai Araki Murashige, a trusted adviser to Oda Nobunaga. However, the year after Matabei was born his father rebelled unsuccessfully and had to flee for his life. His wife and legitimate offspring were put to death, but Matabei escaped with his wet nurse and was allowed to live in hiding in Honganji in Kyoto. Thus he grew up in the capital and probably established a painting studio there before he left for Fukui in 1615.

His style, fully mature by the time he reached Edo, probably had great appeal for the rough, brawling *chōnin* and low-ranking samurai of the early city, with their taste for action-packed Kabuki plays, and may well have influenced artists there who were working with block-printing techniques, enabling them to create designs of greater intensity and forcefulness. A pair of word pictures (*moji-e*) attributed to him displays the kind of witty imagery and brush technique that came to be identified with the man and his painting style (Fig. 316). At first glance they seem to be caricature sketches of a beggar and a samurai retainer. However, the thick black outlines of each are in fact *hiragana* characters; one forms the word for beggar (*tsu ma ichi*), while the one of the samurai official forms the phrase "I humbly thank you" (*orei o moshi sōrō*). Christine Guth in her study of these images, and the concept of *asobi* (or playfulness) in Edo-period art, has pointed to *moji-e* images as evidence also of the growing literacy amongst the general population.

A second step toward the formation of true *ukiyo-e* was a type of painting, *bijinga* (or alternatively, *bijin-e*), depicting a single courtesan against a flat, neutral background, which became popular in the Kanbun era (1661–72). These paintings, generally executed by artists who did not sign their works, were presumably produced as expensive souvenirs for purchase by well-to-do *chōnin* or samurai patrons of the pleasure district. In contrast to Matabei's work, Kanbun *bijinga* display delicate brushwork and elaborate textile patterns in restrained colors combined with a characterization of the women as remote and elegant creatures. An excellent example of this style of painting is the hanging scroll of a Kanbun-era beauty (Fig. 317). A slender young woman stands with her knees slightly bent, her arms drawn into her sleeves. Her mouth is hidden by an undergarment that has been pulled out of place, and her eyes are directed to the left. Whether her attitude denotes shyness or the coy allure of a courtesan is left for the viewer to decide, and therein lies much of the painting's charm.

316 Pair of word pictures (*moji-e*), attributed to Iwasa Matabei. Edo period, 17th century. Album leaves, ink on paper; each: 11 ½ x 8 ¾ in. (29.2 x 22.2 cm). The Mary and Jackson Burke Foundation, New York.

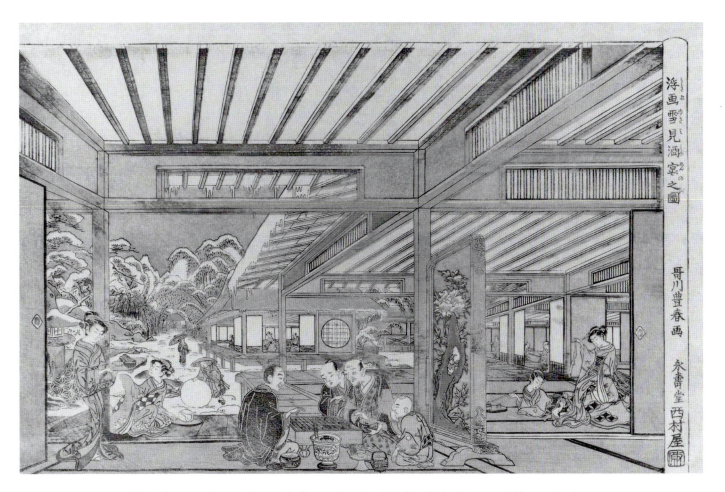

315 *A Perspective Picture of Viewing the Snow and Drinking Saké (Uki-e Yukimi Shuen no zu)*, Utagawa Toyoharu.
Color woodblock print; 10 x 15¼ in. (25.5 x 39 cm).
The Art Institute of Chicago. Clarence Buckingham Collection. (1925.3184).

being lowest in the social hierarchy although the nation's wealthiest citizens. Furthermore, when the shogunate ran short of funds, it would exert levies on the merchants living in cities such as Osaka, Edo, and Nagasaki which were under the direct control of the Tokugawa *bakufu*. On other occasions the *bakufu* would "invite" the merchants to lend money, which it then often refused to repay, issuing Acts of Grace that amounted to repudiations of all or part of the debt. Although aware of the rising discontent at every level of society, the Tokugawa *bakufu*, terrified to alter too much the structure established in the seventeenth century, seemed to have no solutions.

Another contributing factor to the government's instability was the growing presence of the European powers in East Asia. By the early nineteenth century Britain had already gained control of much of India, and the Dutch of Southeast Asia, and the British were about to trigger the century-long collapse of the Qing empire through the agency of the Opium War and enforced trade concessions in the main Chinese ports. Perhaps wisely, considering the colonization of the rest of East Asia by the European powers, the Tokugawa government dealt harshly with any foreign interlopers trespassing on their domain outside the Dutch concession on Deshima Island. However, feeling increasingly besieged on all fronts, the regime

vacillated between the hard-line policy it had instituted in 1825, which ordered daimyo with coastal lands to drive off foreign vessels by force and to kill any crew members who came ashore, and the softer policy of 1842 that instructed local authorities to supply foreign ships with food and fuel and urge them to go away. But the trend of international events was moving against the policy of isolation. In 1842, the English defeated the Chinese in the Opium War and forced the opening of Canton and other ports to trade. Finally, in 1853, Commodore Matthew Perry sailed into Uraga harbor at the mouth of Edo Bay with four warships and a letter from the president of the United States urging that American mariners be given good treatment by the Japanese. The following year the government formally ended its isolationist policy.

There had also been increasing awareness throughout the eighteenth and nineteenth centuries that Western technology far surpassed that of the Japanese. Of great interest were advances in weaponry and, as visits from Western ships became more numerous and more threatening, many factions within Japan began to push for open access to Western technology. Others realized that trade with the West could provide an alternative to the one-crop dependence of the Japanese economy, the source of perennial economic problems. Both of

these factors—the dislocations within the society and the pressure from technologically more advanced nations—led to a mood of discontent and uncertainty among the Japanese that is reflected in the arts of this period, which is known as the *bakumatsu*, (or waning of the *bakufu*). While there were no major artistic innovations in the years before the fall of the Tokugawa shogunate in 1868, the foremost artists of each school of painting were rethinking their approaches to pictorial expression and seeking fresh inspiration in an effort to revitalize their work.

Images of the Floating World: *Ukiyo-e*

Ukiyo-e is the type of pictorial expression most characteristic of the Edo period, depicting as it does the world of the theater, the pleasure district, and the *chōnin* and samurai who frequented both. The word *ukiyo* had first appeared in the context of Buddhism, where it was used to describe the impermanence of the world of humans—the sense that all things are illusory and ephemeral—but in the Edo period the word took on a different tone: now this ephemeral character was to be savored with gusto by a society devoted to sensual pleasures all the more exciting for their constantly changing nature. In addition *ukiyo* was used to refer specifically to the demimonde of the pleasure district—a quarter of the city which housed courtesans, their attendants, and the theaters, where Kabuki plays and Bunraku performances were presented. By the Genroku era the principal vehicles for literary and artistic expression were the *ukiyo zōshi*, prose stories of the floating world; *ukiyo-e*, paintings and woodblock prints of genre subjects; *bijinga*, paintings and prints of courtesans; and Kabuki and Bunraku plays.

The artist traditionally credited with parentage of the entire *ukiyo* genre of illustration is Iwasa Matabei (1578–1650), although the only extant works attributed to him are paintings. The best explanation yet advanced for the references in Edo-period documents to "Ukiyo Matabei" is that the artist pioneered a style of painting in which wiry black outlines and bright colors were combined with themes depicting human beings in moments of extreme emotion—caught in the noise, excitement, and confusion of a festival, or even crimes of passion—and that this mode of painting was transmitted by him from Kyoto to Fukui prefecture, where he worked for the daimyo Matsudaira Tadanao (1595–1650) and his son, and finally to Edo, where he moved in 1637. Matabei was the illegitimate son of the samurai Araki Murashige, a trusted adviser to Oda Nobunaga. However, the year after Matabei was born his father rebelled unsuccessfully and had to flee for his life. His wife and legitimate offspring were put to death, but Matabei escaped with his wet nurse and was allowed to live in hiding in Honganji in Kyoto. Thus he grew up in the capital and probably established a painting studio there before he left for Fukui in 1615.

His style, fully mature by the time he reached Edo, probably had great appeal for the rough, brawling *chōnin* and

low-ranking samurai of the early city, with their taste for action-packed Kabuki plays, and may well have influenced artists there who were working with block-printing techniques, enabling them to create designs of greater intensity and forcefulness. A pair of word pictures (*moji-e*) attributed to him displays the kind of witty imagery and brush technique that came to be identified with the man and his painting style (Fig. 316). At first glance they seem to be caricature sketches of a beggar and a samurai retainer. However, the thick black outlines of each are in fact *hiragana* characters; one forms the word for beggar (*tsu ma ichi*), while the one of the samurai official forms the phrase "I humbly thank you" (*orei o moshi sōrō*). Christine Guth in her study of these images, and the concept of *asobi* (or playfulness) in Edo-period art, has pointed to *moji-e* images as evidence also of the growing literacy amongst the general population.

A second step toward the formation of true *ukiyo-e* was a type of painting, *bijinga* (or alternatively, *bijin-e*), depicting a single courtesan against a flat, neutral background, which became popular in the Kanbun era (1661–72). These paintings, generally executed by artists who did not sign their works, were presumably produced as expensive souvenirs for purchase by well-to-do *chōnin* or samurai patrons of the pleasure district. In contrast to Matabei's work, Kanbun *bijinga* display delicate brushwork and elaborate textile patterns in restrained colors combined with a characterization of the women as remote and elegant creatures. An excellent example of this style of painting is the hanging scroll of a Kanbun-era beauty (Fig. 317). A slender young woman stands with her knees slightly bent, her arms drawn into her sleeves. Her mouth is hidden by an undergarment that has been pulled out of place, and her eyes are directed to the left. Whether her attitude denotes shyness or the coy allure of a courtesan is left for the viewer to decide, and therein lies much of the painting's charm.

316 Pair of word pictures (*moji-e*), attributed to Iwasa Matabei. Edo period, 17th century. Album leaves, ink on paper; each: 11 ½ x 8 ¾ in. (29.2 x 22.2 cm). The Mary and Jackson Burke Foundation, New York.

A third stimulus to the development of *ukiyo-e* was the popularity of *ukiyo zōshi*, short stories and novellas written in simple Japanese about the life of townspeople and courtesans. The foremost novelist working in this genre, indeed the man often credited with developing this form of fiction, was Ihara Saikaku (1642–93), the son of an Osaka merchant. Saikaku began his career by writing linked verse (*renga*), but in his forties he turned to the production of erotic fiction, including *The Life of a Man Who Lived for Love*, *Five Women Who Chose Love*, and *The Life of an Amorous Woman*. The last mentioned, arguably the best of Saikaku's *ukiyo zōshi*, deals with a woman who began life as the daughter of a courtier, an attractive, well-trained girl with a promising future. However, allowing herself to be ruled by her sensual desires rather than by her head, she fell into one disastrous situation after another, until she ended her days as a common prostitute too old to attract a customer even in the darkness of night. In Saikaku's hands the story, which could have been a very melancholy tale, becomes lighthearted and humorous.

Many editions of this novel and of Saikaku's other works were published, the better editions having illustrations interspersed with the text. Saikaku even tried his hand at designing monochrome woodblock prints, both for his own and friends' books. Illustrated books were first produced and commonly circulated in the early seventeenth century, but they gained tremendously in popularity as townspeople became more interested in literature and affluent enough to purchase them. By the Genroku era the quality of the writing and of the illustrations had improved to the point that they were significant art forms.

Aside from these traditions typical of the great urban centers, the small towns of the provinces also entered very much into the spirit of *ukiyo-e*, especially those plotted along the main routes, such as the Tōkaidō, connecting major cities or pilgrimage and tourist sites. These much cruder images are known as *Ōtsu-e*, after a town famous for producing them on the Tōkaidō. This "Eastern Sea Route" was the main highway that followed the east coast of Honshū from Edo to the head of Ise Bay and then turned inland towards Lake Biwa and the terminal point of Kyoto. It is clear, however, that there were artists turning out such images all over Japan. *Ōtsu-e* appear at roughly the same time as *ukiyo-e*, in the mid-seventeenth century, although for the most part these early examples are Buddhist and Shinto icons. Matthew Welch, who has worked extensively with this genre, has posited that an initial reason for the creation of *Ōtsu-e* might have been a demand by all levels of society for affordable icons to display to the Tokugawa officials, then going door to door querying religious affiliation, and checking that no one was Christian. Having an *Ōtsu-e* icon on display would have helped to quieten any suspicions on the part of the officials, and its purchase would have been

within reach of most households. By the Genroku era, the zeal of the government's social reforms had waned, and accordingly so did the demand for cheap icons. Painters of *Ōtsu-e* began therefore to copy the subject matter of the *ukiyo-e* of the cities, from *bijinga* to narrative illustrations to satirical images

317 *Kanbun Beauty.* 17th century. Hanging scroll, color on paper; 24 ⅛ × 9 ⅝ in. (61.2 × 24.4 cm). The Mary and Jackson Burke Foundation, New York.

of society. One particularly charming example is an image of a samurai falconer (*takajō*), a type seen traveling in the retinue of a great daimyo (Fig. 318). The image of the warrior has a sweet simplicity, and the glum-looking bird on his upraised arm adds a note of whimsicality. However, by far the most representative art form of *ukiyo-e*, and indeed of the entire period, is the woodblock print.

UKIYO-E WOODBLOCK PRINTS

The man generally credited with bringing the woodblock-print artist out of the shadows of anonymity into the light of public acclaim was Hishikawa Moronobu (1618–94). Born into a family that made its living by designing and executing embroidery on textiles, Moronobu began his artistic career making underdrawings on cloth. It was a short step from this to the designing of woodblock prints, utilizing supple black lines on the white ground of the paper. It is important to remark here that the great woodblock print artists are, in fact, designers of the images. That is, they produce the cartoons which the printer's workmen would then carve onto a wooden block, rub with ink, and then impress onto paper. Sometime after the great Edo fire of 1657, Moronobu is thought to have moved from the Chiba region to Edo, where he began to design prints. His period of greatest activity was from 1673 to 1687, although few prints have survived from this time. Primarily employed in book illustration, his great innovation was the production of sets of single-sheet illustrations without any accompanying text, depicting such Edo themes as the pleasure districts, flower-viewing in the municipal gardens, and the like. He was also the first print designer to append his name to his prints. A particularly fine example of his work is the single sheet from the 1678 set *Yoshiwara no tei* (*The Appearance of Yoshiwara*), Yoshiwara being the city's principal pleasure quarter. The print shows the interior of a teahouse, with several patrons sitting on the floor watching as a courtesan dances to the accompaniment of a drum and two *samisen* (Fig. 319). To the left is a two-panel screen with Moronobu's signature clearly visible as part of the surface decoration.

A group of artists known as the Torii school benefited not only from the new prominence that Moronobu brought to individual woodblock-print designers, but also from certain elements of his style and the new standards of excellence he set for the medium. Torii Kiyomoto (1645–1702), the founder, was an *onnagata* (performer of female roles) in the Kabuki theater. In 1687, he moved with his family from Osaka to Edo, where he was asked to design a poster for one of the Kabuki theaters, His work received such favorable comment that he was asked to do posters for other theaters in the city, and gradually he developed a monopoly on the designing of theater posters and programs. Kiyonobu I (l664?–1729), Kiyomoto's

318 *Falconer* (*Takajō*). Edo period, 18th century. Hanging scroll, ink and color on paper; 23 ⅛ x 8 ⅞ in. (58.7 x 22.5 cm). The Minneapolis Institute of Arts, Minnesota. Gift of Harriet and Edson Spencer. (99.59.2).

319 Illustration from *Yoshiwara no tei* (*The Appearance of Yoshiwara*), a woodblock series by Hishikawa Moronobu, showing a teahouse scene. 1678. One-color woodblock print on paper; horizontal *ōban* size: 9 ⅛ x 15 in. (23.2 x 38.1 cm). Tokyo National Museum.

son, made a singular contribution by developing a style of depiction that captured the rough, vigorous acting technique devised by the actor Ichikawa Danjurō, then immensely popular in Edo. Kiyonobu I's style has been characterized rather unflatteringly as "gourd legs, wormlike," referring to the heavy muscular legs of his male figures and to the strong line, varying considerably in width, that he uses to define the forms. A third, rather mysterious, figure in the Torii family is the artist called Kiyomasu I (act. 1697–mid-1720s). The documentary evidence regarding his birth and death dates and his relationship to Kiyomoto and Kiyonobu I presents numerous problems of interpretation. However, from the few extant works attributed to Kiyomasu I, it would appear that he was a more accomplished and versatile artist than Kiyonobu I. An excellent example of his work is the print depicting Ichikawa Danjurō in the role of "Gorō Uprooting a Bamboo Tree" (Gorō Takenuki) (Fig. 320). The actor, a stocky man with bulging arm and leg muscles, exerts all his strength as the character Gorō to pull a thick bamboo trunk out of the ground. The line that marks the contour of the body is remarkably calligraphic, resembling exuberant brushwork rather than lines cut in a block of wood. On the basis of this print, it is easy to see why the work of Kiyomasu I is greatly appreciated by connoisseurs for its vigorous and forceful style.

Nishiki-e

A major innovation of the eighteenth century was the evolution of polychrome woodblock techniques to create images known as *nishiki-e* (brocade pictures). The technology for making color prints had existed in Japan since the seventeenth century and was used in the printing of mathematical and scientific books, but it was not until the mid-eighteenth century that single-sheet polychrome prints began to appear. The first *nishiki-e* were commissioned by a group of wealthy *chōnin* and samurai who shared an interest in the arts, literature, and particularly the composition of haiku, and who indulged in elaborate and elegant pastimes, such as the exchange on New Year's Day of ingeniously designed and expensively printed calendars. One of the reasons that amateurs of the arts had to exercise such ingenuity in the creation of these year-end gifts was that the *bakufu* held a monopoly on the printing of calendars. Since these were privately printed and distributed, they were in violation of the law, and consequently the symbols for the months were subtly introduced into the composition so that at first glance the prints seemed to be nothing more than pretty pictures. It was no doubt this intrigue that made the activity so appealing.

The first to produce *nishiki-e* was Suzuki Harunobu (1725–70), an Edo artist with a relatively undistinguished career until he was commissioned by a group of connoisseurs to design a multicolor calendar print. By 1766, these polychrome prints were being marketed commercially—minus their calendric markings. From then until his death four years later, Harunobu turned out hundreds of multicolor prints dealing with contemporary and classical themes. One of his favorite subjects, of which he made five different versions, was Fūryū nana Komachi—the seven major events in the life of the most beautiful Heian poet, Ono Komachi (act. mid-ninth century), treated in a modern style and in modern dress. The subject was drawn from a group of Nō plays about Komachi by the great Muromachi-period playwrights Kan'ami and Ze'ami. One of these plays, *Kayoi Komachi* (*Komachi of the Hundred*

320 *Gōrō Uprooting a Bamboo Tree*, by Torii Kiyomasu I. 1697. Polychrome woodblock print on paper, with hand coloring; *ōban* size: 15 x 9 ⅛ in. (38.1 x 23.2 cm). Tokyo National Museum.

Nights), focuses on one of the poet's would-be lovers, with whom she made the agreement that if he would visit her house without seeing her for a hundred successive nights then she would grant him a rendezvous. According to Kan'ami's play, the youth came faithfully for ninety-nine nights, passing the time on the mounting block of her carriage, but died before nightfall on the last night. Harunobu's modernization chose a less melancholy ending: the young man's father died on the hundredth day, and therefore the young man could not come. In the print illustrated here, Komachi is shown as a beautiful and elegant, but heartless, courtesan of the Edo period, standing on the veranda of her house while her maidservant counts off on her fingers the number of nights the would-be lover has kept his promise (Fig. 321). The poem she wrote to him on the day after his nonappearance appears in a cartouche in the upper-right corner, written around the shape of the young man shielding himself from the elements as he struggles to meet her demands:

321 *Kayoi Kamachi*, from the series *Fūryū nana yatsushi komachi* (*Seven Modern Dandified Komachi*), by Suzuki Harunobu. 1766–7. Polychrome woodblock print on paper; *hosoban* size: 13 x 5 ⅝ in. (33 x 14.2 cm). Tokyo National Museum.

In the early dawn
You marked up a hundred nights
On the mounting block—
But the night you failed to come
It was I who counted that

D.B. Waterhouse, *Harunobu and his Age*, London, 1964, 85.

Woodblock Printing

Woodblock prints are made by transferring an image carved into the surface of a wooden block—for traditional Japanese prints usually of cherry wood—to a sheet of paper. The artist first makes a design on ordinary paper and has it transferred to a special thin, semi-transparent paper, which is pasted face down on the wood block. The surface of the block is cut and chiseled away to leave a design formed of raised lines and solid areas. Ink is applied to this surface and a piece of paper placed over it. The reverse of the paper is rubbed with a *baren*, or disk-shaped pad, which causes the transfer of ink from the block to the obverse of the paper.

Early woodblock prints used only black ink, but by the 1760s techniques for printing in many colors—up to twenty—had been developed and were in wide use. In order to apply several colors to a single sheet of paper by mechanical means, as opposed to hand coloring, a separate block was carved for each color. Furthermore, it was necessary to develop a system for aligning each block so that it would register a single color within the initial black outlines printed on the sheet. *Kento*, a set of two cuts on the edge of each block, accomplished this. To stand up to many rubbings, the paper used for woodblock prints has to be strong and absorbent. Traditionally, the favored paper has been *hoshō*, made from the inner layers of the bark of the mulberry tree.

The sizes of Japanese woodblock prints were largely determined by the stock papers available for printing. Thus paper dimensions have provided the terminology for print sizes. Among the most frequently found are *oban* (large print), about 15 x 10 inches (38 x 26 cm); *chūban* (medium print), about 6.5 x 7 inches (15.5 x 18 cm); *hosoban* (narrow print), about 14 x 6 inches (35 x 15 cm); and *hashira-e* (pillar print), about 28 x 6 inches (70 x 15 cm). In the late eighteenth century and in the nineteenth century, *oban* sheets were frequently joined together to form triptychs and even pentiptychs.

322 *Morning Haze at Asakusa*, from the set *"Eight Sophisticated Views of Edo,"* by Suzuki Harunobu. *c.* 1769. Polychrome woodblock print on paper; *chūban* size: 10 × 7 ½ in. (25.4 × 19 cm). Tokyo National Museum.

Harunobu's favorite contemporary subjects were the two great beauties of the day in Edo, Osen and Ofuji. The first was a daughter of the proprietor of a teahouse on the grounds of Kasamori Shrine and the second of the owner of a toothpick shop behind Asakusa Kannonji. In the print "Morning Haze at Asakusa," from the set *Eight Sophisticated Views of Edo*, Ofuji is shown flirting with a young samurai (Fig. 322). Like all of Harunobu's female figures, she is depicted as a slender, graceful girl, innocent and untouched by the rigors of life. Harunobu never tries to individualize his young women; they are presented without unique features. Ofuji was known as the "ginko girl" because of the ginko trees near her father's shop, and Harunobu has made reference to this by including several ginko leaves in the foreground of the print. However, he has gone a step beyond this cliché by placing Ofuji against the backdrop of a willow tree, again a reference to her youth and pliability, and to the "willow world," another euphemism for the pleasure district.

UKIYO-E ARTISTS

Torii Kiyonaga

The *ukiyo-e* artist who best depicts the elegant surface of Japanese life in the late eighteenth century is the great master

of the Torii school, Torii Kiyonaga (1752–1815). Although not a blood relation of the Torii family—his official surname was Sekiguchi—Kiyonaga assumed leadership of the Torii school in 1785, when his master Kiyomitsu (1735–85) died suddenly. At the time there was no male heir who could take over, and Kiyonaga was Kiyomitsu's most accomplished pupil. He accepted the position with reluctance and forced his son to abandon thoughts of a career as an artist, presumably to prevent any disputes about who would succeed him, his own kin or Kiyomitsu's grandson. His work demonstrates a quality of reticence in the assertion of his own personality and of gentility in the depiction of his subjects. In the years 1781 to 1785, Kiyonaga developed a style of *bijinga* which became the preferred form for the genre for the remainder of the century. In his prints the women—whether important figures from history or literature, geisha, or wives of the merchant class—are depicted as tall, elegant creatures engaged in gentle, decorous activities. After 1787, Kiyonaga mainly produced actor prints in accordance with his role as head of the Torii school, and by 1800 he seems to have retired from the active production of prints, contenting himself with drawings for his own and his friends' amusement. A particularly interesting pair of New Year prints shows two groups of women meeting on the Edo bridge called Nihonbashi (Fig. 323). The group on the left is presumably returning from a pilgrimage to Enoshima, an island off the coast of Kamakura, as the figure at the head of the group is holding a hat with the word "Enoshima" written on it. The women in the right half of the diptych cannot be so specifically identified, but they appear to be acquaintances of the returning figures. The setting for their chance meeting affords the artist an opportunity to depict the environs of the Nihonbashi River, with Edo Castle and Mount Fuji visible in the background.

A copy of another Kiyonaga diptych, called *Interior of a Bathhouse* (Fig. 324), was owned by the nineteenth-century French painter Edgar Degas (1834–1917), who hung it in his bedroom. Degas admired it a great deal, and not only for the obvious reasons, but also for its spatial dissonances, which he attempted to integrate into his own work. The diptych depicts a familiar Japanese scene, the public bathhouse. These bathhouses, which became such a feature of Japanese culture, were first recorded in the fourteenth century, in the Gion district of Kyoto, and by the early seventeenth century most urban neighborhoods were equipped with one. The undeniably prurient nature of this print highlights the numerous regulations regarding bathhouses of the eighteenth century, most of which seem aimed at separate bathing for the sexes. In the right panel a mother washes her child's face, and in the left panel two squatting women chat as they rinse their bodies. In the upper left the head of the proprietor can be seen. In addition Kiyonaga used a couple of compositional elements that, although natural outgrowths of the Japanese illustrative tradition, were profoundly challenging to Western artists of the late nineteenth century. He created an impression of space within the enclosed area of the building by using the oblique

323 *New Year's Scene: Women Meeting on Nihonbashi Bridge*, by Torii Kiyonaga. 1786. Polychrome woodblock print diptych on paper, each ōban size: 15 x 9 ⅛ in. (38.1 x 23.2 cm). The Honolulu Academy of Arts. Gift of James A. Michener. 1991 (21, 801).

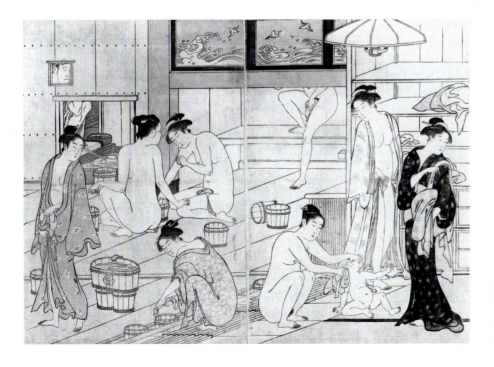

324 *Interior of a Bathhouse*, by Torii Kiyonaga. 1780s. Polychrome woodblock-print diptych, ink and color on paper, ōban size: as mounted, 15 ¼ in. x 20 ⅛ in. (38.7 x 51 cm). Museum of Fine Arts, Boston. William Sturgis Bigelow Collection. (30.46-7).

lines of the floorboards to lead the viewer's eye deep into the inner room. The figures are arranged in an asymmetrical pattern, with a recess at the center of the composition.

Tōshūsai Sharaku and Kitagawa Utamaro

The artists who best reflect a change in mood in popular taste in the shogunal capital at the end of the eighteenth century are Tōshūsai Sharaku and Kitagawa Utamaro, who attempted to show the figures of the *ukiyo-e* world, the actors and courtesans, as they really were, even when vain, frivolous, and addicted to sensual pleasures. Sharaku is one of the most famous creators of woodblock prints, and also the most enigmatic—the dates and events of his life are unknown. He appeared on the scene in the spring of 1794, produced a series of nearly one hundred and fifty print designs of Kabuki actors, and disappeared again after the New Year's performance in 1795. However, in that brief period he created some of the most extraordinarily insightful pictures of players, showing them in the act of portraying a specific dramatic character and at the same time revealing the personality of the actor behind the makeup and elaborate costumes.

The print depicting Segawa Tomisaburō II as Yadorigi, the wife of a *chōnin*, is a superb example of Sharaku's work

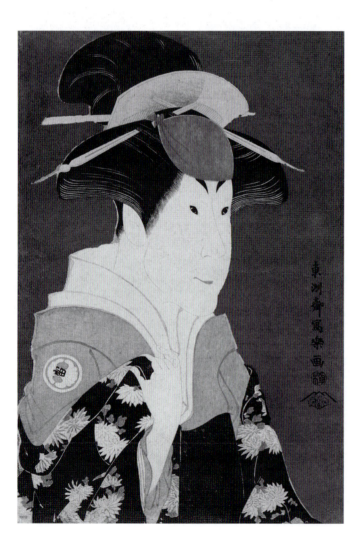

325 *Segawa Tomisaburō as Yadorigi, Ōgishi Kurando's Wife*, by Tōshūsai Sharaku. 1794. Polychrome woodblock print with mica background on paper; *ōban* size: 15 × 9 ⅛ in (38.1 × 23.2 cm). Tokyo National Museum.

(Fig. 325). The man, often called "Nasty Tomi" because of his ascerbic offstage personality, is shown tight-jawed, glaring meanly through tiny, hard eyes as he mincingly pulls up one sleeve of his *kosode*. The truthful and unflattering quality of the portrait and the glistening gray mica background combine to create an incisive and vital image, an actor in a *mie* pose—a moment frozen in time expressing the character's emotional state—in the glimmering light of a stage illuminated by lanterns placed along the front edge of the platform. Thwarted by the sumptuary law of 1794 forbidding the use of mica as well as other luxury items, Sharaku was forced in his later prints to use a flat yellow ground to suggest the atmosphere of the stage on which his figures moved, but it was never as successful as the gray mica grounds. His last works show a distinct decline in quality, which may have been the reason he gave up printmaking.

Kitagawa Utamaro (1753–1806) was a more lasting and versatile artist who turned out picture books on insects, the libretti for Kabuki plays, and prints based on the plots of such famous stories as *Chūshingura*—the revenge of the forty-seven *rōnin*. His favorite subject matter seems to have been beautiful women: not only those resident in the pleasure districts, but ordinary *chōnin* wives and daughters as well, engaged in everyday activities such as bathing their children or cooling themselves by the river on a warm summer evening. Little is known about Utamaro's early years, but he studied art with Toriyama Sekien (1712–88), an *ukiyo-e* artist who trained in the Kanō school, and who is known today primarily for his illustrated volumes of humorous verse. With Sekien's death, Utamaro adopted a signature, which suggested that he considered himself to be an artist in his own right, and no longer a disciple.

Throughout the last decade of the eighteenth century, his was the dominant presence in the production of *ukiyo-e*. In 1804, he made a three-panel print depicting Hideyoshi in the midst of a party with his five concubines under the cherry blossoms at Daigoji. The *bakufu* took exception to the print because it violated the prohibitions against identifying famous historical figures and punished Utamaro with a three-day jail sentence and fifty days in hand chains, an ordeal that contributed directly to his death. Sharaku's forte was the personality behind the makeup of the Kabuki actor; Utamaro's was the female psyche in all its nuances. In his series *Hokkoku goshiki sumi* (*Five Kinds of Ink from the Northern Provinces*), Utamaro has penned a title cleverly punning on the five different classes of courtesan, from one of the highest, the *geigi*, a kind of geisha, a charming and coquettish young woman carefully dressed in elegant garments, to the *teppō*, the lowest and most debased of prostitutes (Figs 326 and 327).

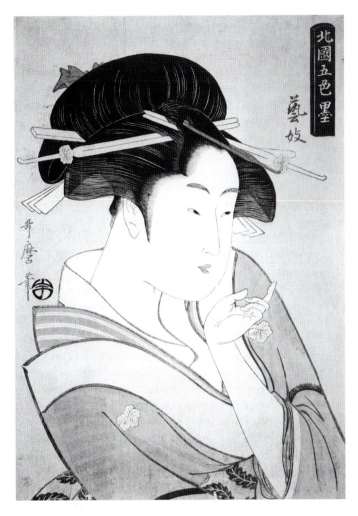

326 *Geigi*, from the series *Hokkoku goshiki sumi* (*Five Kinds of Ink from the Northern Provinces*), by Kitagawa Utamaro. Early 1790s. Polychrome woodblock print on paper; ōban size: 15 × 9 ⅛ in. (38.1 × 23.2 cm). Private collection.

discovered by the legendary general Minamoto no Yorimitsu (948–1021), Kintarō, a chubby-cheeked, orange-skinned boy, is wrestling with a bear. The soldier is fascinated and asks the boy to introduce him to his mother. A strange but attractive woman appears, clad in a garment of leaves, her hair long and scraggly. Yet in spite of her rough appearance Yamauba speaks to Yorimitsu in the cultured manner of a noblewoman. The general, impressed by the boy's strength and his unusual upbringing, makes him a retainer, and Kintarō matures into an exemplary warrior who vindicates his father's name. The theme of Yamauba and Kintarō was still popular in the late eighteenth and early nineteenth centuries and became the vehicle for expressing a maternal and, in some cases, almost sensual relationship between the beautiful, rustic woman and her rather animal-like child. One of the most charming prints of Utamaro's group shows Yamauba teasing the boy by holding a twig bearing two chestnuts just beyond his reach. Frustrated, Kintarō grabs the cloth of her kimono and tries to climb up her leg. After Utamaro's death, pictures of actors and

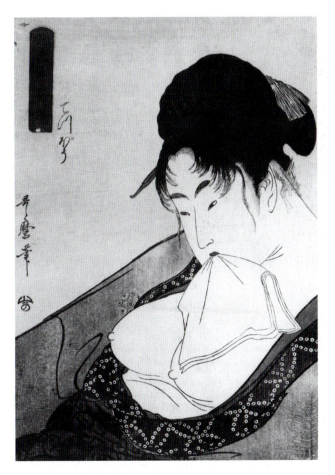

327 *Teppō*, from the series *Hokkoku goshiki sumi* (*Five Kinds of Ink from the Northern Provinces*), by Kitagawa Utamaro. Early 1790s. Polychrome woodblock print on paper; ōban size: 15 × 9 ⅛ in. (38.1 × 23.2 cm). Ohta Memorial Museum.

Utamaro's *teppō* is caught in the midst of her trade, her unseen client implied by her dishevelled hair, disarrayed garments, and the sheets of paper gripped in her teeth, a detail often included in erotic prints. The *geigi*, on the other hand, is a gay and animated woman who is bent on amusing her customer through conversation.

Another example of Utamaro's art can be seen in his prints of Yamauba and her son Kintarō, with their depiction of the warm maternal relationship between the beautiful, if slightly rough and unkempt, mother and the chubby, mischievous child (Fig. 328). The Yamauba theme had appeared in many different forms, ranging from folktales and songs sung to the accompaniment of the *samisen* to Nō chants, and, depending on the context, different elements of the story receive emphasis. Yamauba is either a mountain spirit or a mortal woman who married a great warrior but was left behind when he was wrongfully banished from court. A child is born of this union, and the mother is forced to retreat to the mountains to save herself and her son. When they are later

328 *Yamauba and Kintarō: The Chestnut*, by Kitagawa Utamaro. 1796–9.
Polychrome woodblock print on paper; *chūban* size: 10 x 7 ½ in. (25.4 x 19
cm). Tokyo National Museum.

The Utagawa School

Ukiyo-e in the last years of the Edo period took quite a different
direction from the prints produced in the eighteenth century.
The most prolific school of the nineteenth century was the
Utagawa, founded in the late 1700s by a rather minor artist,
Utagawa Toyoharu (1735–1814), who specialized in prints
using Western one-point perspective—**uki-e**. His greatest
accomplishment was as a teacher, and he managed to assem-
ble a studio of talented young artists who not only produced
commercially successful prints, but were able to attract stu-
dents who could continue the Utagawa line. Two outstanding
printmakers of the nineteenth century, Toyokuni and
Kuniyoshi, though working in their own individual styles,
traced their artistic lineage to the Utagawa school.

At about the same time that Sharaku made his brief
appearance as a printmaker in the 1790s, Utagawa Toyokuni
I (1769–1825) developed his own style for representing single
actors seen in dramatic, full-length poses against a light gray
ground. His most impressive work of this period is a group of
more than fifty prints entitled *Yakusha butai no sugata-e* (*Views
of Actors on Stage*), produced between 1794 and 1796. Given
his new-found popularity, by the end of the century he was
able to include other subject matter in his prints: beautiful
women, young children, and humorous scenes. However, the
increasing demand for actor prints forced Toyokuni to work
too quickly; toward the end of his life, the quality of his work
declined markedly. Nevertheless, in his heyday he produced
work of considerable intensity and power.

Typical of his prints depicting beautiful women is a series
of fan-shaped designs of 1823 entitled *Imayō Juni-kagetsu* (*The
Twelve Months of Fashion*), from which Minazuki, the month
without water (according to the Western calendar, late July
after the rainy season had ended), is illustrated (Fig. 329).
Ostensibly the subject is a young woman holding a mirror
behind her head so that she can check the appearance of the
nape of her neck—considered by the Japanese to be an eroge-
nous zone—by projecting its reflection onto a mirror in front
of her. The double mirror image was a popular theme among
Utagawa artists, but in this scene the table mirror is covered
with a cloth. The print would seem to be a pun on the name of
the month. *Mi* is a homonym meaning both "water" and "to
see," thus Minazuki could also mean, "month of not seeing" a
charming and witty variation on a familiar theme.

Utagawa Kuniyoshi (1798–1861) studied with Toyokuni,
but preferred then to branch off in his own direction. In 1827,
he produced a series of warrior prints depicting one hundred
and eight heroes from the sixteenth-century Chinese novel
Shuihuzhuan (JAP. *Suikoden*), which recounts the adventures of
a group of bandits who valiantly sacrifice themselves for the
emperor. The images, inspired stylistically by Shoun Genkei's
(1648–1710) sculptures of the five hundred *rakan* in Edo's
Gohyaku Rakanji, were an instant sensation. Though
Kuniyoshi worked also in other genres of *ukiyo-e*, he is best
known today for such *musha-e* (warrior pictures), especially
his triptychs.

courtesans no longer retained the master's naturalism and
insight into human character. It was not until the 1820s,
when a new group of artists turned to the depiction of land-
scape scenes in a romantic vein, that woodblock prints
regained their popularity.

329 *Minzuki (July)*, by Utagawa
Toyokuni I, from the series *Imayō
Juni-kagetsu* (*The Twelve Months of
Fashion*). 1823. Woodblock fan print;
horizontal *ōban* size: 9 ⅛ x 15 in.
(23.2 x 38.1 cm). Private collection.

One of his most dramatic and gruesome prints is the triptych of *Takiyasha the Witch and the Skeleton Specter*, of c. 1845 (Fig. 330). The subject derives from the Kabuki play *Soma dairi* (*The Palace of Soma*), performed in 1844 and based on the story of the rebellion of Taira no Masakado (d. 940). Masakado was one of the first samurai to rebel against imperial authority when in 930 he embarked on a rampage to acquire land in the northern provinces around Hitachi. The power of the court was largely ineffective in these outlying regions, and in 940 Masakado proclaimed himself emperor and appointed governors to the eight provinces he controlled. Within two months, however, he was captured and killed, his head taken back to Kyoto for display. In the mid-1800s this story found its way to the Kabuki stage, focusing not on Masakado's rebellion but on its aftermath. Masakado had left behind two children, a son, Yoshikado, and a daughter, Takiyasha. A local samurai, hearing that a ghost had appeared at Masakado's residence, the Soma palace, goes to investigate and encounters Takiyasha disguised as a courtesan. When she fails to win the samurai's affection, she summons a giant skeleton to overpower him. Skeletons have appeared in Japanese art from the twelfth century onward, but seldom have they been treated as such menacing figures. In this triptych Kuniyoshi has truly captured the late Edo period taste for the bizarre.

Katsushika Hokusai

Another aspect of popular taste at the end of the Edo period was a fondness for romantic views depicting human beings and their place in nature. The woodblock-print artist

Katsushika Hokusai (1760–1849) was the first to capture the attention of collectors of *ukiyo-e* with visions of the Japanese landscape. Hokusai's personality is well expressed in the signature he adopted toward the end of his life, "Old Man Mad With Painting."

Apprenticed to a woodblock-print engraver in his teens, Hokusai learned the technical and interpretive skills involved in translating the stylistic nuances of an original ink drawing into the engraved lines of the print block. As this was a period when polychrome prints were being produced in great numbers, he must also have acquired considerable knowledge of the total process. In 1778, he embarked on his creative career by becoming a pupil of Katsukawa Shunshō (1726–92), under whose tutelage he produced a wide variety of works, including single sheets depicting beautiful women, sumo wrestlers, birds and flowers, and even some landscapes in which he experimented with Western perspective. The climate of the art world in Edo at this time was such that affiliation with a particular group of artists was essential to economic survival and, as the Katsukawa school was no longer so popular, Hokusai found it advantageous to seek other connections. At one time he studied painting under the Kanō master Yūsen, but was expelled from the studio for criticizing his teacher's handling of a particular painting. Hokusai dropped from sight in 1794, the year Sharaku produced his actor prints, giving rise to speculation that he briefly adopted the name and style associated with that enigmatic artist. However, today few scholars accept this as a possibility. Later Hokusai assumed the headship of the Tawaraya school, a group of artists dedicated to the revival of the Rinpa style of decorative art. Finally, in

330 *Takiyasha the Witch and the Skeleton Specter,* from *Soma dairi* (*The Palace of Soma*), by Utagawa Kuniyoshi. *c.* 1845. Polychrome woodblock print on paper triptych; each *ōban* size: 14 ⅝ x 10 in. (37.3 x 25.5 cm). Spencer Museum of Art, The University of Kansas (Weare-West Fund). (84.32a, b, c).

331 *The Barrel-maker of Fujimihara,* from *Thirty-six views of Mount Fuji,* by Katsushika Hokusai. *c.* 1830. Polychrome woodblock print on paper; horizontal *ōban* size: 9 ⅛ x 15 in (23.2 x 38.1 cm). Tokyo National Museum.

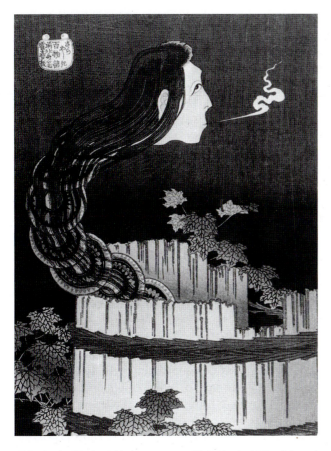

332 *Sarayashiki*, from *Hyaku monogatari* (*One Hundred [Ghost] Stories*), by Katsushika Hokusai. *c.* 1830. Polychrome woodblock print on paper, with embossing; *chūban* size: 10 x 7 ½ in. (25.4 x 19 cm). Tokyo National Museum.

1799, Hokusai struck out on his own, in spite of the financial losses that entailed, and for the next thirty years he worked steadily and single-mindedly to develop a personal style.

His most popular achievement was a series of forty-six prints entitled *Thirty-six Views of Mount Fuji*, begun in 1823 and completed around 1831. Several of the illustrations are studies of the volcano under various atmospheric conditions, but the majority depict Fuji as a backdrop against which common people, such as a barrel-maker at Fujimihara, are shown engaged in everyday activities (Fig. 331). In Hokusai's hands the routine task of barrel-making is treated with a typically Japanese light-hearted humor as a tiny man kneels inside an enormous barrel, smoothing the joints between the planks. Behind him is a parched and cracked rice field, and in the far distance, the tiny snow-covered tip of Mount Fuji. The circle of the barrel encloses all: the craftsman and his world, the bareness of the soil, and the beauty of the natural landscape seen in the distance.

Just as Hokusai reflected the contemporary taste for romantic, untroubled views of nature, he also had a flair for the bizarre. About the same time he finished the *Thirty-six Views of Mount Fuji*, he began a series titled *Hyaku monogatari* (*One Hundred [Ghost] Stories*). A then popular game involved

placing one hundred lighted tapers in a shallow oil dish and telling ghost stories. Each time a tale was finished a taper would be extinguished, until the room in which the raconteurs were assembled was completely dark, and the spirits summoned by the storytelling swirled around those present. For some reason, after Hokusai had executed five prints in the series he stopped. Nevertheless, several of his designs are truly memorable for their bizarre and ghostly quality, none more so than *Sarayashiki* (*House of Plates*) (Fig. 332). In this tale a young girl serving in the house of a wealthy samurai is falsely accused of breaking one of a set of ten valuable blue-and-white porcelain dishes. She is thrown into a well by her enraged master and drowned. Thereafter her voice is heard in the night, counting slowly up to nine and then wailing pitifully. Hokusai depicts the top of the well, its vertical wooden planks bound by stout vines, and, against a deep-blue midnight sky, a woman's head rising from the well on a curving neck of blue-and-white dishes. From her mouth emerges a thin trail of white smoke, suggesting the sound of her counting. These prints are among the finest of Hokusai's work in terms of the technical quality of carving and inking the block as well as the drama and eerie beauty of the design.

Totoya Hokkei

The pupil of whom Hokusai was fondest was undoubtedly his daughter, Katsushika Oi (act. 1818–54), who gained a great deal of fame in her lifetime as a painter of *ukiyo-e* subjects such as *bijin*, but also in subjects taken from Chinese popular mythology and literature. However, Hokusai's most distinguished pupil in print design was Totoya Hokkei (1780–1850), a fishmonger turned professional artist. Although he designed book illustrations and some commercially published, single-sheet prints, he is best known today for his *surimono*, or limited editions—sometimes no more than a single sheet—of elegantly printed, small-size woodblock prints, used most often for announcements or to be included with a New Year's gift. Usually a poem or two, either the seventeen-syllable haiku or the thirty-one-syllable humorous form called *kyōka*, accompanies the design, as in Hokkei's 1821 surimono of *Mount Fuji and the Island of Enoshima, from the Shichiri Beach* (Fig. 333).

Enoshima was believed to be the hiding place of an evil dragon who was eventually tamed by the goddess Benten (SKT. Saraswati) and turned into a companionable white snake. For this reason, the island was frequently used as a symbol for the year of the snake on printed New Year's greetings. Along the lower margin of Hokkei's print is a long sandy beach, the Shichiri (Seven League Beach), partially obscured by gray embossed cloud forms. In the white area of water above, embossed lines are used to suggest waves rolling toward the shore. At the base of the mountains, which rise sharply from the water's edge, is a village of pale red, thatch-roofed houses, and almost hidden in the olive-green forest above is a temple pagoda. Finally, in the upper right is the white triangle of Mount Fuji, a delicate embossed accent almost invisible

333. *Mount Fuji and the Island of Enoshima,* from *Shichiri Beach,* by Totoya Hokkei. 1821. *Surimono* polychrome woodblock print on paper, with embossing; *kaku* size: 8 ¼ x 7 ⅛ in. (21 x 18.2 cm). The Chester Beatty Library, Dublin.

against the pale beige sky. Two *kyōka* appear at the top of the print. This kind of New Year's card is surely one of the finest examples of the Japanese printer's craftsmanship, a quiet gem of pictorial expression.

Ando Hiroshige

The last of the great Edo-period print designers, Ando Hiroshige (1797–1858), achieved recognition as an artist almost overnight, with the publication in 1834 of a series of landscapes called the *Fifty-three Stations of the Tōkaidō.* Hiroshige had undergone a long apprenticeship under Utagawa Toyohiro and afterward tried his hand at standard *ukiyo-e* themes such as *bijinga.* However, in the summer of 1832, perhaps inspired by the success of Hokusai's views of Mount Fuji, or bewitched by the same gods who moved the haiku master Matsuo Bashō (1644–94) to undertake his journey to the northern provinces, Hiroshige set out for Kyoto along the Tōkaidō with a convoy escorting a group of horses, an annual gift from the shogun to the emperor. From his experiences on this trip and his knowledge of the Japanese landscape in general, Hiroshige produced a series of prints that combine a lyrical view of the countryside throughout the course of the four seasons with charmingly humorous depictions of the people and the local customs of each post station along the road.

One of the most skillfully designed prints in the series presents the port town of Kuwana (Fig. 334). In the foreground are two ships, their sails lowered, having just completed the seventeen-mile (27.4 km) voyage across Ise Bay from Miya. Directly behind the boats is Kuwana Castle, and to the left, the bay dotted with sailboats stretches to the horizon. Not only does the print convey the essence of the scenery, the longest water passage along the Tōkaidō and also the most dangerous, but it also utilizes several elements of style, both classical and modern, that would appeal to *chōnin* of the early nineteenth century. Kuwana Castle is depicted in dark gray and white, as it should be, but the trees behind it are treated in black and pale gray, in the manner of a monochrome landscape. The left half of the print, on the other hand, has a distinctly Western feeling, the slightly tilted ground plane terminating in the far distance with the horizon line.

So popular was the Tōkaidō series that Hiroshige's reputation quickly eclipsed that of Hokusai. Hiroshige devoted most of the remainder of his artistic career to the production of landscape prints depicting two principal types of subject matter: post stations along the two main Kyoto–Edo highways, the Tōkaidō and the Kisokaidō, the inland highway through the Kiso Mountains, and famous scenic spots around the two major cities. For people living with the challenges and uncertainties of the end of the Tokugawa shogunate, Hiroshige's idyllic landscapes must have cast a romantic shadow over the realities of the times.

Decorative and Applied Arts

THE PORCELAIN REVOLUTION

In the 1590s Toyotomi Hideyoshi had launched two massive invasions of Korea, both of which ended in failure for the Japanese troops and devastation for the Korean people. For Japan the greatest legacy of the campaigns was probably the thousands of civilian prisoners of war taken back to Japan to work out their lives in indentured labor. Several of the daimyo accompanying the invasions, and particularly those from Kyūshū, who held business interests in the booming ceramic industry, had a special preference for Korean potters, and several hundred of these were brought back to their domains to work at their new lords' kilns. At this point in the late sixteenth century, the Chinese and Korean ceramic industries were leagues ahead of their Japanese equivalents in terms of potting and kiln technology. In the fourteenth century, the Chinese had perfected a particular type of high-fired ware made out of a white, kaolin-rich clay that was both highly malleable and, when fired, durable. This porcelain soon became one of China's major exports, rivaling silk's previously unchallenged position among the nation's commodities. From a massive kiln center set up at Jingdezhen, China began exporting porcelain wares all over the world, and not least to Japan. It was one of the most highly prized commodities that

334 *Kuwana, Shichiri Watashiguchi*, from the series *Fifty-three Stations of the Tōkaidō*, by Andō Hiroshige. 1834. Polychrome woodblock print on paper; horizontal *ōban* size: 9 ⅛ x 15 in (23.2 x 38.1 cm). Tokyo National Museum.

East Asia had to offer to the European markets, whose traders in the sixteenth century had begun to arrive by the sea routes, and over the subsequent centuries it was one of the primary reasons that they kept on coming. Porcelain technology soon spread to Korea, and Korean wares quickly came to be as highly prized as those of China. Japan by the late sixteenth century was one of both Korea and China's major clients for porcelain; the closest the native ceramic industry came was the Karatsu ware developed by Korean potters in Kyūshū around 1590 (see Fig. 289). Although far from being true porcelain, the enormous success of this ware in the native Japanese markets had made the daimyo who sponsored and controlled these industries all the keener to create a Japanese product.

Arita

They did not have long to wait. Among the potters brought back from Korea was Ri Sampei, who was taken by the daimyo Nabeshima Naoshige (1538–1618) to the Arita region of Kyūshū, where in 1616 he discovered a kaolin-rich clay that could produce porcelain. These indentured Korean potters also introduced to Japan a new type of kiln, the *nobori gama* (or climbing kiln), consisting of a series of ovens built along the incline of a hill. Both the segmentation of the kiln space and its arrangement in tiers along a slope permitted greater control of the temperature in any one oven. These first Japanese porcelains were unsurprisingly identical to Korean wares, but the Korean potters soon also began to copy the blue-and-white porcelain designs of China, which had long been a popular import on the Japanese market. Porcelain is fired at such a high temperature that few of the colored glazes traditionally

used in stonewares, most famously the jade-like celadon, could survive the firing process. Two underglaze pigments, however, were discovered that could; these were cobalt, which produced a blue color, and copper oxide, which produced a red. The copper oxide was extremely sensitive to firing, and unless circumstances were absolutely right could instead turn out a flat, grayish hue. But cobalt much more dependably produced a rich blue color, which explains why the predominant type of Chinese porcelain has a clear white surface decorated with a pattern painted in cobalt blue underneath a transparent glaze. By the time the technology was transmitted to Japan, however, a double-firing process had also developed, by which a porcelain ware was first fired with a transparent glaze at high temperature, with or without a cobalt underpainted design. After cooling, the ware was then painted from a wider range of colors available in lead-fluxed pigments, and fired once again at a much lower temperature.

For more than a hundred years Arita held a virtual monopoly on the production of porcelain, making the Nabeshima one of the richest samurai clans in the country. Shipped out to eager markets all over Japan via the port of Imari, the porcelain of Arita became famous as Imari ware. In the middle of the seventeenth century, the Nabeshima directly benefited from the suspension of activities at the Jingdezhen kilns in China in the chaos attending the switch from the Ming empire (1368–1644) to that of the Qing (1644–1911). European traders turned to the Arita kilns to fulfill their numerous orders for porcelain, and it was a market that Jingdezhen found itself unable totally to recover once it was back on its feet later in the century. Ko (Old) Imari is the name

traditionally given to these early wares made between 1620 and c. 1670, although a more recent scholarly term is Shoki (Early) Imari. A typical example is a bottle decorated with a design painted in cobalt blue and clearly based on Chinese landscape motifs: a tall mountain in the background, a thatch-roofed pavilion, and in the foreground tall, angular pine trees (Fig. 335). Ko Imari wares are more thickly potted than later production, when the potters had perfected the clay mixture and firing techniques. They also not infrequently betray signs of hasty execution, even to the point of sloppiness, with imprints of the potter's fingers and sand grit on the foot rims after firing. On this bottle, the pine trees of the foreground seem to have been added as an afterthought, and the decorator was apparently unsure how they should follow the contour of the curved surface. However, such clumsiness often found a receptive audience amongst adherents to the *wabi* aesthetic of the tea ceremony, and Ko Imari wares have long been appreciated for their rustic and naive charm.

A significant advance in decoration of Arita porcelain was achieved in the mid-1600s by the Arita potter Sakaida Kakiemon (1596–1666). From immigrant Chinese potters at the port of Nagasaki, he learned how to make the lead-fluxed overglaze enamels that added so considerably to the palette of porcelain decoration. Characteristic of wares made at his Kakiemon kiln are designs in bright hues including blue, black, green, yellow, occasionally purple, and a particular

orange–red, said to be based on the color of the fruit of a persimmon tree in the potter's garden. A fine example of his work is a saké bottle ornamented with a phoenix and paulownia leaves (Fig. 336). The bird is depicted in mid-flight, his tail feathers spread, their curves complimenting the boldly shaped body of the vessel. Below are the clusters of leaves and flowers. Stylized paulownia leaves were adopted as the *mon* (crest) of several samurai families, and it has been suggested that this saké bottle may have been made on commission for a particular daimyo or a wealthy merchant.

Nabeshima ware was produced in Arita from 1625, and originally intended for the use of the daimyo's family alone, although presents of it were made as diplomatic gifts to the shogun in Edo. However, by the end of the Genroku era, the client base had expanded to include other samurai clans and the court aristocracy. This high-quality ware was made primarily for use at official functions, and the range of shapes is limited. Most numerous are shallow dishes with a high foot made in sets of ten and twenty. It is thought that the original inspiration for this type of plate was lacquerware. In order to maintain uniformity of shape, the clay was pressed into molds, and to ensure uniformity of decoration the motifs were transferred from a single sketch to the clay surface. Various sources were used, including textile patterns, subjects treated by the Kanō and Tosa schools of painting, and popular decorative motifs. The whole design was outlined on the plate in underglaze cobalt blue and, after the plate was fired, colors were applied in overglaze enamels, covering the blue outlines. A particularly striking plate combines a motif of a blossoming cherry tree with an abstract pattern suggesting the curtains set up outdoors to create a blossom-viewing enclosure (Fig. 337). The surface is further articulated by three color zones, pale blue, pale green, and dark chocolate brown.

Ko Kutani

The second major category of porcelains produced in the early Edo period was Ko Kutani, or Old Kutani wares, from the village of Kutani in Ishikawa prefecture on the main island of Honshū, to the southwest of the city of Kanazawa. The history of this type of ware is the most problematic of all the porcelains. The prevailing opinion is that the Kutani kilns were opened in the late 1650s, when clay appropriate for making porcelain was discovered in the area. The first daimyo of the Daishōji fief was a cultured man with a strong interest in the tea ceremony, but he was also credited with having a head for business. It is not unreasonable to think that when clay for porcelain was discovered he saw an opportunity to develop an official clan kiln like that of the Nabeshima in Kyūshū. The kilns are thought to have been closed at the turn of the eighteenth century, following the deaths of the second daimyo and soon after that of the man believed to have been in charge of

335 Saké bottle with landscape design, Ko Imari ware. 17th century. Porcelain; height 15 in. (38 cm). Umezawa Memorial Museum, Tokyo.

production. Because Ko Kutani wares were produced on commission for the clan, and not for popular consumption, they consist mainly of plates and bowls; pieces used for serving and drinking saké are also numerous. The inspiration for the decorative motifs is primarily Chinese, although, as always, filtered through the lens of Japanese taste. A distinctive example of Ko Kutani is the plate decorated with the bold, mannered design of a phoenix (Fig. 338). Depicted against a crude gray–white ground is the fantastic bird, its feathers ranging in color from blue to yellow, green, and rust; the pose is taut, one claw clenched, the beak open as if to caw raucously.

However, the potters did not often make clear marks indicating the place of manufacture on their wares, and in many cases it is hard to determine exactly which kiln made a particular vessel. Many pieces traditionally considered to be Ko Kutani are now thought, following excavations at both the Arita and Kutani kiln sites, to be actually of Arita manufacture. There was often a great deal of imitation in the decoration and potting between the different kilns, and as the seventeenth century drew to a close the refinement of technique coincided with improvements in methods of mass production. From the late seventeenth century, there is a great outpouring of high-quality Japanese porcelains onto the

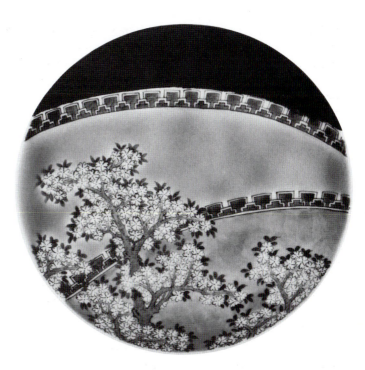

337 Shallow dish with cherry-blossom design, Nabeshima ware, Nangawara kiln, Kyūshū. Between 1664 and 1675. Porcelain, painted in underglaze blue with celadon and iron glazes; diameter 7 ¾ in. (19.7 cm). The Metropolitan Museum of Art, New York. Gift of Harry G.C. Packard and Purchase, Fletcher, Rogers, Harris Brisbane Dick and Louis V. Bell Funds, Joseph Pulitzer Bequest and the Annenburg Fund, Inc. (1975.268.555).

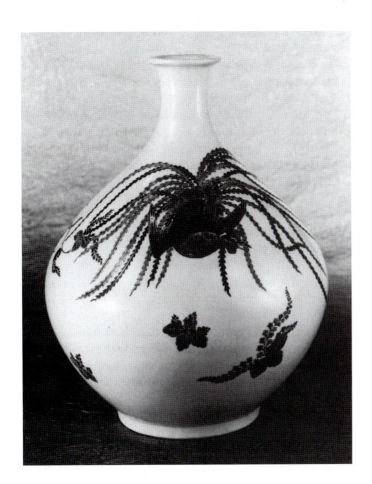

336 Saké bottle with phoenix and paulownia design, by Sakaida Kakiemon, Kakiemon ware. 2nd half of the 17th century. Porcelain; height 12 ⅞ in. (32.2 cm). Seikadō Foundation, Tokyo.

domestic market, and they graced not only the table of the country's elite, but also those of the chōnin. Another feature of these late seventeenth-century wares is a shift to Japanese designs and motifs, such as that seen on the Nabeshima ware plate. Although Chinese imagery would still be popular, native imagery and design would gain an equal market share. A pair of blue-and-white plates from the period amply demonstrate this native aesthetic (Fig. 339). The one on the left, thought to be from a Kakiemon kiln in Kyūshū, has at its center a hare leaping over waves. The hare is a common enough motif in Chinese ceramics, but a hare leaping over waves is a specifically Japanese image, symbolizing fecundity. The plate on the right, thought to be a Kutani ware, is a completely abstract motif comprising an apparently asymmetrical group of five dots placed opposite a design painted along only half the rim. William Rathbun has conjectured that it could be a stylized design for a samurai mon. On wares commissioned for the European market, heraldic designs formed a significant proportion of the orders. The Japanese samurai were similarly fond of using their mon, and perhaps this was part of a special commission to the Kutani kilns.

In the course of the eighteenth century, porcelain became a staple of any home of even moderate means, and by the first half of the nineteenth century even such "family" kilns as those producing the Nabeshima wares were offering their goods to a broader clientele—that is the chōnin—provided

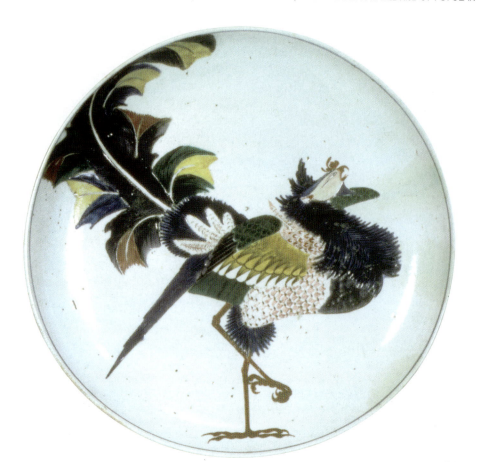

338 Dish with phoenix design, Ko Kutani ware. 17th century. Porcelain with overglaze enamels; diameter 13 ½ in. (34.3 cm). Ishikawa Prefectural Museum of Art.

they could pay. By this point there were a number of potteries all over Japan producing porcelain, and the material had became so standard that it was also used to produce ceramics once reserved for stoneware clays and firing. A saké bottle covered with a crackled celadon glaze in imitation of the Chinese stoneware prototype is the work of a virtuoso (Fig. 340). The product of a double-firing process, the celadon glaze with a luminescent jadelike quality and a network of crazing (cracks in the glaze) remains one of the hardest to achieve, and something of a game of chance. Nonetheless, this is a ware typical either of Nabeshima production, or of that of the kilns of Hirado in northwestern Kyūshū.

KYŌYAKI: INDEPENDENT STUDIO POTTERS

Another important stream of Edo-period ceramics flowed through the old capital of Kyoto. In the Momoyama period, *raku* wares had developed in response to the taste of tea masters such as Sen no Rikyū (1522–91). In the succeeding Edo period, a very different style of ceramic appeared, largely in response to the burgeoning production of porcelains in Kyūshū. These works were known as **kyōyaki**, and their essential characteristics were a stoneware base and delicate traditional Japanese designs in bright overglaze enamels. It is thought that they were the work of artisans from the Seto–Mino region, lured to Kyoto by the lucrative patronage given to the production of tea-ceremony utensils.

One of the most interesting facets of *kyōyaki* is the appearance of craftsmen identifiable by name and by a stylistically consistent body of work. The first of these potters to achieve recognition as an independent artist was Nonomura Seiemon (c. 1574–1660s). Born in the village of Nonomura in the ceramics center of Tamba, he established a kiln around 1650 in the Omuro district on the outskirts of Kyoto, close to Ninnaji. This temple had always a special cachet because its abbot was traditionally an imperial prince, and, although the temple had declined during the sixteenth century, the shogun Iemitsu (1604–51) provided funds for its rebuilding. It has been suggested that Ninnaji was one of several Kyoto temples —such as Rokuonji, which also had as abbots members of the imperial family—that became centers for cultural activities. Seiemon clearly valued his association with Ninnaji, creating his studio name "Ninsei" by combining the first syllable of the temple's name with that of his own.

Ninsei's first products were off-beat designs for tea-ceremony utensils—faceted tea caddies and the like—created under the influence of tea master Kanamori Sōwa (1584–1656). However, about 1660 a new type of Ninsei ware began to appear: stoneware vessels— both tea bowls and large jars with four "eared" handles for the storage of tea leaves—with traditional Japanese decoration, such as wisteria, poppies, and other floral motifs, and even landscapes. A particularly fine example from this group is a storage jar based on the round, short-necked vessels produced at the Tamba kiln near Kyoto in the medieval period. This surface he decorated with a design of low, gently rounded hills overlaid with small

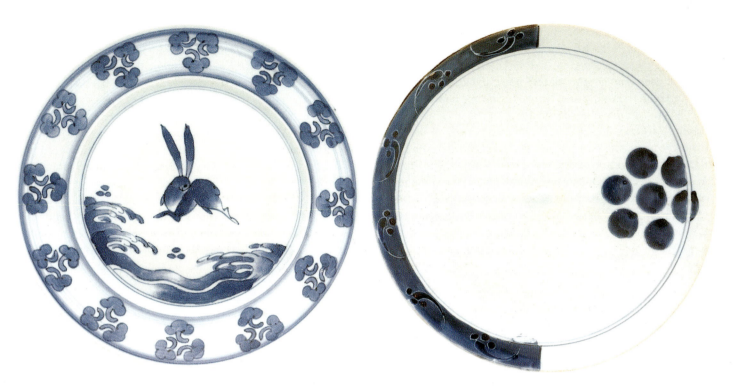

339 Plate with motif of hare leaping over waves and plate with geometric motif. Left 1670/90, right: 1650/90. Imari ware, *ai* Kakiemon-type
(left) and *ai* Kutani-type (right), porcelain with underglaze cobalt blue decoration;
left: diameter 8 in. (20.4 cm), right: diameter 8 in. (20.4 cm).
Seattle Art Museum. Gift of Frank D. Stout. (92.47.11 and 92.47.12).

squares of gold leaf and flowers in the shape of cherry blossoms (Fig. 341). The combination of hills and cherry blossoms suggests Yoshino, which was particularly known for its cherry blossoms in the spring. The inspiration for the decoration of this storage jar is clearly the *yamato-e* revival triggered by Kōetsu and Sōtatsu, and the jar is an excellent example of Kyoto taste. As American scholar Richard L. Wilson has noted, Ninsei wares stand at the turning point in the *kyōyaki* tradition, the transition from the *wabi* aesthetic of Sen no Rikyū and his disciples to the use of ceramics as a "canvas" for painting and calligraphy.

The next independent ceramics master to appear on the scene was Ōgata Kenzan (1663–1743), the younger brother of the multi-talented artist Ōgata Kōrin, who was to revitalize Sōtatsu and Kōetsu's aesthetic in what came to be known as the Rinpa school. Research by Wilson sheds new light on this artist's life and career. After the death of his father, Sōken, in 1687, Kenzan (born the third son and named Gonpei), received a generous inheritance that included three houses, the family library, and half the family cash and art collection. However, unlike his profligate brother Kōrin, Gonpei chose not

340 Saké bottle. Edo period, 1st half 19th century. Possibly Hirado or Nabeshima ware, porcelain with celadon glaze; height 8 ⅞ in. (22.5 cm), diameter of base 5 ¾ in. (14.6 cm). The Nelson-Atkins Museum of Art, Kansas City. Purchase: Nelson Trust. (32-59/4).

to become an urban playboy, but instead established himself in a secluded villa in Omuro near Ninnaji. He changed his name to Shinsei, meaning "deep meditation," and devoted himself to culture: poetry, music, the tea ceremony, and calligraphy.

In 1699, the young man turned his life in a new direction. He had built a three-chamber climbing kiln on a piece of property in Narutaki, adjacent to Ninnaji, and began to produce ceramics under the name of Kenzan, a reference to the location of his kiln in the northwestern mountains. The first steps in setting up his kiln follow one month after the last mention of the Ninsei kiln in the Ninnaji records, and Wilson suggests that Kenzan moved in to fill the gap caused by the demise of the older kiln. He also hired a technician, Magobei, who had served as an apprentice to the Oshikōji, a family that produced earthenwares in competition with *raku* production in the Momoyama and early Edo periods. Kenzan, unlike Ninsei, was not a potter; rather he was a person with creative control of a kiln, and the works produced under his direction are best described as pottery-imitating art objects. Many pieces are square plates decorated with motifs alluding to Heian poetry (the poems are inscribed on the base) and are more like ceramic versions of a poetry album or a lacquerware plate.

In 1712, he left Narutaki for central Kyoto, specifically Chōjiyamachi, where he established a studio for the production of ceramics fired on a rental basis in local kilns. He also frequently used stoneware blanks and common ceramic shapes, mass-produced with no thought to their decoration. Some have interpreted this as a decline by Kenzan into commercialism. Certainly the suburban setting of Narutaki could not compete with central Kyoto, an important distribution center for ceramics, in boosting the shrinking income from his inheritance. It may be also that he realized his strength lay not in the potting process but in surface decoration. A further motivation for Kenzan's move may have been his brother Kōrin's return to Kyoto in 1709. The two brothers had frequently collaborated on the square dishes produced at Narutaki, and the possibility of renewing that relationship may have seemed attractive. Whatever the reason, in Chōjiyamachi Kenzan made a remarkable breakthrough in style. Using patches of white slip and representational elements such as cranes and grasses or spring flowers brushed in cobalt and iron, he adapted his brother's Rinpa designs to the rounded surfaces of bowls and plates, wrapping the images around and into the shapes (Fig. 342). These works, which also combine traditional poetic motifs such as autumn leaves and waves with a consciously rustic style of painting, are the masterpieces of Kenzan's oeuvre.

His last move was to Edo in 1731, fifteen years after Kōrin's death and twelve years before his own. The reason is unclear, but by this time it is certain that he no longer engaged in ceramic production on a commercial scale. Wilson suggests that in Kyoto Kenzan was continually compared to Kōrin as a painter, but in Edo he was viewed as his successor and appreciated both for his ceramics and his cultural sophistication.

Kenzan's greatest contribution to the development of *kyōyaki* was the conversion of ordinary ceramic vessels for practical use into art objects. Working with both stoneware and earthenware, he developed a technique for applying colored enamels directly on a bisque-fired vessel. When enamels were applied after glazing, they beaded on the surface and created slight projections. However, when they were applied first, the glaze flowed over and around them, producing a bonding of color with the clear, hard surface of the final glaze. A particularly restrained example of Kenzan's work is a tea bowl decorated with a spray of plum blossoms painted under the glazed surface in rust brown and cream (Fig. 343). The flower petals are so impressionistically rendered that the design seems almost pure abstraction.

Aoki Mokubei (1767–1833) is often grouped with Ninsei and Kenzan as one of the Three Great Masters of *Kyōyaki*. Although from Kyoto, he came from a cultural climate quite different from that of the other two men. Mokubei made his money as the proprietor of a teahouse in one of the city's pleasure districts, but found kindred souls among the literati centering on the poet Rai Sanyō (1781–1832), a group that included many of the great painters in the Chinese literati tradition (*bunjinga* or *nanga*) of the period. Mokubei studied ceramics with the potter Okuda Eisen (1753–1811), a

341 Tea jar with Mount Yoshino design, by Ninsei.
17th century. Earthenware; height 14 in. (35.5 cm).
Fukuoka Art Museum, Fukuoka prefecture.

342 Set of food dishes, by Ōgata Kenzan. Early 18th century. Stoneware with underglaze iron and cobalt blue and overglaze enamel decoration; 1 ⅓ x 6 ½ in. (3.4 x 16.5 cm). Shumei Collection, Miho Museum.

craftsman whose major contribution to the development of *kyōyaki* was the introduction of porcelain and porcelain decoration techniques. Mokubei combined Eisen's techniques with his own veneration for things Chinese to produce ceramics that ranged from pieces using ancient forms of Chinese script as the main source of decorative patterning to works made in imitation of types of Chinese porcelain. He was especially inspired by a kind of Chinese porcelain developed in the eighteenth century and decorated with overglaze enamels in a palette of colors that has been called in the West *famille-noire*—that is red, green, yellow, and even purple floral designs against a black ground. A typical Mokubei product of this type is a bowl with a design of melons and peaches in yellow, green, purple, and beige against the black ground (Fig. 344). However, in contrast to the meticulous detail and highly finished quality of Chinese *famille-noire*, Mokubei has opted for an earthenware body and a certain crudeness of execution, making the bowl a much more personal statement.

Another Kyoto studio potter of the first part of the nineteenth century inspired by Chinese porcelain was Eiraku

343 Tea bowl with plum-branch design, by Ōgata Kenzan. 18th century. Earthenware, with underglaze painting; height 3 ⅛ in. (8 cm). Umezawa Memorial Museum, Tokyo.

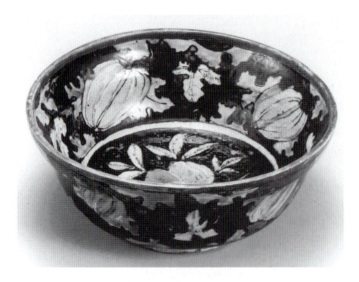

344 Bowl with peach and melon design, by Aoki Mokubei. 1807 or 1808. Earthenware, painted with color enamel; height 4 ⅜ in., diameter 9 ⅜ in. (height 10.8 cm, diameter 24 cm). Museum Yamato Bunkakan, Nara.

Hozen (1795–1854). Where Mokubei sought a deliberate crudeness, however, Eiraku instead aspired to match the Chinese potters in refinement. As Patricia Graham has noted in her study of both potters, while Mokubei's aesthetics were informed by the more consciously amateur approach of the Japanese *bunjinga* artists, Eiraku's were aimed at his clientele amongst the wealthy *chōnin* and high-ranking samurai. In 1827, Eiraku, together with his adoptive father Nishimura Ryōzen (d. 1841) moved to Kii province to establish a private kiln for a daimyo of the Tokugawa clan. In reward for his service he was given the name Eiraku, that being a Japanese

345. Set of five teacups, by Eiraku Hozen. 2nd quarter of the 19th century. Porcelain with underglaze cobalt blue, overglaze enamel, and gold foil decoration; height 1 ½ in. (3.8 cm). The Saint Louis Art Museum, purchase: Museum Shop Fund. (355:1991.1–5).

reading of the name Yongle—the Chinese reign era (1403–24) most revered by the Japanese of the period for its porcelain production. A particularly beautiful example of Eiraku's oeuvre is a set of porcelain tea cups for drinking *sencha*—a variety of tea made from leaves (*chanoyu* tea being a powdered product known as *macha*). In this case, Eiraku has chosen a particularly difficult process of overglaze enamel decoration, the application of cut gold leaf to a bright red ground (Fig. 345). The Chinese-inspired motifs of birds, flowers, and *lingzhi* fungus (symbolizing long life) have been rendered with a deliberately archaic feeling meant to evoke the lost splendors of the fifteenth-century Ming empire.

LACQUERWARE

By the seventeenth century, lacquerware had been one of the mediums of expression for Japanese poetry and poetic imagery for almost a thousand years. In the fifteenth century it had developed and refined its decorative techniques to a level unequalled elsewhere in East Asia, and in the sixteenth century had proved itself capable of creating everything that the minds of such flashy patrons as Hideyoshi could dream up. It was one of the most adaptable and dazzling of Japan's applied arts, and under the patronage of the burgeoning *chōnin* class and the expansive culture of the "floating world," it would achieve new and exhilarating heights of expression.

The Rinpa designs of Ōgata Kōrin (1658–1716) were among the first elements to impact on lacquer in any major way during this period. Kōrin turned his hand to many art forms, being a designer of the decoration of lacquer, textiles, and ceramics, but he is primarily known as a painter, and as such he will be discussed in more detail below. Kōrin looked to the art of Kōetsu and Sōtatsu as his starting point, picking up on their stylizations of the *yamato-e* tradition of the Heian period and stylizing them further until they became flattened, isolated motifs. Where Zen ink painters had created abstraction with line, Kōrin created it with form. In this way he brought new life to a poetic imagery that after so many

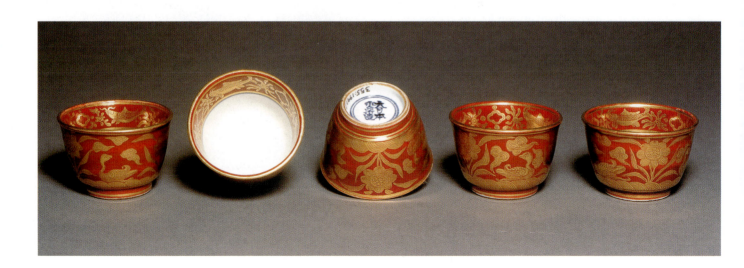

centuries could appear dull and even trite. And as such imagery made up a great deal of the repertoire of lacquer decoration, the Rinpa style had a massive effect on the way it evolved in the Edo period. One of Kōrin's contemporaries was the lacquer craftsman Tsuchida Sōetsu (1660–1745), who created many works that obviously owe a heavy debt, if not actually to Kōrin's own design, then to his revival of interest in the work of Sōtatsu. A writing box by Sōetsu (Fig. 346) has what must be, if not a quotation from, then a tribute to, Kōetsu and Sōtatsu's famous *Deer Scroll* (see Fig. 309). Inlaid in lead on a glossy black surface, the deer are grouped together in a well-articulated collection of shapes which the black ground flattens out into an almost abstract design. The contrast of textures between the glistening black lacquer and the matte gray of the lead further heightens the paradoxical richness of what is an essentially simple design.

Away from the refined literary circles of Kyoto, decorative lacquerware was also much in demand, not least for a personal accessory that made its first appearance in the seventeenth century—the *inro*. A small multi-tiered box held together by a cord strung through it, the *inro* was initially meant for the carrying of the personal seals and seal ink with which the Japanese gentleman sealed his contracts of business, whether merchant, peasant, samurai, or aristocrat. It was hung from the sash of the outergarment by the cord that strung them together, at the end of which there was often attached a carving known as a netsuke. In addition there would be a kind of a bead (*ojime*) fitted on the cord just above the uppermost tier of the *inro* to help hold all the compartments in place. In large part due to the sumptuary laws aimed at the *chōnin*, the *inro*, netsuke, and *ojime* became highly decorated objects which could be safely hidden when necessary from the government's prying eyes, but which could be displayed at other times for personal enjoyment and not uncommonly as a demonstration of one's wealth and cultivation.

All three were made of a variety of materials, including wood, ceramic, metal, and even cloth. By far the most classic form for netsuke, however, was as a small bone or ivory carving, the best examples of which were miniature sculptural masterpieces. The *ojime* was often a polished stone bead, but the *inro*, no matter what its core material, usually had a lacquered surface. *Inro* production was of such importance to the lacquer industry that it was one of the major specializations of a master lacquer craftsman. The ingenious ways in which designs were placed on the multi-tiered *inro* surface are perhaps as numerous as the *inro* themselves. However, in the fashion-conscious world of Edo-period popular culture, *inro* designs not infrequently represented scenes from Kabuki or Nō performances of the moment or from the more eye-catching of the woodblock prints in circulation.

A particularly elegant and playful *inro* from the late Edo period depicts the shadows projected onto a *shoji* panel of the drunken merriment at a teahouse party (Fig. 347). The profile of a courtesan playing a *samisen* accompanies the—probably —comic recital of one of her customers, while the reverse of

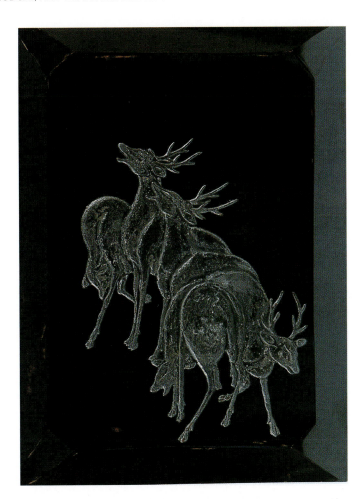

346 Writing box (*suzuribako*), attributed to Tsuchida Sōetsu. 18th century. Lacquer with lead inlay; 2 x 8 ⅖ x 11 ⅖ in. (5.1 x 21.4 x 29 cm). Edmund J. Lewis Collection, USA.

the *inro* shows the profile of a courtesan stoically observing a dance with a fan. The method used to execute the piece is known as *togidashie*, and entailed, in this case, first creating a gold-gray ground to evoke the color of *shoji* panels at night, and then cutting away this layer in the pattern of the latticework and human shadows to reveal the black lacquer beneath. At the bottom, the gold lacquer has been cleverly worked to suggest the wooden structure of the *shoji* panel. In her study of this *inro*, Julia Hutt has traced the inspiration for the design to a woodblock triptych of 1820 by Kikugawa Eizan (1787–1867) showing three geisha in the foreground playing a game similar to "scissor, paper, stone," while in the background are the shadow projections adapted for the *inro* design. The *inro* does bear the signature of its maker, Koma Kyūhaku, but curiously does not also mention the name of the print designer, which was standard practice with such *inro*. The *ojime* of bone is carved with the face of Daruma, the founder of Zen Buddhism, who had long since become a comic motif in popular culture.

Another important source of lacquerware in the Edo period was the Ryukyu islands. This chain of around sixty islands

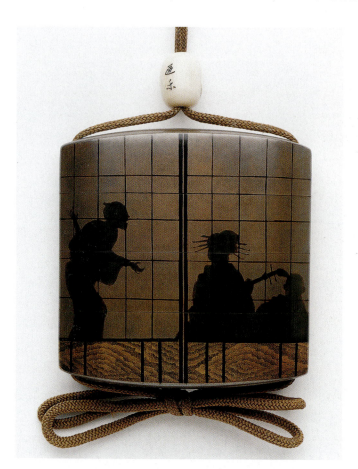 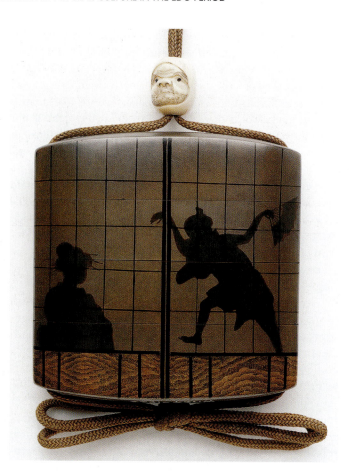

347 *Inro* with silhouettes of teahouse entertainments, by Koma Kyūhaku. 1820s. *Togidashie* lacquer; 2 ½ x 2 ½ in. (6.3 x 6.3 cm). Victoria and Albert Museum. Pfungst Gift. (W.164–1922).

stretching from south of Kyūshū for almost 746 miles (1200 km) down toward Taiwan was not formally annexed into Japanese territory until 1879. However, its many dialects are more closely related to the Japanese language than to those of China, with which it also had close cultural and political contacts. Until the late nineteenth century, Ryūkyū was governed as an independent kingdom, but in 1609 its ruler had been captured by the daimyo of Satsuma in Kyūshū and sent to Edo. Thereafter, Ryūkyū became a vassal state of the Tokugawa *bakufu*. Since the fourteenth century, the islands had been well known for their lacquer production, and especially for those wares incorporating mother-of-pearl into their decoration. Mother-of-pearl had long been a favorite material in Japanese lacquer, but it can be fairly stated that the Ryūkyūan crafts-men employed this material in its greatest refinement. An eighteenth-century offering tray with a pair of dragons con-tending for a pearl employs the kind of mother-of-pearl known as *yakogu* (nocturnal light shell), and against the black ground it glistens in hues ranging from blue to purple (Fig 348). Such trays were part of the island's tribute to the Tokugawa regime, but also to the Chinese Qing court, to whom they were simi-larly pledged in vassalage.

METALWORK

Throughout the Edo period, a great percentage of metalwork-ers remained employed in producing the arms and armor of the samurai. Although rarely put into use on the battlefield, a samurai was expected to have at the very least a sword, and if wealth allowed a complete set of armor. While sword produc-tion continued to turn out ever more durable and deadly weapons, the armor became increasingly decorative as the possibility of its practical use became ever more remote. However, the workmanship itself did not deteriorate, and these decorative pieces often reflect the extraordinary virtuos-ity of the amorer's craft as much as do the swords. A face mask of 1745 created by master craftsman Myochin Muneakira (1673–1745) is in the form of Jikokuten, one of the Shitennō (Four Guardian Kings) of Buddhism, and brilliantly recreates the fierce features to be found on the guardian Niō figures at the gates to many Buddhist temples (Fig. 349). The lacquered iron of which it is made is still the material that would be used by a fighting warrior, but the form into which it is fashioned has become one for display in procession and on the parade ground rather than for combat.

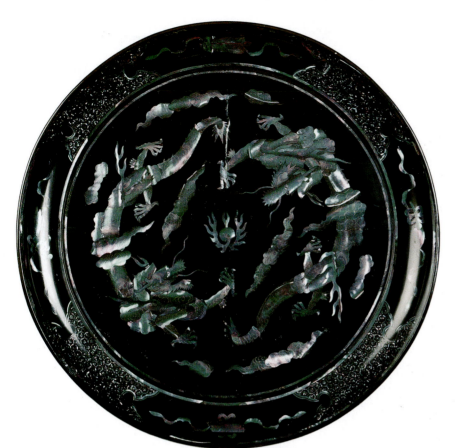

348 Tray with dragon designs, Ryukyu islands. 18th century. Lacquer with mother-of-pearl inlay; height 3 in. (7.8 cm), diameter 26 ⅞ in. (68.3 cm). Museum für Ostasaiatische Kunst, Berlin. Klaus F. Naumann Collection.

In the bustling urban culture of the Edo period, metal-workers could also find employment outside samurai equipage. One such area was the creation of flower vases. The shogun Ashikaga Yoshimasa (1430–90) had been a great devotee of the art of *ikebana* (flower arranging), and it had continued to be a popular pastime with cultivated men and women of all classes. Vases could be made of a variety of materials, not least ceramic, but in his research on the subject Joe Earle has revealed that bronze was the flower arranger's material of choice. The later Ashikagas' cultural arbiter, Sōami (d. 1525), wrote a treatise in 1511 in which he stated that when a set of paintings are placed in display alcoves such as the *tokonoma*, they should be accompanied by the tradition-al Buddhist altar setting of three objects: a flower vase, a censer, and a candlestick (*sagusoku*). Because these objects were traditionally made from bronze, bronze became the prime material for *ikebana* vases. They could take many forms, often imitating classic Chinese ceramic and bronze vessel shapes, but they were often also uniquely Japanese interpreta-tions of these forms. One early eighteenth-century vase of the *mimikuchi* (ear–mouth or flying handle) variety has exaggerat-ed the flow of the handles so much that it is hard to believe they are of rigid bronze (Fig. 351). The viewer concentrates on the beauty of the abstract form and movement rather than on any reference to the ritual bronzes that were produced in ancient China.

With the end of the Edo period and the collapse of the Tokugawa regime in 1868, all samurai armor was banned—

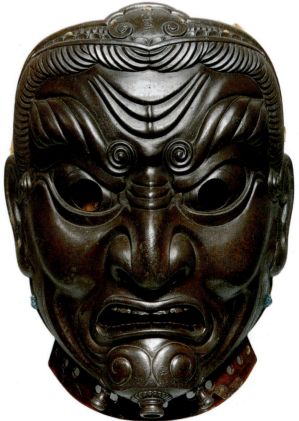

349 Face mask in the form of Jikokuten, by Myochin Muneakira. Dated 1745. Lacquered iron with a yellow silk backing; height 9 ½ in. (24.1 cm). The Metropolitan Museum of Art. Rogers Fund. (19.115.2).

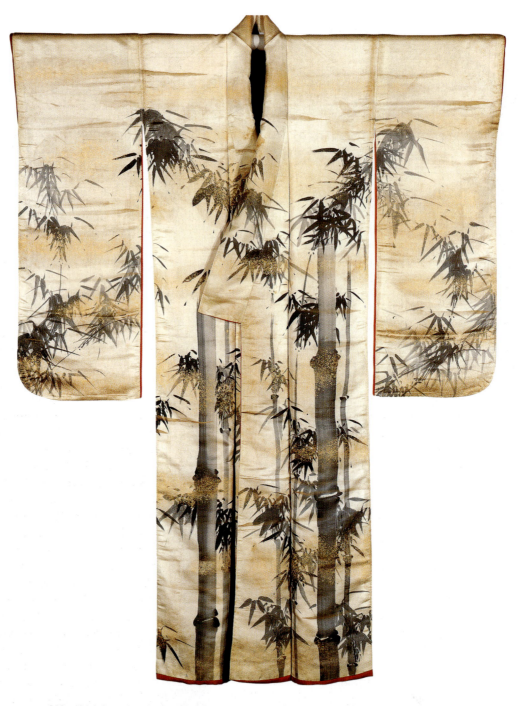

350 *Uchikake* with a design of bamboo and mist, attributed to Gion Nankai. *c.* 1700–50. Ink, gold leaf, and gold powder on white figured silk satin; 64 ¾ x 48 ⅞ in. (164.5 x 124.1 cm). The Metropolitan Museum of Art. Gift of Harry G. C. Packard and Purchase, Fletcher, Rogers, Harris Brisbane Dick and Louis V. Bell Funds, Joseph Pulitzer Bequest and the Annenberg Fund, Inc. (1975.268.88).

weapons becoming the exclusive domain of the modern army set up by the restored emperor. After more than a millennium, this ancient armory tradition became virtually extinct, and those metalworkers engaged in its production were obliged to find new subjects on which to exercise their talents, such as *ikebana* vases and other objects that would be required by a civilian population.

TEXTILES

With the Edo period, the makers of the traditional Japanese robe, or *kosode*, entered into their period of greatest productivity and creativity, and simultaneously their last great flowering. Amidst the modernizing reforms following the imperial restoration of 1868, the populace was encouraged to drop the

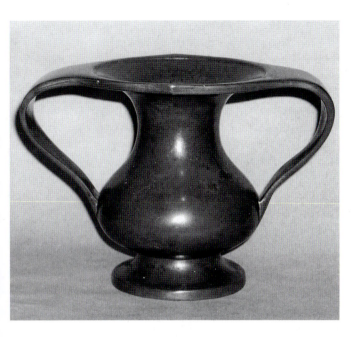

351 Flower vase (*mimikuchi*). Edo period, 18th century. Bronze; height 6 in. (15.24 cm). Courtesy of Phoenix Oriental Art, London.

traditional robe and instead adopt Western-style dress. However, in the *kosode's* development during the Edo period there is no deterioration that would indicate its future relegation to "traditional costume"; instead the main concern on the part of the *chōnin* was how to obtain the most sumptuous garments without incurring the displeasure of the authorities. On the whole, *kosode* worn by the vast majority were of what might seem rather plain design and decoration, but amongst the upper ranks of the *chōnin* these garments are invariably worth a second look, as the weave pattern, at the very least, will reveal a level of refinement seldom found elsewhere. Whether the sumptuary laws were relaxed or not, however, there still existed a ready market for more obviously glamorous *kosode*, and not just amongst the courtesans of the pleasure districts.

One garment that was particularly subject to lavish decoration was the *uchikake*—the robe worn by women underneath an outer *kosode*. Such undergarments were, of course, hidden from the eyes of the patrols on the street, but could be revealed in part or whole inside the teahouse or private residence. One such *ukikake* is of particularly spectacular design; painted on white-figured silk decorated with gold leaf and gold powder is a haunting image of bamboo in the mist (Fig. 350). According to research by Robert T. Singer, this design was painted by the founder of the Japanese literati school of painting, Gion Nankai (1677–1751). The source for the attribution is a poem by Rai Sanyō praising this *uchikake* and describing the circumstances of its creation. The robe was a commission of a wealthy *chōnin* of Izumi by the name of Karakaneya Baishō for his mistress. Baishō was a close acquaintance of Nankai, and persuaded him to add his brush to the project. According to Sanyō, it is one of Nankai's best works.

Buddhist Sacred Arts and Architecture

ARCHITECTURE

One of the first priorities of the newly established shogunate was to continue the policy of rebuilding Buddhist temples that had been initiated in the Momoyama period by Hideyoshi. Kyōōgokokuji in Kyoto, popularly known as Tōji, received aid for reconstruction from both Hideyoshi's son Hideyori (1593–1615) and from the Tokugawa, especially Iemitsu (1604–51), Ieyasu's grandson and the third shogun. The main hall and the lecture hall were rebuilt in 1598, and in the early years of the seventeenth century smaller projects were undertaken to restore the temple to a state approximating its ninth-century appearance under Kūkai (774–835). When its five-storied pagoda was destroyed by fire in 1641, Iemitsu provided funds for its immediate reconstruction, which was completed three years later (Fig. 352). The rebuilt pagoda is constructed in the traditional manner and is remarkable for its austerity and restrained eclecticism in comparison with other buildings of the Edo period as it is relatively free of surface and sculptural ornamentation. Care was exercised to produce a building in the ancient temple tradition that would nevertheless still appeal to contemporary tastes.

A building exemplifying the Edo-period standard is Tōshōgū, the mausoleum of Ieyasu at Nikkō. The custom of building magnificent tombs for the remains of a military leader was first initiated by Hideyoshi, who had the Hōkōkubyō built in Kyoto (see Fig. 281). After his death, Ieyasu was designated a Shinto god with the name Tōshō Daigongen (Great Incarnation Who Illuminates the East) and was given a magnificent memorial building that was both a mausoleum and a shrine. Succeeding shoguns made it a point at least once during their tenure in office to undertake a pilgrimage to Tōshōgū in the company of their principal daimyo and retainers, imitating the ritual of the imperial clan at the shrine to their ancestor, Amaterasu, at Ise. Copies of the Tōshōgū were also built in each of the *han* to honor Ieyasu and prove the local daimyo's loyalty to the Tokugawa.

Begun in 1636, Tōshōgū is set picturesquely on a hill in a cedar grove. Enclosing the compound is a roofed corridor that can be entered through an elaborate gate. A second, inner enclosure, defined by a low tile-roofed wall ornamented with openwork, curvilinear shapes, contains the main buildings of the shrine: the four-by-nine-bay *haiden* (Fig. 353), linked by a building called the Ishinoma (Stone Room) to another hall. This particular arrangement of buildings is typical of the style known as *gongen zukuri* (mausoleum architecture), and based on the layout for the shrines to Kitano Tenjin (see Fig. 199 and page 164). The term *gongen* derives from Ieyasu's posthumous title, Toshō Daigongen. Although the Tōshōgū Shrine complex seems at first glance to be distinctly Chinese in flavor, due to the profusion of ornate painted sculptures covering every

352 Five-storied pagoda, Kyōōgokokuji (Tōji), Kyoto. 1644.

external surface of the buildings, it actually represents a rather free adaptation of these elements into a context that is essentially Japanese. The style of the bracketing between the walls and the roof is Chinese, as are the railings and the round pillars, but there are also details that are indigenous in character. The interior of the worship hall, with its *fusuma* and heavily coffered and decorated ceiling, is very similar to the *shōin zukuri* style of the Momoyama period. Even the subject matter of the wall paintings reveals a mixture of Chinese motifs—the *kirin* (the mythic beast who appeared at Confucius' birth), dragons, lions, and phoenixes—and native ones, chrysanthemums and water birds. Unlike most Japanese buildings, however, it is painted in brilliant colors – clear bright red, blue, and green, contrasted with white, black, and gold.

Another type of temple building that underwent significant development under the Tokugawa regime was the *kōshibyō* or *seidō*—the Confucian temple. From Ieyasu onwards, the regime made Confucianism its moral and ethical framework for national and local government, and advocated that it be studied and practiced by all members of the samurai class. Under Iemitsu, an academy was founded in Edo for the teaching of Confucian doctrine to the future samurai-officials, and along with it a hall in which ceremonies honoring Confucius could be performed. The academy, known as the Shōheikō, was located first in the Ueno section of Edo but was moved in the Genroku era to the Yushima district, where a twentieth-century replica still stands. In addition to official buildings in Edo, the seat of the *bakufu*, Confucian academies and worship halls were established throughout the *han*, although few of these buildings, symbols like the castles of

353 *Haiden* (worship hall), Tōshōgū Shrine. 1636.

samurai privilege and Tokugawa oppression, survived the dissolution of the Tokugawa *bakufu*.

A notable exception is the *kōshibyō* at Taku City in Kyūshū—possibly because it was the daimyo of Kyūshū who aided the emperor in the restoration of 1868 (Figs 354 and 355). Built over a fourteen-year period from 1695 to 1708, the worship hall is a condensed version of the main Confucian temple in Beijing. The standard plan should consist of an open courtyard surrounded by a roofed corridor entered through the Kyōkōmon (Gate of High Aspirations), and climaxing in the Taiseiden (Hall of the Great Sage). In the Taku *kōshibyō* these separate architectural elements are compressed into a single structure. The Kyōkōmon is a simple stone arch at the entrance to the enclosure, its shape and function repeated by the Chinese gable and the wooden arch beneath it that project forward from the façade of the building. Once visitors climb the few steps from the ground to the main platform and pass through the entry porch, they see across a small dirt-floored vestibule—what would be an open courtyard in a full-scale temple—the raised dais of the central worship area, and an elaborately carved shrine containing an image of Confucius and four sages, including Mencius, one of the best known of his later interpreters. Despite the Chinese style of the large curving gable and the decorative carvings of *kirin*, phoenix, elephants, and dragons, the shrine is built in the Japanese style of architecture associated with Zen temples. Covering the entire building is a steeply pitched and tiled hipped-gable roof. The Taku *kōshibyō* is remarkable not only because it is one of the few Confucian temples of the Edo period still standing, but also because ceremonies honoring Confucius and his four disciples have been performed there almost continuously since the temple was built, at first under the daimyo and now under the municipal government of Taku City.

A style of architecture that made its first appearance in Japan in the seventeenth century was associated with monasteries of Ōbaku Zen Buddhism. The school, an offshoot of the Chinese Linjizong (JAP. Rinzai) sect, was brought to Japan by Chinese immigrants who settled in Nagasaki. At first, permission was given by the *bakufu* for Ōbaku temples to be built there so that local residents could have burial ceremonies conducted according to their native customs. However, after the fall of the Ming dynasty and the establishment of the Qing, Ōbaku monks not in sympathy with the new regime emigrated to Japan. Foremost of these was the priest Yinyuan Longqi (JAP. Ingen; 1592–1673), who arrived in Nagasaki in 1654 and began a seven-year campaign to found his own temple. Finally, in 1661, he was given permission and the Konoe family donated land lying to the southeast of Kyoto for the building of the temple of Manpukuji.

The temple buildings are arranged in a symmetrical plan, as is the case with most Zen monasteries, but the buildings included in the Ōbaku enclosure differ somewhat from those in traditional Zen complexes. Between the principal gate (*sanmon*) and the main *butsuden* is a secondary building, the Tennōden, the Hall of the Guardian Kings (Fig. 356). In the

354 Taku *kōshibyō* (Confucian temple), Taku City, Saga prefecture. 1695–1708.

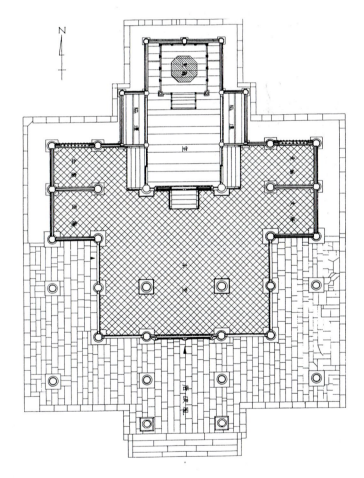

355 Plan of Taku *kōshibyō*.

Tennōden are a set of the Four Guardian Kings, or Shitennō, a seated image of Hotei (an incarnation of the Future Buddha Miroku), and a standing image of the guardian figure Idaten (SKT. Skanda), who is a protector of food. Extending to left and right of the Tennōden are covered passages that connect with subsidiary buildings, forming an enclosure with the *butsuden*. Unlike most Zen temple buildings, with the *butsuden* the bay

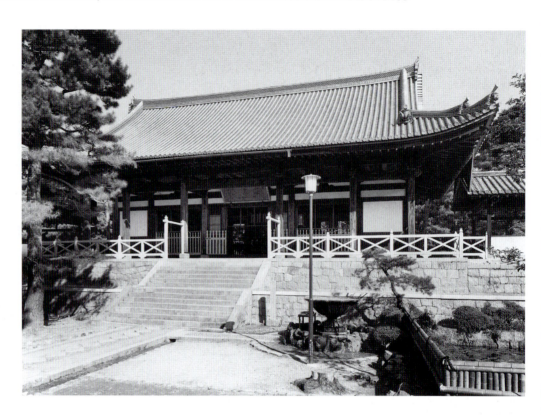

356 Tennōden (Hall of the
Guardian Kings), Manpukuji. 1668.

along the front of each structure is not walled in, but is left open so that it constitutes part of the covered walkway around the main courtyard of the temple. The *butsuden*, which serves as the focal point of the enclosure, is a two-storied building with a hipped-gable roof and hinged doors that have translucent paper inserts above rather tall panels of wood. A Shaka image is installed on a central platform inside and on low platforms along the short sides of the building are a set of sixteen images of *rakan* (*arhats*). Behind the *butsuden* is yet another enclosure, with a single-storied structure set on a high stone platform as its focal point. This is the *hattō*, or lecture hall, serving the same function as the *kōdō* in other Buddhist complexes. To the left of the *hattō*, and attached to it by a walkway, is a smaller building called the **zendō**, where **zazen** and *nenbutsu* meditation are practiced.

In addition to the specific elements—the configuration of the buildings and the combinations of deities—mentioned above, the essentially Chinese flavor of Manpukuji can be seen in such details as the round windows of the *butsuden* and the rather high decorative railings in front of many of the buildings. Manpukuji was an important addition to Japanese Buddhism, not only because it introduced a variant system of Zen thought, but also because it afforded Japanese artists a glimpse of new and different approaches to architecture, sculpture, and painting.

SCULPTURE

It is commonplace in accounts of the art of the Edo period to say that there was no sculpture of any significance. However,

as with most generalizations, fault can be found with this one. Naturally, as Buddhist temples were rebuilt, sculptures were made to replace pieces lost in the ravages of the fifteenth and sixteenth centuries. These were primarily executed by Buddhist sculptors working in traditional styles. It is true that the replacement pieces made for the *kōdō* of Tōji by Kōri and his disciple Kōshō reveal a facile smoothness of surface and little understanding of anatomy or the possibilities of expressive distortion, though they can impress through sheer size and solidity (Fig. 357). A second school of sculpture in the early Edo period can be traced to its point of origin in the work of a Chinese sculptor, Fan Daosheng (JAP. Handōsei, 1637–1701), who accompanied the Zen priest Ingen when he emigrated to Japan, and who executed a number of sculptures at Manpukuji in the 1660s. The Japanese sculptor Shoun Genkei (1648–1710) was directly influenced by his work. Originally a sculptor of Buddhist images in the traditional style, Shoun Genkei left Kyoto and took up the life of a wandering priest, traveling the country without any clear purpose other than finding an establishment for which he could sculpt a set of the five hundred *rakan*. Finally in Edo, he made contact with an abbot of the Ōbaku sect, who gave him permission to undertake the project for a temple now known as Gohyaku Rakanji (Temple of the Five Hundred Arhats). The work took approximately eight years, from 1688 to 1695, and is said to have received some support from the shogun Tsunayoshi (1646–1709). Genkei's sculptures are made of wood in the *yosegi* technique (see page 134), decorated with bright colors, black lacquer, and gold leaf (Fig. 358). However, in contrast to the *rakan* by Fan Daosheng, Genkei's are not as highly polished

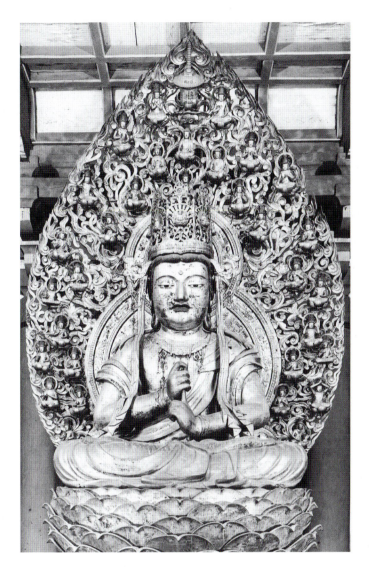

357 Dainichi Nyorai, *kōdō* (lecture hall), by Kōri and Kōshō.
16th–17th centuries. Wood with gold leaf, painted eyes, and metal details;
height including base 70 ⅞ in. (180 cm). Kyōōgokokuji (Tōji), Kyoto.

providing images to inspire and protect them by virtue of the magic with which the carvings were endowed, and that suggests Enkū formulated his own belief system and concentrated on propagating it amongst the humble peasantry. He preached religious revivalism at a time when the Buddhist Church had lost much of its influence with the general population, becoming instead a tool of the government to counter Christianity.

Enkū's life and work exemplify two traditions: the Heian and Kamakura tradition of wandering priests who devoted their lives to bringing Buddhism to the common people in a form they could understand, and the tradition of *natabori* sculpture that flourished along provincial pilgrimage routes, in which the surface of the wood is left unfinished so that the grain and the marks of the axe or chisel can be seen. The exact reasons for the formulation of the *natabori* style or its revival by Enkū are not known, but possibly it was thought that a sculpture bearing clear evidence of the wood from which it was made—and of the process by which it became a representational image—would convey more vividly to the believer the magic of the transformation process and of the divinity itself than would a finished, perfected sculpture.

Among Enkū's work are many small, roughly carved pieces now blackened with smoke. Their appearance and

and exhibit a very Japanese feeling for the original wood typical of Buddhist sculpture of the Heian (794–1185) and Kamakura (1185–1333) periods. Furthermore, although some of the figures are quite exaggerated in appearance, still there is a quality about them that seems to be closer to Japanese naturalism.

An utterly different style of sculpture is that associated with the priest–sculptor Enkū (1628?–95). In the 1960s and 1970s, Enkū studies excited much interest in Japan, and more is now known about his life and his artistic development. Still, many questions remain unanswered. Enkū is thought to have become a priest when he was in his early twenties and to have received instruction in Shingon teachings but he is also known to have studied at Hōryūji in Nara and to have frequented regions in which the Jōdō Shin school of Pure Land Buddhism was popular. But we also know that he spent most of his life traveling around Japan, preaching to the common people and

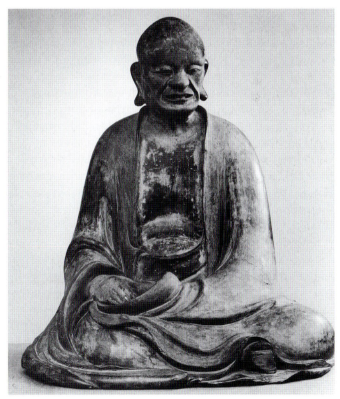

358 *Rakan*, from Gohyaku Rakanji (Temple of the Five Hundred Arhats), from the set attributed to Shoun Genkei. Between 1688 and 1695.
Wood with lacquer; height 32 ½ in. (85.7 cm). The Metropolitan Museum of Art, New York. Fletcher Fund. (27.69).

359 *Niō*, by Enkū. Late 17th century. Wood; height 81 ⅞ in. (208 cm). Senkōji, Gifu prefecture.

condition suggest that they were quickly carved out of wood splinters and hung as amulets in kitchens to frighten evil spirits away from the cooking pot. His larger sculptures reveal more concern for form. His earliest known works were produced in Hokkaidō in connection with a ceremony in which fishermen cast images of Amida and two bodhisattvas into the water so that they might gather up the souls of fishermen lost at sea and carry them to Paradise. After the ritual, the statues were retrieved and installed in a temple dedicated to Amida. Later, Enkū developed the technique of splitting a log into four pieces and creating statues that are triangular in cross section. Using the angle formed at the core as the front of his image, he cut in the details, moving from that point to the wide surface at the back of the piece.

Among his most impressive later works are two Niō images in Senkōji (Fig. 359). Only the faces and peculiar featherlike crowns are indicated at the top of a tall, roughly cut vertical piece of wood. Nevertheless, the figures seem to radiate energy and mystical power. To country peasants for whom the lifeless provincial imitations of classical sculptures installed in local temples had ceased to have meaning, these strange, rough, angular images must have been truly awe-inspiring.

OTHER BUDDHIST ARTS

Buddhist temples and establishments remained richly endowed throughout the Edo period, receiving patronage not only from the upper ranks of the samurai, but also once again from the imperial court and from the wealthy *chōnin*. These funds not only provided new buildings and sculptures, but also the furnishings and paraphernalia necessary to the temple and clergy's functioning, and the quality of such items benefited as much from the general prosperity of the period as did all the other decorative and applied arts. A particularly beautiful example is a pagoda-shaped shrine made for the personal devotions of the empress Tōfukumon'in (1607–78). The granddaughter of Tokugawa Ieyasu, Tokugawa Kazuko was given in marriage to the emperor Go Mizuno (1596–1680; r. 1611–29) and became known by the title Tōfukumon'in (Resident of the Gate of Eastern Happiness) within the court. With this marriage even more wealth flooded into the imperial coffers, and Go Mizuno and Tōfukumon'in presided over a dazzling court both on the throne and in retirement, the like of which had not been seen for many hundreds of years and which has been the focus of considerable research by Elizabeth Lillehoj. Like her husband, Tōfukumon'in was a devout Buddhist, and her personal shrine preserved at the temple of Sennyūji provides an excellent example both of the splendor of the court at this period, and of its patronage (Fig. 360). The inscription on the interior documents that Tōfukumon'in worshiped in front of this shrine every day, and had it bequested to the temple on her death.

Amongst the most important paraphernalia of the Buddhist clergy is the **kasyapa** (JAP. *kesa*), the patchwork robe worn by the Buddha and his original disciples and evidence of their mendicant status in the world, without belongings. Long before the arrival of Buddhism in Japan, such robes had instead become luxurious patchworks of different silks, and those of prominent monks in Japan are no different. The aristocracy's long-established tradition of bequesting old silken

360 Pagoda-shaped shrine of the Empress Tōfukumon'in. Edo period, 17th century. Wood with lacquer and gilt decoration; 14 ⅜ x 8 ⅞ in. (36.5 x 22.5 cm). Sennyūji, Kyoto.

361 Detail of priest's robe (*kesa*). Edo period, 19th century. Brocade silk. Victoria and Albert Museum, London.

robes to temples, a custom also taken up by the samurai and wealthy *chōnin*, also contributed material for these robes. Surviving from the early Edo period is one such *kesa* of the nineteenth century where a patchwork design has been created with silken cord on a single length of brocade figured with butterflies and peonies (Fig. 361). The robe has been further adorned with patches bearing highly stylized Sanskrit characters of sacred syllables. In the detail illustrated, the character appears to be of "Hum," which most famously is the last syllable of the mantra of the bodhisattva Kannon—"Om mani padme hum."

Developments in Painting

KANŌ SCHOOL

By 1640 all the great figures of painting that had dominated the Momoyama and the first decades of the Edo periods were dead, and the conservative aesthetic of the Tokugawa regime, emphasizing unchanging continuity with tradition, came briefly to dominate painting circles, and was particularly espoused by the Kanō school, which had, in fact, played a role

in its formulation. The key Kanō artist during this period was Kanō Tanyū (1602–74), a grandson of Eitoku (1543–90), who reclaimed the Tokugawa commissions which had previously gone to artists such as Sōtatsu, Kaihō Yūshō (1533–1615), and Hasegawa Tōhaku (1539–1610). Familiar with the clan's leading figures from childhood, at the age of fifteen he was named official painter to the *bakufu*, and in 1621 he was offered a tract of land outside the Kajibashi Gate of Edo Castle for his residence and studio. Ultimately, Tanyū's younger brothers, Naonobu (1607–50) and Yasunobu (1613–85), were persuaded to move from Kyoto to Edo by similar land grants. Finally, with the settlement of Naonobu's grandson Minenobu (1662–1708) with a tract of land, four separate branches of the Kanō school were established in the shogunal capital and by the end of the seventeenth century they had been given the official designation *oku eshi*—"painting masters of the inner circle." With the secure patronage of the *bakufu*, these four branches specialized throughout the Edo period in a conservative amalgam of Chinese (and especially Confucian) themes and the decorative style their sixteenth-century ancestors had developed for covering large wall surfaces. Although the work of the Edo branches of the Kanō school is not held in particularly high esteem today, throughout the period they set the artistic standards by which the works of other schools were judged. Many artists continued to serve an apprenticeship in the Kanō school before going on to develop their individual styles.

Tanyū's work provides the model to which the next two centuries of Kanō masters looked. In 1634, when the shogun Iemitsu journeyed to Kyoto, he stopped at Nagoya Castle, and its daimyo had a new building, the Jōrakuden, constructed in the castle's innermost enclosure for his eminent guest. Tanyū was commissioned to execute the wall paintings for the Jōrakuden, and for the *jōdannoma*, the most important section of the building's reception room, he chose the *Teikan zu* (The Mirror of Emperors), the tract on the actions of good and bad emperors of Chinese history judged by Confucian standards. This work, first illustrated in Japan by Kanō Sanraku in the early 1600s, had become one of the most popular themes for wall paintings in daimyo residences by the second quarter of the seventeenth century. One of the best-preserved sections from Tanyū's murals depicts the story of Emperor Wen (Fig. 362), who ordered the construction of a tower but rescinded his order when he found out how expensive it would be—the moral being that lavish expenditure for a nonessential item was unjustifiable. Tanyū has distributed elements of the composition across four *fusuma* panels, and the central image of the emperor being informed by his attendant of the great expense is framed to the right by a gnarled evergreen, the upper branches of which are obscured by white mist and a sprinkling of the gold dust that encircles the entire scene. At the very bottom of the panel, outside an elaborate gate, a servant stands ready to relay the emperor's decision to his workmen. The painting has a decorative, idyllic quality, but no sense of drama.

362 *Emperor Wen* section, from four *fusuma* panels illustrating *Teikan zu (Mirror of Emperors)*, by Kanō Tanyū. Early 17th century. Color, gold paint, and gold dust on paper; each panel: 75 ⅝ x 55 ¼ in. (192 x 140.5 cm). South side, *Jōdanoma, Jō rakuden*, Nagoya Castle.

By the end of the Edo period, little had changed in the Kanō style but the oeuvre of its best known-painter in the first part of the nineteenth century, Kanō Osanobu (also known by his studio name of Seisenin; 1796–1846), demonstrates that the school was still capable of works of great refinement and even poetry. His preferred inspiration was the *yamato-e* of the imperial Tosa school, especially the *emakimono* of the Kamakura period. An example of his mature *yamato-e* style is a pair of folding screens in Hōnenji, illustrating the early chapters of the *Genji monogatari*—"Momijigari" (Autumn Excursion) and "Hatsune" (First Warbler's Song) (Fig. 363). The episode from "Momijigari" is the frequently depicted scene of the dance performed by Genji and his principal rival at court, Tō Chūjō, on the occasion of the imperial autumnal excursion. Perhaps because this episode was so well known from earlier illustrated versions of the text, Seisenin made no effort to rework the scene. However, in the "Hatsune" screen he has captured something of the gentle, romantic tone of the text. The time is a cloudless New Year's Day, the setting the quarters in his palace of Genji's favorite consort, Lady Murasaki.

> The scent of plum blossoms, wafting in on the breeze and blending with the perfumes inside, made one think that paradise had come down to earth.
>
> Edward Seidensticker, trans., *The Tale of Genji*, London, 1976, 409.

The episode begins to the right with the tops of several pine trees silhouetted against white clouds. To the left, the elegant apartments of Lady Murasaki unfold. A number of ladies-in-waiting are settled around the edges of the main room, and in the center Genji, seated behind a low table on which dishes of rice cakes have been placed, is talking to the elegantly dressed Lady Chūjō, one of Murasaki's attendants. Genji has just asked the ladies to tell him their wishes for the future, and Lady Chūjō has come forward to make a graceful reply, referring to the rice cakes, symbols of the New Year celebrations. Several male courtiers can be seen outside the main room, and further to the left is Murasaki's spring garden, ornamented by blossoming plum trees, willows, and a stream with a curved bridge across it. The painting captures the gentle elegance of the scene and even something of the quality of horizontal narrative illustrations. The pine trees to the right of the screen symbolize long life, the universal wish at the beginning of a new year, while the plum trees to the left refer specifically to Murasaki's garden, which was designed to be at its peak of beauty from February through April, the Japanese spring.

ŌGATA KŌRIN AND THE RINPA SCHOOL

The Rinpa school, which from the last quarter of the seventeenth century became such an influence in not only painting, but in all artistic design, officially traces its origins in the work of Sōtatsu and Kōetsu. In reality it is the product of the reworking and revitalization of their concepts by Ōgata Kōrin (1658–1716), as reflected in the school's name—literally the School of Rin, the "rin" taken from the second syllable of Kōrin. Rinpa (often pronounced Rimpa) as a school is not founded upon a family or lineage of masters such as the Kanō or Tosa, but is rather an association of aesthetic and design

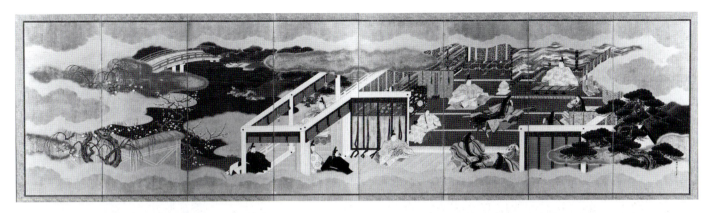

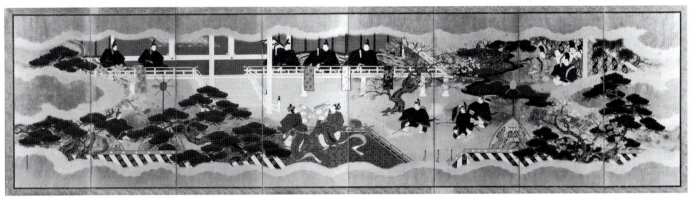

363 Scenes from "Hatsune" (*above*) and "Momijiagari" (*below*) chapters, *Genji monogatari* (*Tale of Genji*), a pair of eight-panel *byōbu*, by Seisenin (Kanō Osanobu). 2nd quarter 19th century. Color on paper; each screen: 39 ¼ x 160 ¼ in. (99.7 x 407.9 cm). Hōnenji, Takamatsu, Shikoku.

values shared by various artists in the years following Kōrin's own production.

Kōrin stands somewhat apart from the mainstream of art at the turn of the eighteenth century. Like Sōtatsu and Kōetsu before him, Kōrin was from the upper ranks of the *chōnin*. His family had long been acquainted with shoguns and daimyo, and had been closely associated with some of the most respected connoisseurs in the country. From the late sixteenth century onward, it had owned a textile shop in Kyoto, the Kariganeya, which supplied fabrics and garments to the wives of Hideyoshi and Tokugawa Hidetada, as well as to the latter's daughter, the empress Tōfukumon'in. Furthermore, Kōrin's great-grandfather had been active in Kōetsu's artistic community Takagamine, and had married Kōetsu's sister. However, by the time Kōrin's father died, the business had lost its prestigious contacts with the *bakufu* and the imperial family and was encumbered by debt. Consequently, although Kōrin lived in an extravagant manner for a few years after he came into his inheritance, he was soon forced to sell family treasures and, in 1696, his large house. Kōrin and his younger brother Kenzan began to make their living: Kōrin by designing textiles and painting hanging scrolls and screens, and Kenzan (who had better managed his inheritance) by launching a pottery. Something of Kōrin's sensibility can be inferred from a well-known incident in which he and a member of the Mitsui family, proprietors of the Echigoya, a forerunner of the modern

department store, were walking together dressed in their finest clothes. Suddenly it began to rain. Mitsui ran for shelter to save his clothing from damage, but Kōrin continued to amble slowly along and even stopped to talk to an old beggar sitting beside the road.

In Kōrin's art three essential elements can be distinguished. Foremost of these is the continuation and reworking of the decorative style and the *yamato-e* themes employed by Sōtatsu, several of his paintings being actual copies of designs originated by Sōtatsu. Like Sōtatsu, he frequently chose to depict themes from the literature favored by the court—the *Tale of Genji*, *The Tales of Ise*, and the poetry of the thirty-six great poets. Other subjects he shared with Sōtatsu were the standard *yamato-e* themes of birds and flowers and the four seasons. A beautiful example of Kōrin's figural and floral designs for a number of fans have been preserved by being pasted on the surface of a gold lacquer box (Fig. 364). The subject of the figural painting has not been precisely identified, but it may be an episode from the *Hōgen monogatari* (*Tales of the Hōgen Rebellion*). This was also a frequent source for Sōtatsu's fan paintings, and Kōrin's scene is similar in theme and style to a fan painting on a screen in the Freer Gallery in Washington, D.C., that has been attributed to Sotatsu's studio.

The Rinpa school is particularly distinguished by its lavish use of bright colors and gold and silver, reminiscent of the gorgeousness of Heian-period art, although Kōrin also uses these

elements to flatten and simplify his images into combinations of near-abstract form. He was known to make numerous drawings of plants and birds from life, attempting to capture accurately the visual reality of the natural world, but the motifs in his more formal paintings are treated like decorative textile designs rather than recreations from life. This element of his style is particularly well displayed in the striking Iris screens (Fig. 365). Kōrin painted the flowers in *mokkotsu*, the boneless method, a style of painting without ink outlines that had originated in China and had been previously exploited by Sōtatsu. Clusters of velvety iris—their petals differentiated by flat areas of light and dark blue rather than by shading—are arranged in rhythmically related clusters over the gold-leaf surface of the two six-panel screens. The shapes of the iris and their spiky green leaves appear like silhouettes against the glowing background.

The theme depicted in the Iris screens can be traced back to a passage from the *Tales of Ise* in which the protagonist, banished from the capital, journeys with several companions to the east. One day they stop beside a marsh, across which there is a simple plank bridge. They all sit down on the bank, along which iris are growing, and the hero composes a poem using the syllables of *kakitsubata*, the Japanese word for a species of iris, to begin each line. These screens represent the scene reduced to its poetic essence, the iris. Kōrin created several other, more explicit, versions of the theme. One, a hanging scroll in the Tokyo National Museum, depicts the exiled man, his companions, the iris growing beside the stream, and even the beginning of the bridge across the marsh. A pair of screens in the Metropolitan Museum of Art, New York, depict the iris and the many turns of the bridge, known as *yatsuhashi* (eight-plank bridge). Yet none of these other works have the luminous power of the pair of Iris screens.

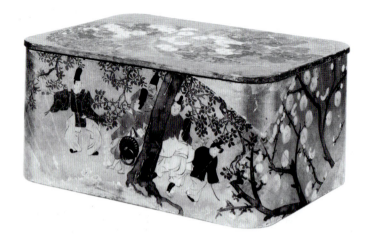

364 Box decorated with fan paintings, by Ōgata Kōrin. Late 17th century. Color on paper, applied to lacquer on wood with gold-leaf ground; 7 ½ x 15 x 10 ⅞ in. (19 x 38.2 x 27.5 cm). Museum of Yamato Bunkakan, Nara.

A third major element of Kōrin's art is his love of luxury and flamboyant display. Anecdotes abound regarding his penchant for extravagant indulgence, but the one that conveys some of the flavor of his self-image as an aristocrat among the *chōnin* deals with an outing he attended not long after his inheritance. Kōrin produced from his picnic basket leaves coated with gold, and he used them as saucers on which to float brimful saké cups on a nearby stream, in the manner of Heian-period poetry gatherings where guests would pluck them from the water and compose a poem before taking a sip. Something of this same love of luxurious display can be seen in the *Red and White Plum Blossoms*, a pair of screens depicting a plum tree on either side of a curving stream, the surface of

365 *Irises*, right screen from a pair of six-panel *byōbu*, by Ōgata Kōrin. *c.* 1701. Color with gold leaf on paper; each screen: 59 ½ x 133 ⅜ in. (150.9 x 338.8 cm). Nezu Museum, Tokyo.

366 *Red and White Plum Blossoms*, a pair of two-panel *byōbu*, by Ōgata Kōrin. *c.* 1710–16. Color and gold and silver leaf on paper; each screen: 61 ⅝ x 67 ⅞ in. (156.5 x 172.5 cm). MOA Museum of Art, Atami, Shizuoka prefecture.

367 Detail of *"Flowers of the Four Seasons,"* Ōgata Kōrin. 1705.
Originally a hand scroll, now mounted on four panels; each: 14 ⅜ x 51 ¾ in. (36.6 x 131 cm). Private collection.

which is treated as a series of flat decorative wave patterns in ink and silver (Fig. 366). The plum branches are slender, angular forms with small, barely emerging blossoms, while the stream in the center is a wide, curvilinear shape, rich in pattern and contrasts of light and dark; the whole design is set against a background of glistening gold.

The chronology of Kōrin's work is not easy to establish with any degree of reliability because so few of his paintings were dated. However, a general distinction has been made between the works produced during his formative period in Kyoto from 1697 to 1703, those painted during his stay in Edo from 1704 to 1710, and those made between his return to Kyoto and his death in 1716. The Iris screens are the best works of his first Kyoto period, produced shortly after 1701, when he was accorded the title of Hokkyō, a Buddhist rank of honor given to artists. During this period Kōrin became acquainted with Nakamura Kuranosuke, a senior official in the silver mint, perhaps through their mutual interest in Nō drama. Profiting handsomely from the recoinage ordered by the *bakufu* in 1695, Nakamura began to live on an extravagant scale and apparently became Kōrin's patron. In 1704, Kōrin followed Nakamura when he was transferred to the Edo silver mint, located in the area of modern Tokyo known as Ginza (literally "seat of silver"), and he lived there for six years. At first most of his work was done for a wealthy lumber merchant, but gradually his clientele shifted to the samurai class, who demanded works in the Kanō style. One of the few dated paintings by Kōrin is a 1705 hand scroll depicting flowers of the four seasons (Fig. 367). The scroll consists of numerous types of flowers and grasses—peonies, hollyhocks, iris, chrysanthemums, daffodils, and many others—depicted across the entire surface. The flowers are outlined in pale ink and filled in with thin, moist colors, and the leaves painted in the boneless method in ink with frequent use of *tarashikomi,* the color-over-wet-color technique associated with Sōtatsu. Kōrin's dream of making a fortune in Edo seems not to have materialized, and the freedom to develop his talents as he wished was frustrated by the need to satisfy samurai patrons who wanted works in

the Kanō style. Consequently, in 1710 he returned to Kyoto, where he could work with fewer constraints. The *Red and White Plum Blossoms* screens, which are from this last period, reflect his assurance in their successful combination of seemingly inappropriate motifs, their tension between the real and the unreal, and their barely controlled sense of flamboyance.

Kōrin left no disciples to continue his work upon his death, but the influence of the Rinpa style has been amply demonstrated in the discussion of the decorative and applied arts, and Hokusai's Tawaraya school was also devoted to the revival of the Rinpa aesthetic. The two artists most famous for continuing the Rinpa style in painting in the Edo period are Sakai Hōitsu (1761–1828) and his follower Suzuki Kiitsu (1796–1858). Hōitsu was born into the daimyo family of Himeji Castle, and received an education appropriate to his station in life. However, he entered the priesthood in 1797 at the age of thirty-six, perhaps due to ill health or because he wished to free himself from the responsibilities of his position within the *han.* Hōitsu's interest in painting ranged from the meticulous and brightly colored depictions of birds and flowers of Chinese professional painting, to *ukiyo-e* works, and even to the styles of the Tosa and Kanō, but after 1797 he turned his attention exclusively to the Rinpa style. From 1810 to 1819 he devoted himself to a revival in Edo of Kōrin's style, and even held a ceremony in 1815 commemorating the centennial of Kōrin's death. He also published two books on the master, the *Kōrin hyakuzu* (*One Hundred Paintings by Kōrin*) and the *Ōgataryū ryaku inpu* (*Collected Seals of the Ōgata School*). During his last years Hōitsu brought his personal Rinpa painting style to its full maturity, continuing certain elements of Kōrin's painting but combining with them themes and techniques from other contemporary schools.

Hōitsu's most famous work is a set of hanging scrolls depicting birds and flowers of the twelve months, dated 1823, when the artist was sixty-two. The painting for the ninth month is particularly beautiful (Fig. 368). Four autumn plants—one with white blossoms and three types of grasses, two of which turn a bright reddish purple with the advent of cold

weather—are depicted against a pale harvest moon. The placement of the flowers and grasses is so subtle that it suggests a slight breeze touching the plants, causing the leaves to rub together. The work captures not only the decorative quality of the Rinpa school, but also the naturalism of Maruyama Ōkyo (1733–95), discussed below. Hōitsu's major accomplishment was to revive Rinpa-style painting and to establish it, as Kōrin could not, in Edo. However, toward the end of his life he went beyond his sources to create subtle depictions of nature

368 *Ninth Month*, one of twelve hanging scrolls of *Flowers and Birds of the Twelve Months*, by Sakai Hōitsu. 1823. Color on silk; 55 ⅛ × 19 ⅝ in. (140 × 50 cm). Imperial Household Agency.

freed from the need to impose references to classical literature onto them.

Hōitsu's follower, Suzuki Kiitsu, was born into a family of dyers, but was allowed to break with tradition and study with Hōitsu from 1813 onward. When Suzuki Reitan, a retainer and disciple of Hōitsu, died in 1817, Kiitsu married Reitan's older sister, through the master's good offices. He served Hōitsu until the latter's death, and developed his own distinct version of the Rinpa style. A particularly interesting example of Kiitsu's mature work is a pair of screens depicting white camellias and autumn grasses (Fig. 369), although originally these two paintings were pasted on the obverse and reverse of a single two-panel screen. They constitute a remarkable contrast between two aspects of the natural world. The camellia screen is dominated by an area of deep green arching across the top, silhouetted against which are the bright camellia blossoms meticulously outlined in pale gray ink. The painting betrays an attention to decorative detail typical of the Rinpa school, but the sharp apposition of flat areas of color and the contrast between abstract shapes and naturalistic details are the product of Kiitsu's own creative sensibility. His painting of autumn grass could not be more different from the Rinpa-style norm. Rows of grasses painted in gray ink appear against a silver ground, which over the years has tarnished, giving it a rich, grayish-brown tone. The regular placement of the grasses is further accented by the remarkably even edges of the sheets of silver leaf applied to the backing paper. However, a sinuous line of mist softens this impression by twisting across the surface from the upper right to the mid-left and back again to the right. The grasses can be seen indistinctly through the misty passages, but an element of uncertainty has been added to the painting. The two works complement each other, suggesting the clarity as well as the mystery of nature. Kiitsu succeeded in taking Rinpa painting a step beyond his master, making it into a more boldly abstract depiction of nature.

REALISTIC SCHOOLS OF PAINTING: *YŌFŪGA* AND THE MARUYAMA–SHIJŌ SCHOOL

Yōfūga

When around 1620 shogun Yoshimune lifted the restrictions on the importation of foreign books, he initiated, amongst other things, a new trend in Japanese painting, a trend inspired by contact through printed books with Western painting. Various artists, each with different training and a different point of view, attempted to recreate, as believably as possible on a two-dimensional surface, phenomena observed in the real world of three-dimensional space. Even Kōrin, master of the gorgeous pictorial abstraction based on classical narrative themes, had been moved to make drawings of flora and fauna from life. This interest in realistic rendering took two distinct paths: *yōfūga*, or **yōga** as it would later be called, a Western-style painting in oils or traditional Japanese pigments, with an emphasis on perspective and modeling in light and shade; and the Maruyama–Shijō school, in which classic

369 *White Camellias and Autumn Grasses*, a "pair" of two-panel screens, by Suzuki Kiitsu. 2nd quarter of the 19th century. Ink and color and gold and sliver leaf on paper; each screen: 59 ⅞ × 66 in. (152 × 167.6 cm). Freer Gallery of Art, Smithsonian Institution, Washington, DC. (F1974.35 and 36).

Japanese techniques were combined in new ways to achieve greater accuracy of depiction and a sense of naturalism and the everyday.

The man initially responsible for the popularization in Japan of *yōfūga* was a samurai turned *rōnin*, Hiraga Gennai (1728–79). Gennai was the son of a low-ranking *han* official

and herbalist to the daimyo of Takamatsu on Shikoku Island, who was encouraged by his master to advance his studies by going to Nagasaki, learning Dutch, and searching for whatever information on the natural sciences might be available there. Because the Dutch were the only Westerners allowed to trade in Japan, the Japanese turned to books in Dutch as their

principal source of Western learning and, until quite late in the Edo period, investigations of Western sciences and the humanities were known as *rangaku* (Dutch studies). Gennai subsequently was given leave to go to Edo to continue his work, but with such harsh provisos that he renounced his position and stipend. In order to support himself in Edo, he wrote popular novels and plays. He also dabbled in painting, using Western techniques for suggesting space and modeling forms which he shared with the group of intellectuals in Edo who were involved in Western studies.

The most competent painter to come under his influence was Shiba Kōkan (1738–1818), a versatile artist who began his training under a Kanō master but switched at the age of twenty-four to Sō Shiseki, a practitioner of Chinese **bird-and-flower painting** in the hyper-realistic academic tradition of the Song dynasty (960–1279) which had once again found popularity with certain painters in China. About the same time he met Gennai, and it is known that the two men went on a field trip together to find precious minerals. Given Kōkan's talent and interests, there can be little doubt that their conversation often turned to Western methods of painting. Until 1780 Kōkan pursued the study of Western art as an avocation, devoting his primary efforts to the lucrative work of designing woodblock prints. Since Suzuki Harunobu was the dominant presence in printmaking circles until his death in 1770, for a while Kōkan produced prints that imitated the master's style so accurately that he would sometimes affix Harunobu's name and seals and market them profitably. However, in the 1780s two Chinese books on Western painting came into his possession, and from then on he devoted himself to perfecting his control of Western techniques. Some of his scorn for traditional Japanese art can be seen in his text on painting, the *Seiyō gaden* (*Commentary on Western Painting*) of 1799, in which he characterized it as no better than a trick to be performed at drinking parties. It is interesting in this context to note that Kōkan was acquainted with the *bunjinga* artist Gyokudō (see pages 335–39), and tried on several occasions to make available to the reclusive artist the new knowledge from Europe then current in Edo.

One example of Kōkan's mature style is *The Barrel-maker*, painted in 1789 (Fig. 370). It must be said that to modern eyes Kōkan's technique in this painting is rather heavy-handed. A man in Western dress stands awkwardly, a hammer in his upraised hand, in his other hand a chisel held against the side of the barrel. Recession into depth is achieved by the placement of buildings and figures of decreasing size on a diagonal line carrying the eye back to the horizon, which is punctuated by a boat and a mountain range. Although the painting purports to depict in realistic fashion the everyday activities of actual human beings, it has the quality of a romantic fantasy about the working class, a quality found more often in Western than in East Asian art. Nevertheless, Kōkan took an important first step in bringing attention to the potential of Western techniques. Today he is regarded as one of the forerunners of the late nineteenth- and twentieth-century *yōga* style.

370 *The Barrel-maker*, by Shiba Kōkan. c. 1789. Hanging scroll, oil paint on silk; 18 ¾ × 23 ⅝ in. (47.6 × 60 cm). Private collection, Yokohama.

Maruyama–Shijō School

The Maruyama–Shijō school, the second aspect of Edo-period realism, was founded by Maruyama Ōkyo (1733–95), the offspring of a farmer who left his land and made a place for himself among the *chōnin* of Kyoto. The word "Shijō" refers to the studio of Ōkyo's successor, Matsumura Goshun (1752–1811), located in Kyoto's fourth ward (Shijō). In his teens, Ōkyo was apprenticed to a toy shop where he learned to paint doll faces and later *megane-e*—the paintings used in stereoscopes. Originally imported from the Netherlands, and then from China, these optical instruments were eventually manufactured in Japan to show images of famous Chinese, Japanese, and Western landmarks. The production of *megane-e* required a knowledge of Western perspective and shading techniques, specifically the network of oblique lines used in copperplate etchings, and it depended on the exaggeration of near and far views. Although he mastered this art form, his later work does not reflect any lasting influence from Western methods of depiction, aside from an increased appreciation of visual realism. His studies of the Kanō style of painting under Ishida Yūtei (1721–86), an artist affiliated with the court, exerted a more lasting influence.

Another element in Ōkyo's art was his affinity with the urban population of Kyoto. He frequently chose as themes for his paintings scenes observable every day within the mercantile district. Perhaps because of his empathy with the common people, he was commissioned in 1768 by Yūjō, the abbot of Emmanin, a temple in Ōtsu, to paint a set of hand scrolls known as *The Seven Fortunes and Seven Misfortunes* as a pictorial explanation of the blessings and evils that result from previous karma. Yūjō stated in his introduction to the scrolls that if people were to be converted to a genuine belief in the Buddha, they had to be shown real-life phenomena, not the fantastic stories of heaven and hell that were usually offered.

371 Sketch for hand scroll, *The Seven Fortunes and Misfortunes*, by Maruyama Ōkyo. 1768. Ink on paper; height 12 ¼ in. (31 cm). Manno Art Museum, Osaka, National Treasure.

The set consists of three scrolls totaling approximately 148 feet (45 m), and took Ōkyo three years to complete. Two scrolls depict the disasters inflicted on mankind by nature and by other human beings, while the third illustrates the good fortunes possible in this life. Ōkyo treated this commission with the utmost seriousness, searching out as models for his paintings actual examples of even the most unusual scenes. One of the most gruesome sketches executed in preparation for the scrolls depicts a naked man being split apart by two bulls (Fig. 371). Each leg has been tied to the hind leg of a bull, and their tails set afire so that they will run panic-struck away from each other. In this image Ōkyo has captured with awesome force and accuracy the appearance of two solid, muscular animals leaping apart in fright and in the process tearing open a frail human body.

Another work that demonstrates Ōkyo's mastery of the traditional elements of the decorative style and his unique use of them to achieve greater naturalism is *Pine Trees in Snow* (Fig. 372). The pair of six-panel screens, painted in ink on a gold ground, was commissioned by a member of the wealthy Mitsui merchant family. On the right screen, a single pine tree thrusts upward from roots invisible below the edge of the painting to heights that far exceed the upper edge, its branches extending to right and left of the trunk, filling the broad horizontal space of the screen. At first glance the painting would seem to be a simple recapitulation of Kanō Eitoku's *Cypress* (see Fig. 296), but Ōkyo's pine trees do not twist impossibly in space. Instead they bend as any tree might in deference to the prevailing winds. In depicting the tree trunks, Ōkyo has used a technique called *tsuketate* that became a hallmark of the Maruyama–Shijō school. The trunks are not outlined, but instead are modeled by means of daubs of ink, dark over light, applied to specific sections to suggest highlights and shadows on the surface, patches of snow, and areas where the rough bark of the trees can be seen, thus creating a sense of volume. The final impression created by this pair of screens is the still, serene beauty of the natural world.

373 *White Plum Tree*, left screen of a pair of six-panel *byōbu*, by Matsumura Goshun. 1781–9. Slight color on silk; each screen: 69 x 147 in. (175.5 x 373.5 cm). Itsuō Art Museum, Osaka.

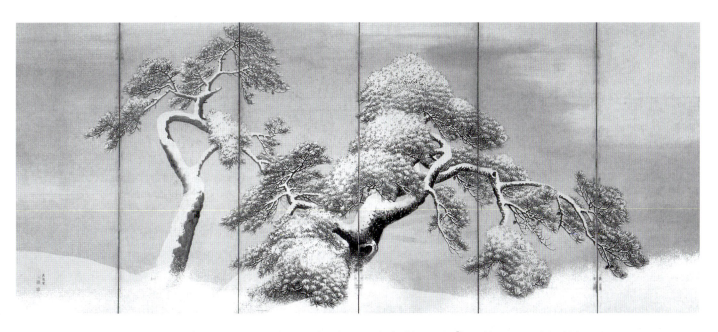

372 *Pine Trees in the Snow*, right screen of a pair of six-panel *byōbu*, by Maruyama Ōkyo. 4th quarter of the 18th century.
Ink, slight color, and gold on paper; each screen: 60 ⅞ x 142 ½ in. (155.5 x 362 cm). Mitsui Bunko, Tokyo.

Ōkyo became highly successful in his own lifetime, with his realist style attracting the attention and patronage of not only the *bakufu* in Edo, but the imperial court in Kyoto. After his death, his style was perpetuated by his close friend Matsumura Goshun. Born into a family that had worked for the mint in Kyoto for four generations, Goshun began his painting studies primarily as an avocation. However, in 1772, when it had become clear that he had talent as an artist, he began serious work under the guidance of the *bunjinga* master Yosa Buson (1716–83) (see pages 333–6). As he did not immediately attract patronage, Buson helped him stay afloat financially by recommending him as an adviser on literature and the arts to wealthy provincials wishing to acquire an aura of culture. In 1781, Goshun's career took a major turn for the worse. Both his wife and his father died, and Buson, near death himself, was apparently no longer able to help his pupil. Goshun left his residence in Kyoto's Shijō district that same year and moved to Ikeda on the outskirts of Osaka, continuing to work in Buson's style. In 1787, he joined with Maruyama Ōkyo and his studio to work on the decoration of screens for Daijōji, a temple in Hyōgo prefecture. The following year, the two men found themselves living at the same temple, Kiunin, after Kyoto had suffered another disastrous fire that had reduced much of the city to ashes. What had been a good working relationship in Hyōgo developed into friendship, and in 1789 Goshun moved back to the rebuilt Shijō district and adopted the basic elements of Ōkyo's style. Ōkyo never looked upon Goshun as a pupil, and in the records of the Daijōji project Goshun is instead described as Buson's best pupil. When Goshun offered to join Ōkyo's studio officially as a disciple, the older man refused, preferring that they remain as friends and equals. Thus Goshun was free to develop his own unique blend of Maruyama and *bunjinga* techniques, and, after Ōkyo's death in 1795, he established his own Shijō school.

A superb example of his fusion of the two older styles is a pair of undated screens depicting white plum trees against a pale blue ground (Fig. 373). Their most unusual feature is the material on which they are painted, a rough yellow pongee silk painted unevenly in gray-blue strokes and pasted across the screen horizontally, producing four seams in each panel. Obviously Goshun wanted the ground of his painting to have a visual texture equal to that of the images themselves. A base line is established by a thin gray wash in each screen, establishing a sense of space within the paintings and stabilizing the compositions. In the left screen, two small plum trees are depicted with greater clarity, as if silhouetted by the moon against a cloudless night sky and creating a delicate, luminous view of the natural world. Goshun has combined Ōkyo's techniques of painting, his *tsuketate* brushwork, and his methods for suggesting space, with Buson's delicate, lyrical approach toward the depiction of landscape, to produce a new type of realism. His style was popularized by his two best pupils, his younger brother Keibun (1779–1843) and Okamoto Toyohiko (1773–1845), and the Shijō style flourished throughout the rest of the Edo period.

ECCENTRIC PAINTERS

During the explosion of new painting schools and styles that characterized the eighteenth century, inevitably there were some highly talented artists who belonged to no tradition and who for whatever reason did not assemble about themselves a group of disciples to create of their style another tradition. These artists have been classed as eccentric, perhaps partly in reference to a similar group of contemporary individualist painters living in the Chinese port of Yangzhou and posthumously known as the Eight Eccentrics. The first of these eccentrics was a pupil of Ōkyo, Nagasawa Rosetsu (1754–99), who took his master's realism as a point of departure in the formulation of a unique style that is often sharply satirical. Little is known of Rosetsu's personal history before he joined Ōkyo's studio, but he seems to have been something of a troublemaker. While there is some doubt about the accuracy of this story, it has been alleged that on several occasions Ōkyo dismissed Rosetsu for uncontrolled and extravagant behavior but, because Rosetsu was such a good painter, always allowed him to return and even entrusted him with the execution of several paintings for commissions from temples distant from Kyoto, which Ōkyo had accepted but could not complete himself. In 1793, at the age of forty, Rosetsu changed his studio name, his seal, and his style of painting. The works executed after this date display a softer, more flexible line and a more subjective treatment of pictorial images.

One of his most famous paintings from this period is an *ema* (votive painting) of 1797 dedicated at the Itsukushima Shrine (Fig. 374). The subject is Yamauba, the mountain woman, and Kintarō, the son she raised to be a warrior of superhuman strength and loyalty. In Rosetsu's painting, Yamauba is an old and ugly court lady, sloppily clad in garments once gorgeous but now tattered, and the child is more monkey than human infant. Compared to conventional treatments of the theme, Rosetsu's painting seems to lay bare a cynically viewed "reality" behind the façade of tender maternal care and nascent heroism.

Two other eccentric masters who are sometimes grouped with Rosetsu are Itō Jakuchū (1716–1800) and Soga Shōhaku (1730–81). Jakuchū was the eldest son of a greengrocer in Kyoto and in his early years took over the business, but his heart was not in it. He preferred painting, and in 1755, at the age of thirty-nine, he turned the shop over to a younger brother, took the tonsure, and for the rest of his days lived the life of a priest devoted to painting. Following the lead of most aspiring artists of his day, Jakuchū began by studying the Kanō style, but very quickly rejected it as being too limiting and looked to other sources for inspiration. At first he copied Chinese paintings preserved in various Kyoto temples, which he thought to date from the Song and Yuan dynasties, but which were more probably of the later Ming. Next he turned to what is called in Japanese *shaseiga*, copying from nature. He began by raising brilliantly colored hens and cocks, observing them day to day, and then sketching them in motion. From

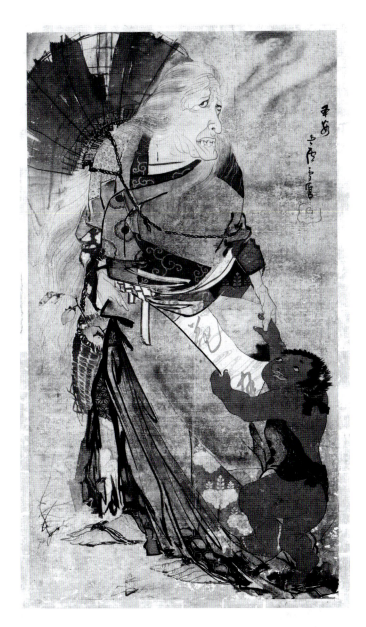

374 *Yamauba and Kintarō*, by Nagasawa Rosetsu. 1797. Color on silk; 62 x 33 ⅛ in. (157.5 x 84 cm). Itsukushima Shrine, Hiroshima prefecture.

However, Rinpa influence can also be perceived in the flattening out of the images, whose impact is primarily in the blending of motifs to create a brilliantly complex, decorative pattern. The stunning results that Jakuchū achieved with this interface of hyper-realism and a Rinpa-inspired decorative aesthetic is also shown in a painting of pond life (Fig. 376). The various insects, frogs, lizards, and snakes are minutely and colorfully depicted, but they and the plants around them are ultimately flattened elements that are arranged in a swirling pattern.

Recent research suggests Soga Shōhaku was born in Kyoto to a family with the surname Miura, and that he began studying with a Kanō master, but quickly struck out on his own. Rather than concentrating directly on Chinese painting styles as Jakuchū did, he turned instead to the masters of the Muromachi period who had been inspired by Chinese literati painting. So deep was his obsession that he constructed for himself a fake genealogy going back to the fifteenth-century artist Dasoku. Nevertheless, his paintings could never be mistaken for works of the fifteenth century, so strong and free is

this he went on to study other birds, such as the crane, and insects, amphibians, and fish, as well as flowers and trees.

A particularly fine example of his work is a painting *Rooster, Hen, and Hydrangea*, dated to around 1757 (Fig. 375). The cock, hen, and hydrangea plant are all meticulously painted, even to the point of hyper-realism—a feature Jakuchū admired in Chinese paintings in the style of the Song imperial academy. Although the interrelation of cock and hen is clearly understandable, space in the painting is suggested through superimposition, one shape overlapping another.

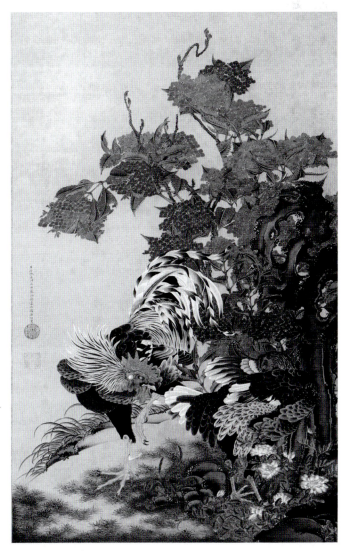

375 *Rooster, Hen, and Hydrangea*, by Itō Jakuchū. *c.* 1757. Hanging scroll, color and ink on silk; 54 ⅞ x 33 ½ in. (139.4 x 85.1 cm). Los Angeles County Museum of Art, Etsuko and Joe Price Collection. (L.83.50.1).

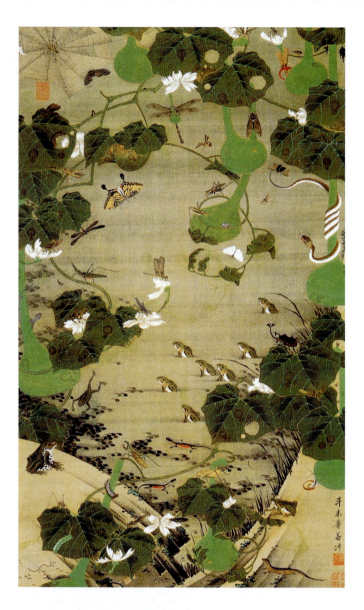

376 *Insects, Reptiles, and Amphibians at a Pond* from *The Colourful Realm of Living Beings*, by Itō Jakuchū. Hanging scroll, one of a set of thirty, ink and color on silk; 55 ⅞ × 28 ¾ in. (142 × 72.9 cm). Museum of Imperial Collections, Sannomaru Shozokan.

his brushwork, and so dramatic are his compositions, which depend on the abrupt juxtaposition of pictorial motifs. Shōhaku is perhaps best known for his eccentric treatment of figures from Chinese history and literature, but he also excelled as a landscape painter. Undoubtedly his most accomplished and dramatic works in this vein are a pair of screens dated by Money L. Hickman to the period shortly after the artist's fortieth birthday (Fig. 377). At first glance the screens seem to employ the familiar motifs of foreground rocks and trees, and soft, hazy mountains at the horizon. Yet the more carefully one examines them, the clearer it becomes that the artist has stretched almost to the limits the juxtaposition of disparate landscape elements. The sense of perspective in the left screen shifts as the eye moves from one rock motif to another. These distortions require the viewer to focus on one pictorial grouping at a time as meditations on topics such as the grandeur of landscape or the tranquillity of a rural retreat, while, taken as a whole, they become a series of well-known motifs arranged in a dynamic pattern which surprises and engages the interest.

THE ZENGA TRADITION

Although every Japanese was required to register with a particular temple, Buddhism per se played a much less important

377 *Landscapes*, left screen of a pair of six-panel *byōbu*, by Sōga Shōhaku. *c.* 1770. Ink on paper; each screen: 62 ⅞ × 138 in. (159.5 × 348.6 cm). Museum of Fine Arts, Boston. Fenollosa-Weld Collection. (11.4508).

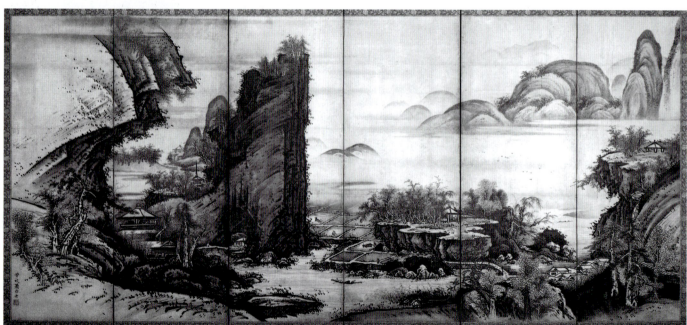

378 The character for *mu*, by Hakuin Ekaku. Mid-18th century. Ink on paper; 17 ⅛ x 16 ⅝ in. (43.6 x 42.2 cm). Private collection. Shown with a printed equivalent.

role in the life of the individual during the Edo period. The elite of the samurai class became much more interested in Confucian scholars and scholarship, and decorated their grand residences with Confucian themes and colorful genre paintings, thus displacing the Buddhist monk's role as both adviser and artist. However, as demonstrated by the example of Jakuchū, among others, the Buddhist clergy did still play an active role in the literary and artistic circles of the period, few of which did not have at least one ordained member. As such, the engagement with society of these individual monks and nuns, not infrequently from the Zen tradition, became almost entirely secular in nature, their Buddhist faith manifesting itself more as a philosophical expression. This shift had already begun in the fourteenth and fifteenth centuries, but by the eighteenth century the transformation was complete. However, paintings by Zen masters and monks as a form of meditation or as a visual aid—or *zenga*—did experience in the Edo period a florescence. Taking as their subject matter the *kōan* or mantra syllables, *zenga* create from them a visual form evoking a particular philosophic concept. These simple, often monochrome, ink paintings were frequently the gifts of the monk–painters and were meant be hung in the *tokonoma* of a residence or a room for the tea ceremony.

Zenga reached a particularly high level of achievement in the work of the priest Hakuin Ekaku (1685–1768), arguably the most influential Zen master of the Edo period. Hakuin was a committed and innovative teacher of Zen precepts with students ranging from daimyo to peasants and *chōnin*, and he was also a painter and calligrapher who, with virtually no formal training, succeeded in producing strong and compelling works. Painting was an activity to which Hakuin assigned a rather low priority in his scheme of life. At fifteen he left his parents' home to become a monk, and for the next seventeen years he endured great physical and psychological hardships until he achieved a state of religious awakening. At the age of thirty-two, Hakuin returned to the village of his birth, Hara in Shizuoka, and devoted himself to the rebuilding of its temple, Shōinji. There he attracted many students.

His primary method of teaching was through the use of the *kōan*, one of his favorites being simply the character "*mu*," a **kanji** character meaning "nothingness." This *kōan* had first been used by the Chinese master Jōshū (CH. Zhaozhou Congshen; *c*. 778–897), who was asked if a dog had Buddha nature, to which he replied "*mu*," meaning not "no," but "nothingness" Ideally the practitioner focuses on the character "*mu*" as "nothingness." avoiding the trap of deciding whether or not a dog has Buddha nature. With continued concentration, one's whole body becomes consumed with doubt on the nature of things, until "nothingness" breaks open, misunderstanding falls away, and the reality of life and death is apparent. Two images Hakuin uses to describe this experience are "a sheet of ice breaking, a jade tower falling." Among Hakuin's surviving works is the single character for "*mu*" (Fig. 378). When carefully executed, the standard configuration of strokes for this *kanji* suggests a means of counting: four items are marked off, and then cancelled by three horizontal lines. In contrast, Hakuin's "*mu*" is a jumble of strokes expressing vitality rather than negation, energy rather than meticulous accounting.

A *kōan* of Hakuin's own devising is "Sekishu no Onjō" (The Sound of One Hand Clapping). In a letter to the lord of Okayama Castle written in 1753, Hakuin explained his *kōan* as follows:

> What is the Sound of a Single Hand? When you clap together both hands a sharp sound is heard; when you raise the one hand there is neither sound nor smell.... If conceptions and discriminations are not mixed within it and it is quite apart from seeing, hearing, perceiving and knowing, and if while walking, standing, sitting and reclining, you proceed straightforwardly without interruption in the study of this *kōan*, then in the place where reason is exhausted and words are ended, you will suddenly pluck out the karmic root of birth and death and break down the cave of ignorance.

Phillip B. Yampolsky, *The Zen Master Hakuin: Selected Writings*, New York, 1971, 164.

An ink painting executed two years before Hakuin's death to illustrate this *kōan* employs the figure of the monk Hotei standing on a cloth bag (Fig. 379). Instead of holding both

hands together in his lap, Hotei has hidden one in the fold of his robe and holds the other up in front of him. In most of Hakuin's drawings of Hotei, his eyes are closed or focused downward and his mouth is relaxed or curved in a slight smile. In this painting, however, Hotei's eyes are focused clearly ahead, the lids curved as if laughing, and the mouth, too, has a distinct upward arc. The expression engages the viewer, and conveys the sense of joy that accompanies a moment of awakening. His inscription reads:

> Young people, no matter what you say, everything is nonsense unless you hear the sound of one hand.
>
> Sylvan Barnet and William Burto, *Zen Ink Paintings*, New York, 1982, 54.

Hakuin has established a contrast between the rounded forms of the body—the sloped head, the black robe pulled in soft curves around the lower part of the body, the hunch at the shoulders, and finally the ball-like shape of the bag supporting the figure—and the straight vertical thrust of the hand. With the simplest of means Hakuin has created a dramatic visual rendering of his favorite *kōan* and also offered a wry image on the odd figure he himself must cut as a Zen teacher.

BUNJINGA

Since the monk–painters of the fourteenth century, the ink paintings of China's literati had been an important influence on Japanese painting, particularly of landscapes—one of its primary subjects. The earliest term for this kind of Chinese painting was *bunjinga*, a translation of the Chinese term *wenren hua*, or painting by the literati. From the late seventeenth century, it was also known as *nanga* (southern pictures), a term lifted from the writings of Dong Qichang (1555–1636), one of China's greatest practitioners of literati painting as well as one of its greatest critics. Using the traditional divisions of the Chinese Chan schools—between a northern branch that favored rigid adherence to ritual practice and a southern branch that favored intuitive understanding—Dong established a similar division in painting, placing the works of professional and imperial court painters in a northern school, and the amateur calligraphic and painterly expressions of scholars and officials within a southern school. According to Dong, the works of the northern school while perhaps skillful and refined were also bankrupt of any true spirit or meaning. The latter, however, was the sole aim of the amateur artist of the southern school.

As has been discussed in previous chapters, many of the monk–painters of the medieval period and officials of the imperial court could be seen as early Japanese *bunjinga* artists. However, it was not until the seventeenth century that a

379 *One Hand Clapping*, by Hakuin Ekaku. 1766. Ink on paper; 33 ⅞ x 10 ⅜ in. (86 x 26.4 cm). Private collection.

380 Woodblock print from the Chinese *Mustard Seed Garden Manual of Painting*. 17th century.

native school arose that consciously referred to itself as *bunjinga*. One of its first proponents was the philosopher Ogyū Sorai (1666–1728), who emphasized calligraphy and painting as the accomplishments of the truly literate person. In China *bunjinga* was often seen as the preserve of the educated officials or landed gentry, but in Edo-period Japan its themes were taken up by the gamut of intellectuals and artists to be found in society—samurai, *rōnin*, haiku poet–painters, and even professional *chōnin* painters. One reason for this more inclusive attitude in Japanese *bunjinga* was the existence of Chinese merchants in Nagasaki who dabbled in calligraphy and landscape painting for pleasure. These representatives of Chinese *bunjinga* on Japanese soil as well as Chinese professional painters who sojourned briefly in the port city would, from a Chinese literati perspective, be of risible pedigree and accomplishment, but for the isolated Japanese, the Nagasaki artists brought them into direct contact with *bunjinga* as well as other contemporary styles of Chinese art.

The third and undoubtedly the most widely available source for Japanese knowledge of *bunjinga* painting was a group of block-printed manuals illustrating models for depicting plants, trees, rocks, mountains, and human figures in the styles of various Chinese masters. Of these the most influential were the *Baozong huapu* (JAP. *Hasshū gafu*; *The Eight Albums of Painting*), first published in China in the 1620s, and the *Jieziyuan huazhuan* (JAP. *Kaishien gaden*; *Mustard-Seed Garden Manual of Painting*), printed in two installments: the first, a set of five volumes on landscape, in 1679; the second, two albums dealing with bamboo, plum blossoms, and bird-and-flower motifs, in 1701. The demand for both of these works in Japan was so great that new editions were printed in Japan, *The Eight Albums of Painting* in 1672 and the *Mustard-Seed Garden Manual of Painting* in 1748. Many Japanese *bunjinga* artists are known to have had copies of one or both works and to have

used them as guides to the basic theory and techniques of literati painting. In addition, through the research of art historians James Cahill and Tsuruta Takeyoshi, it is evident that there were more original Chinese literati paintings in Japan in the eighteenth century than had previously been supposed. These sources of *bunjinga*, however, presented inherent problems for students of the literati style. None of the Chinese artists at Nagasaki were first-rate painters and the manuals on painting were illustrated with woodblock prints, which reduced the rich contrast of brushstrokes and ink tones in the original paintings to single lines and flat colors (Fig. 380). So pervasive was the influence of these block-printed manuals that it was not for many decades that the majority of Japanese artists learned to work in the true Chinese manner of building up brushstrokes to achieve surface texture.

Nankai, Kien, and Hyakusen

The first *bunjinga* artists are two samurai, Gion Nankai (1697–1751) and Yanagisawa Kien (1704–58), and a *chōnin*, Sakaki Hyakusen (1697–1758). Nankai was the eldest son of a doctor attached to a *han* in Wakayama prefecture. Born and raised in Edo, he received an excellent Confucian education in the *bakufu* academy, and in 1697, after his father's death, he moved to Wakayama as an official Confucian teacher. Three years later he was stripped of his stipend and exiled from the *han* for an offense never recorded. For the next ten years he supported himself by teaching calligraphy. In 1710 he was pardoned, probably so that he might serve as translator when an embassy from Korea visited Japan, and later became retainer to a daimyo, put in charge of educational administration in the latter's domain. After his pardon, he began to paint, drawing randomly upon many sources, the printed manuals in particular. One of his most accomplished works, *Plum Blossoms*, executed in the 1740s, reflects not only his knowledge of Chinese techniques, but also his familiarity with literati themes (Fig. 381). The plum is one of the Four Gentlemen, the four noble plants, along with the bamboo, the orchid, and the chrysanthemum. They were used as models for calligraphy practice and served as a transition for the literati from the written word to pictorial imagery. Because each plant is so different in shape and character, it is a significant test of one's ability with a brush to be able to render them with proper balance and clarity, let alone with artistic individuality. In Nankai's monochrome ink painting of the plum, his artistic accomplishment is demonstrated by the strong contrast between the vigorous brushstrokes of the branches executed in the "flying-white" (JAP. *hihaku*) technique, in which the brush tip is split as the stroke is made producing a ragged swathe of black ink with patches where the white of the paper shows through, and the small, delicately rendered petals of the plum blossoms.

The lives of Nankai and his contemporary Yanagisawa Kien are similar in many ways. Born in Edo to the chief retainer of the Yanagisawa family, Kien was well educated and received numerous favors from his daimyo, including the right

381 *Plum Blossoms*, by Gion Nankai. 1740s. Hanging scroll, ink on paper; 37 ¾ x 20 ⅝ in. (96 x 52.5 cm). Private collection, Wakayama prefecture.

to adopt the Yanagisawa name. However, in 1728, at the age of twenty-four, he was punished for misconduct and stripped of his inherited position. Two years later he was pardoned and his suspended stipend restored. That both Nankai and Kien were severely punished for unknown youthful misconduct may indicate that their interest in arts and letters, though sanctioned by one faction of influential Confucian scholars, was not viewed in so favorable a light by their lords. The fact that a landscape painting made by Kien in his late teens or early twenties has an inscription by the scholar and adviser to the *bakufu* Arai Hakuseki (1657–1725) suggests he had the support of a very powerful national figure. Nevertheless his fate was in the hands of his *han* lord, and he was probably penalized for his deviations from the standard expected of the soldier–official at this early period. As a painter Kien was something of a dilettante. His works range from literal depictions of flowers in the small squarish format of sheets of paper, which can be collected into a portfolio or album, to more relaxed vertical landscapes, and finally to those extremely expressive paintings of bamboo executed with his fingers. An example of his bamboo painting is a work executed in green pigment on paper dyed indigo blue (Fig. 382). A stalk of bamboo bends across the upper third of the surface, its curve

382 *Bamboo*, by Yanagisawa Kien. Mid-18th century. Hanging scroll, pale green on indigo blue paper; 37 ½ x 10 ⅛ in. (94.5 x 25.6 cm). Private collection.

383 *First and Second Visits to the Red Cliffs*, a pair of six-panel *byōbu*, by Sakaki Hyakusen. 1746. Ink on paper; each screen 63 ⅝ x 144 ⅞ in. (161.5 x 368 cm).
Hayashibara Museum, Okayama prefecture.

echoed by the down-pointing leaves. Escaping from the leaf cluster, a single thin stem arcs downward, its leaves forming a subtle accent in the lower-right area of the picture. Kien's signature in gold and his seals in red—prominent to the left of the thin stem—stabilize the composition.

At the opposite end of the social spectrum was Sakaki Hyakusen, son of a family who ran a pharmacy in Nagoya. In all probability, Hyakusen's ancestors were Chinese who had emigrated to Japan only a few generations before his birth. Furthermore, they undoubtedly remained in contact with the mainland through the importation of Chinese herbs and

medicines, and possibly of books and paintings as well. At any rate, the sources of Hyakusen's knowledge of Chinese painting were clearly different from those of Nankai and Kien. Hyakusen was also an accomplished writer of haiku and was active during his twenties in poetry circles in Ise. In his thirties, he moved to Kyoto and concentrated on developing his craft as an artist, gradually becoming self-supporting as a professional painter.

A pair of folding screens dated 1746 illustrate the scope and quality of Hyakusen's work as he reached maturity as a painter (Fig. 383). They deal with a popular theme in literati

384 *First Visit to the Red Cliffs*, one of a pair of six-panel *byōbu*, by Ike Taiga. 1749. Color on paper; 58 ⅜ x 138 in. (148.2 x 350.6 cm). Private collection, Tokyo.

art, the poet–scholar Su Dongpo's (1036–1101) recollection of two excursions made in 1082 to a range of cliffs, the Red Cliffs, along the Yangzi River. It is early autumn when Su and a companion make their first trip. The weather is pleasant as they float along the river and there is plenty of food and wine. Su feels as if they have departed the mortal realm and entered that of the immortals. His friend, lamenting the brevity of man's life, wishes that they could indeed join the immortals, but Su in buoyant mood remonstrates that there is nothing to envy. However, visiting the same site some weeks later in the late fall, frost has set in and the trees have been stripped of their leaves. The boating party is ill supplied with food and wine and the appearance of the river and the cliffs is strangely changed. Su disembarks and whooping like a crane—a Daoist symbol for an immortal—begins to climb the cliff, leaving his friends behind. Suddenly feeling the loneliness of the windswept slope, he is overcome with sadness and knows that the magic of the place has passed and that he must leave. He is no longer sure that he doesn't envy the immortals. As he and his friends row away, a crane flies overhead and later, in a dream, he is visited by the immortal in human form who asks the poet if he enjoyed his excursion. On waking, Su understands the encounter that might have been if he had continued up the cliff.

Hyakusen has beautifully captured the Chinese scholar's sentiments. In the right-hand screen, depicting the first trip, the mountains to the right are steep and craggy, but not forbidding. Su and his friend, seated in their boat, gently ride the moonlit summer ripples. The rocks in the first two panels establish a tempo of highlights and deep shadows that is measured and deliberate. In the middle panels the rhythm is slowed, the ink lines lightened, and in the left two panels the theme is concluded with a passage of low rolling hills. In the left-hand screen, depicting the second trip, the crane is shown flying away as Su gazes after him, the Red Cliffs now impossibly steep and convoluted. In the staccato treatment of the dark, heavy forms to the left, we can almost sense the trembling of the trees and the ringing of the mountains that caused Su to retreat to the mortal world. James Cahill has pointed out in a study of Hyakusen how close his work is in style and theme to the paintings of artists of sixteenth-century Suzhou, the golden age of Chinese literati painting. Compared with Nankai and Kien, Hyakusen is clearly not only the better artist, but also more intimately familiar with Chinese literati stylistic tradition.

Taiga and Buson

The first truly great artists to master the literati style were Ike Taiga (1723–70) and Yosa Buson (1716–83). Like Hyakusen, they were professional painters who accepted commissions and sold their work for a living. Taiga's family belonged originally to the peasant class, but his father worked for a number of years in the mint in Kyoto. Although he died when Taiga was only four, his wife and child seem to have had financial backing of some kind. At the age of six, the boy began his study of the Chinese classics. A year later he took up calligraphy, at which he was remarkably proficient, and he is today considered one of the outstanding calligraphers of the Edo period. In his early teens he and his mother maintained a commercial painting shop, for which he produced fans decorated with pictorial quotations from *The Eight Albums of Painting*. In 1738, Taiga became the pupil of Yanagisawa Kien, with whom he studied for several years. However, until around 1749 it cannot be said Taiga's eye was fixed exclusively on the modern *bunjinga* style based on sixteenth- and seventeenth-

385 *True View of Mount Asama*, Ike Taiga. c. 1760. Ink and color on paper; 22 ½ x 40 ⅜ in. (57 x 102.7 cm). Private collection.

century Chinese models. Rinpa influences can be seen in his early work, as well as the paintings of the Muromachi period. In his six-panel screen of 1749, *First Visit to the Red Cliffs* (Fig. 384), the composition and brushwork are reminiscent of fifteenth-century landscapes, specifically the works of Kichizan Minchō (1352–1431) and Tenshō Shūbun (d. c. 1460).

A third influence on Taiga's painting was European art. In 1748, the artist spent several weeks in Edo, where he made a name for himself by executing finger paintings, and where he also had the opportunity to study examples of Western art. Precisely what he saw is not known but, judging from the style of his painting *Asamagadake shinkeizu (True View of Mount Asama)*, it is most likely that he saw copperplate etchings (Fig. 385). Using Western techniques of layered perspective, the hanging scroll depicts in fine, etching-like lines and in light washes what purports to be the actual appearance of Mount Asama in Shigano prefecture. However, as Melinda Takeuchi has demonstrated, this painting is more than just a reflection of Western models.

It is the first painting identified as a *shinkeizu*—a genre of landscape painting combining the idea of factual representation, the stylistic tradition of landscape depiction on which the artist is drawing, and finally the literati concept of a painting reflecting the "spirit resonance" of the artist. As Takeuchi points out, *True View of Mount Asama* combines in a believable composition two different views of a mountain landscape. At the horizon line in the upper-right section of the painting there is a reworking of a sketch by Taiga of Mount Fuji, while the lower-right passage has been taken from a separate drawing of Mount Asama. That this work has been accepted for so long as a literal representation of a particular landscape is a testament to Taiga's artistic gifts. The poem inscribed in the upper part of the picture was composed and written by Taiga after climbing Mount Asama in 1760, and the dedication of the second part of it has been taken as evidence that for Taiga the landscape is an expression of his character, and therefore worthy of being shown to a great literatus.

Clouds billow in the four directions;
The mist breaks—ten thousand and eight peaks [appear].
Heian Mumei [the painting name Taiga adopted in 1750]
dedicates/shows this to the esteemed and venerable Master Gion [either Gion Nankai or his son].

Based on Melinda Takeuchi "'True' Views: Taiga's *shinkeizu* and the Evolution of Literati Painting Theory in Japan," in *Journal of Asian Studies*, Feb. 1989, 16–20.

By the time Taiga turned forty, he had synthesized a number of artistic influences into a style uniquely and distinctly his own, and in his later years his mature works display a fluid use of

386 *Nachi Waterfall*, by Ike Taiga. 1770s. Hanging scroll, color on paper; 49 ¼ x 22 ⅜ in. (125.7 x 56.9 cm). Tokyo National Museum.

trees in the foreground and midground carry the eye back to a large triangular mountain with a void of white paper, the waterfall, in the center. To the left of the mountain, just beyond the dark ink strokes that mark its lumpy outline, is a glimpse of water and hills in the distance. The loose, rhythmic brushwork and abundant washes give the painting a wet, atmospheric quality that captures the essence, if not the precise visual reality, of the scene.

One of Taiga's greatest colleagues and some-time collaborator in calligraphy and painting was his wife Ike Gyokuran (1727–84). The two were noted by their Kyoto peers for a shambolic, but happy conjugal life, in which they shared equally in cultural pursuits and intellectual enquiry. Gyokuran's mother and grandmother had both been famous poets, and she herself was famous as a poet and calligrapher. However, she, like her husband, is reputed to have been a student of Yanagisawa Kien, and her paintings, although not as prolific as Taiga's, are an important part of her oeuvre. A very beautiful landscape in the Shizuoka Prefectural Museum demonstrates that, although closely in tune with Taiga, her conceptual vision and style were very much her own (Fig. 387). In the painting, the mountain scenery piles up in time-honored fashion, but closer examination reveals an exquisite sense of placement that leads the eye across and into the painting's composition. Gyokuran was not the only woman painter and calligrapher of note in the eighteenth century, but she is the first known female *bunjinga* artist in what would long remain a very masculine preserve.

The second of the great *bunjinga* masters, Yosa Buson, came to painting through poetry, specifically haiku, and may have pursued his painting career as a means of earning a living in order that he might write poetry without having to be concerned with its popularity. Haiku emerged as the most popular poetic form in the sixteenth century, evolving out of the first three verses that make up the standard *waka*. According to Stephen Addiss's study of the subject, almost as soon as haiku shaped itself into a distinct poetic genre, **haiga** began to appear. *Haiga* is a painted image accompanying a haiku, and is meant to be a spontaneously created response by the poet to his or her committing of the verse to paper. As this poetic form is also meant to be a spontaneous response from direct observation, the *haiga* in the hands of a master can transcend the merely trite or playful and grasp the sublime. *Haiga* painters are almost as legion as haiku composers, but noted masters are Matsumura Goshun and Matsuo Bashō (1644–94)—considered the greatest haiku master of all.

A *haiga* by one of Bashō's disciples, Enomoto Kikaku (1661–1707), gives some idea of the genre at its best (Fig. 388). The haiku reads:

Melon skin—
spider legs floating
on the water

Stephen Addiss, trans., from *Haiga: Takebe Sōchō and the Haiku-Painting Tradition*, University of Hawaii Press, Honolulu, 1995. p. 32.

the brush. *Nachi Waterfall*, made in the 1770s when he was around fifty, is not a minutely detailed record of observed phenomena, but rather a recreation of the impressions made on him by aspects of the natural setting (Fig. 386). Rocks and

387 *Landscape*, by Ike Gyokuran. Hand scroll, ink and colors on paper; 22 ⅖ x 49 ⅕ in. (58 x 125 cm). Shizuoka Prefectural Museum.

The discarded melon skin observed by Kikaku floating down a stream has been immortalized by the poem and image as a slightly melancholy, but comical image.

Yosa Buson proved to be another great master of the *haiga*. When he arrived in Edo around 1735, he studied haiku with another of Bashō's followers, Hayano Hajin. After Hajin's death in 1742, Buson left the city and spent the next nine years wandering from one province to another. He obviously preferred this life to remaining in Edo and continuing to devote himself to writing haiku in the company of fellow poets whose superficiality and poor craftsmanship he scorned. Buson is today considered to be second only to Bashō in his verse, having a strong visual quality, and witty and sharp contrasts of theme. The following conveys something of his style.

What piercing cold I feel:
My dead wife's comb in our bedroom
Under my heel.
Harold G. Henderson, *An Introduction to Haiku*, New York, 1958, p. 114.

In 1751, Buson established himself in Kyoto, and it is thought that he was in contact with Sakaki Hyakusen, who was also a haiku poet. However, Buson was largely self-taught as a painter, basing his work on Chinese painting manuals and on observation of the Chinese and Japanese paintings available to him, and he did not reach full maturity as an artist until late in life. The paintings produced between 1778, when he began to sign himself Sha'in, and his death in 1783 are outstanding in quality. They blend three stylistic elements with the assurance of a master: the themes and lively brushwork of Chinese

painting, the free and lyrical recording of the natural world as he saw it, and, finally, the spontaneity and humor often found in his poetry. In his great reverence for Bashō, Buson produced several illustrations based on the great man's poetic diaries. The most famous of these *haiga* are in his hand scroll of Bashō's *Oku no hosomichi* (*The Narrow Road to the Deep North*), one scene from which depicts Bashō and his companion Sora starting out on their journey (Fig. 389). Sketchily, but sensitively depicted in ink lines and color washes, the two travelers move away while to the right three friends stand deferentially and sadly bid them farewell. This treatment sets the melancholy, somewhat sentimental tone of the text:

388 *Melon Skin*, by Enomoto Kikaku. Ink on paper; 12 ⅛ x 17 ½ in. (31 x 44.4 cm). Private Collection, USA.

389 Section of *Oku no hosomichi*, by Yosa Buson. 1778. Hand scroll, ink and color on paper; height 11 ½ in. (29.2 cm). Kyoto National Museum.

The months and days are the travellers of eternity. The years that come and go are also voyagers. Those who float away their lives on boats or who grow old leading horses are forever journeying, and their homes are wherever their travels take them.... Everything about me was bewitched by the travel gods and my thoughts were no longer mine to control. The spirits of the road beckoned and I could do no work at all.... My dearest friends had all come to Sampu's house the night before so that they might accompany me on the boat part of the way. When we disembarked at a place called Senju, the thought of parting to go on so long a journey filled me

with sadness. As I stood on the road that was perhaps to separate us forever in this dream-like existence, I wept tears of farewell.... I could barely go ahead, for when I looked back I saw my friends standing in a row, to watch me perhaps till I should be lost to sight.

Donald Keene, ed., *Anthology of Japanese Literature*, New York, 1955, 363–4.

Buson's most personal style can be seen in the short hand scroll *Bare Peaks of Mount Gabi* (Fig. 390). Although the theme of the painting is taken from a poem by the Chinese poet Li Bai (701–62) describing the moonlit appearance of craggy Mount Omei (JAP. Gabi) in Sichuan province, the style of the painting owes little or nothing to Chinese precedents. Beginning with the boldly written title, followed by Buson's signature and seals, the painting unrolls to the left, revealing the peaks of

<div style="text-align:right">

用
るのたてぶよしもとひとところふて
船とよしそれぬ途三重此あらび粉る
十さろて幻のちゃうし離おの涙れる
りまやちる常魚の白い河

</div>

mountain after mountain—the form of each delineated in dark gray ink, filled in with thin red ocher, and each completely different in shape from its predecessor—until across a narrow void the climax of Mount Gabi is reached, a sharply triangular mountain thrusting upward into the gray ink wash of sky. At the very end a sliver of a moon is made by leaving one area of the paper untouched by ink or color. The most remarkable aspect of this painting is the element of surprise. The moon, so important in Li Bai's poem that he included it in the title, appears in Buson's work as a surprising new motif at the end. So that nothing would detract from the impact of the moon as the final element of the scroll, Buson did not include it in his title, and he shifted his signature and seals from the conventional placement at the inner edge of the end of the scroll to the beginning, just to the left of the four-character title. Here, Buson plays upon his audience's knowledge of

hand-scroll conventions to jolt them into a new perception of the natural world.

Beisanjin and Gyokudō

The momentum of the literati style of painting continued into the nineteenth century, and the artists who espoused it created lifestyles for themselves that were much closer than those of their Japanese predecessors to the ideal of Chinese literati. Highly educated men of the samurai class, this generation of *bunjinga* artists kept in close contact with each other, exchanging ideas and often getting together for informal evenings of painting and writing poetry. Two of the greatest masters of

390　*Bare Peaks of Mount Gabi*, by Yosa Buson. *c.* 1778–83. Hand scroll, ink and color on paper; height 11 ⅜ in. (28.8 cm). Private collection.

391 *The Residence*, by Okada Beisanjin. 1793. Hand scroll, ink on paper; Location unknown. Courtesy Betty Iverson Monroe.

this circle are Okada Beisanjin (1744–1820) and Uragami Gyokudō (1745–1820).

Beisanjin may have been orphaned while still a young boy, but by 1775 he was living in Osaka, running a small rice and grain brokerage, a business to which all samurai had to turn in order to transform their wages into hard currency. His art name, Beisanjin, literally "Man of a Mountain of Rice," reflected his profession. Soon after he established himself in Osaka, he was hired by Lord Tōdō, first as a warehouse guard, a position that carried privileges of samurai rank, and later became his personal secretary. As a result of his close association with the Tōdō family, he was given a large house on their estate overlooking the Yodo River, which in time became a gathering place for literati poets and artists of the Kansai area. A painting by Beisanjin commemorates one such gathering, *The Residence*, executed in 1793 following a visit by Tanomura Chikuden (1777–1835), a young scholar–artist (Fig. 391). Chikuden was a samurai from Kyūshū who, longing for the life of a literatus free of the constraints of feudal obligation, visited the master as often as he could. On this particular visit, Beisanjin had assembled a few friends for a night of intellectual pleasures: the viewing and discussion of paintings, the writing of poems, perhaps even the execution of a few paintings, and certainly the drinking of saké. When the hour grew late, Beisanjin's guests took their leave. In the painting, which depicts their departure, we see Beisanjin in the lead, pointing the way through the rice fields, followed by an elderly bearded gentleman, Gyokudō, and a group of younger men including Chikuden and the noted literati poet, Rai Sanyō. To the right can be seen Beisanjin's house, the room reserved for guests open to view, and in the garden are a woman and a boy, probably Beisanjin's wife and son. The technique contrasts bold strokes in dark ink with delicate lines in pale tones, suggesting the quality of vision on a moonlit night. A gentle, quickly executed painting, *The Residence* was intended to capture the mood at the end of a convivial evening and to commemorate an ideal, but all too rare, occasion in these men's lives.

A painting more representative of Beisanjin's mature style is *The Voice of a Spring Resounding in the Valley*, a hanging

scroll dated to 1814 (Fig. 392). The height of the vertical composition is emphasized by the overlapping of rectangular rocks and triangular mountain forms carrying the viewer's eye from the foreground to the deep space of the background. The most unusual feature of the painting is the idiosyncratic treatment Beisanjin gives to the rocks at the base of the composition and the tops of the smooth, triangular mountains. The similarity of the strange, angular shapes at the top—the motifs that appear to be most distant—and those at the bottom, in the foreground, seems to pull the peaks forward, working against the sense of recession in the layered forms. In Beisanjin's later years this was one of his favorite devices—the use of strong brushstrokes to create unnatural forms that establish a tension between the perspective within the landscape and the surface texture of the rendering. Beisanjin was largely self-taught as an artist, working from Chinese painting manuals and what imported paintings came into his hands. Nevertheless he was able to create a strong, personal style in the best literati tradition, and to establish a pattern of life in harmony with the values of the literati.

Uragami Gyokudō, Beisanjin's friend and contemporary, also chose the scholar's life, but his was not an easy existence. Born into the family of an official serving the Ikeda clan, Gyokudō received the standard Confucian education at the *han* school. When he was in service in Edo, however, he studied other unorthodox versions of Confucian doctrine and also the *koto*, or Chinese zither, taking the name of Gyokudō when a particularly fine old *koto* called Gyokudō Seiin came into his possession. In 1794, when Gyokudō was at a resort with his two sons, he wrote a letter to his lord resigning his post. After his resignation he wandered about Japan, wearing eccentric clothing not unlike the feathered cloak of a Daoist recluse, his *koto* slung on his back, and made a living by giving music lessons and perhaps by teaching what he knew about medicine. There was about Gyokudō not only an element of the mystic, but also an informed and rational intelligence. He was one of the first in Japan to recommend the drinking of milk as a healthful food and he advocated the touching of cows by children to develop an immunity to smallpox.

392 *The Voice of a Spring Resounding in the Valley*, by Ōkada Beisanjin. 1814.
Hanging scroll, ink on paper; 53 x 17 in. (134.7 x 43.1 cm).
Collection Yabumoto, Osaka. Courtesy Betty Iverson Monroe.

393 *Building a House in the Mountains*, by Uragami Gyokudō. 1792.
Hanging scroll, ink and slight color on silk; 26 x 12 ¾ in. (66 x 32.5 cm).
Private Collection, Tokyo.

Following the Chinese literati ideal, Gyokudō preferred not to paint on commission, but rather as a means of expressing his feelings. Nothing is known of the sources of his art, but he did not turn to painting in earnest until after the age of sixty, when he developed his own style of landscape painting imbued with a melancholy intensity. Since he was acquainted with the younger *bunjinga* artists in Edo, it is likely that he studied painting there, but the name of his teacher has not been preserved. Yet Gyokudō was one of the first of the major literati painters to utilize the Chinese technique of laying brushstroke upon brushstroke to achieve a dense, rich surface texture. One of his early paintings, *Building a House in the Mountains*, of 1792, has more of an affinity to the works of Taiga than to his own later productions, but the painting's character derives from the extensive use of colored washes, and the repetition of brushstrokes to suggest foliage (Fig. 393).

394 *Eastern Clouds, Sifted Snow*, by Uragami Gyokudō. *c.* 1811. Hanging scroll, ink and color on paper; 52 ½ x 26 in. (133.5 x 66 cm). Private collection.

Only in the foreground rocks, and occasionally in the background mountains, is there an attempt to build up strokes and to exceed the basic outlines of the rock forms.

The full force of Gyokudō's mature style can be seen in *Eastern Clouds, Sifted Snow* of c. 1811. A hanging scroll executed in ink and occasional touches of ocher on paper, it was painted, according to the inscription which also gives the painting its title, after Gyokudō had been drinking saké (Fig. 394). Yet the painting displays a remarkable control of both composition and technique. The motifs employed are familiar to *bunjinga*: the scholar in his thatch-roofed cottage reading, a tiny figure crossing a bridge, a village, and a temple pagoda; but they have been modified by the dense atmosphere of the painting to the point where they are not immediately recognizable. The technique used to achieve this rich density consists of an underlying sketch in light ink, over which increasingly darker shades of ink are applied, until the final accents are added in almost pure-black ink. This, plus the modified shapes of buildings and bridge, and the incongruous size of some forms, suggest the poor visibility one experiences when looking through falling snow. The final impression is of a cold and hostile world, in which only the scholar, isolated in his study and unaware of the realities of life, can survive.

Chikuden, Chikutō, and Baiitsu

Beisanjin and Gyokudō were the elder figures to a group of younger men, including Tanomura Chikuden and Rai Sanyō, as well as the Nagoya painters Nakabayashi Chikutō (1778–1853) and Yamamoto Baiitsu (1783–1850). As more Chinese works were being imported into Japan and the full weight of the Chinese tradition was impressed upon them, these younger *bunjinga* Japanese artists can often seem somewhat timid in their efforts, rather than vibrant new practitioners of the style.

The artist in the forefront of this fourth generation of *bunjinga* painters was Tanomura Chikuden. Born into a family of physicians serving the Oka clan in Kyūshū, he was ordered by his lord to become a scholar and teach at the *han* school. Occasionally he would travel to Edo as part of his official duties, and there he met Tani Bunchō, a literati painter and friend of Gyokudō. In 1811 and again in 1813, serious peasant revolts broke out in the *han*, and on both occasions Chikuden presented formal proposals for remedying the plight of the peasants. His proposals were not accepted, and in frustration Chikuden finally resigned his post, retiring to Kyoto, where he could continue his literati associations. One of Chikuden's gentlest and most romantic paintings is *Boating on the Inagawa* of 1829 (Fig. 395). The occasion for the painting was a day spent fishing with his companion Rai Sanyō, and the two fishermen can be seen in boats at the bottom of the painting, their lines dangling idly in the water, their heads turned toward each other as though deeply absorbed in conversation. Above and to the right appears the house of the wealthy merchant family with whom they are staying, and further bucolic imagery. The pale colors, gray, blue–green,

and pale pink, applied in wet overlapping dotting strokes, heighten the gentle mood of the painting.

Yamamoto Baiitsu is considered one of the most accomplished of this generation of *bunjinga* artists. Born in Nagoya, he first studied a variety of styles, from the hyper-realism of Chinese bird-and-flower painting to the conservative, but decorative traditions of the Kanō school. By the age of eleven, Baiitsu had received his first commission—a set of *fusuma* in a Buddhist temple—and in his teens he came under the protection of a wealthy businessman and collector of Chinese painting, Kamiya Tenyū. While under Tenyū's patronage, he formed a deep friendship with the young artist Nakabayashi Chikutō (1778–1853), and together they studied the Yuan and Ming dynasty paintings in Tenyū's collection as well as instructional texts such as the *Mustard-Seed Garden Manual of Painting*. It was Tenyū who gave both men their studio names, Baiitsu (Plum Leisure) and Chikutō (Bamboo Grotto). In 1802, Tenyū died and soon after the two friends left for Kyoto, where they joined the literati circle headed by Rai Sanyō. Baiitsu lived and worked steadily in Kyoto for the next thirteen years. He traveled to Edo, but was soon recalled to Kyoto, where he met and worked with Tani Bunchō on a new imperial reception room. Later he returned to Edo with Bunchō. Together they founded the painting society called The Tower of Eight Hundred Perfections.

Baiitsu traveled extensively in the middle regions of Honshū and gained more of a reputation for his decorative bird-and-flower paintings than for his quiet *bunjinga* landscapes. His production of bird-and-flower paintings was prolific, to say the least, but they are delicately colored and superbly executed in what soon was recognized as Baiitsu's own inimitable style. Unfortunately, his contemporaries grew jealous of his success and devised a scheme to humiliate him. A story was circulated that a certain geisha wore one of his paintings as an undergarment, suggesting that it was no better than a textile design. Their plan succeeded, and his reputation was tarnished. Two years before his death he returned to Nagoya, where he was subsequently raised to membership of the samurai class by the daimyo of Owari. A man of extraordinary accomplishment, Baiitsu was a master of the tea ceremony, a noted poet, and a skilled *biwa* player. An excellent example of his mature bird-and-flower style is *Egret Under Flowering Mallows* of 1833 (Fig. 396). The body of the egret is executed in a spontaneous manner, with the feathers built up in a series of evocative curves that contrast sharply with the straight forms of its thin dark legs and elongated beak. The leaves of the mallows and the lily pads are painted in a *tarashikomi* technique similar to that pioneered by Sōtatsu. Finally, the pink of the flowering mallow completes a highly decorative and satisfying composition.

395 *Boating on the Inagawa*, by Tanomura Chikuden. 1829. Hanging scroll, ink and light color on paper; 52 × 18 ⅜ in. (133 × 46.5 cm). Private collection.

396 *Egret Under Flowering Mallows*, by Yamamoto Baiitsu. 1833. Hanging scroll, ink and color on silk; 45 ⅜ x 16 ⅛ in. (115 x 41 cm). Private collection.

397 *Mountain Landscape*, by Tani Bunchō. 1794. Hanging scroll, ink and color on paper; 53 ⅛ x 21 ⅛ in. (134.9 x 53.8 cm). The Portland Art Museum, Portland, Oregon. Margery Hoffman Smith Fund and Helen Thurston Ayer Fund. (84.11).

Bunchō and Kazan

For much of the Edo period, Kyoto and Osaka were the undisputed centers for *bunjinga*; literati artists might travel to Edo, but they returned to the Kansai region to be in a community of peers. However, Edo painter Tani Bunchō (1763–1840) was an exception to this pattern. Bunchō was a samurai retainer of the Tayasu family, and due to his efforts an appreciation of the *bunjinga* style finally penetrated to the shogun's capital. Through his friendship with men like Gyokudō and Baiitsu, he gradually turned from the Kanō and Nagasaki styles he first employed to *bunjinga*. Throughout his life, though, he worked in whatever manner suited his subject matter and his mood. As a scholar, he devoted a great deal of his time to copying old paintings and writing about them, and he also practiced *shaseiga*, for which he became so well known that he received several commissions from Matsudaira Sadanobu (1758–1829), chief adviser to the shogun from 1787 to 1793, and also a patron of Maruyama Ōkyo. In 1793, Bunchō accompanied Sadanobu on an inspection tour of the defenses of Edo Bay, making sketches of various installations. He also did the illustrations for a catalog of antiquities compiled by Sadanobu. However, it is for his *bunjinga* that he is best known by posterity.

A particularly fine Bunchō landscape is a work of 1794 (Fig. 397). The grove of snow-covered trees and scholar's pavilion set against towering white mountains is a composition that recalls the work of Sesshū Tōyō (1420–1506) (see Fig. 260). Essentially the painting consists of two overlapping right-angled triangles, the foreground triangle slanting to the left, the background one to the right. Balance is achieved by a strong emphasis on the baselines of both shapes. A painting that shows the more eccentric side of Bunchō's character is the portrait he made of Kimura Kenkado (Fig. 398). Kenkado was a wealthy saké brewer in Osaka, whose fortune was confiscated because he brewed more saké than his government-assigned quota. Ultimately he was pardoned and allowed to open a stationery store in the city. Throughout his life he maintained close contacts with a number of literati artists including Gyokudō and Bunchō, and he recorded their visits in his diary. In 1892, when Bunchō in Edo learned of his friend's death two months earlier, he executed this portrait of Kenkado from memory. It is not a particularly flattering portrait, but it conveys a clear image of the man, a talkative fellow with sharply focused, shrewd eyes. As Bunchō was so prolific, the quality of his oeuvre is very uneven, ranging from the two masterpieces discussed above to some very minor pieces. Yet it is precisely his restless energy and his passionate interest in exploring all kinds of art that make him typical of the late Edo period. Throughout the art world there was a sense of the need for change—either through a return to the origins of a particular style or through the adoption of new techniques.

Watanabe Kazan (1793–1841), a sometime pupil of Bunchō's, exemplifies this spirit of searching and experimentation. Kazan was born into a samurai family serving the Tawara clan. He received a proper Confucian education but

had to give up his ambitions to become a Confucian scholar and his studies of painting and calligraphy due to a financial embarrassment in the family and the pressures of working for the Tawara estate. In order to find any time for his own pursuits, he would stay up half the night reading, practicing his calligraphy, and making copies of paintings. Around 1816 he entered the circle of artists working with Bunchō, and his work until the late 1820s bears the clear influence of Bunchō, although he also experimented with the Kanō style and with bird-and-flower painting. He also turned his attention to *rangaku* (Dutch studies) and began to execute portraits using Western techniques, but working with Japanese materials such as silk and Japanese pigments.

One of the best examples of his Western-style portraits is a painting of Ichikawa Bei'an (1779–1858), completed in 1837 (Fig. 399). Bei'an was a noted calligrapher and Confucian scholar of the day, and, although Kazan did not actually study with him, he regarded him as something of a

398 *Portrait of Kimura Kenkadō*, by Tani Bunchō. 1802. Hanging scroll, color on silk; 27 ⅛ x 16 ½ in. (69 x 42 cm). Osaka Municipal Art Museum, Osaka prefecture.

399 *Portrait of Ichikawa Bei'an*, by Watanabe Kazan. 1837. Hanging scroll, ink and color on silk; 51 x 23 ¼ in. (129.5 x 59 cm). Kyoto National Museum.

400 Sketch for the portrait of Ichikawa Bei'an, by Watanabe Kazan. 1837. Mounted as a hanging scroll, ink and slight color on paper; 15 ½ x 11 in. (39.4 x 27.9 cm). Private collection.

spiritual mentor. In addition to Kazan's formal painting, a preliminary sketch of Bei'an, executed in ink and colors on paper, has survived (Fig. 400). The two works provide a rare glimpse of the artist's technique. The sketch shows Bei'an in an informal pose. He wears the kind of garment one might wear around the house, and his face, although slightly turned to the right, still reveals a swelling just below his right ear. His unfocused eyes look directly forward, suggesting the thoughtful gaze of an intelligent, middle-aged man. The painting, by comparison, lacks the immediacy of the sketch. It was intended as a memorial portrait, and in the year after its completion, when Bei'an turned sixty, laudatory inscriptions were added to the upper portion of the painting. Still, Kazan has remained faithful to the spirit of the Western techniques he admired. The volumes of the face are suggested by highlights and shadows with a minimal use of line. Bei'an wears a formal court costume and cap, but even here Kazan used details like the white cord holding the cap in place to convey the particular shape of Bei'an's head.

Kazan's interests in Western studies were not confined to art alone. He also informed himself on geography, history, military science, and Western firearms. As a result he was put in charge of coastal defences, but his vision was much broader. He saw the need to reform Japanese military practices and to bring the country into line with political and technological developments in the West. Joining forces with other *rangaku* scholars, he began to put forth his ideas publicly in such writings as *Shinkiron* (*A Discourse on a Modest Opportunity*). In 1839, as part of a general crackdown on dissidents, he was put under house arrest outside Tokyo. The positive aspect of his imprisonment was that it gave him a great deal of time to paint. However, the conditions under which he and his family were forced to live were extremely painful, and in 1841 he committed suicide. Traditionally, Kazan has been classified as a *bunjinga* artist because of his association with Tani Bunchō. Today it is clear that he also played a part in the modernizing of Japan—bringing the importance of Western technology to the attention of the Japanese people.

CHAPTER 7

Forging a New Identity

THE MEIJI RESTORATION AND JAPAN'S ENTRY INTO THE MODERN WORLD

Following the official opening of Japan's ports to the American Commodore Matthew Perry in 1853, the Tokugawa bakufu lingered on for a further fifteen years, trying to harness and direct the flood of change caused by the country's first unfiltered exposure to the rest of the world in two hundred and fifty years. Westerners set up a new settlement at Yokohama near Edo, and Europeans and North Americans of all descriptions began to appear on the streets of Japan's cities. The commodities and new technologies they brought with them would irrevocably change the Japanese way of life. Growing frustration with the moribund Tokugawa government was now also directed at the newcomers, whose presence was interpreted as an invasion and humiliation.

The Meiji Restoration

To fill the power vacuum that existed at the heart of the *bakufu*, there stirred among the middle- and lower-ranking officials of the regional governments of the *han* a desire to secure once again for Japan an inviolate supremacy, and they took as their focus the emperor in Kyoto. At first these **shishi** (men of determination) had no very unified conception beyond the slogans *jōi* (expel the barbarians) and *sonnō* (revere the emperor). The remainder of the 1850s and the early 1860s were punctuated by assassinations of figures within the Tokugawa *bakufu* and of foreigners—both prominent and not so prominent. The latter responded with such actions as the British bombardment of the town of Kagoshima in 1863, but every effort the *bakufu* made to rein in rebellious daimyo and the *shishi* met ultimately only with failure. Finally, in January 1868, a well-organized coalition of *shishi* overthrew the *bakufu* and deposed the Shogun. The seventeen-year-old emperor Meiji (r. 1867–1912) and the imperial household

accompanied them to Edo, and, renaming it Tokyo (Capital of the East), the leaders of the Meiji Restoration proceeded to set Japan on course for its greatest cultural, social, and political revolution since the Taika Reforms of 645.

In the next twenty years, the new leaders would completely alter the make-up of the nation from its system of government down to how the daily lives of the people were conducted. The Meiji government was nothing if not astute and practical, and, taking into consideration the significant military and economic superiority that the foreigners derived from their new technologies, it abandoned its original anti-foreigner stance. It promoted Westernization as the only path by which Japan could regain its glory, and in 1871 the Iwakura Mission, comprised of some of the Restoration's most powerful leaders, left Japan on a two-year tour to Europe and the United States to study foreign statecraft and economic development. By this point, however, they had completely dismantled the mechanisms of the *bakufu*, and pensioned off the daimyo ,whose 273 *han* were restructured into 75 prefectures governed by appointees from the central government in Tokyo and advised by local committees of citizens—the germ for the future representational government. The old Confucian-based class system that had held sway for more than a millennium was abolished, court aristocrat, samurai, peasant, and *chōnin* all being technically equal within the eyes of the emperor and government, and wealth and ability becoming the official indicators by which social status could be measured.

On the return of the Iwakura Mission, the government instituted a regime for its brave new world. The intention was two-fold: Japan should achieve complete industrialization and "modernization" as quickly as possible and simultaneously gain standing equal to that of the Western powers. Given the absence of any successful coup d'etat or popular revolution in

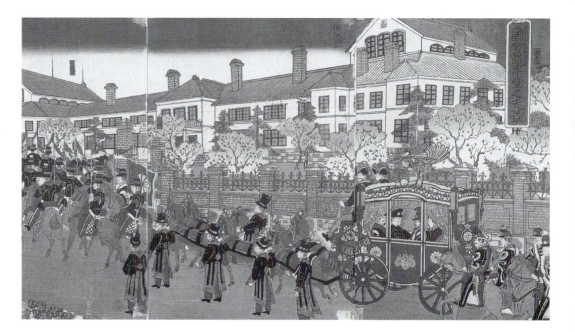

401 *Tōkyō fuka Kōjimachi-ku Sawaishō Kokkai Gijidō no kōkei* (*Spectacle of the Imperial Diet Building at Sawai-chō in Kōjimachi Ward, Tokyo*), by Kunitoshi. 1890. Woodblock print; *oban* triptych: ink and color on paper; 14 ½ x 28 ¾ in (37 x 73 cm). Arthur M. Sackler Gallery, Smithsonian Institution, Washington, DC. Gift of Ambassador and Mrs. William Leonhart. (S.1998.39a–c).

the following decades, the decisions of the Meiji government must be credited as well judged. During the 1870s, Western-style universities were established and the government invited Western experts to chair their departments and teach a generation of Japanese students who would in the years to come pave the way in the arts and sciences. These students were also encouraged to travel to Europe and North America to continue their studies, not infrequently with government sponsorship and funding. By the 1880s, the government could afford a brief reaction against the intensive "Westernization." This it neatly turned into a rediscovery of Japanese culture, shepherding Japanese society to a combination of the familiar and old with the foreign and new in the creation of a smoothly operating modern identity that was uniquely Japanese. In 1889, the emperor proclaimed the new constitution, and in the following year he opened the Diet building, home to the newly established legislative branch of the government modeled on the British parliament (Fig. 401).

A Cultural Exchange: Westernization and Japonisme

At the time of the construction of the Western-style Diet in 1890, Tokyo and Japan's other major cities had already experienced twenty years of change determined by "modern" Western fashion (Fig. 402). The frontages of the shops and homes in the smarter areas had taken on appearances recognizable from the vocabulary of Western nineteenth-century commercial and domestic architecture, just as the streets that they flanked carried horse-drawn omnibuses, rickshaws imported from British India, and citizens dressed in purely Western costume, purely Japanese costume, and combinations of the two. Soon would be added the tracks for trams and the wires for electricity and telephones, but behind these

façades the essential pattern of a traditional Japan continued, exemplified by the floor-based, tatami-carpeted environment of domestic life. In the public arena, however, the Western architects invited by the government, and their Japanese students, were beginning to transform the face of the Japanese city. In the decades leading to World War II, Japanese architects would continue to look to the West for inspiration. They would master both the classical and modernist vocabularies of Western architecture, but ultimately these would be added to a very Japanese sense of design and proportion. Western architects also visited Japan, most notably Frank Lloyd Wright (1867–1959), and the impressions they gained from the harmonic but simple functionality of *shoin*-style interiors and exteriors would have an important influence on the minimalist strains within twentieth-century Western architecture, out of which the German Bauhaus developed in the 1920s. The philosophy of the latter would prove to be the guiding principle behind the International Style that has transformed the concept of the urban landscape throughout the world since the 1950s.

As part of its efforts to improve Japan's status in the world the Meiji government also engaged in the passion for international exhibitions and fairs that had swept the Western world. Held in the major European and American cities, they promised the visitor the innumerable wonders and commodities on offer within the newly conceived world community. The Japanese pavilions at these events offered a glimpse of the nation to a greater number of people than could afford the luxury of actually visiting the country, and the second half of the nineteenth century witnessed the phenomenon of Japonisme, which influenced many of the major art movements in the West including impressionism, postimpressionism, symbolism, art nouveau, and the British arts and crafts movement. The intention of the Meiji government was to

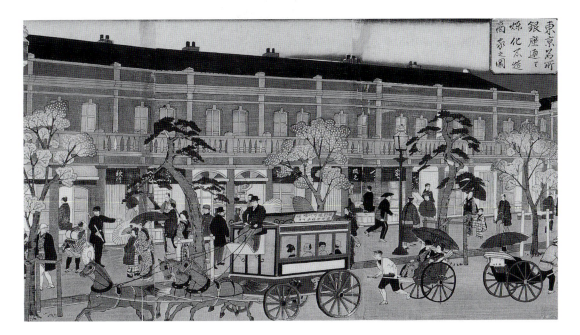

402 *Tōkyō meisho Ginzadōri renga ishizukuri shōka no zu* (*Famous Views of Tokyo: Picture of Brick and Stone Shops on Ginza Avenue*), by Hiroshige III. 1876. Woodblock print; *oban* triptych: ink and color on paper; 14 ⅞ x 28 ¾ in. (37.5 x 73.1 cm). Arthur M. Sackler Gallery, Smithsonian Institution, Washington, DC. Gift of Ambassador and Mrs. William Leonhart. (S.1998.32).

demonstrate to foreign powers the sophistication of Japan's traditional crafts and the integrity of their craftsmanship. Therefore, many of the Japanese pavilions showcased only virtuoso works by carefully selected master craftsmen in the fields of ceramics, lacquer, and metalworking. But, although only a very small minority of artisans ever managed to secure a place on an exhibition stand, still the official sponsorship of Japanese crafts helped not only to garner praise for them abroad, but to also maintain an appreciation for them within the "industrializing" society at home.

Painting and Sculpture Re-defined

At the same time that Western artists were getting excited about traditional Japanese concepts of design and color, an influential school of Western-style painting—or *yōga*—grew out of the initial tutoring by European painters and sculptors in the 1870s. The young artists soon took themselves off to Europe to study with painting masters there, and also formed into study and exhibition societies at home to explore modernist developments in Western painting. By the beginning of the twentieth century, they were writing their own commentaries and critiques on Western-style painting, with several publications serving as forums for their debates and as showcases for new developments in the West. Until after World War II, Western-style painting and sculpture would always remain a few steps behind movements in the West, in part due to the fact that those Western masters who would take on students rarely came from the avant-garde themselves. Therefore, within *yōga* circles the last decades of the nineteenth century were characterized by the academic history painting of the French Salon, and the first two decades of the twentieth century by impressionism, postimpressionism, and symbolism. The

1920s and 1930s saw the emergence of fauvist and cubist styles. In sculpture the guiding lights would be first academic realism, and then the expressionism of Auguste Rodin (1840–1917).

The reaction in the 1880s against intensive Westernization did set the cause of *yōga* back temporarily, but it is primarily notable for the birth of a new style of traditional painting that came to be characterized as **nihonga**. Drawing initially on the Kanō and Tosa school traditions of Chinese-style and *yamato-e* painting, in the twentieth century it would increasingly look to the Rinpa tradition, which had also influenced Western movements such as symbolism and art nouveau. However, *nihonga* artists made a conscious effort to adapt these traditional styles to a modern ethos, and as such competed directly with *yōga* artists in terms of contemporaneity. Of the pre-Meiji painting traditions, only *bunjinga*, *haiga*, and *zenga* continued to develop relatively unaffected by the great changes. As a result, they came to be largely preserved within a kind of aspic of "heritage" in the course of the twentieth century, although a few masters have arisen in the past 150 years to challenge the achievements of the great eighteenth- and early nineteenth-century masters and keep these traditions alive and vital.

Mingei: Japan's Folkcraft Movement

While the refined and virtuosic works sponsored by the government for international expositions helped to sustain traditional crafts and feed a sense of national pride and achievement, at the beginning of the twentieth century advocates of Japan's more subtle and less glamorous beauties began to formulate their reaction to the exuberant glitz of the Meiji period. Foremost among these thinkers was Yanagi Sōetsu

(1889–1961), who advanced the idea that true beauty could be achieved only in works that were functional and were made of natural materials by anonymous craftspeople using traditional techniques. Such an ideal redefined the Japanese aesthetic of simplicity and austerity—*wabi* and *sabi*—in terms meaningful to the twentieth century. The **mingei** (folkcraft) movement also tapped into a sense of national identity, but from a less aggressive and more liberal base. Due to its efforts a great deal of Japan's vibrant folk culture has been preserved, and its crafts taken up by succeeding generations of craftspeople and clients. Traditionalist movements such as *mingei* helped foster an environment within the Japanese cultural elite that led to the establishment of a system of evaluating the works of the past, thus preserving for the nation as National Treasures the greatest surviving works of Japan's artistic heritage instead of watching them disappear overseas as has happened with so many other Asian nations. Similarly the establishment of a system of Living National Treasures has provided the recognition Japan's traditional craftspeople need to enable their arts to survive.

Prewar Militarism and Postwar Avant-Garde

The ambitious sensibility of Meiji nationalism turned before the end of the nineteenth century into a much more aggressive stance. The humiliation of the Chinese Qing empire (1644–1911) at the hands of the European powers in the course of the century had initially fueled Japanese fears about opening themselves up to the West. However, with the initial success of the Meiji Restoration, by the late 1870s anxiety had been replaced by a growing contempt for East Asian neighbors who had failed to adapt as well as the Japanese to the modern industrial world. In 1879, they officially annexed the Ryūkyū kingdom, which had also been the vassal of the Qing empire, and in 1895, they annexed the island of Taiwan, which was officially part of the Qing dominion. With their military's successes in the Sino–Japanese war of 1894–5 and the Russo–Japanese war of 1904–5, the Japanese considered that they had become the peers in military might of the great Western powers. Both wars had the objective of further expanding the Japanese imperium, and concerned first Chinese and then Russian influence on the Korean peninsula. In 1910, the Japanese officially took over Korea as a colony, thus achieving some three hundred years later what Hideyoshi had set about at the end of the sixteenth century. In the succeeding Taishō (1912–26) period and early years of the Shōwa (1926–89) period, the imperialist and militaristic tendencies of the government only increased, resulting in the Japanese invasion of the Chinese mainland in 1937 and then their campaign for empire throughout Asia and the Pacific in World War II.

Following their defeat at the end of 1945, the Japanese, with the rest of the world, entered into a phase of transformation almost as radical as that entered in 1868. Reduced in their political domain to their traditional archipelago—with the addition of the Ryūkyū islands—the Japanese began the process of rebuilding their society on a sense of nationhood less militaristic and more mercantile in outlook. By the 1960s, the so-called Economic Miracle had been achieved and the country went on to dominate the world markets in a way that they could never have hoped to do politically. The post-war environment brought about the end of many of the remaining taboos within Japanese society, and it became the role of the artist to challenge and break them. As demonstrated in Alexandra Munroe's landmark history and exhibition of this period, *Japanese Art After 1945—Scream Against the Sky*, the 1950s and 1960s witnessed an explosion of artistic movements. *Yōga* and *nihonga* were relegated to academic status, and the new artists directly questioned the nature of art and the kind of materials that can be used in its creation. They also questioned what the role of the artist in society is—often with the answer "agent provocateur." Their inspiration derived from artists such as Marcel Duchamp and the dada and surrealist movements of the inter-war years in Europe. However, their approach was no longer several steps behind that of their Western contemporaries, and these Japanese artists have entered the international arena with a confidence that their prewar counterparts could not have shared. At the same time, more traditional elements in Japanese art have continued to develop and thrive. *Mingei* was the single prewar aesthetic movement that found immediate favor in the postwar era. In the succeeding decades it has become part of a greater and more disparate movement that has fostered continued growth in many of Japan's traditional arts, whether of humble folk origin or of the ancient urban and courtly cultures. With the death of Emperor Hirohito in 1989, the last of the taboos seems to have been lifted, and in the 1990s Japan's artists and society as a whole began to confront the legacy of their imperial policies from the 1890s until 1945. At the beginning of the twenty-first century, the Japanese can look back over millennia of cultural and artistic evolution and also enjoy the fruits that this has borne in their contemporary culture.

Architecture

When Japan opened its doors to receive Western culture, the differences between its own architecture and that of nineteenth-century Europe and the United States could be grouped under two major headings: technique and style. Western steel-reinforced brick and concrete required different skills from those needed to erect wooden structures. Equally, Western-style pillars and pilasters with their classical capitals were completely foreign to Japanese design. The Japanese response to this perceived "progress gap" was to import experts who could train Japanese architects, primarily in Western technology but also in style. Most influential of these were Josiah Conder (1852–1920) and the Berlin architectural firm of Hermann Ende (1829–1907) and Wilhelm Bockmann

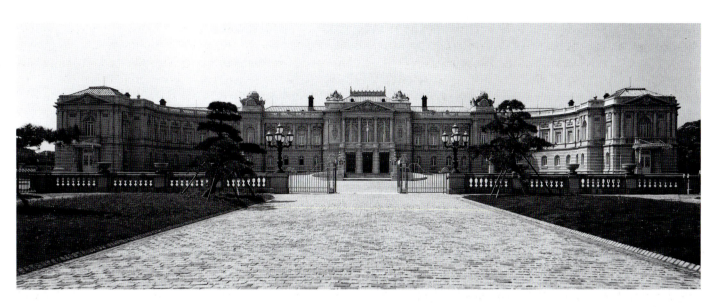

403 Akasaka Detached Palace, Tokyo, by Katauyama Tōkuma. 1909.

(1832–1902). Conder, who taught at the new Kobū Daigakkō (University of Technology), had trained at the Royal Institute of British Architects under William Burges (1827–81), a man noted for his eclectic combination of building styles and his antiquarianism. After teaching for many years at the Kobū Daigakkō, Conder opened his own firm in Tokyo and continued to design both public and private structures well into the 1910s. Conder's major influence on the history of Japanese architecture derived from the training he gave his students. Among his graduates in the class of 1879 were three young men who went on to become the leading architects of the late Meiji period: Tatsuno Kingo (1854–1911), Katayama Tōkuma (1853–1917), and Sone Tatsuzō (1853–1937).

While Tatsuno Kingo was subsequently sent by the government to study with Conder's old professor Burges, Katayama Tōkuma was made an officer in the Ministry of Technology, where he spent two years in the Building and Repairs Department along with Conder. In 1881, he became involved in the construction of a mansion designed by his English mentor for Prince Arisugawa (1835–95). Through this association, Katayama was sent as a member of the Japanese delegation to attend the coronation of Czar Alexander III of Russia in 1883. He spent the next two years abroad, studying the architecture of England and France. Upon his return, Katayama received commissions from the government and the Imperial Household Agency and went on to become architect to the imperial family. His first major projects were completed by the mid 1880s—the Japanese Ministry in Beijing and two imperial museums in Nara and Kyoto. Particularly in the museums Katayama employed a full-blown French style, emphasizing mansard roofs and decorative elements such as pilasters in high relief against flat walls. In 1886, in connection with work on the imperial palace, Katayama traveled to Germany and Austria, staying for almost

a year and absorbing influences that were to have a profound effect on his last buildings, and in particular the Akasaka Detached Palace (Fig. 403).

Completed in 1909, the Akasaka Detached Palace is the first Meiji-period building to achieve true grandeur using Western techniques and vocabularies of style. Often called the Japanese Versailles, it boasts a magnificent staircase, a large dining room for state occasions, a ballroom, elaborate ceiling paintings executed by some of the most important Japanese painters of the time, and lavish appointments, such as gilt lamps atop the balustrades on either side of the grand staircase. There are also some distinctly Japanese features, such as the designation of reception rooms as front, middle, and inner. However, its very magnificence was the palace's undoing. When the Meiji emperor first inspected it, he declared it too luxurious for his son (who in the following year would become emperor), and it was never used as an imperial residence. Until the 1970s, it housed the Diet's library but now it has been restored and is used for official state visitors.

The third of Conder's star pupils, Sone Tatsuzō, joined in 1890 the Mitsubishi real estate company and became involved with Conder in the design of London Block, the group of office buildings erected to the west of his fellow pupil Tatsuno's Tokyo Station. London Block consisted of four-storied structures built of reinforced brick, with brick also used as the outer surface material. In 1906, Sone left Mitsubishi to open his own firm, and from then on worked exclusively for private clients, including Mitsubishi and other newly emerging business conglomerates. Some architectural historians consider him, rather than Tatsuno or Katayama, the most influential figure in late Meiji and Taishō architecture. Sone's great achievement was to move in his later buildings beyond Conder's reinforced brick to a new technique developed in America, steel-reinforced concrete.

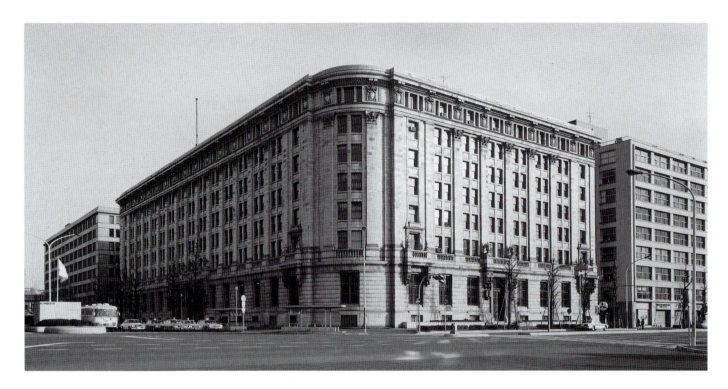

404 Nihon Yūsen Building, Tokyo, by Sone Tatsuzō. 1923.

The use of steel-reinforced concrete for large commercial structures had been perfected by Chicago-based architects, including most notably Louis Sullivan (1856–1924). The first Japanese office building to use this material was the Tokyo Maritime (Kaijo) Building, completed by Sone's firm in 1918. There, however, the architects had retained the structural plan developed for reinforced brick, namely the use of numerous thick, load-bearing piers. The next reinforced-concrete project to be undertaken was the Marunouchi Building, affectionately known as the Maru Biru, executed by the Fuller Company of Chicago, using its own patented system of reinforced concrete and plans drawn by the real estate section of the Mitsubishi Corporation; it was followed one year later by Sone's Nihon Yūsen (Japan Mail Line) headquarters (Fig. 404). At first, the Japanese were not completely happy with Chicago's patented system. In the great Tokyo earthquake of 1923, the Maru Biru remained standing but sustained considerable damage, whereas the structurally more traditional Tokyo Maritime Building fared much better. It was said at the time that the Japanese methods of construction used in the Maritime Building were clearly superior to those developed in the United States. Nevertheless, steel-reinforced concrete was the building material of the future: the superior strength of reinforced concrete used horizontally requires fewer vertical supports and permits the creation of wide expanses of open space. It remained for Japanese architects to master completely the new technology after World War II in order to produce what, it is hoped, are earthquake-proof structures. Whatever its structural integrity, Sone's Nihon Yūsen headquarters is clearly the most successful of these early reinforced concrete

structures as a design. It is a seven-storied structure, the first story being emphasized by the use of rusticated shapes and large window openings and set apart from the upper floors by a balustrade. Although the remainder of the building also appears to be faced in stone, it is actually covered with terra cotta tiles, which give it a rich, almost iridescent color.

While Josiah Conder was fostering the first generation of Japanese architects, the German firm of Ende and Bockmann was already shaping the style of buildings to be used for the ministries of government, both national and provincial. Ende and Bockmann were asked to submit a design for a building to house the newly created Diet. In 1886 and 1887 both men visited Tokyo and took back with them a group of Japanese students for further training. The first design they submitted in 1887 was for a neoclassical building similar to the three-pavilion design they were to use later in the Ministry of Justice offices. When this design was not accepted, they again produced a tripartite building, this time incorporating Asian motifs such as curving roofs. Finally a compromise was reached (see Fig. 401), but the great Diet building controversy raged on until the present art deco structure was completed in 1936. At the heart of the controversy was the question perennially posed during the Meiji period: what is the role of tradition in the arts of Japan? Should an indigenous form of traditional theater like Kabuki be housed in a Western-style building? In what style of architecture should traditional painting be displayed? Could a uniquely Japanese style of architecture be developed that would be appropriate to house not only institutions of culture but could also be used for modern business structures?

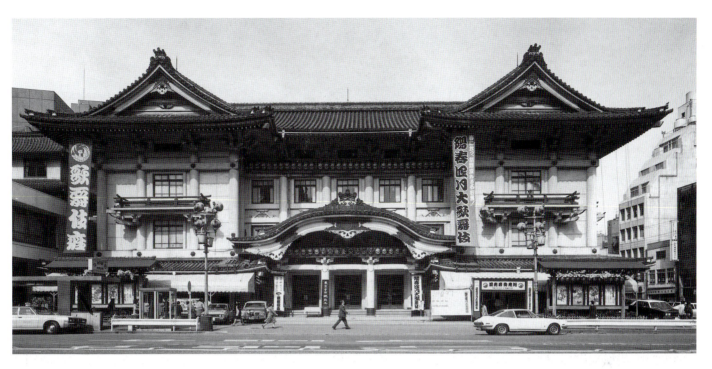

405 Kabukiza, Tokyo, by Okada Shinichirō. 1924.

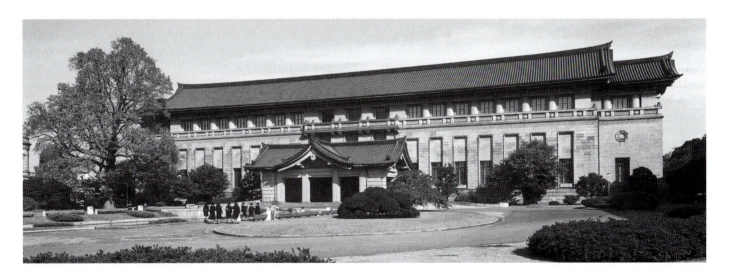

406 Tokyo National Museum, Tokyo, by Watanabe Hitoshi. 1937.

In 1924, the architect Okada Shinichiro (1883–1932) answered one of these questions with the new Kabukiza in the Higashi Ginza area of Tokyo (Fig. 405). Inspired by Edo-period buildings with hipped-gable roofs and Chinese gables, he constructed the theater from steel-reinforced concrete. In 1937, Watanabe Hitoshi's (1887–1973) prize-winning design for the Tokyo Imperial Museum, now the Tokyo National Museum, was built in the so-called "imperial-crown style" that in the thirties became a symbol of Japanese nationalism (Fig. 406). The most obvious characteristic of the imperial-crown style is the curving Japanese roof, but porte-cocheres, small roofed structures extending from the entrance of a building over an adjacent driveway, are another common feature. The front of the Tokyo National Museum has one with gracefully curving gables forward and to the sides. The museum building is actually three stories tall, but the façade is articulated as though it had only two. The lower course of windows provides natural light in the first-floor galleries, which house sculpture, metal objects, and ceramics; the upper illumines staff offices on the third floor. The second-floor galleries are illuminated artificially, a necessary feature for displaying light-sensitive paintings.

The buildings cited above notwithstanding, Tokyo in the 1920s and 1930s came into the mainstream of an international style of modern architecture, developed in the United States in the years before World War I by such architects as

407 Okada residence from the south side, Ōmori district, Tokyo, by Horiguchi Sutemi. 1934 (no longer extant).

Frank Lloyd Wright (1867–1959). Particularly significant was the commission given to Frank Lloyd Wright to design and build the second Imperial Hotel. His building, completed in 1922, was important in his oeuvre because it demonstrated his stylistic debt to Japanese architecture and at the same time his skill as a structural technician, since the building sustained only minor damage during the disastrous Tokyo earthquake of 1923, which occurred the day the building was scheduled to open. However, it must be said that Wright and his designs for the Imperial Hotel had little impact on Japanese architects. Much more influential was his assistant Antonin Raymond (1888–1976), a Czech–American architect who stayed on in Tokyo and opened his own office.

In the second decade of the twentieth century a controversy in world architectural circles surfaced also in Japan, namely, structure versus design. Is architecture primarily technology, or is it a marriage of technology and style? The former argument was given voice by Noda Toshihiko (1891–1929) in his 1915 article postulating that "Architecture Is Not Art." Noda had studied under Sano Riki (1880–1956), a pioneer in the field of earthquake-proof architecture, and his article is thought to reflect the ideas of his mentor, who clearly put a high premium on construction techniques. Five years later a group of six young architects trained at Tokyo University rebelled against Sano's ideas and constituted themselves as the Bunriha Kenchikukai (Secessionist Architectural Society), the first architectural movement native to modern Japan. The group survived until 1928 and advanced their ideas primarily through exhibitions at Tokyo department stores, which in Japan are a respected locus for art shows.

One of the most important architects to emerge from the Bunriha, and undoubtedly its philosophical leader, is Horiguchi Sutemi (b. 1895). In 1923, Horiguchi had the opportunity to travel extensively in Europe and took the occasion to visit many of the most avant-garde architects, including Erich Mendelsohn (1887–1953), Walter Gropius (1883–1969), and J. J. P. Oud (1890–1963). These men had an appreciation of Japanese traditional architecture and design, and with them Horiguchi enjoyed an exchange of ideas and theories rather than a pupil–teacher relationship. As a result of the constrained economic climate that prevailed in Japan after the 1923 earthquake, on his return Horiguchi found that most of his commissions were coming from individual clients desiring modern residences. Thus he began to work with the concept of integrating traditional Japanese forms into a modern context.

His best-known pre-World War II design is the Okada residence in the Omori district of Tokyo, completed in 1934 and no longer extant (Fig. 407). Perhaps the most interesting juxtaposition in the structure was the placement of two Japanese tatami rooms next to a Western-style living room. The Japanese rooms projected forward into the space of a garden enclosed by cement walls, while the Western-style room was recessed. The vista from each room was distinctive, the view from the two Japanese rooms being a garden at its peak in the autumn, whereas that from the Western-style room was more geometric, with a flat expanse of green grass punctuated only by a tree to the left and a low shrub to the right. What is most striking about this building is that the modernist ideas he had brought back from Europe carried him in almost a full circle to the practical simplicity of *shoin* architecture (see Figs 276–8).

408 View of the strolling garden of the Murin-an, Kyoto. Meiji period, 1894.

In garden-design tradition the Japanese saw little that the West could provide by way of improvement. One of the more beautiful gardens of the Meiji period is that created for the retirement villa of Murin-an outside Kyoto of one of the Restoration's leading characters (Fig. 408). Yamagata Aritomo (1838–1922) led a full career as both a statesman and general in the Meiji period. The house itself is largely in the traditional *shoin* style, although there is also a two-story Western-style pavilion. The garden surrounding it was designed by Ogawa Jihei (1860–1933) and has views towards the famed scenery of Higashiyama. It is conceived as a strolling garden and does incorporate large expanses of lawn adapted from the British tradition, but in the main it comprises streams, ponds, mossy banks, mature spreading trees, and well-placed stones, allowing visitors to lose themselves in a naturalistic but very Japanese sylvan idyll. Ogawa Jihei was the preeminent gardener of the Meiji and Taishō periods, and he designed a number of private gardens in the Kyoto area, but his most famous surviving work is at Murin-an.

By the end of the postwar Occupation, in 1952, Japanese architecture was once again finding its feet, and with many of the nation's cities needing reconstruction there were few architects going spare. The new Japan was resolutely built in the International Style that had been developed by the students of Walter Gropius and Mies van der Rohe in the United States, and its Japanese practitioners took easily to the concepts of spare, simple rooms brought together to create great box-like towers or low-rise complexes. However, several of them were confident enough to utilize the principal material—reinforced concrete—to create less orthodox shapes. The most famous building of the 1960s was the Yoyogi Stadium (Fig. 409), which was used for the Olympic Games of 1964. Many social historians rank this the pivotal event which demonstrated Japan's Economic Miracle to itself and to the world, the moment at which it once again entered the ranks of the "First World." The stadium was the design of Kenzo Tange (b. 1913), and his work and that of his students remains at the forefront of Japanese and world architecture.

Decorative and Applied Arts

Two factors in the years immediately following the Restoration determined the course of the decorative and applied arts in the rest of the Meiji period. The first was the radical reorganization of society by the Restoration's leaders. Not least among the measures was the abolition of the samurai class, which not only disenfranchised the samurai themselves but put almost the entire industry that produced the warriors' accoutrements out of work. The reforms also brought to an end the *chōnin* culture which had developed in the Edo period as the merchants and townsmen turned away from traditional fashions and crafts to those that came from abroad. The second factor, however, was the eagerness of the new leaders to communicate to the Western powers Japan's cultural sophistication, specifically (as mentioned above) by entering the many international expositions taking place in Europe and America and showcasing Japan's traditional crafts in metalworking, ceramics, and lacquer. Although the domestic market declined in the 1860s and 1870s, many disenfranchised craftsmen hoped they might be able to take advantage of the Japonisme craze that was sweeping Europe and North America. From the

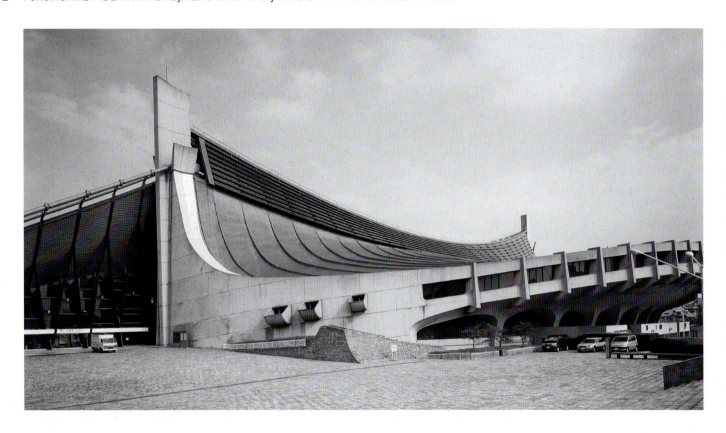

409 Yoyogi Stadium, designed by Kenzo Tange, 1961–4. Structural Expressionist style; concrete and steel cable. Tokyo.

1860s to the advent of World War I, Japanese craftsmen jockeyed with each other to win selection for exposition, primarily through the forum of a series of industrial exhibitions held throughout Japan. Although these "exhibition" pieces appear in a variety of media, they are united in a display of virtuosity and decorative excess not seen since the Momoyama period (1573–1615). Such objects were sneered at in the years following the Meiji period, but recently it has been possible to begin to appreciate the quality of the craftsmanship and also, in the best of them, a beauty in the decoration that—while catering to the vogue for busy and gaudy surfaces both in Japan and in the West at this period—managed to create quite elegant and stunning pieces.

One such master was the ceramic decorator Yabu Meizan (1853–1934), who specialized in painting gilt designs on the surface of low-fired earthenware vessels. This kind of vessel—popularly known as Satsuma—had been developed in the early nineteenth century in the Kyūshū domain bearing its name, and was primarily made for export. The purpose of making these decorative display pieces in earthenware was to produce inexpensively highly-colorful ceramic vessels meant

to catch the Western orientalist eye. This development was, perhaps, caused in part by the successful production of a European porcelain in the eighteenth century which had significantly undercut one of the Kyūshū porcelain kilns' primary markets. Such Satsuma wares were, therefore, by the time of the international expositions in the middle of the nineteenth century, one of Japan's most identifiable craft exports.

410 Vase. Signed Yabu Meizan, made by Yabu Meizan Studio, c. 1910. Painted and gilded earthenware; height 7 ⅕ in.(18.3 cm). The Khalili Collection of Japanese Art, London. (S111).

Yabu Meizan, however, raised this ceramic ware from a mass-produced and often poorly painted craft to something much more sublime. In his vase of c. 1911, the artist has painted an autumnal branch descending gracefully from the lip of the vessel over the undulating double-gourd shape (Fig. 410). The changing leaves are picked out in tones of gold and red, and a single swallow flies amidst the foliage.

Most hard hit amongst the traditional craftsmen were the metalworkers, who had provided the samurai with their armory. In the scramble for position in the new society, some lucky few were able to retrain themselves to produce *objets de vertu* for the international expositions. While utilizing the techniques which had often been perfected over generations within a single family, they created some of the more fantastic and exotic objects to be found at the expositions. A good example is an elephant-shaped censer (Fig. 411) signed Shōami Katsuyoshi (1831–1908). The Shōami had been a school of sword-guard makers, and this piece demonstrates an overwhelming array of metal inlay techniques. Another of the craft "stars" of the Meiji period was the lacquer master Shibata Zeshin (1807–91), one who managed to maintain a good market both at home and abroad. His writing box decorated with "elegant pastimes" (Fig. 412) is remarkable for the quality of its craftsmanship. On the cover are folded sheets of paper pressing autumn leaves, as well as a spool of silk thread, and on the interior are the paddle and balls for a New Year's game similar to shuttlecock.

While these goods were enthusiastically received at the expositions and often purchased, perhaps the greatest impact they had was in selling traditional arts back to the Japanese themselves. By the 1880s the reaction against the blind plunge into Westernization of the 1870s was giving these craftsmen a better foothold in the domestic market. In 1890, the imperial household instituted a system of appointments of craftsmen and artists to the court, known as Teishitsu Gigeiin (Imperial Craftsmen), who could make on commission the gifts the emperor was expected to give to foreign, and Japanese,

411 Incense burner in the form of an elephant, by Shoami Katsuyoshi. Silver with gold and colored metal inlay, stones, and enamel; 14 ½ x 14 ⅛ in. (37 x 36 cm). The Khalili Collection of Japanese Art, London. (M72).

dignitaries. In 1950, the government established the status of Ningen Kokuhō (Living National Treasure), which was accorded to individuals in recognition of extraordinary achievement in traditional crafts and arts.

Although the expositions and imperial patronage gave new life to the refined, urban-centred crafts, by the early twentieth century the question of quality in the production of

412 Writing box decorated with leaves, folding paper, and a reel of cord, by Shibata Zeshin, signed Zeshin. Lacquer; height 2 x 8 ⅔ x 8 ½ in. (4.8 x 22 x 21.5 cm). The Khalili Collection of Japanese Art, London. (BL 39).

413 Shallow dish with loop designs in black and cream, by Hamada Shōji. 1954. Stoneware, with glazes; diameter 10 ½ in. (26.7 cm). Private collection, USA.

414 Vase, by Ono Hakuko. c. 1990. Porcelain with lacquer-coated gold foil under a transparent glaze; height 9 ¼ in. (23.5 cm), diameter 2 ¾ in. (7 cm). Private collection, USA.

everyday objects had also become an issue. Yanagi Sōetsu (1889–1961) redefined the Japanese aesthetics of simplicity and austerity—*wabi* and *sabi*—into a concept of beauty in works that were functional and were made of natural materials by anonymous craftspeople using traditional techniques. An artist who took up Yanagi's idea of anonymous craftsmanship was Hamada Shōji (1894–1978). He was a friend and associate of the major figures in the folk-craft (*mingei*) movement—Yanagi and Bernard Leach (1887–1979), the English potter who played a major role in the revival of Japanese ceramics in the twentieth century. Hamada was so interested in Leach and his ideas that he went to England for three years, from 1920 to 1923, to help Leach set up his community of craftsmen at St Ives, in Cornwall, where they built a climbing kiln. On his return to Japan, Hamada established himself at Mashiko, a remote, rural town to the north of Tokyo. Although Hamada believed in Yanagi's movement and never signed his work, his best pieces were a unique blend of modern shapes and abstract designs.

One example of Hamada's mature style is a round plate decorated with a traditional loop design called a horse's eye (Fig. 413). The pattern, commonly found on peasant wares of the Edo period, consists of a number of ovals, one inside another, sharing a common point along the rim. Usually there are six or more sets of ovals drawn in dark-brown iron oxide on a light gray–brown ground. Hamada has given this motif a thoroughly modern treatment. The upper side of his plate is a dark rich brown, the underside black, and over its surface black and white glazes have been trailed unevenly, forming two large "horse's eyes." So strong was Hamada's mature style that instead of remaining anonymous, he attracted a legion of imitators and gave new direction to the folkcraft movement. *Mingei* continues to flourish in Japan today, its varied expressions offering appealing and easily comprehensible insights into a special—yet utterly consistent—dimension of traditional Japanese sensibilities.

415 Tea Bowl known as *Kanto* (*Winter Rabbit*), by Kichizaemon XV. 1991. *Raku* ware, earthenware; height 4 ⅓ in. (11 cm), diameter 4 ¼ in. (10.9 cm). International Chado Culture Foundation, Urasenke Konnichian, Tokyo.

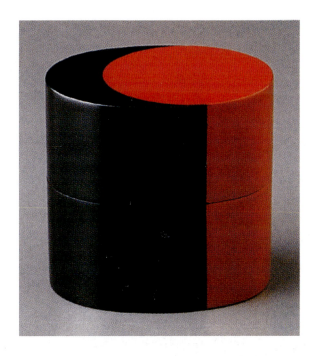

416 Tea container with sun and moon design, by Hiroko Nakamura (Sotetsu XII). 1993. *Nakatsugi* lacquer; height 2 ¾ in. (6.9 cm), diameter 2 ⅔ in. (6.8 cm). International Chado Culture Foundation, Urasenke Konnichian, Tokyo.

In the post World War II years other trends in studio pottery and crafts developed in addition to those solely concerned with the precepts of the *mingei* movement. Similarly concerned with utilizing traditional forms and materials, they were instead committed to making contemporary statements in tune with developments in the other arts. A particularly gifted master is Ono Hakuko, who took as her specialty the complicated Chinese process of using cut gold foil which had also been espoused by Eiraku Hozen (1795–1854; see Fig. 345). Ono has modified the technique by treating the gold foil with lacquer before application to the vessel and then covering it with a translucent glaze (Fig. 414). As a result, her gilding has a much brighter and more luminous presence than that on vessels using the traditional method. The passion for the tea ceremony has continued to attract a small, but committed and discerning following throughout the modern period. Potters and lacquer craftsmen—particularly of the *mingei* persuasion —have habitually found a welcome market amongst this cultivated community. At the upper end of this market, the craftsmen are often survivors of craft lineages established in the Edo period, and in some cases even earlier. Such is the case with the tea bowl named *Kanto* (*Winter Rabbit*) of 1991 (Fig. 415). The artist is Kichizaemon XV (b. 1949), who, as indicated in his studio name, is the fifteenth generation of his ceramic tradition. Another example is the lacquer tea container by Sotetsu XII, who has used his lineage's tradition to create a very contemporary form of decoration that uses a traditional motif (sun and moon) and traditional lacquer colors and techniques (Fig. 416).

Sculpture

The Western concept of sculpture initially proved as revolutionary to the Japanese as did European painting and architecture. Before the Meiji period, the Japanese did not conceive of sculpture as a medium for the artist's personal statement— Buddhist sculpture had to display specific iconographic and stylistic features. The carvings of netsuke and *ojime* came closest to personal statement, but were ultimately decorative objects created to a client's specifications or with an eye to his or her tastes. Immediately following the Restoration, there was, unsurprisingly, a revival of the imperial cult, and of Shinto in general. What was surprising was the violent reaction against Buddhism that occurred at the same time. For about three years, the new regime not only withdrew any government sponsorship or funding, but also confiscated a large number of estates belonging to temples. The temples themselves were forced to close most of their subtemples, and reduce the numbers of their clergy. Perhaps most destructive of all was the dismantling of the millennium-old fusion of Buddhism and Shinto that had been so carefully engineered in the eighth century. Shinto shrines and altars in Buddhist compounds—such as those consecrated to Hachiman—were taken down and demolished, and Buddhist material in Shinto shrine compounds similarly erased. By 1871, the fury of this persecution had largely abated, but to this day the old syncretic fusion has never been reasserted officially between the Shinto and Buddhist communities, although it lives on in popular Japanese belief. Equally, neither the confiscated property

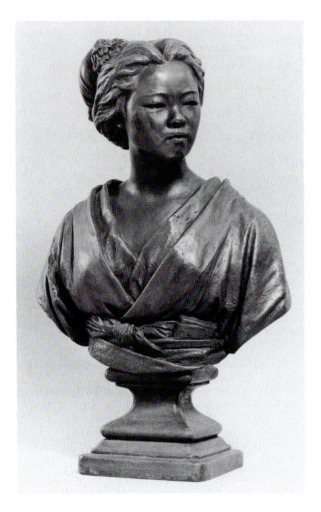

417 *Kiyohara Tama*, by Vincenzo Ragusa. 1878. Bronze; height 19 ⅛ in. (48.5 cm). Tokyo University of Fine Arts and Music.

arts, he returned to Italy. During his stay in Japan, however, Ragusa set up a foundry in his house in order to turn out his own work. The bronze bust of his wife Kiyohara Tama (1861–1939), a painter in her own right, exemplifies his style at this time (Fig. 417). Completed in 1878, the young Kiyohara's face is rendered accurately in smoothly curving planes that contrast with the raised tresses of her Western-style hairdo. The sculpture is a technically accomplished example of the realistic neoclassical style in which Ragusa had been trained.

Ragusa's most talented student was Ōkuma Ujihiro (1856–1934), who went on to further his studies in both Paris and Rome. Ōkuma's masterwork is his seated portrait of Fukuzawa Yukichi (1835–1901), the founder of Keiō University, completed in 1892 (Fig. 418). Fukuzawa is considered one of the founders of the new Japan after the Meiji Restoration. Through his teaching and his writings, he tried to instill the concepts that, he believed, had propelled the West to a position of superiority over Japan. Ōkuma shows Fukuzawa seated in a formal pose, with an alert and enquiring expression, his brow wrinkled in concentration. The treatment of the clothing, too, reveals sensitivity of observation as well as technical ability. The texture of the cloth used for the outer jacket is clearly different from that of the trousers, and the surfaces of both are treated so that natural light on the sculpture creates a believable pattern of highlights and shadows.

nor government funding was ever returned, and temples began to plunder their treasure houses and altars for much needed funds, instead of commissioning new works. Artisans of the three-dimensional form, whether in wood, lacquer, metal, ivory, or bone had to reorient themselves and redefine the concept of sculpture in the Japanese context.

Leading the way in this effort was the Kōbu Bijutsu Gakkō (Technical Fine Arts School) in Tokyo, in which the Italian sculptor Vincenzo Ragusa taught from 1876 until its closure in 1882. He taught modeling from life in clay and plaster, and such specialized sculpting techniques as Western methods of bronze casting and the use of wire armatures—the latter a skill practiced in the Nara period (710–94) but long since lost. Ragusa found teaching his students a difficult task because, as he noted in his journal, they seemed to lack the ability to visualize objects in terms of their volume. When the school was closed in 1882 due to the anti-Westernization backlash in the

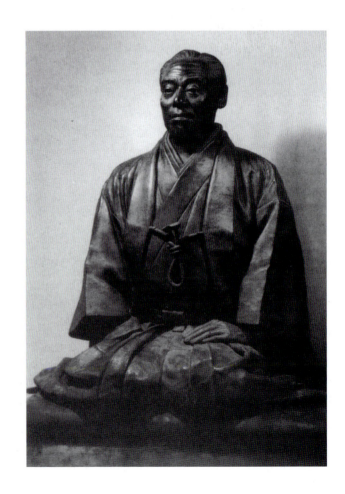

418 *Fukuzawa Yukichi*, Ōkuma Ujihiro. 1892. Bronze; height 47 ½ in. (120 cm). Keiō Gijuku Shiki High School, Shiki City, Saitama prefecture.

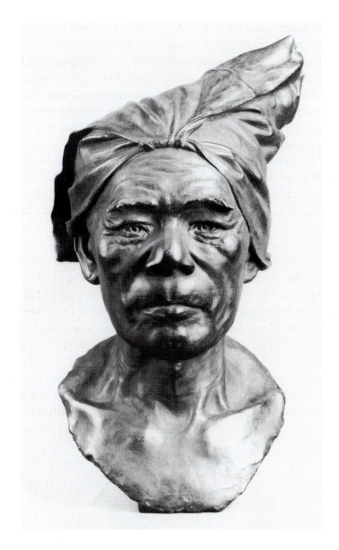

419 *Old Man*, by Naganuma Moriyoshi. 1898. Bronze; height 21 ⅝ in. (55 cm). Tokyo University of Fine Arts and Music.

420 *Suspended Cat*, by Asakura Fumio. 1909. Bronze; height 20 ¼ in. (51.5 cm). Asakura-Choso Museum, Tokyo.

A contemporary of Ōkuma, Naganuma Moriyoshi (1857–1942) worked for the Italian delegation in Tokyo, and through this connection was subsequently to pursue studies in Venice during the 1880s. On his return, Naganuma became the leading exponent of Western-style sculpture. In 1888 he joined with the painter Asai Chū (1856–1907) and several other artists to form the Meiji Art Society (see page 373). Naganuma's best-known work is the 1898 bronze head entitled *Old Man* (Fig. 419). It is said that the model for the sculpture was a gardener who worked near the artist's house. The modeling is both softer and deeper than Ōkuma's handling of the Fukuzawa sculpture. The fact that Naganuma was not striving for a portrait likeness allowed him greater latitude for creative expression, and he has produced a work that seems to penetrate beneath the surface of the sitter's features to a deeper reality.

The outstanding talent to emerge in the early twentieth century was Asakura Fumio (1883–1964). Trained in the Tokyo Bijutsu Gakkō (Tokyo School of Fine Arts), which had replaced the Kōbu Bijutsu Gakkō, Asakura also taught there from 1920 to 1944 as well as directing his own private institute, and thus had a considerable influence on the next wave of young sculptors. His teaching notwithstanding, he remained a productive artist, turning out portrait sculptures on the one hand and serious interpretive works on the other. One theme that Asakura frequently treated was the feline form—the cat being held by the scruff of the neck; the cat crouching, lying in wait for its prey; the cat eating its catch. The *Suspended Cat* of 1909 is a particularly fine example of his work (Fig. 420). Although the modeling of the sculpture is strongly three-dimensional, the most impressive aspect of this work is its fidelity to an observed phenomenon. One senses the cat's discomfort and its frustration as it dangles in midair, and one cannot help but appreciate its sleek, muscular body.

The pendulum swing of taste—from Western-style art to works in traditional Japanese styles, materials, and techniques—which occurred in the 1880s and 1890s affected sculpture as well as architecture and painting. However, because the

421 *Old Monkey*, by Takamura Kōun. 1892. Wood; height 36 ⅛ in. (90.9 cm). Tokyo National Museum.

powerfully to the right, glaring upward into space and grasping a few feathers that were all he could snag of the bird that was too quick for him to catch. His contorted body and fierce expression speak tellingly of his frustration. The sculpture is carved out of a single piece of horse-chestnut wood that Kōun had sourced himself. The texture of the fur is beautifully rendered as a mass of wavy curls, and the sculpture is arguably one of the masterpieces of Meiji-period sculpture.

By the end of the first decade of the twentieth century, a perceptive understanding of contemporary developments in Western art theory as well as of sculpture had been brought back to Japan by two sculptors—Ogiwara Morie (1879–1910) and Takamura Kōtarō (1883–1956)—returning from studies in America and Europe. Their ideas provided a welcome stimulus to young sculptors and contributed to the artistic ferment of the late Meiji and early Taishō periods. Takamura Kōtarō, the adopted son of Kōun, had been trained by him in woodcarving techniques, and subsequently also studied Western-style sculpture at the Tokyo Bijutsu Gakkō. Between 1906 and 1909, he resided in New York, London, and Paris, and his experiences there reinforced not only his conviction that the artist must use his talent as a means of self-expression, but also that the model for such expression in sculpture was the venerable Auguste Rodin (1840–1917). As a result, he

Western concept of sculpture—as an end in itself, a vehicle for the personal expression of the artist—was so different from the Japanese tradition of sculpture, it was impossible for artists to fall back to native precedents. Thus the main difference between Western and Japanese styles of sculpture made by native artists of this period is the material in which the work is created.

Takamura Kōun (1852–1934) was a sculptor who came to the fore at this time because he worked in traditional materials such as wood and ivory. Apprenticed in 1863 to the sculptor of Buddhist imagery Takamura Tōun (d. 1879), and eventually adopted by his family, Kōun was trained in the traditional techniques of Buddhist image-making. However, he was much impressed with the realism of Western sculpture and with the notion of subject matter as a vehicle for self-expression. He adapted Japanese wood-carving techniques to the new subjects of Western-style sculpture, which were simultaneously observations of nature and the artist's exploration of forms in space. His first public work was a White-robed Kannon which he submitted to the first Domestic Industrial Exposition in 1877, and soon came to the attention of the *nihonga* movement's founder Okakura Kakuzō (1862–1913). When Okakura's Tokyo Bijutsu Gakkō opened in 1889, Kōun was appointed professor in the sculpture department, while also accepting commissions for portraits (usually in bronze) and private, interpretive works (usually carved in wood). An example of the latter is *Old Monkey* of 1892 (Fig. 421), the old but muscular subject twisting

422 *Hand*, by Takamura Kōtarō. 1918. Bronze; height 15 ⅜ in. (39 cm). National Museum of Modern Art, Tokyo.

refused to take over Kōun's studio as he had been expected to do—he was unwilling to accept commissions from wealthy patrons who might limit his creative freedom. It was Kōtarō's 1910 article, "The Green Sun," that inspired a number of Taishō-period artists to resist the tyranny of the establishment's naturalist and realist aesthetics. Although he thought of himself primarily as a sculptor, Kōtarō is best known today as a poet. However, his work in both bronze and wood, although small in size, often has a jewel-like quality. His *Hand* from 1918 is probably his best-known piece (Fig. 422), and may have been modeled after his own. The taut flexing of the fingers is a pose not easy to duplicate in real life, and is instead meant to evoke an emotional state, in keeping with the work of Kōtarō's hero Rodin and with his stance against rote reproduction from nature.

Ogiwara Morie spent more time, seven years, studying in New York and Paris and accordingly made better and longer-lasting contacts with sculptors there. However, for him also Rodin would prove to be the spiritual mentor of his further artistic development. While in Paris in 1904, he saw Rodin's *The Thinker* and subsequently introduced himself to the artist in 1906. The latter clearly welcomed the acquaintance and Ogiwara was a frequent visitor to his studio and clearly

424 *Woman*, by Ogiwara Morie. 1910. Bronze; height 39 in. (99 cm). National Museum of Modern Art, Tokyo.

absorbed many of Rodin's ideas. When he arrived back in Japan in 1908, he entered three works in the Bunten exhibition (see page 376), two of which he had completed in Paris and one, *Mongaku*, executed after his return (Fig. 423). Only the latter was accepted for display, the realism-obsessed committee feeling that the other two had not been completed—a reflection of its lack of understanding of the expressionism he had picked up from Rodin. *Mongaku* nevertheless won third prize and brought the artist to the attention of the Japanese art world. Mongaku (act. c. 1100–1203), the restorer of Jingoji, was a former warrior, and the sculpture powerfully evokes the monk's strong but aged body. The physical distortions, the very broad shoulders for example, coupled with such clearly expressed elements as the strength of Mongaku's gaze, create a potent image. Ogiwara had become fascinated with Mongaku when, in the course of studying classical Japanese sculpture, he saw a wooden image that Mongaku himself was thought to have made. Another motivation was that he, like Mongaku, had fallen in love with a married woman, although Ogiwara did not end by accidentally killing his beloved as had Mongaku. Ogiwara's most accomplished work, and also his last, is the bronze sculpture *Woman* of 1910 (Fig. 424). The kneeling nude figure with hands clasped behind and face turned upward has soft and voluptuous contours. Before this

423 *Mongaku*, by Ogiwara Morie. 1908. Bronze; height 35 ¼ in. (89.5 cm). Rokuzan Art Museum, Hodaka-cho, Nagano prefecture.

425 *Reincarnation*, by Hiragushi Denchū. 1920. Wood, with slight color; height 94 in. (239 cm). Tokyo University of Fine Arts and Music.

426. *Mu*, by Isamu Noguchi. 1950–1. Sandstone; height 89 ¾ in. (228 cm). Keiō University, Tokyo. Photo courtesy The Isamu Noguchi Foundation, Inc., Long Island City.

sculpture could be cast, Ogiwara became ill and died suddenly. In spite of the few works he produced after returning to Japan, he had a strong influence on contemporary sculptors through the knowledge he brought them of Rodin's work.

Another of Takamura Kōun's students, Hiragushi Denchū (1872–1979) remained relatively unaffected by Western sculpture, and focused instead on the expressive possibilities of traditional Japanese subject matter, materials, and techniques. He had begun his studies in Osaka, with a craftsman who made dolls for the Bunraku theater, but in 1897 he moved to the Tokyo Bijutsu Gakkō to study under Kōun. In 1907, he founded the Japan Sculpture Society, together with three other sculptors, and the following year exhibited his work in the society's first annual show. He caught the attention of Okakura, who encouraged him to continue working in wood. When the Nihon Bijutsu'in (Japan Fine Arts Academy) was reorganized after Okakura's death, he joined its sculpture department, and from 1914 until 1961, when the department was disbanded, he was its focal point. Hiragushi's masterpiece is *Tenshō* (*Reincarnation*) of 1920 (Fig. 425). A male figure clad in a loincloth, scarves draped across his torso, steps forward and leans over as if to vomit. From his open mouth appears the

head and upper torso of a tiny human figure. The main figure is reminiscent of a wrathful Buddhist defender of the faith—a Fudō Myōō or a Kongō Rikishi. Behind him is a halo of flames, symbolic of his burning energy. Another possible inspiration is the officials of hell who oversee the daily torture of the wicked. The tiny human is clearly a loathsome wretch at best—possibly so unpalatable that even a demon would not eat him—unworthy of release from the cycle of death and rebirth, the ultimate goal of Buddhist practice. Whatever the exact identification, the image's expression of divine disgust at the human condition is patently clear. Using traditional materials and fusing classic Buddhist themes, Hiragushi has succeeded in creating a powerful and modern statement.

In the postwar period bronze sculpture in the Western realist-expressionist style became an academic exercise whose heyday belonged to the Meiji and Taishō periods. Some sculptors emerged out of the folk-craft *mingei* movement, primarily working in wood, while others began experiments with a variety of combined materials as well as found objects which ultimately evolved into the installation and conceptual art to be discussed below. Perhaps most representative of the new forms of sculpture is the Japanese–American Isamu Noguchi (1904–88), who arrived in Japan in 1950 and quickly immersed himself in a study of the country's culture and art history. He regretted the Americanization of the Occupation years, and was an active supporter of the new traditionalism that emerged amongst liberals and artists in response to the militaristic trends of the Occupation and the Korean War. Until his death in 1988 he collaborated with leading figures of the art world and maintained a sculpture atelier in the country, producing large, abstract, biomorphic sculptures—usually of stone—heavily influenced by his immersion in Zen philosophy and poetry. A good example is the artist's first major commission in Japan, *Mu* (Fig. 426), made in 1950 to 1951. A visualization of the Japanese term for the Buddhist concept of "nothingness," the practitioner's prime objective, this had been a frequent subject of *zenga* (see Fig. 378). However, in contrast to the *zenga* tradition of creating an expression based on the *kanji* character for "*mu*," Isamu conceived an image of the concept with no other point of reference than to itself. This was an important aspect of contemporary Western concepts of form, such as in abstract expressionism, and Isamu has seemingly effortlessly applied it to Japanese tradition and culture.

Painting

BUNJINGA, ZENGA, AND HAIGA

The painting traditions that most serenely maintained their development with hardly a glance at the upheavals caused by the Meiji Restoration were *bunjinga*, *haiga*, and *zenga*, whose scholarly practitioners and audiences saw nothing in the modernization to interrupt their approach to artistic

expression. Indeed, each of these traditions had always placed an importance on the work being a personal expression of the artist, and this matched the modus operandi of the artists of the new Western-style traditions. In the first part of the Meiji period, there were a number of important *bunjinga* artists, including Tanomura Chokunyū (1814–1907), Murase Taiitsu (1803–81), and Tomioka Tessai (1837–1924). The most famous of these was without a doubt Tessai. Born in Kyoto to a merchant family dealing in Buddhist robes and accessories, Tessai was given a thorough education in the Confucian classics, history, poetry composition, and painting, with the aim of making him a Shinto priest. However, he was encouraged to continue his painting studies by the Buddhist nun Otagaki Rengetsu (1791–1875)—a famous poet and painter herself—and, although Tessai actually did serve as a Shinto functionary, he gradually shifted toward painting as a career. He favored *bunjinga* in particular, although throughout his life he explored such diverse styles as the Rinpa and *yamato-e*, as well as *Ōtsu-e* folk paintings.

One of Tessai's favorite themes was the well-established *bunjinga* subject of the life and poetry of Su Dongpo (1036–1101), perhaps because they were born on the same day. A pair of paintings executed in 1922 during his most creative period—when he was in his eighties—treats the subject of Su's visits to the Red Cliffs (Fig. 427). The compositions of Tessai's two paintings are almost identical; it is only the coloring of the foliage that indicates which is the first visit in the late summer/early autumn, and which the second visit in late autumn/early winter. The way Tessai has added patches of color to motifs delineated in strong strokes of dark ink constitutes one of his greatest innovations and gives his paintings a vivacity not often found in the work of earlier masters.

Bunjinga continued to be practiced after Tessai, but where Tessai still belonged to a larger culture that engaged with *bunjinga* as one of its essential cultural expressions, literati painting in the decades to follow never regained the territory it lost to the *yōga* and *nihonga* movements, and in its purest form has become the preserve of a few dedicated masters. However, as will be demonstrated below, its influences have always been evident throughout the history of *nihonga*, as well as the works of postwar artists. Similarly *zenga* has had a significant impact on modern art movements while also surviving with Zen compounds and practiced by Zen masters—as was envisioned by Hakuin Ekaku (1685–1768). One of these was Nantenbō (1839–1925), who in the late nineteenth century became one of the most well-known Buddhist masters of his day, attracting followers both from the top levels of society and the government. As a painter, Nantenbō probably has a claim to the greatest productivity, once announcing that he had produced over a hundred thousand works. Whether or not this was true, a vast number of his works survive, produced over the span of a very long life. One of his favorite subjects was Daruma, the founder of Zen Buddhism, and a common subject of *zenga* (Fig. 428). Indisputably, Nantenbō took as his model Hakuin's paintings of the founding patriarch, but he further abbreviated the

427 *The Second Visit to the Red Cliffs*, by Tomioka Tessai. 1922. Hanging scroll, slight color on paper; 57 ¾ x 16 ¼ in. (146.6 x 40.4 cm). Kiyoshi-Kojin, Seichoji, Takarazuka-shi, Hyogo prefecture.

428 *Daruma*, by Nantenbō. 1917. Hanging scroll, ink on paper; 59 ¾ x 32 ¾ in. (152.1 x 83.4 cm). Private collection, USA.

master's robe so that Daruma appears as a rather startled and comical face isolated in space and framed by a single, thick, rough brushstroke that represents his one-time robe.

Although prose-writing dominated literary circles in the late nineteenth and twentieth centuries, haiku remained the most popular poetic format. *Haiga* also, therefore, have continued to be painted by some of its modern masters. One of the twentieth-century's greatest practitioners was Hayashi Buntō (1882–1966), who spent part of his youth studying *nihonga* painting styles, but who ultimately turned towards haiku and expressed himself visually through their accompanying *haiga*. According to Stephen Addiss in his research on this genre, Buntō was particularly noted for his humor and direct visual expression as demonstrated by his *Autumn Neighbors* (Fig. 429), the haiku of which reads:

Shops by the beach
all closed and boarded up—
insect voices

Stephen Addiss, trans., from *Haiga: Takebe Sōchō and the Haiku-Painting Tradition*, University of Hawaii Press, Honolulu, 1995, p. 126.

The image is of a forlorn seaside holidaymaker dressed in a beach robe and scarf, but the dejected figure is unmistakably a *kappa*—a Japanese demon who inhabits the undersides of bridges and attempts to drown travelers unless they can trick him into emptying the reservoir of power-giving water he carries in an open cavity at the top of his head. The easiest way to do so is to wish the *kappa* a good day, bowing in the process. Out of politeness, the *kappa* is obliged to do the same, thus emptying his water reservoir. In Buntō's image, this reservoir is covered by a scarf, and his unhappy *kappa* is denied his fun by the end of the summer season.

NIHONGA: JAPANESE-STYLE PAINTING

Beginning in 1878, private and then public voices were raised in opposition to the dispersal of the nation's artistic heritage. The following year government leaders involved with Japan's participation in international expositions formed a private club called the Ryūchikai (Dragon Pond Society) to promote traditional arts. One of their aims was to encourage the kinds of Japanese arts preferred by foreigners in order to take advantage of the current Western craze stimulated at the world fairs for things Japanese. Another voice raised was that of Ernest Fenollosa (1853–1908), who had come to Japan from Harvard in 1878 to teach philosophy and political economy at the newly established Tokyo University. In a speech to the Ryūchikai in 1882, he strongly denounced the study of Western art, and two years later he joined with several members of the group and one of his former students, Okakura Kakuzō (1862–1913), also known by his art name of Tenshin, to form the Kangakai (Painting Appreciation Society) to encourage the study of traditional arts and the creation of a new approach of traditional painting.

According to Fenollosa, this new style should combine elements of Western painting, like perspective and shading, with traditional Japanese techniques, such as the use of water-based pigments on silk. He took as his model the output of the Kanō school. Fenollosa and Okakura also fostered the study of Japanese art history, and performed the invaluable service of cataloging and authenticating many works of art; Fenollosa went on to produce the first English history of East Asian art, *Epochs of Chinese and Japanese Art*. The two men also collaborated in the founding of the Tokyo Bijutsu Gakkō (Tokyo School of Fine Arts) and it therefore became a focus for the new movement for a Japanese style of painting. After Fenollosa's return to the United States in 1890, Okakura continued as director of the school until 1898, when a dispute

429 *Autumn Neighbours*, by Hayashi Buntō. Ink and colors on silk; 13 x 11 ½ in. (33.1 x 29.2 cm). Private Collection, USA.

with the Ministry of Education resulted in his forced resignation. He and several of his colleagues then founded a private school, the Nihon Bijutsu'in (Japan Fine Arts Academy), which took as its goal the synthesis of Japanese and Western art forms.

The first beneficiaries of the revived interest in traditional art were the painters Kanō Hōgai (1828–88) and Hashimoto Gahō (1835–1908). Hōgai's father, Kanō Seikō, had served as a painter for the Mori family, the daimyo of Yamaguchi prefecture. In 1840, at the age of nineteen, Hōgai was sent at the expense of the *han* to Edo for ten years of study with the Kanō master Shosenin (1823–80), son of Seisenin (1796–1846). In 1859, he received the commission to do ceiling paintings for the *honmaru* of Edo Castle, which had been destroyed by fire again that year. Yet despite his excellent training, his artistic talent, and his connections with the influential Kobikichō branch of the Kanō family, Hōgai fared badly in the pro-Western climate of the early years after the Meiji Restoration. To survive, he turned to such activities as casting iron and selling writing implements. He came to the attention of Fenollosa in 1884, when the latter saw his work at the Second Domestic Painting Competition and bought several of his paintings. With his preference for the Kanō style, Fenollosa saw in this artist a means to give reality to his concept of a new Japanese-style painting. Hōgai became active in the Kangakai, and in the last four years of his life achieved a synthesis of Eastern and Western elements in harmony with Fenollosa's ideals, as seen in his *Fudō Myōō* of 1887 (Fig. 430). The Fudō's

430 *Fudō Myōō*, by Kanō Hōgai. 1887. Hanging scroll, color on paper;
62 ⅜ x 31 ⅛ in. (158.3 x 79 cm).
Tokyo University of Fine Arts and Music.

when the Tokyo Bijutsu Gakkō opened, he was given the position of chief professor of painting. Later, in 1898, when Okakura resigned as director of the school to found the Nihon Bijutsu'in, Gahō followed him to become the principal instructor in the new institution. His *White Clouds, Red Leaves* of 1890 combines Western spatial perspective, in this case the atmospheric perspective preferred by Fenollosa, with a very traditional scheme of landscape composition (Fig. 431). Layers of rock formations overlap, carrying the eye back into distant space, which is obscured by mist and clouds.

Among Gahō's students were three men who became the movement's leaders in the first three decades of the twentieth century: Yokoyama Taikan (1868–1958), Shimomura Kanzan (1873–1930), and Hishida Shunsō (1874–1911). They forged a lasting friendship during their student days at the Tokyo Bijutsu Gakkō, and all three also taught at their alma mater, resigned when Okakura left, and helped him and

431 *White Clouds, Red Leaves*, by Hashimoto Gahō. 1890. Hanging scroll, color on paper; 103 x 63 in. (2.65 x 1.59 m).
Tokyo University of Fine Arts and Music.

dark-gray body and bright-red robe are modeled by highlights and shadows and have a solid volumetric quality, giving the figure a palpable physical presence.

Hashimoto Gahō, who was also a student of Kanō Shosenin, maintained the stylistic innovations of Hōgai and taught many of the new generation of *nihonga* painters. He also had experienced hard times immediately after the Restoration, and supported himself by painting fans for export to China and drawing maps for the Naval Cadet School. However, he also was discovered by Fenollosa, and in 1889,

432 *Fallen Leaves*, a pair of two-panel *byōbu*, by Hishida Shunsō. 1909. Color on paper; each screen: 60 x 60 in. (152 x 152 cm). Private collection, Tokyo.

Gahō form the Nihon Bijutsu'in. Yokoyama and Hishida were particularly close and when Yokoyama accepted a teaching position in Kyoto, Hishida accompanied him, and the two men collaborated in making a study of Buddhist temples in Kyoto and Nara. In 1903, the two traveled to India, and the next year they visited Europe and the United States. During these years Shimomura was in England studying watercolor painting, sponsored by the Ministry of Education. Yokoyama and Hishida developed a style that did not rely on the outlines which are a staple of much traditional Japanese ink painting, but instead defined forms with planes of color—an approach previously explored particularly by early *yamato-e* and later Rinpa artists.

The Rinpa influence is clear in Hishida Shunsō's *Fallen Leaves* of 1909, a pair of two-panel screens (Fig. 432). Only three visual motifs appear in the painting—trees, leaves, and three tiny birds powerfully evoking a quiet corner deep in the forest. Hishida has used a minimum of outline, none on the tree trunks and only the thinnest, lightest possible lines on the leaves; the trees are so tall that not even their lower branches can be seen; and the forms overlap each other in flat planes of color—all elements of the Rinpa vocabulary. This style of painting formulated by Hishida is called *mōrōtai* (murky style), and ironically attempts to bring Western techniques emphasizing space and light into *nihonga* by reducing or eliminating the reliance on line, and particularly on outlines. Alternatively called "muddled style" by his critics, it is more neutrally known as "buried-line technique."

Shimomura was more of a classicist, looking back not only to the Kanō style, as well as to Rinpa and *yamato-e*. Of the latter he was particularly renowned as a scholar. In his own

painting, he took his subjects from Japanese literature and Buddhist narratives. Perhaps because of his great interest in traditional art as well as his talent as a painter, in 1917 he was appointed Artist for the Imperial Household.

A dramatic and strikingly modern work is Shimomura's *Yorobōshi* (*The Beggar Monk*) of 1915 (Fig. 433). The theme is taken from a Nō play of the same name, in which the central figure is a blind monk, Shuntokumaru. Falsely accused of a crime and disowned by his family, he leads a vagrant's existence. The passage depicted occurs at the end of the play, when the blind mendicant looks to the west, and, holding the image of the sun in his heart, knows that it is about to set. So at one with the natural world is he, so deeply embedded in his heart are the distant blue mountains, that he sees in his mind's eye the entire landscape around him. The composition spreads across the twelve panels of a pair of folding screens, using a flowering plum tree set against a gold ground as the unifying motif. Between its curving branches the blind monk can be seen, his hands pressed together in a gesture of worship. He is a thin and pathetic figure, slightly hunched over, his angular face resembling a Nō mask. To the left, almost obscured by the trunk of the plum tree, a cluster of grave markers can be seen. The branches with their lush white blossoms extend horizontally onto the left screen and seem to reach out toward the orange circle of the setting sun. Shimomura's debt to Rinpa style, and in particular Ōgata Korin's *Red and White Plum Blossoms* (see Fig. 366), is obvious, and he has found in them a very modern expression.

Yokoyama Taikan's great contribution was in the further development of the *mōrōtai* style, and his *Floating Lights* of 1909 shows his handling of it (Fig. 434). The subject is a kind

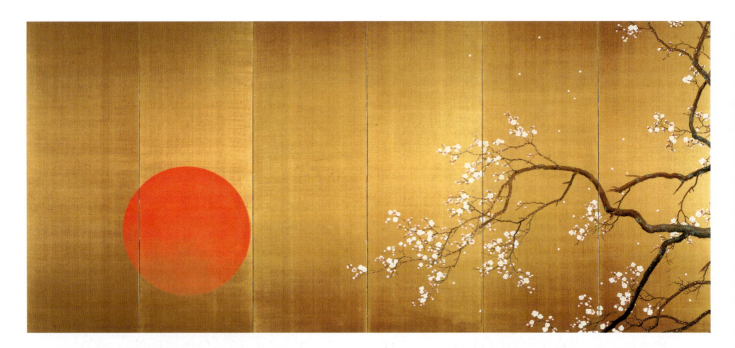

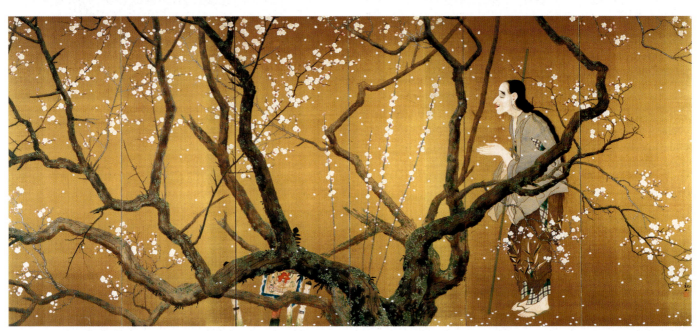

433 *Yorobōshi (The Beggar Monk)*, a pair of six-panel *byōbu*, by Shimomura Kanzan. 1915. Color and gold leaf on paper; each screen: 73 ⅜ x 160 ½ in. (187.5 x 407 cm). Tokyo National Museum.

of divination practiced in India which Hishida and Yokoyama had witnessed in Varanasi. To the right a young woman clad in a pale peach and white striped sari holds an earthenware plate filled with burning vegetable oil, shielding the flame upon it with her hand. In a moment she will bend down and float the plate on the water of the Ganges River. If it does not sink, and the flame is not extinguished, she will have good fortune in the future. Two other women have already placed their plates on the surface of the water and now, hands clasped in a prayerful gesture, watch intently to learn their fate. Yokoyama

has placed them in pale saris against the light gray of the stone steps beside the river, using no outline, only flat areas of color. The atmosphere of the painting is light and clear, almost as though it had been bleached by the hot Indian sun.

Yokoyama's 1898 painting *Kutsugen* suggests the mood of the artists in the newly established Nihon Bijutsu'in (Fig. 435). The eponymous subject is the Chinese poet Qu Yuan (act. third century B.C.E.), who like Sugawara no Michizane (845–903) fell from favor with his ruler, and in his despair drowned himself after composing his most famous poem—"Li Sao" (Encountering Sorrow). In Yokoyama's painting, he stands heroically against a hostile wind that whips the shrubbery beside him and raises clouds of dust behind. When the painting was put on view at the academy's first exhibition, it

was recognized immediately as a comment on the battle between Okakura Kakuzō and the hostile Ministry of Education, from which Okakura emerged alone (but for his artists) and scorned by the establishment. By 1906, Okakura's academy had fallen into such financial straits that it moved from Tokyo to Izura, a fishing village in Ibaraki prefecture to the northeast of the capital. Nevertheless, Okakura's disciples remained faithful. In 1914, a year after his death, Yokoyama and Shimomura, along with a new generation of *nihonga* artists, reorganized and revitalized the academy, which continues to be a viable institution today, holding two annual shows known as the Inten.

Although Okakura moved to Izura, he was still regarded as the guiding spirit of the *nihonga* movement, and the new generation of artists in Tokyo following that of Yokoyama, Shimomura, and Hishida fell equally under his influence. The principal members of this new group were Yasuda Yukihiko (1884–1978), Imamura Shiko (1880–1916), Maeda Seison (1885–1977), and Kobayashi Kokei (1883–1957). Yasuda was a student of the Tosa-school master Kobori Tomone (1864–1931), who had succeeded Shimomura Kanzan in the *nihonga* department of the Tokyo Bijutsu Gakkō after the latter departed with Okakura to found the Nihon Bijutsu'in. With his fellow students, he founded the Kōjikai organization, which served as the focus for the next fifteen years of the new generation's activities. In 1907, Yasuda and Imamura were invited to work under Okakura, and in addition received funding to study collections in Nara. In 1913, in the wake of Okakura's death, they helped Yokoyama Taikan reorganize the

434 *Floating Lights*, by Yokoyama Taikan. 1909. Hanging scroll, color on silk; 56 ¼ x 20 ½ in. (143 x 52 cm). The Museum of Modern Art, Ibaraki.

435 *Kutsugen*, by Yokoyama Taikan. 1898. Hanging scroll, color on silk; 52 x 114 in. (132.7 x 289. 7 cm). Itsukushima Shrine, Hiroshima prefecture.

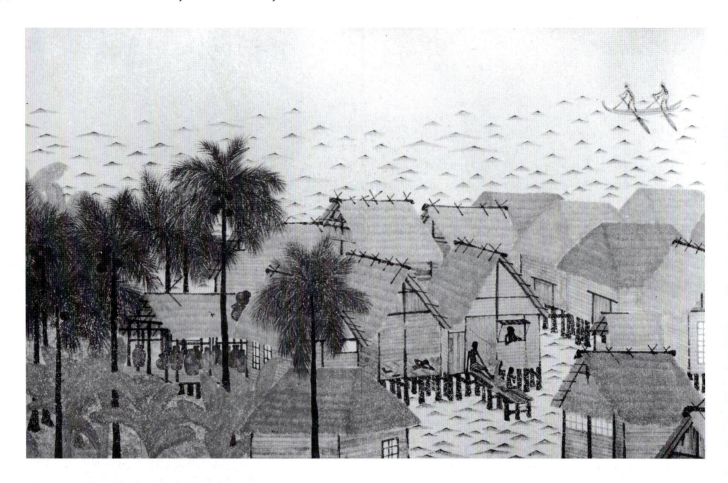

436 *The Tropics*, section of the hand scroll called *Morning*, by Imamura Shikō. 1914. Color on paper; height 18 in. (45.7 cm). Tokyo National Museum.

academy. Famous as the guiding force behind the Kōjikai generation, Yasuda is primarily remembered as an artist for his modernization and revitalization of the *yamato-e* style long fostered by the Tosa school at the imperial court. His colleague Imamura Shiko, however, took the *nihonga* principles into much less familiar territory. His masterpiece, *The Tropics*, was based on a trip to India in 1914, and is a seamless and moving blend of Eastern and Western techniques (Fig. 436). The work consists of two *yamato-e*-style hand scrolls depicting a south Indian landscape in the morning and evening. The absence of outlines is a nod to Rinpa technique, and the naive charm and repetitive brushstrokes are particularly reminiscent of the work of the postimpressionists Vincent van Gogh (1853–90) and Paul Gauguin (1848–1903).

Maeda Seison and Kobayashi Kokei, who joined the Kōjikai in 1907 and 1910 respectively, had been students of Kajita Nanko (1870–1917), a newspaper and magazine illustrator trained in the Maruyama–Shijō school still prevalent in Kyoto. Life-long friends, they too fell under Okakura's influence, and at his suggestion studied the Rinpa aesthetic, and accordingly adapted their styles. In 1922, both men traveled to London, where they studied and copied one of the most

famous and earliest of Chinese paintings, Gu Kaizhi's (c. 344–c. 406) *Admonitions of the Court Instructress to the Ladies of the Palace*, in the possession of the British Museum. Maeda Seison's best-known work is *Yoritomo in a Cave* of 1929 (Fig. 437), in which he treats the episode from the *Heike monogatari* in which Minamoto no Yoritomo (1147–1199) and six of his warriors have retreated from the Taira forces and hidden in a mountain cave. Yoritomo sits surrounded by his men, waiting for the enemy to move out of the area. Maeda's knowledge of the two types of armor worn in the twelfth century is clearly demonstrated in the picture, and is a result of his careful study of old hand scrolls. However, the painting has many elements derived from the Rinpa school: for example, the monumental size of the figures and the use of the *tarashikomi* technique of layering wet colors first developed by Sōtatsu.

One of Kobayashi Kokei's greatest masterworks is an early painting, *Amidadō* of 1915 (Fig. 438). The long and narrow format of the hanging scroll is divided horizontally by a brightly colored representation of the Phoenix Hall of the Byōdōin (see Fig. 172). The effect is to suggest that the moon has suddenly illuminated the temple, splashing light across the upper part of the red posts, leaving the lower part in shadow. Through the open doors, the Amida statue can be clearly seen, as if there were a second light source in the building emanating from the golden Buddha. Kobayashi's vision is wonderfully romantic, yet not in the least sentimental.

437 *Yoritomo in a Cave*, a two-panel *byōbu*, by Maeda Seison. 1929. Color on silk; 59 ⅜ × 109 ½ in. (150.9 × 278 cm). The Okura Cultural Foundation.

438 *Amidadō*, by Kobayashi Kokei. 1915. Hanging scroll, color on silk; 85 × 35 ⅝ in. (216 × 90.6 cm). Tokyo National Museum.

Nihonga painting in Kyoto centered around artists trained in the Maruyama–Shijō school, which from the eighteenth century had incorporated elements of Western realism— perspective, the modeling of form through the use of highlights and shadows, and drawing directly from nature. One of the most influential figures of this Kyoto *nihonga* was Takeuchi Seihō (1864–1942), who in 1881 began studies with the Maruyama–Shijō master Kōno Bairei (1844–95). Takeuchi later opened his own private art school and also taught at the Kyoto Prefectural Painting School, helping to cultivate the next generation of *nihonga* artists in Kyoto.

One of Takeuchi's students in the 1890s was Uemura Shōen (1875–1949), Japan's most notable female painter of this pre-World War II period, and the first woman to receive the Order of Cultural Merit. Shōen was born the second daughter in a family that sold tea, also serving brewed tea to special clients. Following her father's death two months before she was born, her mother continued to run the shop as well as to raise her daughters. When Shōen showed a talent for painting, her mother made it possible for her to enter the Prefectural Painting School in 1888. Two years later, at the age of fifteen, she won a prize for her painting *Beautiful Women of the Four Seasons*. Shōen continued working with the *bijinga* genre, and in the first two decades of the twentieth century she turned to the related genre of depictions of famous female characters in Nō plays, aiming to express not just their physical appearance but also their innermost feelings. In order to capture the look of a mad woman, she spent time at an insane asylum outside Kyoto, observing and sketching some of the inmates.

In the 1930s, Shōen returned to the subject of *bijinga*, and due to her psychological studies managed to imbue these images with an emotional depth that elevates them above the level of a rather refined "pin-up." *Evening*, painted in 1941, is typical of this late work (Fig. 439). Shōen said of this picture, in which an industrious and frugal young woman tries to thread a needle by moonlight, that she wanted to depict a

439 *Evening*, by Uemura Shōen. 1941. Color on silk; 84 ½ in. x 42 in. (214.5 x 99 cm). Private collection.

young woman of the Edo period reminiscent of her own mother. In 1941, Japan was in the midst of its epic effort at empire building, and, as part of the war effort, women were entreated to tend to their families and to conserve the country's resources. Shōen has created a lyric interpretation of this government directive.

Another Kyoto *nihonga* artist known for *bijinga* was Kaburagi Kiyokata (1878–1972). He came to the subject through his training as an *ukiyo-e* artist, and he went on to train two of the best woodblock-print designers of the early twentieth century, Ito Shinsui (1898–1972) and Kawase Hasui (1883–1957). In 1901, Kiyokata began to move from printmaking to painting, and he was so successful in making the transition that in 1919 he was appointed a judge for the

government-sponsored Teiten exhibition (see page 376). The typical Kiyokata figure is a young, slender and graceful woman who seems fragile and vulnerable—a woman with a traditional upbringing whose role in the new reality of the twentieth century is not clear. This model had a living representative in the author Higuchi Ichiyō (1872–96). Ichiyō was a precocious child, writing poetry before she was eleven years old, and as a young adult she went on to make a considerable reputation as a writer. However, after her father's death, the responsibility for supporting her family fell on her, and the strain of trying to write and maintain the household at the same time contributed to her death from tuberculosis at the age of twenty-four.

Kiyokata and Ichiyō never met, but in 1934 he executed a group of paintings illustrating her novella *Nigorie* (translated as *Troubled Waters*), written the year before her death. In 1940, he returned to her as a subject, painting a portrait that was shown in the exhibition celebrating the 2,600th anniversary of the founding of Japan (Fig. 440). Kiyokata shows her sitting pensively in the light of an oil lamp, with wrapping paper lying open in front of her revealing swatches of cloth. In their penury, Ichiyō had moved the family to a less desirable neighborhood frequented by prostitutes and there began to do sewing for the locals. Kiyokata has thus captured Ichiyō's dilemma—the desire to write overshadowed by the need to generate income—and created within the *nihonga* tradition of painting an insightful and moving "portrait of the artist."

YŌGA: WESTERN-STYLE PAINTING

As one of the Tokugawa *bakufu*'s efforts after 1853 to open up to the West, they established in 1855 a bureau for the study of Western documents, first known as the Yōgakusho (Bureau of Western Studies), but renamed the next year Bansho Shirabesho (Institute for the Study of Western Books). Here Western styles of painting and drawing were studied not because they were seen to have intrinsic value but rather because mastery of them was considered essential for catching up technologically with the West. The most important artist to emerge from the Bansho Shirabesho was Takahashi Yuichi (1828–94). Born in Edo to a low-ranking samurai family, Takahashi had received lessons in the Kanō style of painting, along with training for a military career. However, Takahashi decided that his talents lay in painting, and specifically in Western-style painting. Taking the only route then available, in 1862 he entered the Bansho Shirabesho, where he distinguished himself as the first artist to fuse the objective description and subjective interpretation of a visual image in a Western-style painting. Next he turned to the English journalist Charles Wirgman (1835–91) for further training. Wirgman, the Japan correspondent for the *Illustrated London News*, was not a professional painter, but a very talented amateur who helped Takahashi gain mastery over the Western techniques. Takahashi went on to open his own school for the teaching of Western art and subsequently played an

440 *Ichiyō*, by Kaburagi Kiyokata. 1940. Color on silk, in the form of a hanging scroll; 56 ½ x 31 ¼ in. (143.6 x 79. 4 cm). Tokyo University of Fine Arts and Music.

441 *Oiran* (courtesan), by Takahashi Yuichi. 1872. Oil on canvas; 30 ½ x 21 ⅝ in. (77.5 x 55 cm). Tokyo University of Fine Arts and Music.

important role in the creation of *Kōkka*, the first Japanese art journal, and added his support for the establishment of an art museum in the 1870s. A particularly interesting example of his work is the 1872 oil painting *Oiran* (*Courtesan*; Fig. 441). According to a contemporary report in the *Tōkyō Mainichi Shinbun* (*Tokyo Daily Newspaper*), the painting was a commission from a gentleman who wanted a portrait of the geisha Koine of the Inamotoro House, specifying that she be depicted with the intricate hairstyle known as *hiyōgomage*, which had, to his regret, fallen from fashion in the city's pleasure districts. What the artist has achieved in this painting is much more than social documentation. The geisha sits in a slumped position, her gaze unfocused, her expression enigmatic. The numerous hairpins used to keep the complicated hairstyle in place provide a sharp contrast to this stolid human figure and suggest something of the artificiality of the geisha's life.

The next generation of Western-style painting, however, would be products of the Kōbu Bijutsu Gakkō (Technical Fine Arts School) established soon after the Restoration. Like the Tokugawa, the Meiji government's initial interest in Western art was for what could be gleaned from it of such Western-style disciplines as cartography, drafting, and architectural rendering. Fortunately, however, for the students, the instructors who were brought from Europe were of more aesthetic bent: the architect Giovanni Cappelletti (d. c. 1885), who taught the basic principles of geometry and perspective; Vincenzo Ragusa (1841–1928), who gave instruction on modeling in clay and plaster, and Antonio Fontanesi (1818–81), who taught drawing and painting. Thus in 1877, at the same time as the Japanese architects Tatsuno, Katayama, and Sone were beginning their instruction under Josiah Conder at the Kobū Daigakkō (University of Technology), the Japanese painters who were to establish Western-style painting, or *yōga*, as a viable form of expression began their studies under Italian masters.

442 *Shinobazu Pond*, by Antonio Fontanesi. 1876–8. Oil on canvas; 20 ½ x 28 ⅞ in. (52 x 73.3 cm). Tokyo National Museum.

Ragusa's influence has already been discussed in relation to sculpture (see page 356), while Cappelletti's impact was primarily on the technical side. The first generation of *yōga* painters' aesthetic and stylistic tutoring, however, came from Fontanesi, an adherent of the Barbizon school of landscape painting, who particularly held up for admiration the works of Camille Corot (1796–1875) and Charles-François Daubigny (1817–78). At the time of his invitation to teach in Japan, Fontanesi had achieved a degree of prominence in European art circles, having been appointed professor of landscape painting at the Royal Academy of Art in Turin. By all accounts, he was a man of great personal warmth who cared deeply for his students and for their training. So great was the loyalty he inspired that after he was forced by ill health to return to Italy in 1878, his students could find no one worthy of taking his place. After they had appraised his replacement, eleven of them withdrew from the Kōbu Bijutsu Gakkō to form their own study group, which they called the Society of the Eleven and which would spearhead the future of the *yōga* movement. An excellent example of Fontanesi's work in Japan is *Shinobazu Pond*, an oil painting depicting the small lake to the southwest of the Tokyo National Museum in Ueno Park (Fig. 442). Fontanesi has chosen the moment of sunset as his subject, and he depicts the last rays of pink light glistening on the surface of the pond while the trees and marsh grass around its perimeter begin to fade into brown dusk.

Tranquillity and lyrical beauty, the hallmarks of Fontanesi's work, pervade the painting.

One of Fontanesi's devoted students was Yamamoto Hōsui (1850–1906), a young man who came to the Kōbu Bijutsu Gakkō from Kyoto, where he had studied *bunjinga*. So complete was Yamamoto's conversion to Western art that after a year at the school he journeyed to Paris to study with Jean-Léon Gérôme (1824–1904), a master of the kind of conservative,

443 *Nude*, by Yamamoto Hōsui.
c. 1880. Oil on canvas; 32 ⅝ x 52 ⅞ in. (83 x 134.4 cm).
The Museum of Fine Arts, Gifu.

academic history painting which dominated the French Salon during much of the nineteenth century. Yamamoto was the first Japanese artist to study abroad, but he was soon followed by other Fontanesi students as well as by future sculptors and *nihonga* artists. The painters found places in the classrooms of academicians rather than of more avant-garde artists primarily because it was these painters who took on students in their ateliers. Thus, although these future *yōga* masters obtained a solid foundation in classical European painting techniques, they inadvertently limited themselves to working in styles that were already becoming passé. *Nude*, an oil painting executed by Yamamoto around 1880 during his stay in Paris, illustrates both his stylistic accomplishments and the academic character of his pictorial themes (Fig. 443). A beautiful, technically accomplished painting, it is one that, in terms of style, looks back to a time when this type of idealized representation was fresh and original. Perhaps Yamamoto's greatest contribution to the development of *yōga* was his conversion of Kuroda Seiki (1866–1924), a young scion of a politically prominent family, from a career in law to one as a painter. Kuroda eventually went on to become one of the most successful practitioners of *yōga* in the Meiji period.

Without question, Fontanesi's most talented pupil was Asai Chū (1856–1907). Born to a samurai family, Asai was first educated in a *han* school where, among many subjects, he was taught *bunjinga*. At the age of sixteen he went to Tokyo to study English, but he became much more interested in painting. Finally, after a year of study in a private studio, he entered the Kōbu Bijutsu Gakkō and came under Fontanesi's influence. Dissatisfied with the latter's replacement, in 1878 Asai withdrew from the school as one of the Society of the Eleven. The subsequent decade of the 1880s was a difficult time for *yōga* artists, as the pendulum of public favor swung towards traditional Japanese arts, so in 1889 a group of artists and intellectuals who believed in the importance of Western-style painting founded the Meiji Art Society to promote their point of view. Asai, a founding member of the society, contributed one of his masterpieces, *Harvest*, to their annual exhibition in 1890 (Fig. 444). Soft golden light pervades the painting, giving the whole a lyrical, unfocused quality much like that found in Fontanesi's work. Then, in 1893, Asai's career collided with that of Kuroda Seiki. This was the year Kuroda returned from a decade in France, bringing with him a new style of plein-air painting using the bright colors of the French impressionists. Suddenly Asai's work looked old-fashioned. For seven years Asai and Kuroda maintained an uneasy truce, and when Asai was given the chance in 1900 to travel to France to study, he took it as an opportunity to sever his connections with Tokyo *yōga* circles. He stayed in France for two years, painting prodigiously, turning out some of his best work, and after his return to Japan he established himself in Kyoto, in the Kyoto Higher School of Design.

Overshadowed by Kuroda, Asai was not appreciated in his own lifetime. Today, however, he and Kuroda are recognized as

444 *Harvest*, by Asai Chū. 1890. Oil on canvas; 27 ¼ x 37 ⅞ in. (69 x 98.5 cm). Tokyo University of Fine Arts and Music.

445 *Autumn at Grez*, by Asai Chū. 1901. Oil on canvas; 31 ¼ x 23 ⅝ in. (79.5 x 60 cm). Tokyo National Museum.

446 *Morning Toilet*, by Kuroda Seiki. 1893. Oil on canvas; 70 ¼ x 38 ⅝ in. (178.5 x 98 cm). (Destroyed.)

the two most talented masters of the early *yōga* movement. One of Asai's most famous paintings from his sojourn in France is *Autumn at Grez* of 1901 (Fig. 445). Grez-sur-Loing was a small town to the south of Paris, near Fontainebleau, where Asai spent six months, from October 1901 to March of the following year. The poplar tree, a common feature of the local countryside, is a motif he painted over and over again while in Grez. As with *Harvest*, yellow, green, and light-brown tones dominate the painting, offsetting the gray of the bare limbs and trunks.

Kuroda Seiki, Asai Chū's rival, also came from a samurai family. However, at the age of four he was adopted by his uncle, Kuroda Kiyotaka (1840–1900), a major figure in the Meiji Restoration, and was groomed to play an important role in politics. In 1884, he was sent to Paris to study law but, through the intervention of Yamamoto Hōsui, he was diverted to a career as a painter. To this end he studied with Raphael Collin (1850–1916), an artist noted for his paintings of nudes and also for large-scale figural works for public commissions. The most controversial and also the most accomplished painting Kuroda produced during his stay in France is his *Morning Toilet* of 1893 (Fig. 446), which was sadly destroyed during World War II. Its nude Western woman standing in front of a

mirror was first shown in Paris at the Société Nationale des Beaux-Arts, where it won acclaim. After Kuroda's return to Japan it was exhibited again, where it was considered pornographic—a frontal female nude having never before been a subject for public display. Acceptance of the nude in art did not come until several decades later.

Nevertheless, the style of painting and the palette of colors Kuroda brought with him from France were well received by the younger *yōga* artists tired of Fontanesi's quiet, somber landscapes. Although not an impressionist himself, Collin's great influence on Kuroda was to introduce him to the light, bright colors used by the French impressionist school, which

had been in part inspired by the palette of Japanese woodblock prints. Collin used the impressionists' lighter palette, but his plein-air realism did not follow the impressionists' theories about natural light and the use of color. However, a generation of Japanese *yōga* painters in the 1890s came also under Collin's influence—largely through Kuroda's work—and it was their understanding that this was impressionism. It must also be said that Kuroda's coming from a politically powerful family gave his paintings and his ideas particular importance and contributed to their acceptance.

The clash of Kuroda's new style with that of Fontanesi—as exemplified by the works of Asai—was dubbed the "Brown versus the Purple." The new generation even adopted *bunjinga* terminology to qualify Kuroda's bright palette as "southern" and the more subdued palette of Fontanesi and Asai as "northern." The battle escalated to the point where in 1896 Kuroda and several young artists resigned from the Meiji Art Society to form the Hakubakai (White Horse Society), which held rival exhibitions and constituted a powerful force in the art world until 1911, when it was dissolved. Kuroda's other great contribution was to stimulate an appreciation for *yōga* among the general public, and in 1897 he achieved something that would have been unthinkable in the previous decade. He was invited to teach Western-style painting at the Tokyo Bijutsu Gakkō, the institution initially founded for the promotion of *nihonga*.

Aoki Shigeru (1882–1911) belonged to the younger generation who most benefited from the liberating influence of Kuroda's lighter palette of colors. Born to a family who served as retainers to the Arima clan in Kyūshū, Aoki took no interest in his inherited position. Instead, as soon as his father grudgingly permitted him to do so, Aoki left for the heady intellectual and artistic climate of Tokyo, and the following year, 1900, he was admitted to the Tokyo Bijutsu Gakkō, and exhibited frequently at the Hakubakai. As a youth, Aoki was attracted to the Romantic literary movement which had been adapted from its early nineteenth-century European origins into a vibrant interpretation using Japan's own rich mythology and legends. Aoki tried to combine in his paintings interpretations of Japanese myths with what he felt to be a deeply personal stylistic expression. His most famous work is an oil painting executed in 1907, *Palace Under the Sea* (Fig. 447). Unfortunately, however, by this time Romanticism's popular appeal was on the wane, and when his painting was first exhibited at the Tokyo Industrial Exposition it received a poor reception.

The myth concerns two brothers, one a skilled hunter and the other a skilled fisherman. One day they decide to exchange their roles, but the hunter soon loses his brother's precious fishhook and descends to the bottom of the sea to find it. Aoki depicts the young man sitting on the branches of a tree in the garden of the underwater palace, falling in love with its princess, on the left, who is accompanied by her servant. The hunter marries the princess and lives under the sea, but ultimately decides to return to his own world, and the pregnant

447 *Palace Under the Sea*, by Aoki Shigeru. 1907. Oil on canvas; 71 ⅞ x 27 ½ in. (181.5 x 70 cm). Ishibashi Museum of Art, Ishibashi Foundation, Kurume, Fukuoka prefecture.

princess follows him. As she gives birth, however, her husband breaks her injunction and looks at her, and instead encounters the form of a crocodile. The shamed princess abandons her child and flees back to her father's palace. Aoki's life, too, had a sad ending. He returned to Kyūshū after his father's death

448 *Butterflies*, by Fujishima Takeji. 1906.
Oil on canvas; 17 ½ in. square (44.5 cm). Private collection.

held each autumn, and its exhibits were chosen by a committee of jurors. There were three sections in the show: Japanese-style painting, Western-style painting, and sculpture, each with its own group of judges. Initially the Bunten exhibitions permitted rival factions to exhibit side by side and to receive the approval of the cultural establishment—leaders in the art world and in government. It also provided artists with a showcase enabling them to attract buyers, at a time when the wealthy were more often concerned with the latest fashion in modern gadgetry than in the arts, traditional or otherwise. However, over time the judging, particularly in the *yōga* section, became rigidly conservative, and in order to gain entry to the exhibition, artists were forced to paint to please the jurors.

In 1914, a group of young artists rebelled and founded their own group, called the Nikakai (Second Division Society), which was in essence the Japanese equivalent of the French Salon des Refusés. Nevertheless, the Bunten continued to provide an important public forum for artists, as well as an artistic standard to accept or reject. In 1919, the annual exhibition was reorganized into the Teiten (Exhibition of the Imperial Fine Arts Academy), and in 1935 into the Shin Bunten (New Bunten). In 1958, it was again renamed—the Nitten (Japan Art Exhibition)—and its sponsorship was transferred from the government to a private organization by the name of Nitten, Incorporated.

and was expected to support his now impoverished family. Unequal to the responsibility, he drifted into a life of vagrancy, and died at the age of twenty-nine of tuberculosis.

The other major artist to gain recognition through participation in the Hakubakai was Fujishima Takeji (1867–1943). Perhaps because both he and Kuroda Seiki came from Kagoshima in Kyūshū, they developed a close friendship. Kuroda allowed the younger artist to study the Western paintings he had brought from Paris, and when Kuroda was appointed to the Tokyo Bijutsu Gakkō, he designated Fujishima as his assistant. Not surprisingly, the young artist's early works were executed in the style developed by Kuroda. However, through association with the artists of the Hakubakai, Fujishima began to develop his own personal idiom. *Butterflies*, of 1904, is a representative work from this period (Fig. 448). A young girl kissing a flower is highlighted against a ground of deep blue, and flying around her are a swarm of butterflies. Some shading has been used to model the girl's face and hands, but the overall impression of the painting is one of flat, two-dimensionality, a thoroughly modern work that nevertheless draws on Japan's rich decorative tradition. In 1905 Fujishima was sent abroad by the government to study painting, first in Paris and then in Rome. When he returned to Japan, he was appointed professor at the Tokyo Bijutsu Gakkō.

One event altered entirely attitudes to painting at the end of the Meiji period—the founding in 1907 of the Monbushō Bijutsu Tenrankai (Ministry of Education Fine Arts Exhibition), popularly known as the Bunten, and the Japanese equivalent of the official Salon in France. This exhibition was

449 *Reiko with a Woolen Shawl*, by Kishida Ryūsei. 1920. Oil on canvas; 17 ⅜ × 14 ¾ in. (44.2 × 36.4 cm). Tokyo National Museum.

450 *Portrait of Mrs. F.*, by Yasui Sōtarō. 1939. Oil on canvas; 34 ⅝ x 26 in. (88 x 66 cm). Private collection, Tokyo.

Some measure of the energy in *yōga* painting circles in the early twentieth century can also be taken by looking at a cross section of the art-related events that took place in 1910. The magazine *Shirakaba* (*White Birch*) was founded, and continued publication until 1923. The moving force behind the magazine was a group of writers, including the novelist and playwright Mushanokōji Saneatsu (1885–1976) and the novelists Shiga Naoya (1883–1971) and Arishima Takeo (1878–1923), men who had known each other since school in Tokyo. In addition to literary contributions, each issue contained an article on contemporary Western art, providing many Japanese artists with their first exposure to such

451 *Reclining Woman*, by Yorozu Tetsugorō. 1912. Oil on canvas;
63 ¾ x 38 ¼ in. (162 x 97 cm). National Museum of Modern Art, Tokyo.

important European artists as Paul Cézanne (1839–1906), Vincent van Gogh, and Paul Gauguin. In this same year, the poet, art critic, and sculptor Takamura Kōtarō (1883–1956) published in the literary magazine *Subaru* (*Pleiades*) an essay titled "The Green Sun," in which he advanced the idea that truly Japanese modern art would be created only if Japanese artists could learn to express their unique and personal view of the physical world. The recreation of the artist's authentic vision would make a work more Japanese than the addition of ethnic details. As a by-product of his belief in individual artistic expression, he further supported the cause of anti-naturalism. In response to this essay the *yōga* painter Saitō Yori (1885–1959) organized an exhibition of his own works at which like-minded artists including Kōtarō, Kishida Ryūsei (1891–1929), and Yorozu Tetsugorō (1885–1927) met. Their discovery of each other resulted in the creation in 1912 of the Fusainkai (Sketching Society), the first organization to rebel against the conservatism of the Bunten. Its avowed aim was to

promote fauvism in Japan. In the early twentieth century the images, ideas, and techniques of postimpressionism, fauvism, cubism, and surrealism were to appear in Japan in quick succession. Greater numbers of painters were traveling with the result that misinterpretation, such as occurred with Japan's first, limited exposure to impressionism in the 1890s, would no longer be a problem.

Kishida Ryūsei was the son of a well-known journalist, Kishida Ginkō, and was raised in an intellectual and culturally rich milieu. He began his study of painting under Kuroda Seiki and achieved recognition at an early age. When he was only nineteen, a painting of his was selected for the fourth Bunten exhibition. Through the *Shirakaba* magazine he discovered the postimpressionists, and he himself admitted that his early work was "unabashedly painted in the style of van Gogh." Later he discovered the Late Gothic imagery of the German printer Albrecht Dürer (1471–1528) and the Flemish painter Jan van Eyck (1390–1441). Inspired by Kōtarō's "Green Sun" article, Kishida formulated a rationale for his own work, independent of the styles of his mentors. After his house was destroyed in the 1923 Tokyo earthquake, Kishida moved to Kyoto and began to experiment with painting in a more traditional *ukiyo-e* style. He died after a short illness in 1929. Kishida's best-known work is a series of portraits of his daughter Reiko, including the 1920 *Reiko with a Woolen Shawl* (Fig. 449). At the time of this painting, Reiko was six years old. The artist has captured the full cheeks of the young child as well as an intensity of expression in her eyes. The smooth planes of her face contrast sharply with the texture of her woolen shawl.

Of the early twentieth-century *yōga* painters, Yasui Sōtarō (1888–1955) stayed the longest abroad. Raised in Kyoto, he studied with Asai Chū following the latter's return from France and, after Asai's death in 1907, Yasui left for Paris, where he studied at the Académie Julian with Jean-Paul Laurens (1838–1921). One of the most formative experiences of his stay was the Cézanne retrospective exhibition of 1907, which gave him the opportunity to study the evolution of the master's style. After three years, Yasui left the Académie to develop an independent idiom of his own, and in 1914 the outbreak of World War I forced him to return to Japan. For the next fifteen years Yasui struggled to find an authentic style that would combine what he learned in France with a personal and Japanese mode of expression. By his own admission he did not think he had achieved this until 1929. From then until his death in 1955, Yasui further refined his technique and became one of the greatest *yōga* painters.

Among Yasui's undisputed masterpieces is the *Portrait of Mrs. F.* of 1939, which effectively captures the subject's personality (Fig. 450). Mrs F. was the wife of a businessman and art collector, an articulate woman who launched a career as an essayist after World War II. She has assumed a Western pose, her legs crossed and her body at a slight angle. However, Yasui places her against a brownish-yellow ground dotted with green and white Japanese-style medallions, an odd

background for such a Westernized woman. It is perhaps a commentary on Mrs. F.'s position between two worlds. The sitter is given some volume, but is placed in a shallow space that tends to flatten the total image. Yasui has blended such Japanese elements as flatness and decorative motifs with Western details, in this case the costume and pose of the sitter.

Yorozu Tetsugorō was probably the most cerebral and innovative of the *yōga* artists in the Taishō period. Experimenting with one European style after another, from fauvism to futurism and cubism, he was able to achieve his own personal expression in each of them. He began his artistic training at the Hakubakai, followed by six months in the United States, and then entered in 1907 the Western painting section of the Tokyo Bijutsu Gakkō. In 1912, the year of his graduation, he joined Takamura Kōtarō and Kishida Ryūsei in founding the Fusainkai. However, in 1919, he suddenly turned his back on *yōga*, and moving to Kanagawa prefecture in that same year began to study and paint in the *bunjinga* manner, with an attempt to blend into it Western elements. His *Reclining Woman* of 1912 is a good example of his unique vision for *yōga* (Fig. 451). A woman, nude to the waist, lies on a grassy hill. Above her head are trees, a distant mountain range, and a big white cloud. More subtly, the picture contains three subject areas shown from different perspectives. The grass on which the woman reclines is treated as though it were a receding, slanting plane. At the bottom of the painting, the leaves are large and detailed, while toward the middle they are smaller and more impressionistically rendered. Finally, the background details are represented as though the viewer is looking down on them. Yorozu said of this work that he was attempting to meld the styles of Henri Matisse (1869–1954) and Vincent van Gogh. Those influences can be seen, but the painting is certainly Yorozu's own vision.

Umehara Ryūsaburō (1888–1986), like Yasui, was born and raised in Kyoto and studied with Asai Chū. In 1908, he went to France with the avowed intention of studying with Auguste Renoir (1841–1919), which he did for five years, meeting some of the outstanding artists of the day, including Pablo Picasso (1881–1973), who encouraged him to travel in Spain to study images in a different kind of light. Two experiences strongly influenced Umehara's painting: the work of Renoir and his own early exposure to the silk-weaving industry in Kyoto. From these two sources he was able to develop a style that combined flat decorative patterns with brilliant colors. The *Tzu-chin-ch'eng Palace* of 1940 reflects Umehara's mature style (Fig. 452) and also his six visits to the Chinese capital between 1939 and 1943, when the city was occupied by the Japanese. The subject is the palace of the emperors of the Qing empire, and is a riot of color, with the light orange of the tile roofs, the red–orange of the stucco walls, the vibrant green trees, the blue–white of the clouds. Pigment is applied in broad areas with details roughly sketched. Umehara has used a shifting perspective, showing the first palace buildings from above, and the next group from the side. The effect of the painting is flat and decorative, rather like a gorgeous textile pattern.

POSTWAR ABSTRACTIONS

With the end of the war, and the beginning of the Allied Occupation, all the restrictions on subject matter imposed during wartime were lifted. In the subsequent decades both *yōga* and *nihonga* continued to be practiced. However, Western-style painting was to come under renewed influence from the West from surrealism, dada, and abstract expressionism. The term *yōga* came to refer to artists practicing a more academic style that looked back to the prewar oeuvre dominated by fauvism and expressionism, while the work of artists engaging with the new influences was called **gendai kaiga**, literally "contemporary painting." By the 1960s the impact of these new influences went beyond working in oils, and also embraced multimedia and performance art, mirroring developments internationally. Japan now entered the international art scene and market. *Nihonga*, like *yōga*, became an academic exercise and was often criticized by the postwar generation for its mindless devotion to technique. For most of the second half of the twentieth century, both *yōga* and *nihonga*, were bywords for the unfashionable, but recently there has been a reappraisal of the prewar styles and masters, and it remains to be seen what the present generation of artists will make of them.

The anti-traditional stance of the late 1940s and early 1950s, however, was already being met by a reaction amongst certain artists, particularly those inspired by the *mingei* movement of folk art. Curiously enough where tradition in the prewar environment was dominated by a conservative, aggressively nationalistic ethos, the new traditionalism that arose in the postwar era had a decidedly liberal air. In part this had to do with the *mingei* movement, which, appealing to the *wabi* aesthetic, emphasizes that art comes from the people and world around them and places equal value on village craft as on the produce of the trained artist. For this reason, the polished techniques of *nihonga* ateliers did not become the natural focus for this new traditionalism. In part also the traditionalism was a reaction by a portion of the population against governmental neo-, and strictly contained, militarization, as encouraged by the Americans in the face of their Korean and Vietnam campaigns.

One group representative of this new traditionalism is the Bokujinkai (Ink Human Society). Founded in 1952 in Kyoto by a group of five calligraphers, it looked to calligraphy as the basis of East Asian culture, and sought to reconceptualize it as a kind of expressionist painting. Foremost among this group are Morita Shiryū (1912–99) and Inoue Yūichi (1916–85). Morita became particularly famous for utilizing the Momoyama-style gold screen as his canvas (Fig. 453). In the four-panel screen entitled *Okitsu (Offing)*, Morita has used lacquer and ink to create a calligraphic landscape out of the characters of the title. The term "offing" refers to the moment of departing the mouth of the harbor and entering into the open sea—an idea that has resonance in Buddhism with the notion of the soul leaving behind its self-inflicted confines and embracing the ocean of Buddhist wisdom. Inoue was more of

452 *Tzu-chin-ch'eng Palace*, by Umehara Ryūsaburō. 1940. Oil on canvas; 45 ¼ x 59 in. (112.4 x 149.9 cm). Eisei Bunko Foundation, Tokyo.

453 *Offing (Okitsu)*, by Morita Shiryū. 1965. Four-panel screen, pigment and lacquer on gold-leafed paper; 65 ⅜ × 122 ⅘ in. (166 × 312 cm). Kiyoshikōjin Seichōji Temple.

454 *Ah! Yokokawa National School (Ah! Yokokawa kokumin gakkō)*, by Inoue Yūichi. 1978. Ink on paper; 57 × 96 in. (145 × 244 cm). Unac Tokyo, Inc.

a wild-man in his work, subverting everything to the divinity of the brush. He created his own brushes out of brooms and even used his own head and hands, and was once kicked out of his rented premises for creating an intolerable mess. A good example of his work is his *Ah! Yokokawa National School*, in which the mass of characters are merely there as an expression of his brush, achieving in many ways the natural outcome of fifteen hundred years of Japanese calligraphy (Fig. 454).

Woodblock Prints

The period between the Meiji Restoration and World War II in Japan witnessed the transformation and eventually the demise of the *ukiyo-e* print and the birth of **shin hanga** (new prints)—works produced by designers who wanted to revitalize the *ukiyo-e* tradition—and **sōsaku hanga** (creative prints)—made by artists who preferred to follow the Western practice of designing and executing their own works. *Ukiyo-e* prints had three basic characteristics: they depicted popular subjects, they were affordable (and therefore disposable), and they were produced commercially. The artist was, as already explained, merely the designer of the cartoon, which a printer's shop would interpret by carving a woodblock and then printing from the latter. The first element of the woodblock print to change in the Meiji period was the subject matter. Although there still existed some government censorship, depictions of, and even commentaries on, current events that had been disallowed in the Edo period were tolerated and even enthusiastically encouraged by the Meiji government as tools to promote nationalism. The unsettled but generally liberated climate of the times also revived a perennial Japanese interest in blood and gore, grotesque human beings, even ghosts, often side by side with scenes of lyrical beauty. Some of these subjects came from the Kabuki theater, while others were from as yet undramatized legends and historical events, but the *ukiyo* (or "floating world") that so charmed and excited seventeenth- and eighteenth-century audiences ceased to be interesting to the general populace.

The print artist who best responded to the changing demands of the time was Tsukioka Yoshitoshi (1839–92). Born in Tokyo, Yoshitoshi entered the studio of Utagawa Kuniyoshi in 1850 and studied with him until the latter's death in 1861. His early work consisted primarily of triptychs depicting famous warriors in battle and single sheets of famous actors. After the publication of the series *One Hundred Warriors in Battle* in 1869, Yoshitoshi's popularity waned, and he experienced a period of extreme poverty. It is said that he and his mistress Okoto had to burn the floorboards of their rented room for fuel. Perhaps due to the privations of this time, Yoshitoshi fell ill both physically and mentally and had long periods in which he could not work at all. In 1874, however, he created a triptych of the assassination of Ii Naosuke in 1860. Naosuke (1815–60) was the last strong member of the Tokugawa *bakufu*, and was cut down in front of Edo Castle by a group of samurai angry that he had placed under house arrest their "reformist" lord. The relative contemporaneity of the event, and its dramatic depiction in front of the castle's gates, made the triptych a considerable success, and Yoshitoshi entered into his second great period of productivity. In 1875, he also began a career as an illustrator for the newly expanding newspaper industry, a fashion that had been instigated the year before by an enterprising editor wishing to enliven some of his more sensational stories. The idea quickly spread through publishing circles, and not a few woodblock-

455 *Kiyohime Turning into a Serpent*, from the series *One Hundred Ghost Stories from China and Japan*, by Tsukioka Yoshitoshi. 1865. Color woodblock print on paper; *ōban* size: 15 × 10 in. (38.6 × 26.4 cm). Los Angeles County Museum of Art, Herbert R. Cole Collection. (M.84.31.125).

print artists found employment this way. In addition to simple illustrations, some of the designs were more like cartoons satirizing the foibles of the day. The *Yūbin Hōchi Shinbun* (*Postal Dispatch*) commissioned Yoshitoshi to design a series of sixty prints illustrating stories reported in the paper, and included such titles as *A Widower Witnesses His Wife's Ghost Nursing Their Child* and *A Group of Blind Masseurs in Niigata Injured by a Speeding Rickshaw*.

Throughout his life Yoshitoshi was interested in the phenomenon of ghosts. Shortly after his mistress Okoto's death, he reportedly saw her ghost and was inspired to create a series of designs for thirty prints of famous ghosts, which were never published. However, he returned later to the theme and created a masterful set of prints, *One Hundred Ghost Stories from China and Japan*. Particularly effective is his depiction of Kiyohime (Fig. 455), a girl who fell in love with a monk who did not return her affection. Fleeing from her rage at his rejection, he crossed a wide river and sought asylum at the temple of Dōjōji, where he hid himself inside a large bell the monks

456 *Tennōji in Yanaka, Tokyo*, from the series *Kiyochika Ponchi*, by Kobayashi Kiyochika. *c.* 1881. Full-color woodblock print on paper; *ōban* size: 15 ⅝ × 9 in. (39.7 × 22.9 cm). Private collection.

were about to rehang. Kiyohime crossed the river, and, intuiting his hiding place, turned herself into a giant snake which coiled its hot body around the bell and scorched her would-be lover to death. Yoshitoshi has chosen the moment when the beautiful young girl is transforming herself into a snake in order to effect her revenge. The print is a wonderful blend of textures and patterns: the girl's long black hair, the rough waves of the river she has just crossed, and, of course, the small repetitive patterns of her robe suggesting the reptile she is about to become. An interesting detail of the original printing, but missing in Figure 455, a later impression, is the apparently worm-eaten margin of the prints, suggesting that they were old instead of newly published. This series was Yoshitoshi's last. The madness that had affected him in the 1870s resurfaced, and he had to be hospitalized. He died shortly after his release.

Kobayashi Kiyochika (1847–1915), eight years younger than Yoshitoshi, occupied a transitional place between the last of the early nineteenth-century masters and the artists who would emerge in the twentieth century. Born into a samurai family, hereditary retainers of the Tokugawa clan, Kiyochika was forced to lead a wandering life after the Restoration stripped them of their position. However, in 1874 he settled in Tokyo and began his career as a woodblock-print artist. Though he studied briefly with Charles Wirgman, the English journalist, he seems to have been largely self-taught. His early work centered on views of Tokyo, and he was particularly interested in experimenting with the effects of light— gaslights, fireworks, and even a massive fire at the Ryōgoku bridge—against the night sky. From 1881 to 1894, Kiyochika was chiefly involved in drawing cartoons for the publication *Maruchin*, satirizing contemporary events. His debut in the field was a series of prints called *Kiyochika Ponchi*—an allusion to the models for this kind of satirical image to be found in the English humorous magazine *Punch*. One of his most amusing designs is *Tennōji in Yanaka, Tokyo* of *c.* 1881 (Fig. 456). It satirizes the government's attempt to control nudity, a response to the complaints of Westerners shocked by certain aspects of the Japanese sense of propriety. In the graveyard of Tennōji temple, a skeletal policeman points his finger at two skeletons. One wears a proper summer robe while the other has removed all garments but her underskirt and is fanning herself. Even in a quiet corner of a graveyard, the dead cannot escape the long arm of the law.

The two wars at the turn of the century, the Sino–Japanese war from 1894 to 1895 and the Russo–Japanese war from 1904 to 1905, and the use of woodblock prints to illustrate battles for the civilians back home first popularized and then weakened the genre of *ukiyo-e*. Since the woodblock print had been associated with journalism from the 1870s onward, it was only natural that newspapers should commission artists to depict the battles that were making front-page news. Although some artists actually accompanied the troops in battle and witnessed the fighting at first hand, most did not, preferring to create their designs based on the descriptions sent back by the papers' correspondents and their own imagination. In order to capture the interest of the general populace, the prints had to appear as soon as possible after the actual events. Many fine battle prints were turned out at the time, but this need to produce images as rapidly as possible inevitably led to the publication of crude compositions and rough printing.

Kiyochika's three-sheet depiction *Second Army Attacks Port Arthur, November 1894* (Fig. 457) shows Japanese soldiers standing along an embankment firing at the Chinese on the opposite shore, silhouetted against the setting sun. A column of fire can be seen to the left, and clouds of smoke appear in the sky. A strong contrast is established between the solid poses of the Japanese men led by their able commander, his heroic profile visible below the flames, and the Chinese running helter-skelter, trying to escape the enemy's fire. Historian Henry D. Smith II estimates that Kiyochika produced over seventy such triptychs, probably more than any other artist working at the time, and it was for his war prints that Kiyochika was famous in his day.

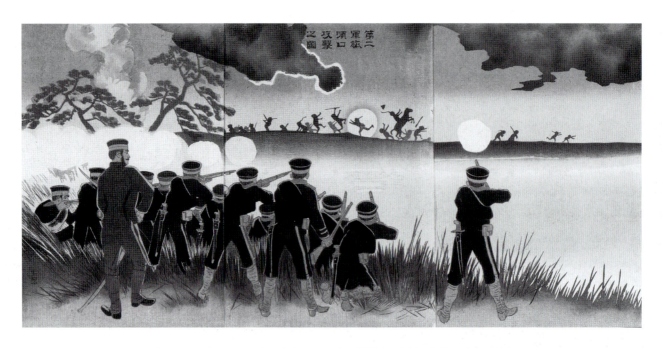

457 *Second Army Attacks Port Arthur, November 1894*, by Kobayashi Kiyochika. 1894.
Polychrome woodblock triptych on paper; each print *ōban* size. Collection Ruth Leserman, Beverly Hills, California.

Traditional *ukiyo-e* had a revival between 1915 and 1940, under the patronage of the publisher Watanabe Shōsaburo (1885–1962), who saw foreigners in Japan and abroad as a likely market for a new style of print dealing with the traditional themes of *bijin*—in this case usually not geishas—as well as actors and landscape scenes. Since the Meiji Restoration allowed Westerners greater freedom to travel in Japan, the country had become a favored destination in the budding tourist industry of the late nineteenth century. Travelers in Japan were especially charmed by woodblock prints, many, including Frank Lloyd Wright, compiling large collections of them. By the second decade of the twentieth century, therefore, Western collectors of such prints were a respectable market and one with an increasingly sophisticated connoisseurship. Watanabe aimed at the production of high-quality prints, and established a studio of print technicians, carvers, and printers who could execute works that measured up to his technical standards. This was the genesis of the *shin hanga* (or new prints), and three of the most important artists Watanabe recruited to work for him were Hashiguchi Goyō (1880–1921), Itō Shinsui (1898–1972) and Kawase Hasui (1883–1957).

Hashiguchi Goyō was the son of a Maruyama-Shijō school painter, and trained in both Japanese and Western painting techniques. However, by the time Watanabe recruited him in 1915, he had established a name for himself as an artist of woodblock-printed books and magazine illustrations. When he began creating single sheets for Watanabe, Goyō chose to reassess traditional *ukiyo-e* methods of depicting women, and particularly looked at the work of Utamaro. He was impressed by the pensive, enigmatic aura of the eighteenth-century master's beauties, and sought to incorporate

these same qualities into his own prints. In 1918, Goyō severed his connection with Watanabe and set up his own print shop, and many of his best works date from the year 1920, shortly before his death. An excellent example is *Nakatani Tsura Sitting Before the Dressing Stand* (Fig. 458). Against a silvery mica background, the subject sits clad in a gossamer black kimono with a diamond design and a gold wedding ring on her finger. The only hints of color are the dusty rose of the cushion and the blue–green cloth hanging from the mirror. These subdued tones were popular in the 1920s, but Goyō has used them sparingly, reserving his central figure in monochromatic tones accented only by the glint of gold of the ring. True to Utamaro's example, Nakatani Tsura is cool and pensive, set apart in her private world.

Itō Shinsui and Kawase Hasui were recruited by Watanabe in 1916 and 1918 respectively, remaining affiliated with the studio throughout their lives. It is generally agreed that both men had done their best and freshest work by 1923, the year of the Tokyo earthquake. Itō is primarily noted for his *bijinga* and Kawase for his landscapes. *Young Girl Washing* of 1917 is a particularly fine example of Itō's early style (Fig. 459). The subject, nude to the waist, squats on a platform to reach the washing bucket on the floor. The strong curves of her back and thigh are moderated by the gentle curvature of her arms. Her neck—for the Japanese a particularly erotic part of a woman's body—is partially obscured, like her breast. With remarkable economy of means Itō has created a wonderfully sensual image.

Sōsaku hanga, the innovative creative-print movement, was the other major development in Japanese printmaking in the early decades of the twentieth century. The Nihon Sōsaku Hanga Kyōkai (Japan Creative Print Society), founded in

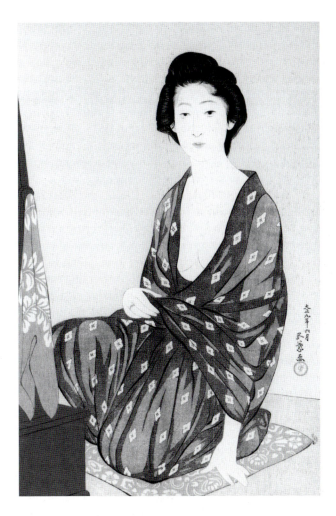

458 *Nakatani Tsura Sitting Before the Dressing Stand*, by Hashiguchi Goyō. 1920. Woodblock print on paper; *ōban* size: 17 ⅝ x 11 ½ in. (44.9 x 29 cm). Courtesy Christie's New York.

His portrait print of 1943, a depiction of Hagiwara Sakutarō, the nihilist poet and author of *Hyōtō (Frozen Island)*, is one of his most profound figural works, and perhaps his master print (Fig. 460). Hagiwara and Onchi had known each other for many years, their friendship dating back to the 1910s, when they were involved in various publishing projects together. The print is the artist's response to Hagiwara's death in 1942. Hagiwara had been a deeply troubled man, fighting depression, alcoholism, and bouts of insanity throughout his life. Yet he was able to work through his problems to the point of expressing them in poetry. Onchi shows a three-quarter view of the man with rumpled hair and an intense, unfocused gaze. The wrinkles of Hagiwara's face look almost like the grain in a piece of wood. Elizabeth de Sabato Swinton, evaluating Onchi's technique in this print, notes that seven separately carved blocks were used, re-inked and used again through fifteen different stages in the printing process. Furthermore, a variety of pigments were used, ranging from black ink and watercolor, which could be applied in thin

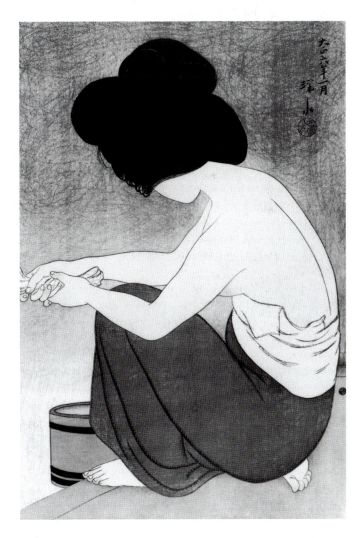

459 *Young Girl Washing*, by Itō Shinsui. 1917. Polychrome woodblock print on paper; *ōban* size: 17 ⅛ x 11 ⅝ in. (43.5 x 29.5 cm). The British Museum, London.

1918, believed that the print artist should be responsible for each step in the creation of a print. Artists should, of course, design the image, but they should also cut their own blocks, and ink and print them. Some artists stretched the concept to the extent of making their own paper. The movement took its impetus from printmaking in Europe, where artists made their prints themselves, and where they could build a reputation solely on the basis of their printmaking.

One of the men instrumental in the founding of the Nihon Sōsaku Hanga Kyōkai and the promulgation of its ideals was Onchi Kōshirō (1891–1955). From the 1930s onward he was the leader of the movement. Born to a tutor of the imperial family, Onchi received the best education available to children of the upper class. He entered the Tokyo Bijutsu Gakkō to study oil painting, but rebelled against the restrictions of the program and turned to printmaking. Onchi was also a poet, and in 1914, the year of his rebellion, helped to found the magazine *Shirakaba*. Throughout his artistic career, Onchi worked in two very different styles: an abstract mode illustrating poetic themes and a representational style.

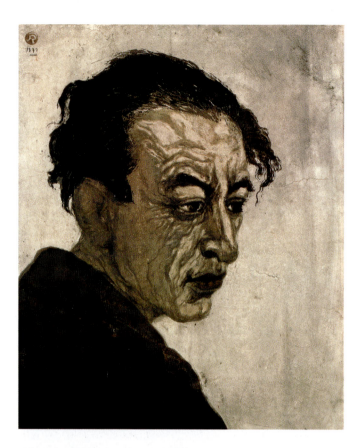

460. *Portrait of Hagiwara Sakutarō*, by Onchi Kōshirō. 1943. Polychrome woodblock print on paper; 20 ⅝ x 16 ¾ in. (52.5 x 42.5 cm). Private collection, Tokyo.

complicated, but still experimental processes of printing and to the use of purely abstract forms inspired by his poetry. One of the more evocative examples is his *Image No. 7: Black Cat (a)*—a second, version, (b), of this print also exists with a completely different composition, but both were executed in a deliberately primitive method of blocks, each carved with a simple shape, pressed onto the paper (Fig. 461). The result was often messy, with the ink smearing outside its desired form, but it was an expression of the old Zen *wabi* aesthetic and gives this image a stark and even numinous quality.

In the decades following the 1950s, the *sōsaku hanga* movement was subsumed into the creative output of Japanese artists working within an international art scene, but its central concern—that the print be not only an expression of the artist but also his or her sole creation from design to print—has remained a defining principal of those working with printing in the arts. Among the many strands of creativity that today make up the Japanese print scene, there is the curious case of Tsuruya Kōkei (b. 1946), who has single-handedly revived the old *ukiyo-e* genre of actor prints, albeit in strictly limited series (Fig. 462). Tsuruya is his studio name, his real name being Mitsui Gen, and he is the grandson of the *yōga* painter and printmaker Nakazawa Hiromitsu (1874–1964).

washes as well as deep colors, to opaque poster paint, to create a rich definition of the poet's facial features. The labor involved in achieving such results is difficult to appreciate at first glance, and he made only seven impressions. After World War II, when there was renewed interest in the image, he allowed another artist, Sekino Junichirō (b. 1914), to make fifty further prints.

In 1939, Onchi was sent to China as a war artist working within the government's propaganda machine, but before his departure he also founded the Ichimokukai (First Thursday Society), which alone kept the creative-print movement alive during the long years of the war. After 1945 Onchi was the movement's and printmaking's undisputed head until his death in 1955. *Shin hanga* did not survive the war, but *sōsaku hanga* did, in part because of its sympathy with the *mingei* movement, advocacy of any craft that came from the people and was made by their hands. In part also it was because the idiosyncratic and often folksy subject matter of *sōsaku hanga* appealed more to the new clients among the occupying forces than did the new *ukiyo-e* of *shin hanga*. Onchi, in particular, forged a close relationship with the American William Hartnett, who brought the creative-print artists to the renewed attention of the West, and, with Onchi's exhibiting at the Sao Paolo Biennale in 1951, to the world. Onchi's work in these last ten years of his life was a reversion to less

461 *Image No. 7: Black Cat (a)*, by Onchi Koshirō. 1952. Color paperblock print; 19 ⅝ x 14 ⅓ in. (49.9 x 36.1 cm). The British Museum, London.

462 *The Actor Nakamura Utaemon VI as Tonase in Kandehon Chūshingura*, from *Ōkubie* ("Bust Portraits"), Series IV, by Tsuruya Kōkei. 1984. Color woodblock print with powdered mica; 15 ½ x 9 ¾ in. (39.5 x 25 cm). The British Museum, London.

Until 1978, he pursued a business career, but inspired by the work of the great Sharaku (act. 1794–5), he began producing bust portraits of actors at the Kabukiza. The Kabuki theater today has become a venerable cultural institution, and is no longer the racy and slightly unsavory stage of Sharaku's day. However, it remains a popular entertainment with the older generation, and Tsuruya's print of 1984 depicts the great *onnagata* (an actor specializing in female roles) Nakamura Utaemon VI (b. 1917). Depicted in the twilight of his career, the actor is in the character of one of the most famous of all the female figures in the Kabuki repertoire, Tonase. Amidst the complex plot of the *Kandehon Chōshingura*, Tonase is an old but strong and virtuous samurai lady who, in the absence of her husband, accompanies their daughter to the imperial capital to ensure that the girl's marriage is properly performed. As a mark of her assumed office, Tonase wears her missing husband's swords, and in Tsuruya's depiction the hilt of one of them is grasped by the actor's hand in the foreground. The

sharp-eyed form of an old woman rising ominously behind the large hand leaves no doubt that she is a force not to be trifled with. Tsuruya works on paper are always of an almost translucent thinness, heightening the sense of ephemerality of his art. Furthermore, the artist always defaces his blocks after their initial run (of usually no more than 70 imprints) so that they cannot be used in the future.

Photography

Not long after the opening up of Japan in 1853, a British journal, the *Illustrated London News*, began publishing photographic images of the country, and the new and exciting medium of photography became one of the Western technologies to be obtained at all costs. In 1863, the Italian photographer Felice Beato arrived in Japan and set up commercial premises, making colored studio portraits of people from all ranks of society in compositions not a little influenced by *ukiyo-e* prints. In 1871, the Austrian Baron Reteniz von Stillfried purchased Beato's studio, but around this time Kusakabe Kimbei also opened a studio of his own. Kusakabe made his living by studio portraiture and genre tableaux, but he also began setting up his camera outside and documenting Japanese life and landscape. Reportage, social documentary, and studio portraiture remained the mainstays of photography in Japan before World War II. Some photographers did experiment with decorative images imitating painting or the soft-focus pictorialism popular in the West in the late nineteenth century, and there were an exceptional few who experimented more daringly.

It was not until after World War II, however, that Japan's art photography hits its stride. Unlike photographers of this kind in the United States and Europe, who were focused on limited editions of high-quality prints, such photographers in Japan continued to rely on publication for their livelihood. This had a major impact on their imagery, and, similar to the *ukiyo-e* print designer, their artistic input had to be visible in the composition and exposure of the image rather than in the details of the printing process. This has altered over time, but it has meant that Japanese photographic imagery is often visually arresting.

One of the photographers to emerge in the late 1950s was Eikoh Hosoe (b. 1933). Hosoe is a good example of the kind of cutting-edge artist that the postwar period produced. The repressive wartime years had come to an end, along with the militant nationalism of the prewar government. At the same time, for Hosoe's generation of artists—who spent half of their childhood within the smug security of the prewar years and the other half trying to survive in a devastated social landscape—there was a new kind of "floating world" to depict. As the 1950s continued and Japan's Economic Miracle began to take shape, these artists took a cynical look at the stability of such prosperity in the context of the volatile international political situation of which Japan was now firmly a part. To avoid falling back into the old prewar complacency, they

463 *Yukio Mishima*, from *Barakei (Killed by Roses)*, by Eikoh Hosoe. 1963. Courtesy Eikoh Hosoe.

believed, it was imperative to break all the taboos, and they were the ones to do it.

In 1959 Hosoe met the dancer Tatsumi Hijikata (d. 1986) after his dance performance based on the writer Yukio Mishima's *Forbidden Colors*, a novel set amidst Tokyo's homosexual community. The exploration of homoerotic themes and the killing of a chicken on the stage shocked the audience, but were greatly appreciated by Mishima and Hosoe. In the following year, Hosoe held an exhibition of nude portraits of Hijikata and dancers associated with his company, and also made a film with the dancer entitled *Navel and Atomic Bomb*. Against an atomic explosion, Hijikata emerges from the sea as a demon intent on consuming the navel of a child—the subtext being a loss of innocence. In 1961, Hosoe began creating books in which his photographs, often using composite imagery, combined to form as a visual statement or narrative which it was the viewer's challenge to work out. The most famous of these is *Barakei (Ordeal by Roses)* of 1963, which grew out of a series of sessions he had photographing Yukio Mishima at his Tokyo home in 1961 and 1962 (Fig. 463). In 1970, Mishima sensationally grabbed the world's headlines by leading an unsuccessful coup d'etat with an elite corps of youths modeled on the prewar military. They occupied the headquarters of the

Self Defence Corps, and, when Mishima's demands for the resignation of the current government were ignored, he committed suicide in the fullest traditional expression—one of his aides cutting off his head in a gesture of mercy. *Barakei* was subsequently often interpreted as a kind of rehearsal for Mishima's death, and indeed the startling series of images of the author seem to combine an almost hysterical sensuality with a morbid sobriety.

The "radical image" pioneered by artists like Hosoe, Mishima, and Hijikata had already by the 1960s begun to penetrate to the world of commercial design, and by the 1980s Japanese visual design led the international community. One of its most brilliant practitioners at that period was Eiko Ishioka, whose design and art direction for the poster of the exhibition *Tradition et Nouvelles Techniques* in Paris in the autumn of 1984 represented a highly contemporary marriage of Japanese traditional imagery and the modern (Fig. 464). A torso-shaped bodice by the fashion designer Issey Miyake (b. 1938) is held like a prop or puppet of the Bunraku theater by a puppeteer, whose traditional costume is bright red instead of the masking black. In creating such images, the photographer —in this case Masayoshi Sukita—becomes part

464 Offset poster for *Tradition et Nouvelles Techniques*, Paris, 1984, designed by Eiko Ishioka, photography by Masayoshi Sukita, Torso design by Issey Miyake. 40 ½ x 28 ⅔ in. (103 x 72.8 cm). Courtesy Eiko Ishioka.

465 *Psychoborg 22*, by Morimura Yasumasu. 1994.
Computer manipulated photograph; 51 ⅛ x 43 ⅓ in. (130 x 110 cm).
Collection of the artist. Courtesy of the artist and Luhring Augustine.

Performance, Multimedia, and Conceptual Art

While more traditional concepts of well-delineated media such as painting, sculpture, and printmaking are still pursued by a healthy community of artists in Japan, as in the rest of the world many artists are also experimenting with limitless media. They not only combine standard materials and techniques for two- and three-dimensional art, but also explore the bounds between the visual and dramatic arts. As demonstrated by Eikoh Hosoe's relationship with the dancer Tatsumi Hijikata, Japanese artists were in fact among the first to investigate these syntheses, and indeed a great deal of the performance and conceptual art currently in vogue on the international scene must look to Japan for a certain amount of inspiration. In 1955, near Osaka a group of artists took over a beachside park for a thirteen-day exhibition of paintings, sculptures, and simply objects installed in a grove of pine trees. Described as an "event," this first experiment in both performance and conceptual art was organized by the Gutai Bijutsu Kyōkai (Gutai Art Association), which had been founded the year before by Yoshihara Jirō (1905–72), a *yōga* painter with a substantial private income. The stated aim of the Gutai was to take art out of the gallery and museum and back into the open environment. The association promoted participation by all in the process of making art, and in the breaking down of all preconceptions of what art is. The artists of the group could work in conventional painting and printing formats, but most usually they combined media or performance to place an ordinary image, action, or object within an extraordinary circumstance. In the 1960s, such groups, which had already flirted with surrealism, looked a bit further back to the iconoclastic chaos of dada. Their neo-dada, although adapted from a European social context of the aftermath of World War I, oddly enough hit a chord in the traditional Japanese consciousness, the seeming nonsense of their images and performance being not entirely strange to a cultural elite which was familiar with the Zen *kōan* (see page 212). Among the young artists to emerge from this fulcrum of activity are several who would help define and advance conceptual and performance art on the world stage: Nam June Paik (b. 1932), Yoko Ono (b. 1939), Yoshimura Masunobu (b. 1932), and Kusama Yayoi (b. 1929).

While many of these artists moved to New York, London, and Paris to pursue their careers, there was one group of conceptual artists who remained in Japan, and which Alexandra Munroe has dubbed the "School of Metaphysics." Their work investigates the nature of time and space, existence and death, the finite and the infinite, combining elements of Buddhism, cosmology, European alchemy, and modern science. One of the metaphysical conceptualists, Kawaguchi Tatsuo (b. 1940), has been particularly concerned with concepts of eternity and the infinite. In his 1990 work *Time of the Lotus* (Fig. 466) he has taken this powerful symbol of Buddhist liberation and rebirth and encased three separate lotus fronds in lead. While on a conceptual level this precious symbol of eternity has been

of an ensemble cast for a performance directed by the designer Eiko and executed as a still print or tableau. Photography, therefore, also became very much the medium of the performance artist.

The moving image was obviously another highly desirable medium for performance, but until recently the cost of its production was too prohibitive to be used with the same frequency as the photographic image. Also, quite often the performance artist could communicate a visual statement better through still images rather than moving ones. One such performance artist is Morimura Yasumasu (b. 1951). From Osaka, Morimura began in the 1980s by making pastiches of paintings by European masters in which images of himself supplant the subject of the painting. Alexandra Munroe qualifies Morimura's work as an attack on contemporary Japanese obsessions with appropriating Western culture and "commodifying" it. In his computer-manipulated image *Psychoborg 22*, Morimura appears twice in the dazzlingly reproduced costumes of pop phenomena Michael Jackson and Madonna (Fig. 465). Here again, Morimura appropriates these American personalities for himself. However, his reproduction of trademark poses by both entertainers also draws parallels between them and the characters found in Japanese cartoons about futuristic worlds dominated by freakish monsters and their equally freakish superheroes.

466 *Time of the Lotus:*
Relation-Plant (Hasu no toki:
Kankei-shokubutsu); (D), (E),
and (F), by Kawaguchi Tatsuo.
Lead and lotus; each: 67 x 31
½ x 2 in. (170 x 80 x 5 cm).
Collection of the artist.

467 *Mirror Room — Pumpkin,*
by Kusama Yayoi. 1991. Mirror-
encased wooden cubicle,
installed with soft sculptures
of pumpkins;
78 ¾ in. cubed (200 cm
cubed). Hara Museum of
Contemporary Art, Tokyo.

468 *Hinomaru Illumination (Amaterasu and Haniwa)*, by Yanagi Yukinori. 1991. Neon and painted steel with ceramic *haniwa* figures; neon flag: 118 ⅛ x 177 ⅛ x 15 ¾ in. (300 x 450 x 40 cm); each *haniwa*: 39 ⅜ in. (100 cm) (approx.). The Museum of Art, Kōchi. Photo courtesy The Council for the International Biennale in Nagoya.

encased and protected by the lead, Kawaguchi has also created a series of three elegiac monochrome images with a distinctly decorative appeal.

One of the most successful of the conceptualists is Kusama Yayoi (b. 1929), whose work has also been characterized as "obsessional art" due to its fascination with the infinitely repeated image. Indeed, Kusama has been officially resident in a psychiatric institution since 1979, but simply to qualify her installations as expressions of a madness would deny the rather compelling and provocative voice in which they speak to the viewer. Kusama's oeuvre runs over four decades, but a relatively recent example is her *Mirror Room—Pumpkin*, first created in 1991 (Fig. 467). The mirrored room which the viewer looks at from one open end is a kind of canvas that Kusama has used repeatedly since the 1960s. In this installation, the room is filled with soft-sculpture pumpkins imbuing Kusama's environment with a psychedelic and almost ominously cute vision of the infinite.

Amongst the newer generation of conceptualists is Yanagi Yukinori (b. 1959). Following the death of Emperor Hirohito in 1989, Yanagi was one of the group of artists who took on the last great taboo in Japanese society—nationalism and its imperialist legacy during the first half of the twentieth century. In his *Hinomaru Illumination*, subtitled *Amaterasu and Haniwa*, a group of *haniwa* are placed in reverence—some saluting—of a huge neon sun panel in the form of the *hinomaru* or the national flag (Fig. 468). Throughout the long process of Japan's history the imperial family and the imperial cult, with the sun goddess Amaterasu at its head, have served

as the political, social, and cultural unifiers for the Japanese people. This identification was given its most emphatic expression in the Meiji Restoration and the following decades as Japan struggled to industrialize its society and take its place in an international setting without losing its own identity. And yet the negative aspects of this identification—the outcast classes to be found in Japanese society throughout its history, the imperialism which climaxed with the devastation of its immediate neighbors, begun by the European powers in the nineteenth century, and the issues of discrimination and non-entitlement still surrounding ethnic minorities in Japan, such as the Ainu, the Koreans, and the new influx of immigration from Southeast Asia—are also important, if unattractive, facets of Japanese nationalism. It is to this dichotomy that Yanagi addresses his work. The primitive, doll-like *haniwa* represent the unthinking and un-individuated mass slavishly worshipping a merely modernized image of nation and nationhood.

Evaluation of Japan's postwar artistic culture is difficult because it is, so to speak, a work still in progress. A more extensive assessment of its diverse movements and achievements so far could easily fill the pages of several volumes. Making any definitive statement at the present moment and within the space of a few pages, therefore, would be tantamount to trying to define Japanese classical art at the end of the eighth century when the entire Heian period lay yet ahead. What would be fair to say is that—from the evidence of the last one hundred and fifty years—Japan's arts are not only alive and well, but confidently embarking on their future.

Timeline

B.C.E.	Japan	Korea	China
98,000	First evidence of human occupation of the Japanese archipelago		
30,000	Date of earliest stone tools		
14,000	Date of earliest pottery shards		
12,000	End of the Last Ice Age		
11,000	**Jōmon period** (c. 11,000–400 B.C.E.) **Incipient Jōmon** (c. 11,000–8000 B.C.E.)		
10,000			
9,000			
8,000	**Initial Jōmon** (c. 8000–5000 B.C.E.)		
7,000			
6,000			
5,000	**Early Jōmon** (c. 5000–2500 B.C.E.)		
4,000			
3,000			
2,000	**Middle Jōmon** (c. 2500–1500 B.C.E.)		
1,000	**Late Jōmon** (c. 1500–1000 B.C.E.) **Final Jōmon** (c. 1000–400 B.C.E.)		**Shang** (c. 1550–1050 B.C.E.) **Western Zhou** (c. 1050–770 B.C.E.) **Eastern Zhou** (c. 770–221 B.C.E.)
500			
400	**Yayoi period** (c. 400 B.C.E.–300 C.E.)		
300			
200			**Qin** (221–206 B.C.E.) **Han** (206 B.C.E.–C.E. 220)
100		Koguryo (37 B.C.E.–C.E. 668) / Paekche (18 B.C.E.–C.E. 660) / Silla (57 B.C.E.–C.E. 660) / Kaya Hill States (C.E. 42–562)	
0 CE			
100			
200			
300	**Kofun period** (300–710)		**Three Kingdoms** (220–280) **Western Jin** (263–316) **Northern Wei** (386–534)

CE	Japan	Korea	China
400			
500			Western Wei (535–557) Eastern Wei (534–550)
600	Asuka period (552–645)		Northern Qi (550–577) Sui (581–618)
700	Hakuhō period (645–710) Nara period (710–794)	Unified Silla (668–918)	Tang (618–907)
800	Heian period (794–1185) Early Heian (794–951)		
900	Middle Heian/Fujiwara (951–1086)	Koryo (918–1392)	Five Dynasties (907–960) Northern Song (960–1126)
1000	Late Heian/Insei (1086–1185)		
1100			Southern Song (1126–1279)
1200	Mediaeval period (1185–1573) Kamakura (1185–1333)		
1300	Nambokuchō (1336–1392)		Yuan (1279–1368)
1400	Muromachi (1392–1573)	Choson (1392–1910)	Ming (1368–1644)
1500			
1600	Momoyama period (1573–1615) Edo period (1615–1868)		Qing (1644–1911)
1700			
1800			
	Meiji period (1868–1911)		
1900	Taishō period (1911–1926) Shōwa period (1926–1989)	Japanese Colony (1910–1945)	Republic of China: Mainland (1911–1949)
	Occupation (1945–1952)	South Korea (1945–present) North Korea (1945–present)	Republic of China: Taiwan (1949–present) People's Republic of China (1949–present)
2000	Heisei period (1989–present)		

Glossary

A

Amida (SKT. Amitabha) Literally, "Boundless Light," the Buddha of the Western Paradise; also known as Amitayus, which means "Boundless Life." Amidism (or Amida Buddhism) refers to saviour cults focused on this Buddha, in which the adherent hopes to be reborn in his Western Paradise, or Pure Land. *See also* Buddhism (traditions and schools) and Pure Land.

Amidism *See* Buddhism (traditions and schools) and Pure Land.

arhat See rakan

B

bakufu Military government led by the shogun, first established by Minamoto no Yoritomo (1147–99).

baku-han Modern historical term for the style of government forged by the Tokugawa regime during the Edo period (1615–1868). It refers to a two-tier system comprising the centralized *bakufu* of the shogun and the local *han* of the daimyo.

bakumatsu Literally, "the end of the *bakufu*"; refers to the last decades of the Tokugawa regime.

bijinga Literally, "paintings of beautiful women"; term originated in the Edo period for portraits of courtesans and other beauties.

bird-and-flower painting (JAP. *kachōga*) The genre of images of birds and flowers established by the imperial academy of the Chinese Northern Song dynasty (960–1126). It underwent a revival in eighteenth-century China, and also became popular in Edo-period (1615–1868) painting circles.

Birushana (SKT. Vairochana) Buddha who is not an earthly manifestation, but is, in fact, Buddhahood's quintessential essence. All other Buddhas, **bodhisattvas**, and deities are merely emanations and aspects of him. Normally, he is configured at the center of a group of five Buddhas, the other four being his emanations to the four directions. As such, he is often referred to as Dainichi Nyorai (SKT. Mahavairochana, or "Great" Vairochana).

biwa (CH. *pipa*) A lute; introduced from China, this type of instrument did not originate there but further west in Central Asia.

bodhisattva (JAP. *bosatsu*) In *Buddhism*, a term for great beings who have developed wisdom to such a degree that they transcend this world, and yet have taken a vow out of compassion to hold back the moment of attaining full Enlightenment until all the myriad beings are ready to join them. There are many different bodhisattvas: Kannon (SKT. Avalokiteshvara), the bodhisattva of mercy and compassion; Seishi (SKT. Mahasthamaprapta), with Kannon the attendant bodhisattva on Amida Buddha; Monju (SKT. Manjushri), the bodhisattva of wisdom, often depicted on his mount, the lion; Fugen (SKT. Samantabhadra), the bodhisattva of ethical perfection, often depicted on his mount, the elephant; Jizō (SKT. Kshitigarbha), the protector of children and rescuer of souls in hell, often depicted as a monk and carrying a monk's staff.

Buddha (JAP. *butsu*) "The Enlightened One," indicating a being who has achieved full Enlightenment. Most commonly "the Buddha" refers to *Shaka* Buddha, also known as the Historical Buddha. But there have been many other earthly Buddha manifestations, and there is in addition the Universal Buddha, Birushana, of whom all else is ultimately a manifestation or reflection.

Buddhism (traditions and schools) As it developed in India from around 410 B.C.E. to *c.* C.E. 500 , Buddhism divided into three principal traditions, out of which all the schools of Buddhism have evolved. The earliest of these has come to be termed by the later strains as the **Hinayana** (Lesser Vehicle). It developed the basic concepts of the Buddhist community, both monastic and lay, and also gathered together all the sutras and writings into the first Buddhist canon—the "Three Baskets" or Sanzō (SKT. Tripitika). By the end of the first century B.C.E., however, growing dissatisfaction with what was perceived as the selfish pursuit of individual enlightenment led to a new Buddhist philosophy, which has come to be characterized as the **Mahayana** (Greater Vehicle). This new tradition focused on the liberation of all living beings. Where the *rakan* pursuing his own enlightenment was the model for the practitioner in the Hinayana, the bodhisattva seeking enlightenment for all became that model within the Mahayana. During the early centuries C.E., Mahayana philosophy was formulated by the Indian scholar Nagarjuna and his followers, and it was Buddhist schools associated with it that were largely transmitted across Central Asia into China and Korea in the first half of the first millennium C.E., although there were also some important Hinayana schools.

When Buddhism was officially introduced to Japan from the Korean kingdom of Paekche in the mid-sixth century, it was in its Mahayana form. By the eighth century, Japanese Buddhism was organized in six primary strains that came to be known as the **Six Schools of Nara** because they established their centers in the imperial capital of Heijō, now known as Nara. The first two of these, **Sanron** (Three Treatises) and

Jōjitsu, had been introduced from Paekche, focused on early Mahayana philosophy, and soon merged with each other. The third was the **Hossō** (SKT. Yocacara; CH. Faxiang), introduced from China about 650 by the monk Doshō, and which espoused a Mahayana philosophy that argued the ultimate existence of the mind. The fourth school, **Kusha**, appeared at about the same time and took as its basis the Mahayana philosophy of the Indian Vasubandhu, which focused on the analysis of phenomena through the Buddha's vision, including the ordering of the universe. The fifth school, **Kegon**, was based on the *Kegon* or *Garland sutra* (SKT. *Avatamsaka sutra*; CH. *Huayanji*), which focuses on Shaka as a manifestation of the supreme, universal Birushana Buddha. The Kegon school became particularly prominent, developing elaborate rituals that appealed to the imperial government. The sixth school was the **Ritsu** (SKT. Vinaya; CH. Luzong). The Vinaya is actually a literary genre forming one part of the Buddhist canon, and includes the texts that lay down the rules one must follow in life—whether as a monk, nun, or householder—in order to work towards Enlightenment. The Ritsu school focused on Hinayana philosophy and particularly that which translated the Buddha's teachings into codes by which one should live one's life. The last of the six to be introduced to Japan, it was brought by the Chinese monk Jianzhen (JAP. Ganjin) in 754.

In the ninth century, two new schools were introduced, the **Tendai** and the **Shingon**. Tendai (CH. Tiantai) was introduced by Saichō (767–822) and, focusing on the *Lotus Sutra* (JAP. *Myōhōrenge kyō*), attempted to synthesize all the different strains of Buddhism into a unified conception. One of these strains was part of the third great Buddhist tradition, the Mantrayana, more commonly known as Tantric Buddhism. The **Tantric** philosophies had begun developing out of the Mahayana in India by at least the mid-first millennium C.E. Tantra, in fact, refers to a literary genre distinct from the sutras. The latter are the collected words of Shaka Buddha's earthly manifestation, whereas the tantra are the words of the celestial Buddhas transmitted through visions to great earthly masters. These Tantric schools reached China soon after their formulation in India, and the Shingon (CH. Zhenyan; SKT. Mantra; True Word) Buddhism brought back to Japan by Kūkai (774–835) was a synthesis of all these new Tantric schools. In the next century there also arose a new, Mahayannist-based movement, Amidism. **Amidism** refers to savior cults focused on the Amida Buddha, in which the adherent hopes to be reborn in his Western Paradise, or Pure Land. Such cults had been brought over from the continent as early as the sixth century, but they did not truly gain a wide credence until the Middle Heian period (951–1086). In the later Kamakura period (1185–1333), several schools of Amidism developed and are known collectively as **Pure Land** (JAP. Jōdo).

In the twelfth century, the last of the great Japanese Buddhist traditions came to be established, **Zen** (CH. Chan; Meditation). The school's origins are connected with one Bodhidharma (JAP. Daruma), who arrived in China during the sixth century, and taught that the key to Enlightenment was intense meditation. In the medieval period, Zen was transmitted to Japan in two main forms, **Rinzai** (CH. Linjizong) and **Sōtō** (CH. Caodong). Rinzai with its belief in the possibility of sudden Enlighten-ment, the efficacy of the *kōan* as a teaching tool, and the ritual drinking of tea was particularly well received by the daimyo and shogun. Sōtō, in advocating a balance of meditation and physical activity leading to moments of understanding and a more gradual enlightenment, had especially strong appeal amongst the peasantry and the samurai of the provinces. In the seventeenth century, a new offshoot of the Rinzai sect, **Ōbaku** (CH. Huangpo), was brought to Japan by Chinese immigrants who settled in Nagasaki.

bunjin (CH. wenren) A term literally meaning "person of letters," in Japan it primarily refers to China's educated elite, or literati, and only secondarily to a Japanese literatus, and then usually with the inference that their erudition follows a classical Chinese model. From the tenth century, the Chinese *bunjin* were acknowledged as the foremost practitioners of painting in China, and their works were known as *bunjinga*.

bunjinga (CH. *wenren hua*) Literati painting; term more or less interchangeable with *nanga* (CH. *nanhua*; southern painting). A genre of painting that developed in China during the Northern Song dynasty (960–1126), in which the artist was meant to be a member of the educated elite: the scholars/government officials. With an emphasis on their amateur status, painting for their own pleasure and that of their friends (thus setting themselves apart from professional artisan painters), these literati artists took as their starting point their calligraphic style, and applied it to the creation of images—most frequently landscapes. Although these early Chinese literati styles made an impact in Japan not long after and particularly in the paintings of the Zen monk–painters, it was not until the Edo period (1615–1868) that the Japanese term *bunjinga* came to be applied to a specific movement of Japanese artists. These Japanese *bunjinja* were in styles emulating those of China of the sixteenth century onwards, and are also referred to as *nanga*.

Bunraku Originating in simple fifteenth- and sixteenth-century puppet theatre on a level with the Western Punch and Judy, Bunraku emerged in the seventeenth century as a sophisticated art form using large figures manipulated by puppeteers clad in black to render them inconspicuous. These shows also featured a seated chanter who would recount the plot and speak the dialogue while a *samisen* player provided musical accompaniment. Like the **Kabuki** theater, Bunraku plays deal with historical events, conflicts of moral duty and personal desire, and even ghost stories.

butsuden Any temple hall in which a Buddha image is enshrined, and also the main worship hall (*hondō*) of a Zen temple; a *daibutsuden* is the hall containing a monumental Buddha image, and often refers specifically to that of Tōdaiji in Nara.

C

chanoyu Toward the end of the fifteenth century, the commonplace act of drinking tea and offering it to guests was formalized into a ritual known as *chanoyu*. In the subsequent centuries it became an essential accomplishment of high samurai and intellectual culture. Espousing the aesthetics of *wabi* and *sabi*, it had a great influence on all the arts, and particularly the ceramic and lacquer industries which produced the paraphernalia for its performance.

chigaidana Shelves in a traditional Japanese room, set at staggered heights.

chōdaigamae Doorway fitted with decorative doors leading off the formal, reception room in a *shoin*-style building. In a small building the *chōdaigamae* would give onto the bedroom of the master. In such structures as Nijō Castle, it concealed a chamber for bodyguards. In some instances, the *chōdaigamae* is purely decorative, with no room of any description behind the doors.

chōnin The townsmen class, comprising artisans and merchants.

chūmon The middle or inner gate of a Buddhist temple leading into the main enclosure of the complex. It corresponds with the later *sanmon*.

D

daimyo Literally "great name"; term made its first appearance in the eleventh century, and was applied to any lord (whether court aristocrat or samurai) of a large estate. In the medieval period, as most of these great estates passed into samurai hands, the title daimyo took on a totally military association. The primary retainers of a shogun, therefore, were by definition daimyo, and in the Muromachi period (1392–1573) they came to be officially recognized by this title. In the Edo period (1615–1868), the daimyo and their fiefs (*han*) were organized into a system of local authorities under the *bakufu* of the shogun.

Dainichi Nyorai *See* Birushana.

dakkatsu kanshitsu Literally, hollow dry-lacquer; technique used to produce hollow sculptures formed of layers of lacquer-soaked cloth, often supported by a wooden armature.

Dharma (JAP. Hō) The teachings of the Buddha.

dōshakuga Tradition of Zen painting in which depictions of Buddhist themes are intended to convey the subjective experience of receiving spiritual insights or revelations.

dōtaku Bronze bells from the early Bronze Age in Japan, usually decorated with outlined designs. The shape developed in China, where *dōtaku* functioned as instruments, while those in Japan seem only to have had a ceremonial purpose.

E

emaki; emakimono Literally, "picture roll" and "rolled object with pictures," respectively; the terms are used interchangeably for pictorial hand scrolls.

engi History and legends, particularly of temples; illustrated *engi*, often in sets of hand scrolls, are among the high points of Heian (794–1185) and Kamakura (1185–1333) art.

F

flower arranging (*ikebana*) As an art form, it first arose during the medieval period, and was particularly espoused by Ashikaga Yoshimasa (1430–90). It has continued to be a popular pastime with cultivated men and women of all classes.

folding screens (JAP. *byōbu*) Freestanding movable room dividers, Japanese folding screens consist of from two to sixteen hinged panels, and a common format are pairs of six-paneled screens. They are made of wooden frames hinged together, with paper glued over the surface, and have been throughout Japanese history an important canvas for painting.

Fudō (SKT. Acala) Known as the Immovable One, Fudō is the most important of Buddhism's Myōō (the Kings of Higher Knowledge), but he was also considered a bodhisattva and a manifestation of Birushana Buddha. He and the other *myōō* usually are given a fierce aspect reflecting their roles as protectors of the Dharma.

fusuma Interior sliding doors or partitions in traditional Japanese buildings, that separate rooms or serve as cupboard doors. Usually a set of panels, constructed of wooden frames with layers of heavy paper glued to both sides, they—like folding screens—have been throughout Japanese history an important canvas for painting.

G

gendai kaiga Literally "contemporary painting"; term for painting styles that have developed since 1945, as distinct from the earlier *nihonga* and *yōga*.

Genji monogatari *See Tale of Genji*.

Genpei Civil War Conflict between the Taira and Minamoto clans dating from 1180 to 1185, which ended with a decisive Taira defeat. It is seen as the final turning point when imperial rule was replaced by military government.

gongen zukuri Style of mausoleum architecture that developed out of the type of Shinto shrine created in the Heian period (794–1185) for the deified spirit Kitano Tenjin, who in life had been the wronged courtier Sugawara no Michizane (845–903). Adopted as the architectural style of the mausoleums of the great leaders of the late sixteenth and seventeenth centuries, its name derives from Toshō Daigongen, the posthumous title of Tokugawa Ieyasu (1542–1616).

Guardian Kings Also known as the Heavenly Kings; *see* Shitennō.

H

haiden Worship hall in a Shinto shrine.

haiga A painted image accompanying a haiku, it is meant to be a spontaneous response to the committing of the verse to paper.

haiku Alternatively *haikai*, "amusing pleasantry"; a poem of seventeen syllables in three lines that evolved out of the *waka* some time in the sixteenth century. As a poetic form it is meant to be a spontaneous response from direct observation.

hakama Style of Japanese trousers worn by both men and

women, with the former as an overgarment and with the latter as an undergarment, until the sixteenth century. After that date, only men continued to wear the *hakama*, until the modern period and the general abandonment of traditional dress.
han Feudal domain or fief; the territory of a daimyo.
hand scroll (JAP. *kimono*) Rolled, horizontal format used traditionally for books and also for painting; *see emaki*.
hanging scroll (JAP. *kakemono*) Vertical, hanging presentation format for painting, in which the image is mounted on a paper and textile backing and suspended from a wooden rod.
haniwa Clay figures of the Kofun period (300–710) that were placed on the surface of a *kofun* burial mound. Basically cylindrical in form, *haniwa* were often shaped into helmets, shields, parasols, architectural objects, and human and animal figures.
hattō "Hall of the Law"; the lecture hall in a Zen temple.
Heiji Rebellion Unsuccessful coup d'état of 1160, during which the Fujiwara in league with Minamoto no Yoshitomo (1123–1160) attempted to reinstate the Fujiwara government over the *insei* regime of retired emperor Go Shirakawa (1127–1192; r. 1156–1158). It was defeated by Taira no Kiyomori (1118–1181), who executed Yoshitomo and reestablished Go Shirakawa's *insei* regime with his clan playing a leading role in its government.
Hinayana *See* Buddhism (traditions and schools).
hiragana *See kana*.
Hōgen Rebellion Conflict lasting from 1156 to 1159, in which the Fujiwara and imperial house first began losing their grip on the government to the powerful Taira and Minamoto samurai clans.
honden Main hall of a Shinto shrine.
hondō Main hall of a Buddhist temple, usually housing its principal statues of Buddhas and bodhisattvas. *See also kondō* and *butsuden*.
honmaru Central area inside the fortifications of a castle, and the site of the keep (*see tenshu*).
Hossō *See* Buddhism (traditions and schools).

I

ichiboku zukuri Literally, "one piece of wood"; sculpture carved from a solid block of wood, rather than assembled from several separate sections. *See also yosegi*.
ikebana *See* flower arranging.
inro A small multi-tiered box held together by a cord strung through it, the *inro* was initially meant for the carrying of the personal seals and seal ink with which the Japanese gentleman sealed his contracts of business, whether merchant, peasant, samurai, or aristocrat. *Inro* were hung from the sash of the *kosode* and at the end of the cord stringing them together there was often attached a carving known as a netsuke. In addition, a kind of a bead (*ojime*) fitted on the cord just above the uppermost tier of the *inro* would help to hold all the compartments in place.
insei Term for retired emperor, and, in the Late Heian period (1086–1185), for a system of government in which the retired, and usually cloistered, emperor conducted the affairs of government for the reigning emperor.
iron wire An even line, unvarying in width, often used to outline figures and landscape elements in ink painting.
iwakura In Shinto, the site at which a *kami* has taken up residence. The *iwakura* is usually represented by a wooden shrine within an enclosure, to which a *torii* gate gives access.

J

Jōjitsu *See* Buddhism (traditions and schools).
Jōkyū Rebellion Failed attempt in 1221 by retired emperor Go Toba (1179–1239; r. 1184–92) to overthrow the Minamoto *bakufu* and reinstate an *insei* regime under his leadership.

K

Kabuki Still the most popular of the traditional theater forms, it employs live male actors, who specialize in either *onnagata* (female roles) or *tachiyaku* (male roles). It developed in the fifteenth and sixteenth centuries alongside puppet shows and took on its definitive form around 1603. Featuring gorgeous costumes and elaborate sets like those of the Bunraku puppet theater, Kabuki plays deal with historical events, conflicts of moral duty and personal desire, and even ghost stories. Musical accompaniment is usually provided by an offstage musician playing a *samisen*.
kabuto Type of helmet.
kaidanin Ordination hall in a Buddhist temple.
kaisandō Founder's hall; structure within Buddhist temple complex dedicated to the temple's founder and his relics.
kami Japanese term for "gods" and "spirits," with specific reference to those of Shinto.
kana Two syllabaries—*hiragana* and *katakana*—developed at the end of the eighth century to represent the syllable sounds of the Japanese language. *Kana* is used in conjunction with *kanji* in writing. *See also kanji*.
kanga Japanese term used from the Muromachi period (1392–1573) for Chinese painting styles. *See also kara-e*.
kanji Chinese characters that form the earliest and still integral part of Japan's written language. *Kanji* can be read in two different ways: there is the *on* reading of a character, which is an approximation of its standard Chinese pronunciation at the time the character entered the Japanese vocabulary—not unusually around the seventh century. There is also the *kun* reading, in which the character is pronounced according to its equivalent in Japan's spoken language. *See also kana*.
Kanō school Lineage of painters and ateliers established in the mid-fifteenth century, but which achieved true ascendance in the sixteenth century when it won the major portion of samurai and even imperial patronage. The artists of this school forged a unique style, marrying *kanga* styles with some *yamato-e* elements with an overall eye to their decorative effect. In the Edo period (1615–1868) it was the school of the Tokugawa regime, and came to be seen as the stale "old guard" against which the newer schools reacted. In the Meiji period (1868–1911), it and the Tosa school were influential in the formulation of the *nihonga* style.

kanpaku "Civil Dictator," title created for the head of state who governed in an adult emperor's name. Administration by *kanpaku* or *sesshō* was the principal form of government during the Middle Heian period (951–1086).

kara-e Japanese term of the early historical periods for Chinese painting styles popular in Japan. *See also kanga.*

karayō Term applied primarily to Chinese architectural styles and motifs, especially that of the Zen temple, introduced into Japan from the thirteenth century onwards. It is in contradistinction to *wayō*, or Japanese style, which refers in particular to the earlier form of Buddhist architecture that had by then come to be seen as a native style.

karesansui Dry-landscape garden, using just a few natural elements, such as rocks, shrubs, moss, and raked sand. It is traditionally believed to have been developed within Zen Buddhist temples as a meditational device.

kasyapa (JAP. *kesa*) The patchwork robe worn by the Buddha and his original disciples and evidence of their mendicant status in the world, without belongings.

Kegon *See* Buddhism (traditions and schools).

Kei school Most important of the Japanese schools of sculptors which flourished in the Kamakura period (1185–1333).

Kenmu Restoration The brief restoration of imperial government between 1333 and 1335 under emperor Go Daigo (r. 1319–39), who with the aid of the samurai general Ashikaga Takauji (1305–58) overthrew the Minamoto *bakufu*. In 1335, however, Takauji chased Go Daigo from Kyoto and set up a new *bakufu*, whereupon Go Daigo established a rival imperial government in Yoshino. Takauji set up a new puppet emperor in Kyoto, and thus was launched the Nambokuchō period (1336–92) and a civil war that lasted for nearly sixty years.

kimono Literally "thing to wear"; term for the traditional Japanese robe in the modern era. *See also kosode.*

kirikane Decorative technique employing cut pieces of gold leaf, sometimes elaborately shaped, on paintings, sculptures, ceramics, and lacquerware.

kōan Questions or exchanges with a Zen master that cannot be understood or answered with rational thought.

kōdō Lecture hall; common feature of Buddhist temple compounds—often located behind the main hall—where monks assemble to hear talks on the Dharma and sutras.

kōshibyō Confucian temple, also known as the *seidō*.

kofun Literally, "ancient tomb" or "ancient mound"; refers to the large burial tumuli of the period 300 to 710, and has become the name of the period itself. The mound was typically keyhole-shaped, was decorated with clay cylinder sculptures (*haniwa*), and contained a burial chamber.

kondō Literally "golden hall"; term popular into the eighth century for the main hall of Buddhist temples. *See also hondō* and *butsuden*.

kongō (SKT. *vajra*) The "diamond scepter" is derived from the ancient Indian emblem for a thunderbolt, but as a potent symbol in Tantric Buddhism, and specifically Shingon ritual, it symbolizes the indestructible nature of truth, which disperses

the shadows of ignorance. It is often paired as a ritual implement with the *suzu* (SKT. *ghanta*; bell).

kosode Literally "small sleeves"; in modern usage, the term for any robe pre-dating the Meiji period (1868–1911). *See also* kimono.

koto (CH. *qin*) An instrument of Chinese origin often referred to in English as a zither. The playing of it came to be one of the accomplishments of a gentleman or woman.

Kusha *See* Buddhism (traditions and schools).

kyakuden Guest hall; term for structure(s) in Buddhist temple complexes for the housing of lay guests. In some cases, individuals—often important temple patrons—would construct *kyakuden* retreats for their own personal use within the precinct.

kyō *See* sutra.

kyōyaki Type of ceramic ware created by independent studio potters of the Edo period (1615–1868), the essential characteristics of which were a stoneware base decorated with delicate traditional Japanese designs in bright overglaze enamels.

L

literati painting *See bunjinga.*

M

magatama A C- or E-shaped bead made from stone—often jade or jasper—amber and even glass. As an object of high status and adornment they are also found in other early Asian cultures, most significantly in that of Korea. From at least Japan's protohistoric periods, they have been an essential component of the regalia of Japan's rulers, what in later epochs came to be called the Three Sacred Treasures (*Sanshu no jingi*). The other two treasures are a sword and a mirror.

Mahayana *See* Buddhism (traditions and schools).

maki-e Literally "sprinkle painting"; technique for decoration developed in lacquer production, in which a design is created by the sprinkling of gold or silver powder.

mandala *See mandara.*

mandara A two- or three-dimensional conceptualization of a deity's palace or of the Buddhist cosmos. In the Japanese tradition, a *mandara* usually takes the form of a painting, although sculptures may be placed to show the relationships among aspects of divinity.

mantra (JAP. *shingon*) A group of mystic Sanskrit syllables given to the Buddhist practitioner for recitation.

manyōgana Early Japanese writing system of the seventh and eighth centuries, in which certain Chinese characters (*kanji*) were used for their phonetic pronunciation within the Chinese language. They were adopted as a primitive phonetic syllabary with which words and phrases in the Japanese spoken language could be spelled out. The name *manyōgana* is derived from the first-known Japanese literary work, the compilation of poems known as the *Manyōshū* (*Collection of Ten Thousand Leaves*).

mappō Period of the Final Law of the Buddha—the degenerate epoch at the end of the age of Shaka Buddha. According to

Buddhist teachings, after a set number of years have elapsed following the death of Shaka, the world will pass into a period in which his teachings are no longer followed and souls can no longer achieve Enlightenment. The date for the beginning of the *mappō* was traditionally believed to be equivalent to 1052.

Maruyama–Shijō school Founded by Maruyama Ōkyo (1733–95), the school's style focused on a Western-influenced realism, but achieved with traditional Japanese painting techniques. Shijō refers to the location of the studio in Kyoto's fourth ward (*shijō*) of Ōkyo's successor Matsumura Goshun (1752–1811). The school continued to flourish in Kyoto into the twentieth century, and was an important inspiration for Kyoto painters in the *nihonga* style.

mingei Folkcraft movement established by Yanagi Sōetsu (1889–1961), redefining the Japanese aesthetics of simplicity and austerity—*wabi* and *sabi*—into a concept of beauty in works that are functional and made of natural materials by anonymous craftspeople using traditional techniques.

Miroku (SKT. Maitreya) Name of the Future Buddha. At present we live in the age of Shaka Buddha, and during this age Miroku exists as a bodhisattva in his Tosotsu (SKT. Tushita) heaven. The next Buddha age is that of Miroku Buddha when he will manifest on earth.

mokoshi Double-roof system on each story of a building, especially of a Buddhist temple hall or of a pagoda.

monogatari Tale, or novel; prose genre that developed in the Heian period (794–1185) and a popular subject of illustrated narrative hand scrolls (*emaki*).

moya Central, rectangular part of a building, particularly of a temple hall; it is usually an odd number of bays wide (three, five, seven, or nine) and two bays deep.

Myōō Properly, the Godai Myōō—The Five Kings of Higher Knowledge; a group of guardian entities who play an important role in the esoteric teachings of the Shingon school. The *myōō* are usually given a fierce aspect reflecting their roles as protectors of the Dharma. They are Fudō (SKT. Acala; the Immovable), Gōzanze (SKT. Trailokyavijaya; Subduer of the Three Worlds), Gundari (SKT. Kundali; Treasure-Producer), Daiitoku (SKT. Yamantaka; Great Awe-Inspiring Power), and Kongō Yasha (SKT. Vajrayaksha; Diamond Demon).

N

nanga See *bunjinga*. The term was lifted from the writings of Dong Qichang (1555–1636), one of China's greatest practitioners and critics of literati painting. Using the traditional division of the Chinese Chan (JAP. Zen) schools into a northern branch that favored rigid adherence to ritual practice and a southern branch that favored intuitive understanding, Dong established a similar division in painting, placing the works of professional and imperial-court painters in a northern school, and the amateur calligraphic and painterly expressions of scholars and officials within a southern school. According to Dong, the works of the northern school while perhaps skillful and refined were also bankrupt of any true spirit or meaning. The latter, however, was the sole aim of the amateur artist of the southern school.

negoro Plain black- or red-lacquered vessels. The standard classical Japanese lacquerware.

nenbutsu Literally, the "thought of the Buddha"; term for the mantra comprising the name of Amida Buddha—"Namu Amida Butsu" (Hail to Amida Buddha). Its recitation is a central practice of Pure Land Buddhism.

netsuke See *inro*.

nihonga Literally, Japanese-style painting; coined in the Meiji period (1868–1911) to identify a style that took its inspiration from traditional Japanese painting styles, while adapting them using aspects of Western pictorial technique. It is in contrast to *yōga* (Western style painting).

nirvana In Buddhism, the state or realm of perfect Enlightenment, beyond all suffering and limitation. It is the ultimate goal of the Buddhist practitioner.

Nō Theater that evolved out of the *kagura* dances performed at the imperial court and imperial-cult shrines since time immemorial, reputedly having first been performed as one of the methods of coaxing Amaterasu from her cave. Nō combined *kagura* with both ancient and more recent peasant dance-traditions into a dramatic performance narrated by a chorus to the sounds of drums and wind instruments while the actors convey their thoughts and emotions through a combination of chanted dialogue and dance. The dramas usually focus on a single character whose inner conflicts must be resolved before his or her soul can achieve peace. Secondary Nō characters enable the focal character to accomplish this goal. Credit for the development of Nō goes to the father and son Kan'ami and Ze'ami, who in the fourteenth and fifteenth centuries formulated this dramatic art under the patronage of the Ashikaga shoguns, and particularly that of Yoshimitsu (1358–1409).

O

ojime See *inro*.

Ōnin War Conflict of 1467 to 1477, arising from the need for a new shogun to follow the retirement of Ashikaga Yoshimasa (1430–90). Large parts of Kyoto were destroyed, as was any real authority exercised by the Ashikaga *bakufu*. It led directly into the Sengoku Jidai (Age of the Country at War).

onna-e Literally "women's pictures"; originating in the Heian period (794–1185), term indicates subject matter in painting felt to be especially of interest to women, such as that illustrating romantic poetry and prose. In style it is exemplified by *tsukuri-e* paintings, in which built-up color dominates, such as in the illustrations to the *Genji monogatari*.

otoko-e Literally "men's pictures"; term first used in the Heian period (794–1185), it evolved out of picture-painting parties and competitions, where the quickly sketched subject often proved to be quite rude in nature, and was therefore judged suitable only for men's viewing. It came to refer to monochrome or lightly colored pictures that relied in the Chinese style on the calligraphic line to convey the visual image, and became a popular style for narrative paintings in the Heian and succeeding periods.

P

pagoda Developing out of the Indian stupa, it is a slender structure with several stories, each marked by the characteristic wide-eaved roof, capped by a tall spire. It functions as a memorial reliquary containing remains of the Buddha or jewels symbolic of such relics.

Pure Land (JAP. *jōdo*) Paradise presided over by a Buddha, a transcendent realm of bliss in which devotees aim to be reborn and in which they will realize nirvana. Pure Land Buddhism consists of several main schools that focus on Amida Buddha and his Western Paradise. *See also* Buddhism (traditions and schools).

R

raigō The welcome to the Western Paradise by Amida Buddha, and possibly one or more bodhisattvas, of a devotee after death. It became an important element in the iconography of the Pure Land schools.

rakan (SKT. *arhat*) Buddhist rank of attainment on the path to Enlightenment. Often used in reference to a group of sixteen of Shaka Buddha's disciples charged by him at his passing into nirvana to uphold and protect the Dharma until the end of the present Buddha age.

raku Literally, "comfort" or "pleasure"; type of ceramic ware that is lead-glazed and fired at low temperatures and that traditionally is hand formed. Originally the work of one family of Kyoto potters, who produced tea bowls and decorative wares.

rakuchū rakugai Literally "scenes in and around the capital," Raku being another of Kyoto's many epithets. The invention of this subject matter is attributed to Tosa Mitsunobu (1434–1525), and usually comprises a bird's-eye view of Kyoto spread over a pair of six-panel screens.

rangaku Literally "Dutch studies"; study of Western sciences and humanities in the Edo period (1615–1868) by means of the Dutch language, the only Western language in which books were available in Japan at that time.

renga Linked poetic format that became popular during the medieval period and developed out of the earlier *waka*. In *renga*, a number of separate *waka* are composed in a chain of developing ideas, which may be up to a thousand stanzas long.

Rinpa school This school officially traces itself back to Sōtatsu (act. 1600–40) and Hon'ami Kōetsu (1558–1637), but in reality it is the product of the reworking and revitalization of their concepts by Ōgata Kōrin (1658–1716), as reflected in the school's name—literally the School of Rin, the "rin" taken from the second syllable of Kōrin. Rinpa (often pronounced Rimpa) is not so much a school but rather an association of aesthetic and design values espoused by different artists in the centuries following Kōrin's own production. Distinguished by its lavish use of bright colors and gold and silver, reminiscent of the gorgeousness of Heian-period art, Rinpa style uses these elements to flatten out and simplify images into combinations of near-abstract form.

Rinzai *See* Buddhism (traditions and schools).

Ritsu *See* Buddhism (traditions and schools).

rokudō-e Genre of Japanese Buddhist painting particularly associated with Pure Land Buddhism and depicting the "six types of existence" into which human beings are reborn: unenlightened heavenly beings, humans, animals, constantly fighting demons, hungry ghosts, and beings in hell. *Rokudō-e* often focus on the less pleasant aspects of the conditions of existence.

running-grass script (JAP. *sōsho*; CH. *caoshu*) Style of calligraphy in which elements of the character are abbreviated or disappear in favor of a smooth and quick execution, appearing much like blades of grass or straw.

S

sabi Taking pleasure in the old, tarnished, and imperfect for their own sake, and as expressions of the ideals of harmony and simplicity; often carries a connotation of loneliness. Like *wabi*, it infuses the aesthetic of the tea ceremony, and is seen in the tea garden's mossy rocks and the tea bowl's uneven shape and rough glaze.

samisen An instrument sometimes described as a three-stringed banjo which became popular in the course of the sixteenth century for narrative and lyrical music, including folk music.

samurai Literally "one who serves"; important military class that developed during the Heian period (794–1185), largely out of the aristocratic and imperial clans. Its role was as a kind of police force in the cities and on the great *shōen* estates. By the end of the twelfth century, the samurai had effectively taken over the government, dominating it until 1868. *See also bakufu*, daimyo, shogun.

sanmon Two-storied inner gate to a temple complex, originally developed within the Zen schools. It is called the mountain gate or the Enlightenment gate, and is reached after entering the main gate. It corresponds to the earlier *chūmon*.

Sanron *See* Buddhism (traditions and schools).

Sanskrit Classical language of India, in which the sacred texts of Buddhism were written before their transmission to East Asia.

satori Zen Buddhist term for Enlightenment. *See also* Buddhism (traditions and schools).

Sengoku Jidai "The Age of the Country at War" Term for the petty wars and conflicts between the various daimyo that characterized the last century of the Muromachi period (1392–1573) following the conclusion of the Ōnin War (1467–77).

sesshō "Regent," appointed head of state governing in the name of an emperor during his minority. Administration by *kanpaku* or *sesshō* was the principal form of government during the Middle Heian period (951–1086).

setomono Initially a term referring in the medieval period to wares of the Seto kilns, it has come to mean pottery of all types, including earthenware, stoneware, and porcelain.

Shaka (SKT. Shakyamuni) The Historical Buddha and the Buddha of the present Buddha age; scholars at present believe him to have lived between 490 and 410 B.C.E.. He abandoned

his princely privileges as a young man to follow instead the path to Enlightenment. Disciples then flocked around him, and he travelled widely in northern India, preaching wherever he went until his passing away into nirvana. His words became enshrined as the sutras, the foundation of all Buddhist teaching. He is often also referred to with the more respectful Shaka Nyorai.

shariden Relic hall; structure in Buddhist temples and Shinto shrines in which sacred relics associated with holy personages are preserved and venerated.

shaseiga Drawing or sketching from nature.

shinden More fully *shinden zukuri*; style of mansion architecture that developed in the Heian period (794–1185), and which became the prototype for all aristocratic residences. It is characterized by a central hall, the *shinden*, where the master lived and received guests. It faced south to a courtyard, garden, and perhaps a lake; hallways extended on the other three sides to subsidiary buildings, where wives and other family members and retainers had their apartments.

Shingon *See* Buddhism (traditions and schools).

shin hanga Literally "new prints"; twentieth-century printmaking movement associated with the Taishō period (1911–26) that joined traditional *ukiyo-e* themes, *bijinga*, and landscapes with Western printing concepts. The result was limited, numbered editions made to high standards in technically proficient print workshops.

shigajiku Tradition of Zen painting in which poetry—often composed and copied by several different priests—is combined with a monochrome image of an imaginary landscape, often in the format of a hanging scroll.

shinmei zukuri Style of Shinto building typified by the Ise shrine, which harks back to Yayoi period granary-style buildings.

shishi "Men of determination"; middle- and lower-ranking samurai officials of the regional *han* governments of the later Edo period (1615–1868) who worked toward securing for Japan an inviolate supremacy in the face of the country's opening up to the West. They took as their focus the emperor in Kyoto, and out of the *shishi* came the men who would effect the Meiji Restoration in 1868.

Shitennō (SKT. Lokapala) Four Guardian or Heavenly Kings; guardian figures associated with the four cardinal directions. They are Tamonten (SKT. Vaishravana; north), Kōmokuten (SKT. Virupaksa; east), Jikokuten (SKT. Dhrtarashtra; west), and Zōchōten (SKT. Virudhaka; south).

shōen Provincial estates which were the main form of landholding in the Heian (794–1185) and medieval (1185–1573) periods.

shogun Abbreviated version of the seiitai shogun (barbarian-subduing general); first given to Minamoto no Yoritomo (1147–99). Rule by the shogun and his military government (*bakufu*) was the primary form of government between 1185 and 1868. Drawn from the military class of samurai, the shogun, like the *sesshō*, *kanpaku*, and *insei* before him, ostensibly ruled in the name of the emperor.

shōhekiga Alternatively, *shōbyōga*; paintings on sliding doors (*fusuma*) and freestanding folding screens (*byōbu*).

shoin Style of residential architecture that developed in the Muromachi (1392–1573) and Momoyama (1573–1615) periods, characterized by tatami floor-coverings, *fusuma*, *shoji*, *tokonoma*, *chigaidana*, and *tsuke shoin*. It became the template for traditional domestic Japanese architecture.

shoji Originally a term for doors, freestanding folding screens, and *fusuma*, it now refers to sliding screens covered with translucent white paper, usually serving as windows and doors to the exterior; probably developed in the late fifteenth century and characteristic of the *shoin* style.

Six Schools of Nara *See* Buddhism (traditions and schools).

sōsaku hanga "Creative prints"; twentieth-century print-making movement associated with the Shōwa period (1926–89), based on the artist's personal involvement in all stages of print production; influenced by contemporaneous Western printmakers, who produce their own work single-handedly.

Sōtō *See* Buddhism (traditions and schools).

stupa Buddhist memorial monument containing relics of the Buddha or of a holy sage. Developed in India, where the traditional shape was a hemisphere on a circular base, topped with a spire; origin of the pagoda of China, Korea, and Japan.

sutra (JAP. *kyō*) The words of *Shaka* Buddha's earthly manifestation; sacred scriptures of Buddhism.

T

tahōtō "Pagoda of many treasures"; form of the pagoda developed within the Shingon school.

Taisha zukuri Reputedly the oldest style of Shinto architecture, it is typified by the Izumo shrine.

Tale of Genji (JAP. *Genji monogatari*) The greatest of the Heian-period (794–1185) *monogatari*, and arguably the world's first novel. It was written by a noblewoman known as Lady Murasaki Shikibu. More than any other work of literature, *Genji monogatari* has been an important source of subject matter for all the Japanese artistic media.

Tantra/Tantric *See* Buddhism (traditions and schools).

tarashikomi Technique believed to have been originated by the painter Sōtatsu (act. 1600–40), in which colors are applied over a still-wet layer of colors to achieve subtle variations in shading.

tatchū Private subtemples in Zen Buddhist temple complexes, where retired senior priests live.

tea ceremony *See chanoyu*.

temple Japanese Buddhist temples (JAP. *-ji*, *-tera*, *-dera*) range from modest single buildings to great monastery complexes; major temples, both urban and rural, contain numerous buildings within an enclosure, commonly including gates (*see chūmon* and *sanmon*), main hall (*see kondō*, *hondō* and *butsuden*), pagodas or relic halls (*see* pagoda and *shariden*), lecture hall (*see kōdō* and *hattō*), guest hall (*see kyakuden*), founder's hall (*see kaisandō*), sutra repository (*see kyōzō*), belfry (*see shōrō*), monks' quarters, and support buildings.

Tendai *See* Buddhism (traditions and schools).

tenjin Shinto term denoting all heavenly beings.

tenmoku Type of tea bowl associated with Zen and *chanoyu*, and whose name is derived from Mount Tianmu in China, the site of the monasteries where this type of ceramic was first created for drinking tea. In Japan, the term refers to a usually somewhat conical tea bowl, that could be decorated with glazes ranging from matte to iridescent black and brown. These glazes could also carry streaks of dark or silvery color, or even almost-blue star bursts.

tenshu Donjon, or keep, of a castle, i.e., the central fortified area; a multistoried building rising above the rest of the castle complex, in some cases it is a single tower but elsewhere it is connected to one or more subsidiary donjons. *See also honmaru.*

tokonoma Shallow alcove in a room, the floor of which is slightly elevated from the main space. Characteristic of *shoin* architecture, it serves as focal point for the display of art, most often a hanging scroll complemented by a flower arrangement.

tonseisha Individuals in the medieval period (1185–1573) who had become monks in order to escape low social rank, but who did not affiliate with any particular Buddhist temple. They played a great role in the cultural life of the times, particularly during the Muromachi period (1392–1573).

torii Gate to a Shinto shrine, marking the entrance to the sacred precinct; constructed of two posts capped by two beams that extend beyond the posts, the ends of the upper beam flaring upward.

Tosa school Lineage of painting centered on the imperial court; founded at the end of the twelfth century by Fujiwara no Tsunetaka, or as he came to be known—Tosa Tsunetaka. Subsequent masters of this school usually have the surname of Tosa, adopting the name as one did a court title. It became the leading school of *yamato-e* painting at the imperial court until the Meiji Restoration of 1868. Critics have often characterized the seven hundred years of the Tosa tradition as hidebound to the conventions of Heian-period *yamato-e*, churning out stale and trite images for a court stagnating in memories of the past. However, in the Meiji period, it and the Kanō school became important sources for the newly established *nihonga* style.

tsuke shoin Attached study; alcove with a built-in desk that projects out of a room—as a deep bay-window might—onto the surrounding porch. Characteristic of the *shoin* style of architecture.

tsukuri-e ("built-up" painting) Style of painting first popular in the Heian period and characterized by heavy applications of color over a cartoon outline, so that few of the outlines remain visible in the finished image.

tumulus Mounded grave site, customary in Japan before the arrival of Buddhism, especially in the Yayoi (400 B.C.E.–C.E. 300) and Kofun (300–710) periods.

U

uki-e Pictures, primarily woodblock prints, using Western-style perspective to achieve a sense of depth; the use of perspective becomes an important feature in nineteenth-century landscape printmaking in Japan.

ukiyo-e Literally, "pictures of the floating world"; images of the pleasure districts of Edo and Kyoto that housed entertainment such as the theater and brothels. These woodblock prints and paintings—mainly genre scenes and portraits—were very popular in the Edo period (1615–1868).

V

vajra See kongō

W

wabi Appreciation of austerity, simplicity and humility; a love of tranquillity and purity that is classically expressed in the tea ceremony's rustic and plain, yet precise and elegant garden, room, appointments, food, manners and particularly its ceramics. *See also sabi.*

waka Literally "poetry of Wa"—or Japan; thirty-one-syllable poem in five lines created in the eighth century as an alternative to the more classical and formal poetic forms adopted from China. It is the basic form from which most other forms of Japanese poetry have evolved, including *renga* and haiku.

wayō "Japanese style"; term for the early style of the Nara (710–794) and Heian (794–1185) periods of Buddhist architecture, which seemed native in comparison to Chinese styles introduced later in the medieval period (1105–1573). *See also karayō.*

Y

yamato-e Japanese-style painting, as distinct from Chinese styles, or *kara-e*. A soft, colorful and narrative style, *yamato-e* was first developed in the Heian period (794–1185) and continued in the medieval period (1105–1573) as an important element of imperial-court painting, particularly of the Tosa school. From the Momoyama period (1573–1615) onward, it has been an important resource for many painters and painting movements, not least Rinpa and *nihonga*.

yōfūga Literally, "Western-style painting"; Japanese painting in the Edo period (1615–1868) influenced by Western painting techniques, particularly to provide a sense of depth and volume through the use of Western and shading perspective.

yōga Literally, "Western painting"; Western styles of painting dating from 1868 and the start of the Meiji period to 1945 by Japanese artists using Western perspective and chiaroscuro, and working in Western mediums, principally oil paints; contrasted with *nihonga*. It has continued in the post-war period as a genre, although generally an academic one that is considered to look back at the pre-war styles and influences.

yoroi Ancient style of Japanese armor typical of the medieval period.

yosegi Sculpture construction technique, in which individually carved blocks of wood are joined together. The carving is

then completed and the assembled sculpture finished with lacquer and gold leaf or paint.

Z

zazen Meditation while sitting straight-backed with legs crossed.

Zen *See* Buddhism (traditions and schools).

zendō Style of building in Ōbaku Zen temples specifically for practice of the meditation.

zenga Zen painting and calligraphy; modern term used in two art-historical contexts: broadly, for paintings by Zen Buddhist priests of China, Korea, and Japan; and, more specifically, for work—usually bold and spontaneous—by Japanese Zen priests from about 1600 to the present, in which the emphasis is on presenting teachings of the Dharma.

Bibliography

History and Literature

Aston, W.G., *Nihongi: Chronicles of Japan from the Earliest Times to* AD *697*, 2 vols, Rutland Vt: Charles E. Tuttle, 1972 (reprint).

Collcutt, Martin, Marius Jansen and Isao Kumakura, *Cultural Atlas of Japan*, New York: Facts on File Publications, 1988.

Frédéric, Louis, *Japan: Art and Civilization*, New York: Harry N. Abrams, 1969.

Frédéric, Louis, *Le Japon: Dictionnaire et Civilisation*, Paris: Robert Laffont, 1996.

Hisamitsu Sen'ichi, *Biographical Dictionary of Japanese Literature*, New York: Kodansha International, 1976.

Honda, H.H., *The Shin Kokinshu: the 13th Century Anthology Edited by Imperial Edict*, Tokyo: Hokuseido Press, 1970.

Keene, Donald (ed.), *Anthology of Japanese Literature*, New York: Grove Press, 1955.

Keene, Donald (ed.), *Modern Japanese Literature, An Anthology*, New York: Grove Press, 1956.

Keene, Donald (trans.), *Essays in Idleness: The Tsurezuregusa of Kenkō*, New York: Columbia University Press, 1967.

Kodansha Encyclopaedia of Japan, 9 vols, New York: Kodansha International, 1983.

Levy, Ian Hideo, *The Ten Thousand Leaves: A Translation of the Many'yōshū*, 2 vols, Princeton Library of Asian Translations, Princeton: Princeton University Press, 1981.

McCullough, Helen Craig (trans.), *Tales of Ise*, Stanford University Press, 1968.

McCullough, Helen Craig trans., *The Tale of Heike*, Stanford: Stanford University Press, 1988.

McCullough, Helen Craig (ed.), *Classical Japanese Prose: An Anthology*, Stanford: Stanford University Press, 1990.

McCullough, Helen Craig and William H. McCullough (trans.), *A Tale of Flowering Fortunes*, 2 vols, Stanford: Stanford University Press, 1980.

Morris, Ivan (trans.), *The Pillow Book of Sei Shōnagon*, 2 vols, Oxford: Oxford University Press, 1967.

Mosher, Gouverneur, *Kyoto: A Contemplative Guide*, Rutland Vt.: Charles E. Tuttle, 1964.

Ryusaku Tsunoda *et al.*, *Sources of Japanese Tradition*, 2 vols, New York: Columbia University Press, 1958.

Sansom, George, *A History of Japan*, 3 vols, Stanford: Stanford University Press, 1958–63.

Sansom, George, *Japan: A Short Cultural History*, Stanford: Stanford University Press, 1978 (revised edition).

Seidensticker, Edward (trans.), *The Tale of Genji*, London: Secker and Warburg, 1976.

Whitney Hall, John, *Japan: Art and Civilization*, New York: Dell, 1970.

Whitney Hall, John *et al.*, *Cambridge History of Japan*, 6 vols, Cambridge: Cambridge University Press, 1988–99.

Waley, Arthur (trans.), *The Tale of Genji by Lady Murasaki*, New York: The Modern Library, 1960.

Watson, Burton, *Cold Mountain*, New York: Columbia University Press, 1962.

Buddhism, Shinto, and their Arts

Addiss, Stephen, *The Art of Zen: Paintings and Calligraphy by Japanese Monks, 1600–1925*, New York: Harry N. Abrams, 1989.

Addiss, Stephen, *Haiga: Takebe Sōchō and the Haiku-Painting Tradition*, Honolulu: University of Hawaii Press, 1995.

Addiss, Stephen, '*Haiga*: the Haiku-Painting Tradition', *Orientations* 26:2 (February 1995), 28–37.

Awakawa Yasuichi, *Zen Painting*, John Bester (trans.), New York: Kodansha International, 1970.

Barnet, Sylvan and William Burto, *Zen Ink Paintings*, New York: Kodansha International, 1982.

Baskett, Mary W., *Footprints of the Buddha*, Philadelphia: Philadelphia Museum of Art, 1980.

Brinker, Helmut, *Zen in the Art of Painting*, George Campbell (trans.), London: Arkana, 1987.

Brinker, Helmut and Hiroshi Kanazawa, *Zen: Masters of Meditation in Images and Writings*, Zürich: Artibus Asiae, 1996.

Childs, Margaret, "Chigo Monogatari: Love Stories or Buddhist Sermons?", *Monumenta Nipponica*, vol. 35:2, 1980.

Dumoulin, Heinrich, *Zen Buddhism: A History*, James W. Heisig and Paul Knitter (trans.), New York: Macmillan, 1990.

Faure, Bernard, *Visions of Power: Imaging Medieval Japanese Buddhism*, Phyllis Brooks (trans.), Princeton: Princeton University Press, 1996.

Faure, Bernard, *The Red Thread: Buddhist Approaches to Sexuality*, Princeton: Princeton University Press, 1998.

Fontein, Jan and Money L. Hickman, *Zen Painting and Calligraphy*, Boston: Museum of Fine Arts, 1970.

Frank, Bernard, *Le panthéon bouddhique au Japan – Collections d'Emile Guimet*, Musée national des arts asiatiques, Paris: Guimet, 1991.

Graybill, Maribeth and Sadako Ohki, *Days of Discipline and Grace: Treasures from the Imperial Buddhist Convents of Kyoto*, New York: Institute for Medieval Japanese Studies, 1998.

ten Grotenhuis, Elizabeth, *Japanese Mandalas: Representations of Sacred Geography*, Honolulu: University of Hawaii, 1999.

Guth Kanda, Christine (trans.), *Shinto Arts*, New York: Japan Society, 1976.

Guth Kanda, Christine, *Shinzō: Hachiman Imagery and Its Development*, Cambridge Mass.: Council on East Asian Studies, 1985.

Harris, Victor (ed.), *Shintō: The Sacred Art of Ancient Japan*, London: British Museum, 2001.

Hisamatsu Shin'ichi, *Zen and the Fine Arts*, Gishin Tokiwa (trans.), Tokyo: British Museum, 1971.

Ishida Mosaku *et al.*, *Japanese Buddhist Prints*, Charles Terry (trans.), New York: Harry N. Abrams, 1964.

Joly, Henri L., *Legend in Japanese Art*, Rutland Vt: Charles E. Tuttle, 1967 (reprint).

Kageyama Haruki, *The Arts of Shinto*, Christine Guth Kanda (trans. and adapt.), New York: Weatherhill, 1973.

Little, Stephen, *Visions of the Dharma: Japanese Buddhist Paintings and Prints in the Honolulu Academy of Arts*, Honolulu: Honolulu Academy of Arts, 1991.

Matsuda Tomohiro *et al.*, *A Dictionary of Buddhist Terms and Concepts*, Tokyo: Nichiren Shōshu International Center, 1983.

Matsunaga, Daigan and Alicia, *Foundation of Japanese Buddhism*, 2 vols, Los Angeles: Buddhist Books International, 1974–76.

Mino Yutaka *et al.*, *The Great Eastern Temple: Treasures of Japanese Buddhist Art from Tōdaiji*, Chicago: Art Institute of Chicago, 1986.

Morse, Anne Nishimura and Samuel Crowell Morse, *Object as Insight: Japanese Buddhist Art & Ritual*, Katonah NY: Katonah Museum of Art, 1995.

Morse, Samuel C., 'Jizū in Mediaeval Japan: Three Works from the Collection of the Ruth and Sherman Lee Institute for Japanese Art', *Orientations* 33:7 (September 2002), 52–59.

Nishikawa Kyōtarō and Emily Sano, *The Great Age of Japanese Buddhist Sculpture A.D. 600–1300*, Fort Worth: Kimbell Art Museum, 1982.

Pal, Pratapaditya and Julia Meech Pekarik, *Buddhist Book Illumination*, New York: Ravi Kumar, 1988.

Pigott, Juliet, *Japanese Mythology*, New York: Peter Bedrick Books, 1983 (revised edition).

Reischauer, A.K., 'Genshin's *Ōjō Yōshū*: Collected Essays on Birth into Paradise', *Transactions of the Asiatic Society of Japan*, 2nd series, vol. 3 (December 1930).

Saunders, Dale, *Mudrā*, Princeton: Pantheon, 1960.

Saunders, Dale, *Buddhism in Japan*, Philadelphia: University of Pennsylvania Press: 1964.

Seckel, Dietrich, *The Art of Buddhism*, Ann E. Keep (trans.), New York: Crown, 1964.

Sekai Isan – Daigoji ten:shinkō to mi no shihō (*The World Legacy of Daigo-ji: Artistic and Religious Treasures*), Fukuoka: Nihon Keizai Shimbun, 2001.

Sharf, Robert H. and Elizabeth Horton Sharf (eds), *Living Images : Japanese Buddhist Icons in Context*, Stanford: Stanford University Press, 2001.

Snellgrove, David L. *et al.*, *The Image of the Buddha*, New York: Kodansha International, 1978.

Tanabe, Willa, Shinryu Izutsu and Julia M. White, *Sacred Treasures of Mount Kōya: The Art of Japanese Shingon Buddhism*, Honolulu: Honolulu Academy of Arts, 2002.

Tange Kenzo and Kawazoe Noboro, *Ise: Prototype of Japanese Architecture*, Cambridge Mass.: , MIT Press, 1965.

Tōji kokuhō ten (*Treasures from the Tō-ji*), Kyoto: Kyoto National Museum, 1995.

Tyler, Susan C., *The Cult of Kasuga Seen through Its Art*, Ann Arbor: University of Michigan Press, 1992.

Washizuka Hiromitsu *et al.*, *Enlightenment Embodied: the Art of the Japanese Buddhist Sculptor (7th–14th Centuries)*, Reiko Tomii and Kathleen M. Fraiello (trans. and adapt.), New York: Japan Society, 1997.

Yampolsky, Phillip B., *The Zen Master Hakuin: Selected Writings*, New York: Columbia University Press, 1971.

Japanese Art

Akiyama Terukazu *et al.*, *Genshoku nihon no bijutsu* (*Japanese Art in Colour*), 32 vols, Tokyo: Shogakkan, 1967–80.

Asiatic Art in the Museum of Fine Arts, Boston, Boston: Museum of Fine Arts, 1982.

Batterson Boger, H., *The Traditional Arts of Japan*, Garden City NY: Doubleday, 1966.

Brennan Ford, Barbara and Oliver R. Impey, *Japanese Art from the Gerry Collection*, New York: The Metropolitan Museum of Art, 1989.

Deutsch, Sanna Saks and Howard A. Link, *The Feminine Image*, Honolulu: Honolulu Academy of Arts, 1985.

Elisseef, Danielle and Vadime, *Art of Japan*, I. Mark Paris (trans.), New York: Harry N. Abrams, 1985.

The Freer Gallery of Art: Japan, Washington DC: Kodansha Ltd, 1972.

Guth, Christine, *Asobi: Play in the Arts of Japan*, Katonah NY: Katonah Museum of Art, 1992.

Hirabayashi Moritoku *et al.*, *Twelve Centuries of Japanese Art from the Imperial Collections*, Washington DC: Freer Gallery of Art, 1997.

Kakudo, Yoshiko, *The Art of Japan*, San Francisco: Asian Art Museum of San Francisco, 1991.

Kidder, J. Edward, *The Art of Japan*, New York: Park Lane, 1985.

Lee, Sherman *et al.*, *One Thousand Years of Japanese Art (650–1650): From the Cleveland Museum of Art*, New York: Japan Society, 1981.

Lee, Sherman E., Michael R. Cunningham and James T. Ulak, *Reflections of Reality in Japanese Art*, Cleveland: Cleveland Museum of Art, 1983.

Murase Miyeko, *Japanese Art: Selections from the Mary and Jackson Burke Collection*, New York: The Metropolitan Museum of Art, 1975.

Murase Miyeko, *Iconography of the Tale of Genji*, New York: Weatherhill, 1984.

Murase Miyeko, *Tales of Japan*, New York: Oxford University Press, 1986.

Nihon bijutsu no zenshū (The Complete Japanese Art Compendium), 24 vols, Tokyo: Kodansha, 1990.

Noma Seiroku, *The Arts of Japan*, John Rosenfield and Glenn T. Webb (trans. and adapt.), Tokyo: Kodansha International, 1966.

Rosenfield, John M. and Shūjirō Shimada, *Traditions of Japanese Art: Selections from the Kimiko and John Powers Collection*, Cambridge Mass.: Fogg Art Museum, 1970.

Shimada Shūjiro, Akiyama Terukazu and Yamane Yūzū, *Zaigai nihon no shihō (The Best of Japanese Art in Foreign Collections)*, 10 vols, Tokyo: Mainichi Newspaper Co., 1980–82.

Shimizu Yoshiaki (ed.), *Japan: The Shaping of Daimyo Culture 1185–1868*, Washington DC: National Gallery of Art, 1988.

Smith, Lawrence, Victor Harris and Timothy Clark, *Japanese Art: Masterpieces in the British Museum*, New York: Oxford University Press, 1990.

Stanley-Baker, Joan, *Japanese Art*, New York: Thames and Hudson, 1984.

Swann, Peter C., *Concise History of Japanese Art*, New York: Kodansha International, 1979.

A Thousand Cranes: Treasures of Japanese Art, Seattle: Seattle Art Museum, 1987.

Warner, Langdon, *The Enduring Art of Japan*, Cambridge Mass.: Harvard University Press, 1952.

Yamasaki Shigehisa (ed.), *Chronological Table of Japanese Art*, Tokyo: Geishinsa, 1981.

Yutaka Tazawa (ed.), *Biographical Dictionary of Japanese Art*, Tokyo: Kodansha International, 1981.

Heibonsha Survey of Japanese Art

Series in 30 volumes published by Weatherhill, New York, 1972–78.

1. Yoshikawa Itsuji, *Major Themes in Japanese Art*
2. Egami Namio, *The Beginnings of Japanese Art*
3. Watanabe Yasutada, *Shinto Art: Ise and Izumo Shrines*
4. Mizuno Seiichi, *Asuka Buddhist Art: Horyu-ji*
5. Kobayashi Tsuyoshi, *Nara Buddhist Art: Todai-ji*
6. Hayashi Ryoichi, *The Silk Road and the Shoso-in*
7. Ooka Minoru, *Temples of Nara and Their Art*
8. Sawa Takaaki, *Art in Esoteric Buddhism*
9. Fukuyama Toshio, *Heian Temples: Byodo-in and Chuson-ji*
10. Ienaga Saburo, *Painting in the Yamato Style*
11. Mori Hisashi, *Sculpture of the Kamakura Period*
12. Tanaka Ichimatsu, *Japanese Ink Painting: Shubun to Sesshu*
13. Hirai Kiyoshi, *Feudal Architecture of Japan*
14. Doi Tsugiyoshi, *Momoyama Decorative Painting*
15. Hayashiya T. *et al.*, *Japanese Arts and the Tea Ceremony*
16. Noma, Seiroku, *Japanese Costumes and Textile Arts*
17. Yamane Yuzo, *Momoyama Genre Painting*
18. Mizuo Hiroshi, *Edo Painting: Sotatsu and Korin*
19. Okamoto Yoshitomo, *The Namban Art of Japan*
20. Okawa, Naomi, *Edo Architecture: Katsura and Nikko*
21. Itoh Teiji, *Traditional Domestic Architecture of Japan*
22. Takahashi Seiichiro, *Traditional Woodblock Prints of Japan*
23. Yonezawa Yoshiho and Yoshizawa Chu, *Japanese Painting in the Literati Style*
24. Kawakita Michiaki, *Modern Currents in Japanese Art*
25. Terada Toru, *Japanese Art in World Perspective*
26. Muraoka Kageo and Okamura Kishiemon, *Folk Arts and Crafts of Japan*
27. Nakata Yujiro, *The Art of Japanese Calligraphy*
28. Hayakawa Masao, *The Garden Art of Japan*
29. Mikami Tsugio, *The Art of Japanese Ceramics*
30. Ienaga Saburo, *Japanese Art: A Cultural Appreciation*

Architecture and Gardens

Alex, William, *Japanese Architecture*, New York: Braziller, 1963.

Bring, Mitchell and Josse Wayembergh, *Japanese Gardens: Design and Meaning*, New York: McGraw Hill, 1981.

Coaldrake, William H., *The Way of the Japanese Carpenter: Tools and Japanese Architecture*, New York: Weatherhill, 1990.

Drexler, Arthur, *The Architecture of Japan*, New York: The Museum of Modern Art, 1966.

Itō Teiji, *The Japanese Garden*, Donald Richie (trans.), New Haven: Yale University Press, 1972 (2nd edition)

Itoh Teiji, *Imperial Gardens of Japan*, New York: Weatherhill, 1970.

Itoh Teiji, *Space and Illusion in the Japanese Garden*, Ralph Friederich and Masajiro Shimamura (trans.), New York: Weatherhill, 1973.

Itoh Teiji, *The Gardens of Japan*, New York: Kodansha International, 1984.

Kawashima Chūji, *Minka*, Lynne E. Riggs (trans.), New York: Kodansha International, 1986.

Kazuo, Nishi and Hozumi, *What is Japanese Architecture?*, H. Mack Horton (trans.), New York: Kodansha International, 1985.

Kidder, J. Edward, *Japanese Temples: Sculptures, Paintings, Gardens and Architecture*, Tokyo: Bijutsu Shuppan-sha, 1964.

Kuck, Loraine, *The World of the Japanese Garden*, New York: Weatherhill, 1970 (corrected edition).

Kuitert, Wybe, *Themes, Scenes, and Taste in the History of Japanese Garden Art*, Amsterdam: J.C. Gieben, 1988.

Paine, Robert Treat and Alexander Soper, *The Art and Architecture of Japan*, Baltimore: Penguin, 1981.

Parent, Mary N., *The Roof in Japanese Buddhist Architecture*, New York: Weatherhill, 1983.

Schaarschmidt, Irmtraud and Osamu Mori, *Japanese Gardens*, Janet Seligman-Richter (trans.), New York: Morrow, 1979.

Shigemori Kanto, *The Japanese Courtyard Garden*, Pamela Pasti (trans.), New York: Weatherhill, 1981.

Slawson, David A., *Secret Teachings in the Art of Japanese Gardens*, New York: Kodansha International, 1987.

Painting

Akiyama Terukazu, *Japanese Painting*, London: Macmillan, 1977.

Bambling, Michele, 'The Kongō-ji Screens: Illuminating the Tradition of *Yamato-e* "Sun and Moon" Screens, *Orientations* 27:8 (September 1996), 70–82.

Grilli, Elise, *The Art of the Japanese Screen*, New York: Weatherhill, 1970.

Lippit, Yukio, 'Ten Episodes from the History of Japanese Painting', *Orientations*, 31:8 (October 2000), 96–105.

Matsushita Takaaki, *Ink Painting*, Martin Collcutt (trans. and adapt.), New York: Weatherhill, 1974.

Miyajima Shin'ichi and Satō Yasuhiro, *Japanese Ink Painting*, Los Angeles: Los Angeles County Museum of Art, 1985.

Murase Miyeko, *Emaki: Narrative Scrolls from Japan*, New York: Asia Society, 1983.

Murase Miyeko, *Masterpieces of Japanese Screen Painting: The American Collections*, New York: Braziller, 1990.

Okudaira Hideo, *Emaki: Japanese Picture Scrolls*, Rutland Vt: Charles E. Tuttle, 1962.

Okudaira Hideo, *Narrative Picture Scrolls*, Elizabeth ten Grotenhuis (adapt.), New York: Weatherhill, 1973.

Rosenfield, John M., *Song of the Brush*, Seattle: Seattle Art Museum, 1979.

Rosenfield, John M. and Elizabeth ten Grotenhuis, *Journey of the Three Jewels*, New York: Asia Society, 1979.

Shimizu Yoshiaki and Carolyn Wheelwright (eds), *Japanese Ink Paintings from American Collections*, Princeton: Princeton University Press, 1976.

Calligraphy

Murase, Miyeko, 'Flecks of Gold and Strips of Silver: Early Paper Decoration in Japan', *Orientations* 33:8 (October 2002), 36–44.

Rimer, J. Thomas, ed., *Multiple Meanings*, Library of Congress: Washington DC, 1986.

Rosenfield, John M., Fumiko Cranston and Edwin A. Cranston, *The Courtly Tradition*, Cambridge Mass.: Fogg Art Museum, 1973.

Shen Fu, Glenn D. Lowry and Anne Yonemura, *From Concept to Context: Approaches to Asian and Islamic Calligraphy*,

Washington DC: Freer Gallery of Art, 1986.

Shigemi Komatsu, Kwan S. Wong and Fumiko Cranston, *Chinese and Japanese Calligraphy – The Heinz Götze Collection*, Munich: Prestel, 1989.

Yoshiaki Shimizu and John Rosenfield, *Masters of Japanese Calligraphy: 8th–19th Century*, New York: Asia Society Galleries and Japan House Gallery, 1984.

Ueda Machida, *Literary and Art Theories of Japan*, Cleveland: Case Western Reserve University Press, 1967.

Prints

Brown, Yu-Ying, *Japanese Book Illustration*, London: The British Library, 1988

Catalog of the Collection of Japanese Prints, 5 vols, Amsterdam: Rijksprentenkabinet/Rijksmuseum, 1977–90.

Hillier, Jack, *The Art of the Japanese Book*, 2 vols, London: Sotheby's, 1987.

Meech, Julia, 'Frank Lloyd Wright and The Art Institute of Chicago', *Orientations*, 23:6 (June 1992), 64–76.

Seckel, Dietrich, *Emakimono: The Art of the Japanese Printed Hand-scroll*, J. Maxwell Brownjohn (trans.), New York: Pantheon, 1972.

Sculpture

Kidder, J. Edward, *Masterpieces of Japanese Sculpture*, Tokyo: Bijutsu Shuppan-sha, 1961.

Mori Hisashi, *Japanese Portrait Sculpture*, W. Chie Ishibashi (trans. and adapt.), New York: Kodansha International, 1977.

Decorative and Applied Arts

Arikawa Hirozaku, *The Gō Collection of Netsuke*, New York: Kodansha International, 1983.

Ceramic Art of Japan, Seattle: Seattle Art Museum, 1972.

Compton, Walter *et al.*, *Nippon-Tō: Art Swords of Japan*, New York: Japan Society, 1976.

Cort, Louise Alison, *Shigaraki: Potter's Valley*, New York: Kodansha International, 1979.

Cort, Louise Alison, 'Japanese Ceramics and Cuisine', *Asian Art* 3:1 (Winter 1990), 9–37.

Davey, Neil K. and Susan G. Tripp, *The Garrett Collection of Japanese Art : Lacquer, Inro and Netsuke*, Dauphin Publishing, 1993.

Earle, Joe (ed.), *Shadows and Reflections. Japanese Lacquer Art from the Collection of Edmund J. Lewis at the Honolulu Academy of Arts*, Honolulu: Honolulu Academy of Arts, 1996.

Earle, Joe, 'Japanese Bronze Vessels: Fifteenth to Nineteenth Century', *Orientations* 27:11 (December 1996), 53–56.

Earle, Joe, *Netsuke: Fantasy and Reality in Japanese Miniature Sculpture*, Boston: Museum of Fine Arts Publications, 2001.

Famous Ceramics of Japan, series including the titles: *Nabeshima, Agano and Takatori, Folk Kilns* (2 vols), *Kakiemon, Imari, Tokoname, Oribe, Karatsu, Kiseto and*

Setoguro, Hagi and *Shino*, New York: Kodansha International, 1981–83.

Graham, Patricia J., 'Studio Potters and Porcelain Manufacture in Japan', *Orientations*, 27:11 (December 1996), 45–52.

Gribbin, Jill and David, *Japanese Antique Dolls*, Weatherhill: New York, 1984.

Hanio Akio, 'Japanese, Korean and Ryukyuan Lacquer in the Naumann Collection', *Orientations*, 31:8 (October 2000), 106–12.

Hanley, Susan B., *Everyday Things in Premodern Japan: The Hidden Legacy of Material Culture*, Berkeley: University of California Press, 1997.

Hauge, Victor and Takako, *Folk Tradition in Japanese Art*, New York: Kodansha International, 1978.

Hawley, W.M., *Japanese Swordsmiths. 13,500 names used by about 12,000 swordsmiths from 700 to 1900 AD*, 2 vols, Hollywood: W.M. Hawley, 1967.

Hayashiya Seizō, 'Tea Ceremony Utensils and the *Wabi* Aesthetic', *Orientations* 34:4 (April 2002), 46–47.

Hutt, Julia, *Japanese inrō*, in Far Eastern series, London: Victoria and Albert Museum, 1997.

Hutt, Julia, 'Masterpieces in Miniature: Aspects of Japanese Inro', *Orientations* 29:10 (November 1998), 55–59.

International Programs Department (ed.), *Mingei: Two Centuries of Japanese Folk Art*, Tokyo: The Japan Folk Craft Museum, 1995.

Itō Toshiko, *Tsujigahana*, Monica Bethe (trans.), New York: Kodansha International, 1985.

Izzard, Sebastian, *One Hundred Masterpieces from the Collection of Dr. Walter A. Compton*, New York: Christie's, 1992.

Jackson, Anna, *Japanese Country Textiles*, Far Eastern series, London: Victoria and Albert Museum, 1997.

Kanzan Satō, *The Japanese Sword*, Joe Earle (trans.), New York: Kodansha International, 1983.

Kennedy, Alan, *Japanese Costume*, Paris: Adam Biro, 1990.

Kinsey, Robert O., *Ojime*, New York: Harry N. Abrams, 1991.

Kuwayama, George, *Shippō: The Art of Enameling in Japan*, Los Angeles: Far Eastern Council, 1987.

Little, Stephen, 'Japanese Lacquer in the Collection of Edmund J. Lewis', *Orientations* 27:11 (December 1996), 37–44.

Lorber, Martin, 'Japanese Arms and Armour at The Metropolitan Museum of Art', *Orientations* 23:10 (October 1992), 48–54.

Matsumoto Kaneo, *Jōdai Gire: 7th and 8th Century Textiles in Japan from the Shōsō-in and Hōryū-ji*, Shigeta Kaneko and Richard L. Mellott (trans.), Kyoto: Shikosha, 1984.

Mayer Stinchecum, Amanda *et al.*, *Kosode: 16th–19th Century Textiles from the Nishimura Collection*, New York: Japan Society and Kodansha International, 1984.

McCallum, Toshiko M., *Containing Beauty: Japanese Bamboo Flower Baskets*, Los Angeles: University of California, 1988.

Miller, Roy Andrew, *Japanese Ceramics*, Tokyo: Charles E. Tuttle, 1960.

Mingei: Masterpieces of Japanese Folkcraft, New York: Kodansha International, 1991.

Münsterberg, Hugo, *The Folk Arts of Japan*, Rutland Vt: Charles E. Tuttle, 1958.

Ogawa Masataka *et al.*, *The Enduring Crafts of Japan: 33 Living National Treasures*, New York: Weatherhill, 1968.

Okada, Barbra Teri, *Netsuke: Masterpieces from the Metropolitan Museum of Art*, New York: The Metropolitan Museum of Art, 1982.

Rathbun, William Jay (ed.), *Beyond the Tanabata Bridge: Traditional Japanese Textiles*, New York: Thames and Hudson, 1993.

von Ragué, Beatrix, *A History of Japanese Lacquerwork*, Annie R. de Wasserman (trans.), Toronto: University of Toronto Press, 1976.

Robes of Elegance: Japanese Kimonos of the 16th–20th Centuries, Raleigh: North Carolina Museum of Art, 1988.

Robinson, Basil W., *Arms and Armour of Old Japan*, London: Her Majesty's Stationary Office, 1951.

Robinson, H. Russell, *Japanese Armor and Arms*, New York: Crown, 1969.

Sakamoto Kazuya, *Japanese Toys*, Charles A. Pomeroy (trans. and adapt.), Rutland Vt: Charles E. Tuttle, 1965.

Spectacular Helmets of Japan: 16th–19th Century, New York: Japan Society, 1985.

Yonemura, Anne, *Japanese Lacquer*, Washington DC: Freer Gallery, 1979.

Watt, James C.Y. and Barbara Brennan Ford, *East Asian Lacquer: The Florence and Herbert Irving Collection*, New York: Metropolitan Museum of Art, 1991.

Yanagi Sōetsu, *The Unknown Craftsman*, Bernard Leach (adapt.), Tokyo: Kodansha International, 1972.

Women

Fister, Pat, *Japanese Women Artists: 1600–1900*, Lawrence: Spencer Museum of Art, 1988.

Weidner, Marsha ed., *Flowering in the Shadows: Women in the History of Chinese and Japanese Painting*, Honolulu: Honolulu Academy of Arts, 1990.

Jōmon, Yayoi, and Kofun Periods

Aikens, C. Melvin and Takayama Higuchi, *Prehistory of Japan*, New York: Academic Press, 1982.

Barnes, Gina L., *Protohistoric Yamato: Archaeology of the First Japanese State*, Ann Arbor: Center for Japanese Studies and the Museum of Anthropology of the University of Michigan, 1988.

Cunningham, Michael, 'Notes on Early Japanese and Korean Ceramics', *Orientations* 26:8 September 1995, 91–96.

Gorman, Michael S.F., *The Quest for Kibi and the True Origins of Japan*, Bangkok: Orchid Press, 1999.

Kaner, Simon, 'Contexts for Jomon Pottery', *Orientations* 33:2

(February 2002), 35-40.

Kenrick, Douglas M., *Jomon of Japan : the World's Oldest Pottery*, London: Kegan Paul International, 1995.

Kidder, J. Edward, *Prehistoric Japanese Arts: Jōmon Pottery*, Tokyo: Kodansha International, 1968.

Kidder, J. Edward, *The Birth of Japanese Art*, New York: Praeger, 1965.

Kidder, J. Edward, *Early Japanese Art*, Princeton: Van Nostrand Reinhold, 1964.

Kiyotari Tsuboi (ed.), *Recent Archaeological Discoveries in Japan*, Gina L. Barnes (trans.), Tokyo: The Centre for East Asian Cultural Studies, 1987.

Kobayashi Tatsuo and Simon Kaner, *Jomonesque Japan*, Oxford: Oxbow Books, forthcoming.

Miki Funio, *Haniwa*, Gina Lee Barnes (trans.), New York: Weatherhill, 1974.

Mizoguchi Koji, *An Archaeological History of Japan: 30,000 BC to AD 700*, Philadelphia: University of Pennsylvania Press, 2002.

Pearson, Richard J. *et al.* (eds.), *Windows on the Japanese Past*, Ann Arbor: University of Michigan Press, 1986.

Pearson, Richard *et al.*, *Ancient Japan*, New York: Braziller, 1992.

The Rise of a great Tradition: Japanese Archaeological Ceramics from the Jōmon through Heian Periods (10,500 B.C.–A.D. 1185), New York: Agency for Cultural Affairs, Government of Japan and Japan Society, 1990.

Asuka, Hakuhō, and Nara Periods

Kaneko S., trans., *The Treasure of the Shosoin*, Tokyo: Asahi Shimbun, 1965.

Kurata Bunsaku, *Hōryū-ji: Temple of the Exalted Law*, W. Chie Ishibashi (trans.), New York: Japan Society, 1981.

Sugiyama Jirō, *Classic Buddhist Sculpture*, Samuel Crowell Morse (trans. and adapt.), New York: Kodansha International, 1982.

Suzuki Kakichi, *Early Buddhist Architecture in Japan*, Mary N. Parent and Nancy Shatzman Steinhardt (trans.), New York: Kodansha International, 1980.

Tokubetsu Ten – Tempyō: Nara Kokuritsu Hakubutsukan (*Special Exhibition – Tempyō: The Magnificent Heritage from the Days of the Great Buddha*), Nara: Nara National Museum, 1998.

Warner, Langdon, *Japanese Sculpture of the Tempyo Period*, Cambridge Mass.: Harvard University Press, 1959.

Heian Period

Carpenter, John T., *Fujiwara no Yukinari and the Development of Heian Court Calligraphy*, Phd Thesis, New York: Columbia University, 1997.

Cunningham, Michael R., 'Spiritual Vows of Compassion: Eleven-headed Kannon Images from the Nara National Museum', *Orientations*, 29:8 (September 1998), 76–83.

Hempel, Rose, *The Golden Age of Japan: 794–1192*, Katherine Watson (trans.), New York: Rizzoli International, 1983.

Ishida Hisatoyo, *Esoteric Buddhist Painting*, E. Dale Saunders (trans. and adapt.), New York: Kodansha International, 1987.

Kita, Sandy, 'A Court Painting of a *Fast Bull* in The Cleveland Museum of Art', *Orientations* 22:9 (September 1991), 47–55.

Kurata Bunsaku and Tamura Yoshiro (eds), *Art of the Lotus Sutra*, Tokyo: Kōsei Publishing, 1987.

Morris, Ivan, *The Tale of Genji Scroll*, Tokyo: Kodansha International, 1971.

Morris, Ivan, *The World of the Shining Prince*, London: Oxford University Press, 1964.

Okazaki Jōji, *Pure Land Buddhist Painting*, Elizabeth ten Grotenhuis (trans. and adapt.), New York: Kodansha International, 1977.

Rosenfield, John, *The Japanese Art of the Heian Period: 794–1185*, New York: Asia Society, 1967.

Tanabe, Willa J., *Paintings of the Lotus Sutra*, Tokyo: Weatherhill, 1988.

Yiengpruksawan, Mimi, 'Monkey Magic: How the "Animals" Scroll Makes Mischief with Art Historians', *Orientations* 31:3 (March 2000), 74–83.

Kamakura, Nanbokuchō, and Muramachi Periods

Berry, Mary Elizabeth, *The Culture of Civil War in Kyoto*, Berkeley: University of California Press, 1994.

Brock, Karen L. *Tales of Gishō and Gangyō: Editor, Artist and Audience in Japanese Picture Scrolls*, Phd thesis, Princeton: Princeton University, 1984.

Carpenter, John T., 'Calligraphy as Self-Portrait: Poems and Letters by Retired Emperor Gotoba', *Orientations* 33:2 (February 2002), 41-49.

Collcutt, Martin, *Five Mountains: The Rinzai Zen Monastic Tradition in Medieval Japan*, Cambridge Mass.: Harvard University Press, 1981.

Court and Samurai in an Age of Transition, New York: Japan Society, 1990.

Cunningham, Michael *et al.*, *Ink Paintings and Ash-glazed Ceramics: Medieval Calligraphy, Painting, and Ceramic Art from Japan and Korea*, Cleveland: Cleveland Museum of Art, 2000.

ten Grotenhuis, Elizabeth, *The Revival of the Taima Mandala in Medieval Japan*, New York: Garland Publishing, 1985.

ten Grotenhuis, Elizabeth, 'Visions of a Transcendent Realm: Pure Land Images in the Cleveland Museum of Art', *Bulletin of the Cleveland Museum of Art* 78:7 (November 1991), 274–300.

Hall, John W. and Toyoda Takeshi (eds), *Japan in the Muromachi Age*, Berkeley: University of California Press, 1977.

Harris, Victor and Ken Matsushima, *Kamakura: The Renaissance of Japanese Sculpture 1185–1333*, London: The British Museum, 1991.

Kanazawa Hiroshi, *Japanese Ink Painting: Early Zen Masterpieces*, Barbra Ford, (trans. and adapt.), New York: Kodansha International, 1979.

Klein, Bettina, 'Japanese Kinbyōbu: The Gold-leafed Folding Screens of the Muromachi Period', *Artibus Asiae* 45:1 (1984), 5–34 and 45:2/3 (1984), 101–74.

Levenson, Jay A., ed., *Circa 1492: Art in the Age of Exploration*, Washington DC: National Gallery of Art, 1991.

Parker, Joseph D., *Zen Buddhist Landscape Arts of Early Muromachi Japan*, Albany, N.Y: State University of New York Press, 1999.

Watanabe Akiyoshi, *Of Water and Ink*, Detroit: Detroit Institute of Arts, 1986.

Yasuhiko Murai, 'The Development of Chanoyu: Before Rikyū', in *Tea In Japan: Essay on the History of Chanoyu*, Paul Varley and Kumakuro Isao (eds), Honolulu: University of Hawaii Press, 1989.

Momoyama Period

Cooper, Michael *et al.*, *The Southern Barbarians*, New York: Kodansha International, 1971.

Cort, Louise Alison, *Seto and Mino Ceramics*, Washington DC: Freer Gallery, 1992.

Cunningham, Michael, *The Triumph of Japanese Style: 16th Century Art in Japan*, Cleveland: Cleveland Museum of Art, 1991.

Elison, George and Bardwell L. Smith (eds), *Warlords, Artists and Commoners: Japan in the Sixteenth Century*, Honolulu: University of Hawaii Press, 1981.

Fujioka Ryōichi *et al.*, *Tea Ceremony Utensils*, Louise Alison Cort (trans. and adapt.), New York: Weatherhill, 1973.

Hashimoto Fumio, *Architecture in the Shoin Style*, H. Mack Horton (trans. and adapt.), New York: Kodansha International, 1981.

Hayashiya Seizo *et al.*, *Chanoyu: Japanese Tea Ceremony*, New York: Japan Society, 1979.

Hinago Motoo, *Japanese Castles*, William H. Coaldrake (trans.), New York: Kodansha International, 1986.

Kirby, John B., *From Castle to Teahouse*, Rutland Vt: Charles E. Tuttle, 1962.

Kuroda Taizō, 'Reception and Variation of Chinese-style Ink Painting in Japan and the Role of Hasegawa Tōhaku', *Orientations*, 27:2 (February 1996), 46–50.

Meech-Pekarik, Julia (ed.), *Momoyama: Japanese Art in the Age of Grandeur*, New York: The Metropolitan Museum of Art, 1975.

Murase Miyeko, *Byōbu, Japanese Screens from New York Collections*, New York: Asia Society, 1971.

Sadler, A.L., *Cha-no-yu: The Japanese Tea Ceremony*, Rutland Vt: Charles E. Tuttle:, 1962.

Takeda Tsuneo, *Kanō Eitoku*, H. Mack Horton and Catherine Kaputa (trans.), New York: Kodansha International, 1977.

Varley, H. Paul and Isao Kumakura (eds), *Tea in Japan*, Honolulu: University of Hawaii Press, 1989.

Edo Period

Addiss, Stephen, *Zenga and Nanga: Selections from the Kurt and Millie Gitter Collection*, New Orleans: New Orleans Museum of Art, 1976.

Addiss, Stephen, *Obaku: Zen Painting and Calligraphy*, Lawrence CA: Spencer Museum of Art, 1978.

Addiss, Stephen and G. Cameron Hurst III, *Samurai Painters*, New York: Kodansha International, 1983.

Addiss, Stephen, *The World of Kameda Bōsai*, New Orleans: New Orleans Museum of Art/University Press of Kansas, 1984.

Addiss, Stephen *et al.*, *Japanese Ghosts and Demons*, New York: Braziller, 1985

Addiss Stephen *et al.*, *Japanese Quest for a New Vision*, Lawrence CA: Spencer Museum of Art, 1986.

Addiss, Stephen, *Tall Mountains and Flowing Waters: The Arts of Uragami Gyokudō*, Honolulu: University of Hawaii Press, 1987.

Becker, Johanna, *Karatsu Ware*, New York: Kodansha International, 1986.

Bogel, Cynthea J. and Israel Goldman, *Hiroshige: Birds and Flowers*, New York: Braziller, 1988.

The Burghley Porcelains: an exhibition from the Burghley House collection and based on the 1688 inventory and 1690 Devonshire schedule, New York: Japan Society, 1986.

Cahill, James, *Scholar Painters of Japan*, New York: Asia Society, 1972.

Cahill, James, *Yosa Buson and Chinese Painting*, Berkeley: Institute of East Asian Studies, 1982.

Cahill, James, *Sakaki Hyakusen and Early Nanga Painting*, Berkeley: Institute of East Asian Studies, 1983.

Clark, Tim, 'Katsukawa Shunshō and the Revolution in Actor Portraiture', *Orientations* 23:6 (June 1992), 53–63.

Clark, Timothy *et al.*, *The Dawn of the Floating World 1650–1765: Early Ukiyo-e Treasures from the Museum of Fine Arts, Boston*, London: Royal Academy of Arts, 2002.

French, Calvin L., *The Poet-Painters: Buson and His Followers*, Ann Arbor: University of Michigan Museum, 1974.

French, Cal, *Shiba Kōkan: Artist, Innovator and Pioneer in the Westernization of Japan*, Tokyo: Weatherhill, 1974.

French, Cal, *Through Closed Doors: Western Influences on Japanese Art (1639–1853)*, Rochester Mich: Oakland University Press, 1977.

From the Suntory Museum of Art – Autumn Grasses and Water: Motifs in Japanese Art, New York: Japan Society, 1983.

Fujioka Michio, *Kyoto Country Retreats*, Bruce Coates (trans.),

New York: Kodansha International, 1983.

Gentles, Margaret O., *The Clarence Buckingham Collection of Japanese Prints: Volume 2, Harunobu, Koryusai, Shigemasa, Their Followers and Contemporaries*, Chicago: Art Institute of Chicago, 1965.

Gluckman, Dale Carolyn and Sharon Sadako Takeda (eds), *When Art Became Fashion: Kosode in Edo Period Japan*, New York: Weatherhill, 1992.

Graham, Patricia J., 'The Development of an Architectural Setting for the Japanese *Sencha* Tea Ceremony', *Orientations* 22:9 (September 1991), 65–75.

Graham, Patricia J., 'Japanese Popular Ceramics in The Nelson-Atkins Museum of Art', *Orientations* 25:9 (September 1994), 32–39.

Grilli, Elise, *The Art of the Japanese Screen*, New York: Weatherhill, 1970.

Gropius, Walter *et al.*, *Katsura*, New Haven: Yale University Press, 1960.

Gunsaulus, Helen C., *The Clarence Buckingham Collection of Japanese Prints: Volume 1, The Primitives*, Chicago: Art Institute of Chicago, 1955.

Hickman, Money L. and Yasuhiro Satō, *The Paintings of Jakuchū*, New York: Asia Society Galleries, 1989.

Hillier, Jack, *The Uninhibited Brush: Japanese Art in the Shijō Style*, London: HM Moss, 1974.

Itō Teiji *et al.*, *Katsura*, Tokyo: Shinkenshiku-sha, 1983.

Jenkins, Donald, *Ukiyo-e Prints and paintings: The Primitive Period, 1680–1745*, Chicago: Art Institute of Chicago, 1971.

Kawahara Masahiko, *The Ceramic Art of Ogata Kenzan*, Richard L. Wilson (trans. and adapt.), New York: Kodansha International, 1985.

Keyes, Roger S. and Keiko Mizushima, *The Theatrical World of Osaka Prints*, Boston: David R. Godine, 1973.

Keyes, Roger S., *The Art of Surimono: Privately Published Japanese Woodblock Prints in the Chester Beatty Library, Dublin*, 2 vols, London: Sotheby's, 1985.

Lane, Richard, *Images from the Floating World: The Japanese Print*, New York: Dorset, 1978.

Lane, Richard, *Hokusai*, London: Barrie and Jenkins, 1989.

Lillehoj, Elizabeth, 'Flowers of the Capital: Imperial Sponsorship of Art in Seventeenth Century Kyoto', *Orientations* 27:8 (September 1996), 57–69.

Link, Howard A., *The Theatrical Prints of the Torii Masters*, Honolulu: Honolulu Academy of Arts, 1977.

Link, Howard A. *et al.*, *Exquisite Visions: Rimpa Paintings from Japan*, Honolulu: Honolulu Academy of Arts, 1980.

Masterworks of Ukiyo-e, series in 11 volumes, New York: Kodansha International, 1967–69.

Maucuer, Michel, 'Kyoto Ceramics of the Late Edo Period in the Henri Cernuschi Collection', *Orientations* 23:8 (August 1992), 37–41.

Meech Pekarik, Julia, 'The Artist's View of Ukifune', in *Ukifune*, Andrew Pekarik (ed.), New York: Columbia University Press, 1982.

Nagata Seiji, *Katsushika Hokusai Ten* (*Hokusai Katsushika Exhibition*, Tokyo: Sansai Shinsha Pub. Co., 1984.

Naito Akira and Nishikawa Takeshi, *Katsura, A Princely Retreat*, Charles S. Terry (trans.), New York: Kodansha International, 1977.

Narazaki Muneshige (ed.), *Ukiyo Masterpieces in European Collections*, New York: Kodansha International, 1988–90.

Nosco, Peter (ed.), *Confucianism and Tokugawa Culture*, Honolulu: University of Hawaii Press, 1997.

Ōkyo and the Maruyama Shijō School of Japanese Painting, St Louis: St Louis Art Museum, 1980.

Rathbun, William, 'Seventeenth Century Japanese Blue-and-White Porcelains', *Orientations* 25:8 (August 1994), 56–62.

Rimer, Thomas *et al.*, *Shisendo: Hall of the Poetry Immortals*, New York: Weatherhill, 1991.

Robinson, B.W., *Kuniyoshi: The Warrior-Prints*, Ithaca NY: Cornell University Press, 1982.

Pekarik, Andrew J., *Japanese Lacquer, 1600–1900*, New York: The Metropolitan Museum of Art, 1980.

Pekarik, Andrew J., *The Thirty-six Immortal Women Poets*, New York: Braziller, 1991.

Sato Masahiko, *Kyoto Ceramics*, Anne Ono Towle and Usher P. Coolidge (trans. and adapt.), New York: Weatherhill, 1973.

Schwab, Dean J., *Osaka Prints*, New York: Rizzoli International, 1989.

Screech, Timon, *The Shogun's Painted Culture: Fear and Creativity in the Japanese States 1760–1829*, London: Reaktion Books, 2000.

Shimizu Yoshiaki and Susan E. Nelson, *Genji: The World of a Prince*, Bloomington: Indiana University Art Museum, 1982.

The Shogun Age Exhibition, Tokyo: The Shogun Age Exhibition Committee, 1983.

Smith, Henry D., III, *Hokusai: One Hundred Views of Mt Fuji*, New York: Braziller, 1988.

Smith, Henry D., III and Amy Poster, *One Hundred Views of Edo*, New York: Braziller, 1986.

Takeuchi, Melinda, *Taiga's True Views: The Language of Landscape Painting in Eighteenth Century Japan*, Stanford: Stanford University Press, 1992.

Tanahashi Kazuaki, *Enku*, Boulder: Shambhala, 1982.

The Tokugawa Collection: The Japan of the Shoguns, Montreal: Montreal Museum of Fine Arts, 1989.

Ueda Makoto, *Literary and Art Theories of Japan*, Cleveland: Case Western Reserve University Press, 1967.

Ulak, James T., 'Views Beneath the Surface: Aspects of Edo Period Lacquer in the Barbara and Edmund Lewis Collection', *Orientations* 23:3 (March 1992), 57–64.

Undercurrents in the Floating World: Censorship and Japanese Prints, New York: Asia Society Galleries, 1991.

Waterhouse, D.B., *Harunobu and His Age: The Development of Colour Printing*, London: The British Museum, 1964.

Watson, William (ed.), *The Great Japan Exhibition: Art of the Edo Period 1600–1868*, London: Royal Academy of Arts, 1981.

Welch, Matthew, 'Otsu-e: Japanese Folk Paintings from the Harriet and Edson Spencer Collection', *Orientations* 25:10 (October 1994), 50–57.

Wilson, Richard L., *The Art of Ogata Kenzan*, New York: Weatherhill, 1991.

Wheelwright, Carolyn (ed.), *Word in Flower: The Visualization of Classical Literature in Seventeenth Century Japan*, New Haven: Yale University Art Gallery, 1989.

Yamane Yūzō *et al.*, *Rimpa Art from the Idemitsu Collection, Tokyo*, London: British Museum Press, 1998.

Zolbrod, Leon M., *Haiku Painting*, New York: Kodansha International, 1982.

Meiji, Taishō, Shōwa, and Heisei Periods

Addiss, Stephen, *Old Taoist: The Life, Art and Poetry of Kodōjin (1865–1944)*, New York: Columbia University Press, 2000.

Baekland, Frederick, *Imperial Japan: The Art of the Meiji Era (1868–1912)*, Ithaca NY: Herbert F. Johnson Museum of Art, 1980.

Baekland, Frederick, 'Modern Japanese Studio Ceramics, the First Generations of Potters', *Orientations* 18:10 (October 1987).

Baekland, Frederick, 'Modern Japanese Studio Ceramics, Developments in Traditional Chinese, Japanese and Korean Ceramics', *Orientations* 19:6 (June 1988).

Berry, Paul, 'Meaning and Multiplicity: The Daruma Images of Nantenbo', *Orientations* 33:7 (September 2002), 71–76.

Bognar, Botand, *Contemporary Japanese Architecture*, New York: Van Nostrand Reinhold, 1985.

Bognar, Botand, *New Japanese Architecture*, New York: Rizzoli International, 1991.

Brown, Kendall H. and Hollis Goodall-Cristante, *Shin-hanga: New Prints in Modern Japan*, Los Angeles: Los Angeles County Museum of Art, 1996.

Cardozo, Sidney and Masaaki Hirano, *The Art of Rosanjin*, New York: Kodansha International, 1987.

Coben, Lawrence A. and Dorothy C. Ferster, *Japanese Cloisonné: History, Technique and Appreciation*, New York: Weatherhill, 1982.

Earle, Joe, 'Marketing the Marvellous: The Promotion of Textiles and Ceramics in the Later Meiji Era', *Orientations* 33:7, 63–70.

Emerson-Dell, Kathleen, 'Beyond the Exotic: Reflections on Later Japanese Decorative Arts in the Walters Art Gallery', *Orientations* 22:4 (April 1991), 43–50.

Fraser, James, *Japanese Modern: Graphic Design between the Wars*, , San Francisco: Chronicle, 1996.

Guth, Christine M.E., *Art, Tea and Industry: Masuda Takashi and the Mitsui Circle*, Princeton: Princeton University Press, 1993.

Harada Minoru, *Meiji Western Painting*, Akiko Murakata and Bonnie F. Abiko (trans. and adapt.), New York: Weatherill, 1974.

Harris, Victor, 'Japanese Imperial Craftsmen of the Meiji Period', *Orientations* 25:9 (September 1994), 50–56.

Hiesinger, Kathryn B. and Felice Fischer, *Japanese Design: A Survey Since 1950*, New York: Harry N. Abrams, 1995.

Holborn, Mark, *Beyond Japan: A Photo Theatre*, London: Jonathan Cape, 1991.

Hosoe Eikoh, *Ba Ra Kei Ordeal by Roses*, New York: Aperture, 1985 (reprint).

Impey, Oliver and Malcolm Fairley, *The Dragon King of the Sea: Japanese Decorative Art of the Meiji Period from the John R. Young Collection*, Oxford: Ashmolean Museum, 1991.

Japan Photographers Association, *A Century of Japanese Photography*, New York: Pantheon, 1980.

Jenkins, Donald, *Images of a Changing World: Japanese Prints of the Twentieth Century*, Portland Or: Portland Museum of Art, 1983.

Johnson, Margaret K. and Dale K. Hinton, *Japanese Prints Today*, Toku: Shufutomo, 1980.

Koplos, Janet, *Contemporary Japanese Sculpture*, New York: Abbeville, 1991.

Kung, David, *The Contemporary Artist in Japan*, Honolulu: East-West Center, 1966.

Leach, Bernard, *Hamada: Potter*, New York: Kodansha International, 1975.

Lieberman, William, *The New Japanese Painting and Sculpture*, New York: The Museum of Modern Art, 1966.

McCarty Cara and Matilda McQuaid (eds), *Structure and Surface: Contemporary Japanese Textiles*, New York: The Museum of Modern Art, 1998.

Meech-Pekarik, Julia, *The World of the Meiji Print: Impressions of a New Civilization*, New York: Weatherhill, 1986.

Merritt, Helen, *Modern Japanese Woodblock Prints: The Early Years*, Honolulu: University of Hawaii Press, 1990.

Morioka Michiyo and Paul Berry, *Modern Masters of Kyoto: The Transformation of Japanese Painting Traditions, Nihonga from the Griffith and Patricia Way Collection*, University of Washington Press: Seattle, 1999.

Munroe, Alexandra, *Contemporary Japanese Art in America: Arita, Nakagawa, Sugimoto*, New York: Japan Society, 1987.

Munroe, Alexandra, *Japanese Art after 1945: Scream Against the Sky*, New York: Harry N. Abrams, 1994.

Munsterberg, *The Art of Modern Japan*, New York: Hacker, 1978.

Rimer, Thomas J. and Gerald D. Bolas, *Paris in Japan: the Japanese Encounter with European Painting*, Tokyo: Japan Foundation, 1987.

Rosenfield, John M., 'Western-style Painting in Early Meiji Period and Its Critics', in *Tradition and Modernization in Japanese Culture*, Donald H. Shively (ed.), Princeton:

Princeton University Press, 1971.

de Sabato Swinton, Elizabeth, *The Graphic Art of Onchi Kōshirō*, New York: Garland, 1986.

de Sabato Swinton, Elizabeth, *In Battle's Light: Woodblock Prints of Japan's Early Modern Wars*, Worcester Mass.: Worcester Art Museum, 1991.

Sanders, Herbert H., *The World of Japanese Ceramics*, Tokyo: Kodansha International, 1967.

Schaap, Robert (ed.), *Japanese Art in Transition*, Haags Gemeentemuseum:, 1987.

Smith, Henry D., III, *Kiyochika: Artist of Meiji Japan*, Santa Barbara Museum of Art: Santa Barbara, 1988.

Smith, Lawrence, *The Japanese Print Since 1900*, New York: Harper & Row, 1983.

Smith, Lawrence, *Contemporary Japanese Prints*, New York: Harper & Row, 1985.

Statler, Oliver, *Modern Japanese Prints*, Rutland Vt: Charles E. Tuttle, 1956.

Stewart, David B., *The Making of a Modern Japanese Architecture: 1868 to the Present*, New York: Kodansha International, 1988.

Suzuki Hiroyuki *et al.*, *Contemporary Architecture of Japan 1958–1984*, New York: Rizzoli International, 1985.

Weisberg, Gabriel P. *et al.*, *Japonisme: Japanese Influence on French Art 1854–1910*, Cleveland: Cleveland Museum of Art, 1975.

Weston, Victoria, *The Rise of Modern Japanese Art*, Greenwich: Shorewood Fine Art Books, 1999.

The Woodblock and the Artist: The Life and Work of Shiko Munakata, New York: Kodansha International, 1991.

Words in Motion. Modern Japanese Calligraphy, Tokyo: Yomiuri Shimbun, 1984.

Yonemura, Ann, *Yokohama Prints from Nineteenth Century Japan*, Washington DC: Smithsonian, 1986.

Zukowsky, John (ed.), *Japan 2000 : Architecture and Design for the Japanese Public*, Munich: Prestel, 1998.

Photograph Credits

Laurence King Publishing and Pearson Prentice Hall wish to thank the libraries, museums, galleries, and private collectors named in the picture captions for permitting the reproduction of works of art in their collections and for supplying the necessary photographs. Photographs from other sources are gratefully acknowledged below. In all cases, every effort has been made to contact the copyright holders, but should there be any errors or omissions the publishers would be pleased to insert the appropriate acknowledgment in any subsequent edition of this book. Each item below is identified by figure number.

Agency for Cultural Affairs, Fukuoka: 17; Art Institute of Chicago. Gift of Joseph and Helen Regenstein Foundation (1959.552): 2 and 233; Asuka-en, Nara: 75, 89, 96, 97, 105, 116, 119, 160, 162, 165, 201, 218, 220, 221; Benrido, Tokyo: 42, 43, 56, 91, 101, 103, 124, 149, 152, 153, 155, 156, 158, 159, 166, 169, 177, 181, 183, 187, 188, 194, 199, 229, 242, 246-248, 252, 258, 294, 300, 301, 352, 356, 357, 435; Bildarchiv Preussischer Kulturbesitz /Jürgen Liepe: 308, 348; Bridgeman Art Library, London/Horyuji Treasure House, Horyuji: 90; China Pictorial, Beijing: 92; Chusonji, Iwate: 131; Sheldan C. Collins, New York: 316; CORBIS/ Sakamoto Photo Research Laboratory: 78, 170, 200, 307, 365; CORBIS / Angelo Hornak: 409; Courtesy Eikoh Hosoe: page 343; Courtesy Dr Kurt A Gitter, New Orleans: 396; Heibonsha Photo Service: 65; Imperial Household Agency: page 13; The Institute for Art Research, Tokyo: 51; Irie Taikiti: 93, 106, 151; Japanese National Tourist Organisation: 273; Japan Society, New York by permission of International Chado Culture Foundation, Urasenke Konnichian, Tokyo: 415, 416; Jodo Shinshi Hongwanji-ha: 235, 235, Junkichi Mayuyama, Tokyo: 66, 68, 69, 72, 87, 154, 173, 175, 241, 263; Courtesy Kajima Institute Publishing Company Ltd.: 407; Kamo Shrine, Shimane: page 235; Kodansha Ltd, Tokyo: 63, 81, 164, 182, 267; Korakudo: 254; Kumamoto Prefecture Board of Education, photo Misawa Hiroaki:

39; Kurihara Tetsuo: 359; Kyoto National Museum: 58, 129, 243, 264, 283, 303, 304, 400; Los Angeles County Museum of Art: 375 (Photograph © 2004 Museum Associates/LACMA), 455 (Photograph © 2004 Museum Associates/LACMA); Paul Macapia, Seattle: 309, 339; Manju-in, Kyoto: 169; Masuda Akihisa: 403-406; The Metropolitan Museum of Art, New York: 204 and page 166 (Photo © 1991), 234 (Photo © 1987), 349 and page 272 (Photo © 1995), 350 (Photo © 1979); Courtesy Betty Iverson Monroe: 391, 392 (Collection Yabumoto, Osaka); Nara National Cultural Properties Research Institute: 44, 46 (Nara Municipal Board of Education © Chisao Shigemori), Otto E. Nelson, New York: 317, 396, 413; Robert Newcombe: 340; Nijo Castle Office: 277; Okamoto Shigeo: 279, 353; Clifton Olds, Brunswick, ME: 250, 251, 280, 408; Osaka Prefectural Board of Education: 398; Saidß Sadamu: 466; Sakamoto Photo Research Laboratory: 14, page 40, 50, 61, 76, 80, 82, 83, 84, 85, 88, 94, 98, 99, 100, 102, 104, 108-115, 118, 120, 122, 123, page 100, 126, 141, 142, 150, 163, 172, 180, 184-186, 195-197, 212, 214-217, 219, 222, 223, 225, 226, 249, 266, 268, 272, 286, 295, 329, 367, 382, 384, 385, 395, 431, 432, 439; Sennyuji, Kyoto: 360; Shibata Akisuke: 262; Shogakukan: 179; Shirono Seiji: 136; Steve Steckly Photography, Portland: 397; Takamara Tadashi: 422; Ian Thomas, London: 347; TNM Image Archives Source: http://TnmArchives.jp/: 9, 10, 11 (Courtesy Mr. Echigoya, Aomoriken), 13, 20, 23, 27, 29, 32, 36, 37, 38, 130, 132, 135, 138, 145, 189-191, 198, 202, 208, 224, 227, 228, 230-232, 245, 253, 259-261, 265, 281, 288, 296, 299, 302, 319-322, 325, 328, 331, 332, 334, 372, 381, 386, 389, 393, 419, 421, 433, 436, 438, 442, 445, 449; Tokyo National Research Institute of Cultural Properties: 446; Wakamiyo-cho Educational Commission: 40; Yoshio Watanabe, Tokyo: 60, 407; Yukio Futugawa: 24, 278

Illustrations on pages 86, 115, 134, 220, 245, 283 were drawn by Lydia Gershey.

Text Credits

We gratefully acknowledge the following for permission to use these quoted materials:

Addiss, Stephen, "*Haiga*: the Haiku-Painting Tradition", *Orientations*, 26: 2 (February 1995), pp. 28-37, reprinted with the permission of the publisher and translator; Henderson, Harold G., *An Introduction to Haiku*, p. 114, © 1958 by Harold G. Henderson. Used by permission of Doubleday, a division of Random House, Inc.; McCullough, Helen Craig, *Tales of Ise: Lyrical Episodes from Tenth Century Japan*, translated by Helen Craig McCullough (Stanford University Press, 1968), pp. 73-74, © 1968 by the Board of Trustees of the Leland Stanford Jr. University, reprinted with the permission of the publisher;

McCullough, William H. and Helen Craig McCullough, *A Tale of Flowering Fortunes: Annals of Japanese Aristocratic Life in the Heian Period* (Stanford University Press, 1980), pp. 553-557, © 1980 by the Board of Trustees of the Leland Stanford Jr. University, reprinted with the permission of the publisher; Takeuchi, Melinda, "True" Views: Taiga's *Shinkeizu* and the Evolution of Literati Painting Theory in Japan", *Journal of Asian Studies* (February 1989), pp. 16-20, reprinted with permission of the Association for Asian Studies, Inc.; Waterhouse, D. B., *Harunobu and His Age: The Development of Colour Printing* (The British Museum, 1964), p. 85, reprinted with the permission of the publisher.

Index